PAINTING AND SCULPTURE IN THE MUSEUM OF MODERN ART
1929–1967

ALFRED H. BARR, JR.

PAINTING AND SCULPTURE
IN THE MUSEUM OF MODERN ART
1929–1967

The Museum of Modern Art, New York

TO
MRS. SIMON GUGGENHEIM
1877–1970

This volume is dedicated
by the Trustees of The Museum of Modern Art
in profound gratitude for the unequaled generosity,
concern for excellence, and modesty of spirit with which, over three decades,
she yearly enriched the Museum's Collection of Painting and Sculpture.

WORKS ACQUIRED WITH THE MRS. SIMON GUGGENHEIM FUND

Jean Arp: *Floral Nude*
Peter Blume: *The Eternal City*
Umberto Boccioni: *The City Rises*
Constantin Brancusi: *Socrates*
Georges Braque: *Woman with a Mandolin*
Alexander Calder: *Black Widow*
Marc Chagall: *I and the Village*
Robert Delaunay: *Simultaneous Contrasts: Sun and Moon*
Charles Despiau: *Assia*
Jean Dubuffet: *Business Prospers*
Jean Dubuffet: *Joë Bousquet in Bed*
James Ensor: *Masks Confronting Death*
Jacob Epstein: *The Rock Drill*
Paul Gauguin: *Still Life with Three Puppies*
Julio Gonzalez: *Woman Combing Her Hair*
Edward Hopper: *Gas*
Wassily Kandinsky: *Panel* (3)
Wassily Kandinsky: *Panel* (4)
Paul Klee: *Portrait of an Equilibrist*
Gaston Lachaise: *Standing Woman*
Roger de La Fresnaye: *The Conquest of the Air*
Fernand Léger: *The Baluster*
Fernand Léger: *The Divers, II*
Fernand Léger: *Three Musicians*
Fernand Léger: *Three Women*
Jacques Lipchitz: *Man with a Guitar*
Jacques Lipchitz: *Mother and Child, II*
Richard Lippold: *Variation Number 7: Full Moon*
Seymour Lipton: *Manuscript*
Aristide Maillol: *The River*
Marino Marini: *Miracle*
Henri Matisee: *The Back, I*
Henri Matisse: *The Back, II*
Henri Matisse: *The Back, III*
Henri Matisse: *The Back, IV*
Henri Matisse: *Gourds*
Henri Matisse: *Piano Lesson*

Henri Matisse: *The Red Studio*
Henri Matisse: *The Rose Marble Table*
Joan Miró: *Dutch Interior, I*
Joan Miró: *Mural Painting*
Amedeo Modigliani: *Caryatid*
Amedeo Modigliani: *Reclining Nude*
Piet Mondrian: *Pier and Ocean*
Claude Monet: *Water Lilies* (single canvas)
Claude Monet: *Water Lilies* (triptych)
Henry Moore: *Large Torso: Arch*
Reuben Nakian: *Hiroshima*
Louise Nevelson: *Atmosphere and Environment, I*
Pablo Picasso: *Baboon and Young*
Pablo Picasso: *Girl before a Mirror*
Pablo Picasso: *Goat Skull and Bottle*
Pablo Picasso: *Night Fishing at Antibes*
Pablo Picasso: *Seated Bather*
Pablo Picasso: *She-Goat*
Pablo Picasso: *Still Life with Liqueur Bottle*
Pablo Picasso: *Three Musicians*
Pablo Picasso: *Woman by a Window*
Arnaldo Pomodoro: *Sphere, I*
George Rickey: *Two Lines—Temporal I*
Auguste Rodin: *St. John the Baptist Preaching*
Mark Rothko: *Red, Brown, and Black*
Henri Rousseau: *The Sleeping Gypsy*
David Smith: *History of LeRoy Borton*
David Smith: *Zig III*
Yves Tanguy: *Multiplication of the Arcs*
Pavel Tchelitchew: *Hide-and-Seek*
Thomas Wilfred: *Lumia Suite, Op. 158*

The following works were acquired between July 1967 and the
date of publication:
Henri Matisse: *Memory of Oceania*
Joan Miró: *Song of the Vowels*
Tony Smith: *Cigarette*

v

PATRONS OF THE COLLECTIONS

Larry Aldrich
Mr. and Mrs. Walter Bareiss
LeRay W. Berdeau
Lillie P. Bliss
Mr. and Mrs. Gordon Bunshaft
Mr. and Mrs. William A. M. Burden
Walter P. Chrysler, Jr.
Stephen C. Clark
Mr. and Mrs. Ralph F. Colin
Katherine S. Dreier
Mr. and Mrs. Allan D. Emil
Julia Feininger
Mrs. Bernard F. Gimbel
Philip L. Goodwin
A. Conger Goodyear
Mrs. Simon Guggenheim
Mr. and Mrs. Alex L. Hillman
Mr. and Mrs. Walter Hochschild
Vladimir Horowitz
Mr. and Mrs. William B. Jaffe
Sidney Janis
Philip Johnson
Mr. and Mrs. Werner E. Josten
Anna Erickson Levene
Mrs. David M. Levy
Mr. and Mrs. Sam A. Lewisohn
Aristide Maillol
Sra. Carlos Martins
Mr. and Mrs. Samuel A. Marx

Saidie A. May
Mrs. Gertrud A. Mellon
D. and J. de Menil
André Meyer
J. B. Neumann
John S. Newberry
William S. Paley
Pablo Picasso
Abby Aldrich Rockefeller
Blanchette H. Rockefeller
Mr. and Mrs. David Rockefeller
Laurance S. Rockefeller
Nelson A. Rockefeller
Grace Rainey Rogers
Mr. and Mrs. Paul Rosenberg
Mr. and Mrs. Peter A. Rübel
Sam Salz
Benjamin Scharps and David Scharps
Mrs. Bertram Smith
James Thrall Soby
Nate B. and Frances Spingold
Louis E. Stern
Kay Sage Tanguy
Mr. and Mrs. Justin K. Thannhauser
G. David Thompson
John B. Turner
Curt Valentin
Edward M. M. Warburg
Mr. and Mrs. Charles Zadok

CONTENTS

FOREWORD

As The Museum of Modern Art approaches the fiftieth anniversary of its founding in 1929, it is worth recalling the first published statement of its founders, that "the ultimate purpose will be to acquire, from time to time, either by gift or by purchase, the best modern works of art." Should this be consistently done, it was argued, New York "could achieve perhaps the greatest museum of modern art in the world." When these words were written, the Museum occupied a rented loft space, had no endowment, no purchase funds—and no collection. It did, however, have a group of enthusiastic and committed founder-Trustees, and its first director, a twenty-seven-year-old art historian, Alfred H. Barr, Jr. The degree to which the founders' hopes and ambitions have been fulfilled may be judged by this publication, which is a catalog of the Collection of Painting and Sculpture in The Museum of Modern Art through mid-1967, when Alfred Barr retired from the Museum, and, in its Chronicle by Mr. Barr, a record of the building of that collection.

As soon as he had been appointed Director, Mr. Barr proposed to the Trustees that they establish a multi-departmental museum, one devoted to all the visual arts of our time: architecture and design, photography, film, as well as painting and sculpture, drawings and prints. With imagination and great perseverance he supervised the foundation of the collections in each of these fields, but his particular genius lay in finding for the Museum great examples of modern painting and sculpture—as well, of course, as in writing about modern art. His pioneering publications on *Cubism and Abstract Art* (1936), *Fantastic Art, Dada, Surrealism* (1936), *Picasso: Fifty Years of His Art* (1946), *Matisse: His Art and His Public* (1951), and other subjects are recognized as classic studies of their kind. Besides producing exhibition-related books and catalogs, however, Mr. Barr keenly felt the importance of publishing works on the Museum's holdings. In 1934, the Lillie P. Bliss Bequest was legally consigned to the Museum, establishing a splendid nucleus for the Museum Collection. In that year, Mr. Barr issued a catalog of this bequest. In 1942, he recognized the need to record the rapidly growing collection, and the first edition of *Painting and Sculpture in The Museum of Modern Art* appeared. Updated catalogs were published in 1948 and 1958.

Following the publication of the 1958 edition of *Painting and Sculpture in The Museum of Modern Art*, a new edition was scheduled for 1963. This was delayed, however, when the Museum closed for expansion and rebuilding in that year, and its completion had to await the relative freedom of Mr. Barr's retirement in 1967, when he was able to write his chronicle of the Museum's first thirty-eight years. Subsequently, the acquisitions from 1964 through 1967 were added to make this volume a complete record of the Collection of Painting and Sculpture as it existed when Mr. Barr retired in 1967. In accordance with Mr. Barr's policy, major works on paper, such as collages, watercolors, and gouaches, are included in the Catalog along with paintings and sculptures, but works in the classic drawing media of pencil, ink, and charcoal are not. Although the Catalog is arranged alphabetically, the Illustrations—representing some two-thirds of the works in the collection—have been placed by Mr. Barr according to period and style, resembling the arrangement of the collection in the Museum's galleries during his tenure. Catalog, Illustrations, and Chronicle together thus present a picture of The Museum of Modern Art and its Collection of Painting and Sculpture during the years 1929 to 1967, and offer the opportunity to review Mr. Barr's tremendous accomplishments, first as Director of the Museum and then as Director of the Museum Collections.

Perhaps Alfred Barr's greatest achievement is that he was the first to conceive of a fully comprehensive modern museum, and to bring such a museum into being. As his Chronicle shows, many of the early debates about the Museum Collection centered on the question: should it be essentially a collection of masterpieces, with quality the only guide for acquisition, or should its function be broadly educational, the aim being to represent the modern movement as completely as possible? Although Mr. Barr was unswerving in his pursuit of quality—once defining his task as "the conscientious, continuous, resolute distinction of quality from mediocrity"—he was, nevertheless, more an art historian and less a sheer connoisseur in his approach to this question. He believed that a museum collection should not be built up on the same principle as a private one, subject only to personal taste, but should, rather, be catholic—and systematically seek to be so. If this no longer seems a novel idea, then it is to Mr. Barr's credit that his concept of a modern museum is now so widely accepted.

All this said, however, Mr. Barr saw no essential conflict between the demands of quality and of providing a historical and educational survey, rightly insisting that both functions could equally be fulfilled by assembling a comprehensive collection of the finest possible works. If there was a bias in his acquisitions, it was in favor of paintings and sculptures of high quality that were also of crucial historical importance in the development of modern art. Hence his determination to shift the collection from its original late-nineteenth-century emphasis, brought about by the composition of the Bliss Bequest, and to acquire major examples of pioneering modern styles. In 1934, by the end of the Museum's first five years, half the collection comprised nineteenth-century works, and the twentieth-century holdings, though some were of high quality, were essentially conservative. By the end of the first decade, with the help of generous purchase funds, principally from Mrs. Simon Guggenheim and Mrs. John D. (Abby Aldrich) Rockefeller, Jr., and with the latter's gift of her own collection, the balance had substantially changed in favor of the twentieth century, with most of the important modern artists and movements at least represented, some by major works. (Rousseau's *Sleeping Gypsy* and Giacometti's *Palace at 4 A.M.* entered the collection at this early date.) Moreover, the basis of what was to become the most complete and important Picasso collection in any public museum had been established with the acquisition of *Les Demoiselles d'Avignon, The Studio* (1927–28), and *Girl before a Mirror*.

Mr. Barr was once described as "the most powerful tastemaker in American art today and probably in the world"; to this he replied that he was a "reluctant" tastemaker, for he did not

believe that it was a museum's primary task to discover the new, but to move at a discreet distance behind developing art, not trying to create movements or reputations but putting things together as their contours begin to clarify. These principles continue to be followed today, as are Mr. Barr's refreshingly straightforward and realistic criteria for the acquisition of recent art: that mistakes of commission are more easily remedied than mistakes of omission. In Mr. Barr's view, the exhibited collection is "the authoritative indication of what the Museum stands for." With this as its base, the temporary exhibitions the Museum organizes can be "adventurous (and adventitious) sorties" into less charted areas. In fact, Mr. Barr organized not only such adventurous exhibitions but also clearly historical ones. The latter were intended to complement the holdings of the Museum Collection and to serve the very useful purpose of discovering potential acquisitions to fill lacunae in the historical collection, just as exhibitions of the former kind led to acquisitions of newer art.

More important, however, than works acquired from Museum-organized exhibitions have been the series of gifts and bequests that Mr. Barr brought to the Museum. After the initial period of expansion, the war years of 1940 to 1946 saw a decline in purchase funds. Nevertheless, certain crucial masterpieces were added as gifts to the collection, including the first of Beckmann's triptychs, *Departure,* and Mondrian's last completed work, *Broadway Boogie Woogie,* while van Gogh's *Starry Night* was obtained through the exchange of works from the Bliss Bequest. Also, the Inter-American Fund was established for the purchase of Latin American art. It was only in the postwar period, between 1947 and 1959, that Mr. Barr saw the collection approaching the status he desired for it. The cubist, surrealist, and abstractionist collections continued to grow. A great Matisse collection was taking shape with the acquisition of *The Piano Lesson, The Red Studio,* and *The Back* series of reliefs, all from Mrs. Simon Guggenheim's funds, and the gift of *The Moroccans* from Mr. and Mrs. Samuel A. Marx. Subsequently, a gift of *The Dance* from Nelson A. Rockefeller in 1963 and life-interest gifts in 1964 of major Matisses from what had become the Schoenborn-Marx collection made the Matisse holdings equal in importance for the Museum to those by Picasso. Additionally, the Katherine Dreier bequest brought important Duchamps to the Museum, and a collection of abstract-expressionist painting was established, though not without opposition, as Mr. Barr's Chronicle shows.

This dramatic growth brought with it crucial problems of space. These had dogged the Museum from its beginning. Indeed, Mr. Barr had insisted that lack of space had proven a more severe handicap to the collection than lack of funds, and he had led the Museum in four different premises in its first ten years. Only in 1945–46, in its building at 11 West 53 Street, designed in 1939 by Goodwin and Stone, was the collection first shown in depth, and then only fifteen per cent of the paintings in the collection were exhibited, approximately the same percentage as is seen now. That exhibition, however, was but a temporary one, and not until the newly enlarged building was opened in 1964 did the collection find a permanent place on the second and third floors.

The expanded space was certainly required. Between 1958 and 1963, major new gifts had come to the Museum: the Larry Aldrich fund for the purchase of recent art, the Kay Sage Tanguy bequest of surrealist works, the Mrs. David M. Levy bequest of European master paintings, the promised gift of the James Thrall Soby collection, the bequest of works from Philip L. Goodwin's collection, and the gift of two late Monets, both of mural scale, from Mrs. Simon Guggenheim, which were installed in a special gallery bearing her name. To these were added, between 1963 and 1967, among other important works, immediate and promised gifts from two Trustees—Mrs. Bertram Smith's gifts of European masterpieces and Philip Johnson's gifts of recent art, part of a succession of generous gifts from Philip Johnson who was one of the earliest donors to the collection—and a donation from Alexander Calder of a large group of his own sculptures. In this period the Museum also received important gifts from William S. Paley and William A. M. Burden, among others. Finally, in 1967, through the good offices of William Rubin, the Sidney and Harriet Janis Collection of 103 works came as a particularly valuable gift to the Museum. By no means all of these newly acquired works could be constantly on view. Although many works from the collection are available to the public through loans and traveling exhibitions, only a fraction of the Museum's holdings can be shown owing to lack of space. Although Mr. Barr's original concept of a comprehensive modern collection, always visible to the public, came closer to realization in the enlarged building of 1964, even then he recognized that space would be inadequate for the future—especially when the many important promised gifts he had obtained eventually passed into the collection; and now, thirteen years later, it becomes necessary to expand yet again.

Although Alfred Barr's role in building the Museum Collection was of the first importance, he was by no means alone in his work but benefited from the help and support of many colleagues. Chief among these were James Thrall Soby, since 1940 an active and generous participant in the Museum's development; Dorothy C. Miller, Curator from 1935 to 1969; René d'Harnoncourt, Director of the Museum from 1949 to 1968; James Johnson Sweeney, particularly important in the Museum's early years; and William S. Lieberman, Peter Selz, and William C. Seitz in the later years. In 1967, Alfred Barr retired from the Museum. The same year, James Thrall Soby left the Chairmanship of the Committee on the Museum Collections and the Committee itself was dissolved, to be divided into separate units, one for each curatorial department. In 1968, René d'Harnoncourt also retired, and Dorothy C. Miller retired the year after. The period chronicled and cataloged in this volume came to an end with the changes in staff these retirements entailed, and The Museum of Modern Art is necessarily different in many respects from what it was under Mr. Barr's

direction. However, its changes are certainly less dramatic than those he himself brought about, particularly in the period of expanded activities that accompanied the enlarged building in 1964. When, in 1930, he unsuccessfully proposed to the Trustees that a room be provided for showing the collection, it comprised only thirteen paintings and sculptures. This catalog of holdings in 1967 contains entries for 2,622 works. Whereas nine staff members administered the Museum in 1931, some 350 are now needed to deal with the greatly expanded functions that Mr. Barr, more than anyone else, foresaw and created. If the Museum is very different from what it was, that it would be so had been predictable once Mr. Barr's ambitions began to be realized. In major respects, however, it remains unchanged. The collection grows on the basis, and follows the principles, that Mr. Barr established. Its standards, and the standards of the Museum's publications—both those devoted to the collection and those accompanying temporary exhibitions—have to match those that Mr. Barr set. And they were formidable standards indeed.

In the publication of this summation of Alfred Barr's work, we have incurred many debts of gratitude. The colleagues, collectors, and Trustees who supported him in his work, of whom but a few have been mentioned here, are more properly thanked in his own acknowledgments. In producing this volume, we have been aided by grants from the Ford Foundation and the National Endowment for the Arts, for which we are most grateful. As an expression of his admiration and affection for Mr. Barr, David Rockefeller, a Trustee since 1948, has also given generous support and encouragement to this project. Among the many who have assisted in bringing this work to publication, I should like particularly to thank Monawee Allen Richards, who has devotedly and patiently researched many of its details, and Dorothy C. Miller, who brought to it her intimate knowledge of the Museum and its Collections.

Richard E. Oldenburg
Director

PREFACE AND ACKNOWLEDGMENTS

THE MUSEUM OF MODERN ART opened its doors in November 1929 with a grand exhibition of paintings by Cézanne, Gauguin, Seurat, and van Gogh, accompanied by the publication of a large catalog. During the first three years of the Museum's existence, painting and sculpture, drawings and prints were its sole concern, and almost all were borrowed. Gradually other arts were shown: first architecture and photography in 1932, then industrial design and decorative arts in 1933 and film in 1935. Within a decade all were established in separate departments that gave the Museum its special importance. The Print Room opened in 1949, and the collection of drawings was added to it in 1960, forming the Department of Drawings and Prints. Collections increased, yet catalogs of them were few.

Painting and sculpture remained predominant thanks to the program of temporary loan exhibitions, but the Museum's own collection at first grew slowly and was shown rarely. At the end of four years it included only twelve paintings and ten sculptures. Then, in 1934, with the final donation of the Lillie P. Bliss Collection, the Museum's Collection of Painting and Sculpture was firmly established.

A catalogue raisonné of the Bliss Collection was published in 1934, followed in 1942 by a simpler catalog of the whole collection, *Painting and Sculpture in The Museum of Modern Art*, listing 690 works of art; in 1948, a second edition included 797 works; and in 1958, a third catalog listed 1,360 paintings and sculptures.

This, the fourth edition of *Painting and Sculpture in The Museum of Modern Art*, covers the Museum's holdings as of June 1967, the date of the writer's retirement. A few additional works that were commissioned or selected before the end of June but acquired later are also included.

The two principal sections of this book are the Illustrations, reproducing 1,693 works of art, and the Catalog, with data on 999 artists and their 2,622 works. Various listings follow, including Donors to the Collection; Gifts, The Donors Retaining Life Interest; Promised Gifts; and Indexes of Artists by Nationality and Portraits by Subject.

At the back of this book is a Chronicle of the Collection of Painting and Sculpture, recounting its beginnings and growth year by year against the general background of the Museum. The Chronicle traces the early plans for forming a collection and records how and when works of art were acquired and purchase funds given, the work of various committees, statements of policy, special exhibitions of the collection, problems of space for continuous exhibition, studies of the collection in relation to those of other New York museums, and other problems and their solutions during the first thirty-eight years.

ACKNOWLEDGMENTS must begin with a thank you to Lillie P. Bliss, Abby Aldrich Rockefeller, and Mary Quinn Sullivan, who came together in the spring of 1929 to establish a museum of modern art, long needed in the city of New York. The enthusiasm and generosity of these three women, along with that of A. Conger Goodyear, Mrs. W. Murray Crane, Frank Crowninshield, and Paul J. Sachs (the original seven founders), and of Stephen C. Clark, Chester Dale, Sam A. Lewisohn, and Duncan

Phillips, who soon joined the Board, made possible the opening of a new museum in the year of a catastrophic stock market crash.

In 1967, when the writer retired, there were thirty-eight Trustees, important committees and councils, Patrons of the Collections, other donors of works of art, 40,000 members, a staff of over 500, and a building too small for the collections.

Although the Chronicle details the generosity of various donors, it is essential to acknowledge the contribution of Lillie P. Bliss, who bequeathed her collection to the Museum at her death in 1931. Her bequest, accessioned in 1934, formed the basis for the Museum's collection and, to an important degree, the Museum as a whole. Later, because of the generous spirit of her bequest, certain unneeded paintings were sold or exchanged to obtain Picasso's *Les Demoiselles d'Avignon*, van Gogh's *Starry Night*, and other major works.

Further, at the height of the depression, the generosity of Abby Aldrich Rockefeller in providing the Museum's first fund for buying works of art enabled the Museum to begin its acquisition of modern works without relying solely on gifts.

Mrs. Simon Guggenheim, to whom this volume is dedicated, for thirty years was foremost among the Trustees as a donor of purchase funds for the Museum's Collection of Painting and Sculpture.

Early donors among the Trustees were President Goodyear, who presented to the Museum its first work of art, a large Maillol bronze, and Stephen C. Clark, who anonymously gave the first painting, an Edward Hopper, and later many other works. Other early donors were Philip Johnson, Aristide Maillol, Mrs. Saidie A. May, Mrs. Stanley Resor, and Edward M. M. Warburg.

From 1930 to 1945 the Advisory Committee of young amateurs was often much concerned with the Museum's collection. Among them were Nelson A. Rockefeller, the first Chairman, Elizabeth Bliss (Mrs. Bliss Parkinson), and William A. M. Burden, each of whom was later to be elected President of the Museum. In 1935, with Mrs. Rockefeller's help and under George L. K. Morris's chairmanship, the Committee raised money to buy, over a period of several years, several major works. Another member, Walter P. Chrysler, Jr., gave a great Picasso to the collection. Four committee members, Lincoln Kirstein, James Thrall Soby, James Johnson Sweeney, and Monroe Wheeler, later served on the staff at various times.

In 1953 the Policy Committee for the Museum's Permanent Collection of Masterworks was appointed. The members, all Trustees, included Mrs. David M. Levy and Philip L. Goodwin, who were later to bequeath to the Museum most of the finest works in their collections; William A. M. Burden (Chairman), Nelson A. Rockefeller, James Thrall Soby, and John Hay Whitney, who have promised to give or bequeath many or all of their best paintings and sculptures; Mrs. Simon Guggenheim, who gave funds for masterworks; and Stephen C. Clark, A. Conger Goodyear, Henry Allen Moe, and Edward M. M. Warburg.

Other Trustees have indicated their intention to leave works from their collections to the Museum. Among them are Philip

Johnson, Mrs. Wolfgang Schoenborn (formerly Mrs. Samuel A. Marx), and Mrs. Bertram Smith. They have already given works of art. Other Trustees, past and present, who have given works to the collection include Walter Bareiss, Ralph F. Colin, Wallace K. Harrison, Mrs. Walter Hochschild, Sam A. Lewisohn, John de Menil, William S. Paley, Mrs. Bliss Parkinson, Duncan Phillips, Mrs. John D. (Blanchette) Rockefeller 3rd, David Rockefeller, Grace Rainey Rogers, G. David Thompson, Edward M. M. Warburg, and Monroe Wheeler.

The Patrons of the Collections have been generous through the years in helping build the Collection of Painting and Sculpture. The complete list of Patrons appears on page vi.

From 1934 to 1944 the Acquisitions Committee comprised a small group of Trustees and advisers who considered works of art and passed on their decisions in the ensuing Trustees' meeting for final approval. Messrs. Clark, Lewisohn, and Warburg served in turn as Chairman. Other members included Messrs. Goodwin and Goodyear and, toward the end of the decade, Mrs. Simon Guggenheim and Mr. Soby.

The Acquisitions Committee was superseded in 1944 by the Committee on the Museum Collections; it was concerned not only with acquisitions of painting and sculpture but with those of the other departments as well. The Committee consisted of about ten members, not all of them Trustees. All were collectors who gave time for seven or eight very long meetings a year, studied and decided on the acquisitions, and often gave works of art of their own, as well as funds for purchases. The complete membership through 1967 is listed on page 655.

In the formation and growth of the Collection of Painting and Sculpture, The Museum of Modern Art indeed owes much to these many good friends. Much is owed as well to the devotion of the staff who worked in many ways with the collection through the years.

During their brief terms in the mid-1940s as Director of Painting and Sculpture, James Thrall Soby and James Johnson Sweeney each made notable accessions. As the writer can attest, they and Dorothy C. Miller, Curator from 1935 to 1969, exerted influence upon the formation of the painting and sculpture collection quite beyond their official roles in the Museum.

René d'Harnoncourt, the Museum's Director from 1949 to 1968, served as adviser to the Committee on the Museum Collections, as did Andrew C. Ritchie, Peter Selz, and William C. Seitz during their terms as Director of Painting and Sculpture Exhibitions. William S. Lieberman, Director of the Department of Drawings, was very helpful in various ways.

Olive L. Bragazzi, Letitia T. Howe, and Betsy Jones served successively as Secretary to the Museum Collections, including the other departmental collections as well as painting and sculpture. Research, the preparation of exhibitions and catalogs, and other special work on the Collection of Painting and Sculpture were performed by the above and by Elizabeth Litchfield, Elise Van Hook, Sara Mazo, Marie Alexander, Nina Kasanof, Monawee Allen Richards, and others.

The Museum's early Registrars, Mary Sands and Alice Mallette, were followed in 1936 by Dorothy H. Dudley, who was responsible for organizing the Museum's renowned registration systems. These include invaluable records on the Collection of Painting and Sculpture and its official card catalog, which were precisely maintained by Miss Dudley (who retired in 1969) and her staff, particularly Dorothy Lytle, Monawee Allen Richards, David Vance, Eric B. Rowlison, and Elizabeth L. Burnham.

Through the Museum's Circulating Exhibition program, begun in 1932, works from the collection were shown first throughout the United States and later abroad. This program was directed in succession by Elodie Courter, Porter McCray, and Waldo Rasmussen, assisted by Jane Sabersky and Helen Franc, among others.

Pearl Moeller, as Supervisor of Rights and Reproductions, supplied photographs of the collection to scholars, students, and publishers all over the world and controlled and recorded their use. Exceptional negatives of the collection were provided by Soichi Sunami, the Museum's chief photographer for over thirty-five years.

The acquisitions and exhibitions of the collection received publicity through the efforts of Sarah Newmeyer, Betty Chamberlain, and Elizabeth Shaw.

The Museum's publications program was directed by Ernestine M. Fantl and Frances Collins during the 1930s and then, from 1939 to 1967, by Monroe Wheeler, who, with the assistance of his staff, particularly Frances Pernas and later Françoise Boas, supervised the publications on the Collection of Painting and Sculpture.

Many gave generous help and criticism to this book, among them Dorothy Miller, Betsy Jones, Sara Mazo, Monawee Allen Richards, Rona Kaplan, Jane Welles, Monroe Wheeler, Françoise Boas, Helen Franc, James T. Soby, and William S. Lieberman. Richard E. Oldenburg, Director of the Museum and formerly Director of Publications, Carl Morse, Harriet Schoenholz Bee, Jane Fluegel, Jack Doenias, Angela Cocchini, and Frederick Myers of the Department of Publications are responsible for the final completion of this volume.

Many are the names in these acknowledgments but even more numerous and more important are the names of the artists in the pages that follow.

Alfred H. Barr, Jr.

ILLUSTRATIONS

THERE ARE SEVERAL WAYS to arrange illustrations in a catalog of works of art. An alphabetical ordering by artists' names is essential if there is no other index, but such a sequence produces a pictorial hodgepodge of non sequiturs—especially if there is, as in this publication, more than one picture to a page. A ruthless succession determined by the year of the artist's birth is little better; and any strict division by nationality, especially in the twentieth century, is often misleading.

The arrangement in this catalog is experimental and sometimes inconsistent. Generally, it resembles the way the Museum's Collection of Painting and Sculpture is installed in its galleries, that is, with some concern for both history and aesthetics.

Some of the groupings within the almost 1,700 illustrations are conveniently coherent and cover short spans of time, such as Italian Futurists (pages 116–120); others are diverse and widely inclusive, such as Figurative Painting (pages 262–291), a section depicting works by some eighty artists from about twenty countries.

The works of each artist are usually shown together in chronological order, even though thirty works of Matisse or forty by Picasso may spread over six decades.

An effort has been made to suggest comparative differences in the sizes of actual works through the relative scale of the illustrations. Thus, two facing pages are used for Monet's forty-foot mural (pages 20–21), while nine tiny Schwitters collages occupy a single page opposite four somewhat larger works by him (pages 160–161). Other factors, such as importance or minute detail, were not overlooked in deciding the size of the illustrations.

The general period and style of the works illustrated, as well as the artists' names, are identified at the top of the page. If a page is devoted to the work of a single artist, his name is not repeated in the captions.

This book has been in preparation for many years; what began as a record of the collection through 1963 was extended to incorporate works acquired within the following four years. Thus there are two virtually parallel sections of illustrations:

Part I Acquisitions of 1929 through 1963
Part II Acquisitions of 1964 through June 1967, including a few works already commissioned or selected before the end of June and acquired in the autumn.

The catalog listing, arranged alphabetically by artist, serves as an index to the illustrations. In addition to supplying the number of the page on which a work is reproduced, it gives the full name of the artist, his dates and nationality, details about the medium of the work, its date, its size in inches and centimeters, the name of the donor or the purchase fund, the accession number, the Museum publication in which it is illustrated, and notes.

A.H.B., Jr.

PART I ACQUISITIONS OF 1929 THROUGH 1963

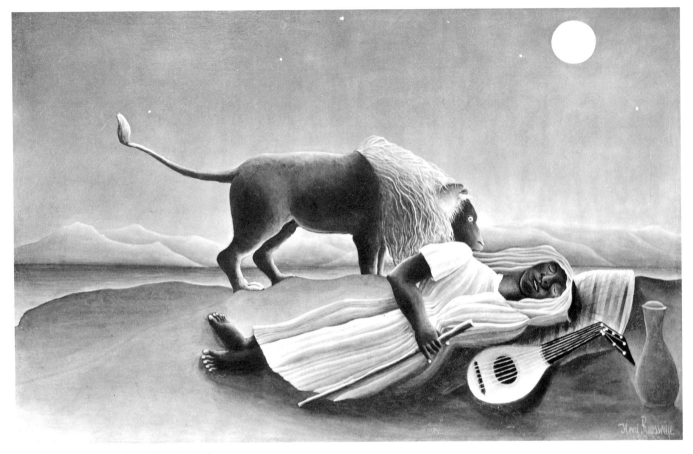

The Sleeping Gypsy. 1897. Oil, 51″ x 6′7″

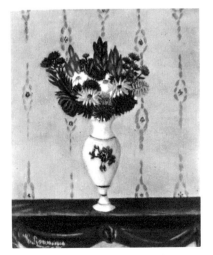

Vase of Flowers. Oil, 16¼ x 13″

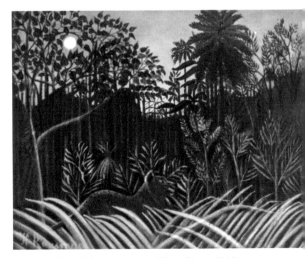

Jungle with a Lion. 1904–10. Oil, 15⅛ x 18¼″

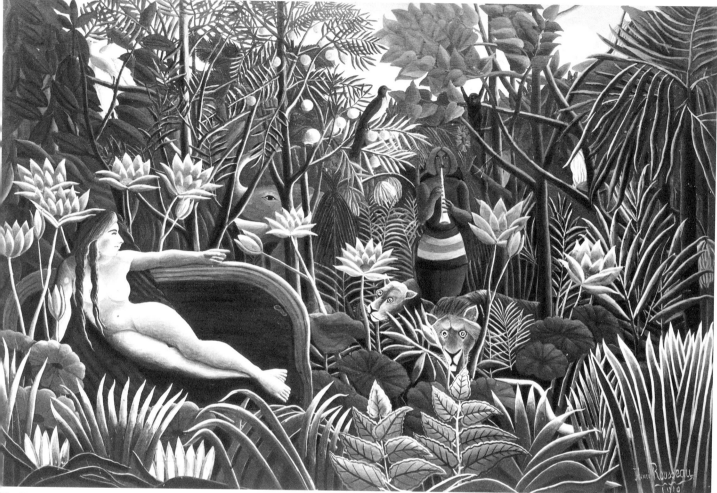

The Dream. 1910. Oil, 6'8½" x 9'9½"

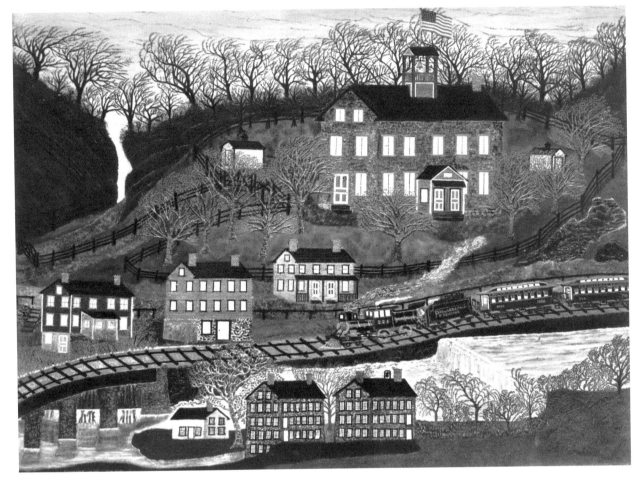

Pickett: *Manchester Valley*. 1914–18? Oil with sand, 45¹/₂ x 60⁵/₈″

Litwak: *Dover, New Jersey*. 1947. Oil, 22 x 32″

Williamson: *The Day the Bosque Froze Over*. 1953. Oil, 20 x 28″

Self-Portrait. 1929. Oil, 36¹/₈ x 27¹/₈″

Scotch Day at Kennywood. 1933. Oil, 19⁷/₈ x 27¹/₈″

Through Coleman Hollow up the Allegheny Valley. Oil, 30 x 38⁵/₈″

Vivin: *The Wedding*. c. 1925. Oil, 18¹/₄ x 21⁵/₈″

Peyronnet: *The Ferryman of the Moselle*. c. 1934. Oil, 35 x 45⁵/₈″

Bauchant: *Cleopatra's Barge*. 1939. Oil, 32 x 39³/₈″

Bauchant: *The Proclamation of American Independence*. 1926. Oil, 30 x 46⁵/₈″

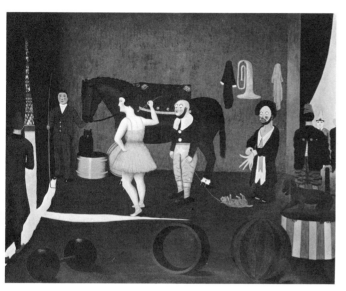

Bombois: *Before Entering the Ring*. 1930–35. Oil, 23⁵/₈ x 28³/₄″

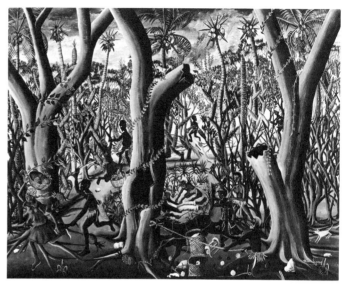

Bigaud: *Murder in the Jungle*. 1950. Oil, 23⁷/₈ x 29³/₄″

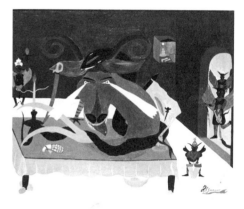

Gourgue: *Magic Table*. 1947. Oil, 17 x 20³/₄″

Mukarobgwa: *Very Important Bush*. 1962. Oil, 23¹/₂ x 36¹/₄″

Obin: *Inspection of the Streets*. 1948. Oil, 24 x 24″

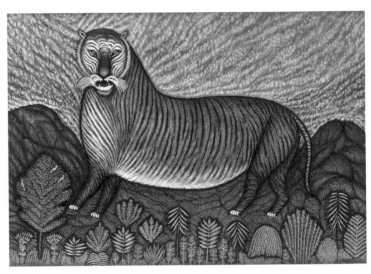

Hirshfield: *Tiger*. 1940. Oil, 28 x 39⁷/₈″

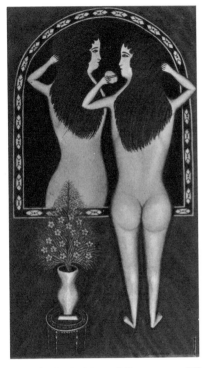

Hirshfield: *Girl in a Mirror*. 1940. Oil, 40¹/₈ x 22¹/₄″

Hamblett: *The Vision*. 1954. Oil, 17⁷/₈ x 48″

Canadé: *Self-Portrait*. c. 1926. Oil, 18⁵/₈ x 14″

Wallis: *St. Ives Harbor*. c. 1932–33. Oil, 10¹/₈ x 12³/₈″

Sani: *Slaughtering Swine*. c. 1950. Marble, 11³/₄ x 12¹/₄ x 4³/₄″

Barela: *The Twelve Apostles*. 1936. Wood relief, 11½ x 61″

right: J. and F. Wallace: *Totem Pole*. 1939. Red cedar, polychrome, 32′ high

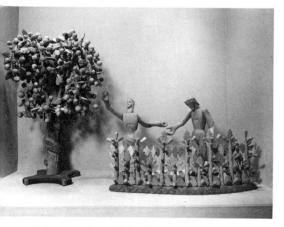

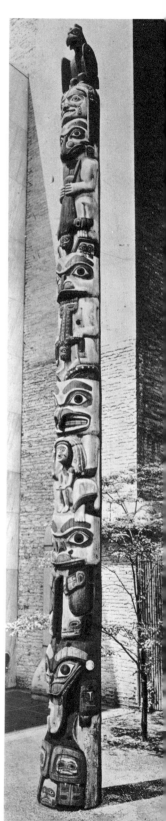

Lopez: *Adam and Eve and the Serpent*. c. 1930. Cottonwood; tree 24⅞″ high; figures 13″ and 14″ high; garden 8½ x 21¼″

Lopez: *Adam* (detail)

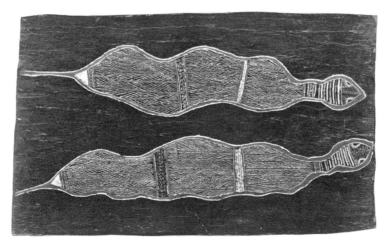

Nagwaraba: *Two Snakes*. 1955. Colored clays over charcoal on eucalyptus bark, about 22 x 36⅜″

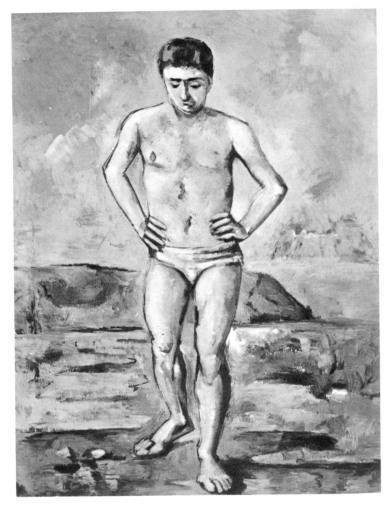

The Bather. c. 1885. Oil, 50 x 38⅛″

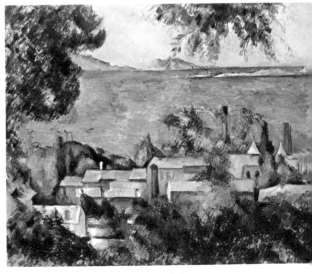

L'Estaque. 1883–85. Oil, 23⅞ x 27¾″

Bathers. 1885–90. Watercolor and pencil, 5 x 8¹/₈″

House among Trees. c. 1900. Watercolor, 11 x 17¹/₈″

The Bridge at Gardanne. 1885–86. Watercolor,
8¹/₈ x 12¹/₄″

Rocks at Le Château Noir. 1895–1900. Watercolor, pencil, 12¹/₂ x
18³/₄″

Foliage. 1895–1900. Watercolor and pencil, 17⁵/₈ x 22³/₈″

Study of Trees. (Reverse side of *Foliage.*) Watercolor

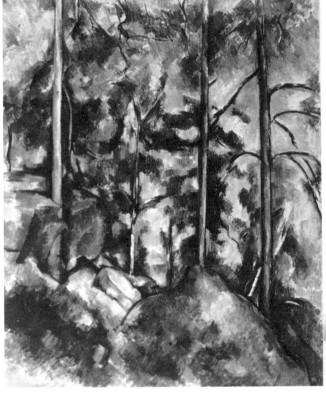

Pines and Rocks. c. 1900. Oil, 32 x 25³/₄″

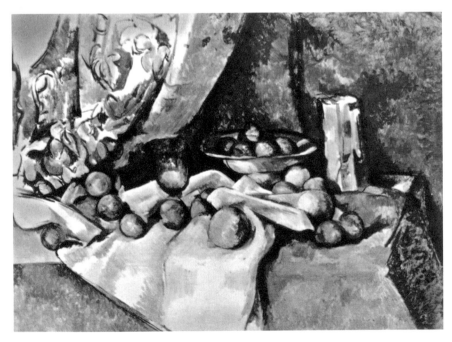

Still Life with Apples. 1895–98. Oil, 27 x 36¹/₂″

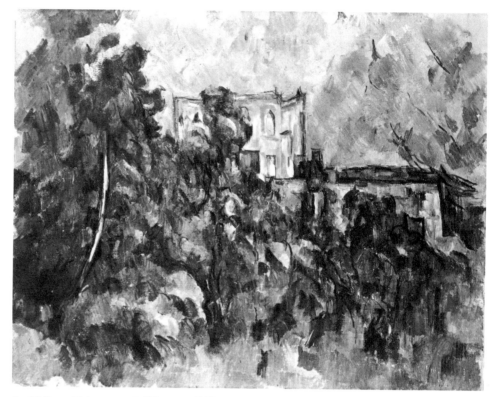

Le Château Noir. 1904–06. Oil, 29 x 36³/₄″

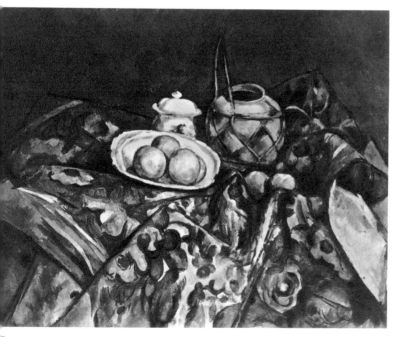

Oranges. 1902–06. Oil, 23⁷/₈ x 28⁷/₈″

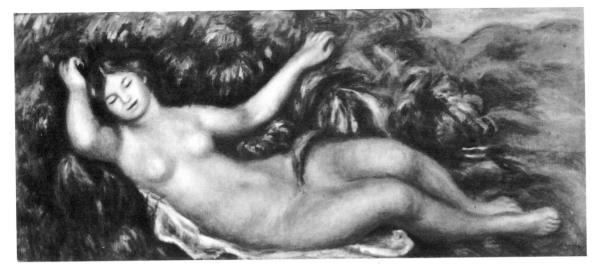

Reclining Nude. 1902. Oil, 26½ x 60⅝″

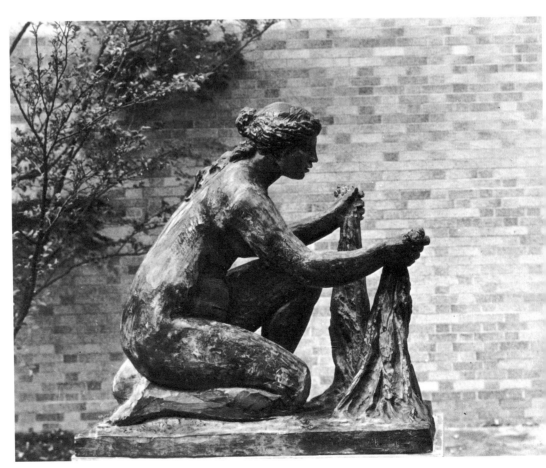

The Washerwoman. 1917. Bronze, 48″ high

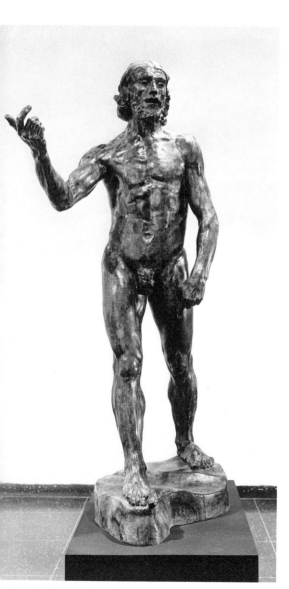

John the Baptist Preaching. 1878–80. Bronze, 6′6¾″ high

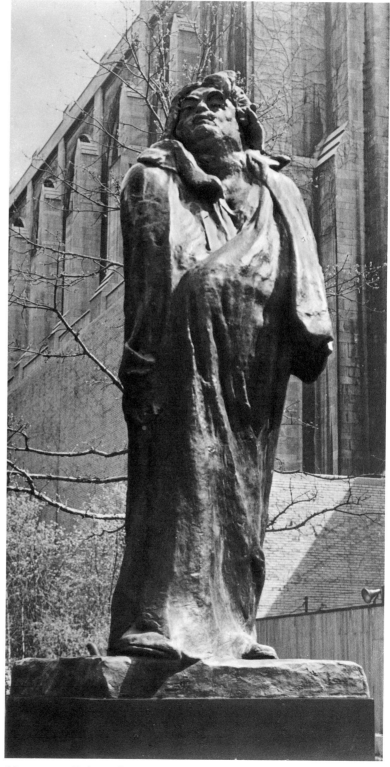

Monument to Balzac. 1897–98. Bronze (cast 1954), 8′10″ high

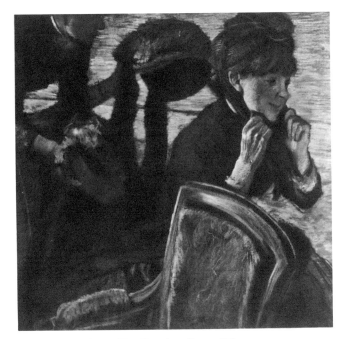

At the Milliner's. c. 1882. Pastel, 27⁵/₈ x 27³/₄"

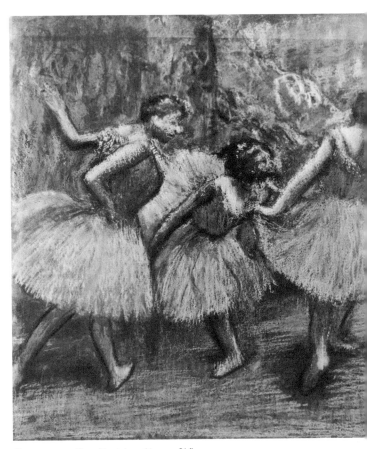

Dancers. c. 1899. Pastel, 37¹/₄ x 31³/₄"

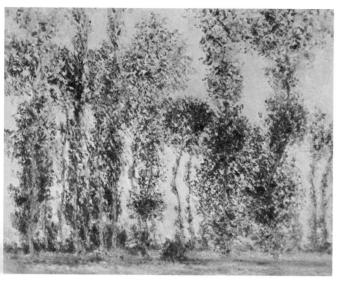

Poplars at Giverny, Sunrise. 1888. Oil, 29¹/₈ x 36¹/₂″

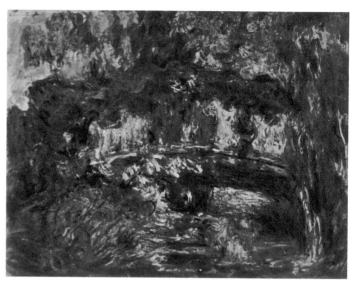

The Japanese Footbridge. c. 1920–22. Oil, 35¹/₄ x 45⁷/₈″

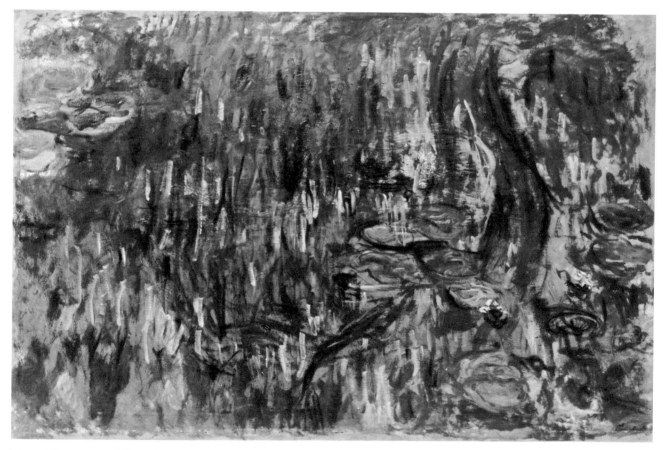

Water Lilies. c. 1920. Oil, 51¹/₂″ x 6′7″

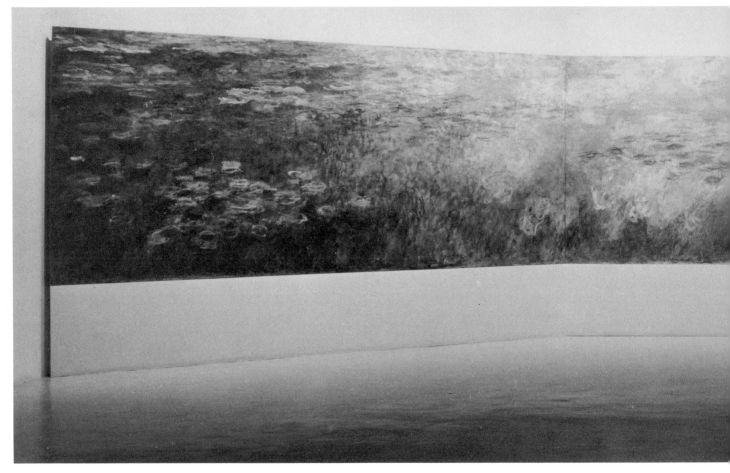

Water Lilies. c. 1920. Oil on canvas; triptych, each section 6′6″ x 14′

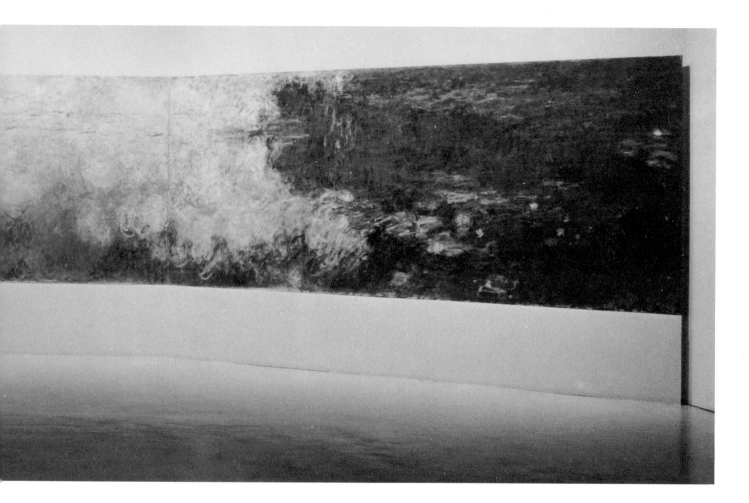

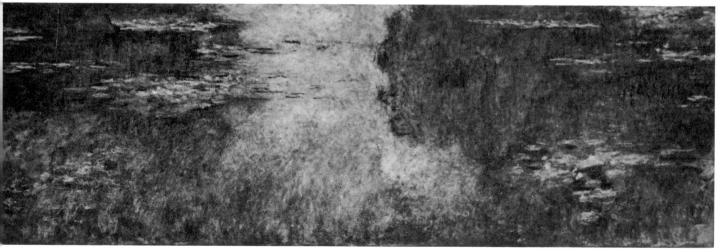

Water Lilies. c. 1920. Oil on canvas, 6′6¹/₂″ x 19′7¹/₂″

Evening, Honfleur. 1886. Oil, 25³/₄ x 32″

Port-en-Bessin, Entrance to the Harbor. 1888. Oil, 21⁵/₈ x 25⁵/₈″

Signac: *Albenga.* c. 1896. Watercolor, 4³/₈ x 7¹/₂″

Signac: *Lighthouse.* c. 1896. Watercolor and charcoal, 5³/₈ x 6¹/₂″

ignac: *Les Alyscamps, Arles.* 1904. Watercolor and charcoal, 16 x 10¹/₂″

Signac: *Harbor of La Rochelle.* 1922. Watercolor, 11 x 17⁵/₈″

ross: *Woodland in Provence.* 1906–07. Oil, 21³/₄ x 7¹/₄″

Cross: *Landscape with Figures.* c. 1905. Watercolor, 9⁵/₈ x 13³/₈″

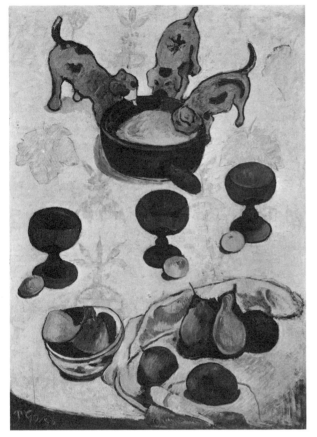

Still Life with Three Puppies. 1888. Oil, 36¹/₈ x 24⁵/₈″

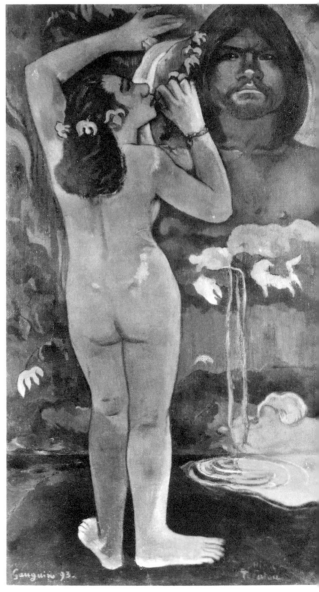

The Moon and the Earth. 1893. Oil, 45 x 24¹/₂″

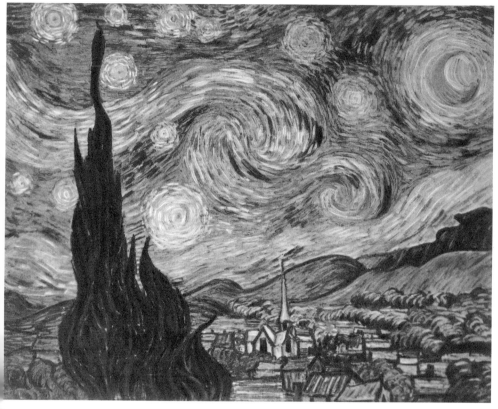

The Starry Night. 1889. Oil, 29 x 36¼″

Hospital Corridor at Saint Rémy. 1889.
Gouache and watercolor, 24⅛ x 18⅝″

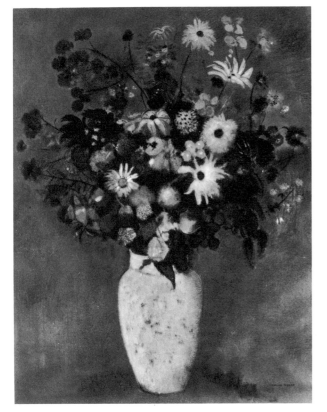

Vase of Flowers. 1914. Pastel, 28³/₄ x 21¹/₈″

Roger and Angelica. c. 1910. Pastel, 36¹/₂ x 28³/₄″

Silence. c. 1911. Oil, 21¹/₄ x 21¹/₂″

Yellow Flowers. 1912? Pastel, 25¹/₂ x 19¹/₂″

Reverie. c. 1900. Pastel, 21¹/₄ x 14¹/₂″

Tribulations of St. Anthony. 1887. Oil, 46³/₈ x 66″

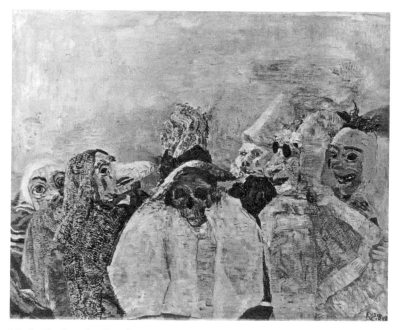

Masks Confronting Death. 1888. Oil, 32 x 39¹/₂″

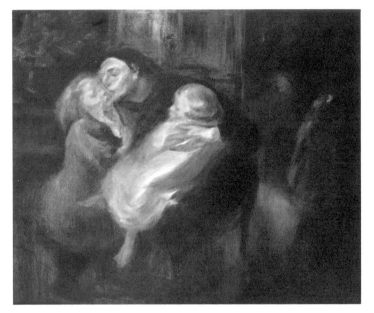

Carrière: *Maternity*. c. 1892. Oil, 37³/₄ x 45³/₄"

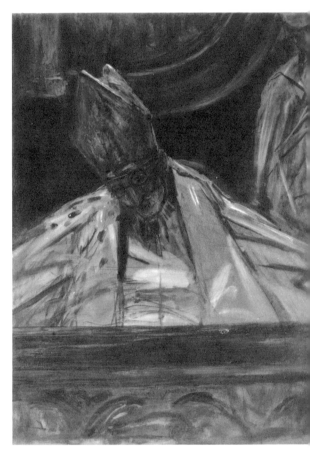

Desvallières: *Notre Dame*. c. 1905? Oil, 40¹/₂ x 28¹/₂"

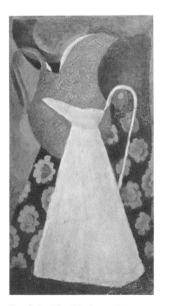

Denis?: *The Pitcher*. 1890–95?
Oil and sand, 17³/₄ x 9¹/₂"

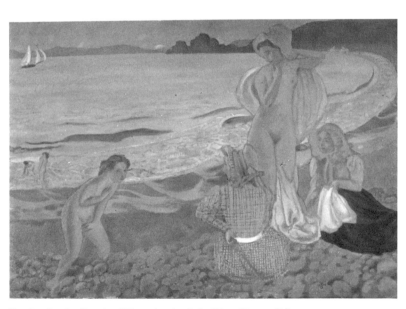

Denis: *On the Beach of Trestrignel*. 1898. Oil, 27⁵/₈ x 39³/₈"

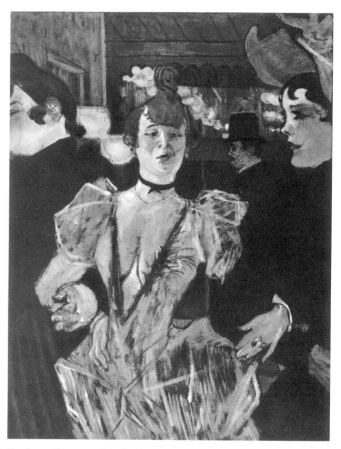

Toulouse-Lautrec: *La Goulue at the Moulin Rouge*. 1891–92. Oil, 31¼ x 23¼"

Bernard: *Bridge at Asnières*. 1887. Oil, 18⅛ x 21⅜"

Still Life. 1892. Oil on wood, 9³/₈ x 12⁷/₈″

Mother and Sister of the Artist. c. 1893. Oil, 18¹/₄ x 22¹/₄″

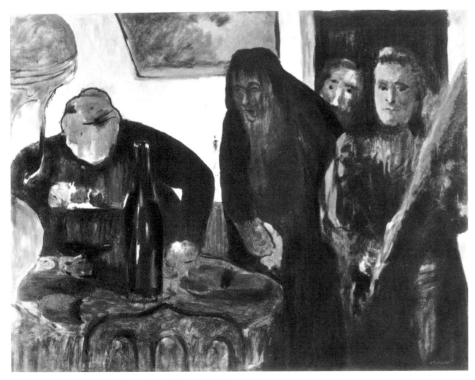

Family of the Artist. 1892. Oil, 28¹/₄ x 36³/₈″

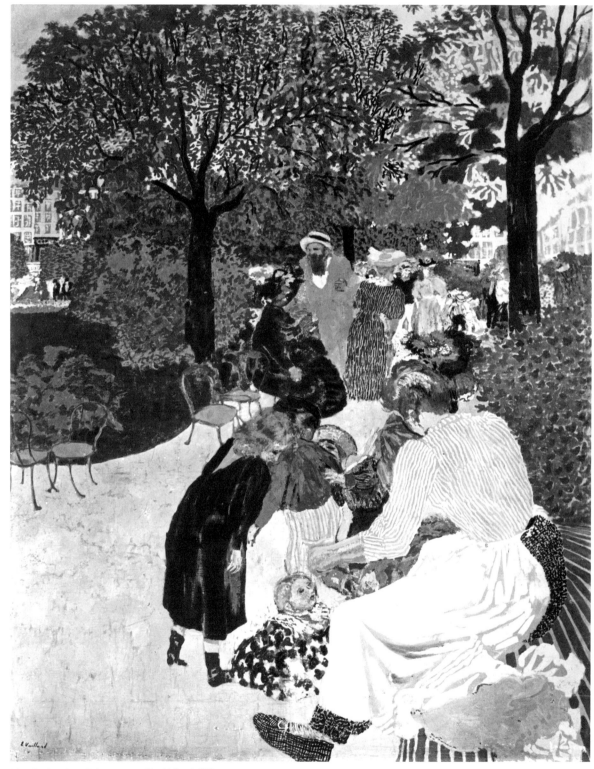

The Park. 1894. Distemper, 6′11½″ x 62¾″

Valtat: *Nude in Forest*. c. 1905. Oil on burlap,
24$^{1}/_{8}$ x 32$^{3}/_{8}$"

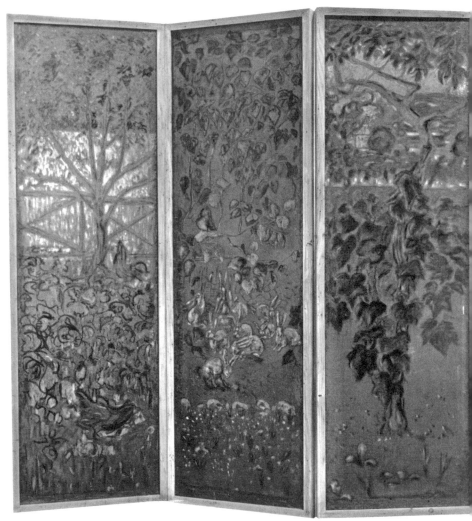

Bonnard: *Three Panels of a Screen*. 1894–96. Oil, each panel about 65$^{3}/_{4}$ x 20"

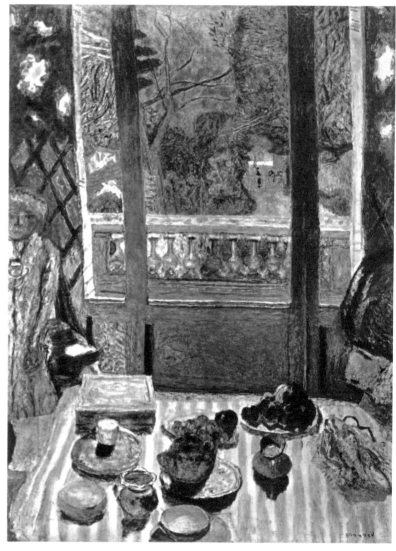

The Breakfast Room. c. 1930–31. Oil, 62⁷/₈ x 44⁷/₈"

...ncheon. c. 1927. Oil, 16¹/₄ x 24¹/₂"

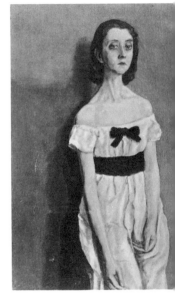

Sickert: *La Gaieté Montparnasse.* c. 1905. Oil, 24¹/₈ x 20"

John: *Girl with Bare Should* 1909–10? Oil, 17¹/₈ x 10¹/₄"

O'Conor: *The Glade.* 1892. Oil, 36¹/₄ x 23¹/₂"

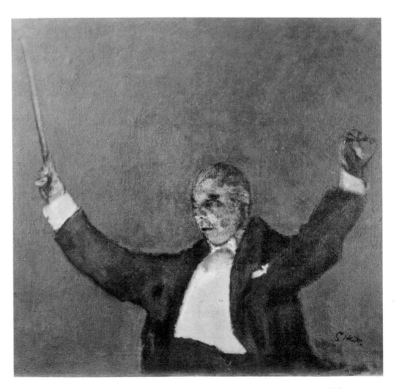

Sickert: *Sir Thomas Beecham Conducting.* c. 1935. Oil, 38³/₄ x 41¹/₈"

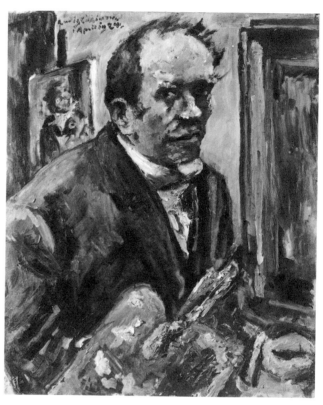

Corinth: *Self-Portrait*. 1924. Oil, 39³⁄₈ x 31⁵⁄₈″

Klimt: *The Park*. 1910 or earlier. Oil, 43¹⁄₂ x 43¹⁄₂″

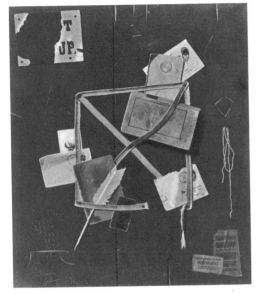

Peto: *Old Time Letter Rack*. 1894. Oil, 30 x 25¹/₈″

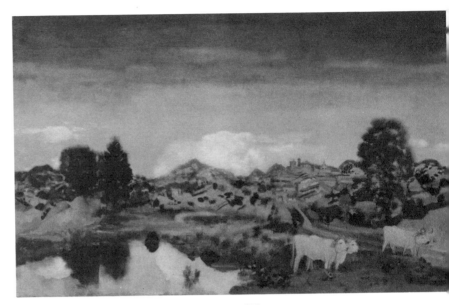

Davies: *Italian Landscape*. 1925. Oil, 26¹/₈ x 40¹/₈″

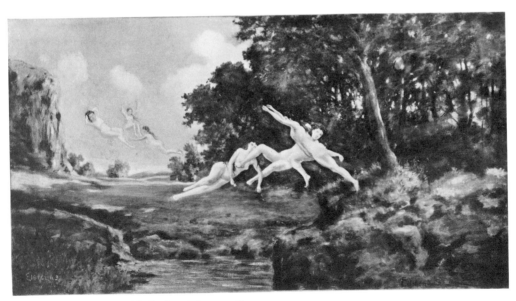

Eilshemius: *Afternoon Wind*. 1899. Oil, 20 x 36″

Eilshemius: *In the Studio*. c. 19
Oil, 22¹/₈ x 13³/₄″

stival, Venice. 1898. Watercolor, 16⁵/₈
4″

Acadia. 1922. Oil, 31³/₄ x 37¹/₂″

Lagoon, Venice. 1898. Watercolor, 11¹/₈ x
″

The East River. 1901. Watercolor, 13³/₄ x 19³/₄″

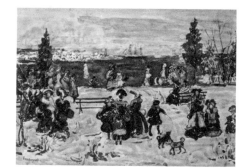

April Snow, Salem. 1906–07. Watercolor, 14³/₄ x
21⁵/₈″

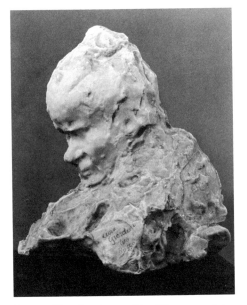

Rosso: *The Concierge*. 1883. Wax over plaster, 14¹/₂ x 12⁵/₈″

Rosso: *Man Reading*. 1894. Bronze (cast 1960), 10 x 11¹/₄ x 11″

Rosso: *The Bookmaker*. 1894. Wax over pl ter, 17¹/₂ x 13 x 14″

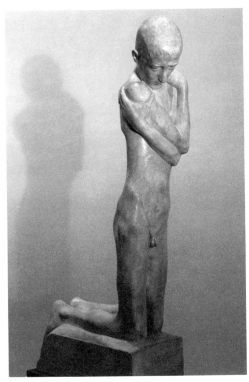

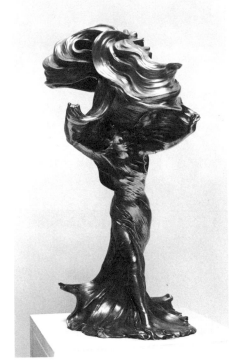

Minne: *Kneeling Youth*. 1898. Original plaster, 31³/₈″ high

Larche: *Loïe Fuller, the Dancer*. c. 1900. Bronze, 18¹/₈″ high

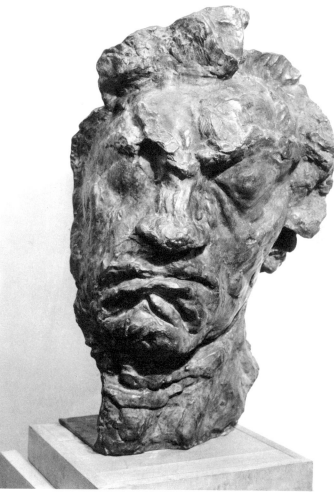

Beethoven, Tragic Mask. 1901. Bronze, 30¹/₂″ high

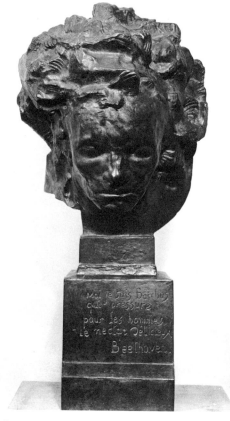

Beethoven. 1901. Bronze, head, 15⁵/₈″ high, cast with base, 11³/₈″ high

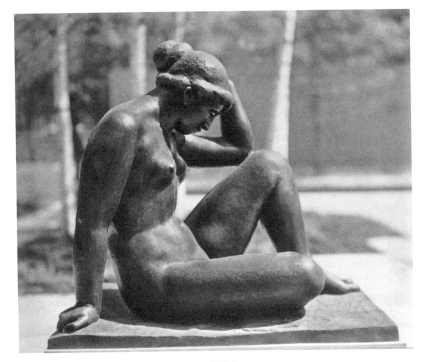

The Mediterranean. 1902–05. Bronze, 41" high

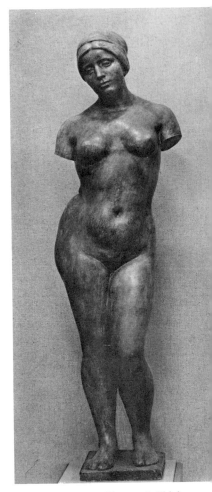

Summer. 1910–11. Plaster, 64" high

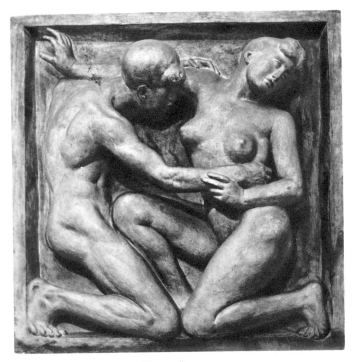

Desire. 1906–08. Plaster, 46⁷/₈ x 45"

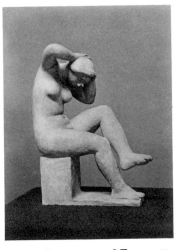

Seated Figure. c.1930? Terra cotta, 9" high

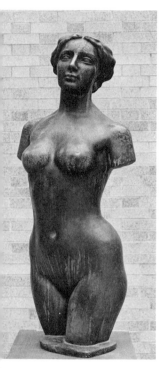

Torso of a Woman. c. 1925.
Bronze, 40" high

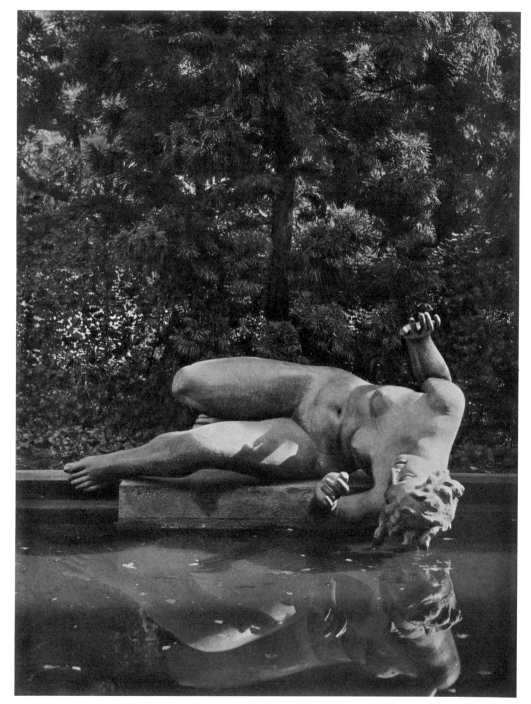

The River. 1938–43. Lead, 53¾" x 7'6"

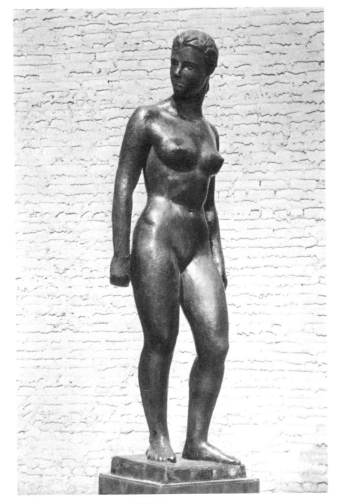

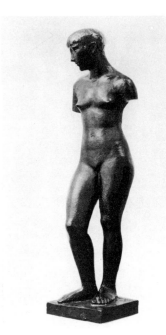

Adolescence (Diana). 1921–28?
Bronze, 25¹/₈″ high

Assia. 1938. Bronze, 6′³/₄″ high

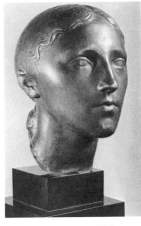

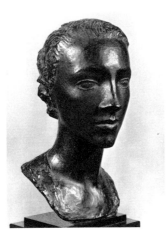

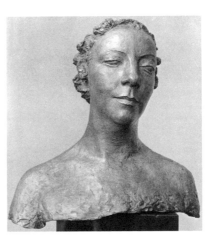

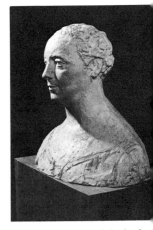

Young Peasant Girl. 1909.
Pewter (cast 1929), 11¹/₂″ high

Anne Morrow Lindbergh.
1939. Bronze, 15¹/₂″ high

Antoinette Schulte. 1934. Bronze, 19″
high

Portrait Head. Original plaster, 18¹/₄″ high

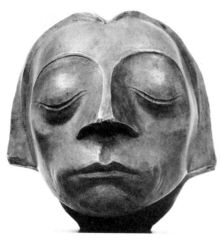

Barlach: *Head (detail, War Monument, Güstrow Cathedral).* 1927. Bronze, 13½″ high

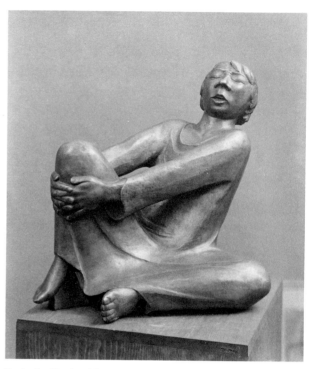

Barlach: *Singing Man.* 1928. Bronze, 19½″ high

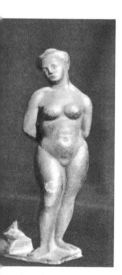

anolo: *Standing Nude.* 12. Bronze, 9⅜″ high

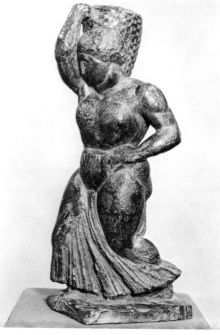

Manolo: *Grape Harvester.* 1913. Bronze, 17¾″ high

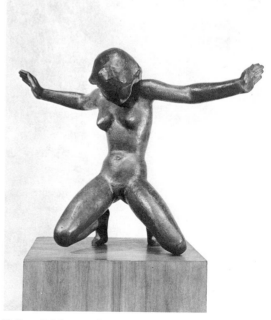

Kolbe: *Grief.* 1921. Bronze, 15¾″ high

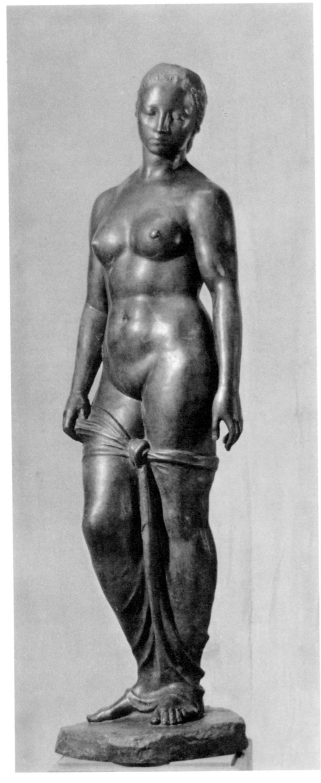

Bust of a Woman. c. 1911. Cast stone, 19³/₈
high

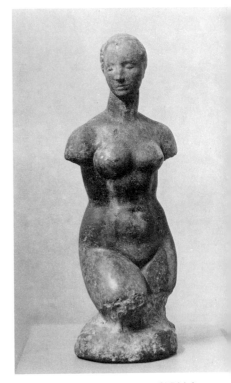

Standing Woman. 1910. Bronze (cast 1916–17), 6'3¹/₈" high

Torso. 1910–11. Cast stone, 27³/₄" high

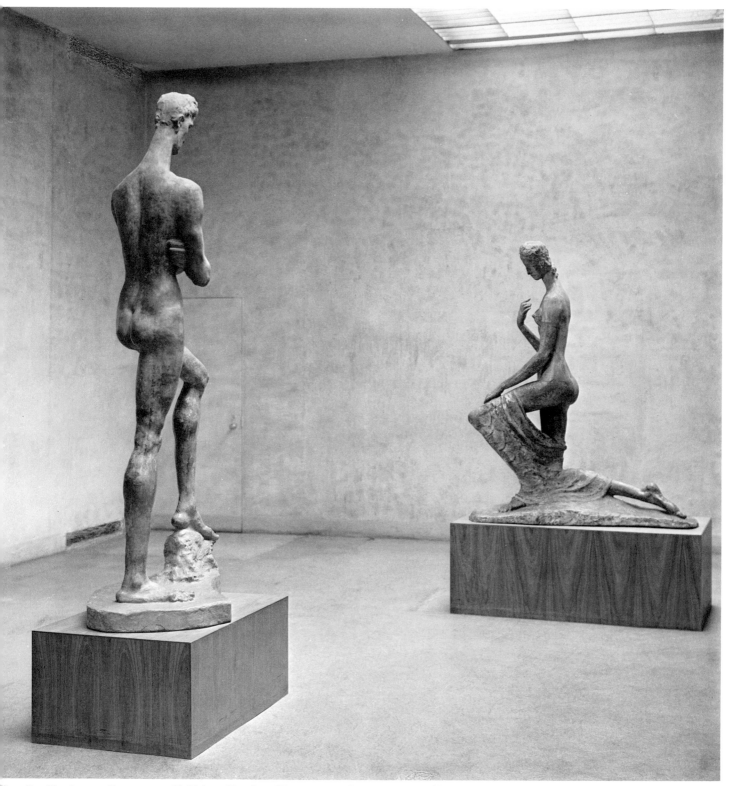

Standing Youth. 1913. Cast stone, 7′8″ high. *Kneeling Woman*. 1911. Cast stone, 69½″ high

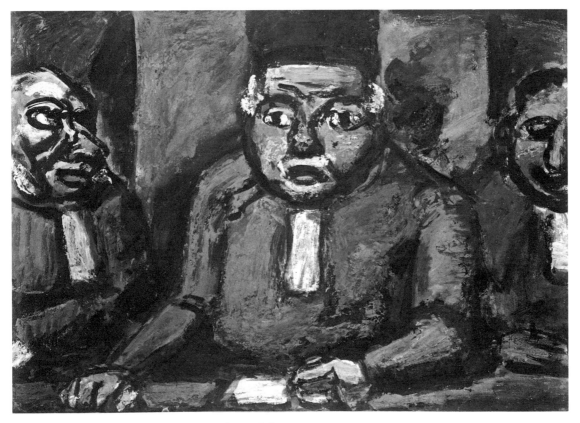

The Three Judges. 1913. Gouache and oil, 29⅞ x 41⅝"

Woman at a Table*.*1906. Watercolor and
pastel, 12⅛ x 9½"

Clown. c. 1907. Oil, 11½ x 12⅞"

Landscape with Figures. c. 1937. Oil, 21³/₈ x 27¹/₂″

Christ Mocked by Soldiers. 1932. Oil, 36¹/₄ x 28¹/₂″

The Lovely Madame X. 1915. Gouache, etc., 12 x 7³/₄″

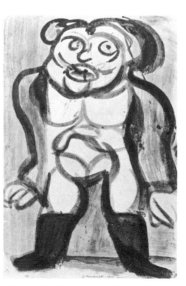

Circus Trainer. 1915. Gouache and crayon, 15⁵/₈ x 10³/₈″

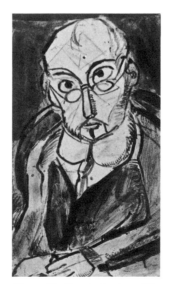

Man with Spectacles. 1917. Watercolor and crayon, 11³/₄ x 6¹/₂″

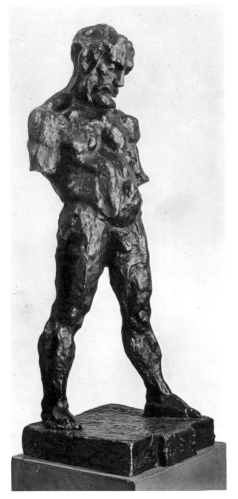

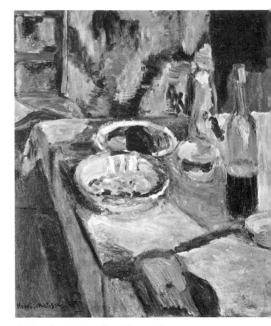

Still Life. 1899? Oil, 18¹/₈ x 15″

The Serf. 1900–03. Bronze, 37³/₈″ high

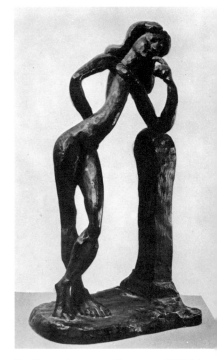

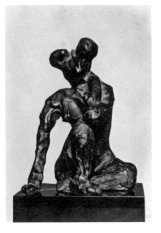

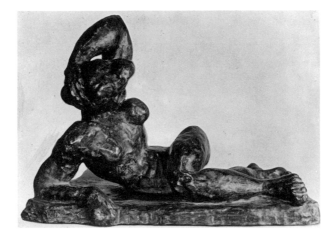

Seated Figure, Right Hand on Ground. 1908. Bronze, 7¹/₂″

Reclining Nude, I. 1907. Bronze, 19³/₄″ long

La Serpentine. 1909. Bronze, 22¹/₄″ high

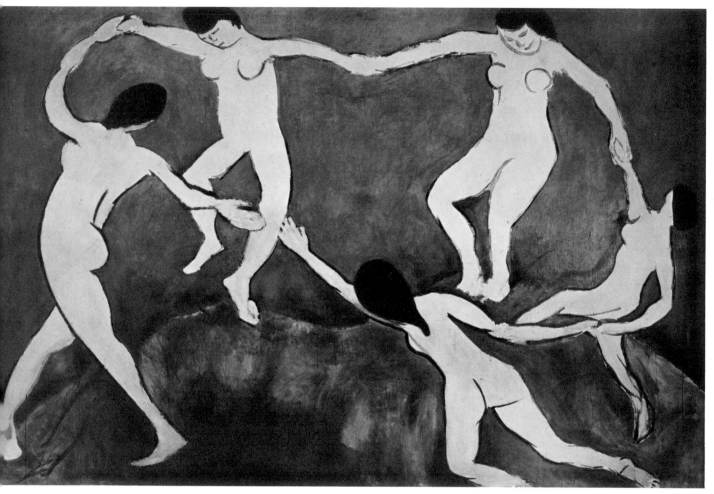

ance (first version). 1909. Oil, 8'6½" x 12'9½"

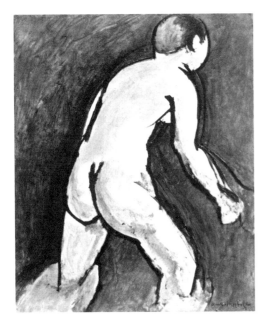

Bather. 1909, summer. Oil, 36¹/₂ x 29¹/₈″

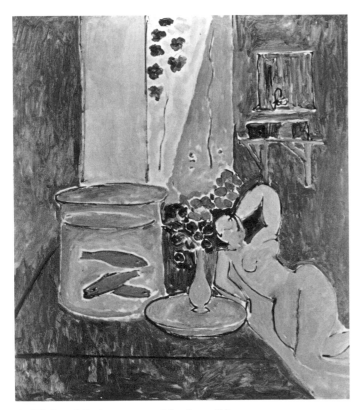

Goldfish and Sculpture. 1911. Oil, 46 x 39⁵/₈″

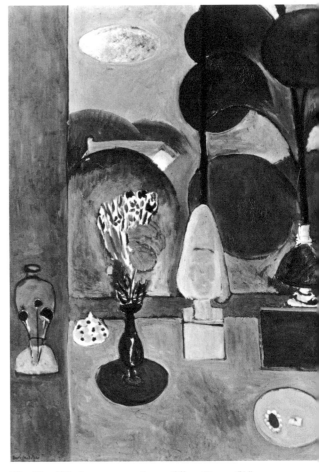

The Blue Window. 1911, autumn. Oil, 51¹/₂ x 35⁵/₈″

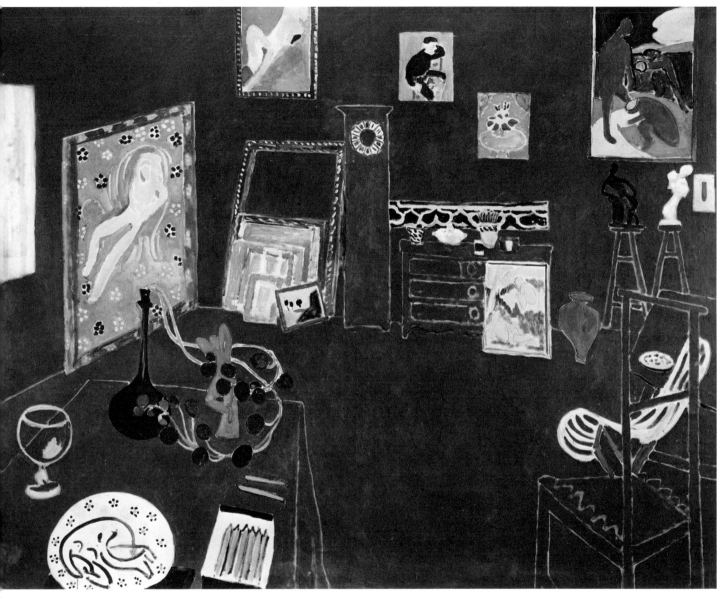

he Red Studio. 1911. Oil, 71¹/₄″ x 7′2¹/₄″

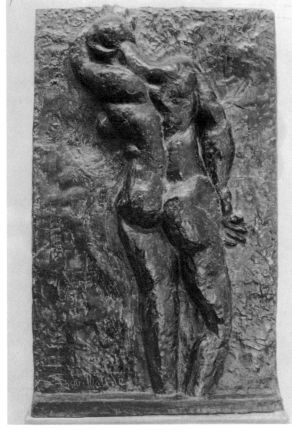

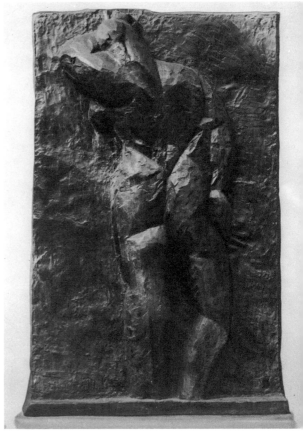

The Back, I. 1909. Bronze, 6′2³/₈″ x 44¹/₂″ x 6¹/₂″

The Back, II. 1913. Bronze, 6′2¹/₄″ x 47⁵/₈″ x 6″

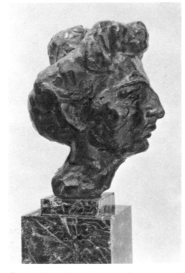

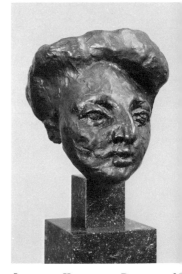

Jeannette, I. 1910–13. Bronze, 13″ high

Jeannette, II. 1910–13. Bronze, 10³/ high

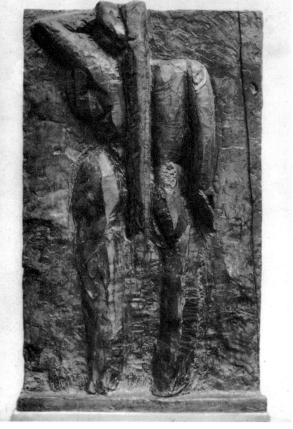

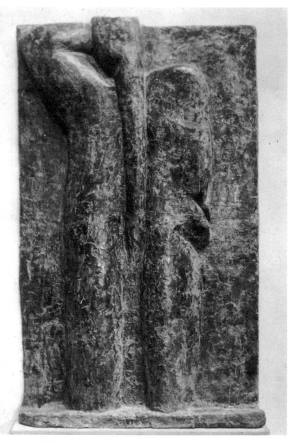

The Back, III. 1916–17. Bronze, 6′2½″ x 44″ x 6″

The Back, IV. 1930. Bronze, 6′2″ x 44¼″ x 6″

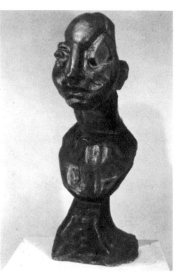

Jeannette, III. 1910–13. Bronze, 3¾″ high

Jeannette, IV. 1910–13. Bronze, 24⅛″ high

Jeannette, V. 1910–13. Bronze, 22⅞″ high

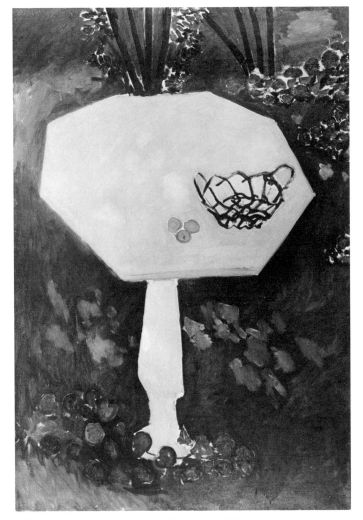

The Rose Marble Table. 1917. Oil, 57¹/₂ x 38¹/₄″

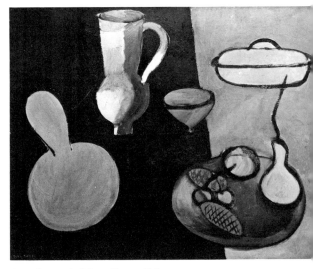

Gourds. 1916. Oil, 25⁵/₈ x 31⁷/₈″

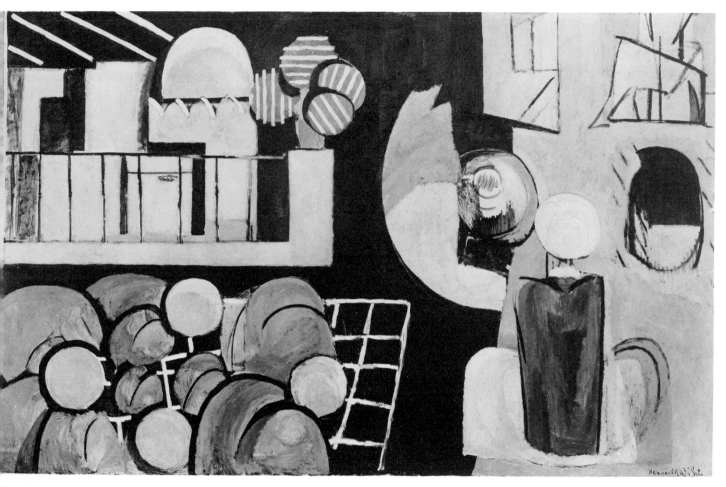

The Moroccans. 1916. Oil, 71³/₈″ x 9′2″

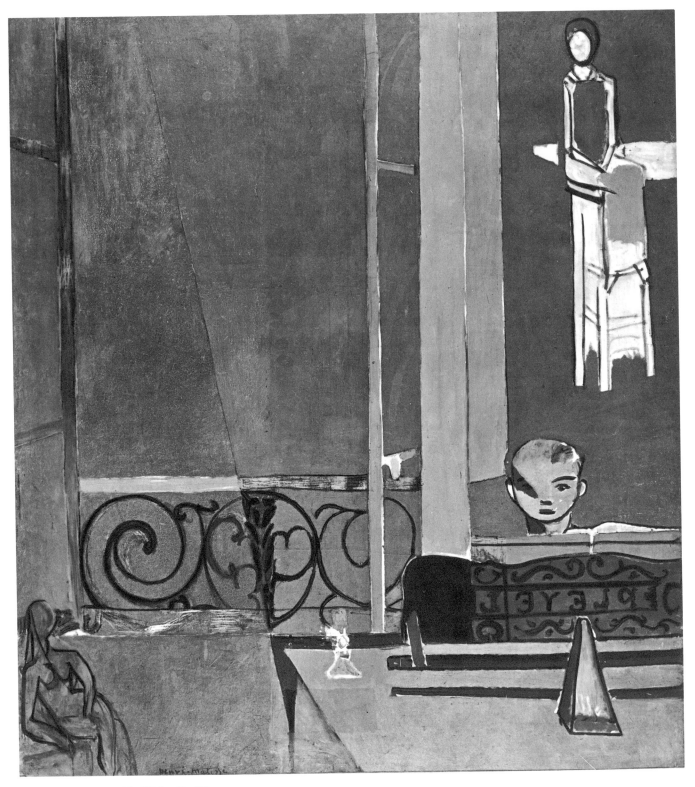

Piano Lesson. 1916. Oil, 8'1½" x 6'11¾"

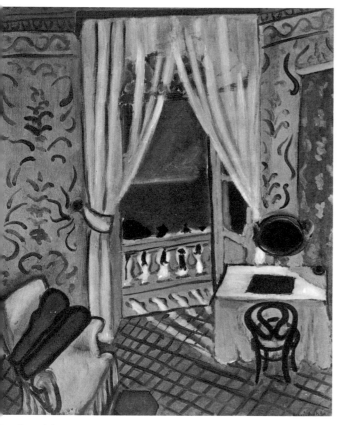

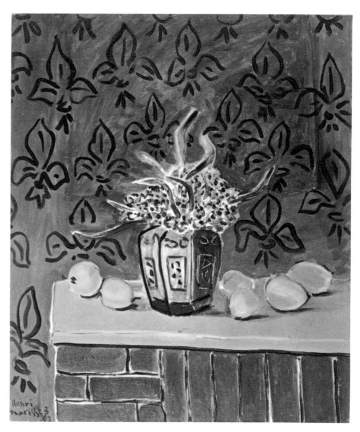

Interior with a Violin Case. 1918–19. Oil, 28³/₄ x 23⁵/₈″

Lemons against a Fleur-de-lis Background. 1943. Oil, 28⁷/₈ x 24¹/₄″

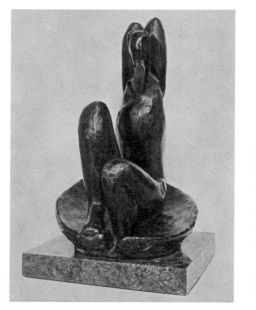

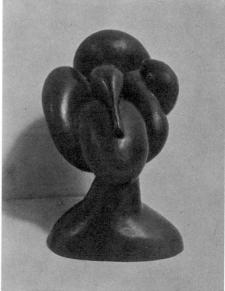

Venus in a Shell, I. 1930. Bronze, 12¹/₄″ high

Tiari. 1930. Bronze, 8″ high

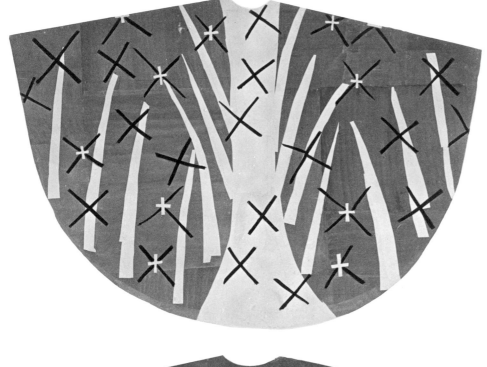

Maquettes for liturgical vestments designed for the Chapel of the Rosary of the Dominican Nuns of Vence. c. 1950. Gouache on paper, cut and pasted

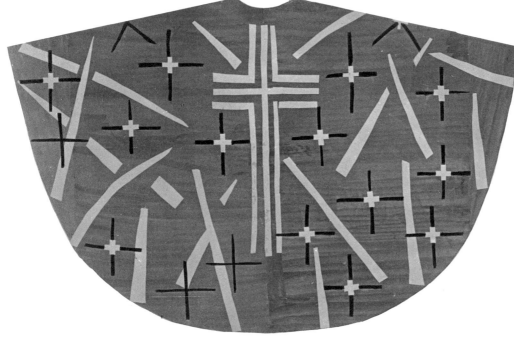

Designs for burse, 10 x 8³/₄″; maniple, 17 x 8³/₈″; chalice veil, 20¹/₄ x 20¹/₄″

Designs for chasuble: front (above), 52¹/₂″ x 6′6¹/₈″; back (below), 50¹/₂″ x 6′6¹/₂″

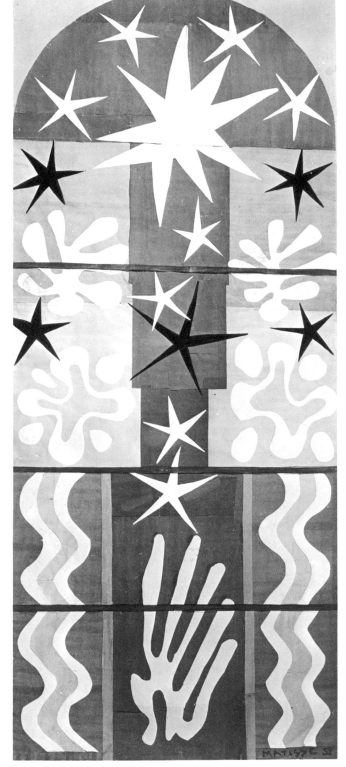

Design, 1951, for jacket of *Matisse: His Art and His Public*, Museum of Modern Art, 1951. Gouache on paper, cut and pasted, 10⁵/₈ x 16⁷/₈″

Nuit de Noël. Design for a window commissioned by *Life*. 1952. Gouache on paper, cut and pasted, 10'7″ x 53¹/₂″

Poplars. c. 1900. Oil, 16¹/₄ x 12⁷/₈″

London Bridge. 1906. Oil, 26 x 39″

left: L'Estaque. 1906.
Oil, 13⁷/₈ x 17³/₄″

Fishing Boats, Collioure. 1905. Oil, 15¹/₈ x 18¹/₄″

Mme Derain in Green. 1907. Oil, 28³/₄ x 23⁵/₈″

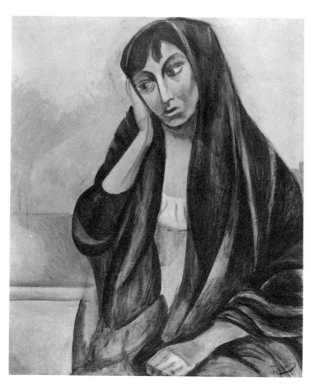

Italian Woman. 1913. Oil, 35⁷/₈ x 28³/₄″

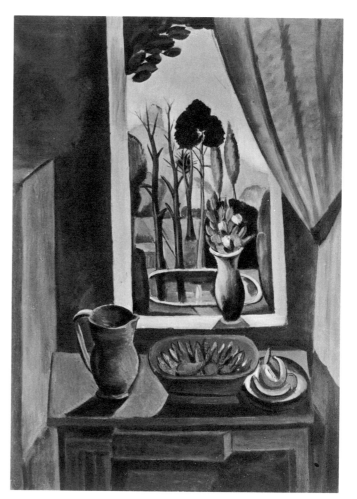

Window at Vers. 1912. Oil, 51¹/₂ x 35¹/₄″

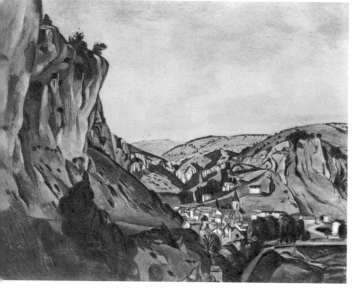

Valley of the Lot at Vers. 1912. Oil, 28⁷/₈ x 36¹/₄″

Landscape near Cassis. 1907. Oil, 18¹/₈ x 21⁵/₈″

Mme Derain. 1920. Oil,
14³/₄ x 9¹/₄"

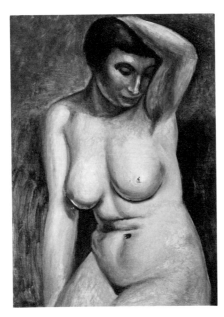

Torso. c. 1921. Oil, 30 x 21³/₈"

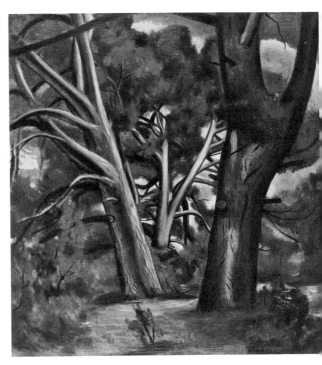

Three Trees. 1923? Oil, 36 x 32¹/₈"

Night Piece with Musical Instruments. Oil,
9¹/₈ x 15³/₈"

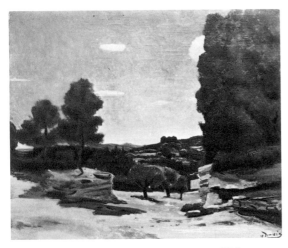

Landscape, Provence. c. 1926. Oil, 23¹/₂ x 28⁵/₈"

Landscape, Southern France. 1927–28. Oil, 31¹/₂ x 38"

Vlaminck: *Mont Valérien*. 1903. Oil, 22 x 30¼″

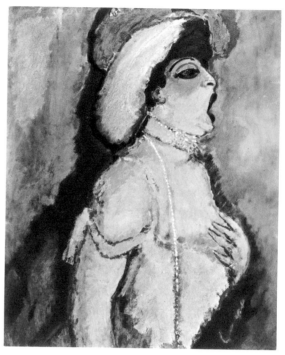

van Dongen: *Modjesko, Soprano Singer*. 1908. Oil, 39⅜ x 32″

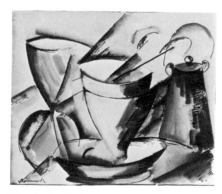

Vlaminck: *Still Life*. 1913–14. Watercolor and gouache, 15⅝ x 18⅞″

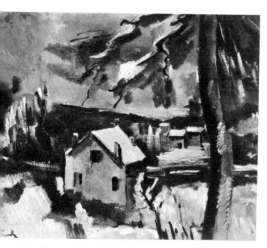

aminck: *Winter Landscape*. 1916–17. Oil, 21¼ x 25½″

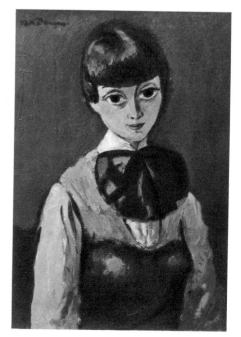

van Dongen: *Mlle Bordenave*. 1925. Oil, 28¾ x 19¾″

63

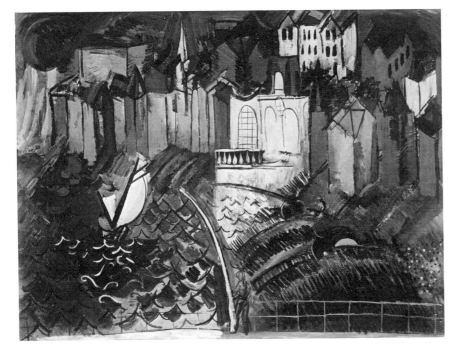

Sailboat at Sainte-Adresse. 1912. Oil, 34⁷/₈ x 45⁵/₈″

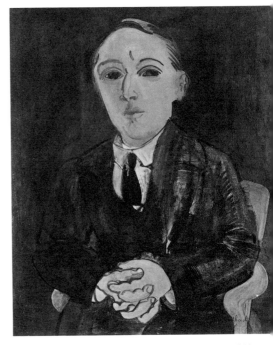

The Poet François Berthault. 1925. Oil, 32 x 25⁵/₈″

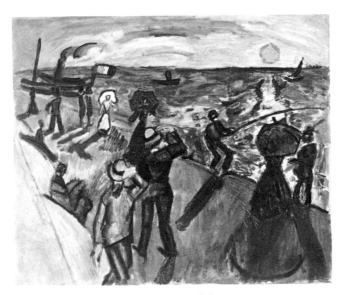

Anglers at Sunset. 1907. Oil, 21³/₈ x 25⁵/₈″

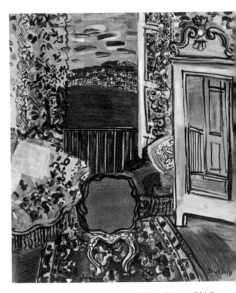

Window at Nice. c. 1929. Oil, 21⁵/₈ x 18¹/₈″

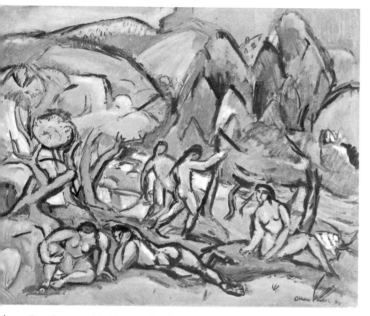

iesz: *Landscape with Figures (Bathers)*. 1909. Oil, 25⅝ x 32″

Utrillo: *The Church at Blévy*. Oil, 25½ x 19½″

fy: *The Palm*. 1923. Watercolor and gouache, 19¾ x 25″

Segonzac: *Landscape*. c. 1928. Watercolor, 18⅞ x 24¾″

Rohlfs: *Man in Top Hat and Tails*. c. 1915–16. Gouache, watercolor, and graphite, 18¹/₈ x 12¹/₂″

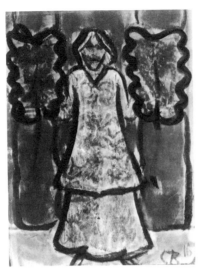

Rohlfs: *Blue Fan Dancer*. 1916. Gouache and watercolor, 19 x 13³/₄″

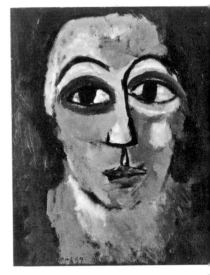

Jawlensky: *Head*. c. 1910? Oil, 16¹/₈ x 12″

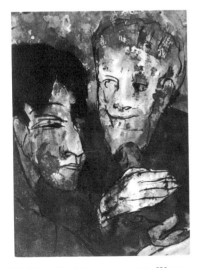

Nolde: *Magicians*. 1931–35. Watercolor, 20¹/₈ x 14³/₈″

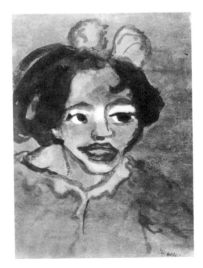

Nolde: *Islander*. 1920–21. Watercolor, 18¹/₂ x 13³/₄″

Nolde: *Amaryllis and Anemone*. c. 1930. Watercolor, 13³/₄ x 18³/₈″

Christ among the Children. 1910. Oil, 34¹/₈ x 41⁷/₈"

...ssian Peasants. 1915. Oil, 29 x 35¹/₂"

Flowers. c. 1915? Oil, 26¹/₄ x 33¹/₄"

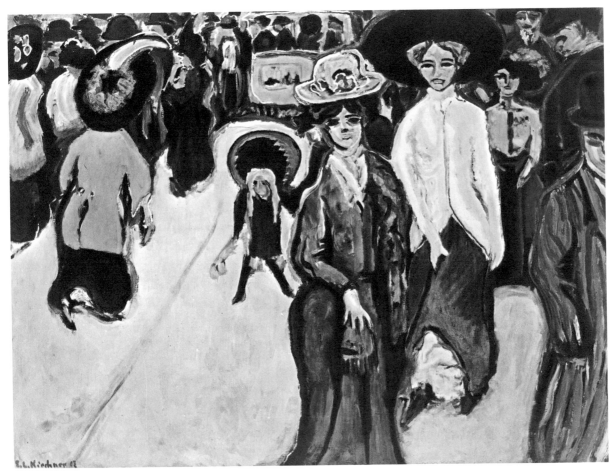

Street, Dresden. 1908. Dated on painting 1907. Oil, 59¼″ x 6′6⁷⁄₈″

Sand Hills in Engadine. 1917–18. Oil, 33¾ x 37½″

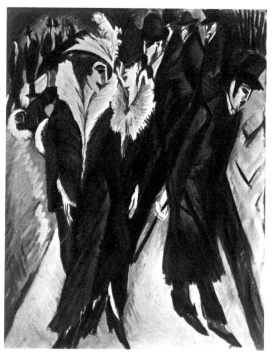

Street, Berlin. 1913. Oil, 47¹/₂ x 35⁷/₈″

Emmy Frisch. 1907–08. Oil, 59¹/₈ x 28⁷/₈″

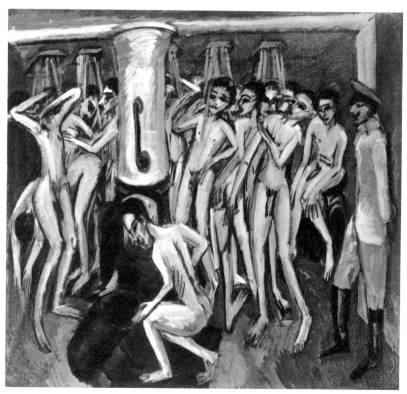

Artillerymen. 1915. Oil, 55¹/₄ x 59³/₈″

Heckel: *Seated Man.* 1909. Oil, 27³/₄ x 23⁷/₈″

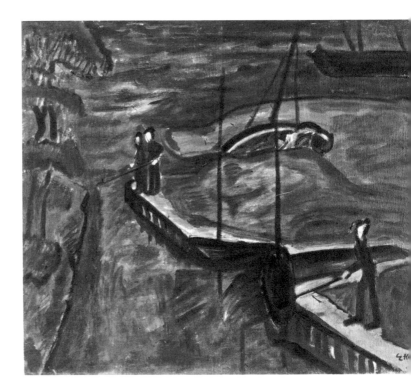

Heckel: *Fishing.* 1912. Oil, 32¹/₂ x 37″

left: Schmidt-Rottluff:
*Landscape with Light-
house.* 1922. Watercolor,
18⁷/₈ x 23⁷/₈″

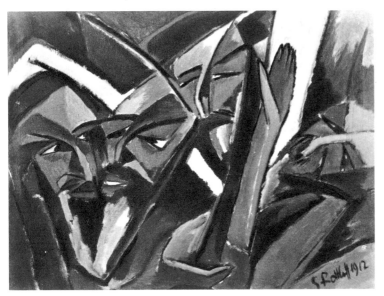

Schmidt-Rottluff: *Pharisees.* 1912. Oil, 29⁷/₈ x 40¹/₂″

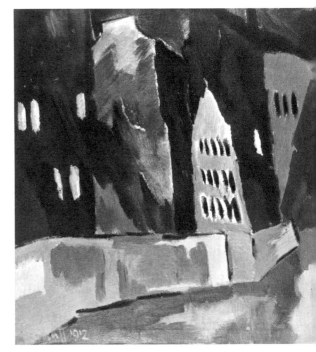

Schmidt-Rottluff: *Houses at Night.* 1912. Oil, 37⁵/₈ x 34¹/₂″

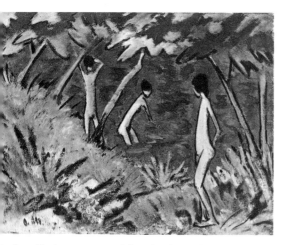

Mueller: *Bathers*. c. 1920. Oil on burlap, 27⁵/₈ x 35³/₄"

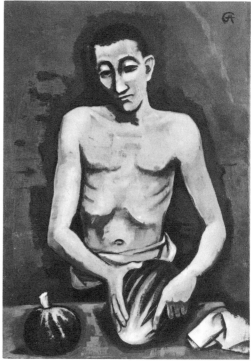

Hofer: *Man with a Melon*. 1926. Oil, 42¹/₄ x 28⁷/₈"

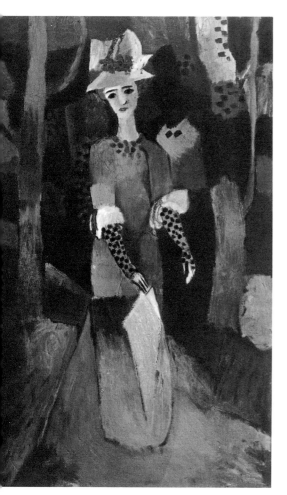

Macke: *Susanna and the Elders*. 1913. Colored inks, 9¹/₈ x 9⁷/₈"

Macke: *Lady in a Park*. 1914. Oil, 38¹/₂ x 23¹/₄"

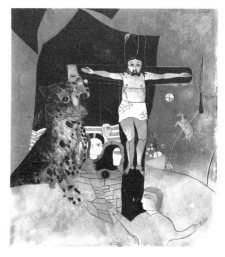

Campendonk: *Mystical Crucifixion*. 1926–28? Oil on glass, 17¹/₂ x 15"

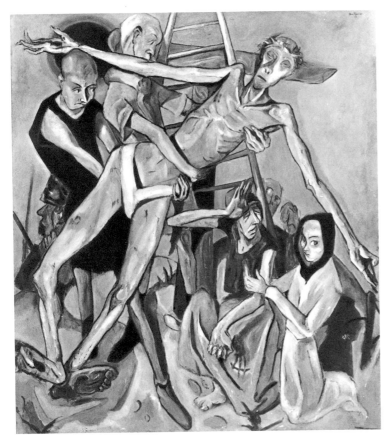

The Descent from the Cross. 1917. Oil, 59$^{1}/_{2}$ x 50$^{3}/_{4}$″

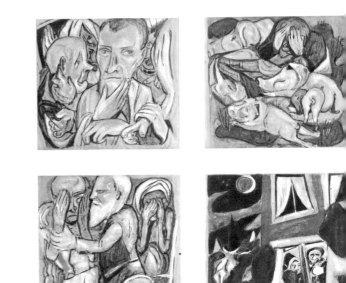

The Prodigal Son. 1921. Four gouaches, 14$^{1}/_{4}$ to 14$^{1}/_{2}$ x 11$^{3}/_{4}$″: *Th Prodigal Son among Courtesans, The Prodigal Son among Swin The Return of the Prodigal, The Feast of the Prodigal*

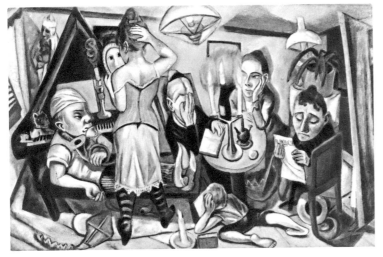

Family Picture. 1920. Oil, 25$^{5}/_{8}$ x 39$^{3}/_{4}$″

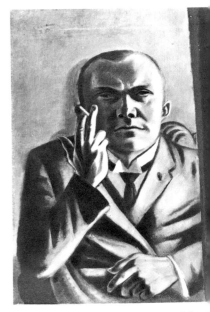

Self-Portrait with a Cigarette. 1923. Oil, 23 x 15$^{7}/_{8}$″

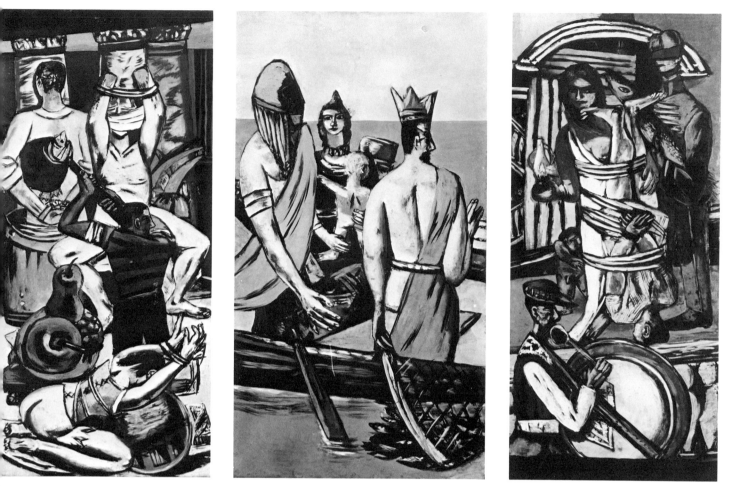

eparture. 1932–33. Oil; triptych, center panel, 7'3/4" x 45³/8"; side panels each 7'3/4" x 39¹/4"

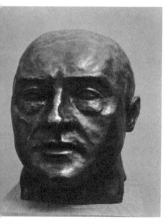

lf-Portrait. 1936. Bronze, 14¹/2"
gh

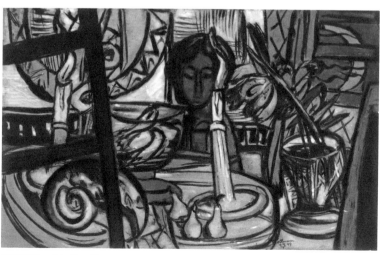

Still Life with Candles. 1949. Oil, 35 x 55⁷/8"

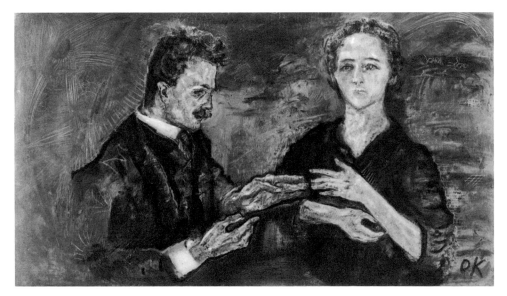

Hans Tietze and Erica Tietze-Conrat. 1909. Oil, 30¹⁄₈ x 53⁵⁄₈″

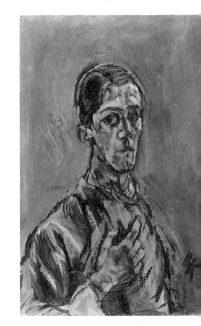

Self-Portrait. 1913. Oil, 32¹⁄₈ x 19¹⁄₂″

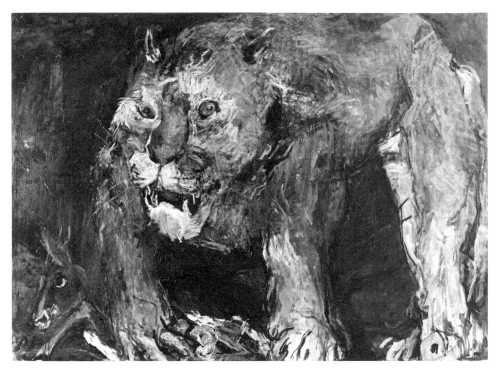

Tiglon. 1926. Oil, 38 x 51″

Nude Bending Forward. c. 1907. Watercolor, chalk, ink, and pencil, 17³⁄₄ x 12¹⁄₄″

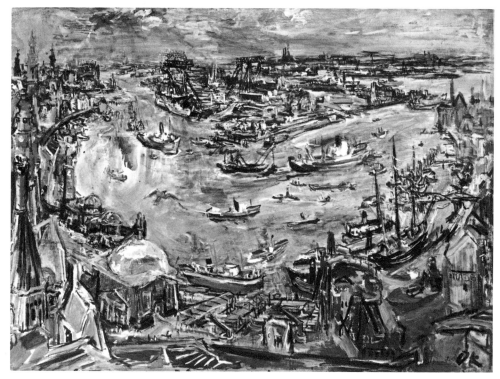

Kokoschka: *Seated Woman.* 1921. Watercolor, 27³/₄ x 20³/₈″

Kokoschka: *Port of Hamburg.* 1951. Oil, 35³/₄ x 47¹/₂″

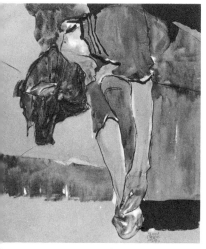

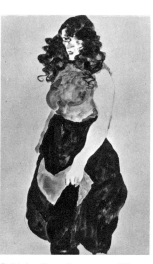

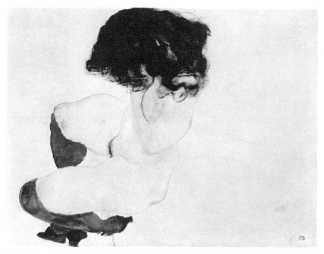

chiele: *Girl Putting on Shoe.* 1910. Watercolor and charcoal, 14¹/₂ x 12¹/₂″

Schiele: *Prostitute.* 1912. Watercolor and pencil, 19 x 12³/₈″

Schiele: *Nude with Violet Stockings.* 1912. Watercolor, pencil, brush and ink, 12⁵/₈ x 18⁵/₈″

Brooding Woman. 1904–05. Watercolor, 10⁵/₈ x 14¹/₂″

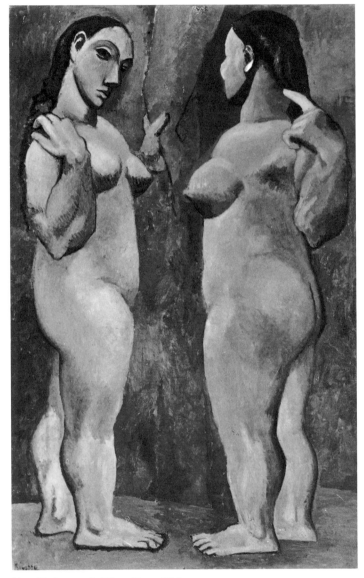

Two Nudes. 1906. Oil, 59⁵/₈ x 36⁵/₈″

Head of a Man. Study for *Les Demoiselles d'Avignon.* Early 1907. Watercolor, 23³/₄ x 18¹/₂″

Bathers in a Forest. 1908. Watercolor and pencil, 18³/₄ x 23¹/₈″

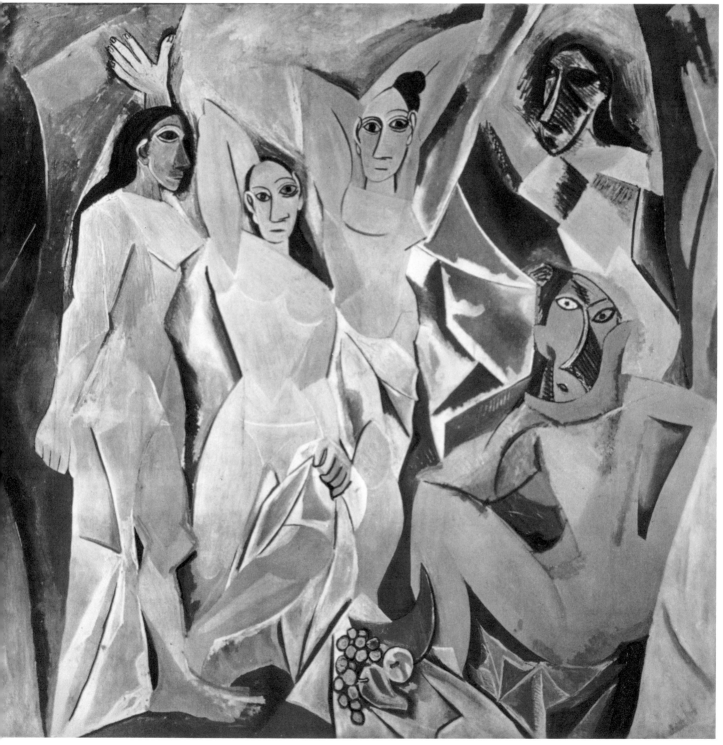

Les Demoiselles d'Avignon. 1907. Oil, 8′ x 7′8″

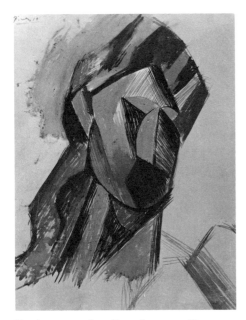

Head. 1909, spring. Gouache, 24 x 18″

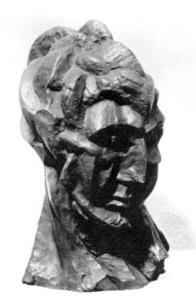

Woman's Head. 1909, fall. Bronze, 16¼″ high

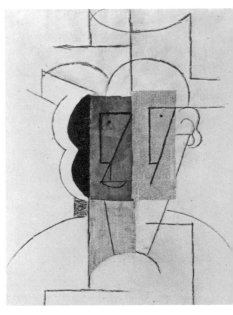

Man with a Hat. 1912, December. Charcoal, ink, pasted paper, 24½ x 18⅝″

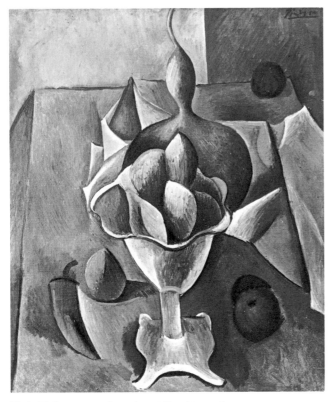

Fruit Dish. 1909, early spring. Oil, 29¼ x 24″

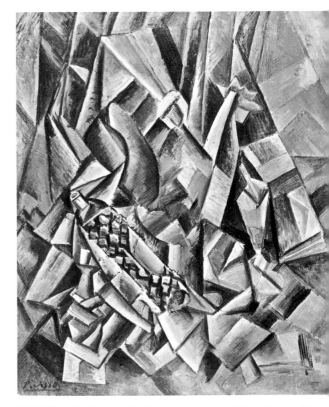

Still Life with Liqueur Bottle. 1909, summer. Oil, 32⅛ x 25¾″

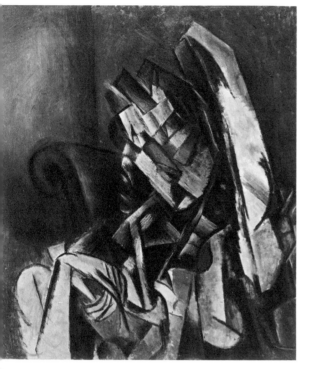

Woman in a Chair. Late 1909. Oil, 28³/₄ x 23⁵/₈"

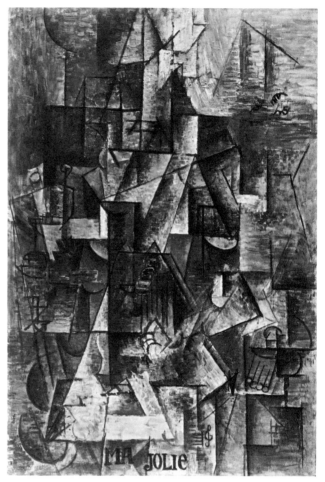

"Ma Jolie." 1911–12, winter. Oil, 39³/₈ x 25³/₄"

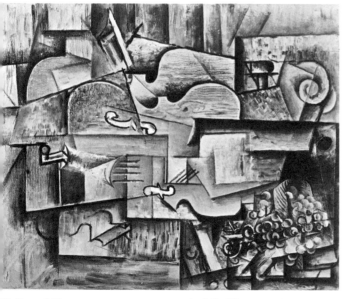

Violin and Grapes. 1912, summer or early fall. Oil, 20 x 24"

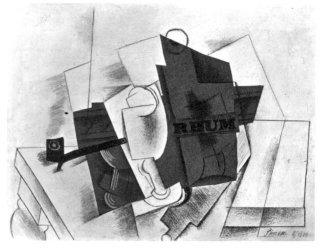

Pipe, Glass, Bottle of Rum. 1914, March. Pasted paper, pencil, gouache, 15³/₄ x 20³/₄"

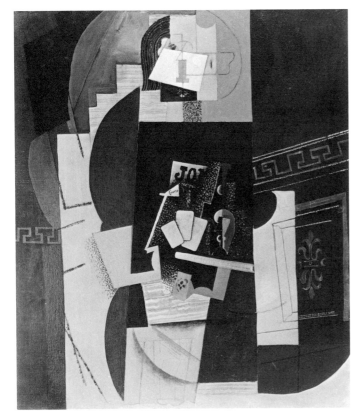

Card Player. 1913–14, winter. Oil, 42¹/₂ x 35¹/₄″

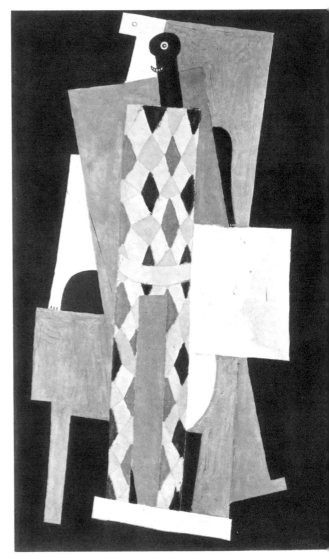

Harlequin. Late 1915. Oil, 6′1¹/₄″ x 41³/₈″

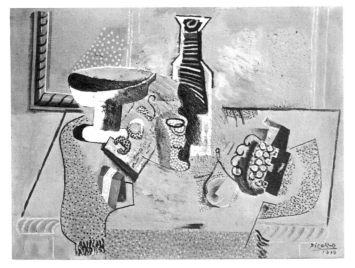

Green Still Life. 1914, summer. Oil, 23¹/₂ x 31¹/₄″

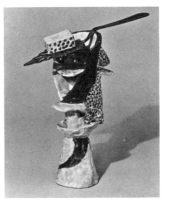

Glass of Absinth. 1914. Painted bronze, 8¹/₂″ high

Seated Woman. 1918. Gouache 5¹/₂ x 4¹/₂″

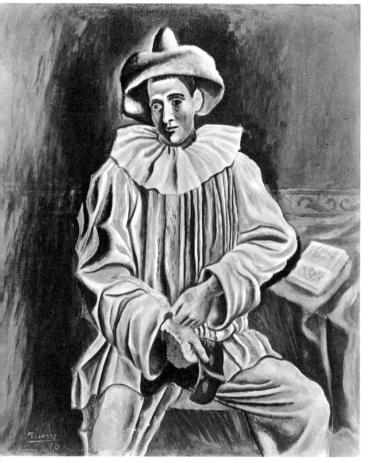

Pierrot. 1918. Oil, 36¹/₂ x 28³/₄"

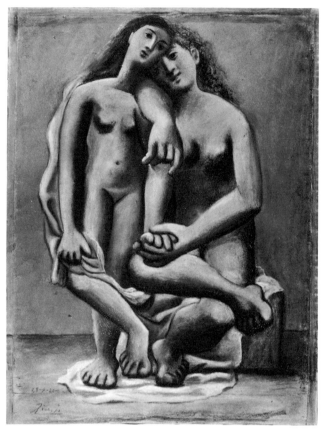

Two Women. 1920. Pastel and pencil, 27¹/₈ x 20¹/₈"

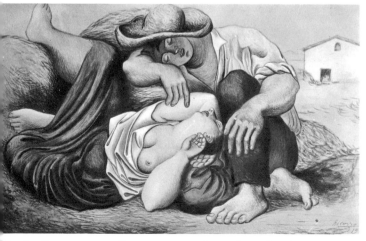

Sleeping Peasants. 1919. Tempera, watercolor, and pencil, 12¹/₄ x 19¹/₄"

The Rape. 1920. Tempera on wood, 9³/₈ x 12⁷/₈"

Three Women at the Spring. 1921, summer. Oil, 6′8¼″ x 68½″

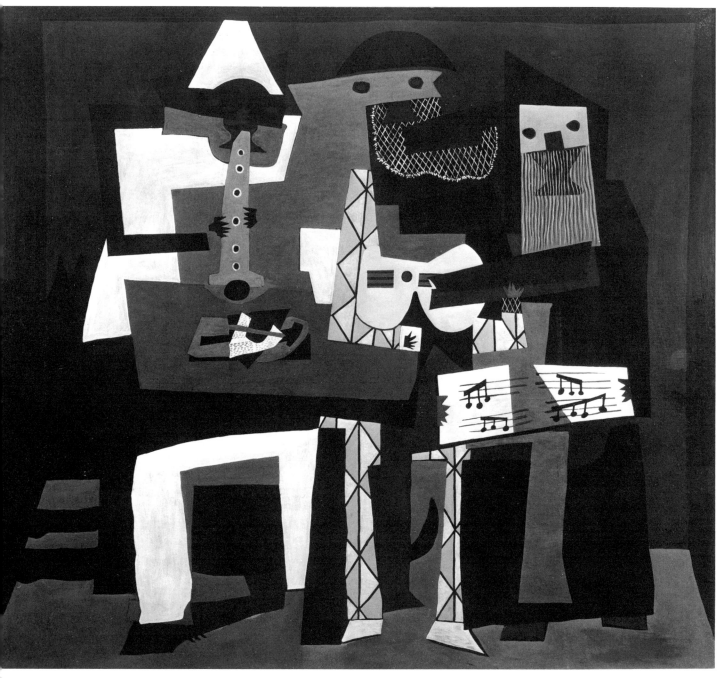

Three Musicians. 1921, summer. Oil, 6′7″ x 7′3¾″

Still Life with a Cake. 1924, May. Oil, 38¹/₂ x 51¹/₂″

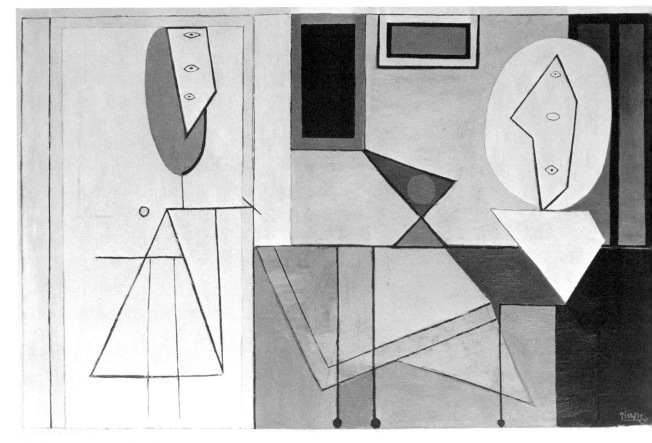

The Studio. 1927–28. Oil, 59″ x 7′7″

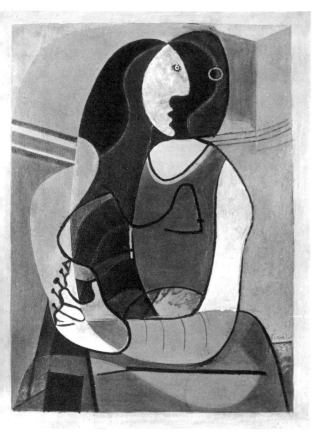

eated Woman. 1927. Oil, 51¹/₈ x 38¹/₄″

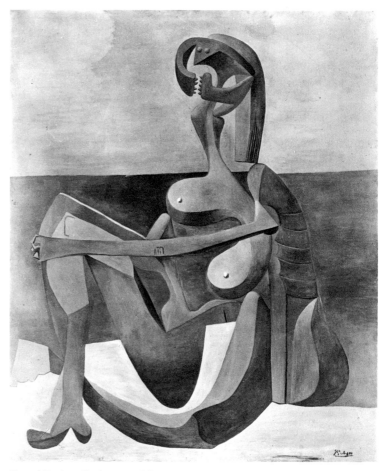

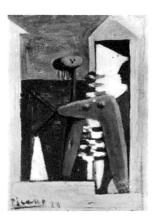

Bather and Cabin. 1928, August. Oil, 8¹/₂ x 6¹/₄″

Seated Bather. Early 1930. Oil, 64¹/₄ x 51″

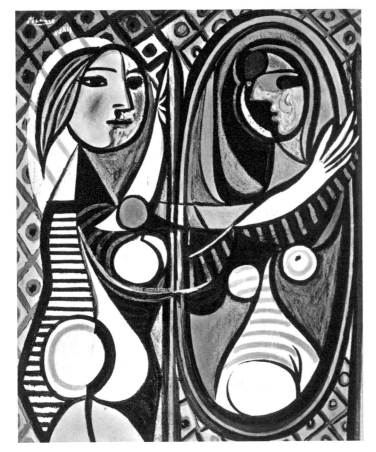

Girl before a Mirror. 1932, March. Oil, 64 x 51¹/₄"

Head. 1940, March. Oil on paper, 25¹/₂ x 18¹/₈"

Head of a Woman. 1945, February. Oil o paper, 25⁵/₈ x 19⁷/₈"

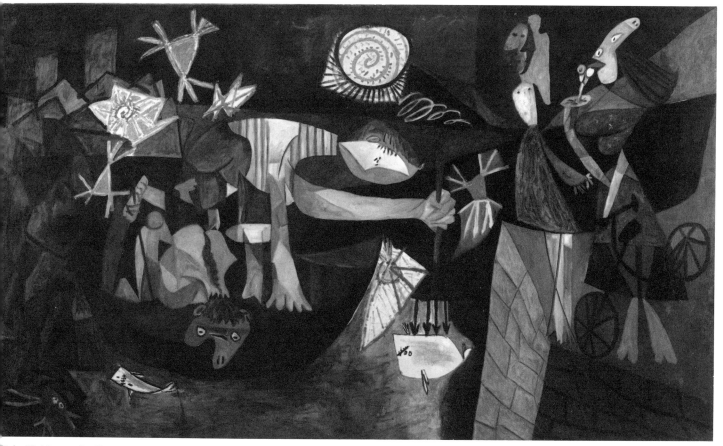

Night Fishing at Antibes. 1939, August. Oil, 6'9" x 11'4"

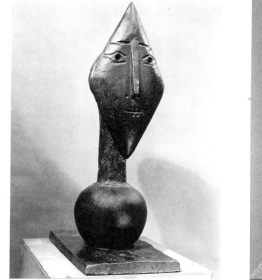

Head of a Woman. 1951. Bronze (cast 1955),
21¹/₈" high, at base 14¹/₈ x 7³/₈"

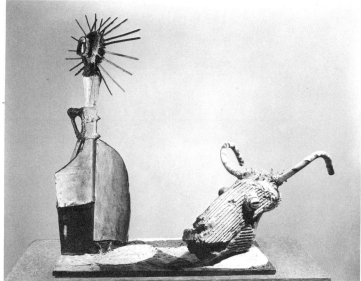

Goat Skull and Bottle. 1951–52. Painted bronze (cast 1954), 31 x 37⁵/₈ x 21¹/₂"

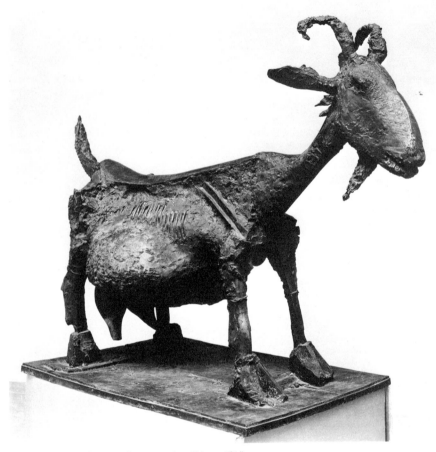

She-Goat. 1950. Bronze (cast 1952), 46³/₈ x 56³/₈"

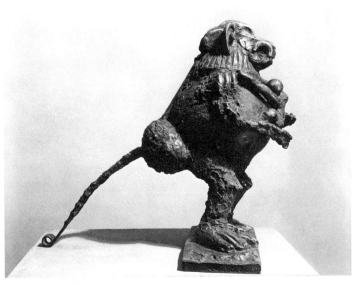

Baboon and Young. 1951. Bronze (cast 1955), 21" high

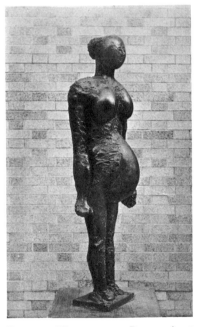

Pregnant Woman. 1950. Bronze (cast 1955), 41¹/₄" high

Bearded Faun. 1956.
Painting on tile, 8 x 8"

Head of a Faun. 1956.
Painting on tile, 8 x 8"

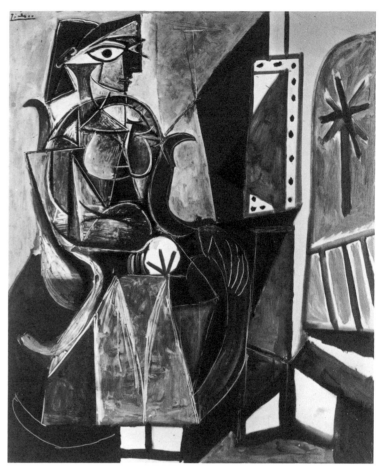

Woman by a Window. 1956, June. Oil, 63³/₄ x 51¹/₄"

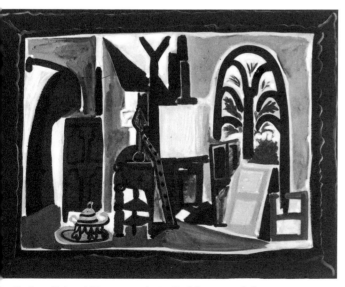

Studio in a Painted Frame. 1956, April. Oil, 35 x 45⁵/₈"

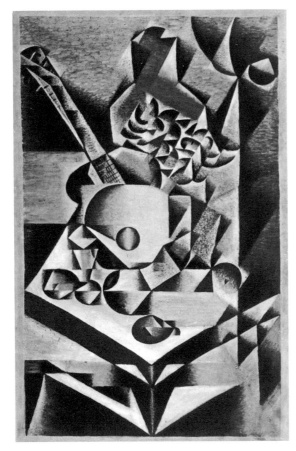

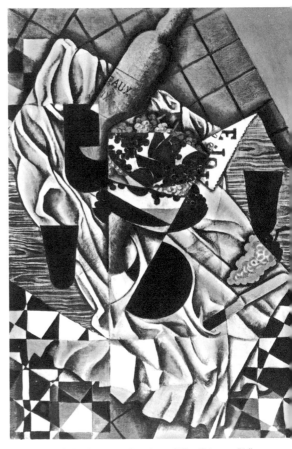

Guitar and Flowers. 1912. Oil, 44¹/₈ x 27⁵/₈″

Grapes and Wine. 1913, October. Oil, 36¹/₄ x 23⁵/₈″

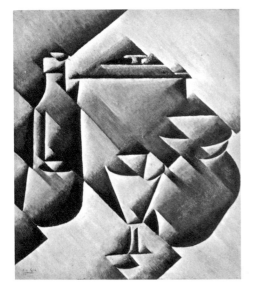

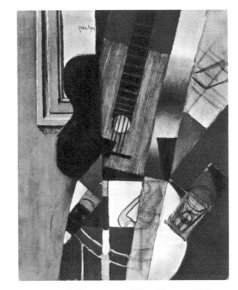

Still Life. 1911. Oil, 23¹/₂ x 19³/₄″

Guitar and Pipe. 1913. Oil, 25¹/₂ x 19³/₄″

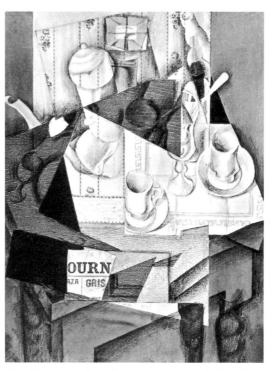

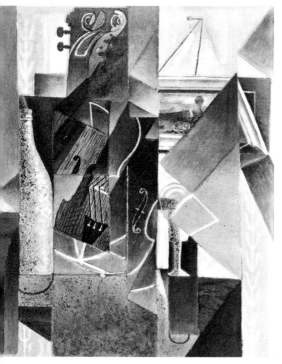

Violin and Engraving. 1913, April. Oil and collage, 25⅝ x ⁹⁵⁄₈"

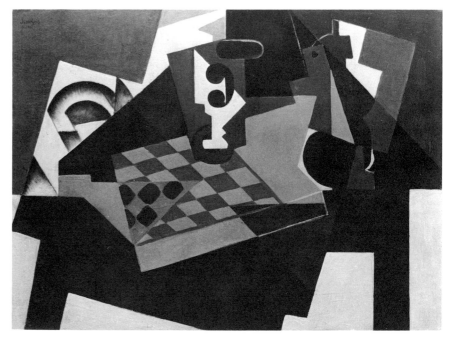

Breakfast. 1914. Pasted paper, crayon, and oil, 31⅞ x 23½"

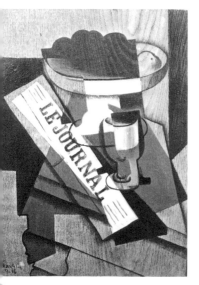

Fruit Dish, Glass, and Newspaper. 1916, July. Oil, 21⅝ x 15"

The Chessboard. 1917, March. Oil, 28¾ x 39⅜"

Road near L'Estaque. 1908. Oil, 23³/₄ x 19³/₄"

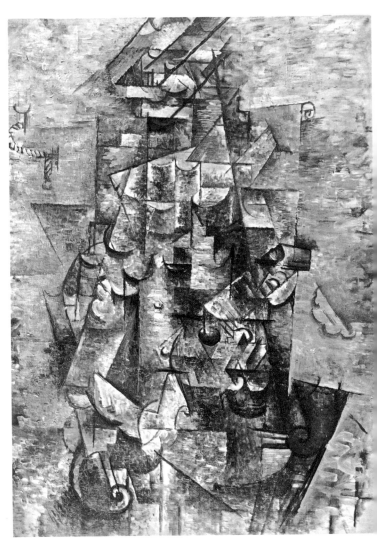

Man with a Guitar. 1911. Oil, 45³/₄ x 31⁷/₈"

Soda. 1911. Oil, 14¹/₄" diameter

Guitar. 1913–14. Gesso, collage, etc., 39¹/₄ x 25⁵/₈″

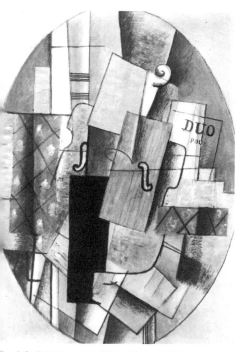

Oval Still Life. 1914. Oil, 36³/₈ x 25³/₄″

The Table. 1928. Oil, 70³/₄ x 28³/₄″

Woman with a Mandolin. 1937. Oil, 51¼ x 38¼″

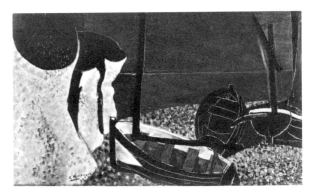

Beach at Dieppe. 1928. Oil, 10¾ x 18⅛″

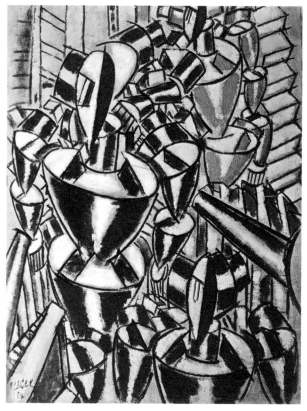

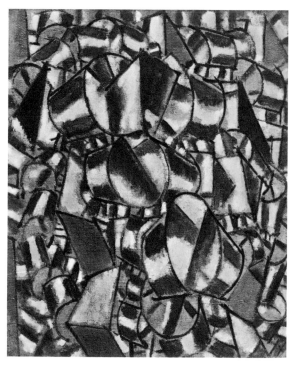

Contrast of Forms. 1913. Oil, 39½ x 32"

Exit the Ballets Russes. 1914. Oil, 53¾ x 39½"

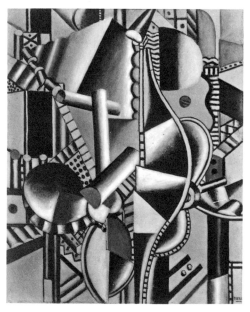

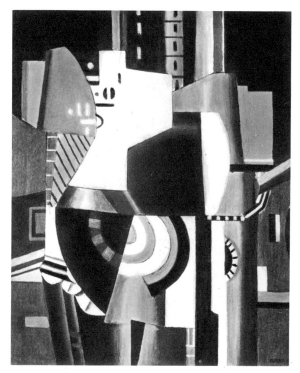

Propellers. 1918. Oil, 31⅞ x 25¾"

The City (study). 1919. Oil, 36¼ x 28⅜"

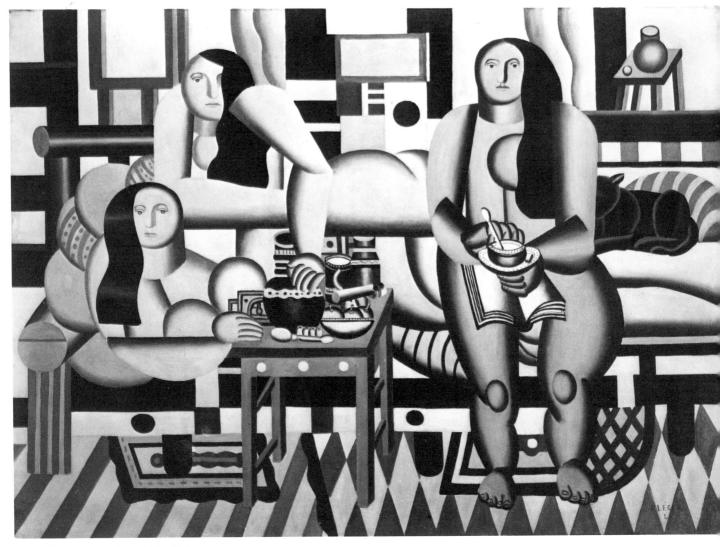

Three Women. 1921. Oil, 6'1/4" x 8'3"

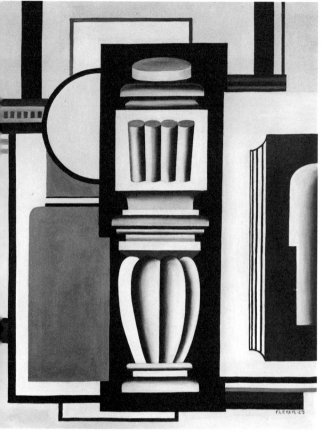

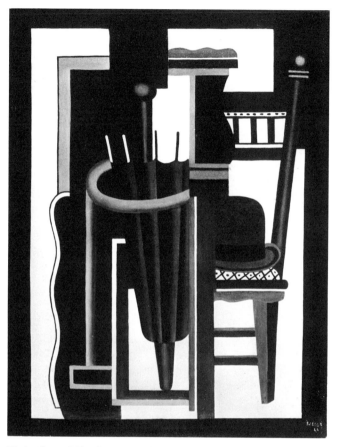

e Baluster. 1925. Oil, 51 x 38¹/₄″

Umbrella and Bowler. 1926. Oil, 50¹/₄ x 38³/₄″

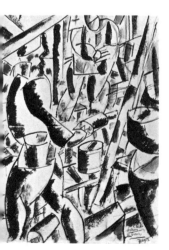

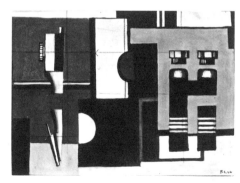

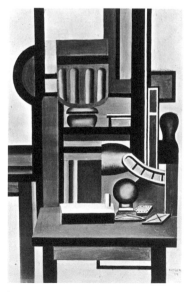

rdun: The Trench Diggers. 1916.
atercolor, 14¹/₈ x 10³/₈″

Compass and Paint Tubes. 1926. Gouache, 10¹/₂
x 14¹/₄″

Still Life. 1924. Oil, 36¹/₄ x 23⁵/₈″

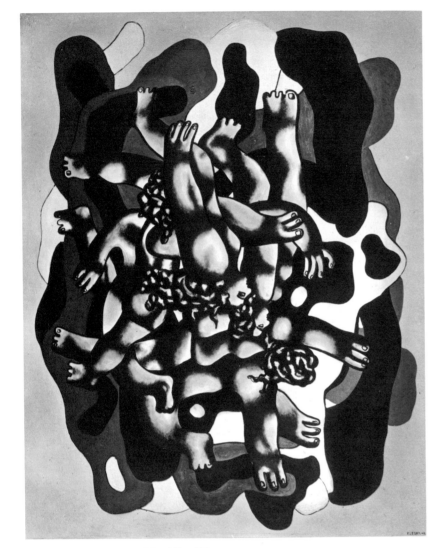

The Divers, II. 1941–42. Oil, 7′6″ x 68″

Red Decoration. 1941. Oil, 70 x 48″

Mechanical Fragment. 1943–44. Oil, 24 x 19⅞″

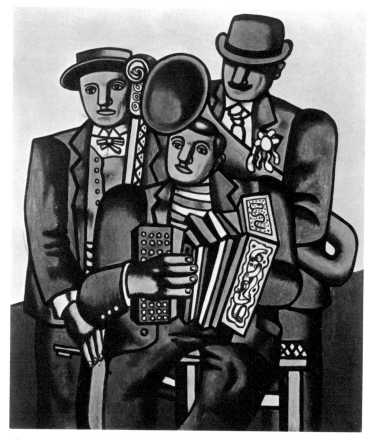

Three Musicians. 1944. Dated on painting 1924–44. Oil, 68¹/₂ x 57¹/₄″

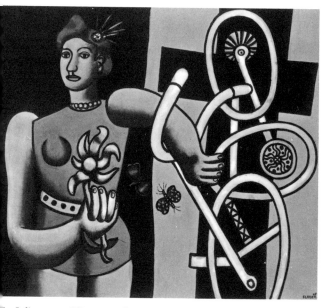

g Julie. 1945. Oil, 44 x 50¹/₈″

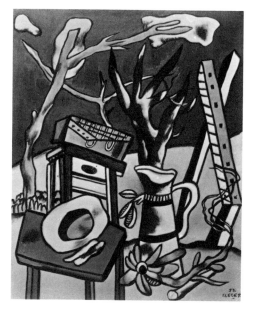

Landscape with Yellow Hat. 1952. Oil, 36¹/₄ x 28⁷/₈″

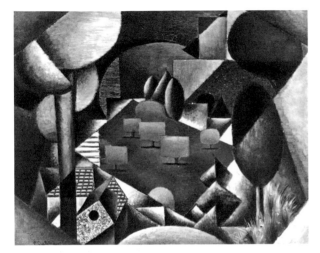

Metzinger: *Landscape*. 1912–14? Oil, 28³/₄ x 36¹/₄"

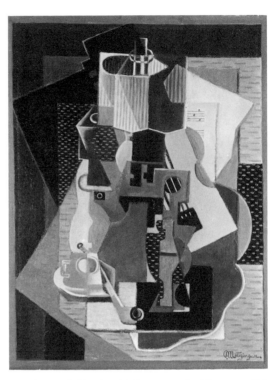

Metzinger: *Still Life with Lamp*. 1916. Oil, 32 x 23⁷/₈"

right: Gleizes: *Composition*. 1922. Gouache, 3¹/₂ x 2³/₄"

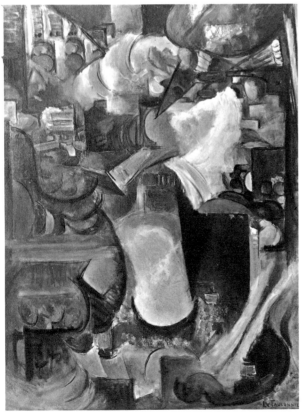

Le Fauconnier: *The Huntsman*. 1912. Oil, 62¹/₄ x 46³/₈"

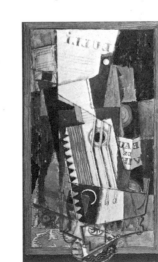

Marcoussis: *Still Life with Zither*. 1919. Watercolor, oil, ink, and pencil on paper, 16³/₄ x 9¹/₂"

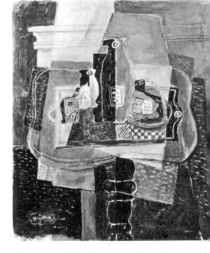

Hayden: *Still Life*. 1917. Gouache and charcoal, 16³/₄ x 14"

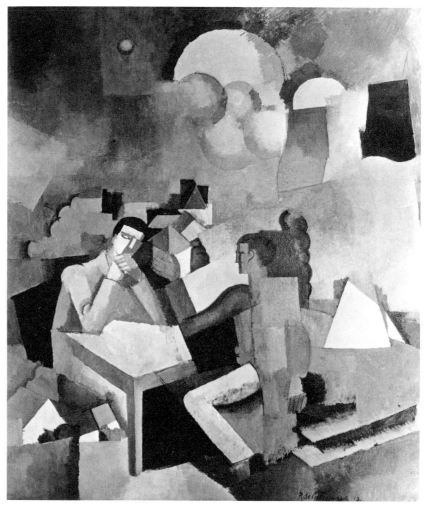

La Fresnaye: *The Conquest of the Air*. 1913. Oil, 7'8⁷/₈" x 6'5"

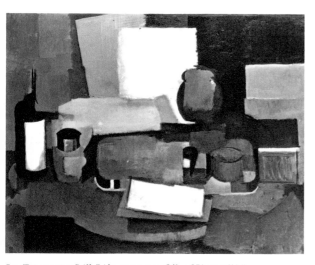

La Fresnaye: *Still Life*. 1913–14. Oil, 28⁵/₈ x 36¹/₈"

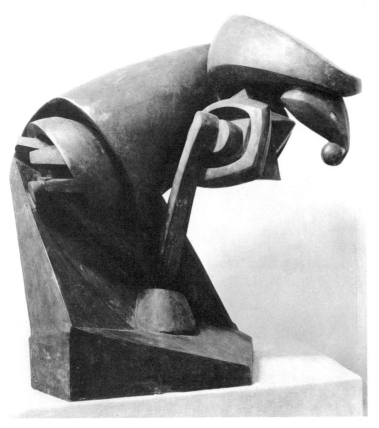

The Horse. 1914. Bronze (cast c. 1930–31), 40″ high

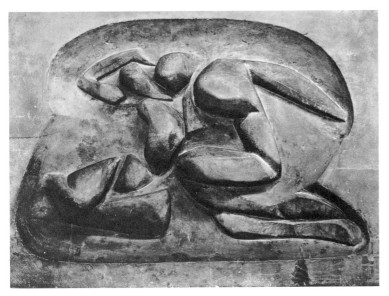

The Lovers. 1913. Original plaster relief, 27¹/₂ x 46 x 6¹/₂″

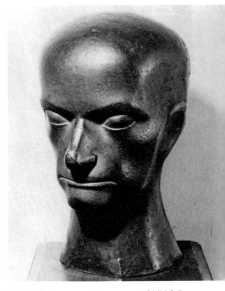

Baudelaire. 1911. Bronze, 15³/₄″ high

Villon: *Color Perspective*. 1922. Oil, 28³/₄ x
3⁵/₈″

Villon: *Dance*. 1932. Oil, 15¹/₈ x 21⁵/₈″

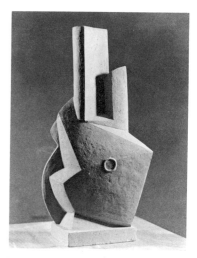

Laurens: *Guitar*. 1920. Terra cotta,
14¹/₄″ high

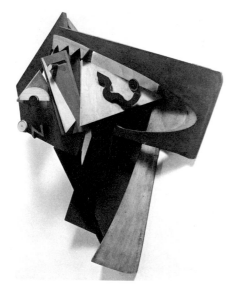

Laurens: *Head*. 1918. Wood construction,
painted, 20 x 18¹/₄″

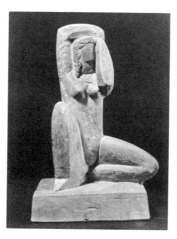

Laurens: *Seated Woman*. 1926.
Terra cotta, 14¹/₂″ high

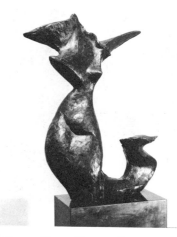

Laurens: *Mermaid*. 1937. Bronze, 10″ high

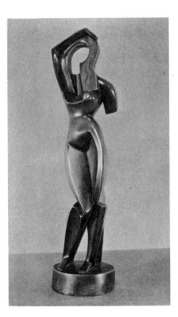

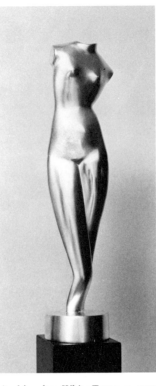

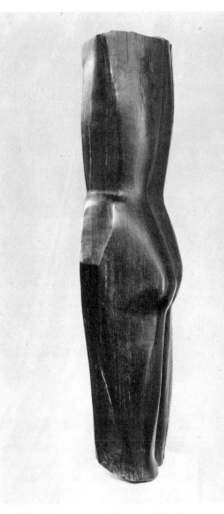

Archipenko: *Woman Combing Her Hair*. 1915. Bronze, 13³/₄" high

Archipenko: *White Torso*. c. 1920 (after marble, 1916). Silvered bronze, 18¹/₂" high

Zadkine: *Torso*. 1928. Ebony, 36" high

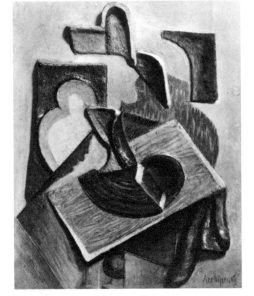

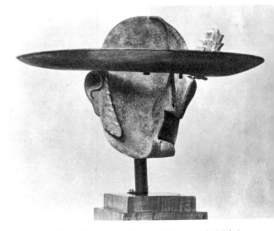

Archipenko: *Glass on a Table*. 1920. Wood and plaster relief, painted, 16¹/₈ x 13"

Gargallo: *Picador*. 1928. Wrought iron, 9³/₈" high

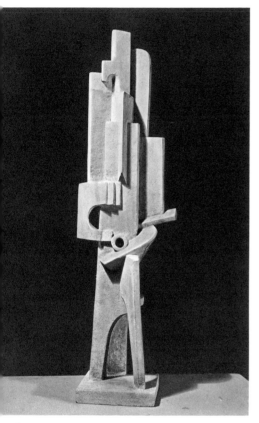

Man with a Guitar. 1915. Limestone, 38¼″ high

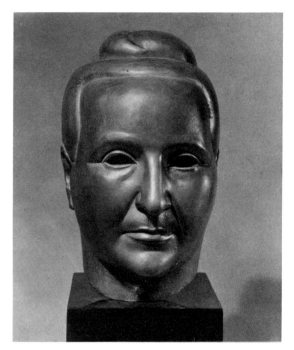

Gertrude Stein. 1920. Bronze, 13⅜″ high

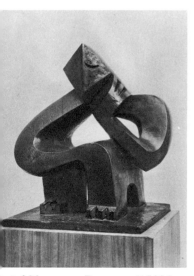

Seated Man. 1925. Bronze, 13½″ high

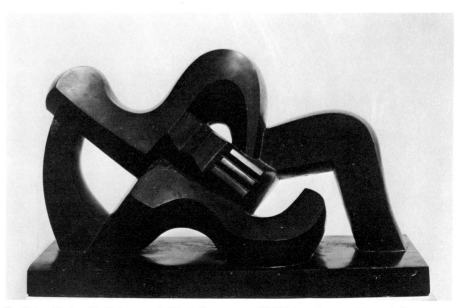

Reclining Nude with Guitar. 1928. Black limestone, 16⅜″ high; at base, 27⅝ x 13½″

Song of the Vowels. 1931. Terra cotta, 14¹/₂
high

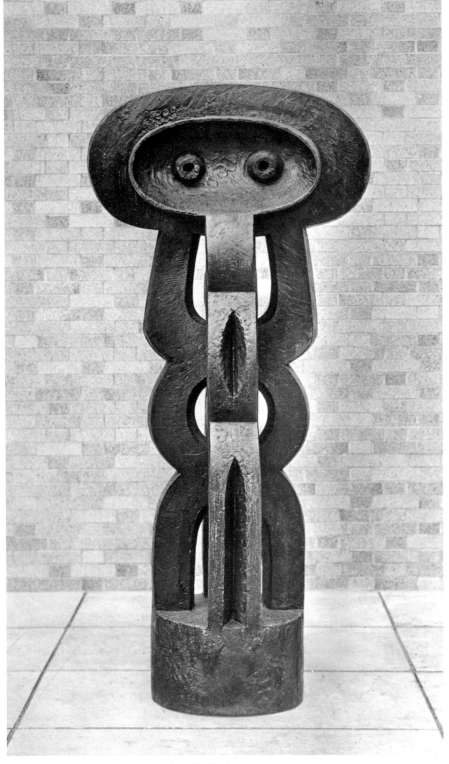

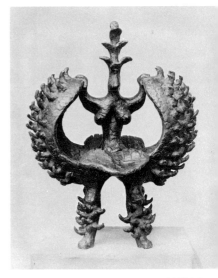

Blossoming. 1941–42. Bronze, 21¹/₂″ high

Figure. 1926–30. Bronze (cast 1937), 7′1¹/₄″ high

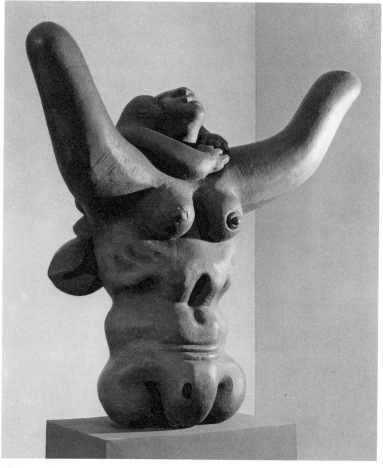

Mother and Child, II. 1941–45. Bronze, 50″ high

The Rape of Europa, IV. 1941. Gouache,
watercolor, brush and ink, 18³/₄ x 13⁵/₈″

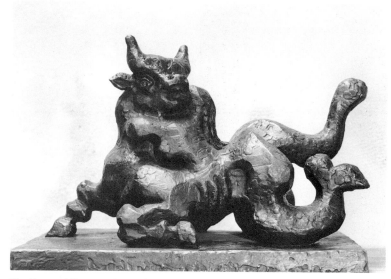

The Rape of Europa, II. 1938. Bronze, 15¹/₄ x 23¹/₈″

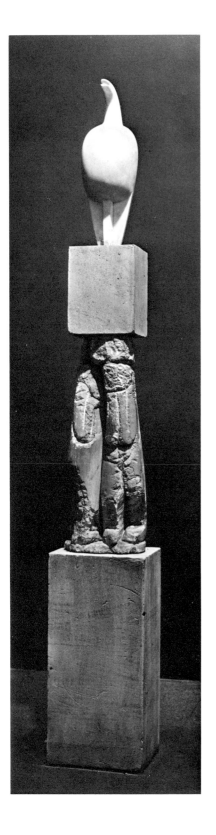

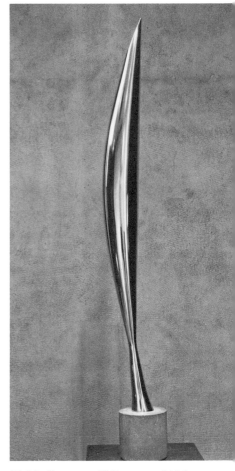

left: Magic Bird. 1910. White marble, 22″ high; limestone pedestal in three sections, 70″ high. Middle section of pedestal is *Double Caryatid.* 1908? 29⁵⁄₈″ high.

Bird in Space. 1928? Bronze, 54″ high

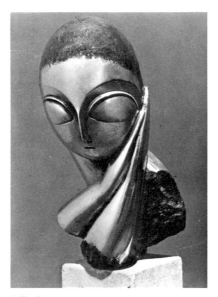

Mlle Pogany. 1913. Bronze, 17¼″ high

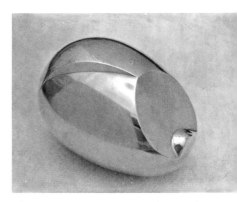

The Newborn. 1915. Bronze, 5³⁄₄ x 8¹⁄₄″

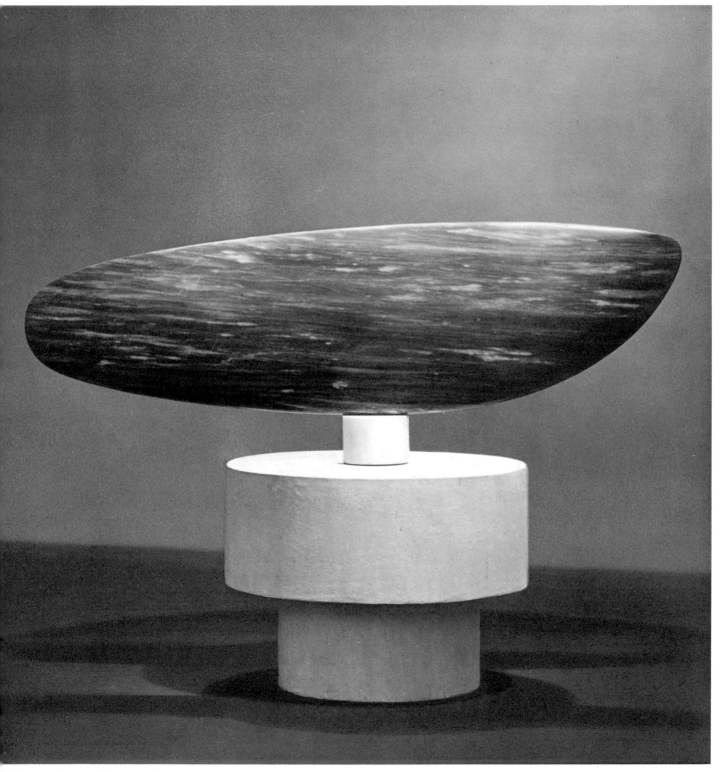

Fish. 1930. Gray marble, 21 x 71″

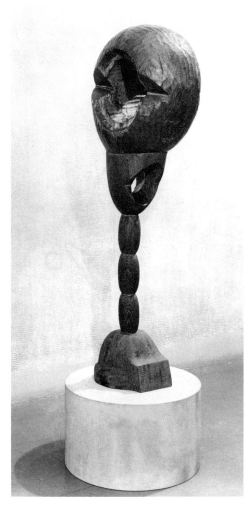

Socrates. 1923. Wood, 51¼″ high

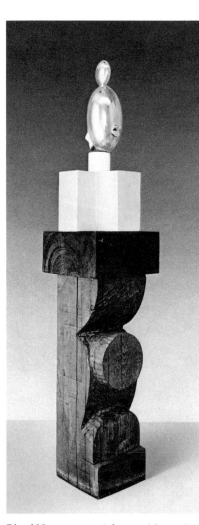

Blond Negress. 1933 (after marble, 1928). Bronze, 15¾″ high; pedestal of marble, limestone, and two sections of carved wood, 55½″ high

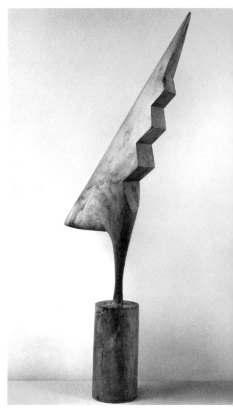

The Cock. 1924. Walnut, 47⅝″ high, including base

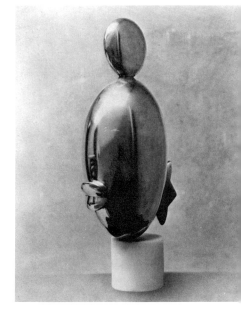

Blond Negress, detail

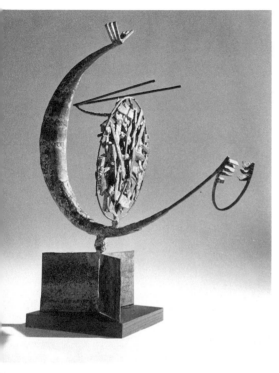

Head. 1935? Wrought iron, 17³/₄″ high

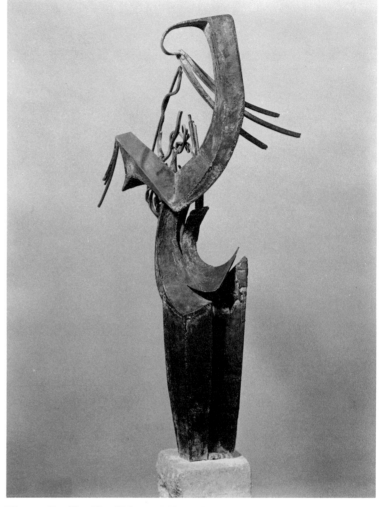

Woman Combing Her Hair. 1936. Wrought iron, 52″ high

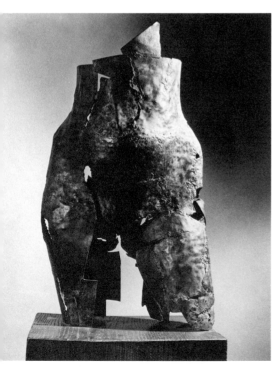

Torso. c. 1936. Hammered and welded iron, 24³/₈″ high

Standing Woman. c. 1941. Water-color, brush, pen, ink, 12¹/₂ x 9⁵/₈″

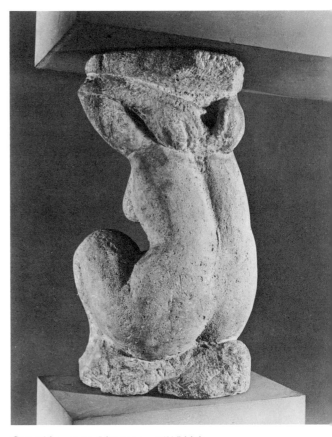

Caryatid. c. 1914. Limestone, 36¹/₄″ high

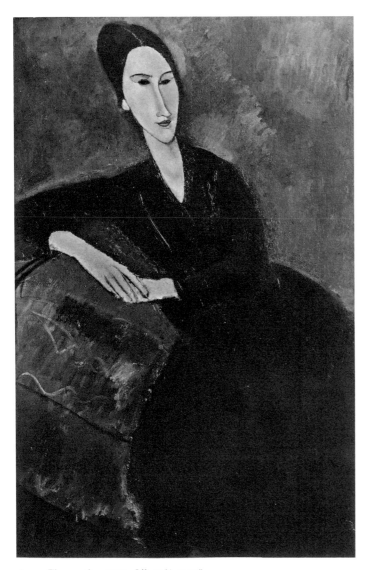

Anna Zborowska. 1917. Oil, 51¹/₄ x 32″

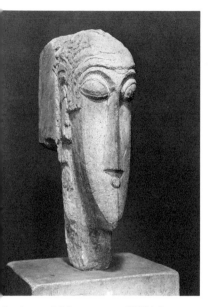

Head. 1915? Limestone, 22¹/₄″ high

Bride and Groom. 1915–16. Oil, 21³/₄ x 18¹/₄″

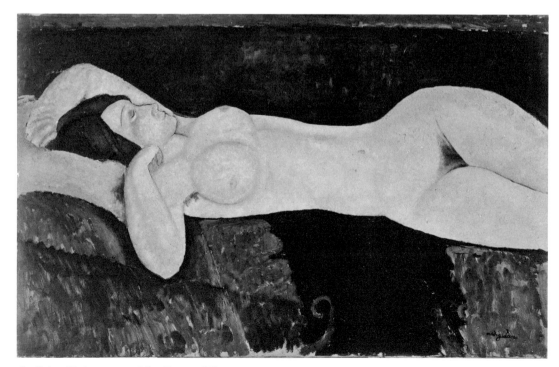

Reclining Nude. c. 1919. Oil, 28¹/₂ x 45⁷/₈″

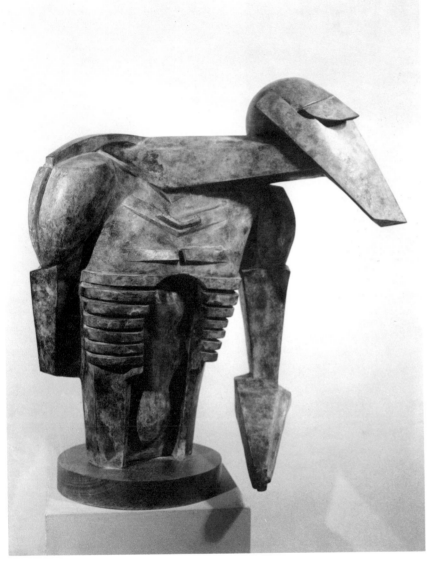

The Rock Drill. 1913–14. Bronze (cast 1962), 28 x 26″

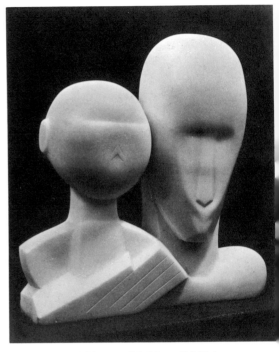

Mother and Child. 1913. Marble, 17¼″ high

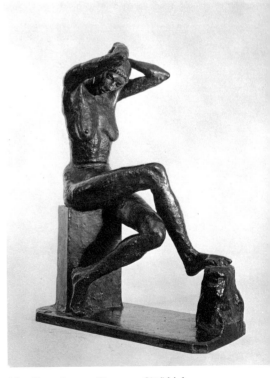

Nan Seated. 1911. Bronze, 18½″ high

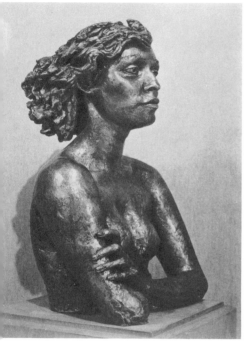

stein: *Oriel Ross*. 1932. Bronze, 26¼" high

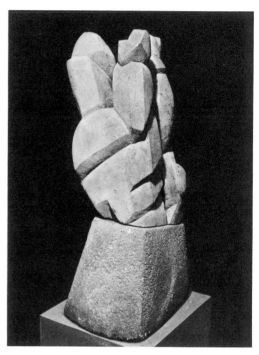

Gaudier-Brzeska: *Birds Erect*. 1914. Limestone, 26⅝" high

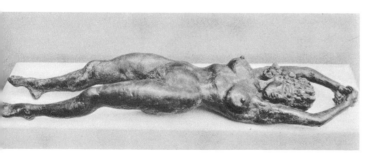

stein: *Reclining Nude Stretching*. 1946. Bronze, 28¼" long

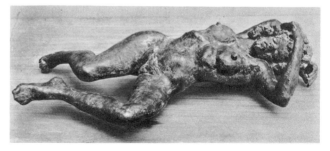

Epstein: *Reclining Nude Turning*. 1946. Bronze, 21¾" long

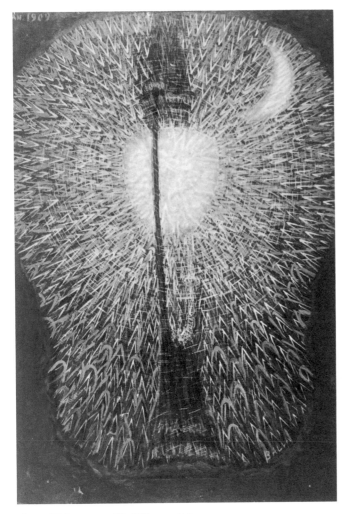

Street Light . 1909. Oil, 68³/₄ x 45¹/₄″

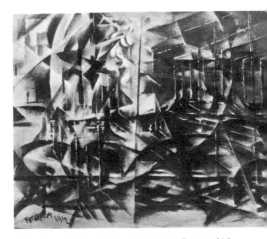

Speeding Automobile. 1912. Oil, 21⁷/₈ x 27¹/₈″

Swifts: Paths of Movement + Dynamic Sequences. 1913. Oil, 38*
47¹/₄″

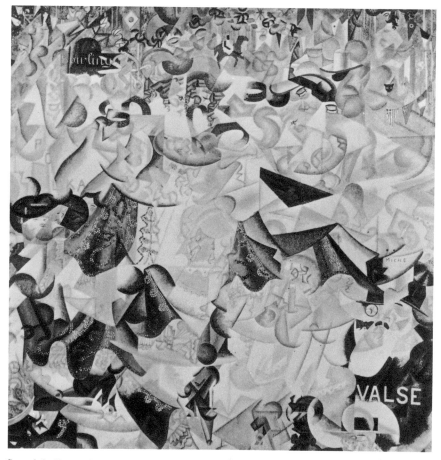

Severini: *Dynamic Hieroglyphic of the Bal Tabarin*. 1912. Oil, with sequins, 63⅝ x 61½"

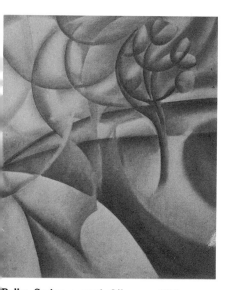

Balla: *Spring*. c. 1916. Oil, 32 x 26⅜"

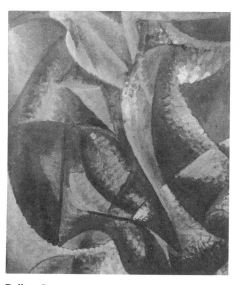

Balla: *Composition*. c. 1914? (Reverse side of *Spring*.) Distemper

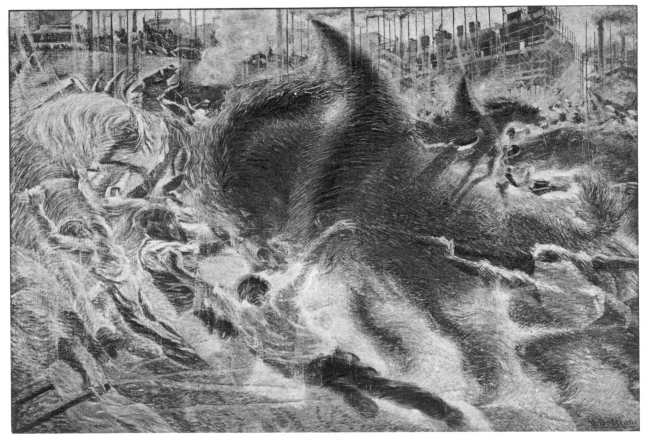

The City Rises. 1910. Oil, 6′6¹/₂″ x 9′10¹/₂″

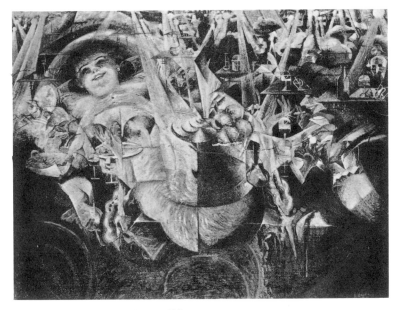

The Laugh. 1911. Oil, 43³/₈ x 57¹/₄″

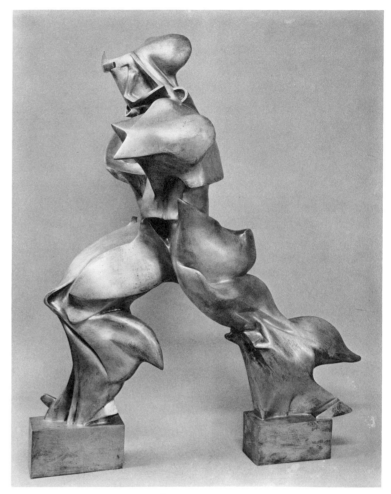

Unique Forms of Continuity in Space. 1913. Bronze (cast 1931), 43⁷/₈″ high

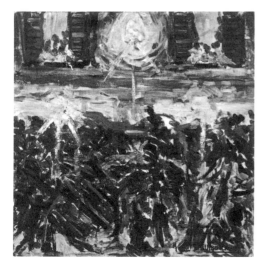

The Riot. 1911 or after. Oil, 19⁷/₈ x 19⁷/₈″

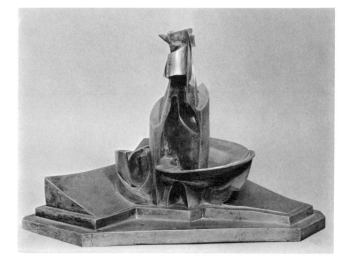

Development of a Bottle in Space. 1912. Silvered bronze (cast 1931), 15″ high

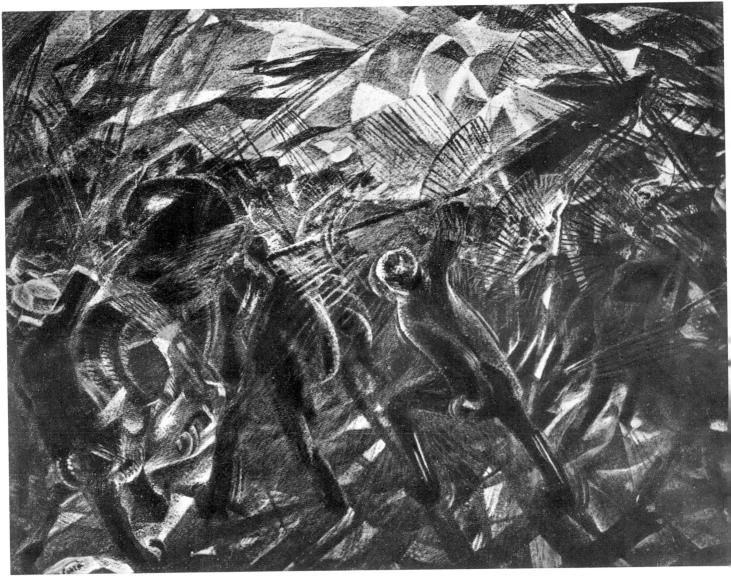

Funeral of the Anarchist Galli. 1911. Oil, 6′6¼″ x 8′6″

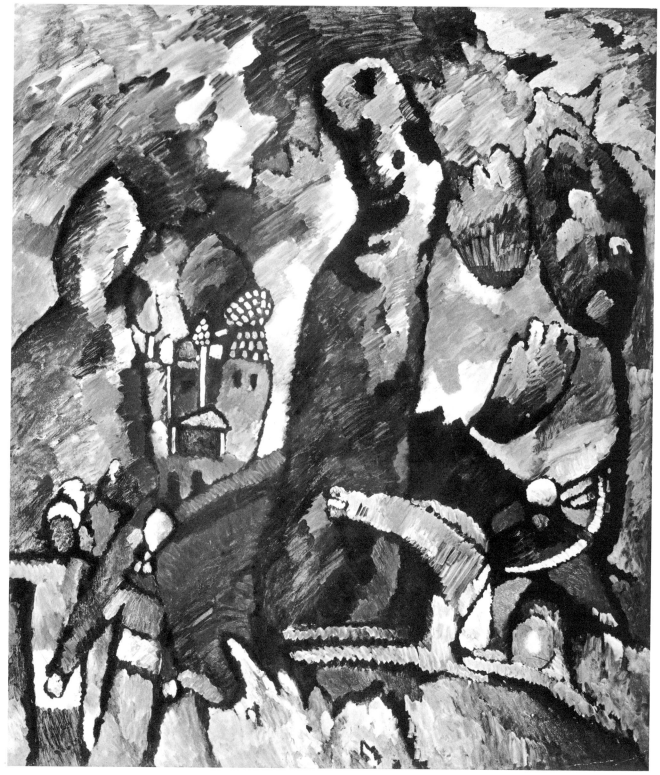

Picture with an Archer. 1909. Oil, 69 x 57″

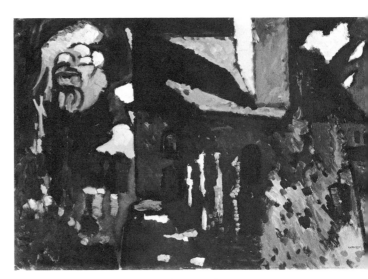

Church at Murnau. 1909. Oil, 19¹/₈ x 27¹/₂″

Watercolor (Number 13). 1913. 12⁵/₈ x 16¹/₈″

Sketch, 14. 1913. Watercolor, 9¹/₂ x 12¹/₂″

Study for *Painting with White Form.* 1913. Watercolor and ink, 10⁷/₈ x 15″

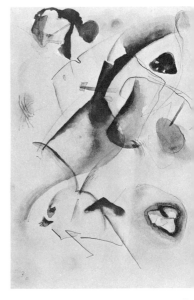

Untitled. 1915. Watercolor, 13¹/₄ x 9″

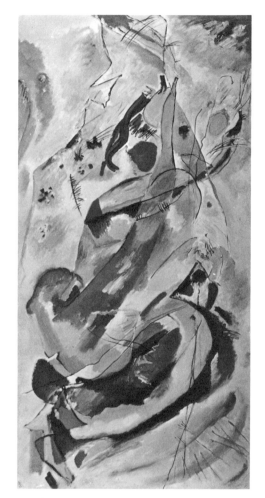

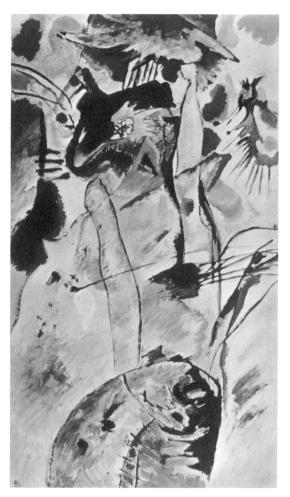

Panel (4). 1914. Oil, 64 x 31½"

Panel (3). 1914. Oil, 64 x 36¼"

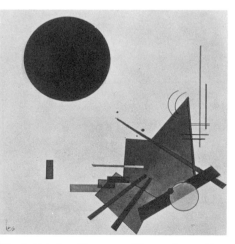

Black Relationship. 1924. Watercolor, 14½ x 14¼"

Blue (Number 393). 1927. Oil, 19½ x 14½"

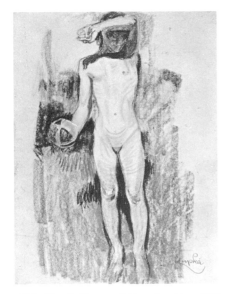

Girl with a Ball. c. 1908. Pastel, 24½ x 18¾"

The First Step. 1910–13? Dated on painting 1909. Oil, 32¾ x 51"

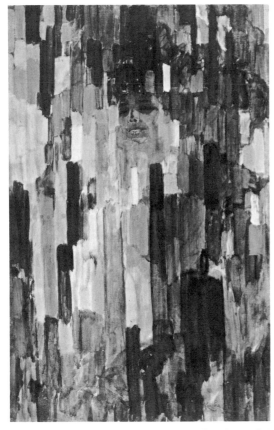

Mme Kupka among Verticals. 1910–11. Oil, 53⅜ x 33⅝"

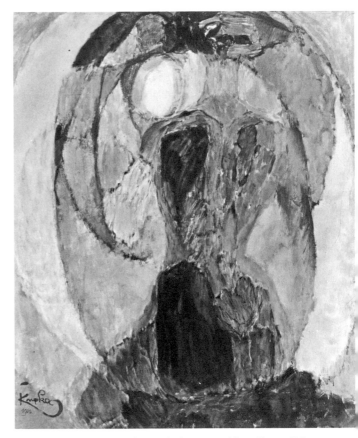

Oval Mirror. 1911? Dated on painting 1910. Oil, 42⅝ x 34⅞"

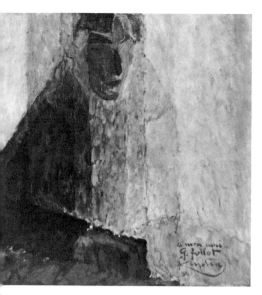

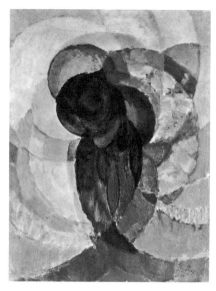

The Musician Follot. 1911? Dated on painting 1910. Oil, 28½ x 26⅛"

Red and Blue Disks. 1911? Dated on painting 1911–12. Oil, 39⅜ x 28¾"

Vertical Planes (study). 1912? Dated on painting 1911. Oil, 25⅝ x 18¼"

Replica, 1946, of *Solo of a Brown Stroke*, 1913. Watercolor, gouache, and pencil, 5¼ x 8½"

left: Replica, 1946, of *Vertical Planes*, 1912–13. Watercolor, gouache, and pencil, 11¼ x 6⅝"

Fugue in Two Colors: Amorpha (study). 1912. Tempera, brush and ink, 16⅜ x 18⅝"

Replica, 1946, of *Fugue in Two Colors: Amorpha*, 1912. Gouache, ink, and pencil, 9 x 9⅝"

...udies preceding the *Fugue in Two Colors: Amorpha.* 1912. Tempera, brush and ink, 16⅜ x 18⅝" to 4⅜ x 4⅞"

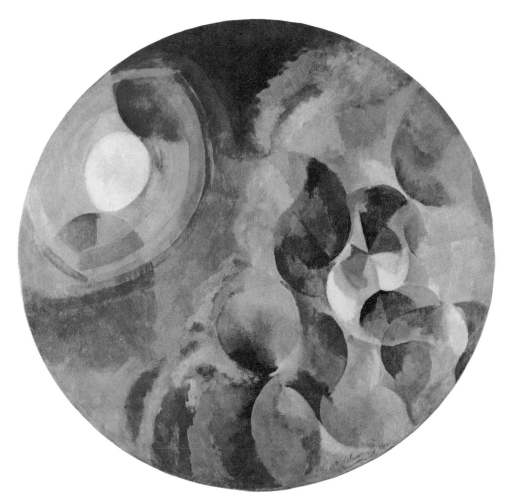

Delaunay: *Simultaneous Contrasts: Sun and Moon.*
1913. Dated on painting 1912. Oil, 53″ diameter

Delaunay-Terk: Detail of scroll, *La Prose d*
Transsibérien. . . . 1913. Gouache and ink

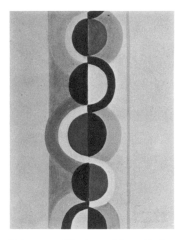

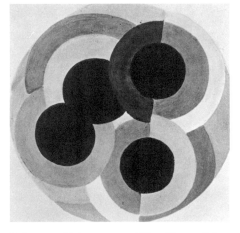

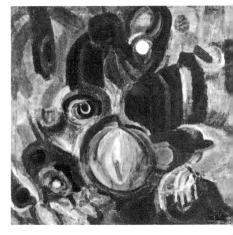

Delaunay: *Rhythm without End.*
1935. Gouache, brush and ink,
10⅝ x 8¼″

Delaunay: *Disks.* 1930–33. Oil, 23⅝ x 23½″

Delaunay-Terk: *Portuguese Market.* 1915. Oi
and wax on canvas, 35⅝ x 35⅝″

Giacometti: *Color Abstraction*. 1903? Pastel cutout mounted on paper, 5⁷/₈ x 5¹/₂″

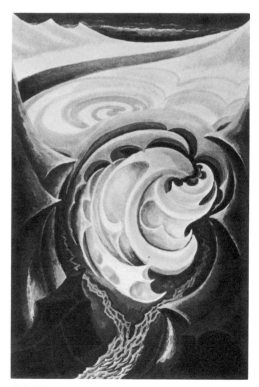

left: Survage: *Colored Rhythm*. Four studies for the film. 1913. Watercolor, brush and ink, each 13 x 12¹/₄″

Schmithals: *The Glacier*. c. 1903. Mixed mediums on paper, 45¹/₄ x 29¹/₂″

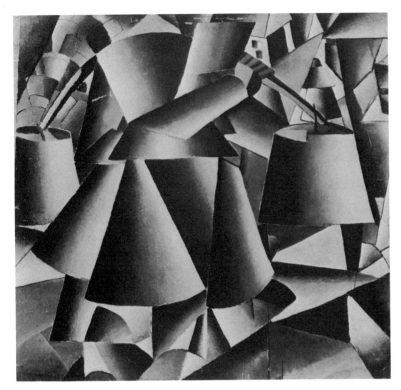

Woman with Water Pails: Dynamic Arrangement. 1912. Oil, 31⁵/₈ x 31⁵/₈″

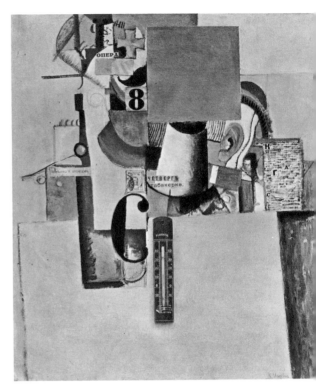

Private of the First Division. 1914. Oil with collage of posta stamp, thermometer, etc., 21¹/₈ x 17⁵/₈″

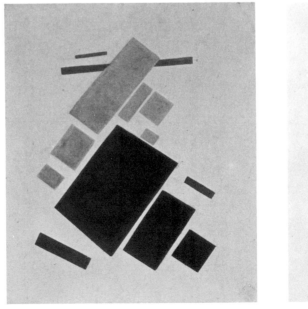

Suprematist Composition: Airplane Flying. 1914. Oil, 22⁷/₈ x 19″

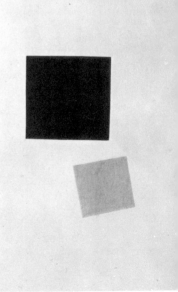

Suprematist Composition: Red Squ and Black Square. 1914–15? Oil, 28 ×

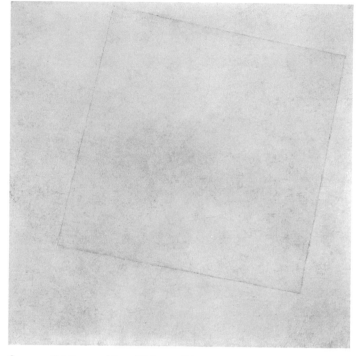

Suprematist Composition: White on White. 1918? Oil, 31¼ x 31¼"

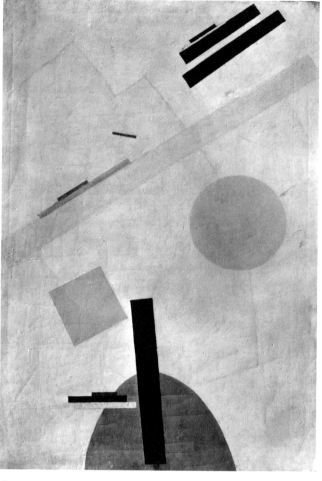

Suprematist Composition. 1916–17? Oil, 38½ x 26⅛"

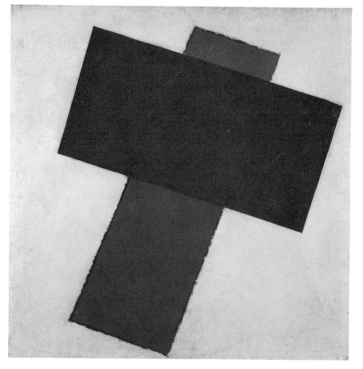

Suprematist Composition. Oil, 31⅝ x 31⅝"

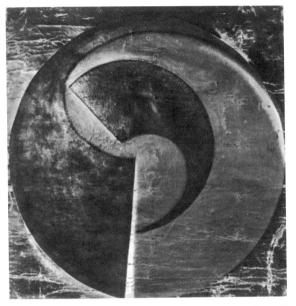

Rodchenko: *Non-Objective Painting: Black on Black*. 1918.
Oil, 32¼ x 31¼"

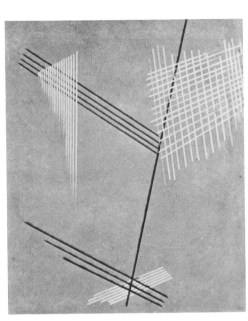

Rodchenko: *Non-Objective Painting*. 1919. Oil,
33¼ x 28"

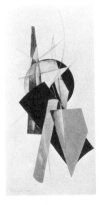

Rodchenko:
Composition.
1918. Gouache,
13 x 6⅜"

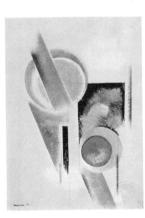

Rodchenko: *Composition*.
1919. Gouache, 12¼ x 9"

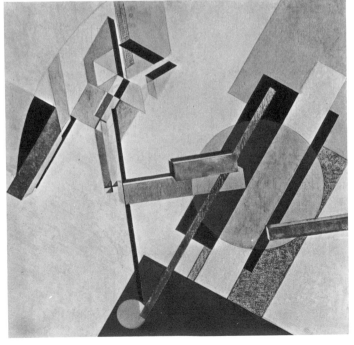

Lissitzky: *Proun 19D*. 1922? Gesso, oil, collage, etc., on plywood, 38⅜
x 38¼"

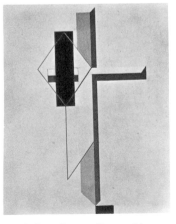

Lissitzky: *Proun Composition*. c.
1922. Gouache and ink, 19¾ x 15¾"

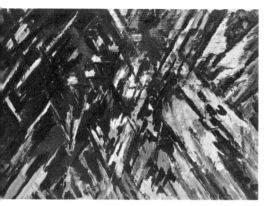

ionov: *Rayonist Composition: Domination of Red*.
2–13. Dated on painting 1911. Oil, 20³/₄ x 28¹/₂″

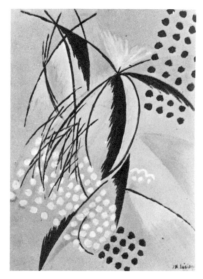

Larionov: *Rayonist Composition: Heads*. 1912–13. Dated on painting 1911. Oil, 27¹/₄ x 20¹/₂″

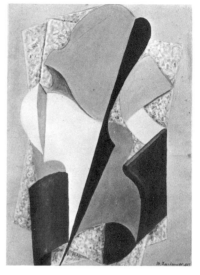

Larionov: *Spiral*. 1915. Tempera, 30⁵/₈ x 21¹/₄″

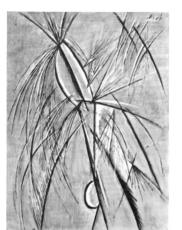

ionov: *Rayonist mposition Num- r 8*. 1912–13. Tem- a, 20 x 14³/₄″

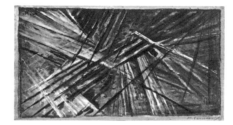

Larionov: *Rayonist Composition Number 9*. 1913. Tempera, 10³/₈ x 18″

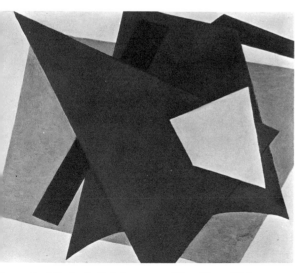

ova: *Architectonic Painting*. 1917. Oil, 31¹/₂ x 38⁵/₈″

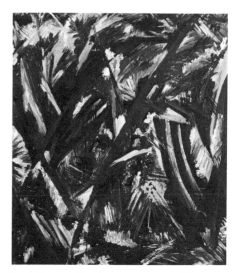

Gontcharova: *Landscape, 47*. 1912. Oil, 21¹/₂ x 18³/₈″

131

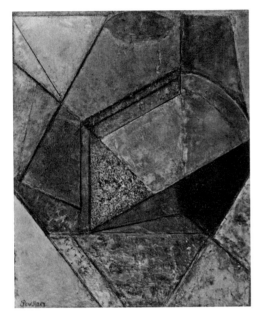

Abstract Forms. 1913? 1923? Encaustic on wood, 17¼ x 13½"

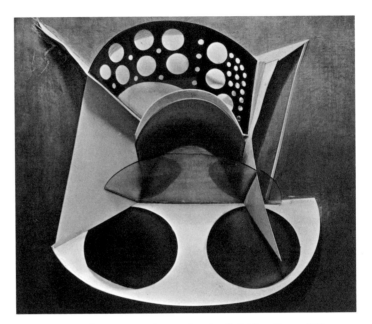

Bust. 1923–24. Construction in metal and celluloid, 20⅞ x 23⅜"

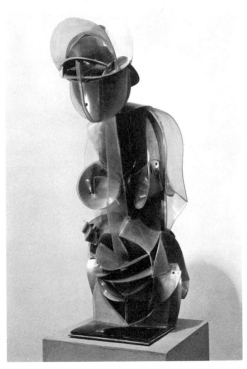

Torso. 1924–26. Plastic and copper, 29½" high

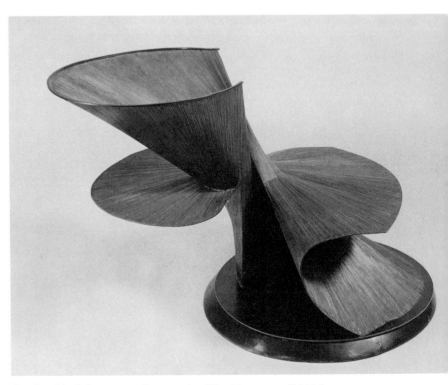

Developable Column. 1942. Brass and oxidized bronze, 20¾" high

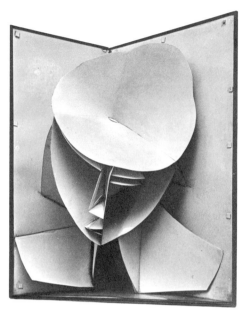

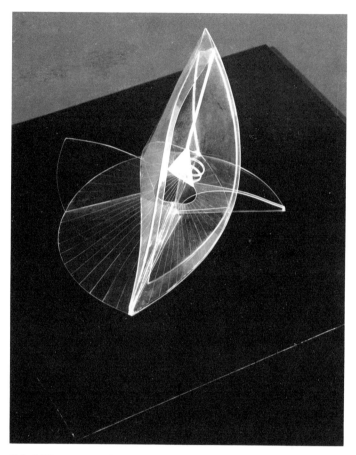

above: Head of a Woman. c. 1917–20 (after a work of 1916). Construction in celluloid and metal, 24¹/₂ x 19¹/₄″

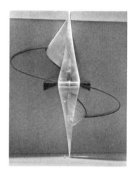

See caption below

Spiral Theme. 1941. Construction in plastic, 5¹/₂ x 13¹/₄ x 9³/₈″, on base 24″ square

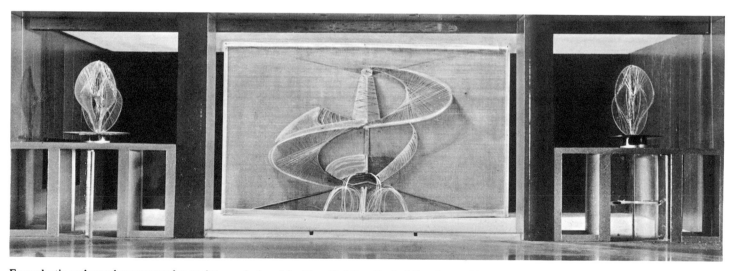

Four plastic and metal maquettes for sculptures designed for Esso Building, Rockefeller Center, New York. 1949. *Upper left:* 51st Street entrance: 8³/₄″ high. *Above:* 52nd Street entrance: center sculpture 6¹/₂″ high, sculptures over two revolving doors, 3″ high

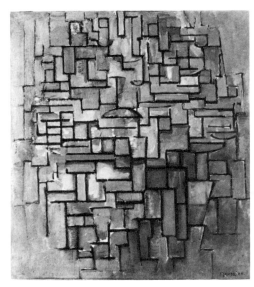

Composition in Brown and Gray. 1913–14. Oil, 33³/₄ x 29³/₄″

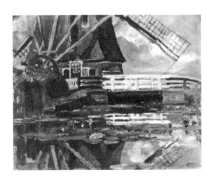

Mill by the Water. c. 1905. Oil, 11⁷/₈ x 15″

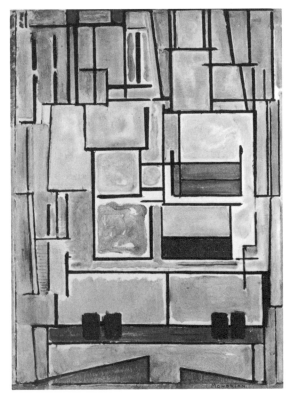

Blue Façade (Composition 9). 1913–14. Oil, 37¹/₂ x 26⁵/₈″

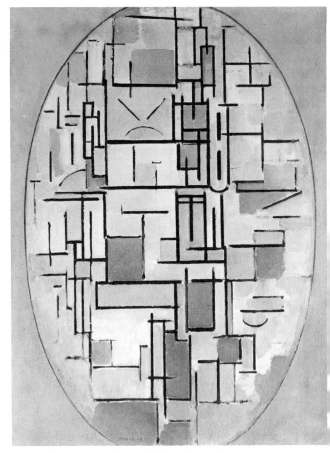

Color Planes in Oval. 1914? Oil, 42³/₈ x 31″

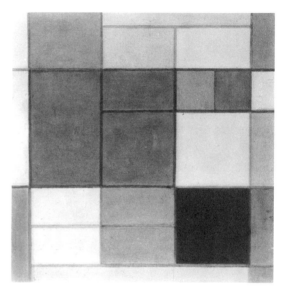

Composition C. 1920. Oil, 23³/₄ x 24″

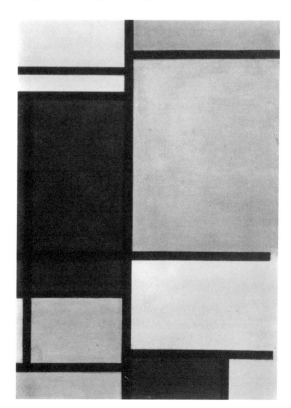

Pier and Ocean. 1914. Charcoal and white watercolor on buff paper, 34⁵/₈ x 44″

Composition. 1921. Oil, 29⁷/₈ x 20⁵/₈″

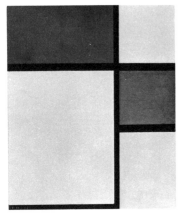

Composition. 1925. Oil, 15⁷/₈ x 12⁵/₈″

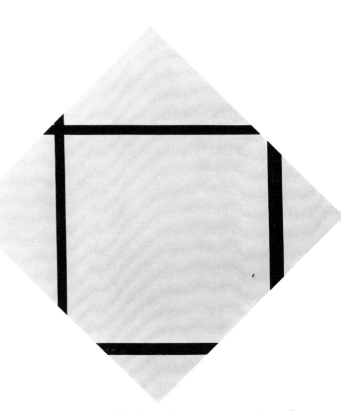

Painting, I. 1926. Oil, diagonal measurements 44³/₄ x 44″

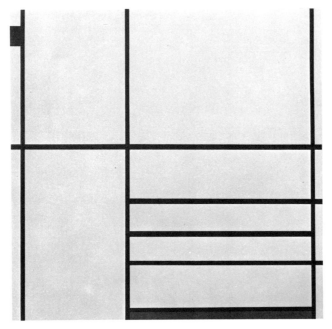

Composition in White, Black, and Red. 1936. Oil, 40¹/₄ x 41″

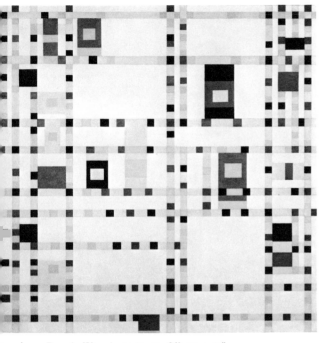

roadway Boogie Woogie. 1942–43. Oil, 50 x 50"

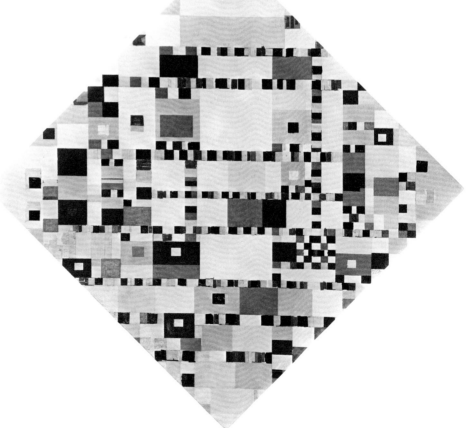

Victory Boogie Woogie. 1943–44, unfinished. Oil with colored tape and paper; diagonal measurements, 70¹/₄ x 70¹/₄"

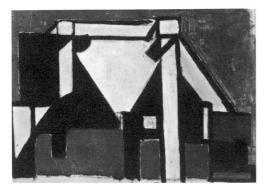

van Doesburg: *Composition (The Cow)*. 1916. Gouache, 15⁵/₈ x 22³/₄"

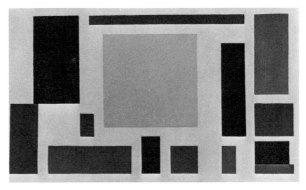

van Doesburg: *Composition (The Cow)*. 1916–17. Oil, 14³/₄ x 25"

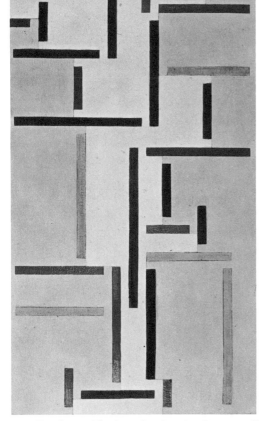

van Doesburg: *Rhythm of a Russian Dance*. 1918. Oil, 53¹/₂ x 24¹/₄"

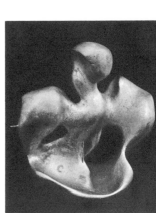

Vantongerloo: *Construction within a Sphere*. 1917. Silvered plaster, 7" high

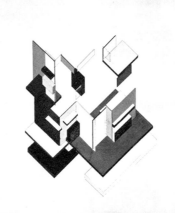

van Doesburg and van Eesteren: *Color Construction: Project for a Private House*. 1922. Gouache and ink, 22¹/₂ x 22¹/₂"

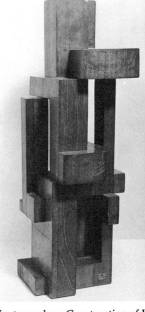

Vantongerloo: *Construction of V ume Relations*. 1921. Mahogar 16¹/₈" high

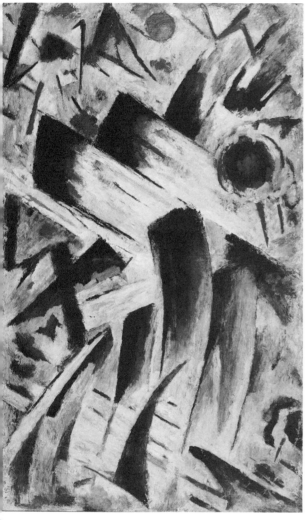

Buchholz: *Forces*. 1921. Oil, 7'7¹/₄" x 53¹/₄"

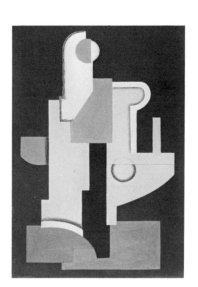

Baumeister: *Composition*. 1922.
Gouache and crayon, 12³/₄ x 8⁵/₈"

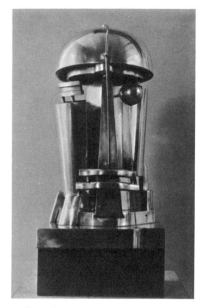

Belling: *Sculpture*. 1923. Bronze, partly
silvered, 18⁷/₈" high

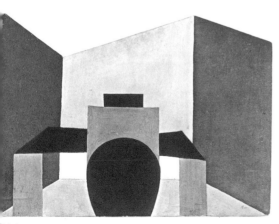

Péri: *In Front of the Table*. 1922. Tempera, 25¹/₄ x 34"

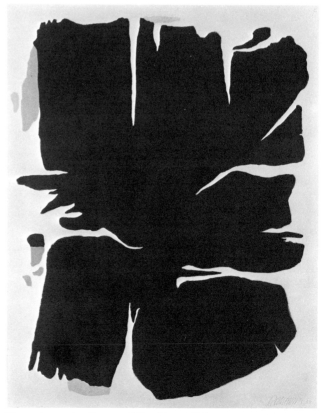

Baumeister: *Aru 6*. 1955. Oil, 51¹/₄ x 39¹/₄"

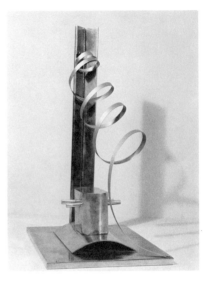

Moholy-Nagy: *Nickel Construction*. 1921.
Nickel-plated iron, welded, 14¹/₈″ high

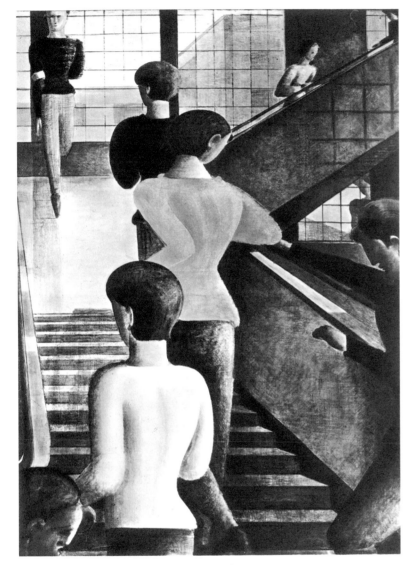

Schlemmer: *Bauhaus Stairway*. 1932. Oil, 63⁷/₈ x 45″

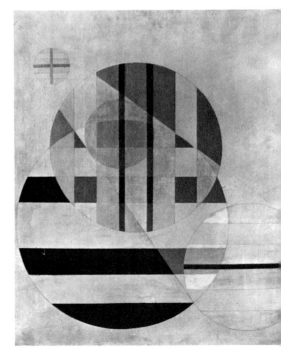

Moholy-Nagy: *Z II*. 1925. Oil, 37⁵/₈ x 29⁵/₈″

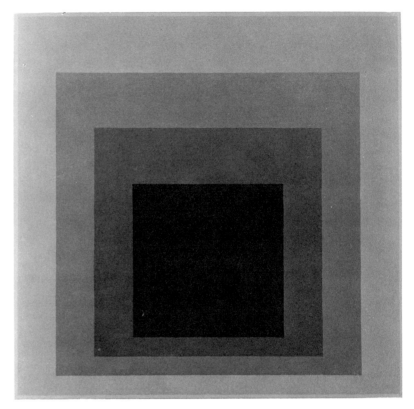

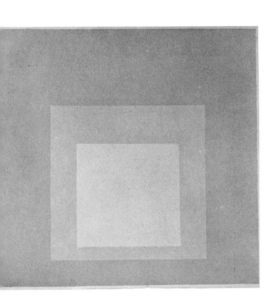

lbers: Study for *Homage to the Square: Early Rising A.* 961. Oil, 24 x 24″

Albers: *Homage to the Square: Silent Hall*. 1961. Oil, 40 x 40″

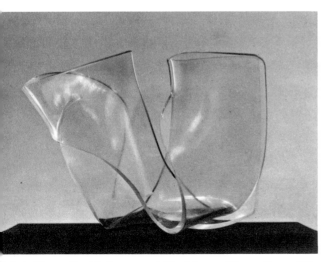

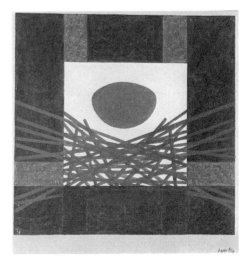

Moholy-Nagy: *Double Loop*. 1946. Plexiglass, 16¼ x 22¼ x 17½″

Bayer: *Image with Green Moon*. 1961. Synthetic polymer paint, 16¼ x 16¼″

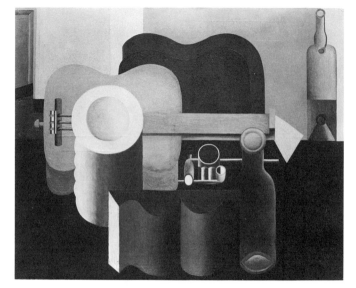

Le Corbusier: *Still Life*. 1920. Oil, 31⅞ x 39¼″

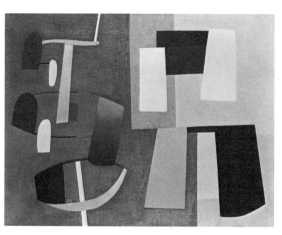

Hélion: *Equilibrium*. 1934. Oil, 10¾ x 13¾″

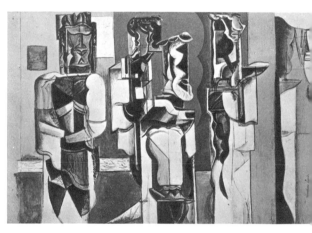

Lewis: *Roman Actors*. 1934. Watercolor, gouache, and ink, 15⅛ x 22⅛″

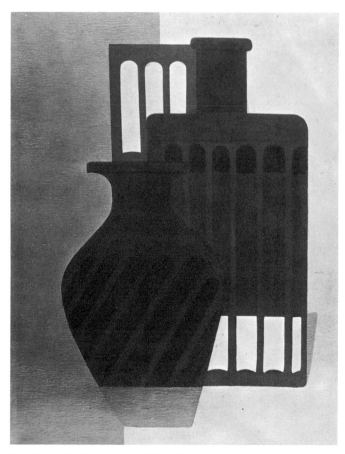

Ozenfant: *The Vases*. 1925. Oil, 51⅜ x 38⅜″

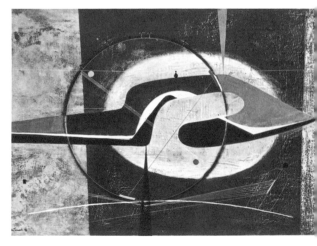

Tunnard: *Fugue*. 1938. Oil and tempera, 24 x 34⅛″

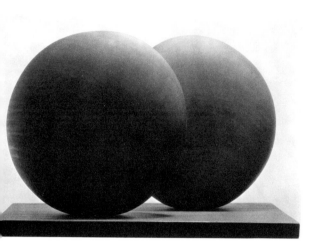

epworth: *Disks in Echelon*. 1935. Wood, 12¼″ high

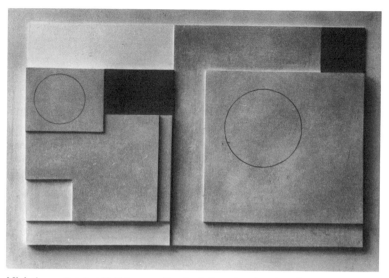

Nicholson: *Painted Relief*. 1939. Synthetic board, painted, 32⅞ x 45″

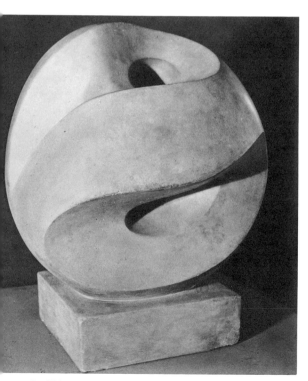

pworth: *Helikon*. 1948. Stone, 24¼″ high

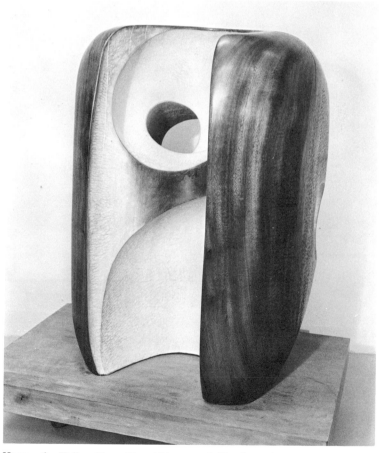

Hepworth: *Hollow Form (Penwith)*. 1955–56. Wood, partly painted, 35⅜″ high

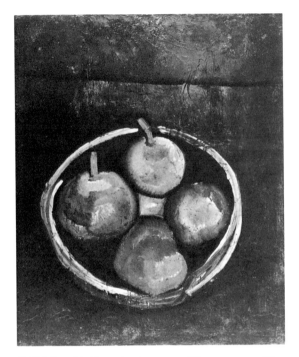

Still Life with Four Apples. 1909. Oil on paper, 13¹/₂ x 11¹/₈"

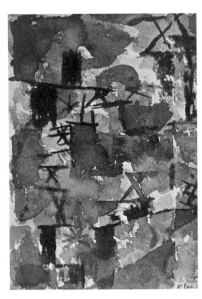

With the Red X. 1914. Watercolor, 6¹/₄ x 4¹/₄"

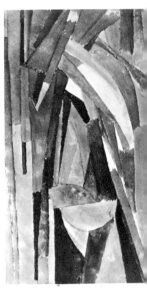

Laughing Gothic. 1915. Water color, 10¹/₄ x 5³/₈"

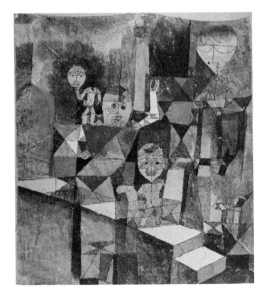

Introducing the Miracle. 1916. Tempera, pen and ink, 10³/₈ x 8⁷/₈"

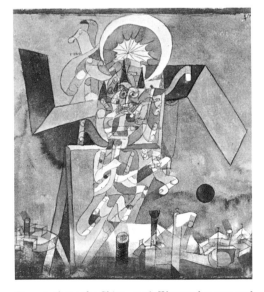

Demon above the Ships. 1916. Watercolor, pen and ink, 9 x 7⁷/₈"

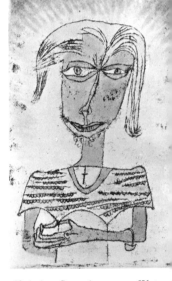

Christian Sectarian. 1920. Water or on transfer drawing, 10¹/₈ x 6⁵/

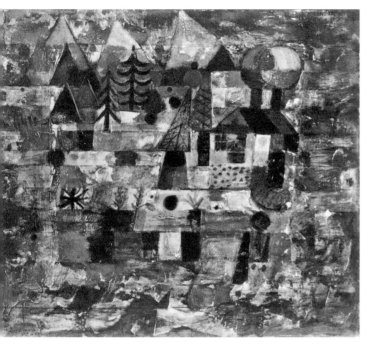

Village in the Fields. 1922. Oil on cardboard, 17⁷/₈ x 20¹/₈″

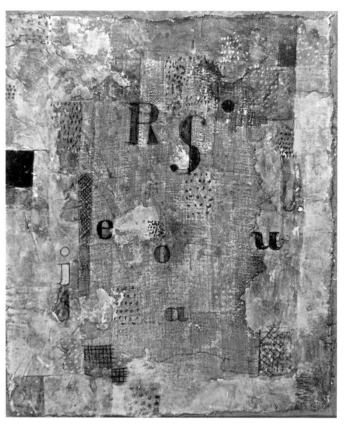

Vocal Fabric of the Singer Rosa Silber. 1922. Gouache and gesso, 20¹/₄ x 16³/₈″

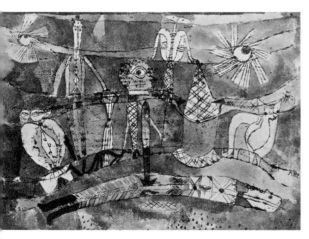

The End of the Last Act of a Drama. 1920. Watercolor on transfer drawing, 8¹/₈ x 11³/₈″

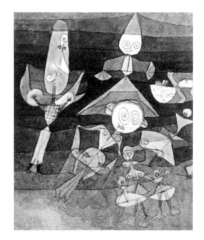

Flowers in the Wind. 1922. Watercolor, pen and ink, 6⁵/₈ x 5³/₈″

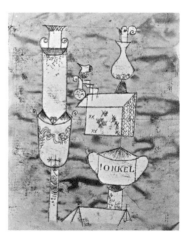

Urn Collection. 1922. Watercolor on transfer drawing, 10⁷/₈ x 8¹/₂″

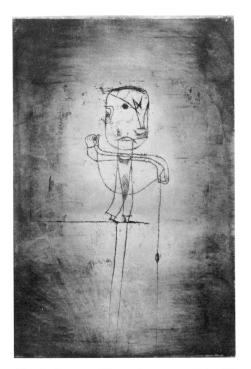

The Angler. 1921. Watercolor, pen and ink, 18⁷/₈ x 12³/₈″

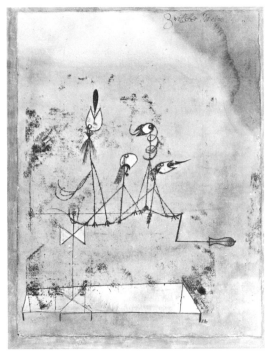

Twittering Machine. 1922. Watercolor, pen and ink, 16¹/₄ x 12″

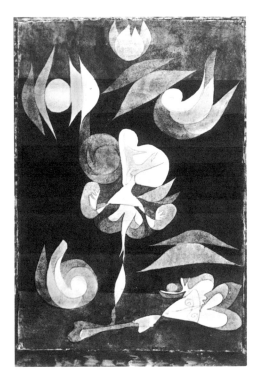

Dying Plants. 1922. Watercolor, pen and ink, 19¹/₈ x 12⁵/₈″

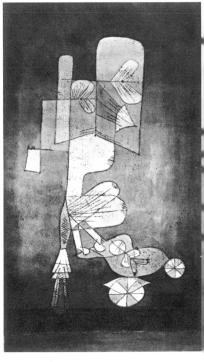

Girl with Doll Carriage. 1923. Watercolor, pen and ink, 15³/₈ x 8³/₈″

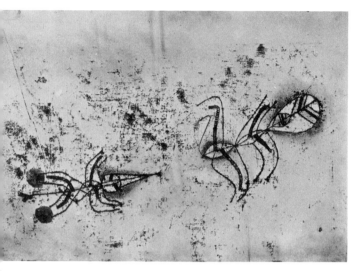

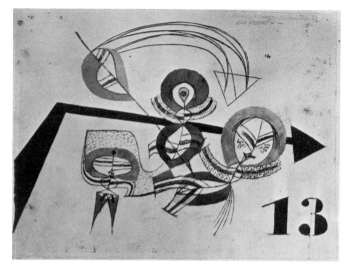

he Arrow before the Target. 1921. Watercolor on transfer drawing, 4 x 12³/₈″

Scherzo with Thirteen. 1922. Watercolor, pen and ink, 8³/₄ x 11⁷/₈″

d City Architecture. 1924. Watercolor, pen and k, 9⁷/₈ x 7¹/₄″

Heron. 1924. Mixed mediums, waxed, on paper, 13⁵/₈ x 7¹/₄″

Flower Garden. 1924. Watercolor and gouache, 14⁷/₈ x 8³/₈″

Around the Fish. 1926. Oil, 18³⁄₈ x 25¹⁄₈″

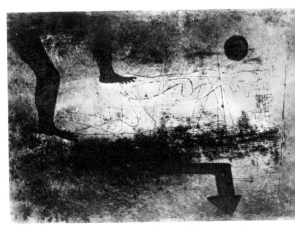

Slavery. 1925. Gouache and printing ink, 10 x 14″

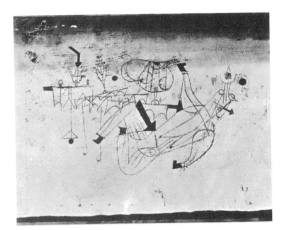

Intoxication. 1923. Watercolor, ink, 9⁵⁄₈ x 12¹⁄₄″

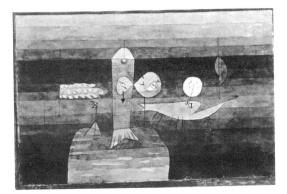

Good Fishing Place. 1922. Watercolor, pen and ink,
10¹⁄₂ x 16¹⁄₈″

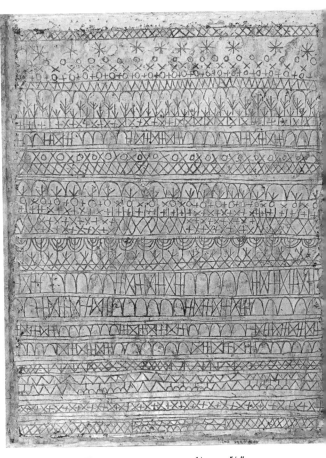

Pastorale. 1927. Tempera on canvas, 27¹⁄₄ x 20⁵⁄₈″

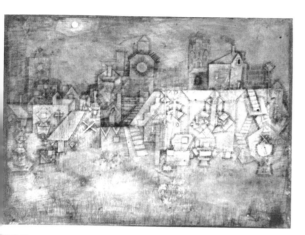

Old Cemetery. 1925. Mixed mediums, 14³/₈ x 19″

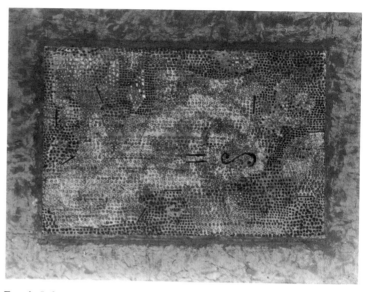

Equals Infinity. 1932. Oil, 20¹/₄ x 26⁷/₈″

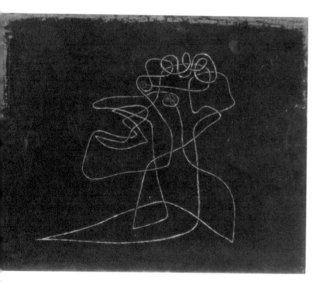

The Mocker Mocked. 1930. Oil, 17 x 20⁵/₈″

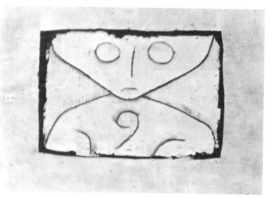

Letter Ghost. 1937. Watercolor, gouache, and ink on newspaper, 13 x 19¹/₄″

Spring Is Coming. 1939. Gouache and watercolor, 8¹/₈ x 11⁵/₈″

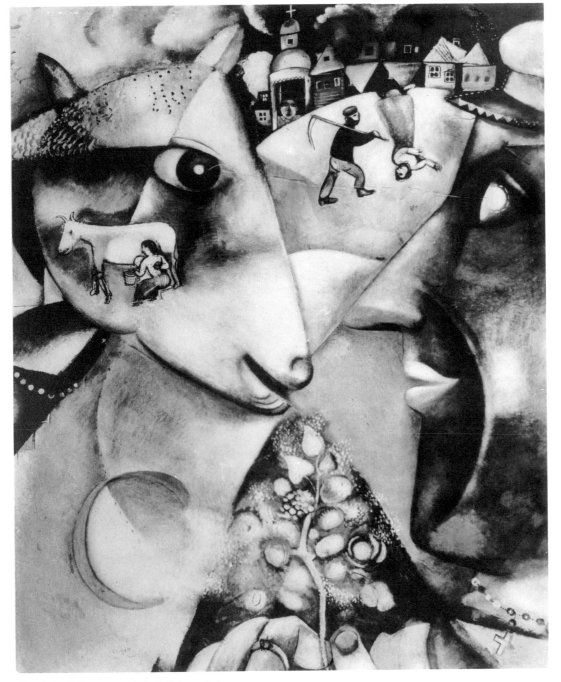

I and the Village. 1911. Oil, 6'3⅝" x 59⅝"

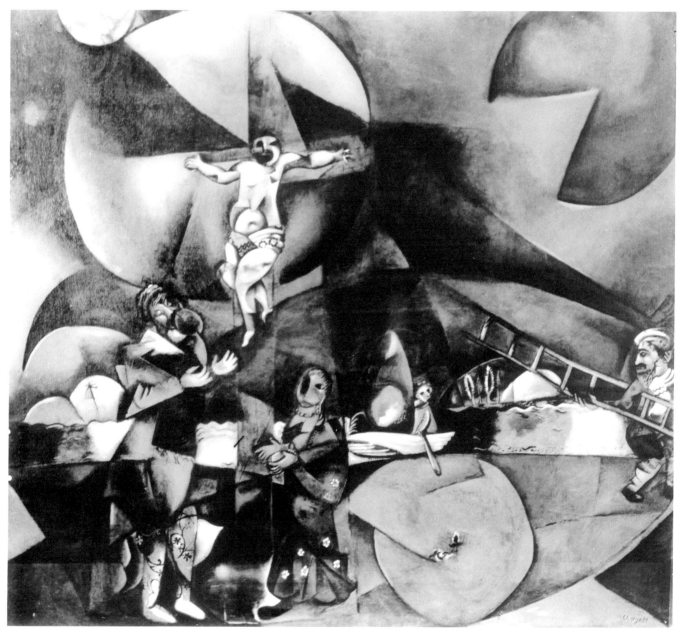

Calvary. 1912. Oil, 68¾″ x 6′3¾″

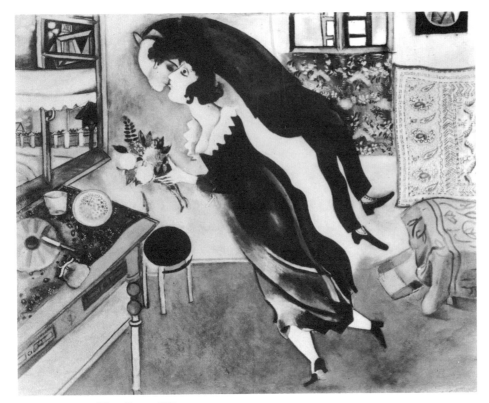

Birthday. 1915. Oil, 31³/₄ x 39¹/₄″

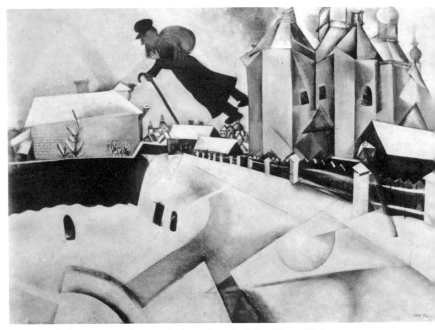

Over Vitebsk. 1915–20 (after a painting of 1914). Oil, 26³/₈ x 36¹/₂″

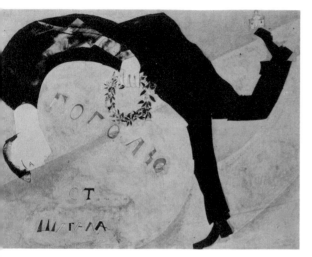

Homage to Gogol. 1917. Watercolor, 15½ x 19¾″

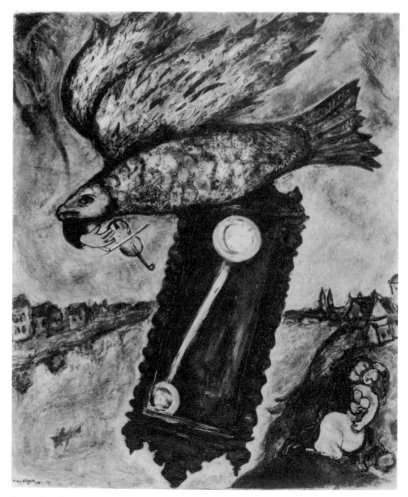

Time Is a River without Banks. 1930–39. Oil, 39⅜ x 32″

The Anxious Journey. 1913. Oil, 29¹/₄ x 42″

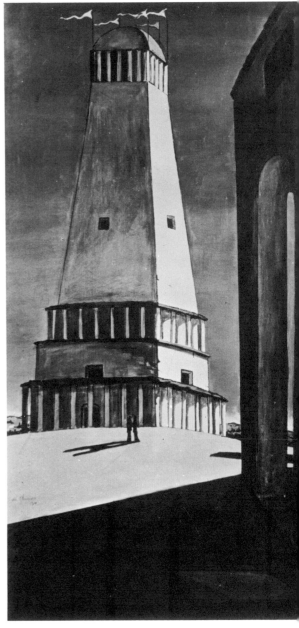

The Nostalgia of the Infinite. 1913–14? Dated on painting 191
Oil, 53¹/₄ x 25¹/₂″

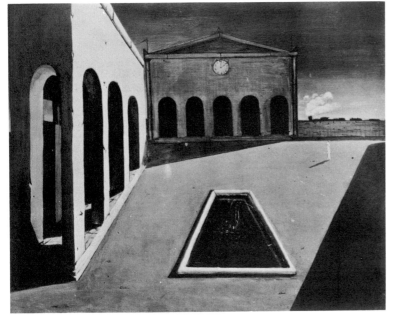

The Delights of the Poet. 1913. Oil, 27³/₈ x 34″

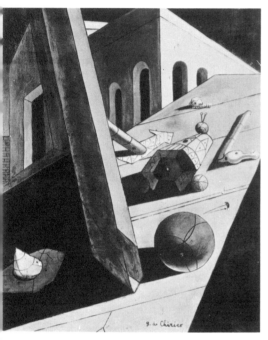

The Evil Genius of a King. 1914–15. Oil, 24 x 19³/₄″

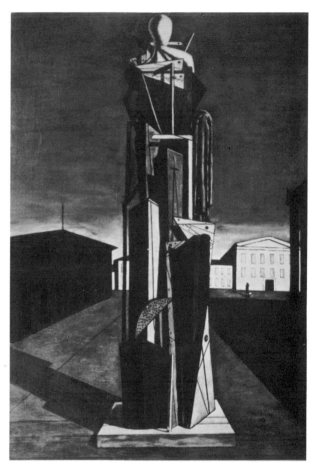

The Great Metaphysician. 1917. Oil, 41¹/₈ x 27¹/₂″

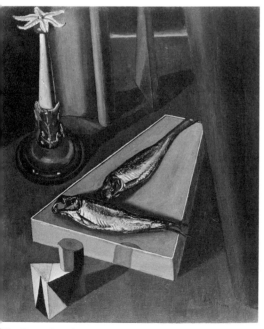

The Sacred Fish. 1919. Oil, 29¹/₂ x 24³/₈″

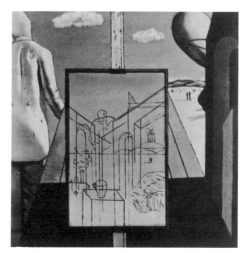

The Double Dream of Spring. 1915. Oil, 22¹/₈ x 21³/₈″

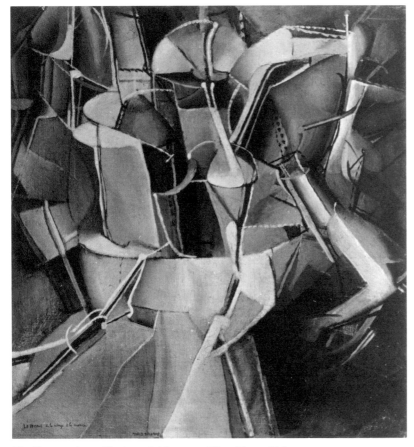

The Passage from Virgin to Bride. 1912. Oil, 23³/₈ x 21¹/₄"

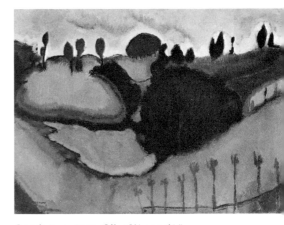

Landscape. 1911. Oil, 18¹/₄ x 24¹/₈"

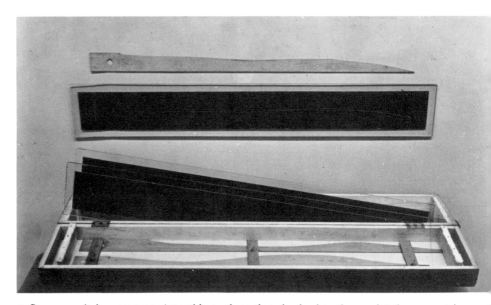

3 Stoppages étalon. 1913–14. Assemblage: three threads glued to three painted canvas strips, each mounted on glass panel, 7¹/₄ x 49³/₈ x ¹/₄"; three wood slats repeat curves of threads; the whole fitted into a wood box, 11¹/₈ x 50⁷/₈ x 9"

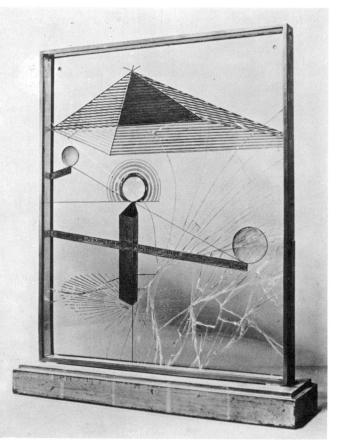

To Be Looked At (From the Other Side of the Glass) with One Eye, Close To, for Almost an Hour. 1918. Oil paint, silver leaf, lead wire, lens, on glass, mounted between two panes of glass in standing frame, 20¹/₈ x 16¹/₄ x 1¹/₂″

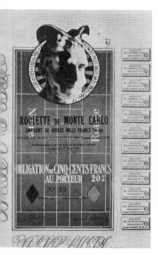

Monte Carlo Bond. 1924. Photo-collage on colored lithograph, 12¹/₄ x 7³/₄″

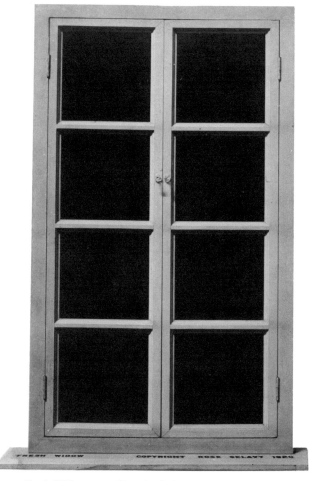

Fresh Widow. 1920. French window, painted wood frame, panes of glass covered with black leather, 30¹/₂ x 17⁵/₈″

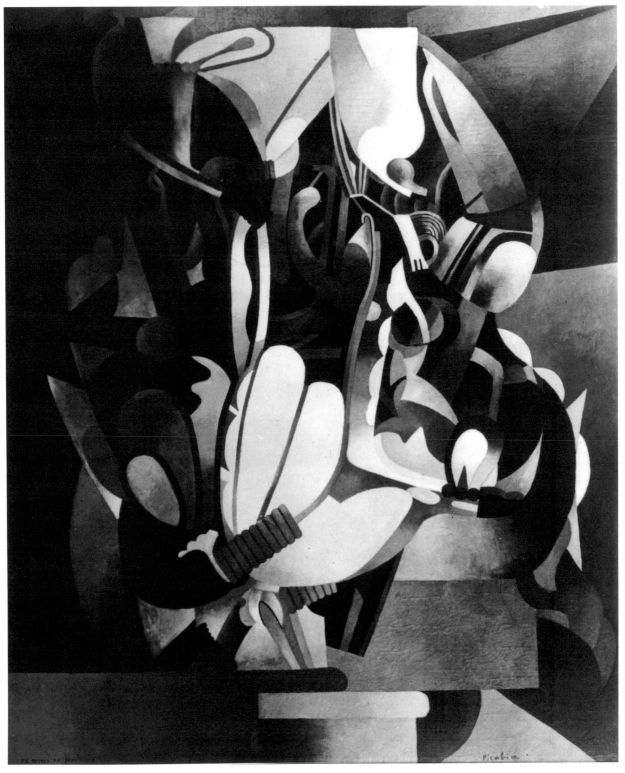

I See Again in Memory My Dear Udnie. 1914. Oil, 8′2½″ x 6′6¼″

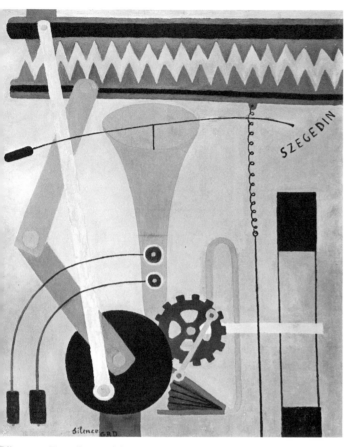

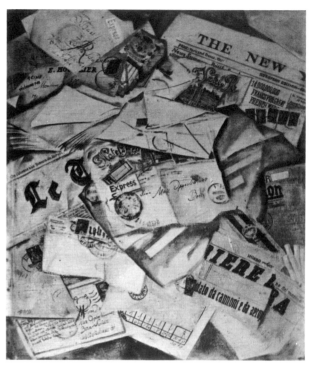

Mopp: *The World War*. 1916. Oil, 21 x 17⁵/₈″

Ribemont-Dessaignes: *Silence*. c. 1915. Oil, 36¹/₄ x 28⁷/₈″

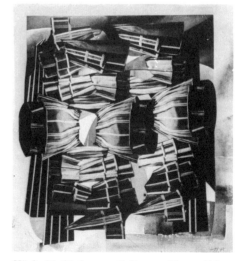

Höch: Untitled. 1925. Collage, 9³/₄ x 7⁵/₈″ Höch: Untitled. 1945. Collage, 13¹/₂ x 12¹/₈″

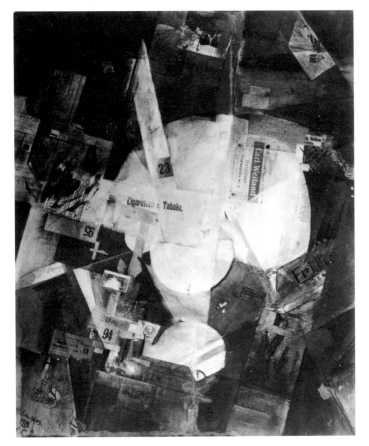

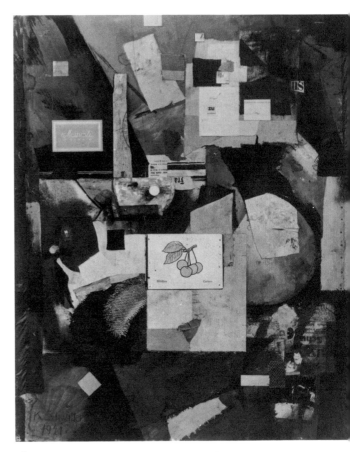

Picture with Light Center. 1919. Collage, oil, 33¼ x 25⅞"

Cherry Picture. 1921. Collage, gouache, 36⅛ x 27¾"

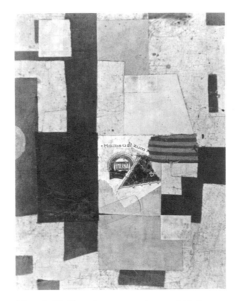

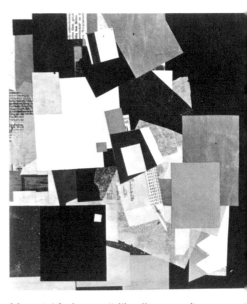

Merz (with Emerka wrapper). 1922? Collage, 13¾ x 10⅜"

Merz (with letters "elikan" repeated). c. 1925 Collage, 17⅛ x 14¼"

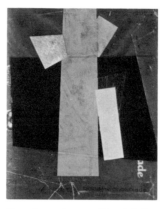

Drawing A 2: Hansi-Scho-kolade. 1918. Collage, 7¹/₈ x 5³/₄″

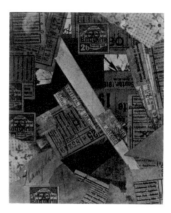

Merz 22. 1920. Collage, 6⁵/₈ x 5³/₈″

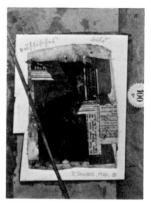

Merz 39: Russian Picture. 1920. Collage, 7³/₈ x 5⁵/₈″

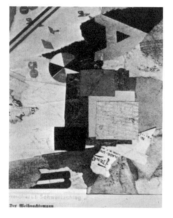

Merz: Santa Claus. 1922. Collage, 11¹/₄ x 8¹/₄″

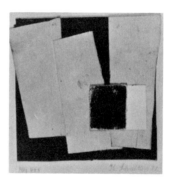

Merz 448: Moscow. 1922. Collage, 6 x 6¹/₄″

Merz 32. 1924. Collage, 5 x 3³/₄″

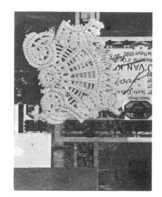

Merz (with paper lace). 1925. Collage, 4³/₈ x 3³/₈″

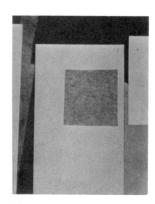

Merz 17: Lissitzky. 1926. Collage, 5¹/₄ x 4¹/₈″

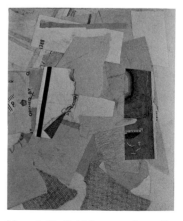

Merz (with British censor's seal). 1940–45. Collage, 7³/₈ x 6¹/₈″

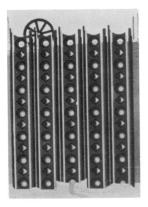

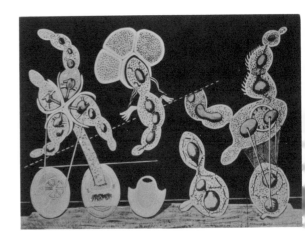

left: The Little Tear Gland That Says Tic Tac. 1920. Gouache on wallpaper, 14¼ x 10″

right: The gramineous bicycle garnished with bells the dappled fire damps and the echinoderms bending the spine to look for caresses. 1920 or 1921. Botanical chart altered with gouache, 29¼ x 39¼″

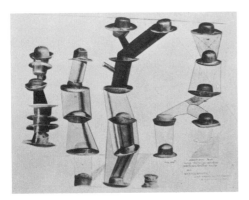

Stratified rocks, nature's gift of gneiss lava iceland moss 2 kinds of lungwort 2 kinds of ruptures of the perineum growths of the heart (b) the same thing in a well-polished box somewhat more expensive. 1920. Anatomical engraving, altered with gouache and pencil 6 x 8⅛″

The Hat Makes the Man. 1920. Collage, pencil, ink, and watercolor, 14 x 18″

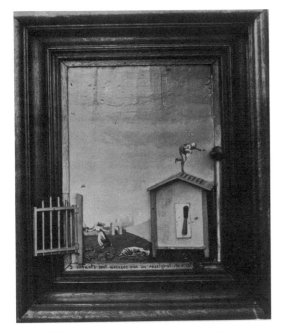

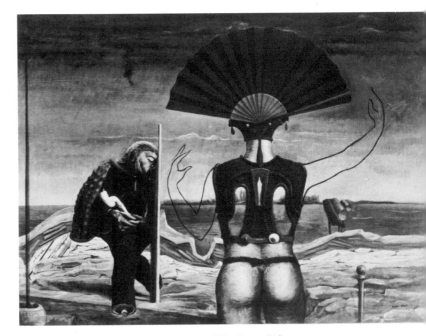

Two Children Are Threatened by a Nightingale. 1924. Oil, wood construction, 27½ x 22½ x 4½″

Woman, Old Man and Flower. 1923–24. Oil, 38 x 51¼″

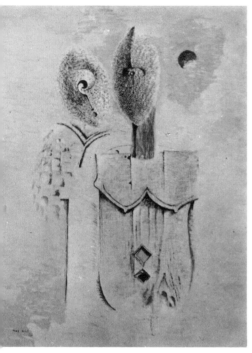

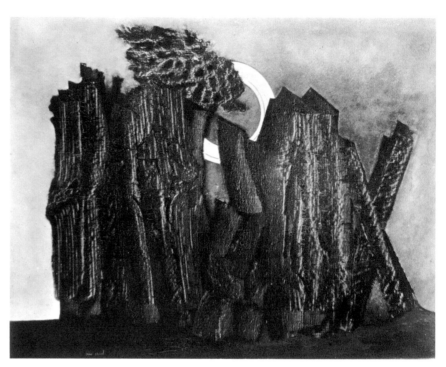

Two Sisters. 1926. Oil and "frottage" with black lead, 39½ x 28¾"

Forest. 1926. Oil, 28¾ x 36¼"

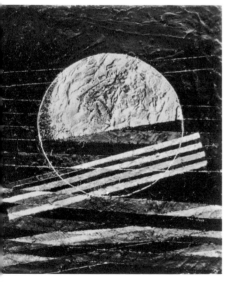

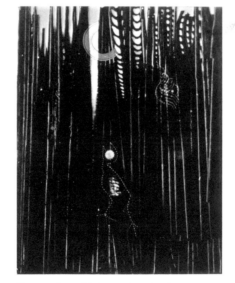

The Sea. 1928. Painted plaster on canvas, 22 x 18½"

Forest, Sun, Birds. 1928–29? Oil on paper, 25½ x 19⅝"

Birds above the Forest. 1929. Oil, 31¾ x 25¼"

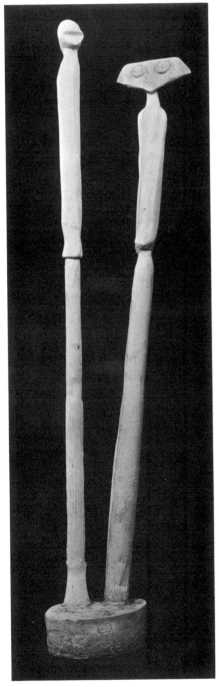

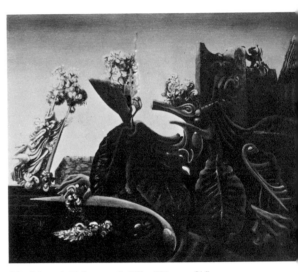

The Nymph Echo. 1936. Oil, 18¼ x 21¾"

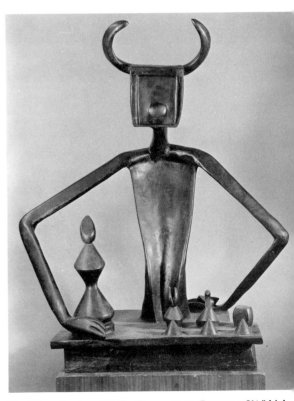

Les Asperges de la lune. 1935. Plaster, 65¼" high

The King Playing with the Queen. 1944. Bronze, 38½" high

ature at Daybreak. 1938. Oil, 31⅞ x 39⅜"

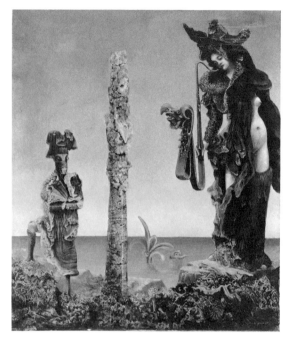

Napoleon in the Wilderness. 1941. Oil, 18¼ x 15"

Mundus Est Fabula. 1959. Oil, 51¼ x 64"

Collage with Squares Arranged According to the Law of Chance. 1916–17. Collage, 19¹/₈ x 13⁵/₈"

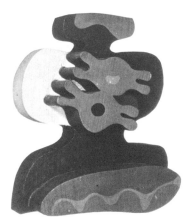

Birds in an Aquarium. c. 1920. Painted wood relief, 9⁷/₈ x 8"

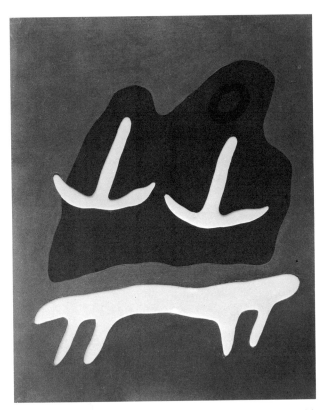

Mountain, Table, Anchors, Navel. 1925. Oil on cardboard with cutouts, 29⁵/₈ x 23¹/₂"

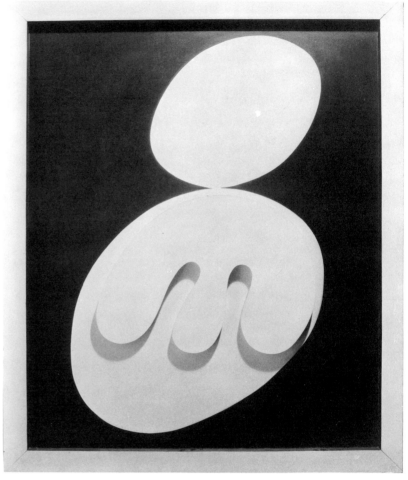

Two Heads. 1929. Painted wood relief, 47¹/₄ x 39¹/₄"

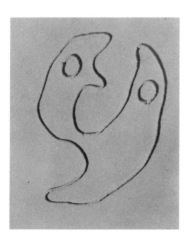

Two Heads. 1927. Oil and string on canvas, 13³/₄ x 10⁵/₈"

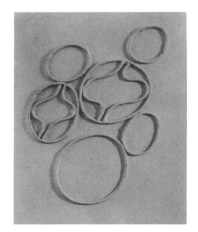

Leaves and Navel. 1929. Oil and string on canvas, 13³/₄ x 10³/₄"

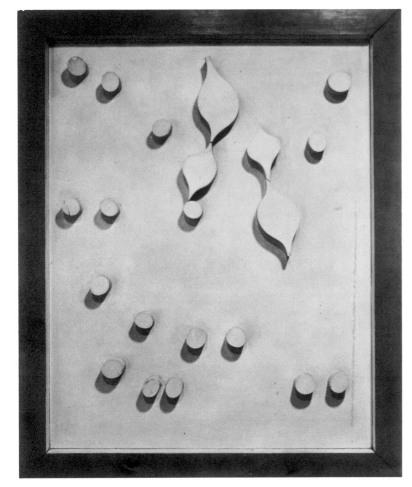

Leaves and Navels, I. 1930. Painted wood relief, 39³/₄ x 31³/₄″

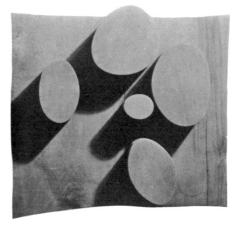

Objects Arranged According to the Law of Chance or *Navels*. 1930. Varnished wood relief, 10³/₈ x 11¹/₈″

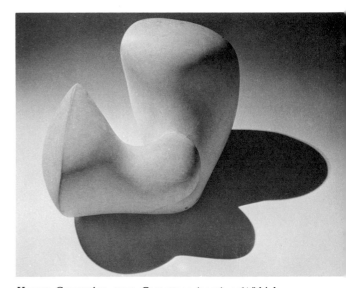

Human Concretion. 1935. Cast stone (1949), 19¹/₂″ high

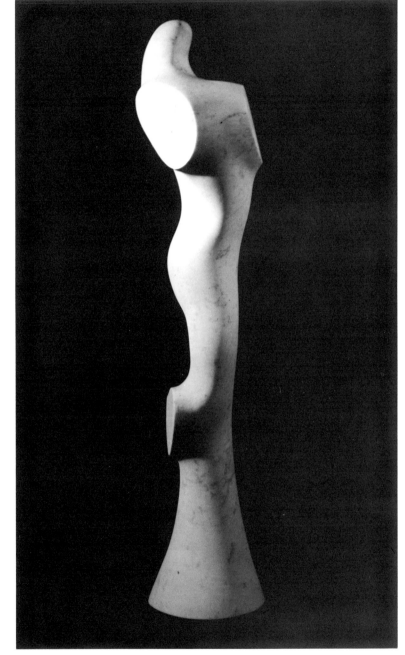

Floral Nude. 1957. Marble, 47¹/₄″ high

elief. 1938–39 (after a relief of 1934–35). Wood, 19¹/₂ x
)⁵/₈″

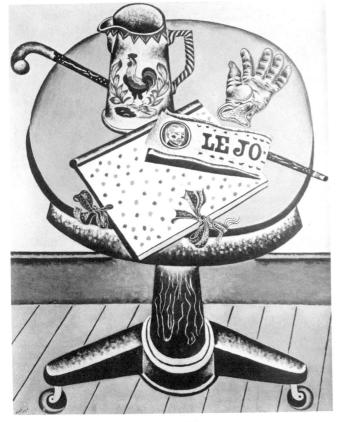

Table with Glove. 1921. Oil, 46 x 35¼"

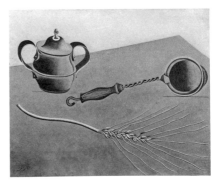

The Ear of Grain. 1922–23. Oil, 14⅞ x 18⅛"

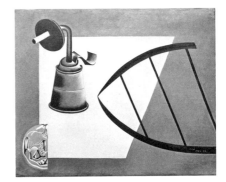

The Carbide Lamp. 1922–23. Oil, 15 x 18"

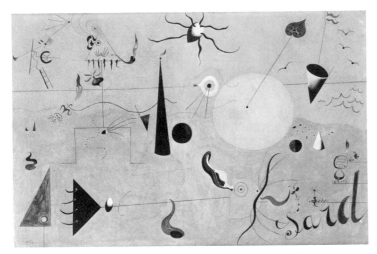

The Hunter (Catalan Landscape). 1923–24. Oil, 25½ x 39½"

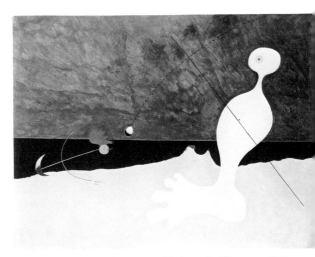

Person Throwing a Stone at a Bird. 1926. Oil, 29 x 36¼"

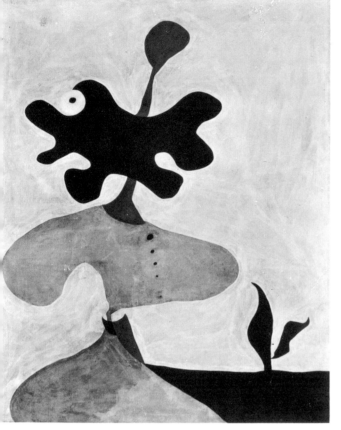

Portrait of a Lady in 1820. 1929. Oil, 45³/₄ x 35¹/₈″

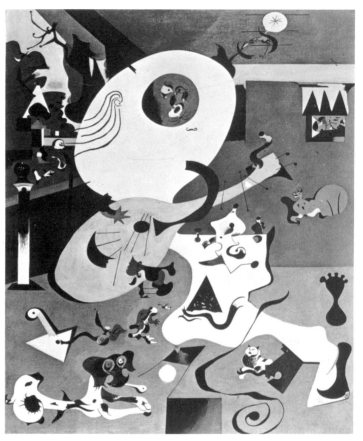

Dutch Interior, I. 1928. Oil, 36¹/₈ x 28³/₄″

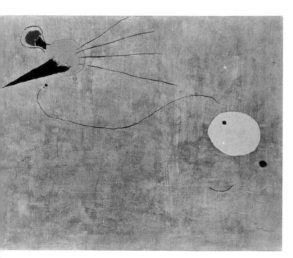

Blue Painting. 1926. Oil, 23¹/₂ x 28³/₄″

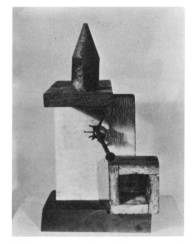

Object. 1931. Assemblage: wood, steel, string, bone, bead, 15³/₄″ high

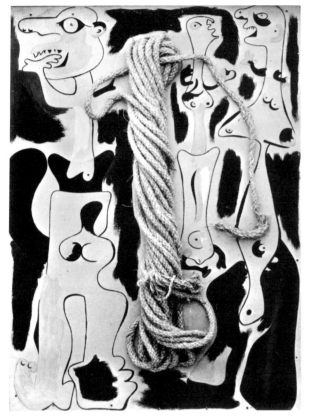

Rope and People, I. 1935. Oil on cardboard with coil of rope,
41¼ x 29⅜″

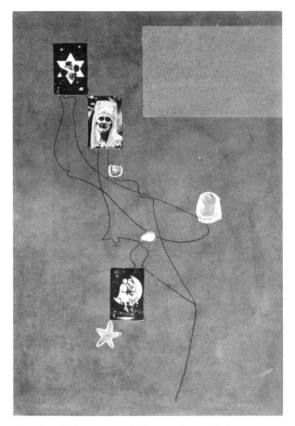

Drawing-Collage. 1933. Collage, 42½ x 28⅜″

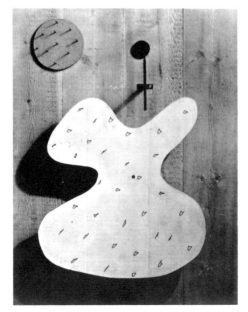

Relief Construction. 1930. Wood and metal, 35⅞
x 27⅝″

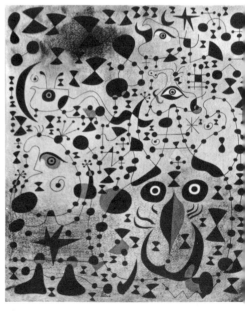

*The Beautiful Bird Revealing the Unknown to a
Pair of Lovers*. 1941. Gouache, oil wash, 18 x 15″

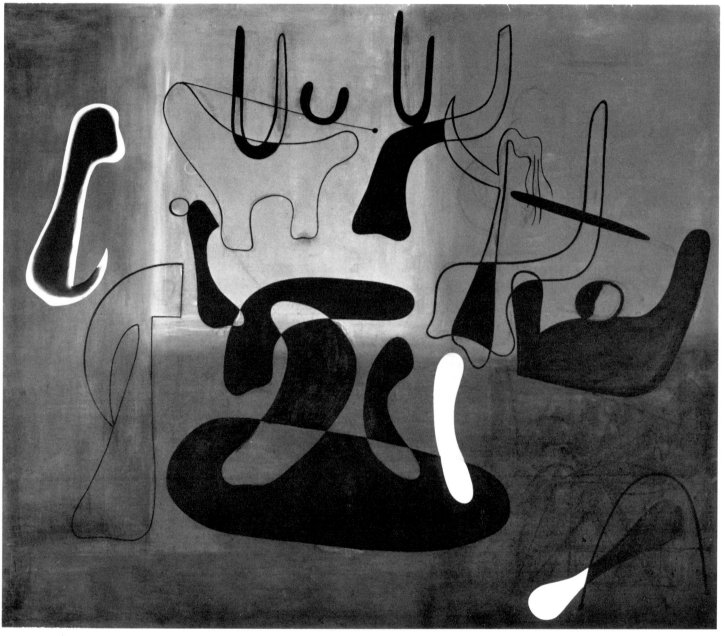

Painting. 1933. Oil, 68¹/₂″ x 6′5¹/₄″

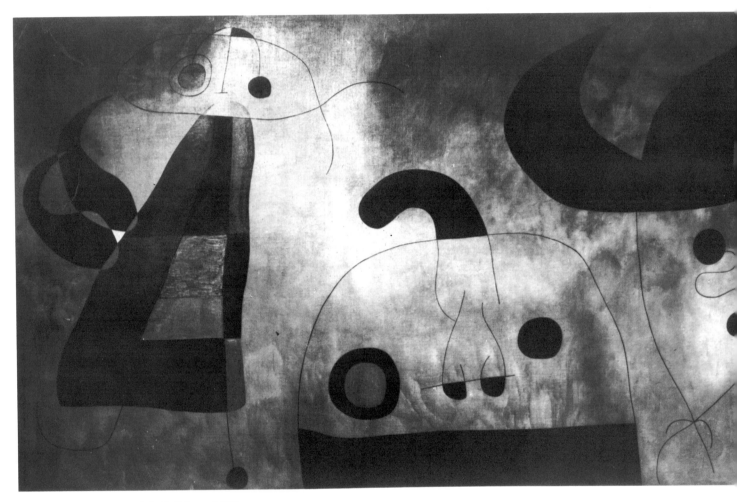

Mural Painting. 1950–51. Oil, 6'2³/4" x 19'5³/4"

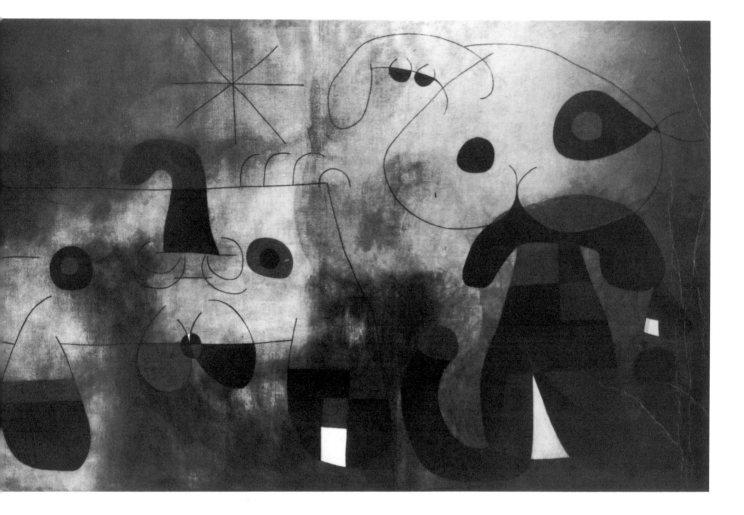

Battle of Fishes. 1927. Sand, gesso, oil, pencil, and charcoal, 14¼ x 28¾"

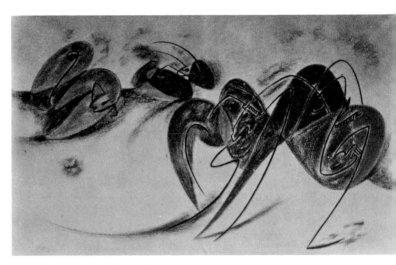

Animals Devouring Themselves. 1928. Pastel, 28¾ x 45¾"

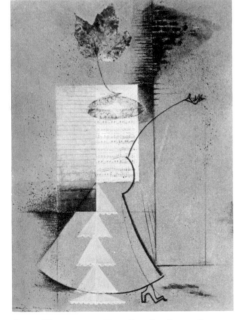

Street Singer. 1941. Pastel and collage of paper,
leaf, and dragonfly wings, 23½ x 17½"

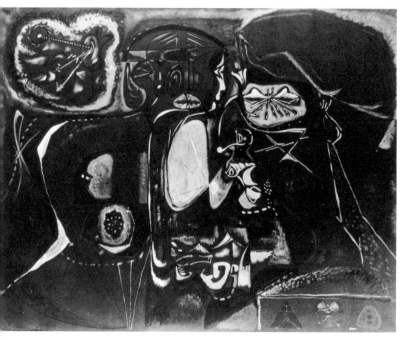

Leonardo da Vinci and Isabella d'Este. 1942. Oil, 39⁷/₈ x 50″

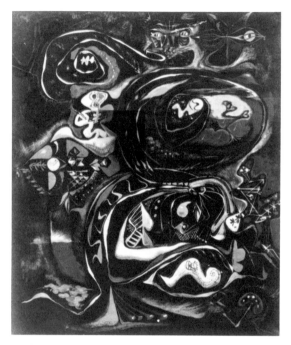

Meditation on an Oak Leaf. 1942. Tempera, pastel, and sand, 40 x 33″

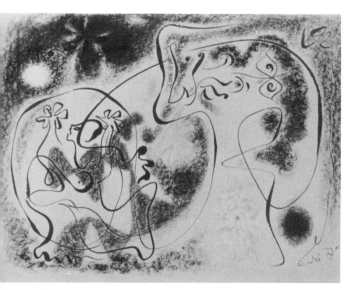

Werewolf. 1944. Pastel, brush and ink, 18 x 24″

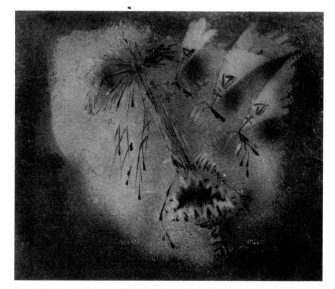

Attacked by Birds. 1956. Oil and sand, 29⁵/₈ x 35¹/₂″

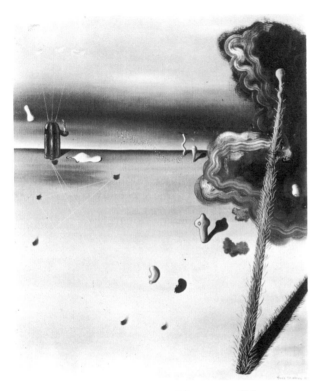

Mama, Papa Is Wounded! 1927. Oil, 36¹/₄ x 28³/₄″

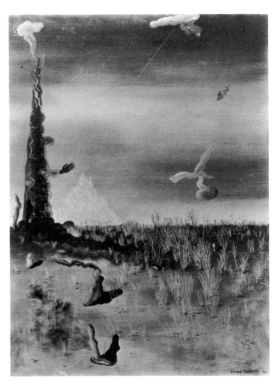

Extinction of Useless Lights. 1927. Oil, 36¹/₄ x 25³/₄″

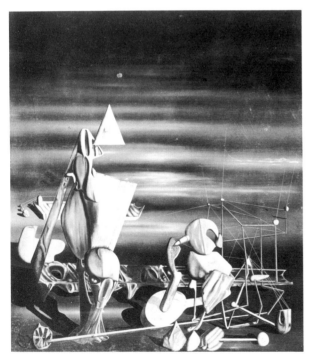

Slowly toward the North. 1942. Oil, 42 x 36″

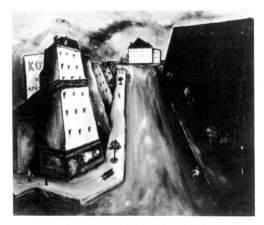

Rue de la Santé. 1925. Oil, 19³/₄ x 24¹/₈″

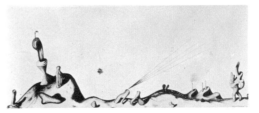

Untitled. 1931. Gouache, 4¹/₂ x 11¹/₂″

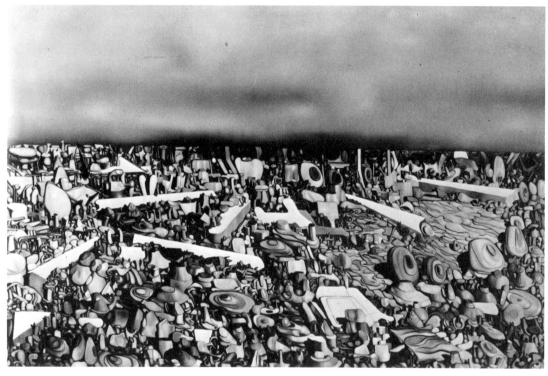

Multiplication of the Arcs. 1954. Oil, 40 x 60″

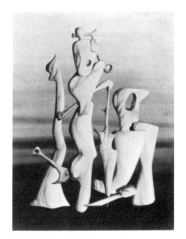

La Grande mue. 1942. Gouache and
pasted paper, 11¹/₂ x 8³/₄″

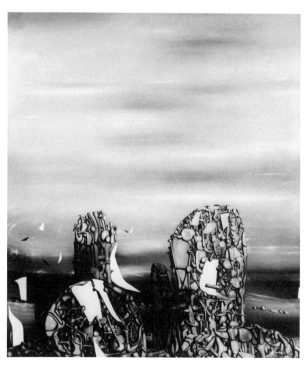

The Hunted Sky. 1951. Oil, 39¹/₈ x 32³/₈″

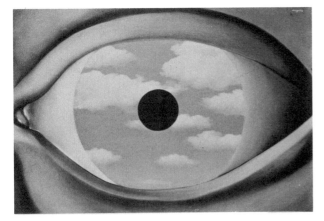

The False Mirror. 1928. Oil, 21¼ x 31⅞″

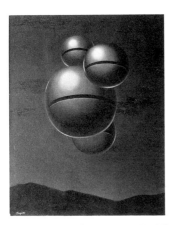

The Voice of Space. 1928. Oil, 25½ x 19⅝″

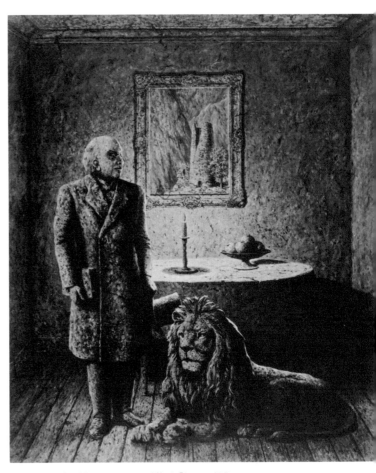

Memory of a Voyage. 1955. Oil, 63⅞ x 51¼″

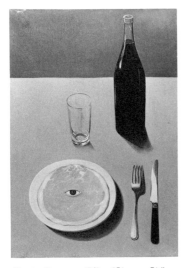

Portrait. 1935. Oil, 28⅞ x 19⅞″

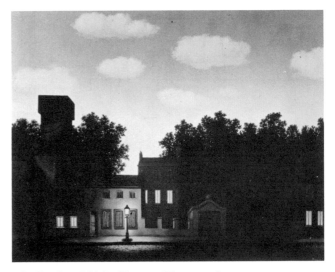

The Empire of Light, II. 1950. Oil, 31 x 39″

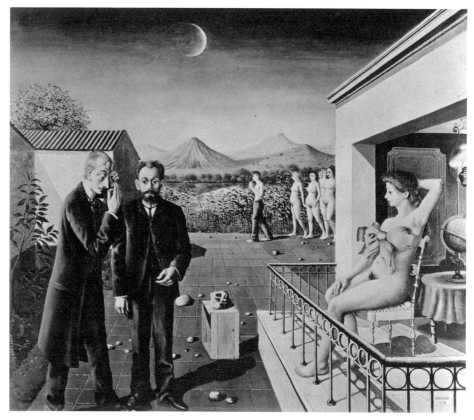

Phases of the Moon. 1939. Oil, 55 x 63"

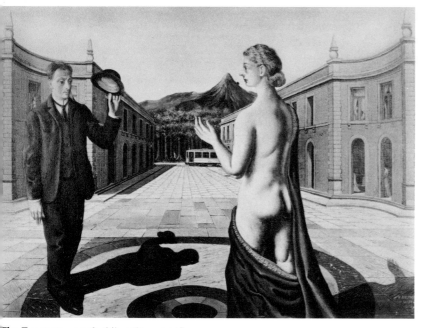

The Encounter. 1938. Oil, 35⁵/₈ x 47¹/₂"

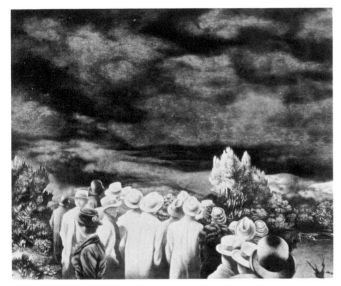

Oelze: *Expectation*. 1935–36. Oil, 32¹/₈ x 39⁵/₈"

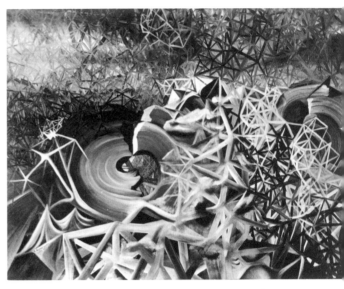

Dominguez: *Nostalgia of Space*. 1939. Oil, 28³/₄ x 36¹/₈"

Paalen: Untitled. 1938. Colored inks, 21³/₄ x 28¹/₂"

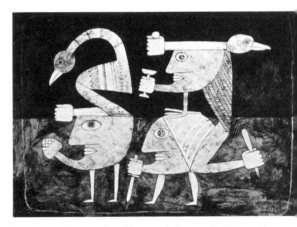

Brauner: *Progression Pantaculaire*. 1948. Encaustic on cardboard, 19³/₄ x 27¹/₂"

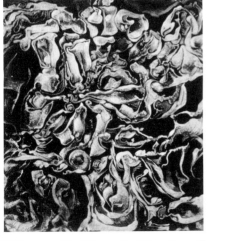

Seligmann: *The King*. 1960. Oil, 24¹/₄ x 20"

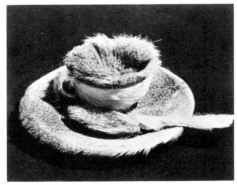

Oppenheim: *Object*. 1936. Fur-covered cup 4³/₈" high, saucer 9³/₈" diameter, spoon 8" long

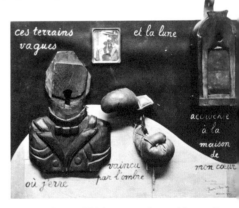

Breton: *Poem-Object*. 1941. Assemblage, 18 x 2 x 4³/₈"

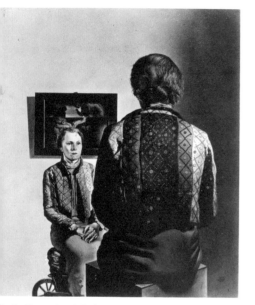

Dali: *Portrait of Gala*. 1935. Oil, 12³/₄ x 10¹/₂″

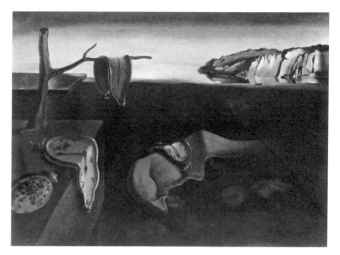

Dali: *The Persistence of Memory*. 1931. Oil, 9¹/₂ x 13″

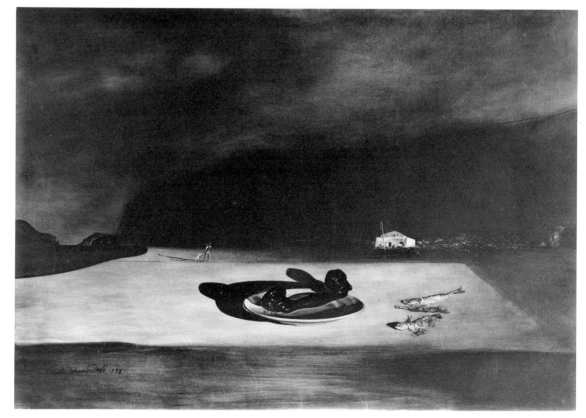

Dali: *Imperial Violets*. 1938. Oil, 39¹/₄ x 56¹/₈″

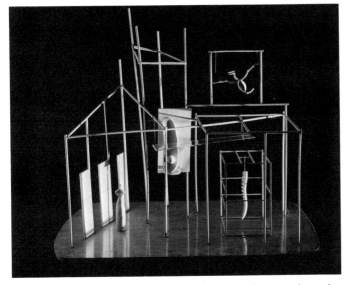

The Palace at 4 A.M. 1932–33. Construction in wood, glass, wire, string, 25 x 28¼ x 15¾"

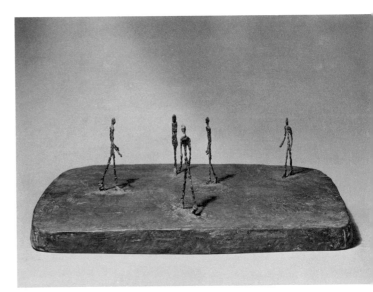

City Square. 1948. Bronze, 8½ x 25⅜ x 17¼"

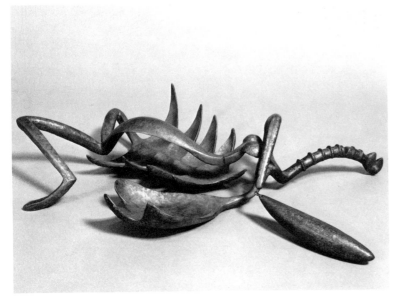

Woman with Her Throat Cut. 1932. Bronze (cast 1949), 8 x 34½ x 25"

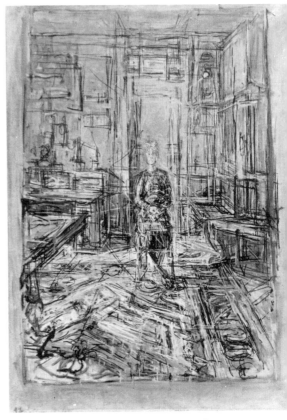

The Artist's Mother. 1950. Oil, 35⅜ x 24"

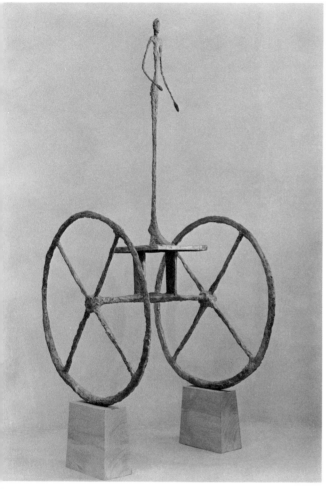

Chariot. 1950. Bronze, 57 x 26 x 26¹/₈″

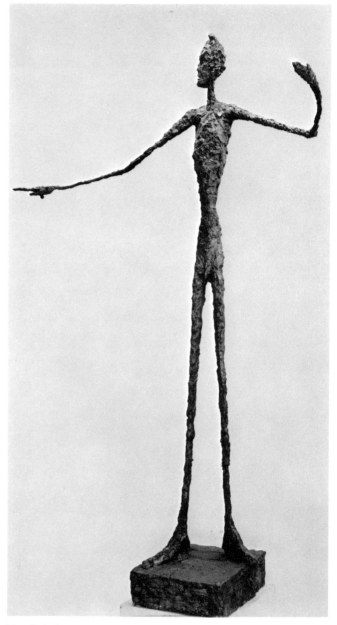

Man Pointing. 1947. Bronze, 70¹/₂″ high

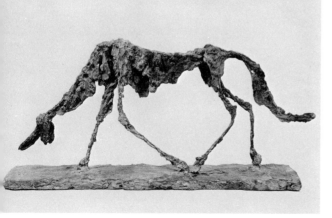

Dog. 1951. Bronze (cast 1957), 18″ high

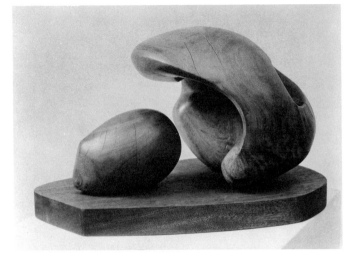

Two Forms. 1934. Pynkado wood, 11 x 17³/₄″

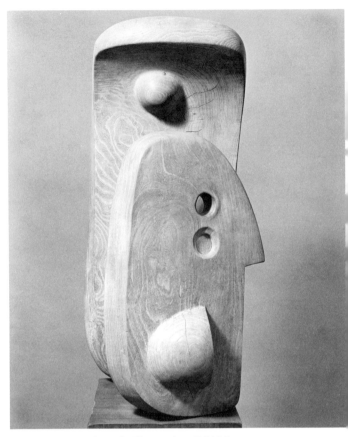

Mother and Child. 1938. Elmwood, 30³/₈″ high

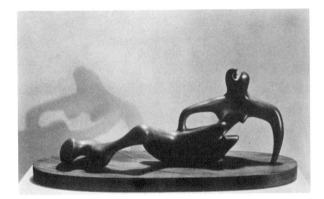

Reclining Figure. 1938. Cast lead, 5³/₄ x 13″

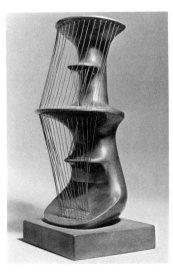

The Bride. 1939–40. Cast lead and copper wire, 9³/₈″ high

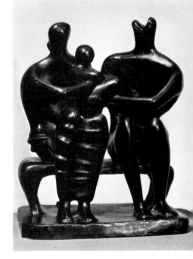

Family Group. 1945. Bronze, 9³/₈″ hig

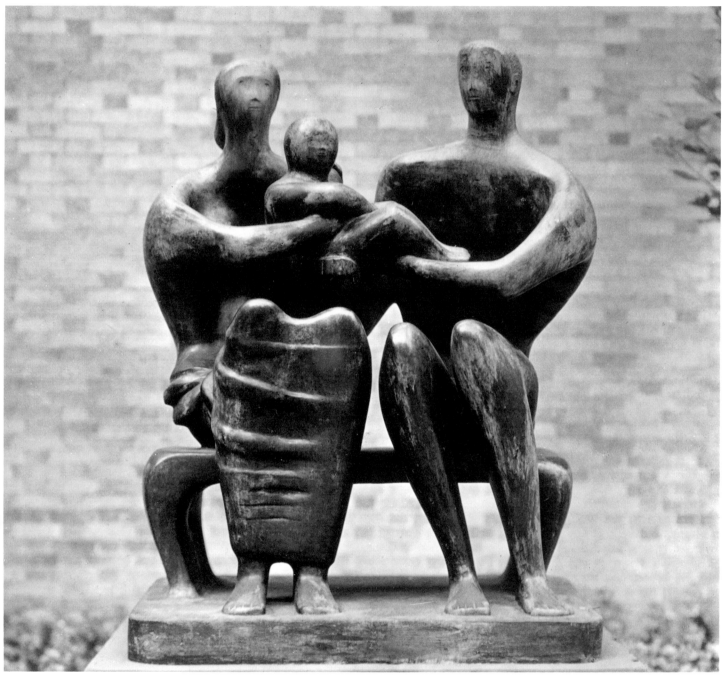

Family Group. 1948–49. Bronze (cast 1950), 59¼" high

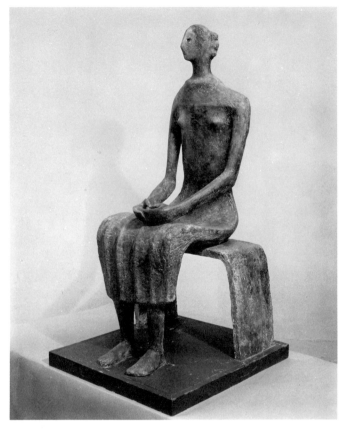

Seated Figure. 1952–53. Terra cotta, 40³/₄″ high

Seated Figures, II. 1942. Crayon, wash, and ink, 22⁵/₈ x 18¹/₈″

Sculpture and Red Rocks. 1942. Crayon, wash, and ink, 19¹/₈ x 14¹/₄″

Study for sculpture on Time-Life Building, London. 1952–53. Bronze, 15 x 38⁷/₈″

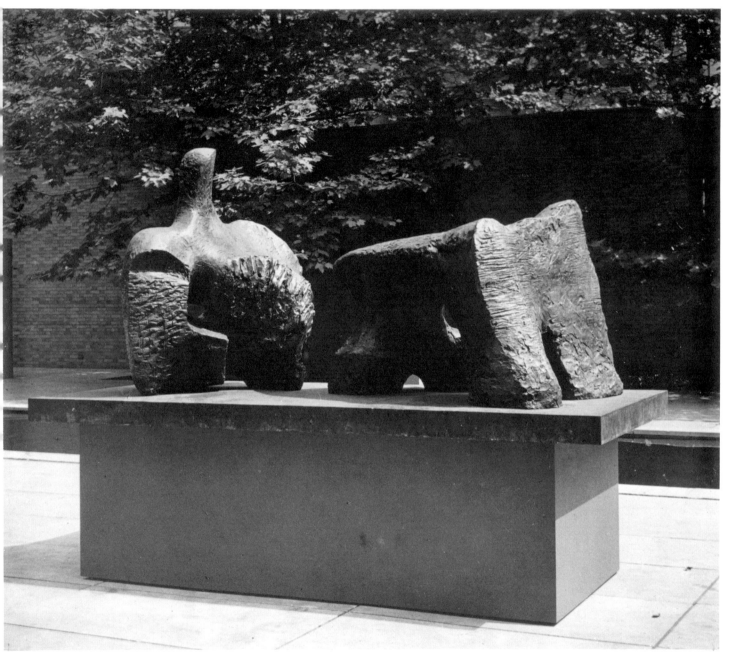

Reclining Figure, II. 1960. Bronze, in two parts, 50″ high, 8′3″ long

The Old Mill. c. 1922–23. Oil, 26¹/₈ x 32³/₈″

Portrait of Maria Lani. 1929. Oil, 28⁷/₈ x 23¹/₂″

Dead Fowl. c. 1924. Oil, 43¹/₂ x 32″

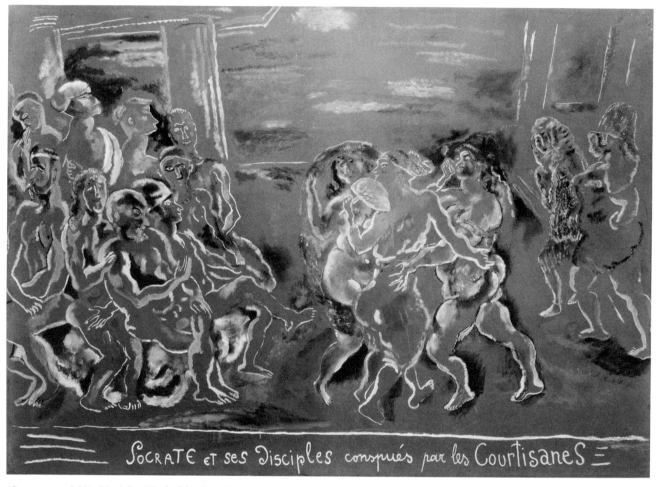

Socrates and His Disciples Mocked by Courtesans. c. 1921.
Oil, gouache, and crayon on paper mounted on canvas, 61¼"
x 7'2"

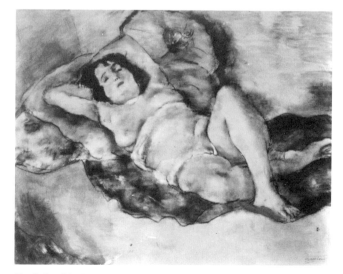

Reclining Model. c. 1925. Oil, 28¾ x 36¼"

Lurçat: *Enchanted Isle*. c. 1928. Oil, 15¼ x 24⅛″

Fautrier: *Flowers*. c. 1927. Oil, 25⅝ x 21¼″

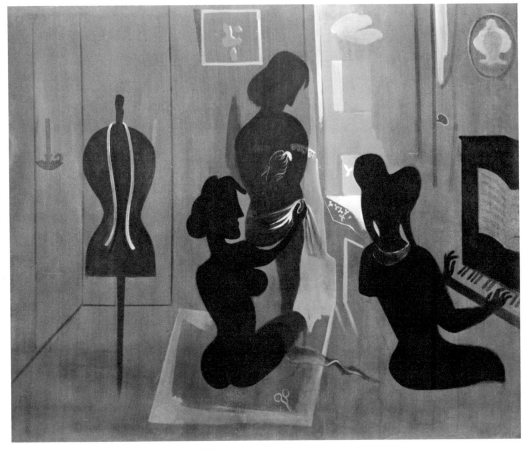

Borès: *The Fitting*. 1934. Oil, 6'3¾″ x 7'2¾″

Bissière: *Red Bird on Black*. 1953. Oil, tempera, 40 x 19⅝″

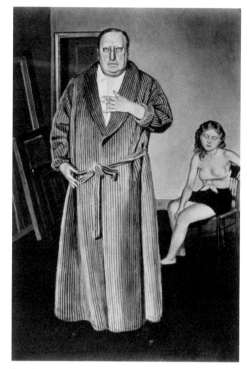

Balthus: *André Derain*. 1936. Oil on wood, 44³/₈ x 28¹/₂"

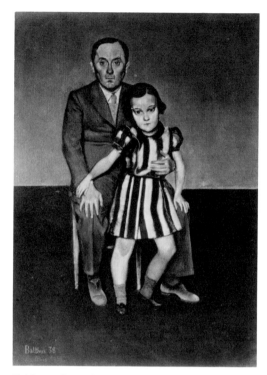

Balthus: *Joan Miró and His Daughter Dolores*. 1937–38. Oil, 51¹/₄ x 35"

issière: *Red and Black*. 1952. Oil and g tempera, 42¹/₂ x 26³/₄"

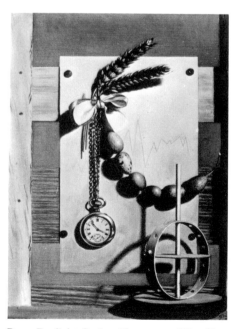

Roy: *Daylight Saving Time*. 1929. Oil, 21¹/₂ x 15"

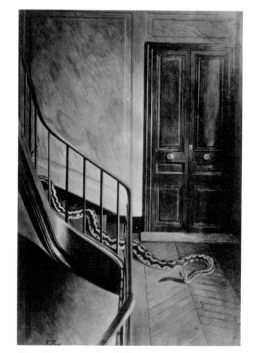

Roy: *Danger on the Stairs*. 1927 or 1928. Oil, 36 x 23⁵/₈"

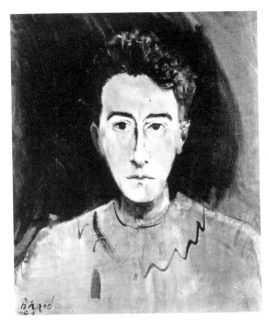

Bérard: *Jean Cocteau.* 1928. Oil, 25⅝ x 21¼″

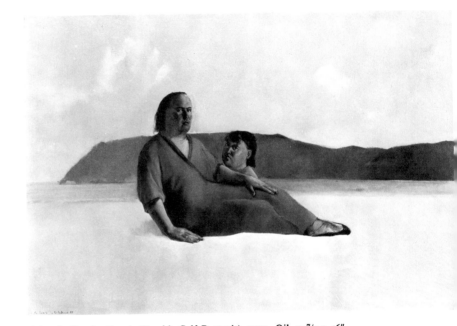

Bérard: *On the Beach (Double Self-Portrait).* 1933. Oil, 31⅞ x 46″

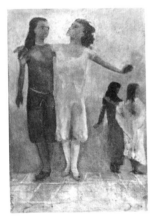

Bérard: *Promenade.* 1928. Oil, 16⅛ x 10⅝″

Berman: *Winter.* 1929. Oil, 36⅛ x 28¾″

Berman: *The Good Samaritan.* 1930. Oil, 36¼ x 28⅞″

Leonid: *Shrimp Fishermen*. 1937. Oil, 21¼ x 31¾"

Leonid: *Malamocco*. 1948. Oil, 36 x 28"

Berman: *Sleeping Figures, Statue, Campanile*. 1932. Oil, ¼ x 28¾"

Berman: *The Gates of the City, Nightfall*. 1937. Oil, 30¼ x 40¼"

Burra: *Bal des Pendus*. 1937. Watercolor, 61¹/₈ x 44⁷/₈"

Tchelitchew: *Natalie Paley*. 1931. Oil, 32 x 21¹/₄"

Tchelitchew: *The Madhouse*. 1935. Gouache, 19⁷/₈ x 25⁵/₈"

Tchelitchew: *Leaf Children*. Study for *Hide-and-Seek*. 1939. Gouache, 25¹/₄ x 19³/₄"

Hide-and-Seek. 1940–42. Oil, 6'6½" x 7'3¾"

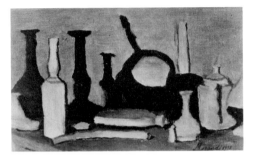

Morandi: *Still Life*. 1938. Oil, 9¹/₂ x 15⁵/₈″

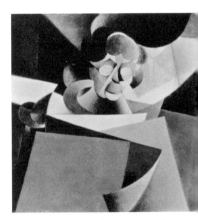

Pannaggi: *My Mother Reading the News
paper*. c. 1922. Oil, 11¹/₈ x 10¹/₄″

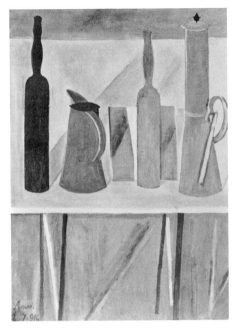

Morandi: *Still Life*. 1916. Oil, 32¹/₂ x 22⁵/₈″

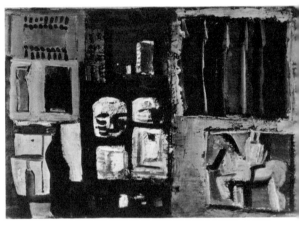

Sironi: *Multiplication*. Oil, 22¹/₈ x 31¹/₂″

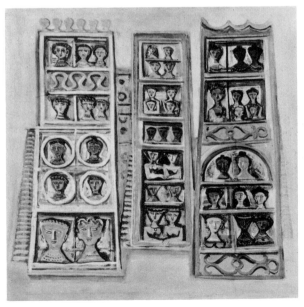

Campigli: Design for mosaic floor of Teatro Metropolitano,
Rome. 1943. Gouache and oil, 32¹/₄ x 33¹/₈″

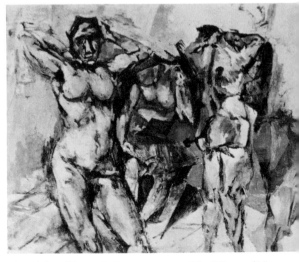

Pirandello: *Women's Quarters*. 1950. Oil, 28¹/₄ x 34¹/₈″

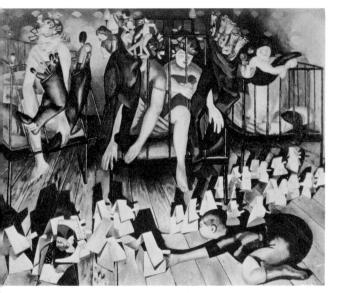

Spencer: *The Nursery.* 1936. Oil, 30⅛ x 36⅛"

Kjarval: *Lava at Bessastadir.* 1947–54. Oil, 29⅝ x 37⅝"

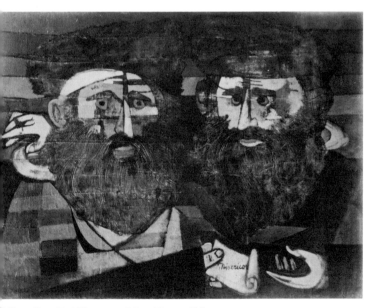

Adler: *Two Rabbis.* 1942. Oil, 33⅞ x 44⅛"

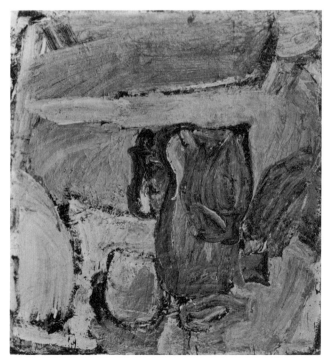

Lundquist: *Pottery, Number 9.* 1949. Oil, 46⅛ x 41³⁄₈"

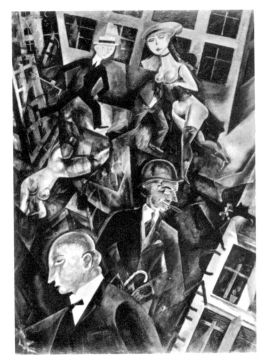

Metropolis. 1917. Oil, 26³/₄ x 18³/₄"

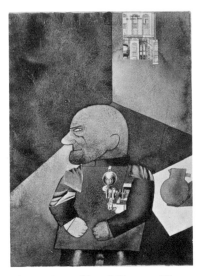

The Engineer Heartfield. 1920. Watercolor and collage, 16¹/₂ x 12"

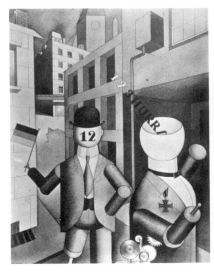

Republican Automatons. 1920. Watercolor, 23⁵/₈ x 18⁵/₈"

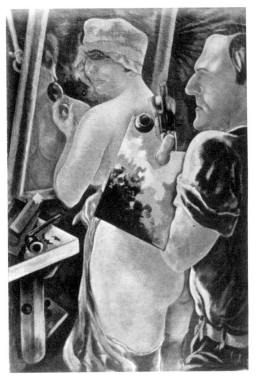

Self-Portrait with a Model. 1928. Oil, 45¹/₂ x 29³/₄"

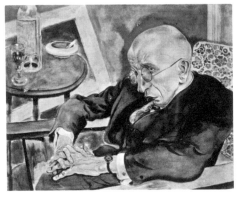

The Poet Max Herrmann-Neisse. 1927. Oil, 23³/₈ x 29¹/₈"

Punishment. 1934. Watercolor, 27¹/₂ x 20¹/₂"

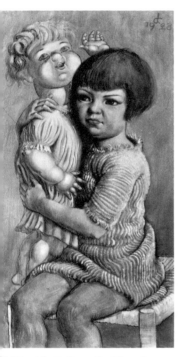

Child with Doll. 1928. Oil and tempera on wood, 29¹/₄ x 15¹/₄"

Dr. Mayer-Hermann. 1926. Oil and tempera on wood, 58³/₄ x 39"

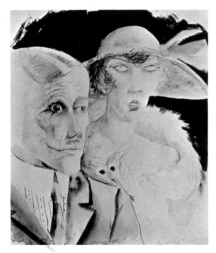

Café Couple. 1921. Watercolor and pencil, 20 x 16¹/₈"

Self-Portrait. 1922. Watercolor and pencil, 19³/₈ x 15¹/₂"

Café. 1922. Watercolor, pen and ink, 19¹/₄ x 14³/₈"

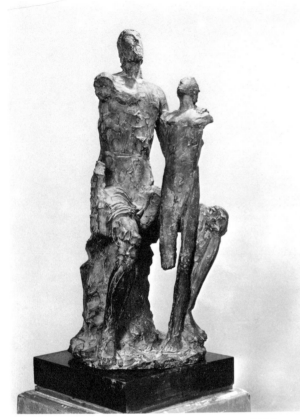

Martini: *Daedalus and Icarus*. 1934–35. Bronze, 24″ high

Sintenis: *Daphne*. 1930. Bronze, 56½″ high

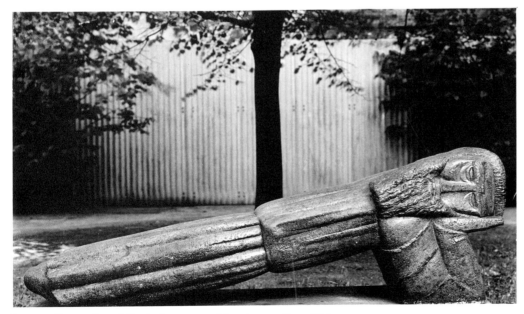

Jespers: *Temptation of St. Anthony*. 1934. Limestone, 17½ x 56¼″

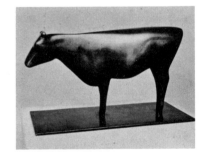

Mataré: *Cow*. 1924. Bronze, 6⅞ x 13⅛″

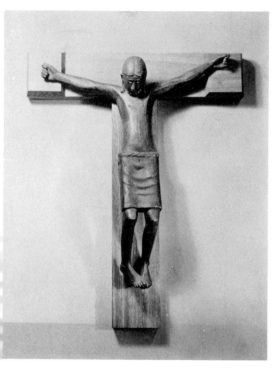

Crucifix. 1948. Bronze, 23″ high

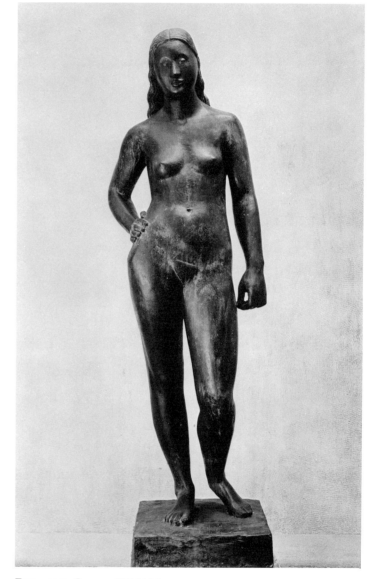

Freya. 1949. Bronze, 66⁵/₈″ high

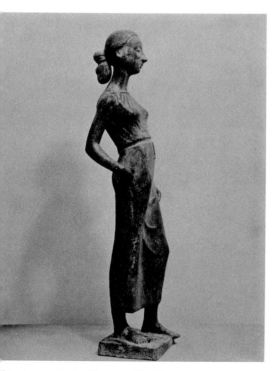

Amazon. 1949–50. Bronze, 26″ high

The Runners. 1924. Bronze,
7³/₄″ high

The Subway. 1928. Oil, 16¹/₈ x 22¹/₈"

Barricade. 1931. Oil, 55 x 45"

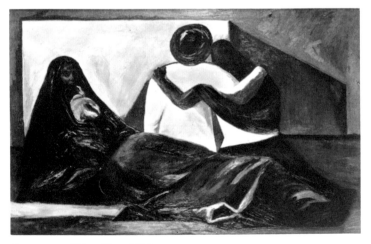

Peace. 1930. Oil, 30¹/₄ x 48¹/₄"

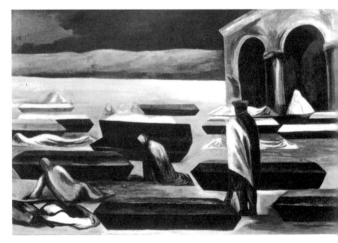

The Cemetery. 1931. Oil, 27 x 39⁷/₈"

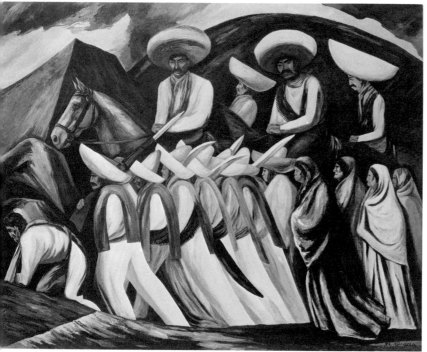

Self-Portrait. 1940. Oil and gouache, 20¼ x 23¾″

Zapatistas. 1931. Oil, 45 x 55″

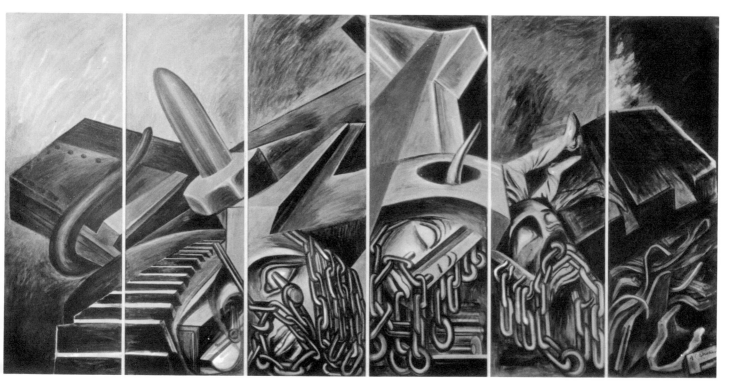

Dive Bomber and Tank. 1940. Fresco, 9 x 18′, on six panels, 9 x 3′ each

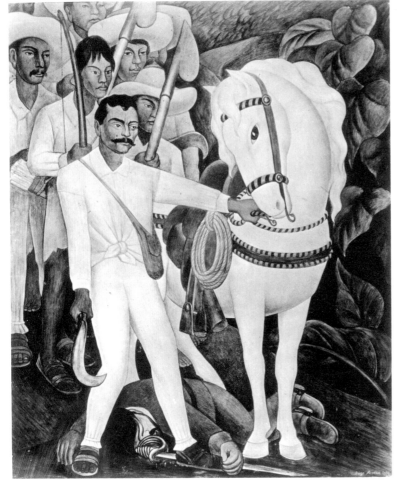

Agrarian Leader Zapata. 1931. Fresco, 7′9³/4″ x 6′2″

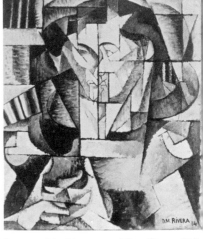

Jacques Lipchitz. 1914. Oil, 25⁵/8 x 21⁵/8″

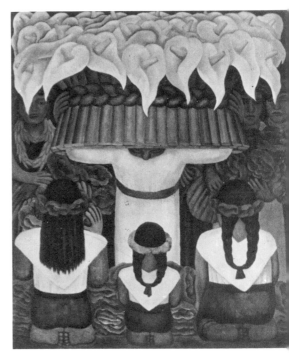

May Day, Moscow. 1928. From a sketchbook of 45 watercolors, 4 x 6¹/4″

Flower Festival: Feast of Santa Anita. 1931. Encaustic, 6′6¹/2″ x 64″

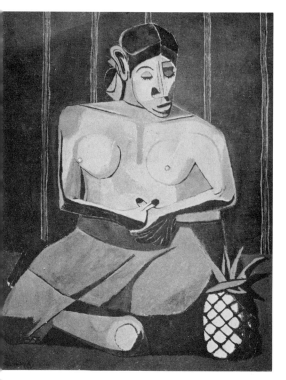

Woman with Pineapple. 1941. Oil, 40 x 30"

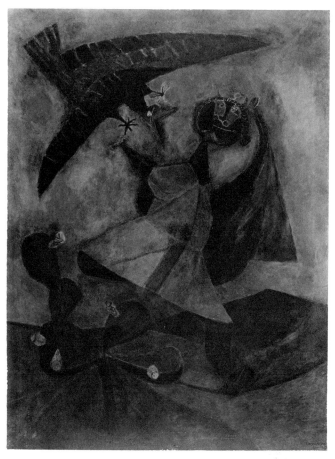

Girl Attacked by a Strange Bird. 1947. Oil, 70 x 50¹/₈"

Melon Slices. 1950. Oil, 39³/₈ x 31³/₄"

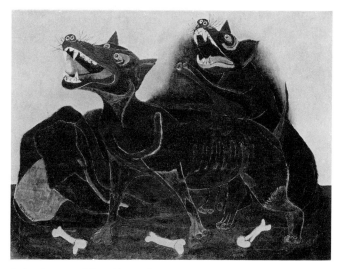

Animals. 1941. Oil, 30¹/₈ x 40"

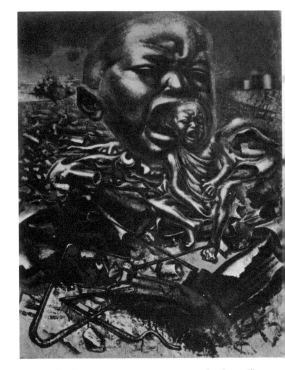

Echo of a Scream. 1937. Duco on wood, 48 x 36″

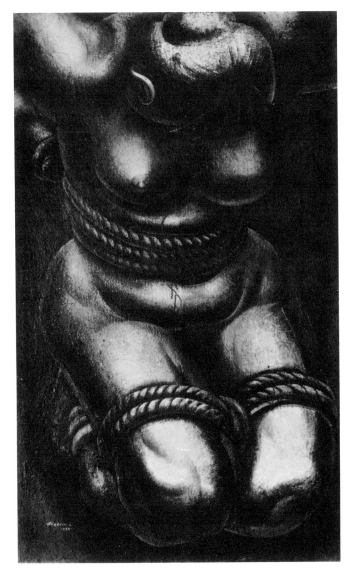

Proletarian Victim. 1933. Duco on burlap, 6′9″ x 47½″

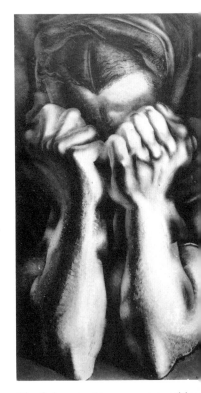

The Sob. 1939. Duco on composition board, 48½ x 24¾″

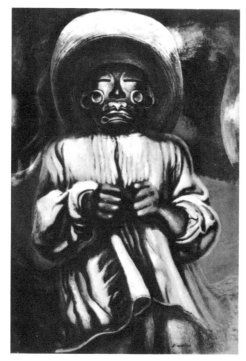

Ethnography. 1939. Duco on composition board, 48¹/₈ x 32³/₈"

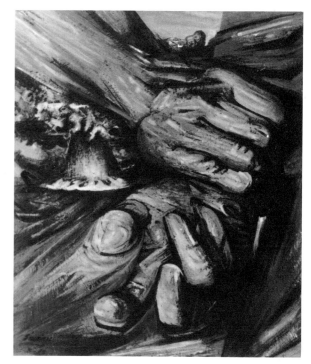

Hands. 1949. Duco on composition board, 48¹/₈ x 39³/₈"

Collective Suicide. 1936. Duco on wood with applied sections, 49" x 6'

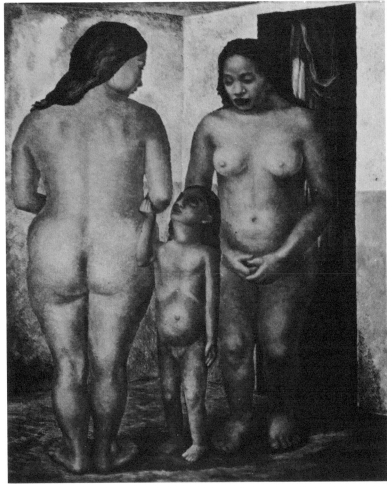

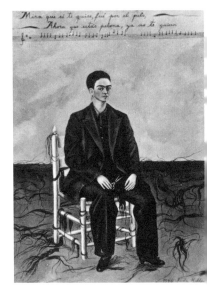

above: Kahlo: *Self-Portrait with Cropped Hair.* 1940. Oil, 15³/₄ x 11″

Castellanos: *The Aunts.* 1933. Oil, 60⁷/₈ x 48³/₄″

Tebo: *Portrait of My Mothe* 1937. Oil, 9¹/₈ x 6¹/₈″

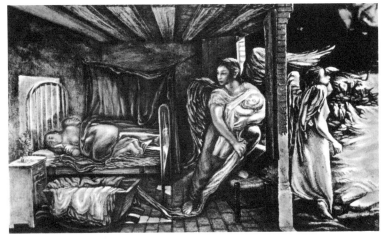

Castellanos: *The Angel Kidnappers.* 1943. Oil, 22⁵/₈ x 37³/₈″

Anguiano: *La Llorona.* 1942. Oil, 23⁵/₈ x 29⁵/₈″

Rodríguez Lozano: *Beyond Despair*. 1940. Oil, 33⅛ x 27⅝"

Guerrero Galván: *The Children*. 1939. Oil, 53¾ x 43¼"

uiz: *The New Rich*. 1941. Oil, 12⅝ x 16⅝"

O'Gorman: *The Sand Mines of Tetelpa*. 1942. Tempera, 22¼ x 18"

Torres-García: *Portrait of Wagner*. 1940. Oil, 16¹/₈ x 14⁵/₈″

Figari: *Creole Dance*. 1925? Oil, 20¹/₂ x 32″

Torres-García: *Composition*. 1932. Oil, 28¹/₄ x 19³/₄″

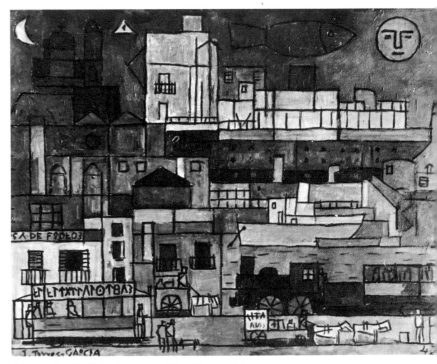

Torres-García: *The Port*. 1942. Oil, 31³/₈ x 39⁷/₈″

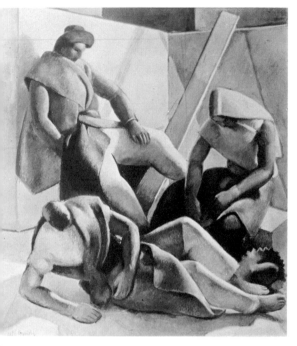

Guido: *Stevedores Resting*. 1938. Tempera, 21¹/₈ x 18¹/₈″

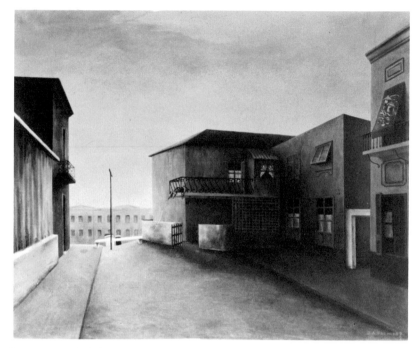

Pacenza: *End of the Street*. 1936. Oil, 33³/₈ x 41³/₈″

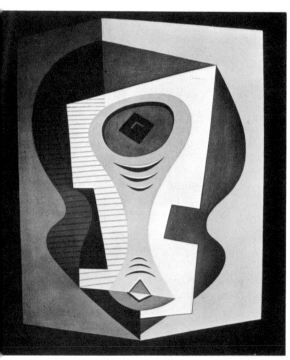

Pettoruti: *The Verdigris Goblet*. 1934. Oil, 21⁵/₈ x 18¹/₈″

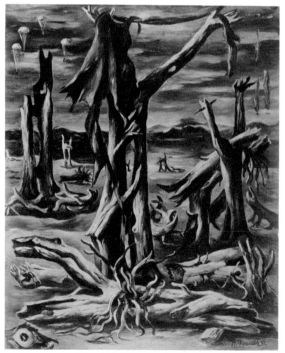

Forner: *Desolation*. 1942. Oil, 36⁷/₈ x 28⁷/₈″

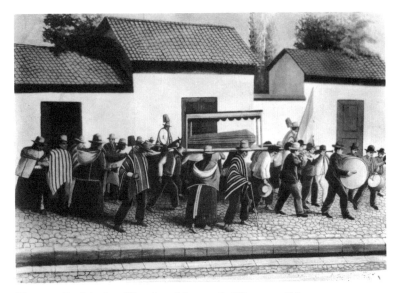

Urteaga: *Burial of an Illustrious Man*. 1936. Oil, 23 x 32¹/₂″

Herrera Guevara: *Snow Storm at the University*. 1941. Oil, 24 x 27⁵/₈″

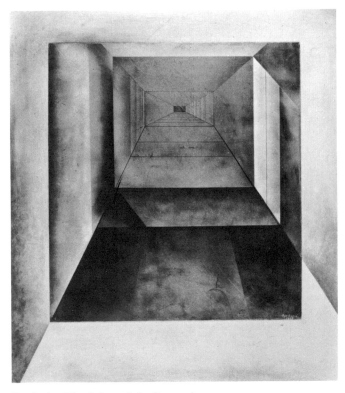

Berdecio: *The Cube and the Perspective*. 1935.
Duco airbrushed on steel panel, 30 x 26″

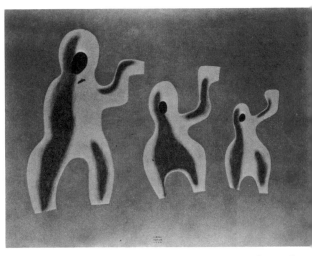

Mérida: *Tempo in Red Major*. 1942. Wax crayon, 17⁷/₈ x 24″

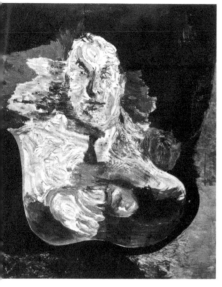

Carvalho: *The Poet Pablo Neruda*. 1947. Oil over gesso, 39³/₈ x 30⁷/₈"

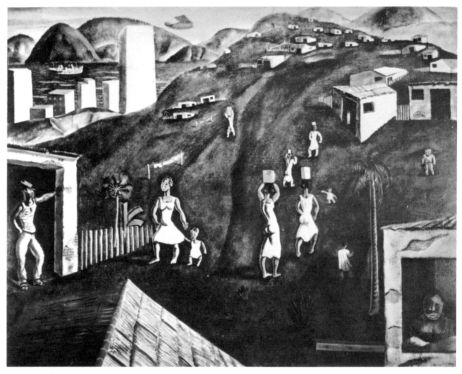

Portinari: *Morro*. 1933. Oil, 44⁷/₈ x 57³/₈"

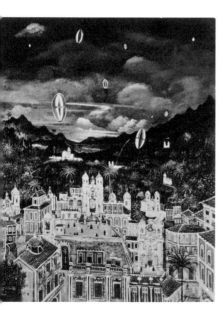

Guignard: *Ouro Preto: St. John's Eve*. 1942. Oil on plywood, 31¹/₂ x 23⁵/₈"

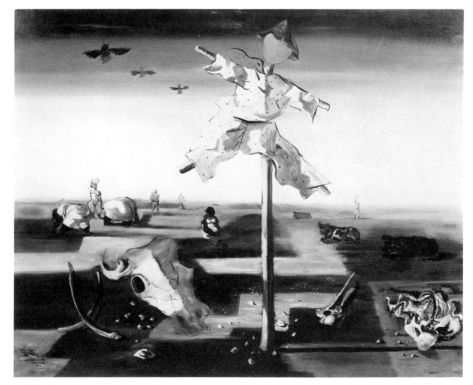

Portinari: *Scarecrow*. 1940. Oil, 51¹/₂ x 64"

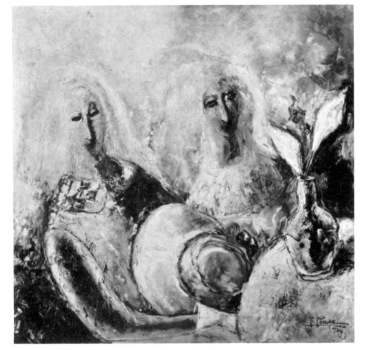

Ponce de León: *Two Women*. 1934. Oil, 39¼ x 39³⁄₈″

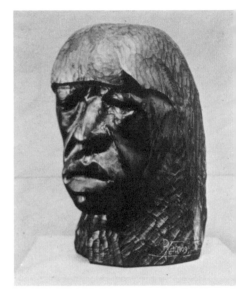

Ramos Blanco: *Old Negro Woman*. 1939.
Wood, 11¹⁄₈″ high

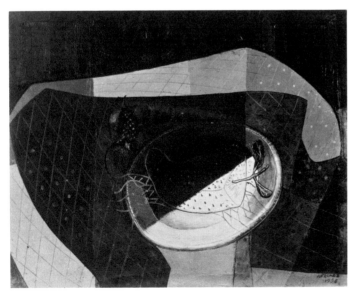

Peláez: *Still Life in Red*. 1938. Oil, 27¼ x 33½″

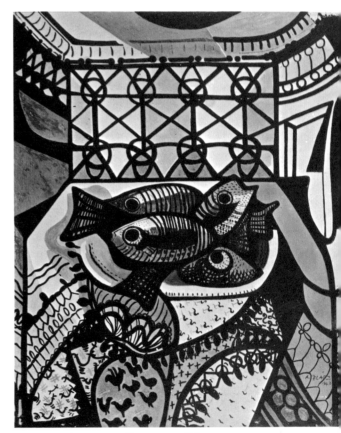

Peláez: *Fishes*. 1943. Oil, 45½ x 35¹⁄₈″

Egas: *Dream of Ecuador*. 1939. Oil, 20 x 25"

Paredes: *Threshers*. 1942. Tempera on cardboard, 20¹/₂ x 19⁵/₈"

Ariza: *Savanna*. 1942. Oil, 19³/₈ x 19¹/₄"

Milne: *Sunburst over the Catskills*. 1917. Watercolor, 15¹/₈ x 21³/₄"

Note: For other paintings by Latin Americans and Canadians, see Index of Artists by Nationality.

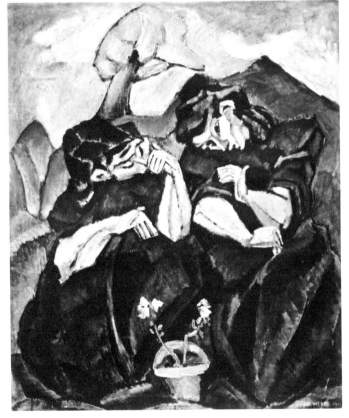

The Geranium. 1911. Oil, 39⁷/₈ x 32¹/₄″

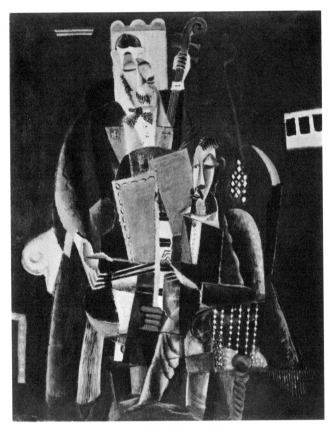

The Two Musicians. 1917. Oil, 40¹/₈ x 30¹/₈″

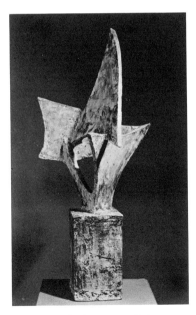

Air-Light-Shadow. 1915. Poly-
chromed plaster, 28⁷/₈″ high

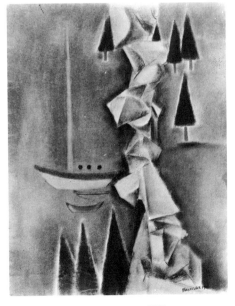

Maine. 1914. Pastel, 24¹/₂ x 18³/₄″

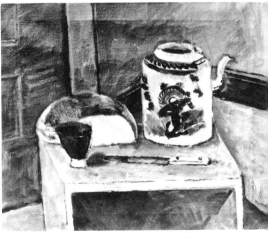

Still Life with Chinese Teapot. 1925. Oil, 20 x 24¹/₈″

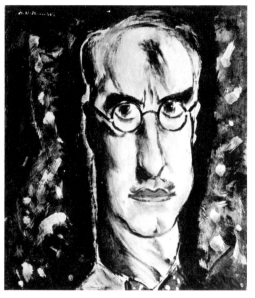

Maurer: *Self-Portrait*. c. 1927. Oil, 21¹/₂ x 18″

Sterne: *Resting at the Bazaar*. 1912. Oil, 26³/₄ x 31¹/₂″

Weber: *Interior with Figures*.
1918. Gouache, 4⁷/₈ x 4¹/₂″

Sterne: *After the Rain*. 1948. Oil, 26¹/₂ x 34″

Weber: *Head*. 1928. Gouache,
5 x 4⁵/₈″

Viaduct. 1920. Oil, 39³/₄ x 33³/₄"

The Steamer Odin, II. 1927. Oil, 26¹/₂ x 39¹/₂"

Glassy Sea. 1934. Wc., ink, charcoal, 13³/₈ x 19"

Dawn. 1938. Watercolor and ink, 12¹/₂ x 19"

Church on the Cliff, I. 1953. Charcoal, wash, ink, 12⁵/₈ x 19¹/₄"

Ruin by the Sea, II. 1934. Watercolor, ink, 12 x 18¹/₂"

Lower Manhattan. 1920. Watercolor, 21⁷/₈ x 26³/₄"

Lower Manhattan (Composing Derived from Top of Woolworth). 1922. Watercolor, charcoal, paper cutout, 21⁵/₈ x 26⁷/₈"

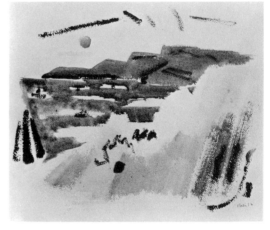

Camden Mountain across the Bay. 1922. Watercolor, 17¹/₄ x 20¹/₂"

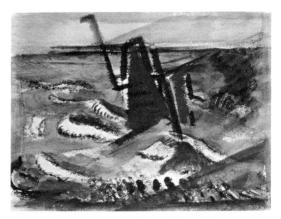

Buoy, Maine. 1931. Watercolor, 14³/₄ x 19¹/₄"

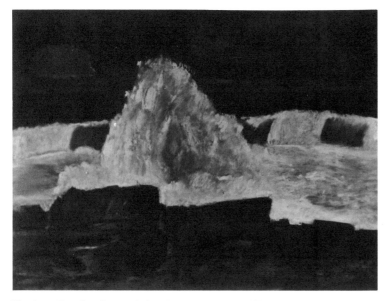

Hartley: *Evening Storm, Schoodic, Maine*. 1942. Oil, 30 x 40″

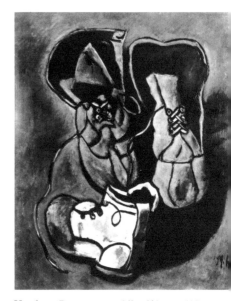

Hartley: *Boots*. 1941. Oil, 28¹/₈ x 22¹/₄″

Walkowitz: *Nude*. 1910 (dated by artist). Watercolor, 19¹/₈ x 14″

Friedman: *Sawtooth Falls*. 1945. Oil, 36¹/₈ x 29⁷/₈″

Walkowitz: *Hudson River Landscape with Figures*. 191 Watercolor, 21¹/₄ x 29¹/₄″

Dove: *Willows*. 1940. Oil, 25 x 35″

Dove: *Portrait of Alfred Stieglitz*. 1925. Assemblage, 15⅞ x 12⅛″

Bluemner: *Sun Storm*. 1927. Watercolor, 10 x 13¼″

Dove: *Grandmother*. 1925. Collage, 20 x 21¼″

Dove: *The Intellectual*. 1925. Assemblage, 17 x 7⅛″

Bluemner: *The Eye of Fate*. 1927. Watercolor, 13⅜ x 10″

Stella: *Battle of Lights*. 1913–14? Oil, 20¹/₄″ diameter

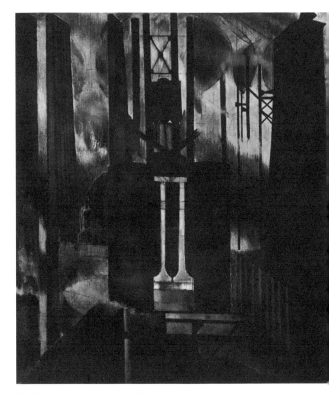

Stella: *Song of the Nightingale*. 1918. Pastel, 18 x 23¹/₈″

Stella: *Factories*. 1918. Oil, 56 x 46″

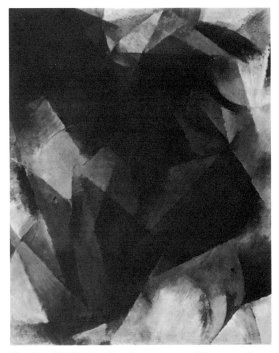

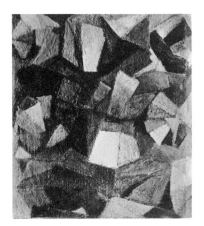

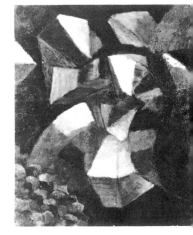

Russell: *Creavit Deus Hominem* 1913. Oil, 11⁷/₈ x 10¹/₄″

Russell: *Color Form Synchromy (Eidos)*. 1922–23. Oil, 14¹/₂ x 10⁵/₈″

Macdonald-Wright: *Synchromy*. 1917. Oil, 31 x 24″

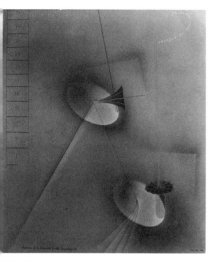

Man Ray: *Admiration of the Orchestrelle for the Cinematograph*. 1919. Gouache, wash, and ink, airbrushed, 26 x 21¹/₂″

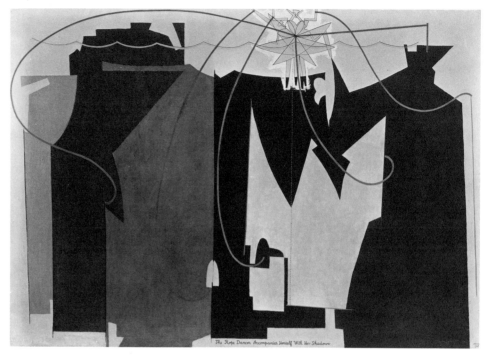

Man Ray: *The Rope Dancer Accompanies Herself with Her Shadows*. 1916. Oil, 52″ x 6′1³/₈″

Covert: *Ex Act*. 1919. Oil on relief of plywood and cardboard, 23¹/₄ x 25¹/₄″

Dreier: *Abstract Portrait of Marcel Duchamp*. 1918. Oil, 18 x 32″

Strolling. 1912. 8¹/₂ x 5¹/₈"

Flowers. 1915. 8¹/₂ x 11"

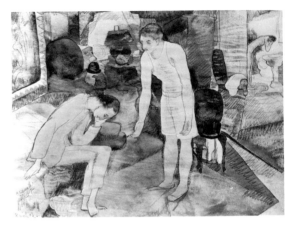

Eight O'Clock. 1917. 7⁷/₈ x 10¹/₈"

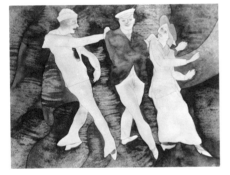

Vaudeville. 1917. 8 x 10¹/₂"

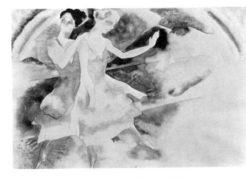

Vaudeville Dancers. 1918. 8 x 11¹/₂"

Dancing Sailors. 1918. 7⁷/₈ x 9⁷/₈"

Vaudeville Musicians. 1917. 13 x 8"

Early Houses, Provincetown. 1918. 14 x 10"

Note:
All works on this page are in watercolor and pencil.

Acrobats. 1919. 13 x 7⁷/₈"

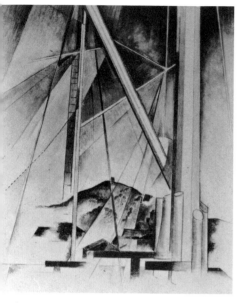

n the Key of Blue. c. 1920. Gouache, 19¹/₂ x 15¹/₂"

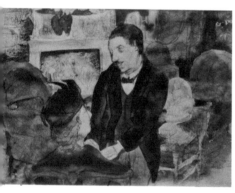

At a House in Harley Street." 1918. Watercolor
nd pencil, 8 x 11"

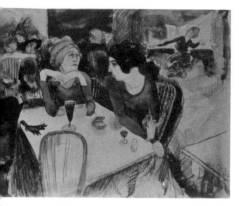

*ana, Seated Left, and Satin at Laure's Restau-
nt.* 1916. Watercolor and pencil, 8¹/₂ x 11"

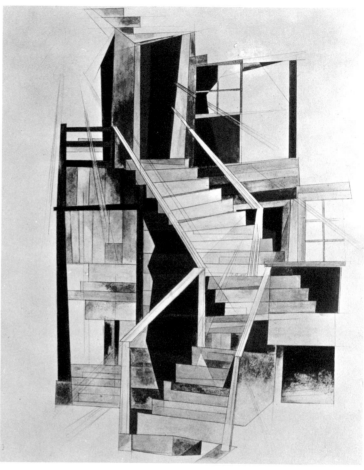

Stairs, Provincetown. 1920. Gouache and pencil, 23¹/₂ x 19¹/₂"

Corn and Peaches. 1929. Watercolor and pencil, 13³/₄ x 19³/₄"

O'Keeffe: *Lake George Window.* 1929. Oil, 40 x 30″

O'Keeffe: *Evening Star, III.* 1917. Watercolor, 9 x 11⁷/₈″

Sheeler: *American Landscape.* 1930. Oil, 24 x 31″

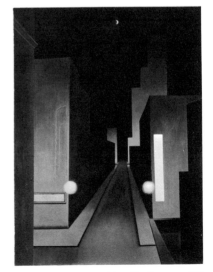

Ault: *New Moon, New York.* 1945. Oil, 28 x 20″

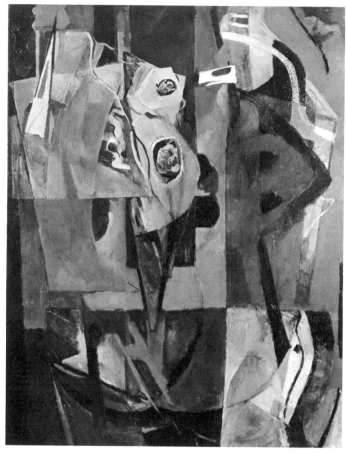

Carles: *Composition, III.* 1931–32. Oil, 51³⁄₈ x 38³⁄₄″

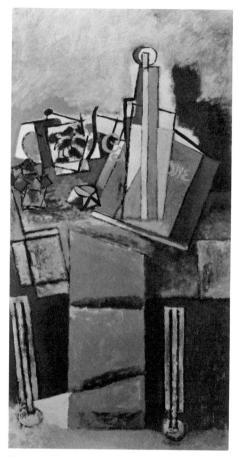

Knaths: *Giorgione Book.* 1941. Oil, 40 x 20″

Dickinson: *Plums on a Plate.* 1926. Oil, 14 x 20″

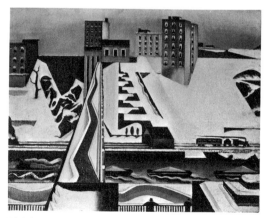

Dickinson: *Harlem River.* Before 1928. Oil, 16¹⁄₈ x 20¹⁄₄″

229

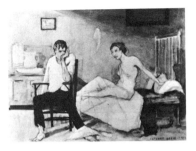

left: The Front Page. 1912.
Watercolor, 11 x 15"

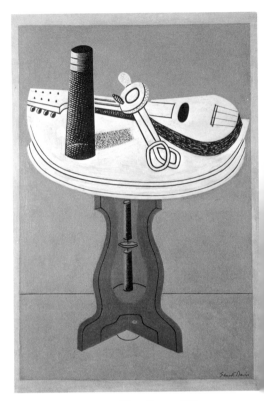

Egg Beater, V. 1930. Oil, 50⅛ x 32¼"

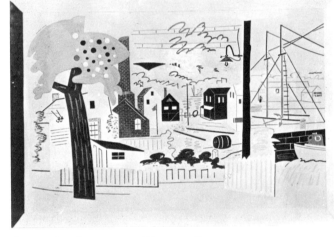

Summer Landscape. 1930. Oil, 29 x 42"

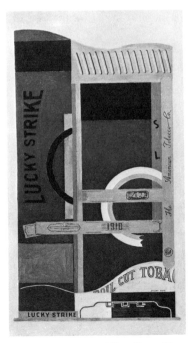

Lucky Strike. 1921. Oil, 33¼ x 18"

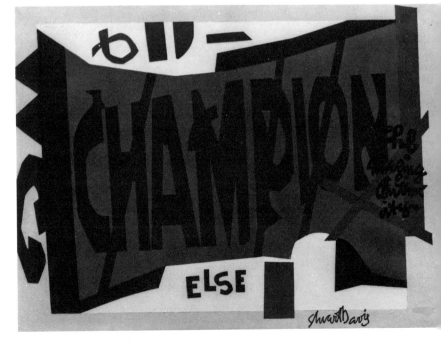

Visa. 1951. Oil, 40 x 52"

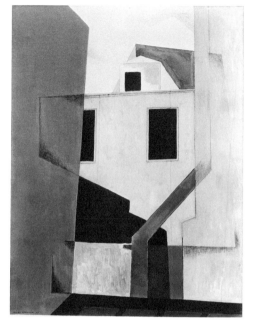

City Walls. 1921. Oil, 39³/₈ x 28³/₄"

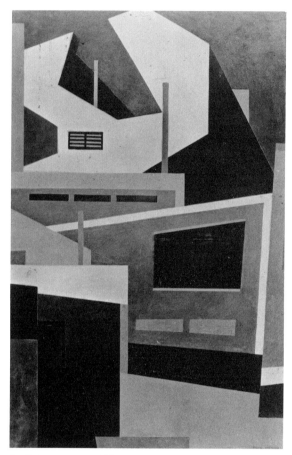

In Fairmont. 1951. Oil, 65¹/₂ x 41¹/₂"

rdnance Island, Bermuda. 1928. Oil, 24 x 36"

Near Avenue A. 1933. Oil, 30¹/₄ x 40¹/₄"

Corner Saloon. 1913. Oil, 24 x 29″

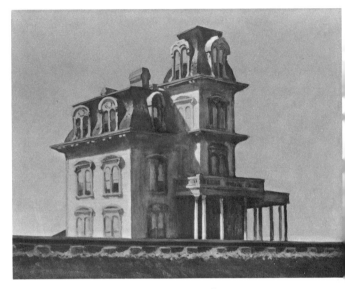

House by the Railroad. 1925. Oil, 24 x 29″

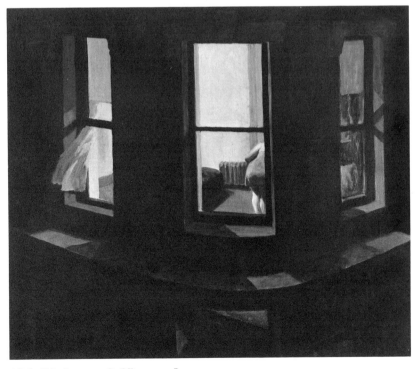

Night Windows. 1928. Oil, 29 x 34″

Mrs. Acorn's Parlor. 1926. Watercolor, 14 x 20″

Box Factory, Gloucester. 1928. Watercolor, 14 x 20″

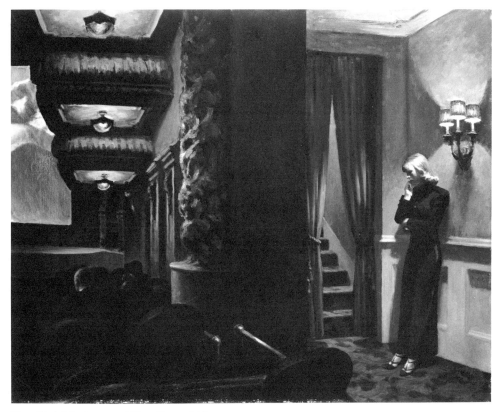

New York Movie. 1939. Oil, 32¹/₄ x 40¹/₈"

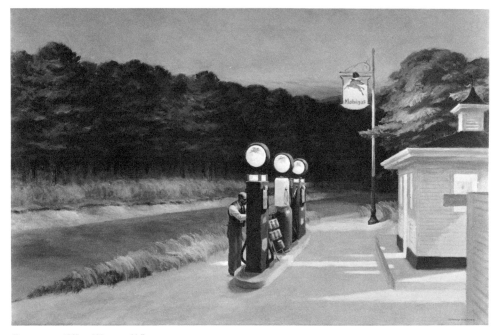

Gas. 1940. Oil, 26¹/₄ x 40¹/₄"

above left: du Bois: *Americans in Paris.* 1927. Oil, 28³/₄ x 36³/₈"

above right: Marsh: *In Fourteenth Street.* 1934. Egg tempera, 35⁷/₈ x 39³/₄"

left: Bellows: *Under the Elevated.* Watercolor, 5³/₄ x 8⁷/₈"

right: Coleman: *Jefferson Market Courthouse.* 1929 or before. Gouache, 12¹/₂ x 15"

Benton: *Homestead.* 1934. Tempera and oil, 25 x 34"

Beman: *Brummitt's Cornfield.* 1939. Oil, 24¹/₄ x 36¹/₄"

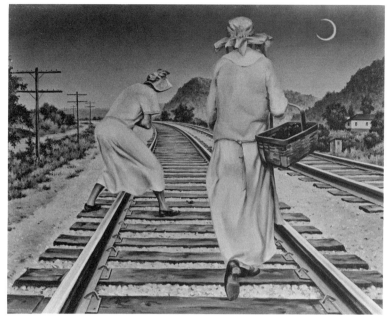

Blumenschein: *Jury for Trial of a Sheepherder for Murder.* 1936. Oil, 46¼ x 30″

above: Carter: *Jane Reed and Dora Hunt.* 1941. Oil, 36 x 45″

right: Awa Tsireh: *Green Corn Ceremony.* c. 1935. Gouache, 19¼ x 27¾″

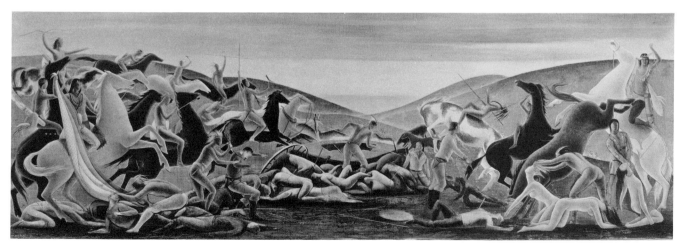

Mechau: *Dangers of the Mail.* 1935. Study (without marginal scenes) for mural in the Post Office Department Building, Washington, D.C. Oil, tempera, and pencil on paper, 25 x 54½″ (entire painting)

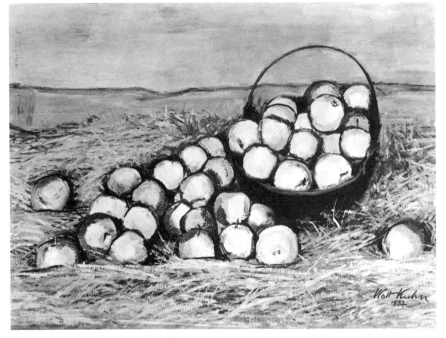

Kuhn: *Apples in the Hay*. 1932. Oil, 30 x 40"

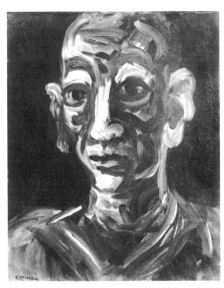

Kopman: *Head*. 1929. Oil, 22⁷/₈ x 18¹/₈"

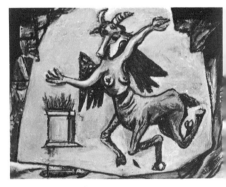

Burlin: *Fallen Angel*. 1943. Oil, 13 x 16¹/₈"

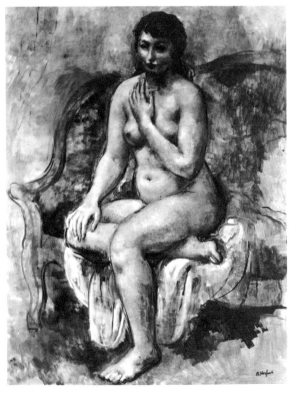

Karfiol: *Seated Nude*. 1929. Oil, 40 x 30"

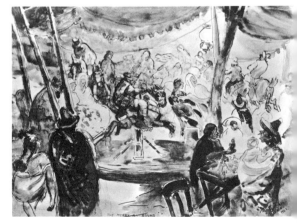

Hart: *The Merry-Go-Round, Oaxaca*. 1927. Watercolor, 17¹ x 23¹/₄"

Levi: *Portrait of Suba*. 1944. Oil, 28¹/₈ x 19⁷/₈″

R. Soyer: *Seamstress*. 1956–60. Oil, 30 x 24¹/₈″

M. Soyer: *Artist and Model*. 1962. Oil, 16¹/₈ x 20¹/₈″

Stettheimer: *Family Portrait, II*. 1933. Oil, 46¹/₄ x 64⁵/₈″

Composition with Still Life. 1933–37. Oil, 8′1″ x 6′5¾″

Dickinson: *Cottage Porch, Peaked Hill*. 1932. Oil, 26¹⁄₈ x 30¹⁄₈″

Avery: *The Dessert*. 1939. Oil, 28¹⁄₈ x 36¹⁄₈″

Avery: *Sea Grasses and Blue Sea*. 1958. Oil, 60¹⁄₈″ x 6′³⁄₈″

Watkins: *Boris Blai*. 1938. Oil, 40 x 35″

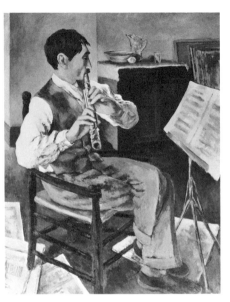

Brook: *George Biddle Playing the Flute*. 1929.
Oil, 40³/₈ x 30¹/₄″

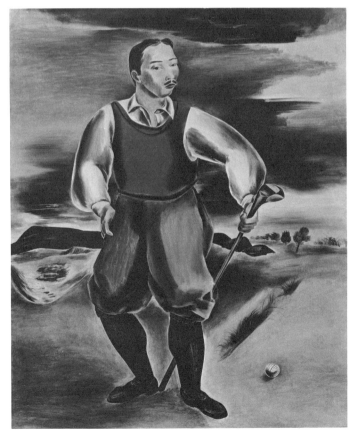

Kuniyoshi: *Self-Portrait as a Golf Player*. 1927. Oil, 50¹/₄ x 40¹/₄″

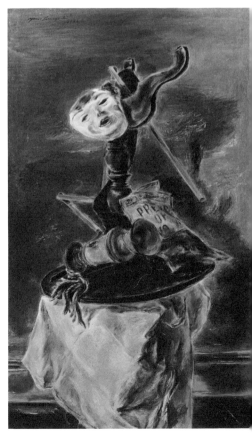

Kuniyoshi: *Upside Down Table and Mask*. 1940.
Oil, 60¹/₈ x 35¹/₂″

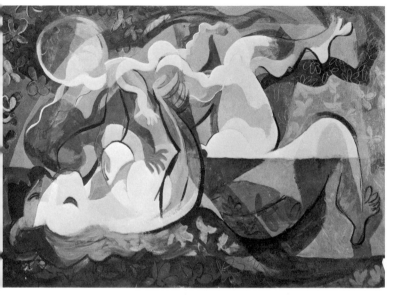

Rattner: *Mother and Child*. 1938. Oil, 28³/₄ x 39³/₈"

Kantor: *South Truro Church*. 1934. Oil, 24¹/₈ x 27"

Schmid: *Father D'Arcy*. 1948–49. Mosaic and modeled fresco, 31¹/₄ x 17¹/₂"

Zerbe: *Harlem*. 1952. Polymer tempera, 44¹/₂ x 24"

right: The Interurban Line. 1920. Watercolor, 14³/₄ x 20³/₄"

left: The Night Wind. 1918. Watercolor and gouache, 21¹/₂ x 21⁷/₈"

right: Railroad Gantry. 1920. Watercolor, 18 x 24⁵/₈"

left: The First Hepaticas. 1917–18. Watercolor, 21¹/₂ x 27¹/₂"

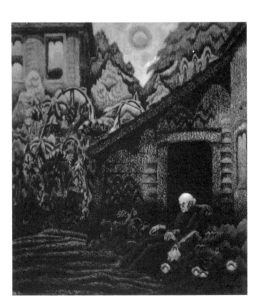

Garden of Memories. 1917. Crayon and watercolor, 25³/₄ x 22¹/₂"

Pippin House, East Liverpool, Ohio. 1920. Watercolor, 26 x 19³/₈"

ght: MacIver: *Shack.* 1934.
il, 20¹/₈ x 24″

r right: MacIver: *Hop-
cotch.* 1940. Oil, 27 x 35⁷/₈″

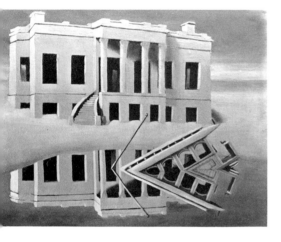

left: Campbell: *Reflected
Glory.* 1939. Oil, 16¹/₈ x 20″

right: MacIver: *Red Votive
Lights.* 1943. Oil, 20 x
25⁵/₈″

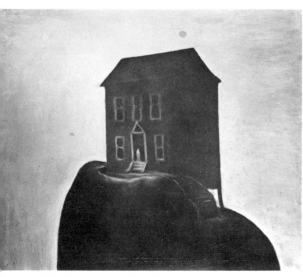

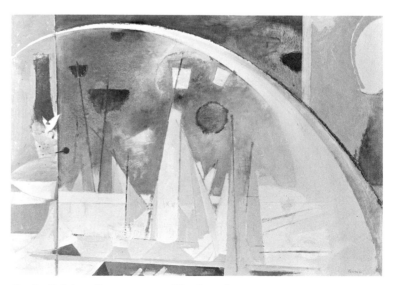

arnes: *High Peak.* 1936. Oil, 36¹/₄ x 42¹/₈″

Gatch: *Rainbow Rampage.* 1950. Oil, 28 x 40″

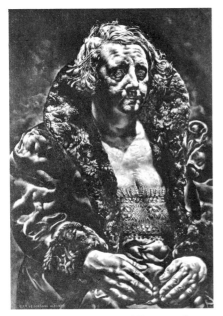

Albright: *Woman*. 1928. Oil, 33 x 22″

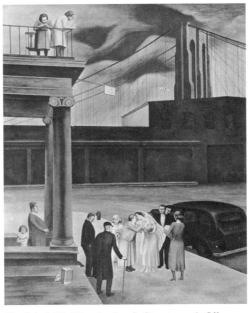

Guglielmi:*Wedding in South Street*. 1936. Oil, 30 x 24″

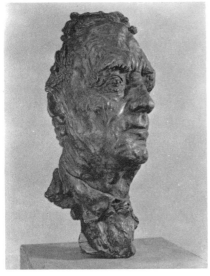

Albright: *The Artist's Father*. 1935.Bronze (cast 1952), 15″ high

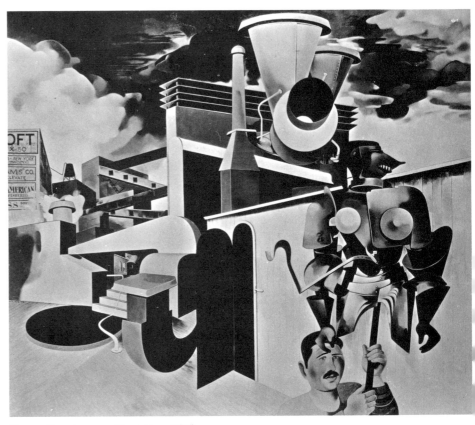

Blume: *Parade*. 1930. Oil, 49¼ x 56⅜″

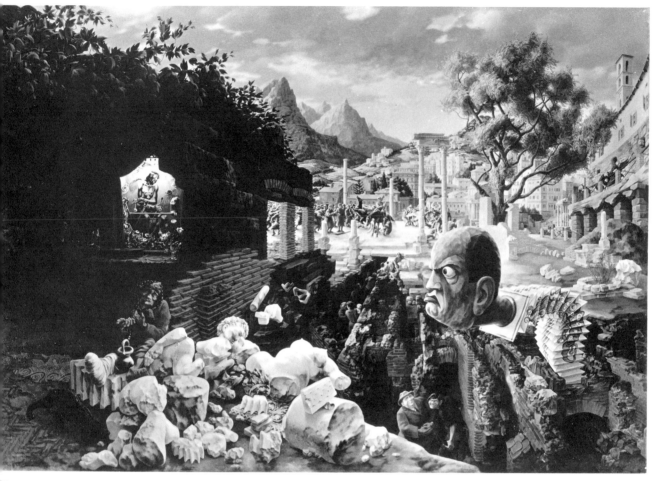

The Eternal City. 1934–37. Oil, 34 x 47⁷/₈″

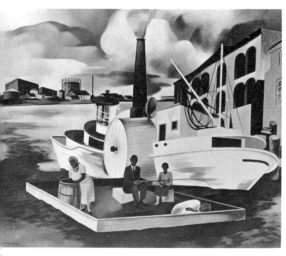

The Boat. 1929. Oil, 20¹/₈ x 24¹/₈″

Landscape with Poppies. 1939. Oil, 18 x 25¹/₈″

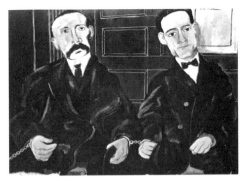

Bartolomeo Vanzetti and Nicola Sacco (Sacco-Vanzetti series). 1931–32. Tempera, 10½ x 14½"

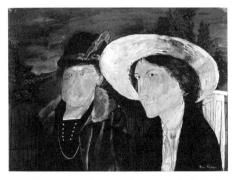

Two Witnesses, Mellie Edeau and Sadie Edeau (Tom Mooney series). 1932. Tempera, 12 x 16"

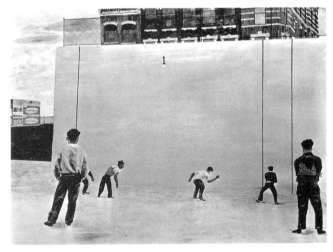

Handball. 1939. Tempera, 22¾ x 31¼"

Willis Avenue Bridge. 1940. Tempera, 23 x 31⅜"

Portrait of Myself When Young. 1943. Tempera, 20 x 27⅞"

Man. 1946. Tempera, 22⅞ x 16⅜"

Welders. 1943. Tempera, 22 x 39³/₄"

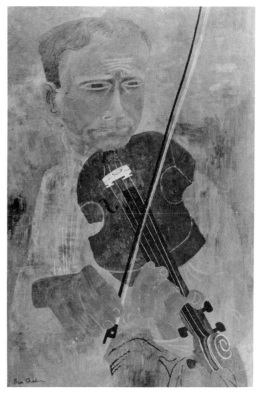

The Violin Player. 1947. Tempera, 40 x 26"

Pacific Landscape. 1945. Tempera, 25¹/₄ x 39"

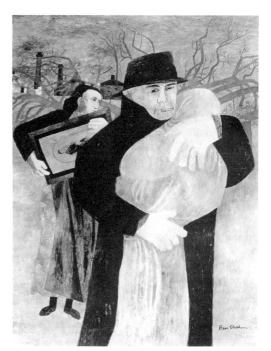

Father and Child. 1946. Tempera, 40 x 30"

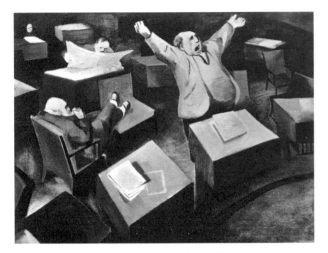

Gropper: *The Senate*. 1935. Oil, 25¹/₈ x 33¹/₈″

Cadmus: *Greenwich Village Cafeteria*. 1934. Oil, 25¹/₂ x 39¹/₂″

Hirsch: *Two Men*. 1937. Oil, 18¹/₈ x 48¹/₄″

Quirt: *Burial*. 1934. Oil, 6³/₈ x 7³/₄″

Evergood: *Don't Cry Mother*. 1938–44.
Oil, 26 x 18″

Levine: *The Feast of Pure Reason*. 1937. Oil, 42 x 48″

The Street. 1938. Oil tempera and oil, 59¹/₂″ x 6′11″

The Passing Scene. 1941. Oil, 48 x 29³/₄″

Election Night. 1954. Oil, 63¹/₈″ x 6′1/₂″

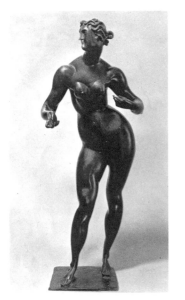

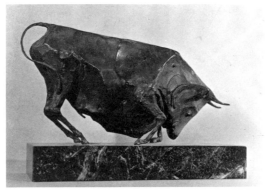

Wounded Bull. 1915. Bronze, 11¹/₂″ long

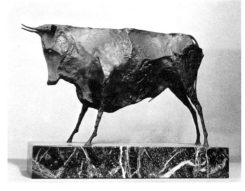

Standing Bull. 1915. Bronze, 11¹/₄″ long

Standing Female Nude. c. 1909.
Bronze, 21³/₄″ high

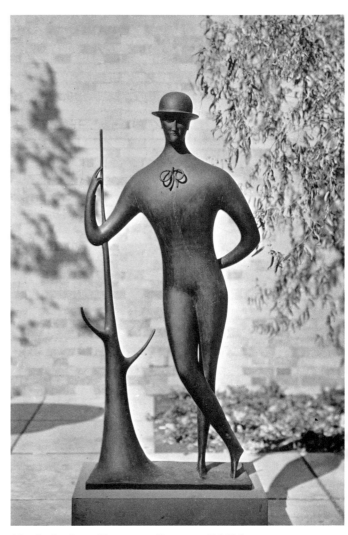

Woman at the Piano. c. 1917. Wood, stained and painted,
35¹/₈″ high

Man in the Open Air. c. 1915. Bronze, 54¹/₂″ high

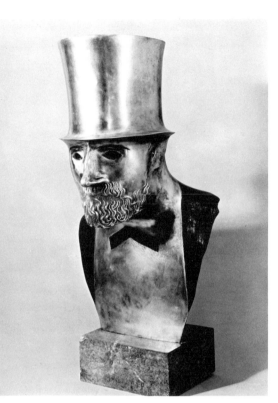

Nadelman: *Man in a Top Hat*. c. 1927. Painted bronze, 26″ high

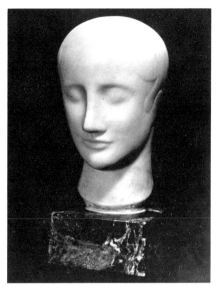

Nadelman: *Head of a Woman*. c. 1942. Rose marble, 15⅝″ high

above right: Nadelman: *Woman with a Poodle*. c. 1934. Terra cotta, 11¾″ high

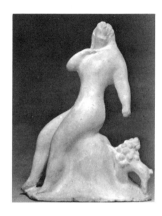

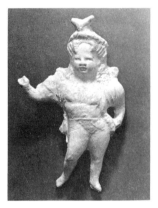

Nadelman: *Figure*. c. 1945. Plaster, 11″ high

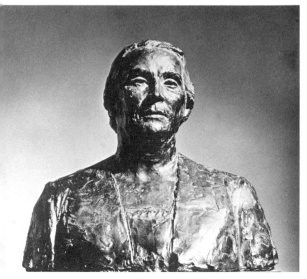

Davidson: *La Pasionaria (Dolores Ibarruri)*. 1938. Bronze, 20½″ high

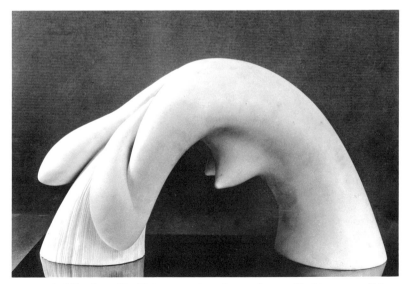

Robus: *Girl Washing Her Hair*. 1940, after plaster of 1933. Marble, 17 x 30½″

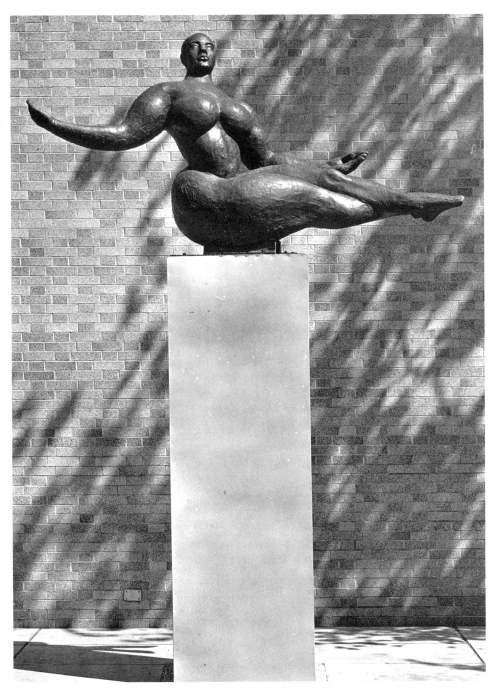

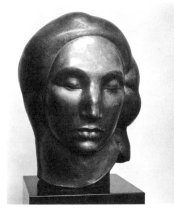

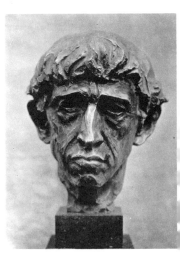

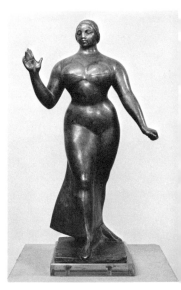

Floating Figure. 1927. Bronze (cast 1935), 51³/₄″ high

above right: Egyptian Head. 1923. Bronze, 13″ high

center: John Marin. 1928. Bronze, 12¹/₂″ high

right: Woman Walking. 1922. Bronze, 18¹/₂″ high

Torso. 1934. Plaster, 45″ high

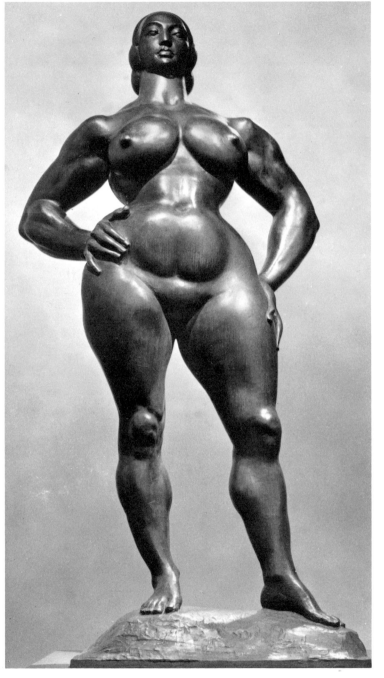

Standing Woman. 1932. Bronze, 7′4″ high

Knees. 1933. Marble, 19″ high

Zorach: *Head of Christ*. 1940. Stone, 14¾″ high

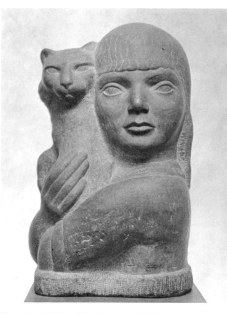

Zorach: *Child with Cat*. 1926. Tennessee marble, 18″ high

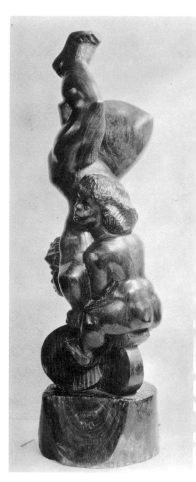

Gross: *Handlebar Riders*. 1935. Lignum vitae, 41¼″ high

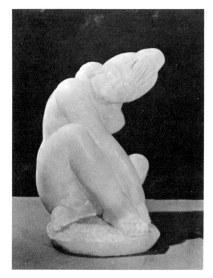

Laurent: *American Beauty*. c. 1933. Alabaster, 12¼″ high

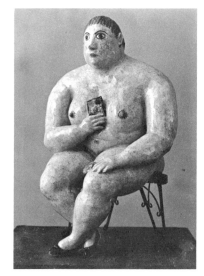

Walters: *Ella*. 1927. Ceramic sculpture, 16¾″ high

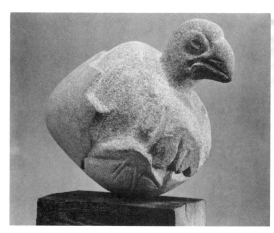

Flannagan: *Triumph of the Egg, I*. 1937. Granite, 12 x 16″

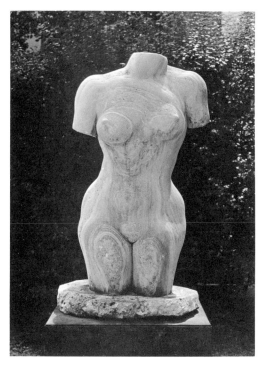

Reder: *Torso*. 1938. French limestone, 45″ high

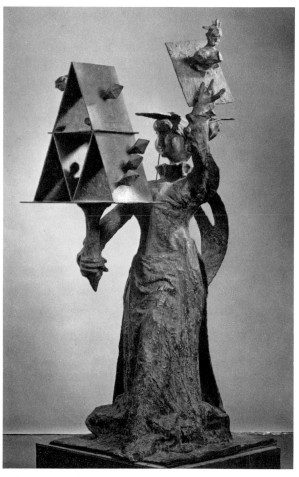

Reder: *Lady with House of Cards*. 1957. Cast bronze, 7′5¹/2″ high

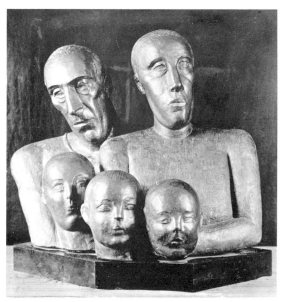

Harkavy: *American Miner's Family*. 1931. Bronze, 27″ high

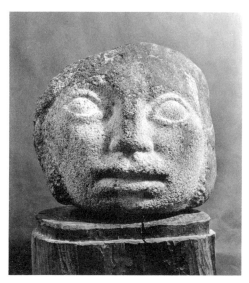

Vagis: *Revelation*. 1951. Stone, 16¹/8″ high

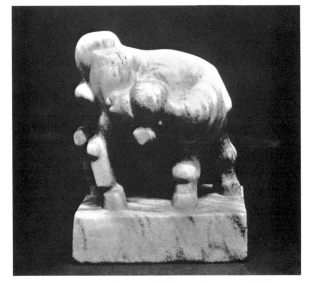

Nakian: *Young Calf*. 1927. Pink marble, 15 x 11½″.

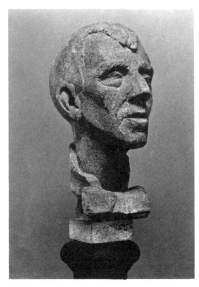

Nakian: *"Pop" Hart*. 1932. Tinted plaster, 17″ high

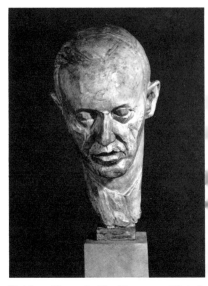

Nakian: *Harry L. Hopkins*. 1934. Tinted plaster, 17½″ high

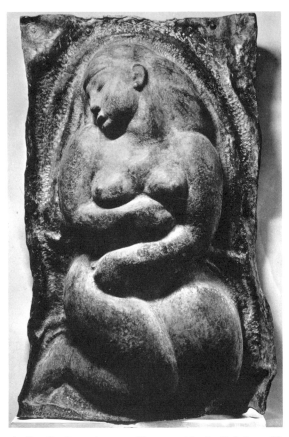

de Creeft: *Saturnia*. 1939. Hammered lead relief, 61 x 38″

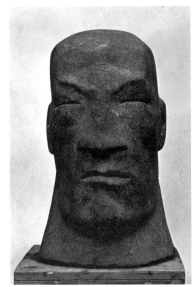

Ben-Shmuel: *Pugilist*. 1929. Black granite, 21″ high

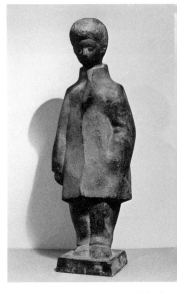

Walsh: *Miner's Son*. 1940. Cast iron 27½″ high

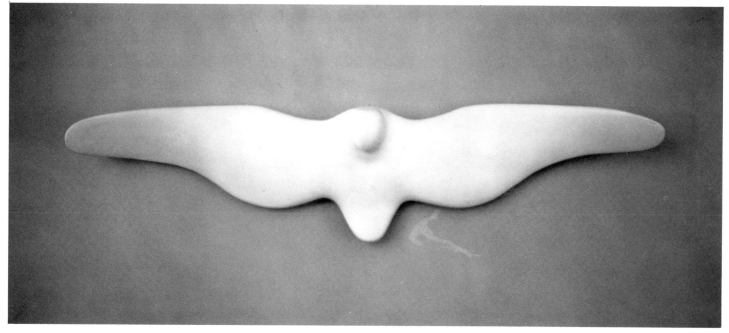

Davis: *Cosmic Presence*. 1934. Wood, painted, 66¹/₄″ long

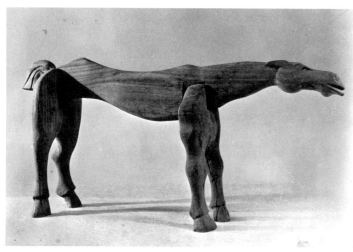

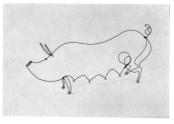

Calder: *Sow*. 1928. Wire construction, 17″ long

Calder: *The Hostess*. 1928. Wire construction, 11¹/₂″ high

Calder: *The Horse*. 1928. Walnut, 34³/₄″ long

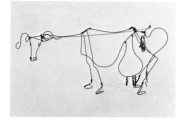

Calder: *Cow*. 1929. Wire construction, 16″ long

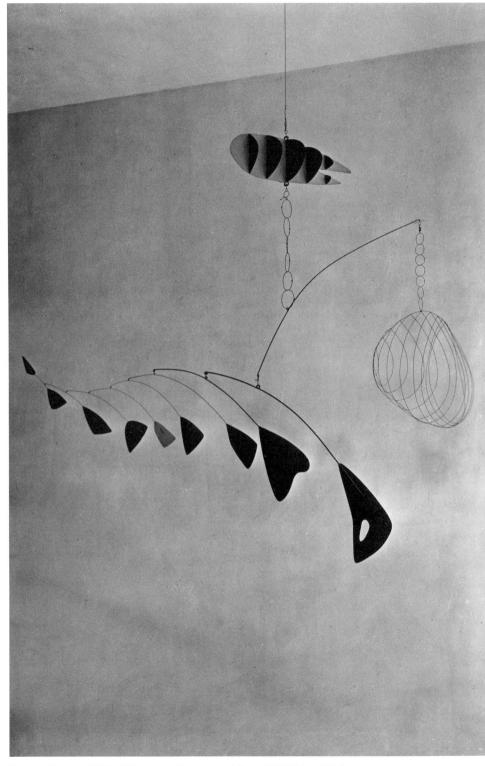

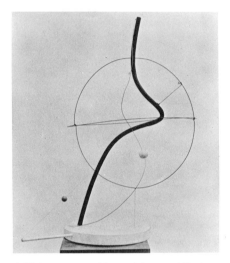

A Universe. 1934. Motor-driven mobile: iron pipe, wire, wood with string, 40¹/₂″ high

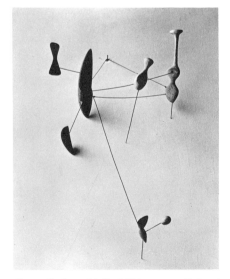

Constellation with Red Object. 1943. Painted wood and wire construction, 25¹/₂″ high

Lobster Trap and Fish Tail. 1939. Hanging mobile, c. 8′6″ high, 9′6″ diameter

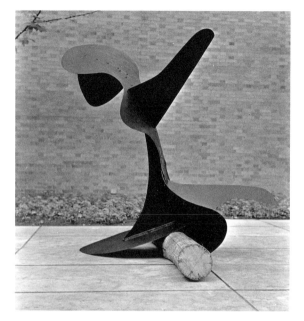

Whale. 1937. Painted sheet steel, 68″ high; replaced by *Whale, II*, page 423

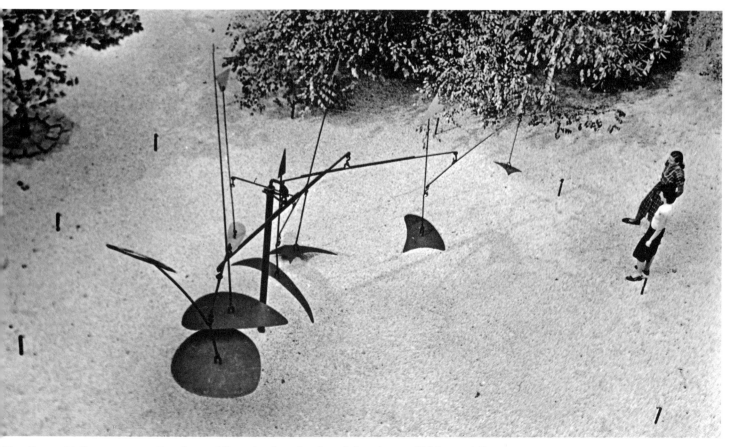

Man-Eater with Pennants. 1945. Standing mobile: painted steel rods and sheet iron, 14′ high, c. 30′ diameter

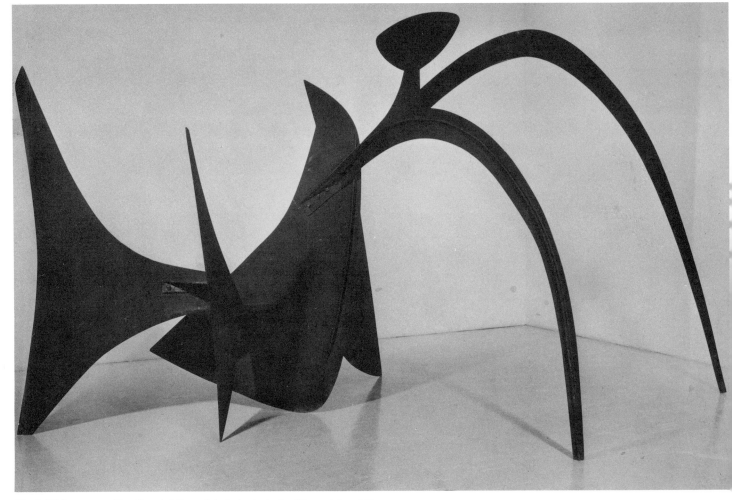

Black Widow. 1959. Standing stabile: painted sheet steel, 7′8″ x 14′3″ x 7′5″

Vertical Sequence, Op. 137. 1941. Lumia composition (projected light on translucent screen). Form cycle 7 minutes; color cycle 7 minutes 17 seconds. The two cycles coincide every 50 hours and 59 minutes. Screen, 15^1/$_4$ x 15^3/$_8$"

Aspiration, Op. 145. 1955. Lumia composition (projected light on translucent screen). Duration of composition, 42 hours, 14 minutes, 11 seconds. Screen, 19^1/$_4$ x 15"

Bouché: *Georges Braque*. 1957. Oil, 45¹/₈ x 34″

Cassinari: *The Mother*. 1948. Oil, 47¹/₂ x 29³/₄″

Neel: *David*. 1963. Oil, 34 x 20¹/₈″

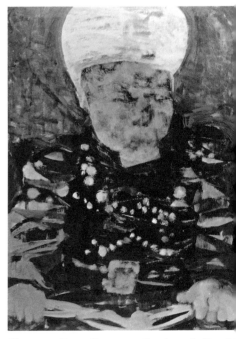

Sherman: *Bear Cat*. 1959. Casein and oil, 39¹/₄ x
27¹/₂″

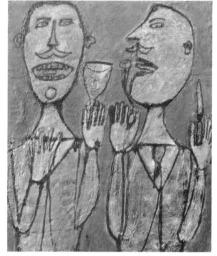

Snack for Two. 1945. Oil, 29¹/₈ x 24¹/₈″

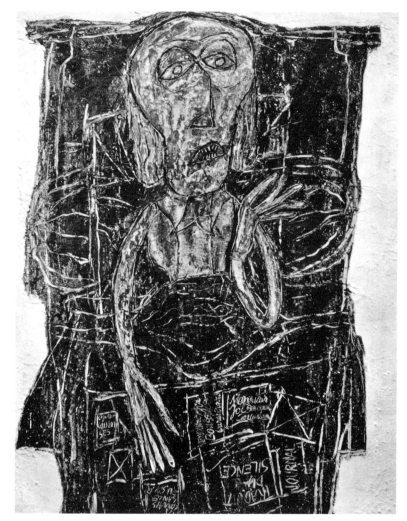

Joë Bousquet in Bed. 1947. Oil, 57⁵/₈ x 44⁷/₈″

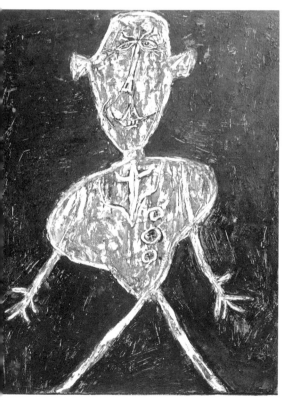

Henri Michaux, Japanese Actor. 1946. Mixed mediums, 51¹/₂ 38³/₈″

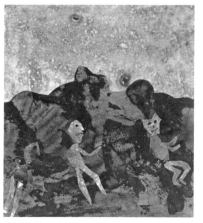

Black Countryside. 1955. Cut-and-pasted paper with ink transfer, 25¹/₂ x 23¹/₈″

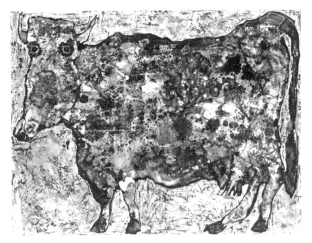

The Cow with the Subtile Nose. 1954. Oil and enamel, 35 x 45³/₄"

Beard of Uncertain Returns. 1959. Oil, 45³/₄ x 35¹/₈"

Work Table with Letter. 1952. Oil in Swedish putty on composition board, 35⁵/₈ x 47⁷/₈"

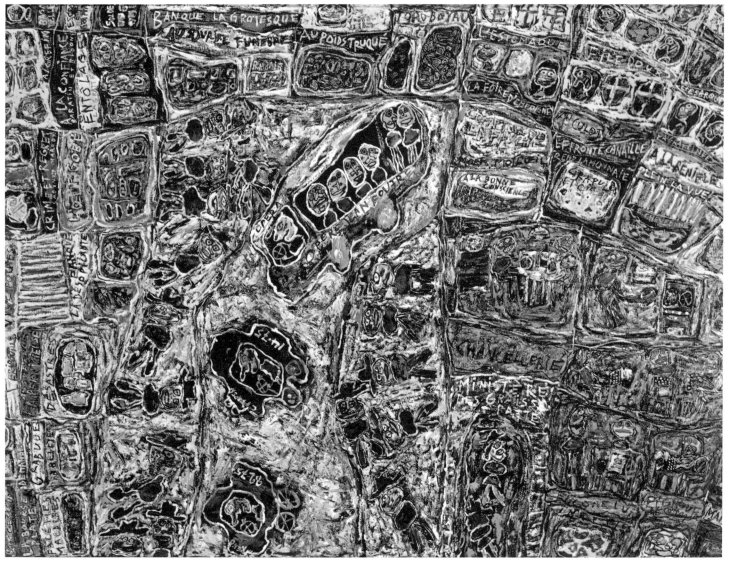

Business Prospers. 1961. Oil, 65″ x 7′2⅝″

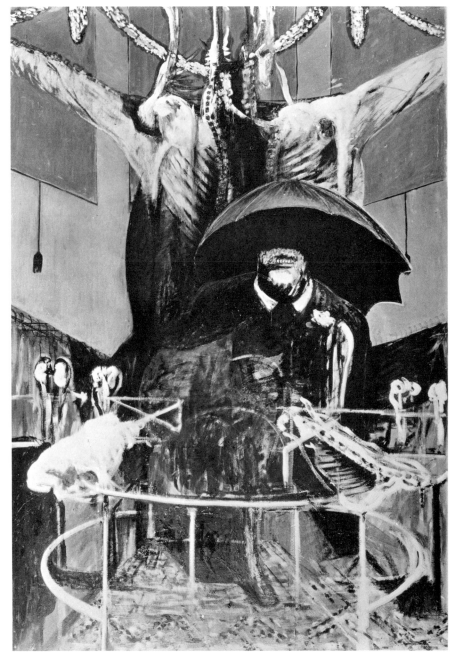

Painting. 1946. Oil and tempera, 6′5⁷/₈″ x 52″

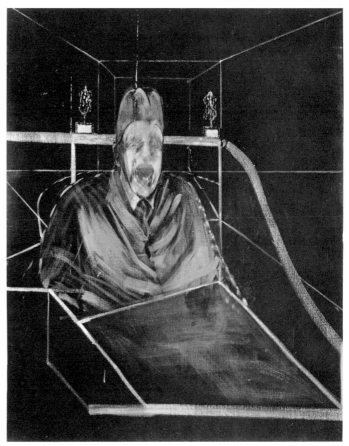

Number VII from Eight Studies for a Portrait. 1953. Oil, 60 x 46¹/₈″

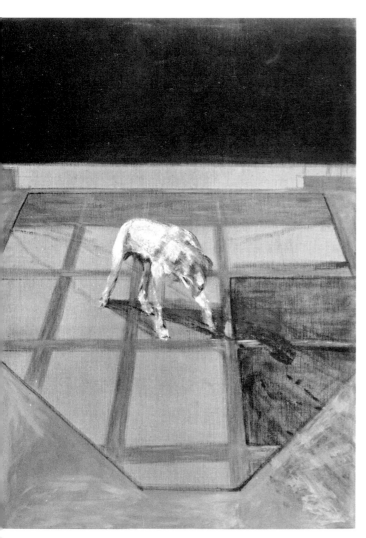

Dog. 1952. Oil, 6′6¹/₄″ x 54¹/₄″

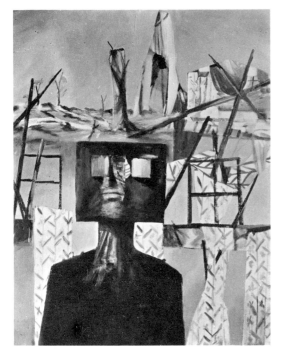

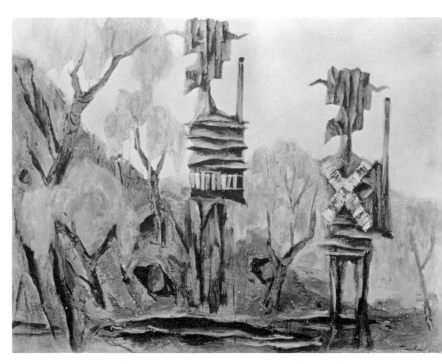

Nolan: *After Glenrowan Siege* (Second Ned Kelly series). 1955. Enamel, 48 x 36"

Tucker: *Explorers, Burke and Wills*. 1960. Oil and sand, 48⅛ x 61½"

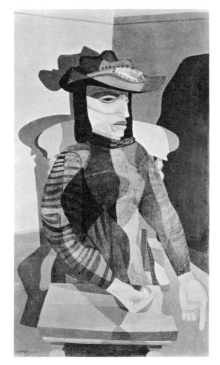

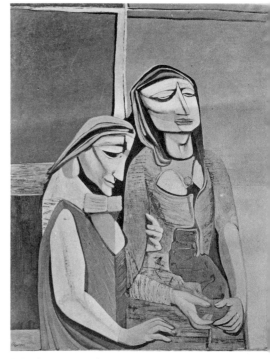

MacBryde: *Woman in a Red Hat*. 1947. Oil, 50 x 28½"

Colquhoun: *Two Scotswomen*. 1946. Oil, 48⅜ x 36"

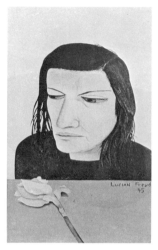

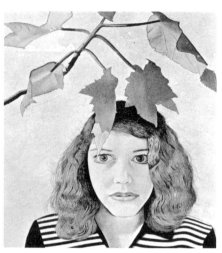

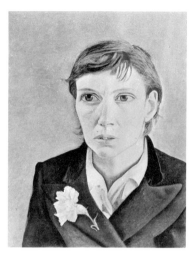

Freud: *Woman with a Daffodil*. 1945. Oil, 9³/₈ x 5⁵/₈″

Freud: *Girl with Leaves*. 1948. Pastel, 18⁷/₈ x 16¹/₂″

Freud: *Portrait of a Woman*. 1949. Oil, 16¹/₈ x 12″

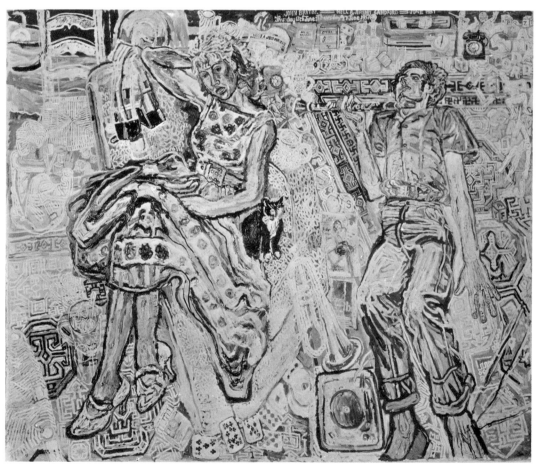

Bratby: *Nell and Jeremy Sandford*. 1957. Oil, 6′5⁷/₈″ x 7′8¹/₈″

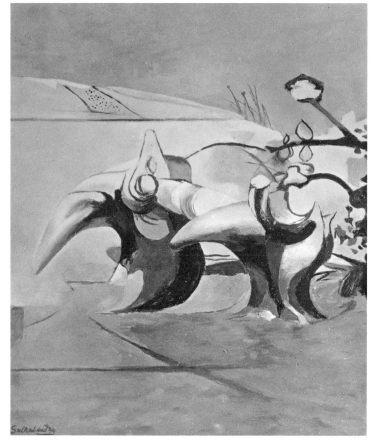

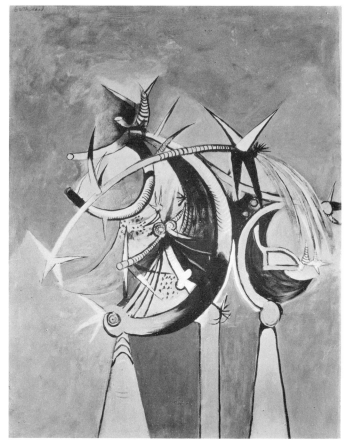

Sutherland: *Horned Forms*. 1944. Oil, 39¼ x 31⅞"

Sutherland: *Thorn Heads*. 1946. Oil, 48 x 36"

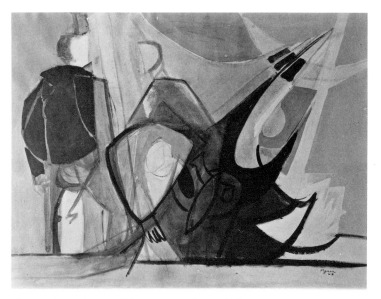

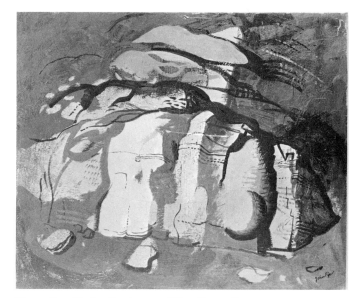

Pignon: *Ostend*. 1948. Watercolor, 20½ x 27½"

Piper: *Cwn Tryfan Rock*. 1950. Oil, 25⅛ x 30"

Landuyt: *Essential Surface, Eye.* 1960. Oil, 51³/₈ x 63¹/₈"

Tucker: *Lunar Landscape.* 1957. Synthetic polymer paint, 37³/₄ x 51¹/₄"

Landuyt: *Purification by Fire.* 1957. Oil, 47⁷/₈ x 35⁷/₈"

Lebrun: *Figure in Rain*. 1949. Duco, 48 x 30¹/₈″

Sievan: *Oompalik*. 1962. Oil, 69¹/₈ x 59¹/₄″

Greene: *Execution (first version)*. 1948. Oil, 39⁷/₈ x 29⁷/₈″

Schwartz: *The Ring*. 1962. Pastel,
22 x 18¹/₄″

The Synagogue. c. 1940. Oil, 65¼ x 46¾"

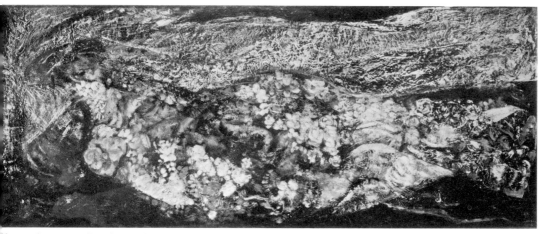

The Bride. 1941. Oil, 20⅛ x 49⅞"

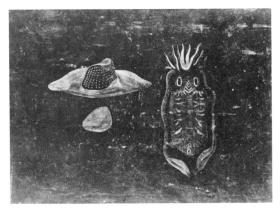

Message IV. 1937. Tempera and wax, 12 x 15¹/₂″

Bird Singing in the Moonlight. 1938–39. Gouache, 26³/₄ x 30¹/₈″

Snake and Moon. 1938–39. Gouache and watercolor, 25¹/₃ x 30¹/₄″

Unnamed Bird of the Inner Eye. 1941. Gouache, 22 x 39″

Owl of the Inner Eye. 1941. Gouache, 20³/₄ x 36⁵/₈″

Little-Known Bird of the Inner Eye. 1941. Gouache, 20³/₄ x 36⁵/₈″

Blind Bird. 1940. Gouache, 30¹/₈ x 27″

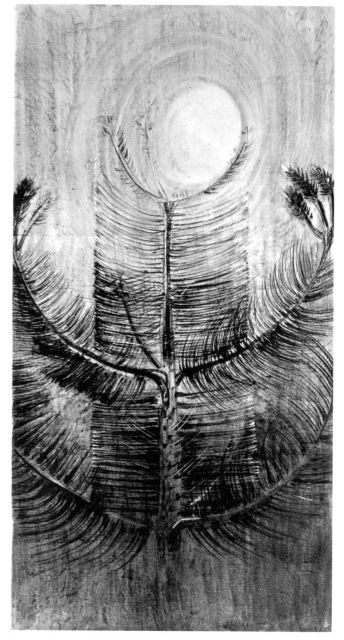

Joyous Young Pine. 1944. Watercolor and gouache, 53⁵/₈ x 27″

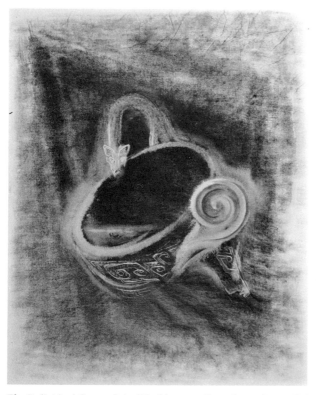

The Individual State of the World. 1947. Gouache, 30¹/₄ x 24⁷/₈″

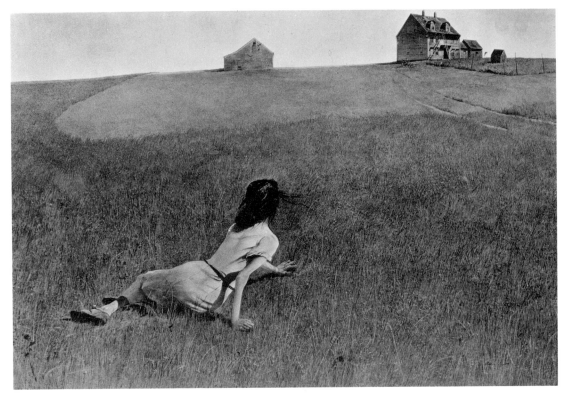

Wyeth: *Christina's World*. 1948. Tempera, 32¹/₄ x 47³/₄″

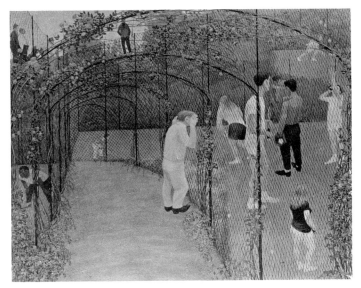

Koerner: *Rose Arbor*. 1947. Oil, 27³/₄ x 35″

Cloar: *Autumn Conversion*. 1953. Tempera, 20¹/₈ x 26¹/₈″

Perlin: *The Lovers*. 1946. Gouache, 30 x 37³/₄"

Tooker: *Sleepers, II*. 1959. Egg tempera, 16¹/₈ x 28"

Sharrer: *Workers and Paintings*. 1943. Oil, 11⁵/₈ x 37"

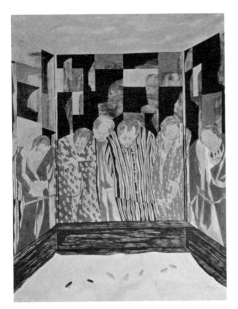

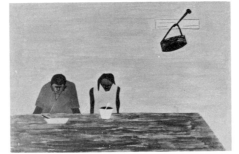

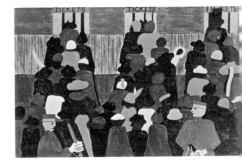

Lawrence: *The Migration of the Negro* (numbers 10 and 12 from a series of sixty). 1940–41. Tempera and gesso, 12 x 18". Left: *They were very poor.* Right: *The railroad stations were at times so overpacked with people leaving that special guards had to be called in to keep order.*

Lawrence: *Sedation.* 1950. Casein, 31 x 22⁷/₈"

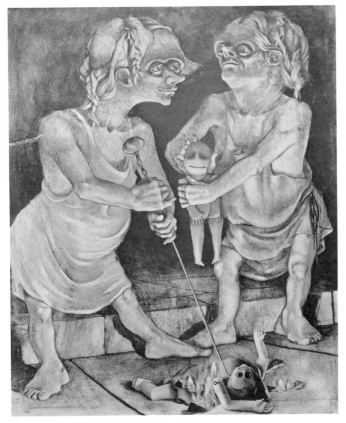

Pickens: *The Blue Doll.* 1942. Oil, 42⁷/₈ x 35"

Pickens: *Carnival.* 1949. Oil, 54⁵/₈ x 40³/₈"

Melon Eaters. 1948. Oil, 35 x 45⁵/₈"

Lava Quarry. 1957. Oil, 57⁵/₈ x 45"

Orange Grove at Night. 1957. Oil, 55³/₈" x 7'6⁵/₈"

Oliveira: *Standing Man with Stick*. 1959. Oil, 68⁷/₈ x 60¹/₄"

Bischoff: *Girl Wading*. 1959. Oil, 6'10⁵/₈" x 67³/₄"

Coughtry: *Reclining Figure*. 1961. Oil, 52³/₄ x 51"

Park: *Group of Figures*. 1960. Watercolor, 11¹/₂ x 14¹/₂"

The Pool. 1956. Oil, charcoal, and bronze paint, 8′7³/₈″ x 7′8⁵/₈″

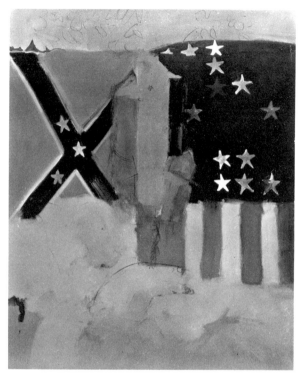

The Last Civil War Veteran. 1959. Oil and charcoal, 6′10¹/₂″ x 64¹/₈″

Washington Crossing the Delaware. 1953. Oil, 6′11⁵/₈″ x 9′3⁵/₈″

Golub: *Torso, III*. 1960. Oil and lacquer, 63¹/₈ x 39¹/₄″

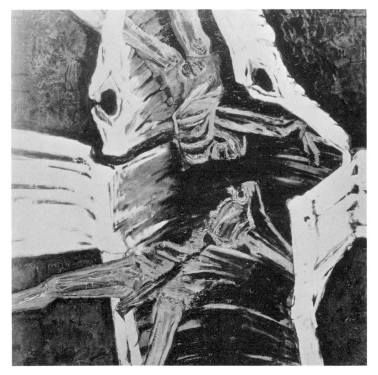

Baden: *The Gate*. 1960. Oil, 6′6″ x 6′3″

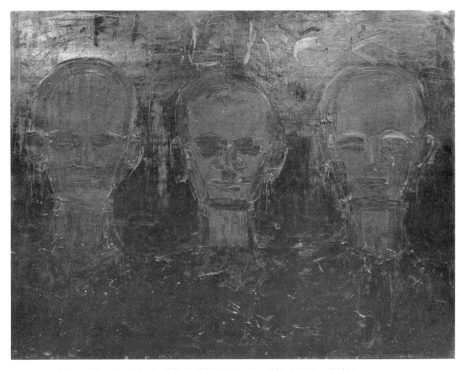

Johnson: *Three Heads with the Word "Black."* 1962. Oil, 60¹/₄″ x 6′6¹/₈″

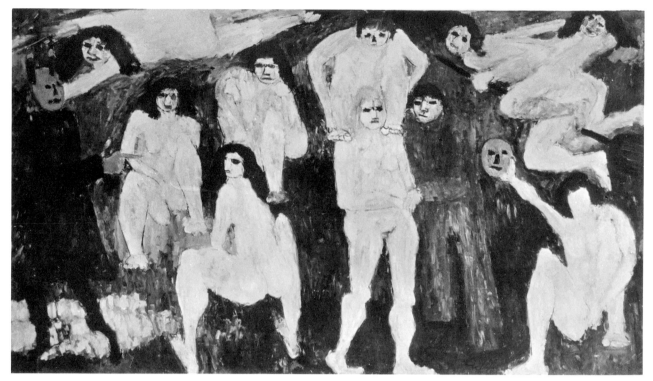

Müller: *Faust, I*. 1956. Oil, 68¹/₈″ x 10′

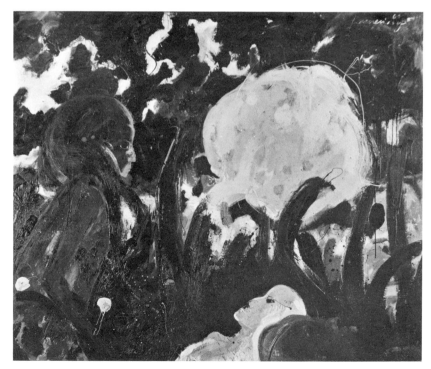

Beauchamp: Untitled. 1962. Oil, 67″ x 6′10″

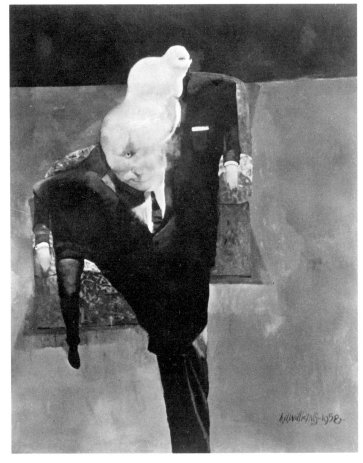

Williams: *Challenging Man*. 1958. Oil and enamel, 8'1/4" x 6'1/8"

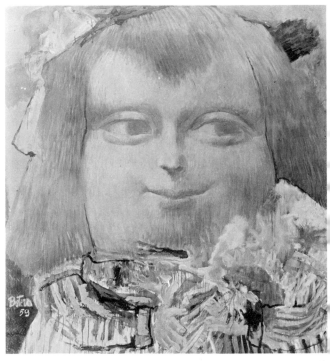

Botero: *Mona Lisa, Age Twelve*. 1959. Oil, tempera, 6'11 1/8" x 6'5"

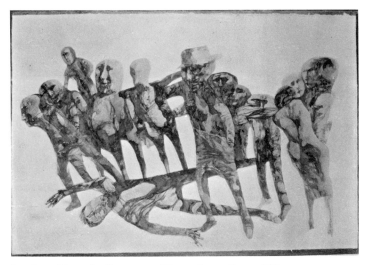

Landau: *Cinna the Poet*. 1959. Watercolor, 27 1/4 x 40 3/8"

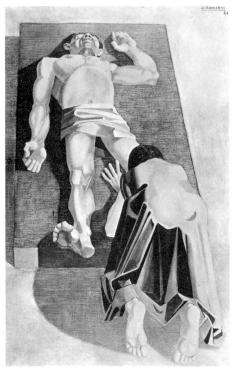

Damiani: *Agony*. 1956. Oil, 6'4 1/2" x 47 1/4"

284

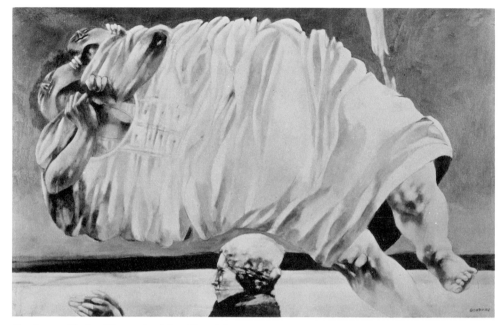

Goodman: *Find a Way*. 1961. Oil, 37³/₄ x 61″

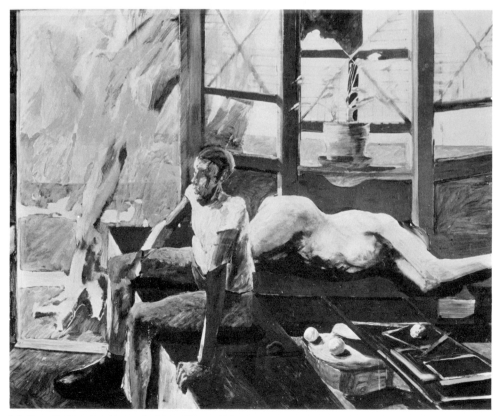

McGarrell: *Rest in Air*. 1958. Oil, 47⁷/₈ x 59⁵/₈″

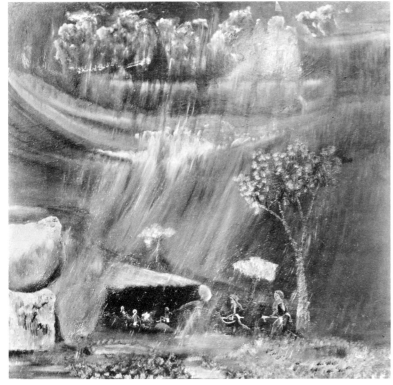

Ndandarika: *Bushmen Running from the Rain*. 1962. Oil, 48¼ x 48"

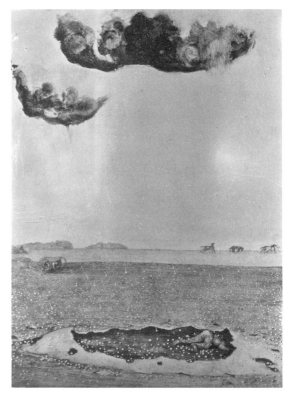

Kurelek: *Hailstorm in Alberta*. 1961. Oil, 27¼ x 19"

Ntiro: *Men Taking Banana Beer to Bride by Night*. 1956. Oil, 16⅛ x 20"

Scott: *Woman Carrying Grasses*. 1958. Oil, 20 x 15"

Carreño: *Tornado*. 1941. Oil, 31 x 41"

Bermúdez: *Barber Shop*. 1942. Oil, 25¹/₈ x 21¹/₈"

Redwood: *Night Scene*. 1941. Oil, 43³/₈ x 33³/₈"

Muccini: *Bull*. 1948. Duco, 13 x 28¹/₄"

Meza: *Demonstration*. 1942. Oil, 19³/₄ x 39³/₈"

Fernández: *Still Life and Landscape*. 1956. Oil, 48 x 55¹/₈″

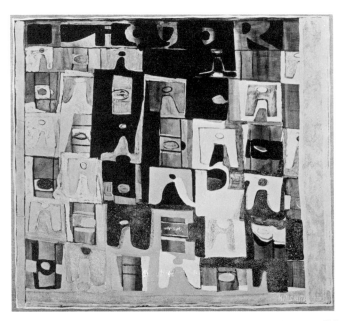

Hillsmith: *Liquor Store Window*. 1946. Oil tempera, sand, 32 x 34¹/₈″

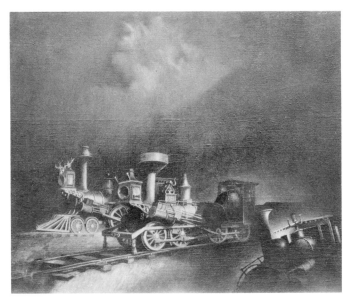

Feininger: *Ghosts of Engines*. 1946. Oil, 20¹/₈ x 24″

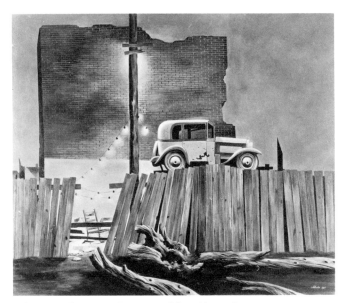

Atherton: *Christmas Eve*. 1941. Oil, 30¹/₄ x 35″

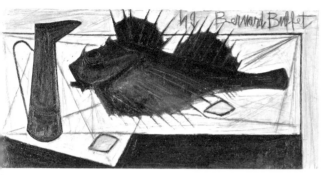

Buffet: *Still Life with Fish, II*. 1949. Oil, 16³/₈ x 33¹/₂″

Chokai: *Gourds*. 1950. Oil, 25⁵/₈ x 21″

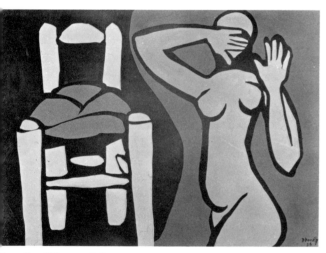

Dorcély: *When to Relax?* 1958. Tempera, 36 x 49¹/₄″

Zverev: *Apples*. 1955. Gouache, 10¹/₂ x 15¹/₄″

Brodie: *Broken Blossom*. 1960. Oil, 25⁵/₈ x 36³/₈″

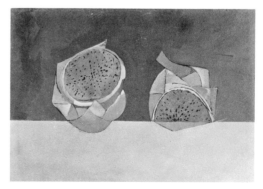

Ossaye: *Pitahaya*. 1953. Oil, 12⁷/₈ x 18³/₄″

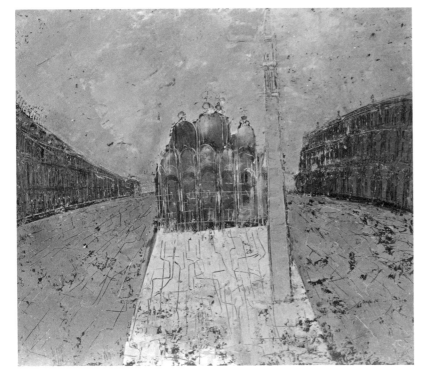

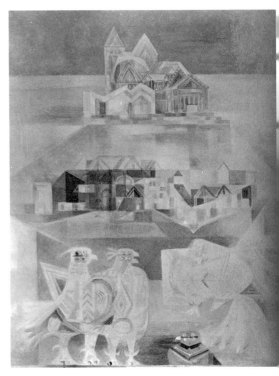

Congdon: *Piazza, Venice, 12.* 1952. Oil, 49 x 56″

Obregón: *Souvenir of Venice.* 1953. Oil, 51¹/₄ x 38¹/₈″

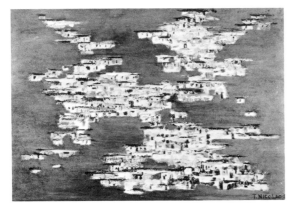

Nicolao: *Shanty Town, I.* 1957. Oil, 26⁷/₈ x 38⁷/₈″

Ardon: *The Tents of Judea.* 1950. Oil and tempera, 31⁷/₈ x 39³/₈″

Rose: *Tower and Tank*. 1947. Oil, 15 x 13″

Fausett: *Derby View*. 1939. Oil tempera, 24⅛ x 40″

Brô: *Spring Blossoms*. 1962. Oil and egg tempera, 25½ x 31⅞″

Sitnikov: *Hillock*. 1962. Oil and colored crayons, 23⅝ x 32¾″

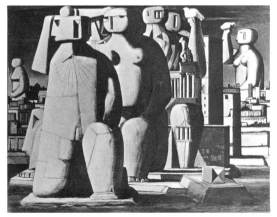

Comtois: *From East to West*. 1961. Oil, 24 x 30″

Fiume: *Island of Statues*. 1948. Oil, 28 x 36¼″

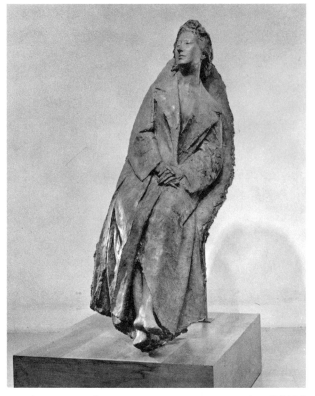

Manzù: *Portrait of a Lady*. 1946. Bronze (cast 1955), 59¼″ high

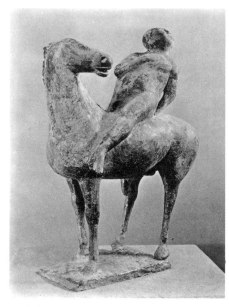

Marini: *Horse and Rider*. 1947–48. Bronze 38¼″ high

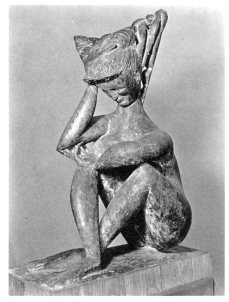

Fazzini: *The Sibyl*. 1947. Bronze, 37¼″ high

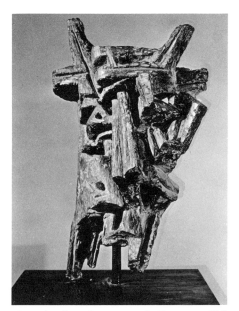

Mastroianni: *Solomon*. 1958. Bronze, 26¾″ high

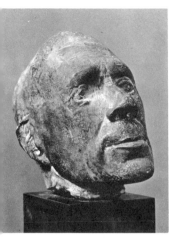

amberto Vitali. 1945. Bronze (cast 949), 9″ high

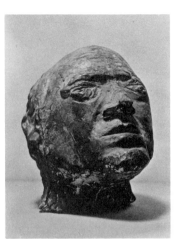

Curt Valentin. 1954. Bronze, 9¹/₈″ high

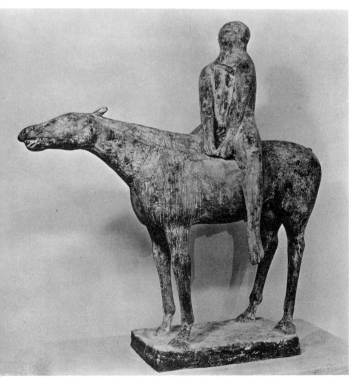

Horse and Rider. 1947. Bronze, 64 x 62″

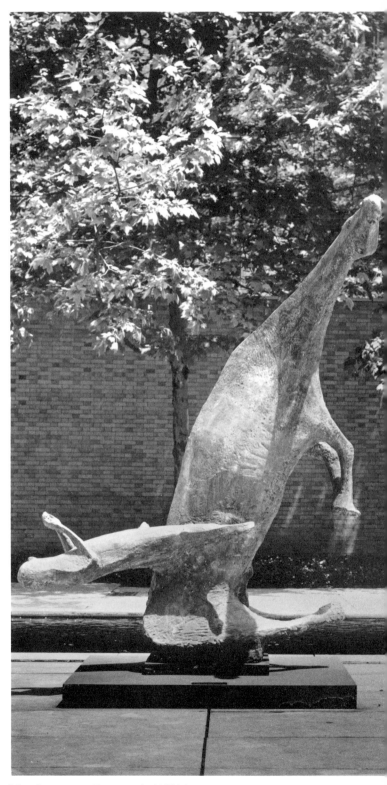

Miracle. 1953–54. Bronze, 7′11¹/₂″ high

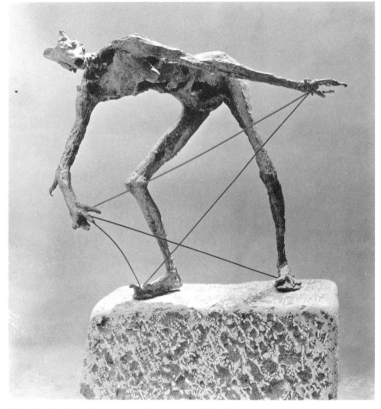

The Devil with Claws. 1952. Bronze, 34¹/₂″ high

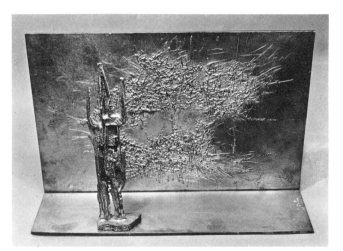

Sculpture with Background. 1955–56. Gilded bronze; figure, 8³/₄″ high;
background, 9¹/₄ x 14³/₄ x 4⁵/₈″

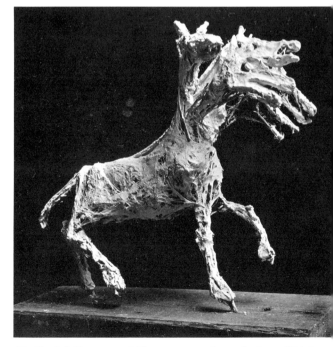

Six-Headed Horse. 1953? Plaster over string and wire, 14″ high

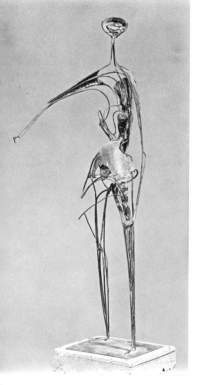

Woman Standing. 1952. Welded bronze and brass sheet and wire, 18½″ high

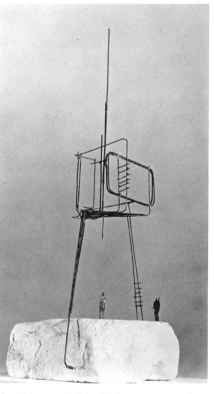

The Unknown Political Prisoner (project for a monument). 1951–53. Welded bronze, brass wire and sheet, 17³/₈″ high

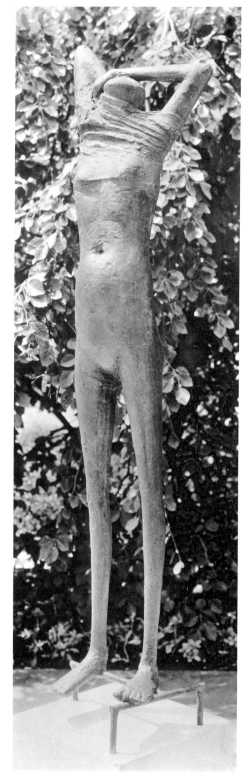

Girl. 1953–54. Cast shell bronze (cast 1955), 68³/₈″ high

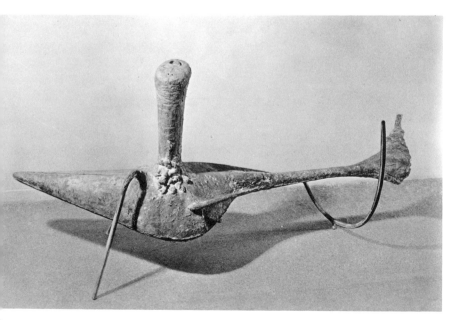

Oracle. 1952. Cast shell bronze welded to forged bronze armature, 6′1″ long

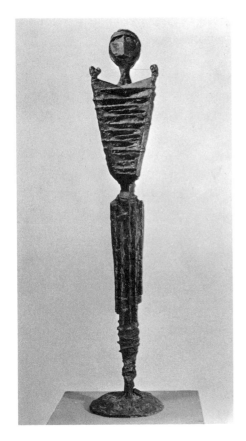

left: McWilliam: *Laza-rus, II.* 1955. Bronze, 38⅝" high

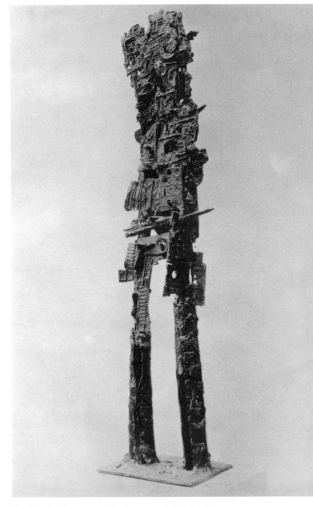

Paolozzi: *Jason.* 1956. Bronze, 66⅛" high

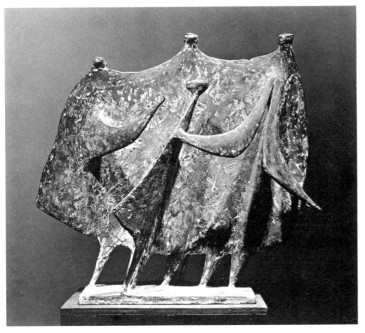

Armitage: *Family Going for a Walk.* 1951. Bronze, 29" high

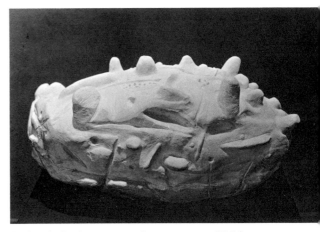

Paolozzi: *Sculpture.* 1951. Cast concrete, 18¼" long

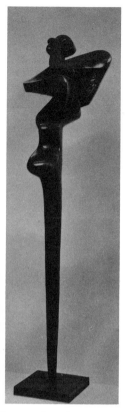

Etrog: *Ritual Dancer.*
1960–62. Bronze, 56¼"
high

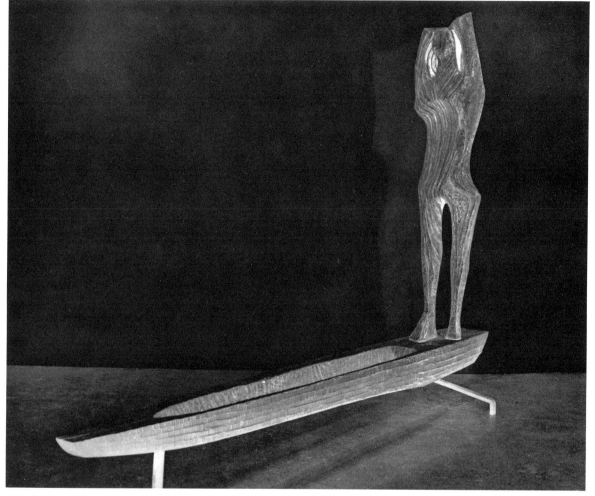

Toyofuku: *Adrift, 3.* 1960. Wood on iron supports; figure 6'3¼" high; boat 10' long

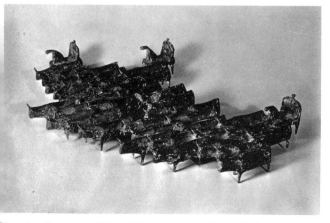

Koenig: *Camargue, X.* 1958. Bronze, 3 x 17¼ x 15⅜"

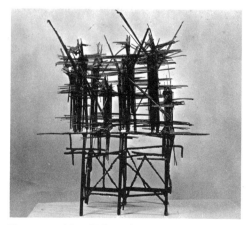

Thornton: *Men Fishing from a Pier.* 1955. Iron
wire, 23 x 21 x 14½"

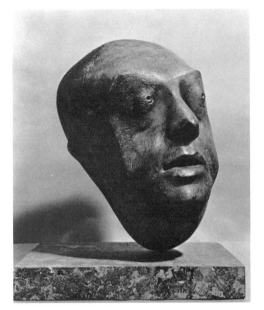

Heiliger: *Ernst Reuter*. 1954. Bronze (cast 1958), 15⁷/₈″ high

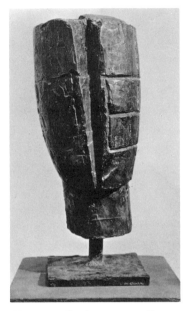

Wotruba: *Head*. 1954–55. Bronze, 16³/₄″ high

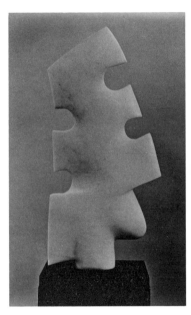

Hajdu: *White Head*. 1958. Marble, 30¹/₂″ high

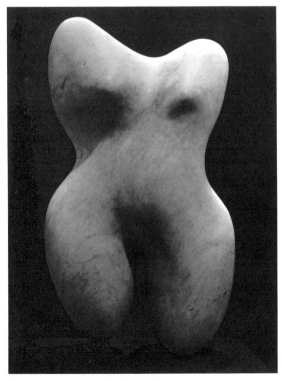

Viani: *Torso*. 1945. Marble, 38″ high

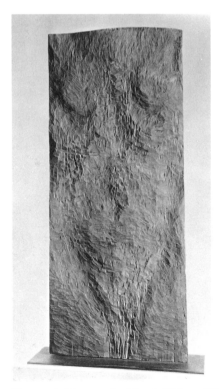

Tavernari: *Torso*. 1961. Wood, 6′6″ x 33¹/₈″

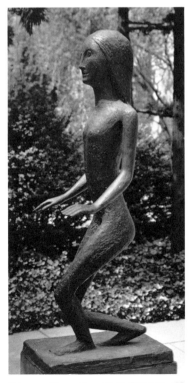

Prinner: *Evocation*. 1952. Bronze, 48″ high

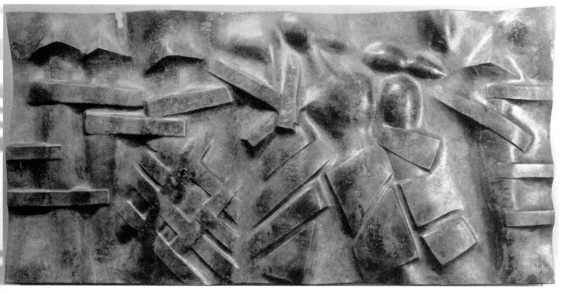

Hajdu: *Soldiers in Armor*. 1953. Sheet copper relief, repoussé, 38¹/₂″ x 6′5¹/₄″

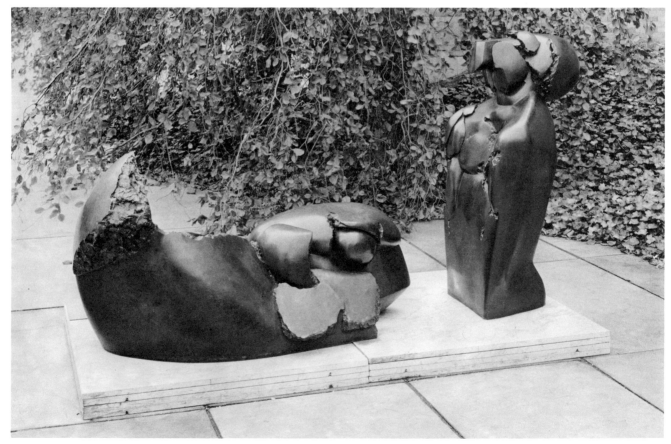

Ipousteguy: *David and Goliath*. 1959. Bronze, two figures in four parts: *Goliath* (three sections), 30³/₈ x 53³/₄ x 29¹/₂″; *David*, 47⁷/₈″ high

Portrait of My Uncle. 1931. Terra cotta, 12¹/₂″ high

right: Even the Centipede. 1952. Kasama ware in eleven pieces, each approximately 18″ wide, mounted on wood pole, 14′ high

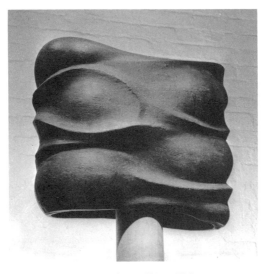

Woman. 1957. Iron, 14³/₈ x 18¹/₄ x 8⁵/₈″

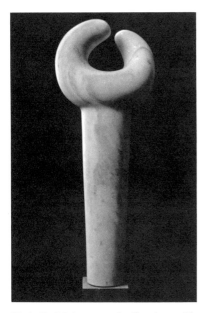

Bird C (Mu). 1952–58. Greek marble, 22³/₄″ high

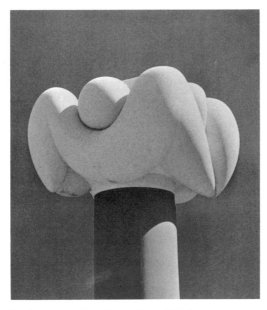

Capital. 1939. Georgia marble, 16″ high

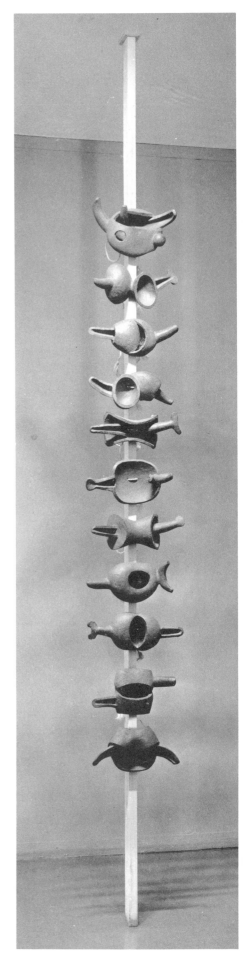

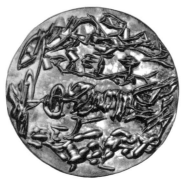

Death by Gas. 1939–40. Bronze medallion, 11³/₈″ diameter (irregular)

Chicago Circle. 1955–56. Bronze medallion, 11″ diameter

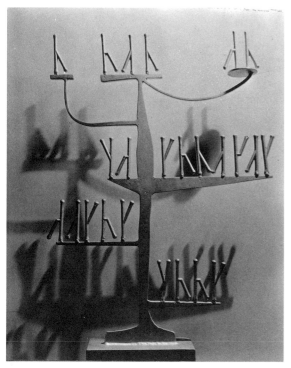

Twenty-four Greek Ys. 1950. Forged steel, painted, 42³/₄″ high

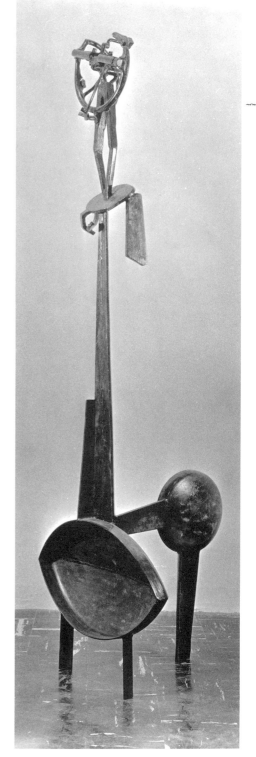

History of LeRoy Borton. 1956. Steel, 7′4¹/₄″ x 26³/₄″ x 24¹/₂″

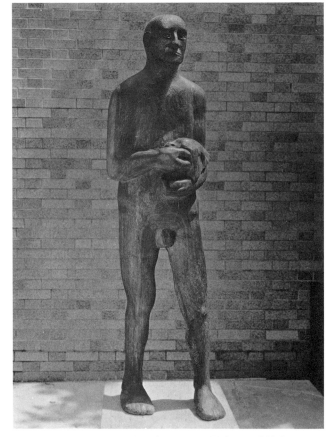

Baskin: *Man with a Dead Bird*. 1951–56. Walnut, 64″ high

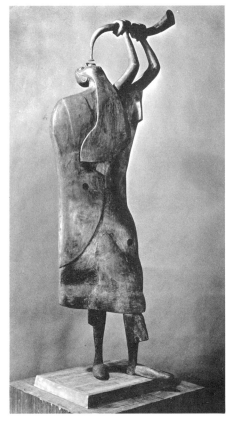

Weinberg: *Ritual Figure*. 1953. Beechwood, 60¼″ high

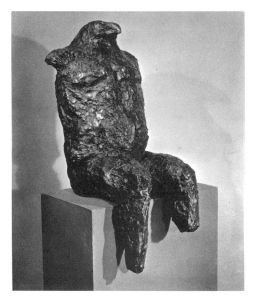

Baskin: *Seated Birdman*. 1961. Bronze, 35¾″ high

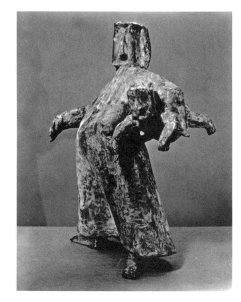

Durchanek: *Fury*. 1958. Welded sheet bronze, 30¾″ high

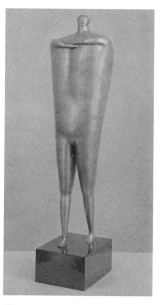

Glasco: *Man Walking*. 1955.
Bronze, 17¹/₂" high

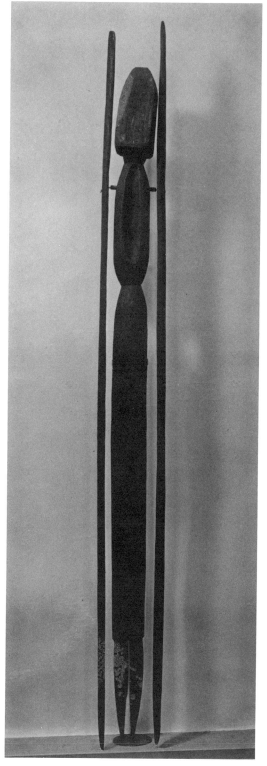

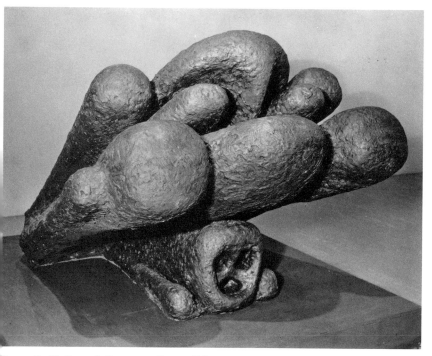

Campoli: *Birth*. 1958. Bronze, 37¹/₄ x 49³/₄"

Bourgeois: *Sleeping Figure*. 1950. Balsa wood, 6'2¹/₂"

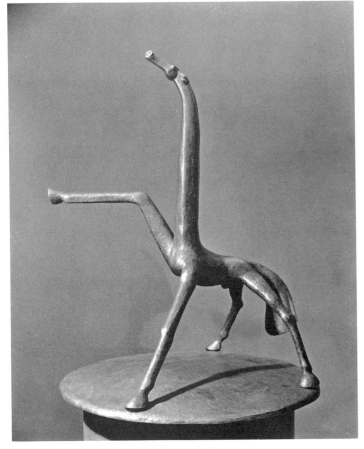

Callery: *Horse*. 1942. Bronze, 49⅛″ high

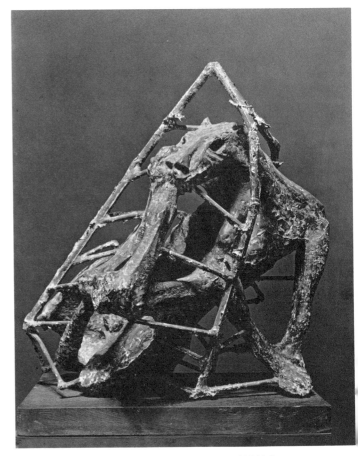

Minguzzi: *Dog among Reeds*. 1951. Bronze, 27⅛″ high

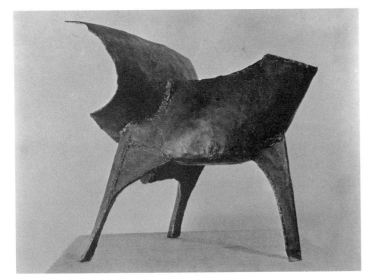

Hayes: *Beast*. 1957. Forged steel, 20⅜ x 21⅛″

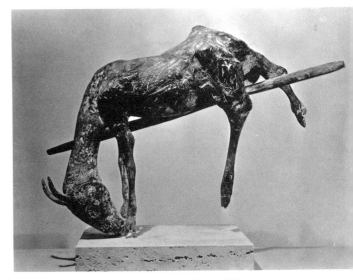

Zajac: *Easter Goat*. 1957. Bronze, 19⅛ x 31¾″

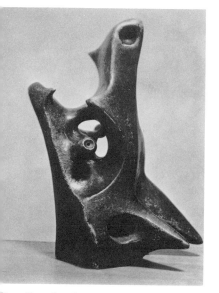

González Goyri: *Wolf's Head*. 1950.
Bronze, 11″ high

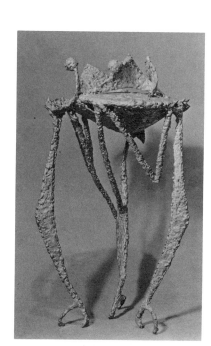

Hare: *Crab*. 1951. Welded bronze, 23¼″ high

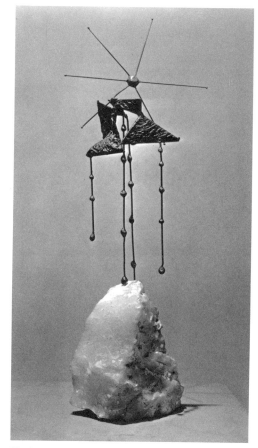

Hare: *Sunset, I*. 1953. Stone and painted wire, 19¼″ high

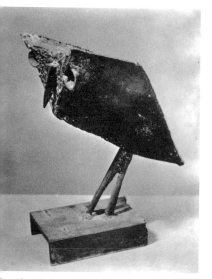

Shemi: *Bird*. 1955. Welded iron, 22½″ high

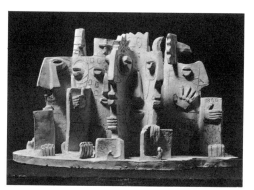

Grippe: *The City*. 1942. Terra cotta, 9½ x 11⅛ x 16″

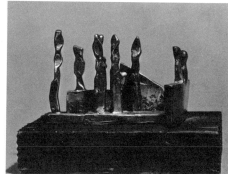

Dehner: *Decision at Knossos*. 1957. Bronze, 3⅛ x 4⅞ x 3″

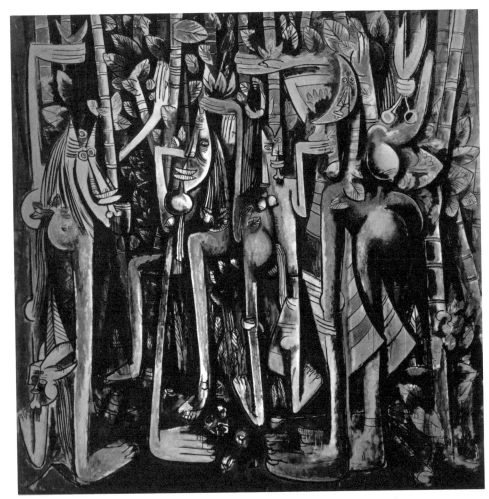

Lam: *The Jungle*. 1943. Gouache on paper mounted on canvas, 7'10¼" x 7'6½"

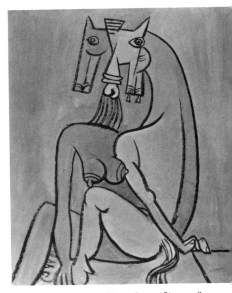

Lam: *Satan*. 1942. Gouache, 41⁷/₈ x 34"

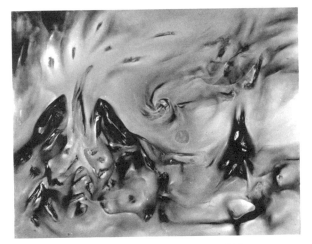

Matta: *Listen to Living*. 1941. Oil, 29½ x 37³/₈"

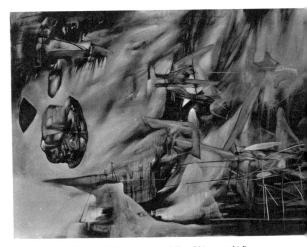

Matta: *The Hanged Man*. 1942. Oil, 38¼ x 51¼"

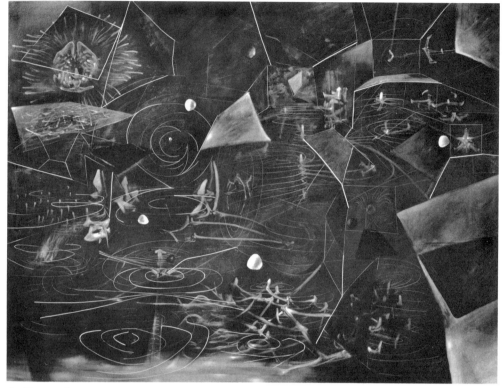

Le Vertige d'Eros. 1944. Oil, 6'5" x 8'3"

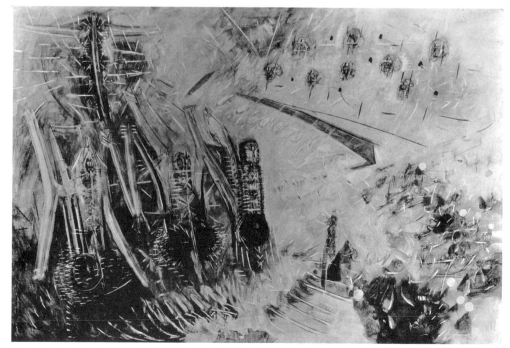

The Spherical Roof around Our Tribe (Revolvers). 1952. Tempera, 6'6⁵/₈" x 9'7⁷/₈"

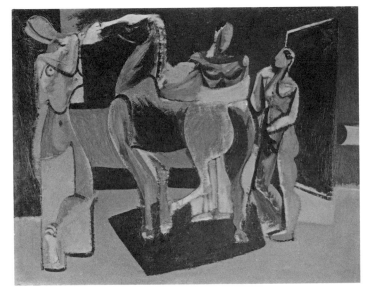

Composition: Horse and Figures. 1928. Oil, 34¼ x 43⅜"

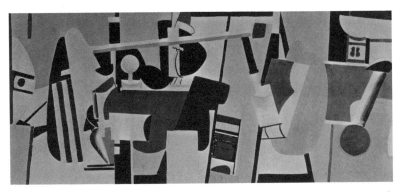

Study for mural, Administration Building, Newark Airport, New Jersey. 1935–36.
Gouache, 13⅝ x 29⅞"

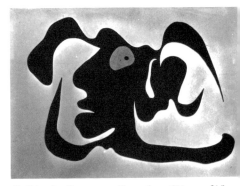

Bull in the Sun. 1942. Gouache, 18½ x 24¾"

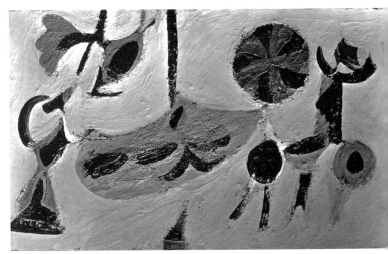

Argula. 1938. Oil, 15 x 24"

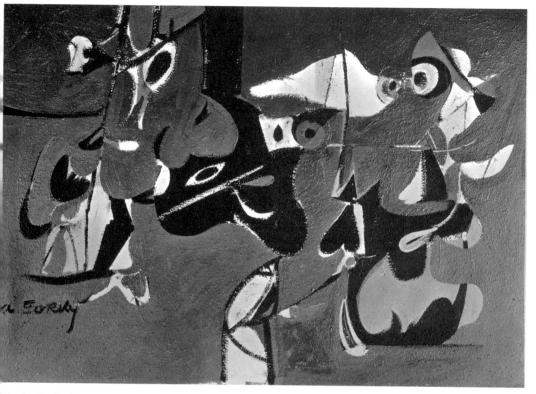

Garden in Sochi. 1941. Oil, 44¼ x 62¼″

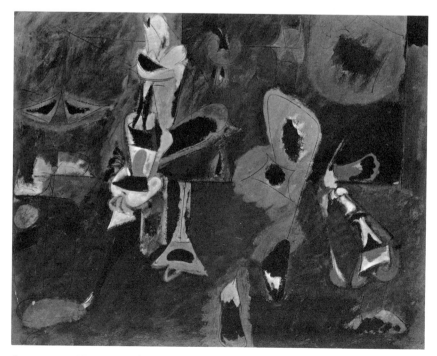

Agony. 1947. Oil, 40 x 50½″

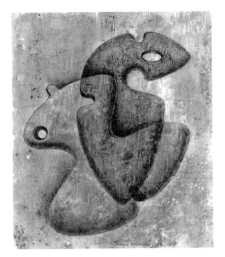

Merrild: *Archaic Form*. 1936. Gesso-wax and pencil, 10¹/₂ x 8³/₄″

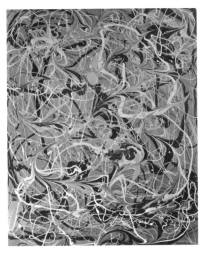

Merrild: *Perpetual Possibility*. 1942. Enamel, 20 x 16¹/₈″

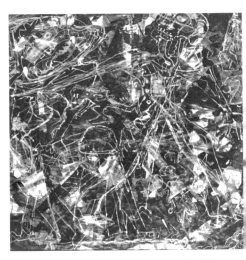

Culwell: *Men Fighting and Stars in the Solomons* 1942. Watercolor and gouache, 8 x 8″

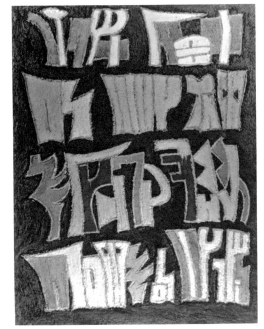

Lewitin: *Knockout*. 1955–59. Oil and ground glass, 23⁷/₈ x 17⁷/₈″

Granell: *The Last Haitian Night of King Christophe*. 1960. Oil, 30¹/₈ x 42¹/₈″

Ernst: *The Flying Dutchman*. 1942. Oil, 20 x 18¹/8″

Ernst: *A Time for Fear*. 1949. Oil, 23⁷/8 x 20″

Donati: *St. Elmo's Fire*. 1944. Oil, 36¹/2 x 28¹/2″

Zañartu: *Personages*. 1956. Oil, 39 x 32″

Cornell: *Taglioni's Jewel Casket*. 1940. Wood box containing glass ice cubes, jewelry, 4³/₄ x 11⁷/₈ x 8¹/₄″

Cornell: *Central Park Carrousel, in Memoriam*. 1950. Wood, mirror, wire netting, and paper, 20¹/₄ x 14¹/₂ x 6³/₄″

Mullican: *Presence*. 1955. Painted wood construction, 36¹/₈ x 17³/₈″

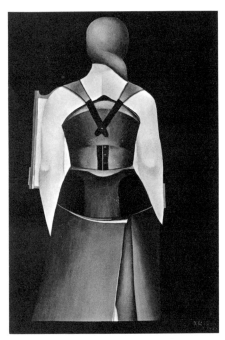

Lindner: *The Mirror*. 1958. Oil, 39³/₈ x 25⁵/₈″

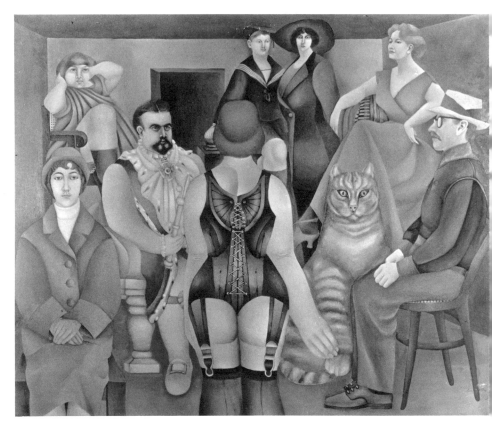

Lindner: *The Meeting*. 1953. Oil, 60″ x 6′

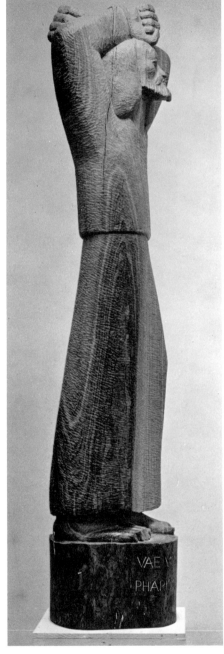

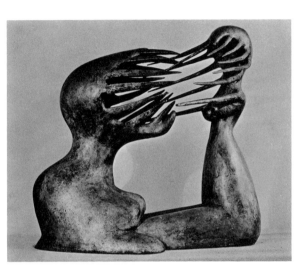

The Impossible, III. 1946. Bronze, 31¹/₂ x 32¹/₂″

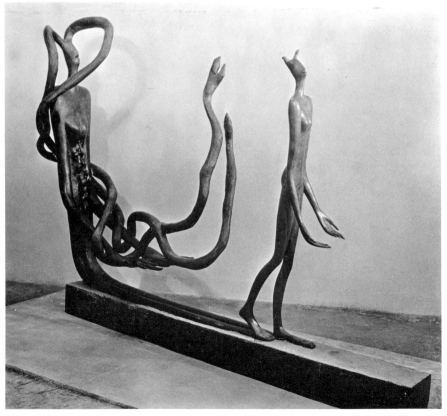

Christ. 1941. Wood, 7′10¹/₂″ high

The Road; The Shadow; Too Long, Too Narrow. 1946. Bronze, 56¹/₂ x 71³/₄ x 23³/₈″

Alcopley: *"Spiritus Ubi Vult Spirat,"* 24. 1962. Watercolor and ink, 26³/₄ x 22⁷/₈″

Cristiano: *Reason and Instinct—Sun and Moon.* 1958. Oil, applied with feet and hands, 36³/₈ x 32⁷/₈″

Trova: *Study.* 1960. Oil and mixed mediums, 20 x 16″

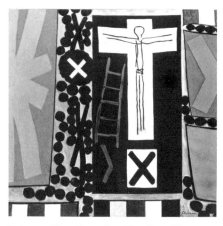

Chimes: *Crucifix.* 1961. Oil, 36 x 36″

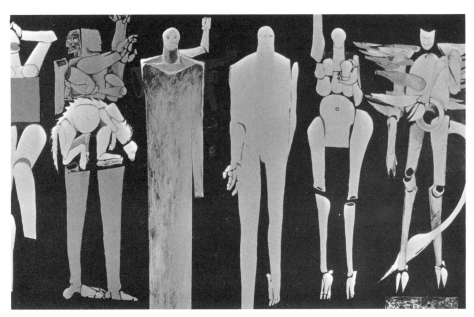

Hansen: *Man-Men: Mirror.* 1959. Lacquer on composition board, 46¹/₈″ x 6′

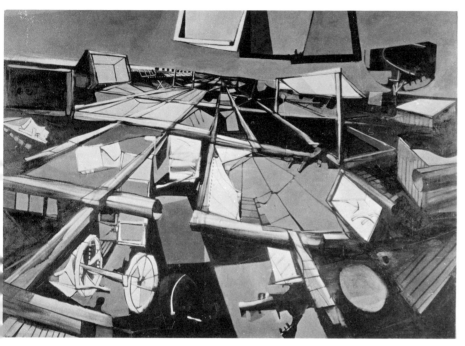

Hultberg: *Tilted Horizon*. 1955. Oil, 54¹/₈″ x 6′4¹/₈″

Sage: *Hyphen*. 1954. Oil, 30 x 20″

Bianco: *Pomegranate*. 1957–59. Oil and gold leaf, 30¹/₈ x 24″

Wood: *Fourth-Dimensional Pebble Beach*. 1962. Oil, 36¹/₄ x 44³/₈″

Chang Dai-Chien: *Lotus*. 1961. Brush and ink, 70³/₄ x 38¹/₄"

Lee: *Sailing*. 1957. Brush and colored inks, 50 x 12⁵/₈"

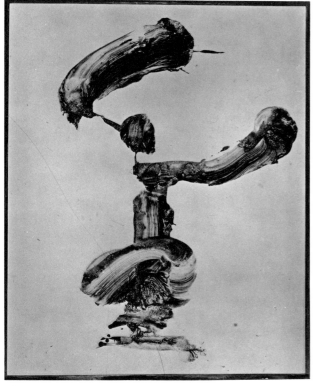

Hidai: *Work 63-14-3*. 1963. Brush and ink, 59⅝ x 47⅜″

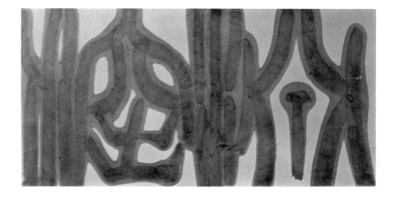

above right: Ikeda: *White Path*. c. 1953. Brush and ink, 25¾ x 54⅜″

center right: Osawa: *The Deep Pool*. c. 1953. Brush and ink, 26⅞ x 54⅜″

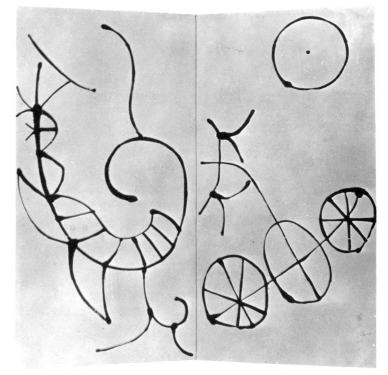

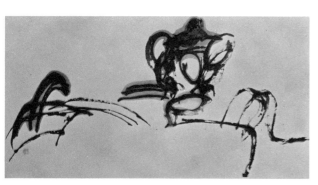

Ueda: *Nine Coves and Three Bends in the River*. c. 1953. Brush and ink, 26½ x 50¼″

Takeshi: *The Sun*. c. 1953. Two-panel screen, brush and ink, each sheet 55 x 27½″

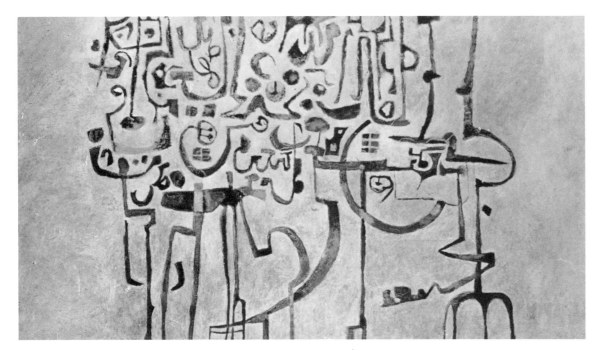

Erol: *The Glory of the Kings*. 1959? Oil, 48" x 7'1/4"

Rahmi: *The Chain*. 1962. Synthetic polymer paint on burlap, 14¹/₈ x 47⁵/₈"

Castel: *Poetry of Canaan, I*. 1963. Mixed mediums, 64 x 51³/₈"

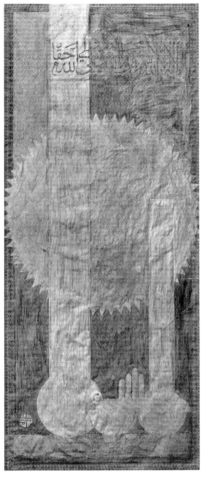

Pilarame: *Laminations*. 1962. Gouache
and metallic paint, 6'5⁷/₈" x 32⁵/₈"

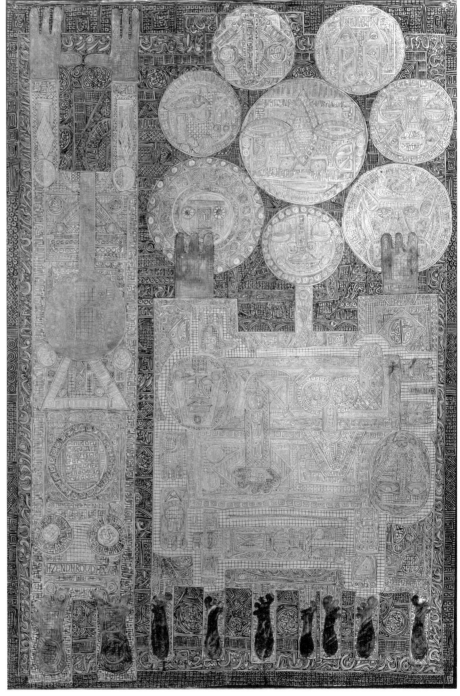

Zenderoudi: *K + L + 32 + H + 4*. 1962. Felt pen and colored ink, 7'5" x 58⁵/₈"

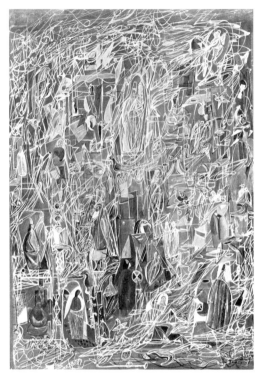

Threading Light. 1942. Tempera, 29³/₈ x 19¹/₂″

Remote Field. 1944. Tempera, pencil, and crayon, 28¹/₈ x 30¹/₈″

Edge of August. 1953. Casein, 48 x 28″

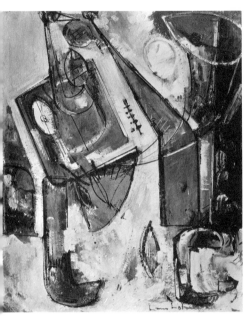

Delight. 1947. Gesso and oil, 50 x 40″

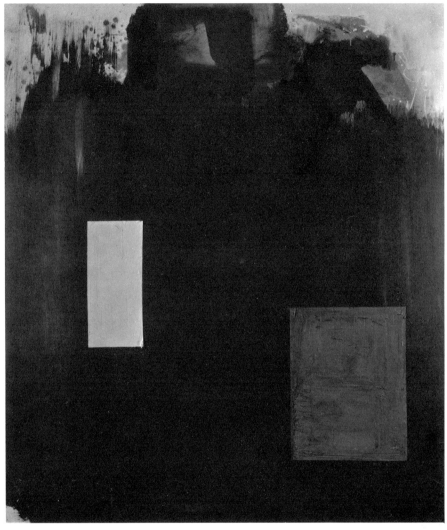

Memoria in Aeternum. 1962. Oil, 7′ x 6′1/8″

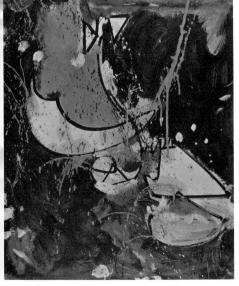

Ambush. 1944. Oil on paper, 24 x 19″

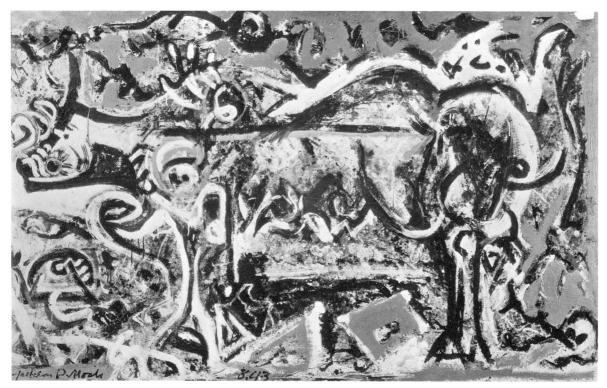

The She-Wolf. 1943. Oil, gouache, and plaster, 41⁷/₈ x 67″

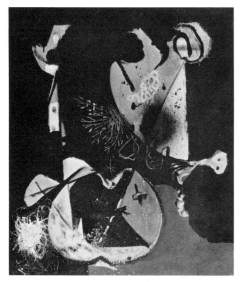

Painting. 1945? Gouache on plywood, 23 x 18⁷/₈″

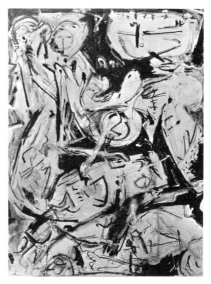

Painting. 1945. Mixed mediums on paper, 30⁵/₈ x 22³/₈″

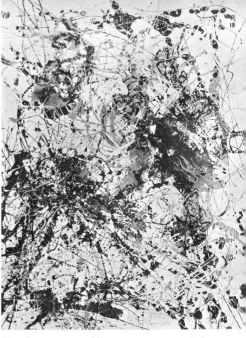

Number 12. 1949. Oil on paper, 31 x 22¹/₂″

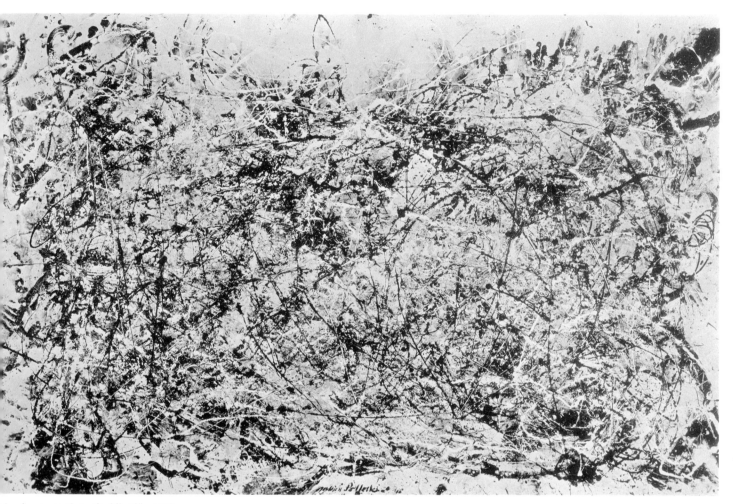

Number 1, 1948. 1948. Oil, 68″ x 8′8″

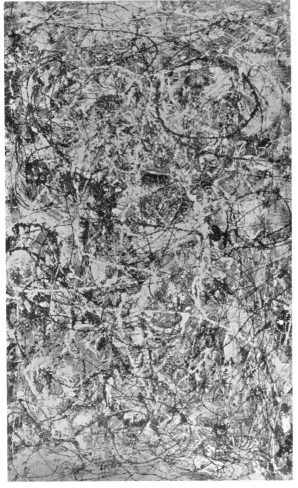

Full Fathom Five. 1947. Oil, etc., 50⁷/₈ x 30¹/₈″

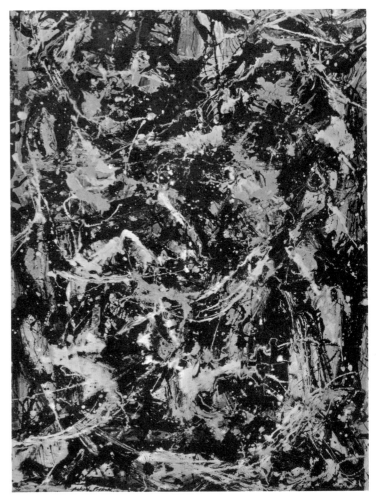

Number 5. 1950. Oil, 53³/₄ x 39″

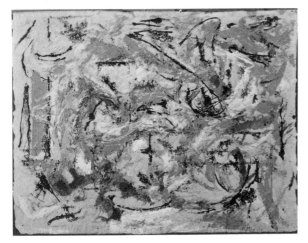

Painting. 1953–54. Oil and gouache, 15³/₄ x 20¹/₂″

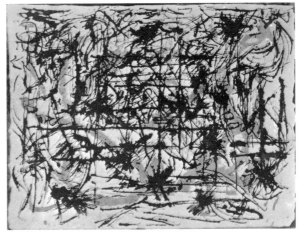

Reverse of *Painting*, 1953–54. Brush and ink

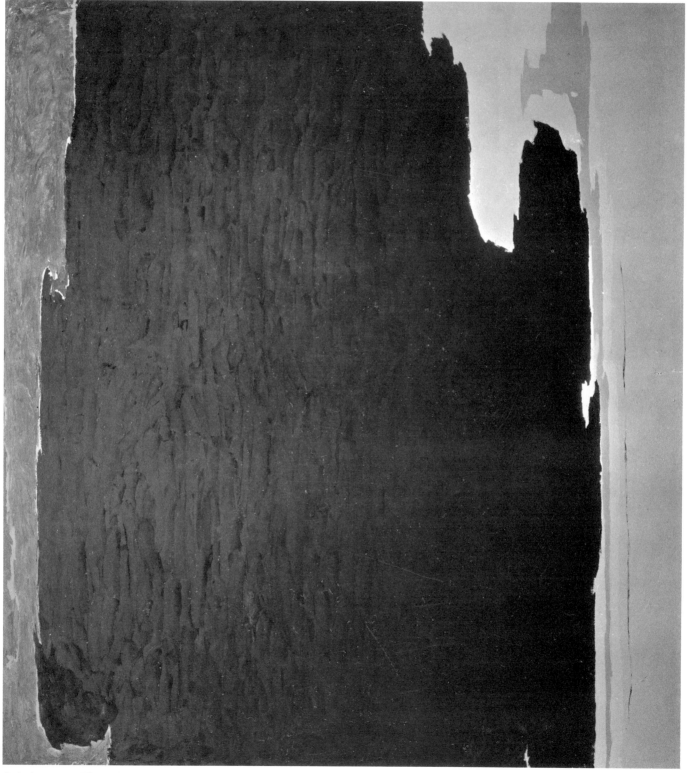

Painting. 1951. Oil, 7'10" x 6'10"

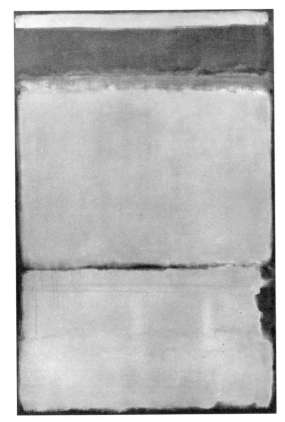

Number 10. 1950. Oil, 7'6³/₈" x 57¹/₈"

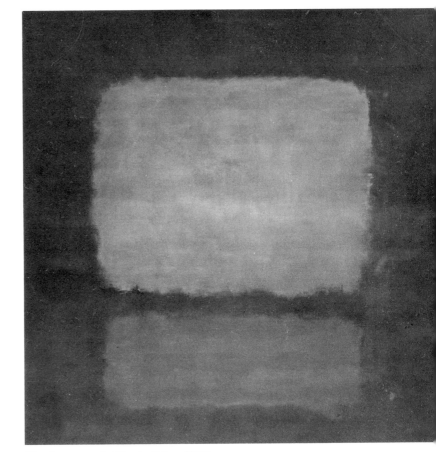

Number 19. 1958. Oil, 7'11¹/₄" x 7'6¹/₄"

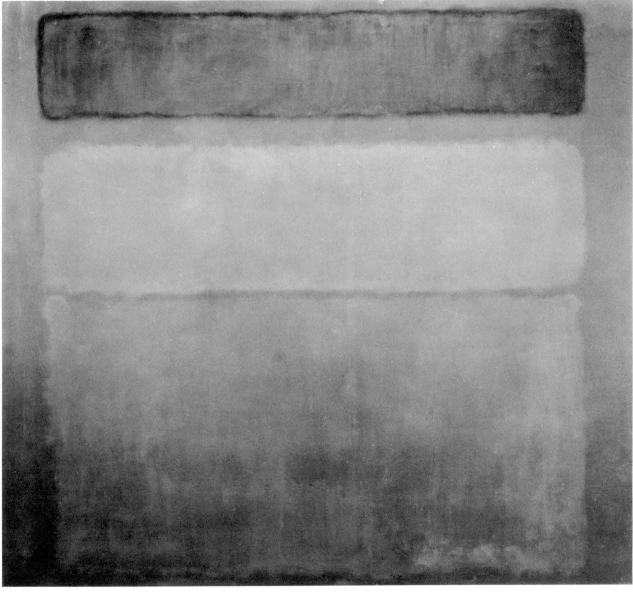

Red, Brown, and Black. 1958. Oil, 8′10⁵/₈″ x 9′9¹/₄″

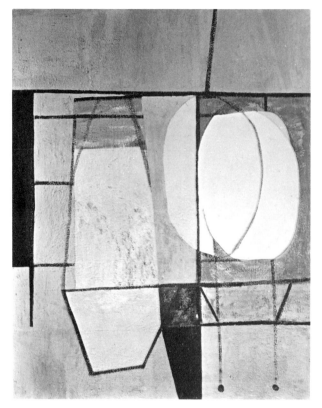

Western Air. 1946–47. Oil, 6′ x 54″

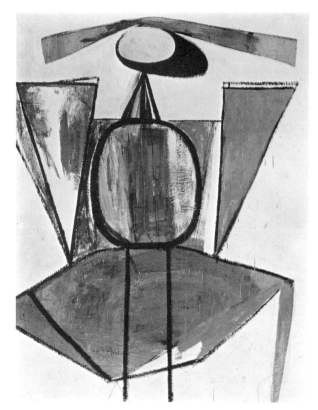

Personage with Yellow Ochre and White. 1947. Oil, 6′ x 54″

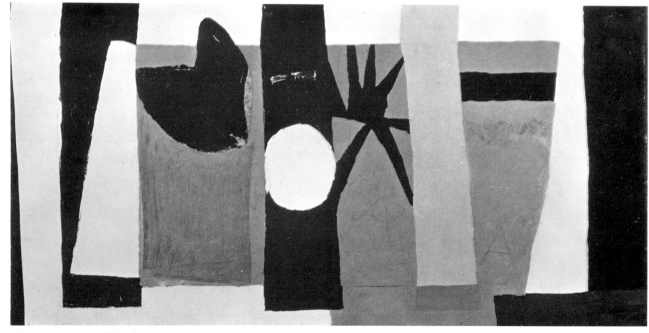

The Voyage. 1949. Oil and tempera on paper mounted on composition board, 48″ x 7′10″

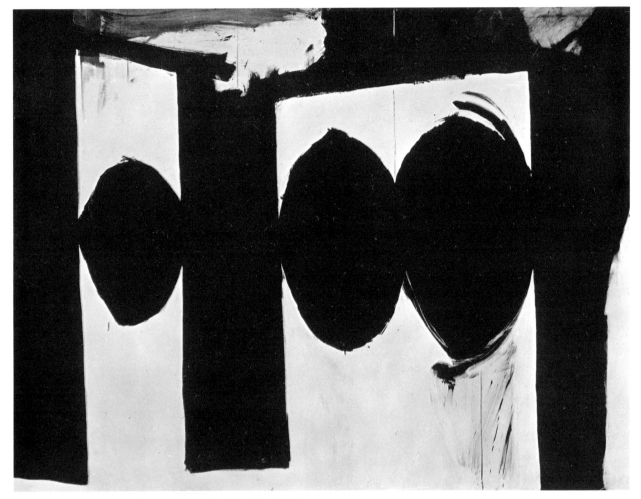

Elegy to the Spanish Republic, 54. 1957–61. Oil, 70″ x 7′6¹/₄″

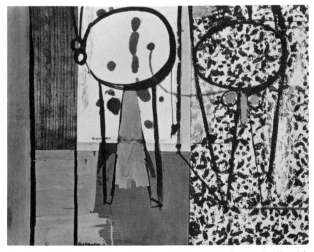

Pancho Villa, Dead and Alive. 1943. Gouache and oil with collage, 28 x 35⁷/₈″

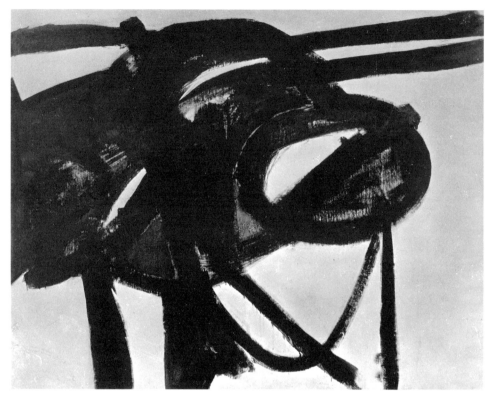

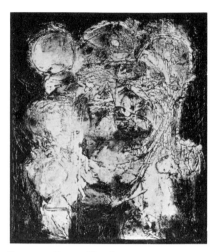

Pousette-Dart: *Number 11: A Presence.*
1949. Oil, 25$^{1}/_{8}$ x 21$^{1}/_{8}$"

Kline: *Chief*. 1950. Oil, 58$^{3}/_{8}$" x 6'1$^{1}/_{2}$"

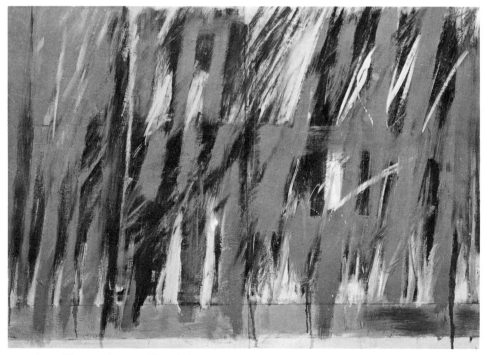

Tworkov: *West 23rd*. 1963. Oil, 60$^{1}/_{8}$" x 6'8"

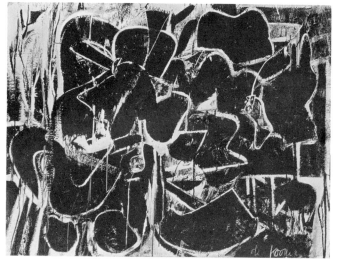

Painting. 1948. Enamel and oil, 42⁵/₈ x 56¹/₈″

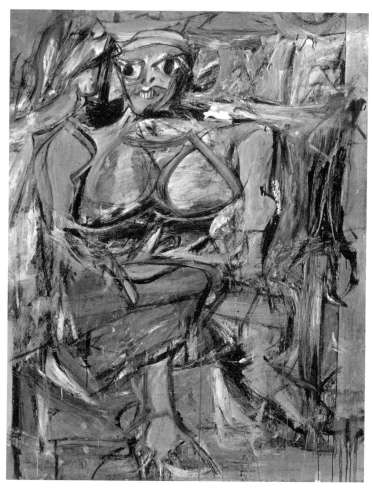

Woman, I. 1950–52. Oil, 6′3⁷/₈″ x 58″

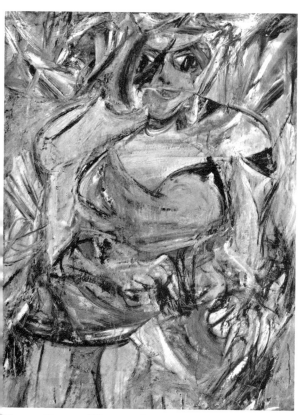

Woman, II. 1952. Oil, 59 x 43″

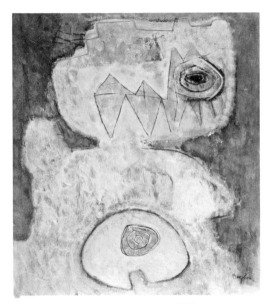

Baziotes: *Dwarf*. 1947. Oil, 42 x 36⅛″

Baziotes: *Pompeii*. 1955. Oil, 60 x 48″

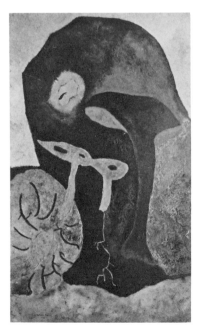

Stamos: *Sounds in the Rock*. 1946. Oil, 48⅛ x 28⅜″

Brooks: *Qualm*. 1954. Oil, 61 x 57⅛″

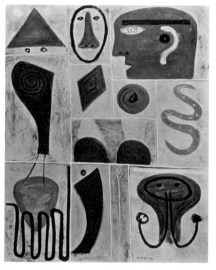

Voyager's Return. 1946. Oil, 37⁷/₈ x 29⁷/₈″

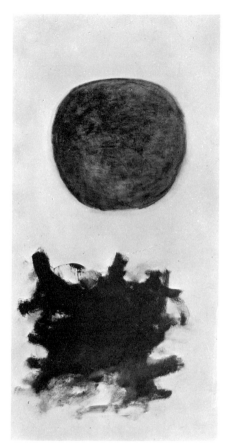

Blast, I. 1957. Oil, 7′6″ x 45¹/₈″

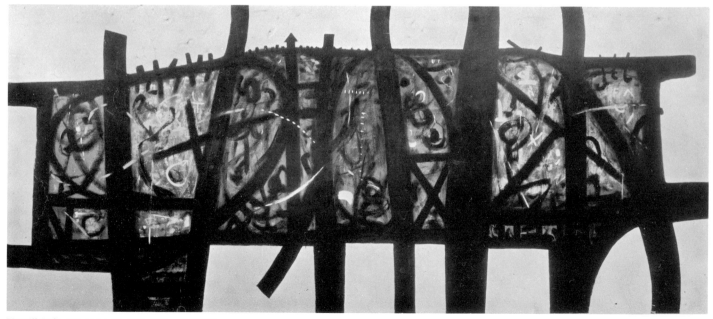

Unstill Life, III. 1954–56. Oil, 6′8″ x 15′5¹/₄″

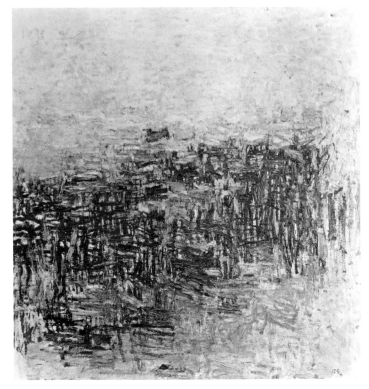

Guston: *Painting.* 1954. Oil, 63¼ x 60⅛″

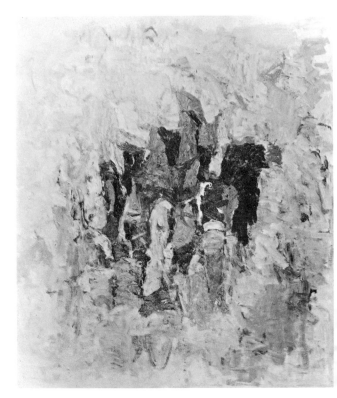

Guston: *The Clock.* 1956–57. Oil, 6′4″ x 64⅛″

McNeil: *Constanza.* 1958. Oil, 47⅞ x 47⅞″

Resnick: *Burning Bush.* 1959. Oil, 63 x 48″

Number 3. 1953. Oil, 46 x 31″

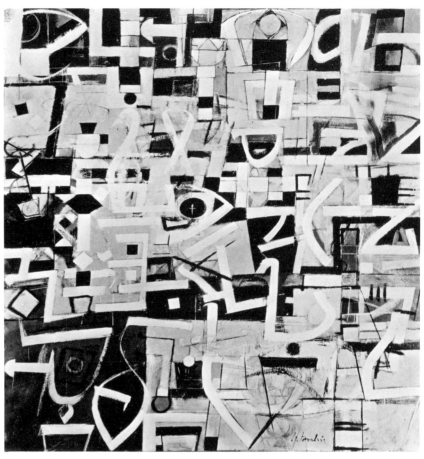

Number 20. 1949. Oil, 7′2″ x 6′8¹/₄″

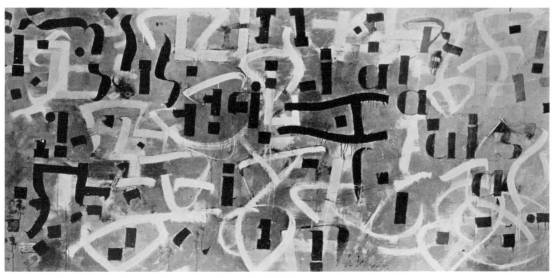

Number 9: In Praise of Gertrude Stein. 1950. Oil, 49″ x 8′6¹/₄″

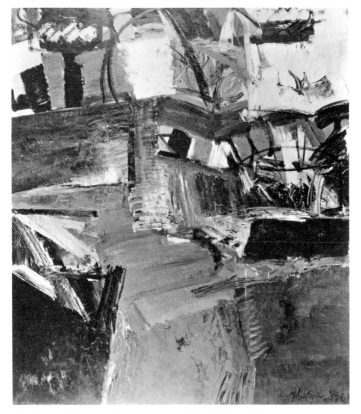

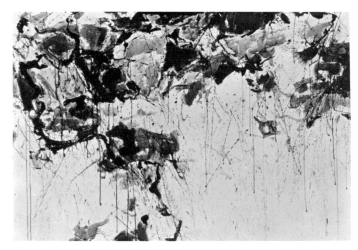

Francis: *Painting.* 1958. Watercolor, 27¹/₈ x 40¹/₈"

Hartigan: *Shinnecock Canal.* 1957. Oil, 7'6¹/₂" x 6'4"

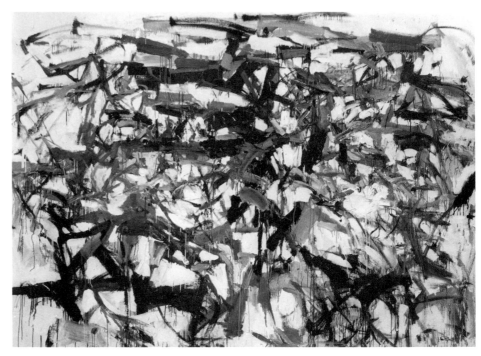

Mitchell: *Ladybug.* 1957. Oil, 6'5⁷/₈" x 9'

Francis: *Big Red*. 1953. Oil, 10′ x 6′4¼″

Frankenthaler: *Jacob's Ladder*. 1957. Oil, 9′5³/₈″ x 69⁷/₈″

Pfriem: *Red Rising Up*. 1960. Oil, 57½ x 45"

Goodnough: *Laocoön*. 1958. Oil and charcoal, 66³/₈ x 54¹/₈"

Jarvaise: *Hudson River School Series, 32*. 1957. Oil on composition board, 60¹/₈ x 48"

Bearden: *The Silent Valley of Sunrise*. 1959. Oil and casein, 58¹/₈ x 42"

Wilson: *The Open Scene*. 1960. Oil, 60³/₈″ x 6′8″

Twardowicz: *Number 11*. 1955. Enamel and oil, 6′ x 50″

Sterne: *New York, VIII*. 1954. Synthetic polymer paint, 6′¹/₈″ x 42″

Yektai: *Still Life D*. 1959. Oil, 48¹/₄ x 68″

Youngerman: *Big Black*. 1959. Oil, 7′7″ x 70¼″

Barker: *I-Ching Series*, 5. 1963. Oil and chalk, 7′1⅛″ x 64⅛″

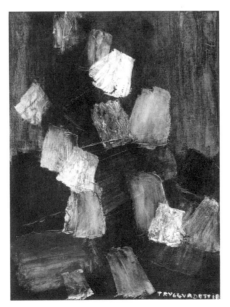

Tryggvadottir: *Painting*. 1960. Oil, 24 x 17⅞″

Reynal: *A Good Circular God*. 1948–5◉
Mosaic, 37 x 24⅜″

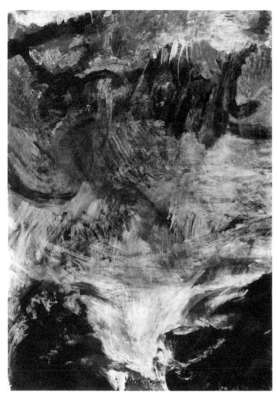

Yunkers: *Hour of the Dog*. 1961. Pastel and gouache, 69 x 47⅞"

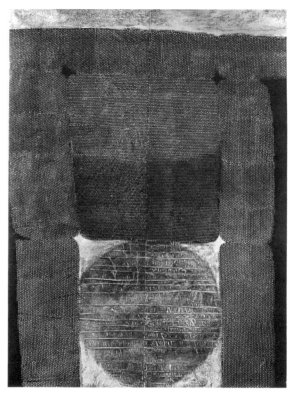

Fernández-Muro: *Silvered Circle*. 1962. Oil on aluminum paper, 68⅛ x 50"

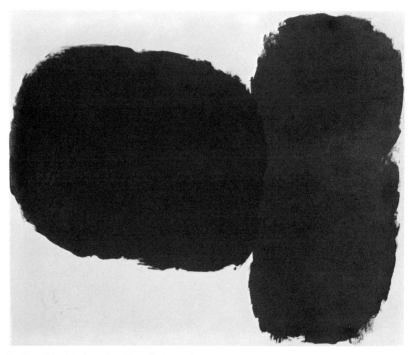

Parker: Untitled. 1960. Oil, 71⅞" x 7'2"

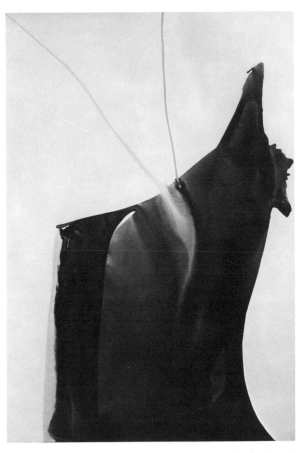

Jenkins: *Phenomena Yellow Strike*. 1963–64. Synthetic polymer paint, 60$\frac{1}{8}$ x 39$\frac{7}{8}$"

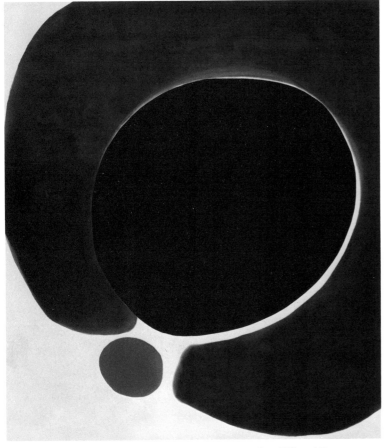

Olitski: *Cleopatra Flesh*. 1962. Synthetic polymer paint, 8'8" x 7'6"

Third Element. 1962. Synthetic polymer paint, 7′1³/4″ x 51″

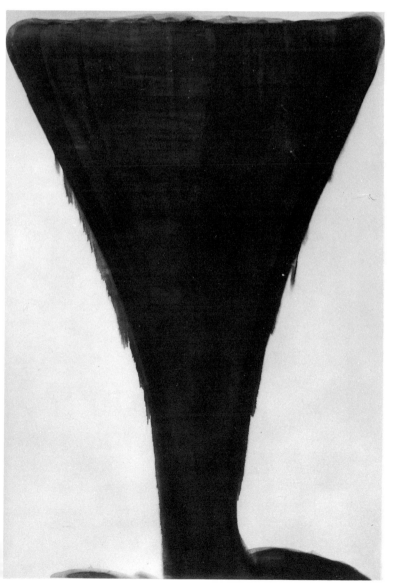

Untitled. 1959. Synthetic polymer paint, 11′7¹/4″ x 7′7¹/4″

Hartung: *Painting*. 1948. Oil, 38¼ x 57½″

Wols: *Painting*. 1944–45. Oil, 31⅞ x 32″

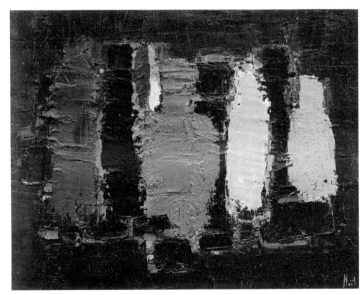

Manessier: *Nocturnal Movements*. 1948. Oil, 31⅞ x 39¾″

de Staël: *Painting*. 1952. Oil, 25¾ x 31¾″

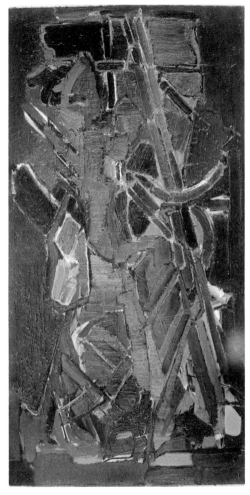

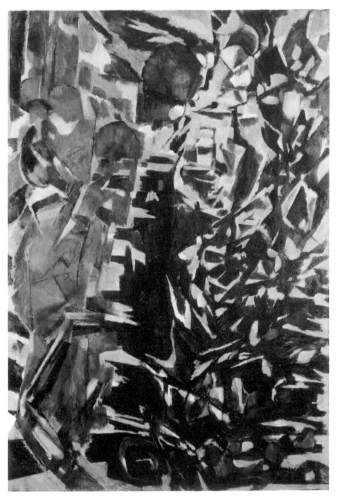

de Staël: *Painting*. 1947. Oil, 6′5″ x 38³/₈″

Bazaine: *The Flame and the Diver*. 1953. Oil, 6′4³/₄″ x 51″

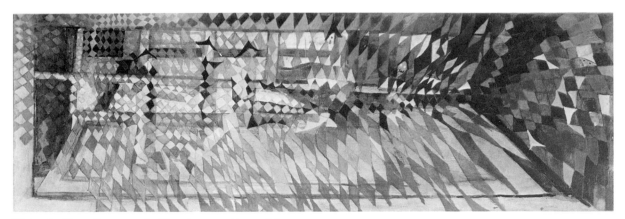

Vieira da Silva: *Dance*. 1938. Oil and wax, 19¹/₂ x 59¹/₄″

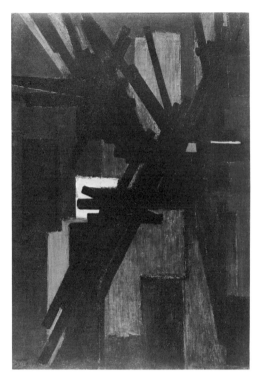

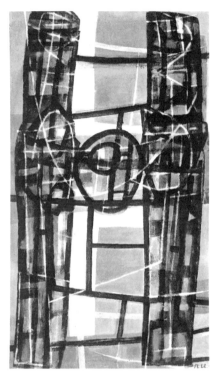

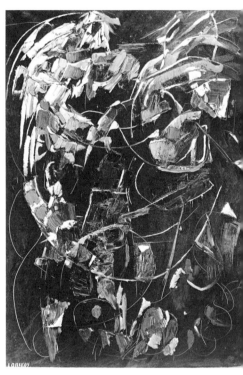

Soulages: *January 10, 1951.* 1951. Oil on burlap, 57¹/₂ x 38¹/₄″

Ubac: *Two Persons at a Table.* 1950. Oil, 51 x 28³/₄″

Lanskoy: *Explosion.* 1958. Oil, 57¹/₂ x 38¹/₄″

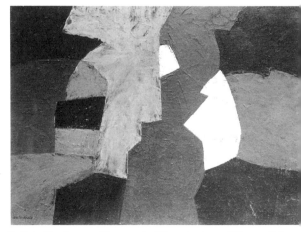

Soulages: *Painting.* 1956. Oil, 59¹/₄″ x 6′4³/₄″

Poliakoff: *Composition.* 1956. Oil on burlap, 38¹/₈ x 51¹/₄″

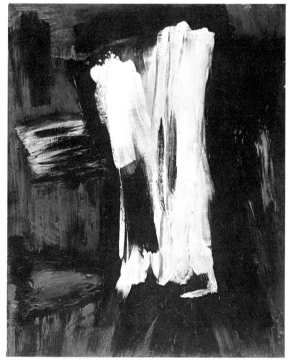

Schneider: *Painting 95 B.* 1955. Oil, 57⁵/₈ x 45″

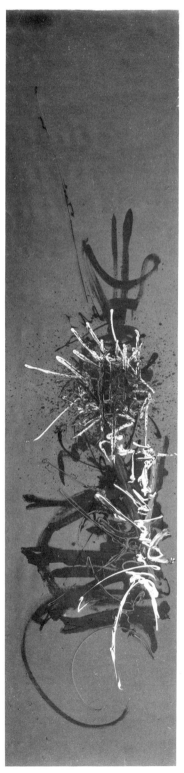

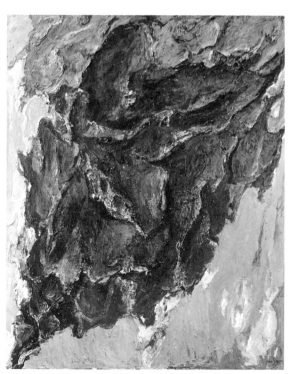

Hosiasson: *Red and Black.* 1956. Oil, 57⁷/₈ x 45¹/₄″

Mathieu: *Montjoie Saint Denis!* 1954.
Oil, 12′3⁵/₈″ x 35¹/₂″

Davie: *Painting*. 1955. Oil, 60 x 48¹/₈″

Wynter: *Meeting Place*. 1957. Oil, 56 x 44″

Martin: *Painting, Positano*. 1953. Enamel on paper, 59 x 39″

Ronald: *Saintpaulia*. 1956. Oil, 48 x 52³/₈″

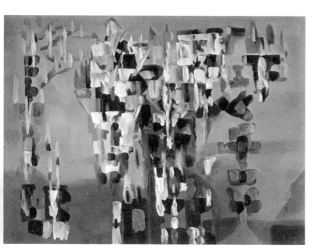

Borduas: *Morning Candelabra.* 1948. Oil, 32¼ x 43″

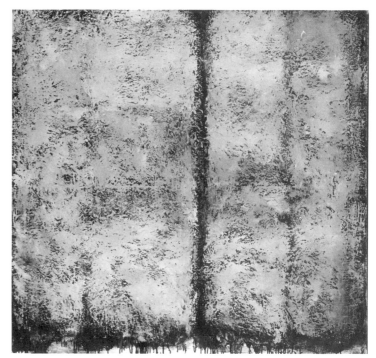

McEwen: *Plumb Line in Yellow.* 1961. Oil, 60¼ x 60⅛″

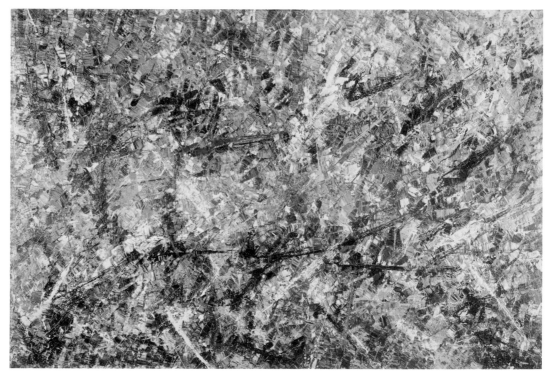

Riopelle: *Forest Blizzard.* 1953. Oil on composition board, 67⅛″ x 8′4¼″

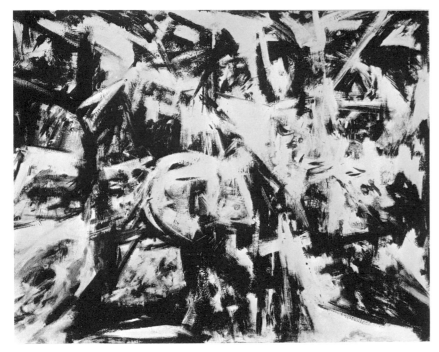

Vedova: *Unquiet Space*. 1957. Tempera and sand, 53¹/₈ x 67″

Corpora: *Divided Hour*. 1958. Oil, 57¹/₂ x 44⁷/₈″

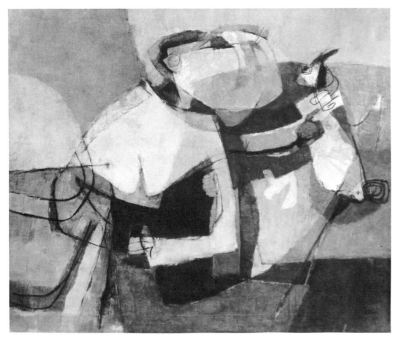

Afro: *Boy with Turkey*. 1954. Oil, 49¹/₈ x 59″

Bacci: *Incident 13R*. 1953. Tempera, 32³/₄ x 56¹/₄″

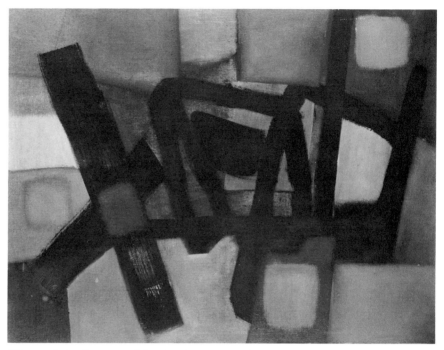

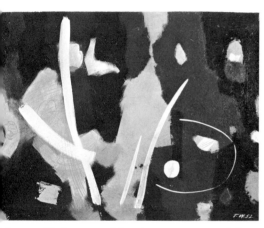

Werner: *Venice*. 1952. Oil and tempera, 32 x 39³/₈"

Winter: *Quiet Sign*. 1953. Oil on burlap, 45 x 57¹/₂"

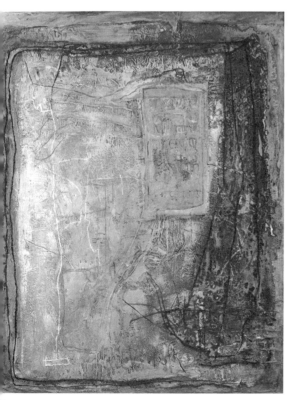

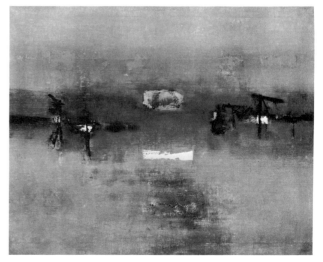

Samant: *Green Square*. 1963. Synthetic polymer paint, sand, and oil, 69¹/₈ x 52"

Gaitonde: *Painting, 4*. 1962. Oil, 40 x 49⁷/₈"

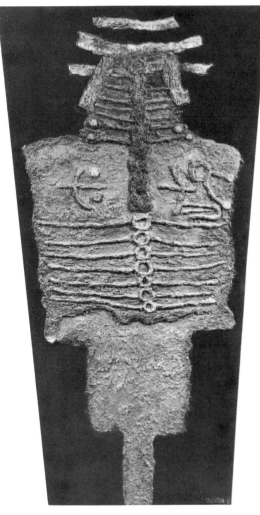

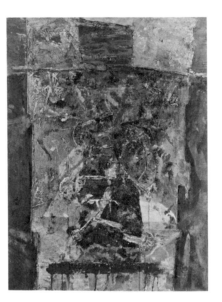

Kobzdej: *Conflict*. 1959. Casein and oil on paper, 39¼ x 28¾"

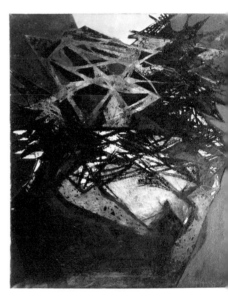

Krajcberg: *Painting, I*. 1957. Oil, 36⅛ x 28¾

Lebenstein: *Axial Figure, 110*. 1961. Oil, 7' 1½" x 46¾" at top, 31½" at bottom

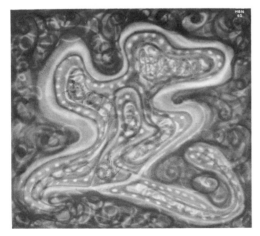

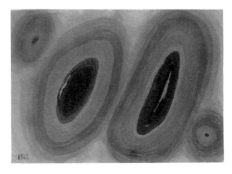

Shashurin: *Elements of Life*. 1962. Oil on cardboard, 13⅞ x 19⅝"

Vasiliev: *Concern for Life*. 1962. Pastel and water-color on cardboard, 27¾ x 30⅞"

Reuterswärd: *Bam Bam*. 1958. Enamel paper, 24 x 17"

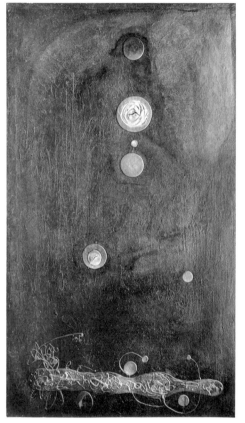

Cuixart: *Painting*. 1958. Latex and synthetic polymer paint with metallic powders, 7'4⁵/₈" x 51¹/₄"

Tàpies: *Gray Relief on Black*. 1959. Latex paint with marble dust, 6'4⁵/₈" x 67"

Tharrats: *That Which Will Be*. 1961. Mixed mediums, 51¹/₄ x 38¹/₈"

Tàpies: *Painting*. 1957. Latex paint with marble dust, sand, 57³/₈ x 35"

Tàpies: *Space*. 1956. Latex paint with marble dust, 6'4⁵/₈" x 67"

Damian: *Red Form on Red Background*. 1960. Mixed mediums, 57¹/₂ x 51¹/₈″

Pedersen: *The Yellow Star*. 1952. Oil and pencil, 48⁷/₈ x 40¹/₂″

Serpan: *Murtsphde, 570*. 1957. Oil, 57¹/₂ x 44⁷/₈″

Sugaï: *Kabuki*. 1958. Oil and gilt paint, 57¹/₂ x 44⁵/₈″

Alechinsky: *Vanished in Smoke*. 1962. Distemper and India ink on paper, 59⁵/₈ x 58¹/₄″

Appel: *Child with Birds*. 1950. Oil, 39¹/₂ x 39³/₄″

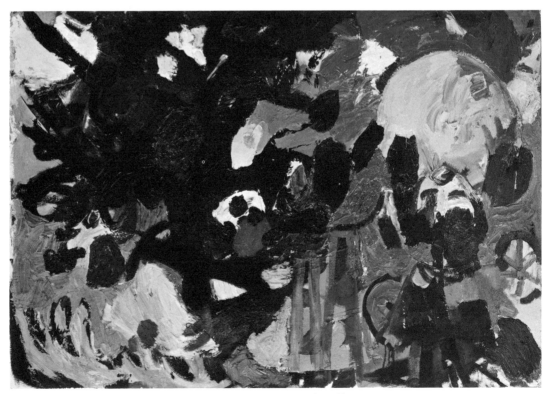

Lataster: *Threatened Game*. 1956. Oil on composition board, 48 x 68″

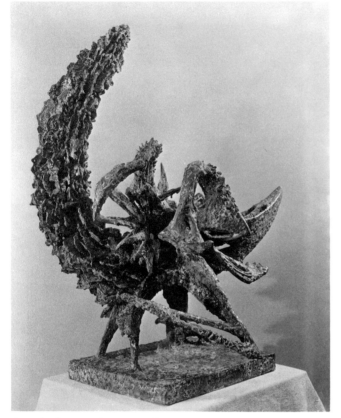

Roszak: *Spectre of Kitty Hawk*. 1946–47. Welded and hammered steel brazed with bronze and brass, 40¼" high

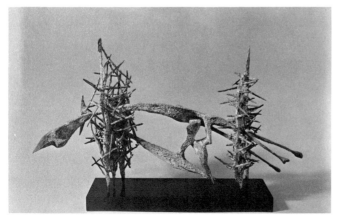

Ferber: *Jackson Pollock*. 1949. Lead, 17⅝ x 30"

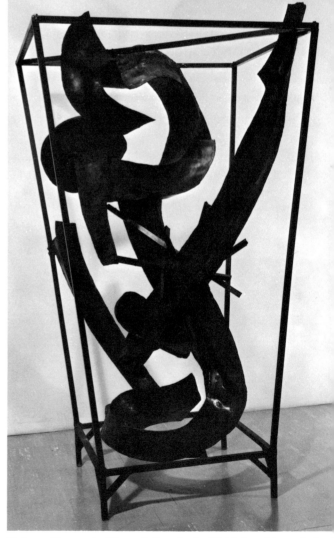

Ferber: *Homage to Piranesi, I*. 1962–63. Welded and brazed sheet copper and brass tubing, 7'7¼" x 48¾" x 48"

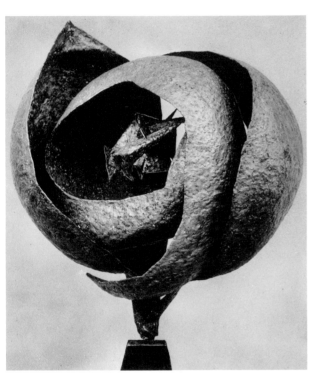

Lipton: *Sanctuary*. 1953. Nickel-silver over steel, 29¼" high

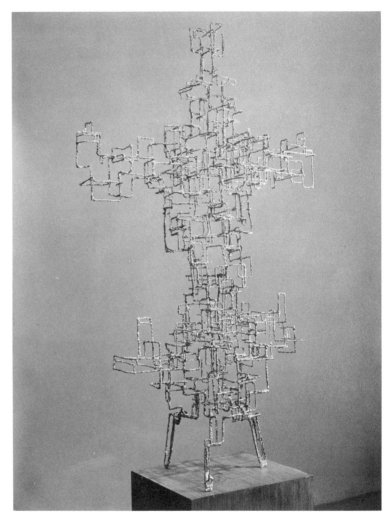

Lassaw: *Kwannon*. 1952. Welded bronze with silver, 6' high

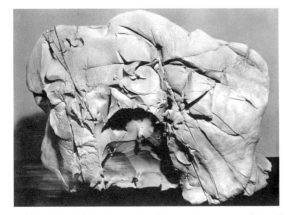

Nakian: *Rock Drawing*. 1957. Terra cotta, 10 x 14¼ x 6"

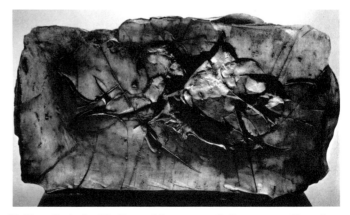

Nakian: Study for *The Rape of Lucrece*. 1958. Terra cotta, 9¼ x 16 x 4¼"

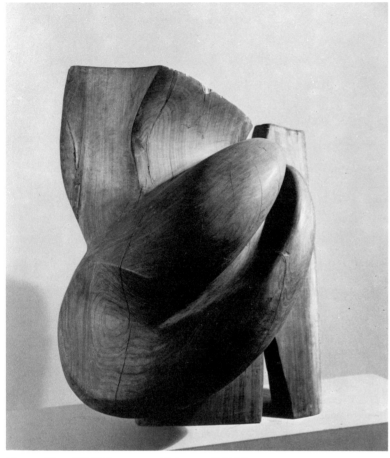

Hague: *Plattekill Walnut*. 1952. Walnut, 35⅝" high

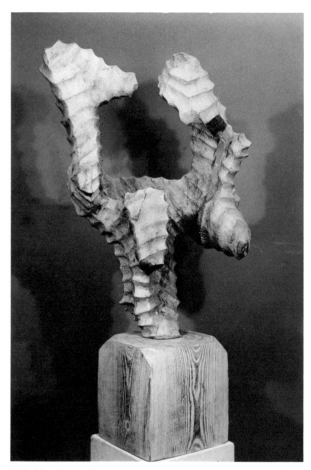

Lekakis: *Ptisis (Soaring)*. 1957–62. Oak, 34⅞ x 25½ x 15¾"

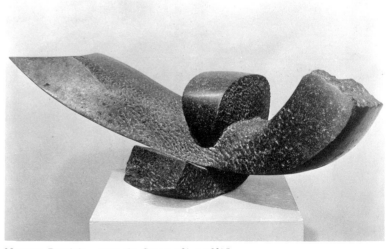

Nagare: *Receiving*. 1959–60. Stone, 9¾ x 28¾"

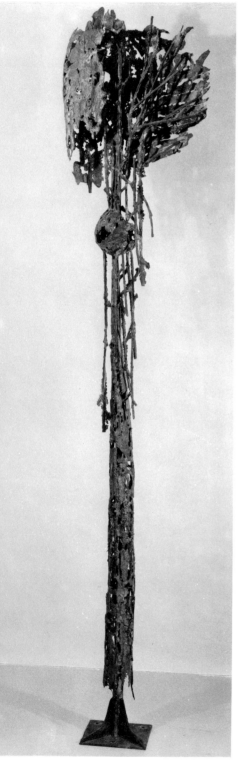

Tajiri: *Mutation*. 1959–60. Brazed and welded bronze, 8'4¾" high

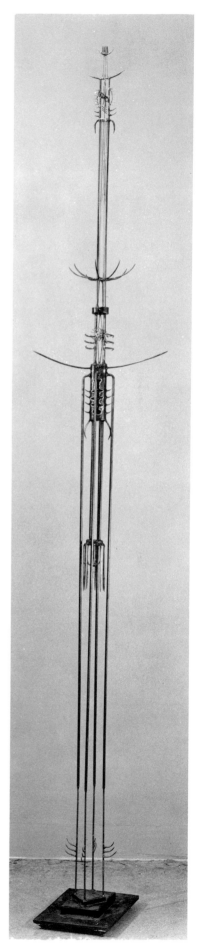

right: Goto: *Organic Form, I*. 1951. Welded steel in two parts, 11'4¼" high

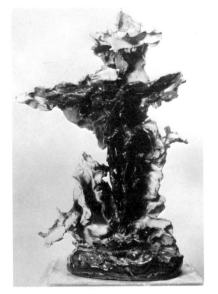

Fontana: *Crucifixion*. 1948. Ceramic, 19¹/₈″ high

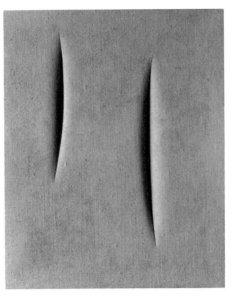

Fontana: *Spatial Concept: Expectations*. 1959. Synthetic polymer paint on burlap, slashed, 39³/₈ x 32¹/₈″

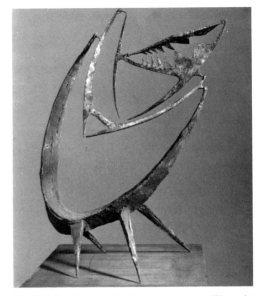

Chadwick: *Balanced Sculpture*. 1952. Wrought iron, 19¹/₂″ high

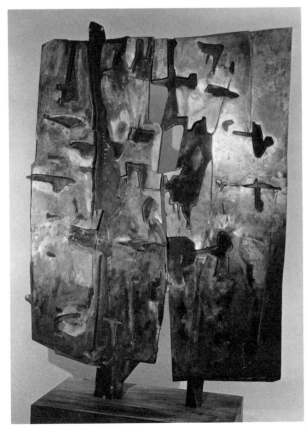

Consagra: *Conversation before the Mirror*. 1957. Bronze relief, 56 x 40⁷/₈″

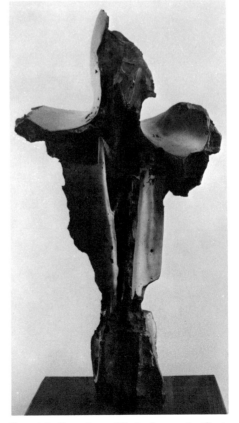

Somaini: *Sanguinary Martyrdom*. 1960. Cast iron, 52¹/₈ x 26¹/₈″

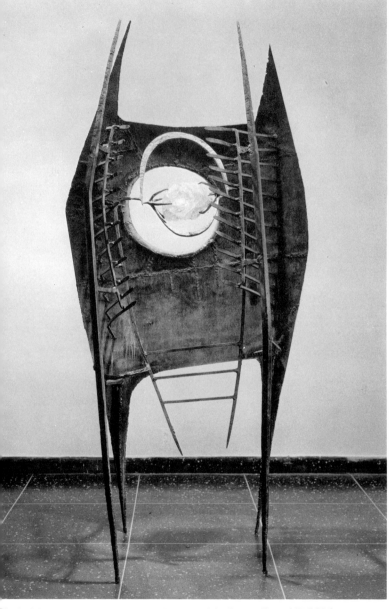

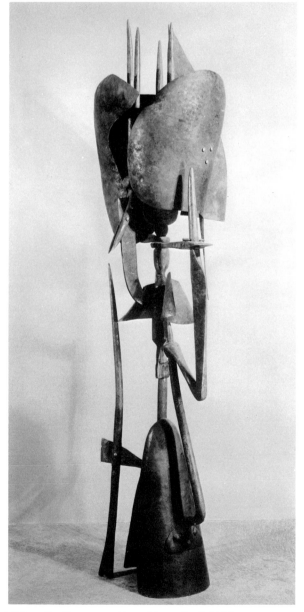

Chadwick: *Inner Eye*. 1952. Wrought iron with glass cullet, 7′6¹/₂″ high

Müller: *Ex-Voto*. 1957. Forged iron, 6′11⁷/₈″ high

Droste: *Relief XIII/60 Vadasa II*. 1960. Bronze, 23¹/₂ x 18¹/₄″

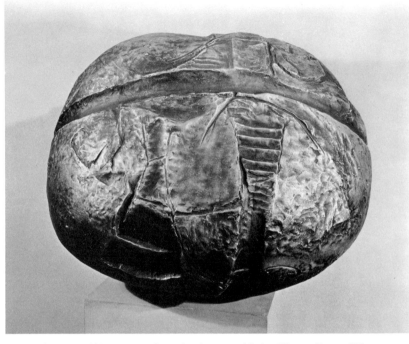

Dalwood: *Large Object*. 1959. Cast aluminum, welded, 28⁷/₈ x 34¹/₈ x 27⁷/₈″

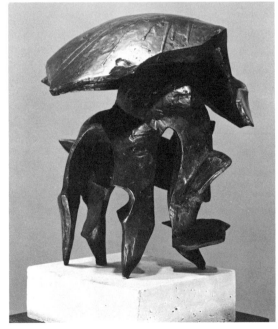

Hadzi: *Helmet, I*. 1958. Bronze, 13¹/₈″ high

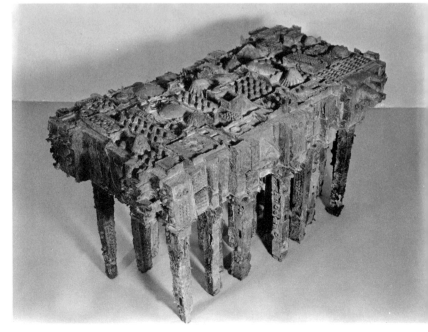

Schmidt: *Iron Sculpture*. 1960. Cast iron, 22¹/₂ x 38¹/₄ x 21³/₄″

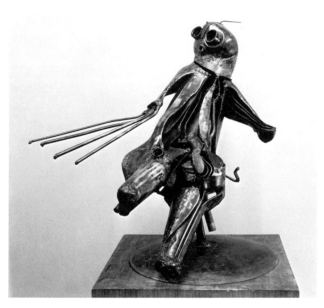

Hunt: *Arachne*. 1956. Welded steel, 30″ high

Higgins: *Double Portrait—Torsos*. 1960. Steel and epoxy, 16¼ x 17 x 7¾″

Scarpitta: *Composition, I*. 1959. Oil and casein on canvas strips, 45¾ x 35⅛″

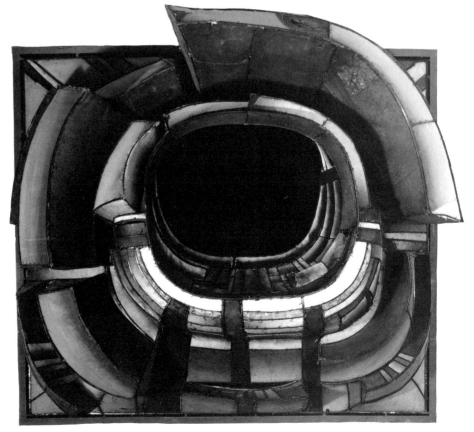

Bontecou: Untitled. 1961. Welded steel, wire, and canvas, 6′8¼″ x 7′5″ x 34¾″

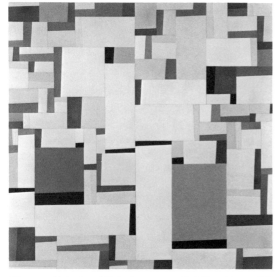

Glarner: *Relational Painting*. 1947–48. Oil, 43⅛ x 42¼″

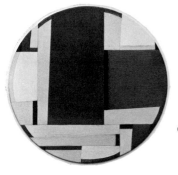

Glarner: *Relational Painting, Tondo 37*. 1955. Oil, 19″ diameter

Bolotowsky: *White Circle*. 1958. Oil, c. 60¾″ diameter

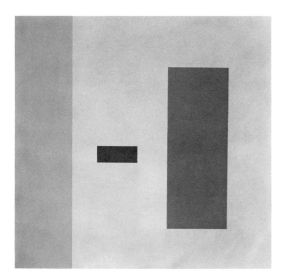

Diller: *First Theme*. 1942. Oil, 42 x 42″

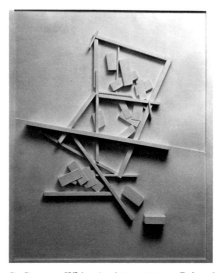

G. Greene: *White Anxiety*. 1943–44. Painted wood relief construction, 41¾ x 32⅞″

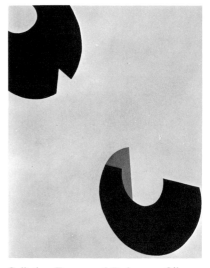

Gallatin: *Forms and Red*. 1949. Oil, 30 x 23″

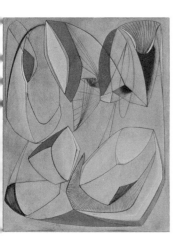

left: Ferren: *Composition*. 1937. Etched and colored plaster with intaglio, $11^7/_8$ x $9^1/_8$″

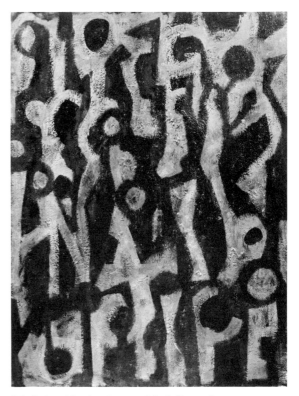

Schnitzler: *Number I*. 1955. Oil, $65^7/_8$ x 50″

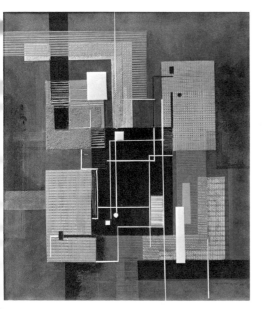

Pereira: *White Lines*. 1942. Oil on vellum with marble dust, sand, etc., $25^7/_8$ x $21^7/_8$″

B. Greene: *The Ancient Form*. 1940. Oil, 20 x 30″

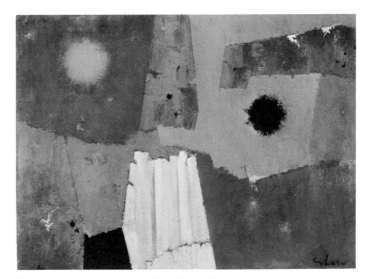

Shaw: *Edge of Dusk*. 1956. Oil, $36^1/_4$ x $48^1/_4$″

Newman: *Abraham*. 1949. Oil, 6′10³/4″ x 34¹/2″

Reinhardt: *Abstract Painting*. 1960–61. Oil, 60 x 60″

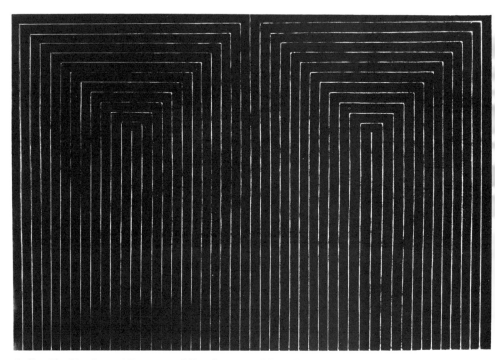

Stella: *The Marriage of Reason and Squalor*. 1959. Oil, 7′6³/4″ x 11′3/4″

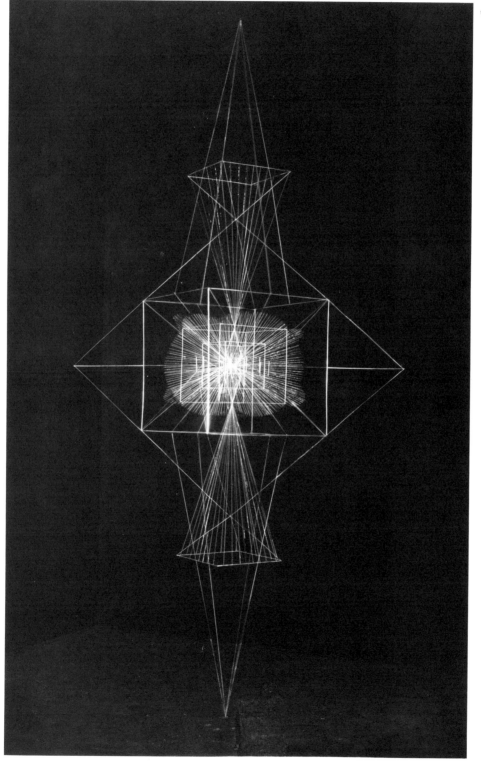

Variation Number 7: Full Moon. 1949–50. Brass rods, nickel-chromium and stainless steel wire,
10 x 6′

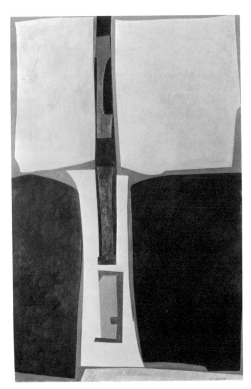

Barnet: *Golden Tension*. 1959–60. Oil and gold leaf, 64 x 39⁷⁄₈″

Martínez Pedro: *Composition 13*. 1957. Oil, 58¹⁄₈ x 38″

Capogrossi: *Section 4*. 1953. Oil, 7′1⁷⁄₈″ x 38⁵⁄₈″

Nakamura: *Inner Core 2*. 1960–61. Oil, 42 x 31″

Okada: *Number 3*. 1953. Oil, 65¹⁄₈ x 57⁷⁄₈″

Stout: *Number 3, 1954*. 1954.
Oil, 20¹/₈ x 16″

Kelly: *Running White*. 1959. Oil, 7′4″ x 68″

Kohn: *Acrotere*. 1960. Laminated wood, 35¹/₄ x 31 x 22¹/₄″

Feitelson: *Magical Space Forms*. 1955. Oil, 6′ x 60″

Vasarely: *Ondho*. 1956–60. Oil, 7′2⁵/₈″ x 71″

Vasarely: *Yllam*. 1949–52. Oil, 51³/₈ x 38¹/₄″

Honegger: *Henceforth*. 1959. Oil over cardboard collage on canvas, 25 x 25″

Yvaral: *Acceleration 19, Series B*. 1962. Construct of plastic and wood, 23⁷/₈ x 24³/₈ x 3¹/₈″

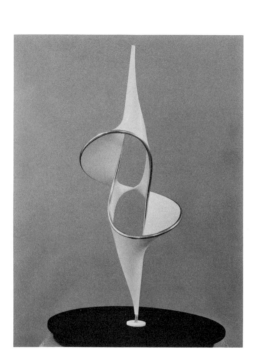

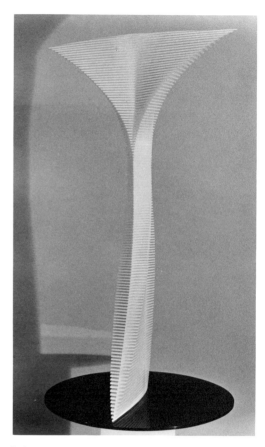

Engman: *A Study in Growth*. 1958. Plastic-coated
stainless steel, 19½″ high

Reimann: *Icon*. 1957. Opaque plexiglass, 34¼″ high

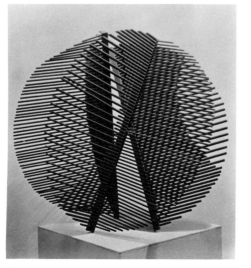

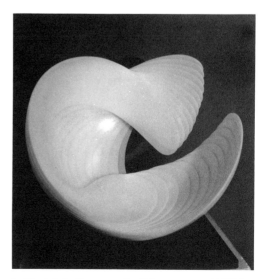

Otero: *Color-Rhythm, I*. 1955. Duco on
plywood, 6′6¾″ x 19″

Gego: *Sphere*. 1959. Welded brass and steel,
painted, 22″ diameter

de Moulpied: *Form* 7. 1960. Polystyrene, 12¼″ high

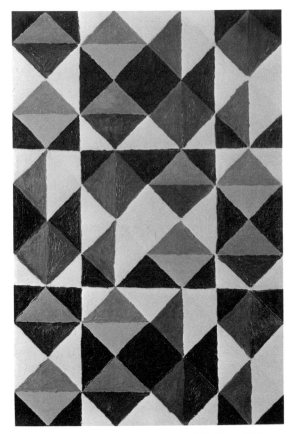

Jensen: *Clockwork in the Sky*. 1959. Oil, 6′ x 46⅛″

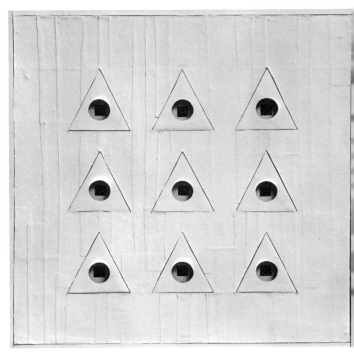

Ortman: *Triangle*. 1959. Collage of painted canvas on composition board with nine plaster inserts, 49⅝ x 49⅞ x 3¾″

Molinari: *Yellow Asymmetry*. 1959. Synthetic polymer paint, 48 x 60″

Cohen: *Mutation Whitsun Series 2*. 1960. Oil and enamel, 54⅜ x 66¼

Anuszkiewicz: *Fluorescent Complement*. 1960. Oil, 36 x 32¼"

Poons: *Night on Cold Mountain*. 1962. Synthetic polymer paint and dye, 6'8" x 6'8"

above: Liberman: *Continuous on Red*. 1960. Oil, c. 6'8" diameter

left: Liberman: *Passage*. 1960. Enamel on metal with marble base, 9¼" high

Ocampo: *Number 172*. 1957. Oil, 21¼ x 31⁷/₈"

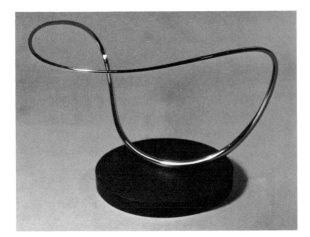

de Rivera: *Construction 8*. 1954. Stainless steel forged rod, 9³/₈″ high

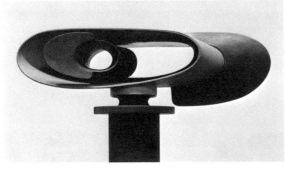

Negret: *Sign for an Aquarium (model)*. 1954. Painted iron, 13¹/₂″ long

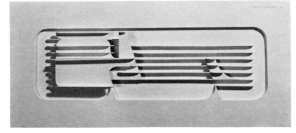

Ramírez: *Horizontal White Relief*. 1961. Synthetic polymer paint on cardboard, 11 x 24³/₈″

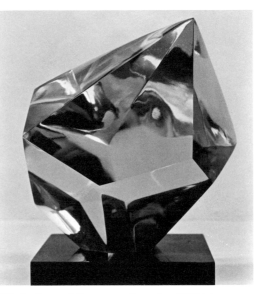

Gilioli: *Sky and Sea*. 1956. Crystal, 10¹/₂″ high

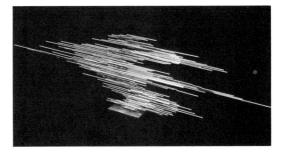

Kricke: *Plane of Rods*. 1960. Stainless steel welded with silver, 8³/₄ x 28¹/₈″

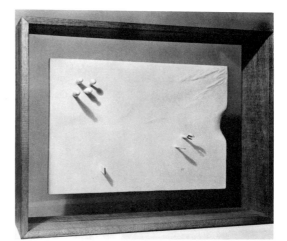

Dorazio: *Relief*. 1953. Painted wood and celluloid in frame, 17 x 21¹/₂ x 5¹/₈″

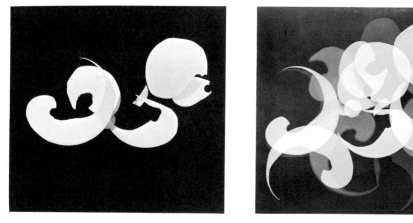

Tinguely: *Hatching Egg*. 1958. Motor-driven relief construction of painted metal and plywood, 30½ x 32½ x 9″

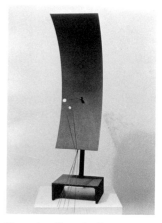

Tinguely: *Puss in Boots*. 1959. Motor-driven construction of painted steel and wire, 30⅛″ high

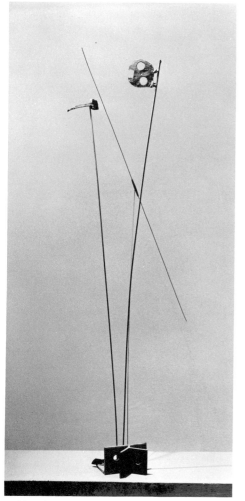

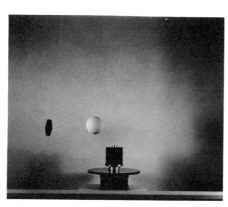

Takis: *Tele-Sculpture*. 1960–62. Three-part construction: electromagnet, 10⅝″ high x 12⅝″ diameter; top-shaped black-painted cork, 4″ high; white-painted wood sphere, 4″ diameter; cork and sphere contain magnets

Takis: *Signal Rocket*. 1955. Painted steel and iron, 48″ high

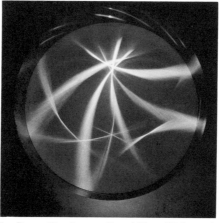

Le Parc: *Continuous Instability—Light*. 1962. Moving light beams projected on screen, 43½″ diameter

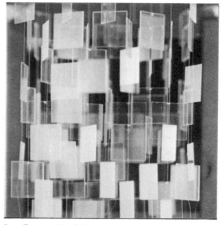

Le Parc: *Double Concurrence—Continuous Light*, 2. 1961. Construction, 21 x 19¾ x 5⅝″

Burri: *Sackcloth 1953*. 1953. Burlap, sewn, patched, and glued, over canvas, 33⁷/₈ x 39³/₈"

Kierzkowski: *Textured Composition, 150*. 1958. Cement and perforated metal strips on board, 20³/₈ x 26¹/₄"

Crippa: *Composition*. 1959. Bark mounted on plywood coated with paint, sawdust, and plastic glue, 6'6⁷/₈" x 6'6⁷/₈"

Kemeny: *Shadow of the Miracle*. 1957. Copper T-sections mounted on wood, 33⁵/₈ x 21⁷/₈"

Galactic Insect. 1956. Welded iron, 19⁷/₈ x 37″

Sculpture Picture. 1956. Welded iron, 30¹/₈ x 39³/₄ x 8″

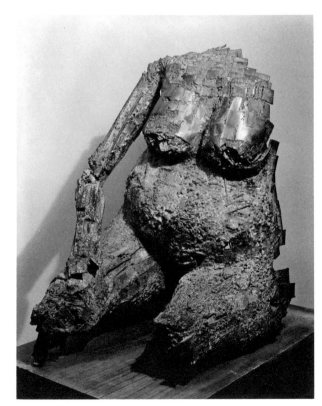

Torso. 1954. Welded iron, 30³/₈″ high

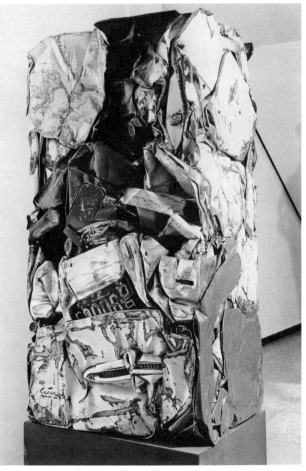

The Yellow Buick. 1961. Compressed automobile, 59¹/₂″ high

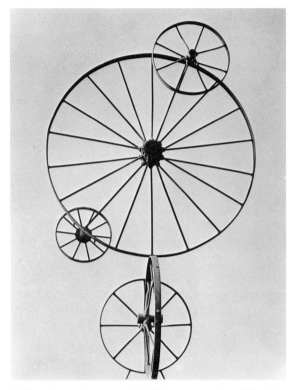

Colla: *Continuity*. 1951. Welded construction of five iron wheels, 7′11⁵/₈″ x 56″

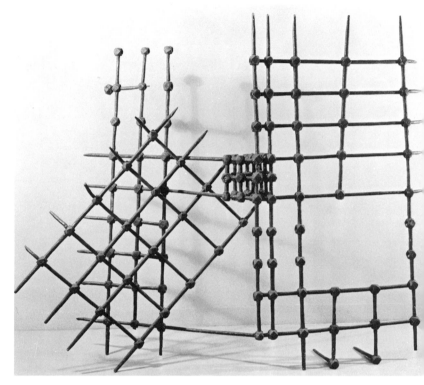

Koman: *My Country's Sun*. 1957. Antique wrought iron, reconstructed, 66¹/₈″ x 6′4¹/₈″

Rivera: *Metamorphosis (Heraldry)*. 1960. Relief of wire mesh on painted wood, 32¹/₄ x 40″

Millares: *Composition 9*. 1957. Whiting and lampblack on burlap and string, 27⁵/₈ x 53¹/₄″

Džamonja: *Metallic Sculpture*. 1959. Welded iron nails with charred wood core, 16³/₈" high

Müritoğlu: *The Unknown Political Prisoner*. 1956. Wood and iron, 53³/₄" high

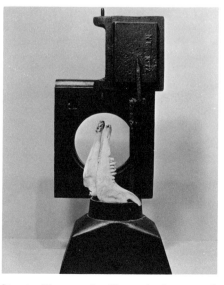

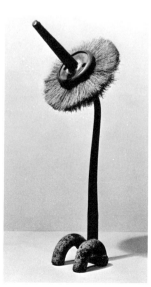

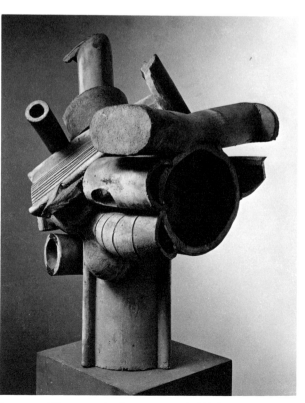

Stuart: *Mayo*. 1960. Sheep jawbones and parts of cast-iron stove, 22" high

Love: *Figure*. 1959. Welded steel and cast iron with brush, 16" high

Sørensen: *Woman*. 1960. Stoneware, 43⁵/₈" high

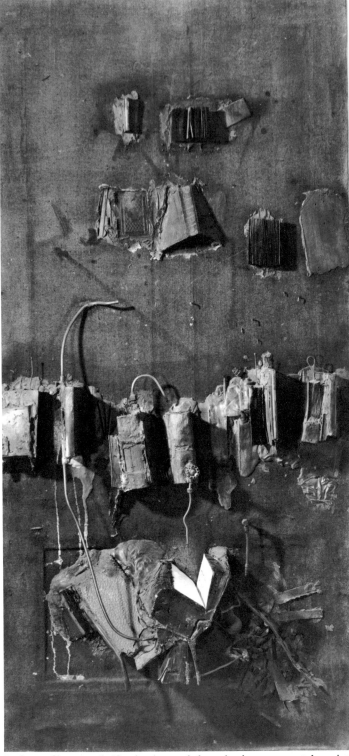

Latham: *Shem*. 1958. Hessian-covered door, books, scrap metals, paint, etc., 8'4½" x 46" x 12½"

Spoerri: *Kichka's Breakfast, I*. 1960. Wood chair hung on wall with board across seat, coffee pot, tumbler, china, eggshells, cigarette butts, spoons, tin cans, etc., 14⅜ x 27⅜"; chair projects 25¾"

Wagemaker: *Metallic Grey*. 1960. Wood panel with aluminum egg slicer and scrap metal, painted, 24 x 19⅝ x 2¾"

Kienbusch: *New England Collage, II*. 1947. Cedar shingles, asphalt roofing, tar paper, etc., nailed to painted board, 21$^1/_8$ x 26$^5/_8$"

Fischer: *Florida Bark*. 1951. Assemblage, 16 x 12"

Lewitin: *Innocence in a Labyrinth*. 1940. Collage of colored photoengravings, 8$^1/_2$ x 17$^1/_2$"

Manso: *Ascent 3*. 1962. Collage of painted fabric on cardboard, 26 x 12$^5/_8$"

von Wiegand: *Number 254–1960*. 1960. Collage of paper, string, bristles, 20$^3/_8$ x 10$^3/_4$"

Ryan: *Number 48*. 1950. Collage of pasted paper, tinfoil, and cloth on cardboard, 15$^3/_4$ x 12$^1/_2$"

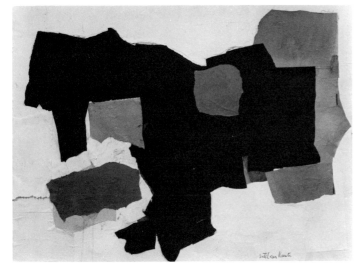

Vicente: *Blue, Red, Black, and White*. 1961. Collage of painted paper, 29⁷/₈ x 40¹/₄″

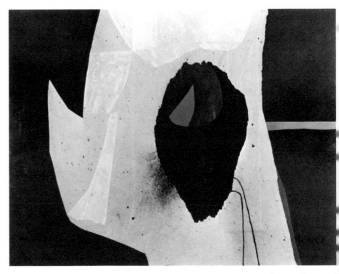

Bermúdez: *Microflora*. 1956. Collage of paper with charcoal, pencil, tempera, 19³/₄ x 25¹/₂″

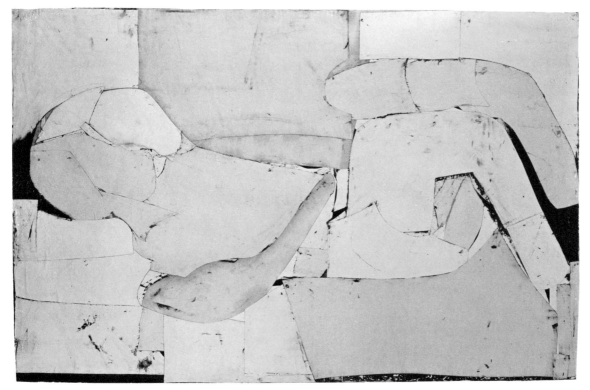

Marca-Relli: *Sleeping Figure*. 1953–54. Collage of painted canvas, 52¹/₈″ x 6′5⁵/₈″

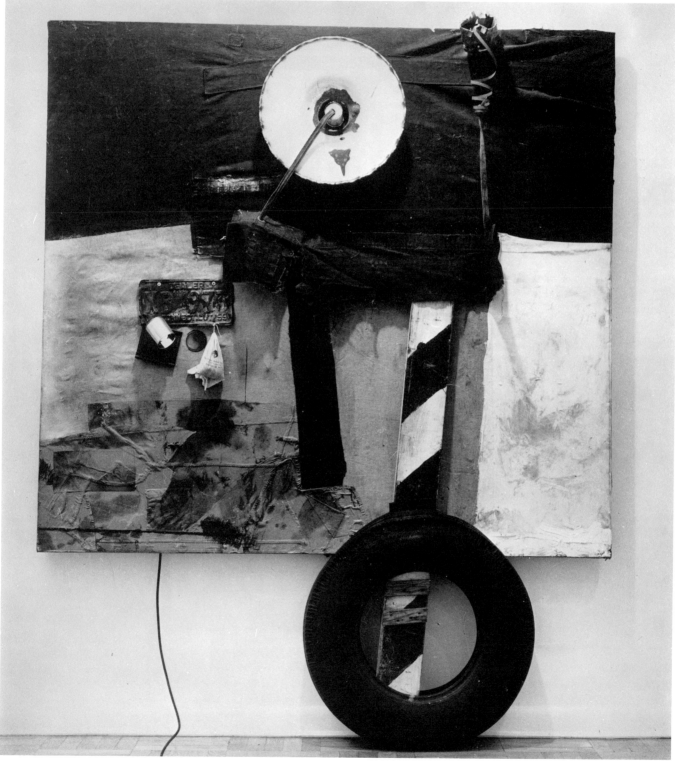

First Landing Jump. 1961. "Combine-painting," 7'5¹/8" x 6' x 8⁷/8"

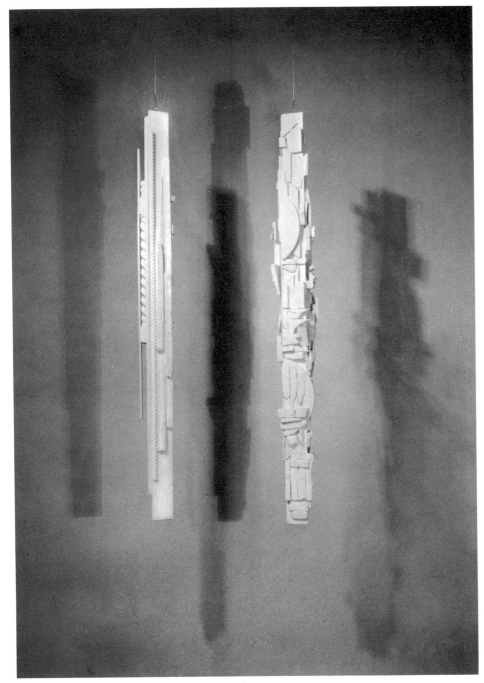

*Two Hanging Columns (*from *Dawn's Wedding Feast).* 1959. Wood painted white, each 6' high

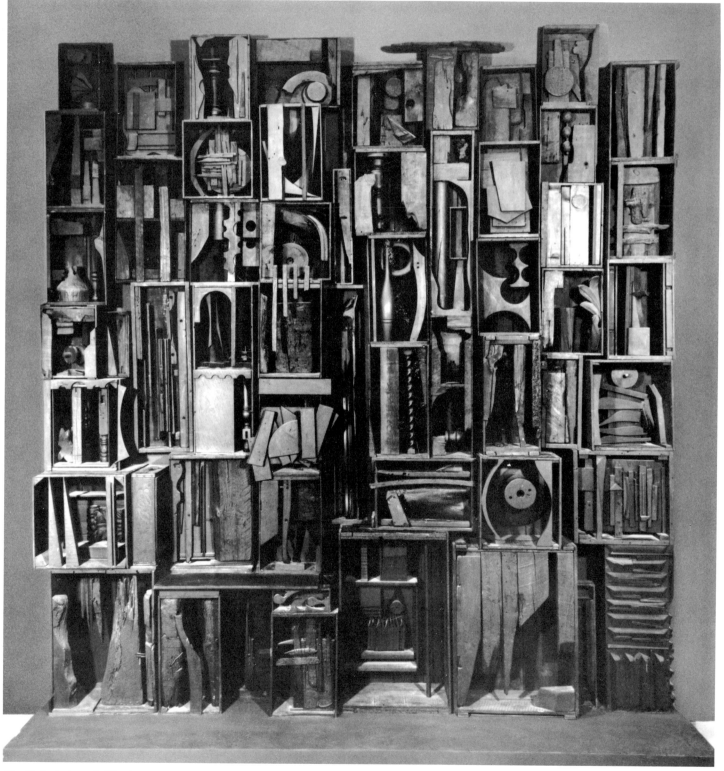

Sky Cathedral. 1958. Wood painted black, 11'3¹/₂" x 10'¹/₄" x 18"

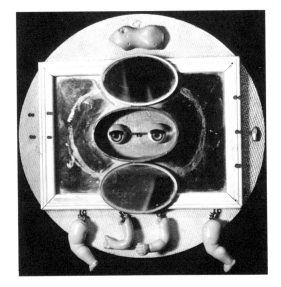

Stankiewicz: *Instruction*. 1957. Welded scrap iron and steel, 12¹/₂ x 13¹/₄ x 8⁵/₈″

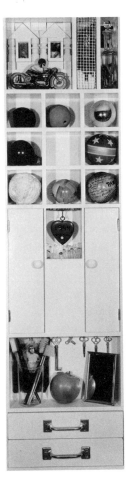

above left: Cohen: *Anybody's Self-Portrait*. 1953. Mirrors, plastic doll's torso, legs, and arms, painted doll's eyes, anchovy tin, etc., on composition board, 9⁵/₈″ diameter

left: Brecht: *Repository*. 1961. Cabinet with watch, thermometer, baseball, plastic persimmon, "Liberty" statuette, preserved worm, etc., 40³/₈ x 10¹/₂ x 3¹/₈″

Stankiewicz: *Natural History*. 1959. Welded iron pipes and boiler within wire mesh, 14³/₄ x 34¹/₄ x 19¹/₄″

Samaras: Untitled. 1960–61. Wood panel with plaster-covered feathers, nails, screws, nuts, pins, razor blades, flashlight bulbs, buttons, bullets, aluminum foil, 23 x 19 x 4″

above left: Follett: *Many-Headed Creature.* 1958. Light switch, cooling coils, window screen, nails, faucet knob, mirror, twine, cinders, etc., on wood panel, 24 x 24″

Conner: *The Box.* 1960. Wax figure, suitcase, tin cans, shredded nylon, etc., in wood box, 32¼ x 20⅜ x 35¼″

Moskowitz: Untitled. 1961. Oil on canvas, with part of window shade, 24 x 30″

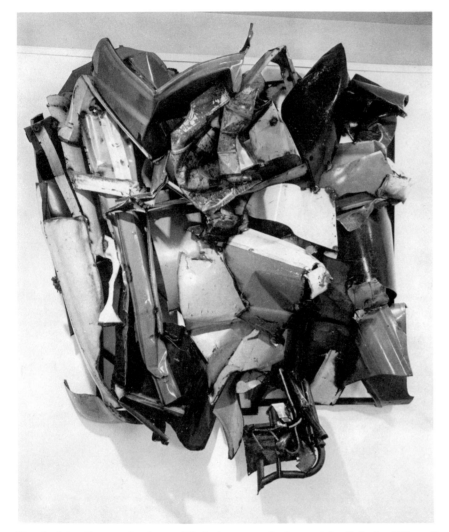

Chamberlain: *Essex*. 1960. Automobile body parts and other metal, relief, 9' x 6'8" x 43"

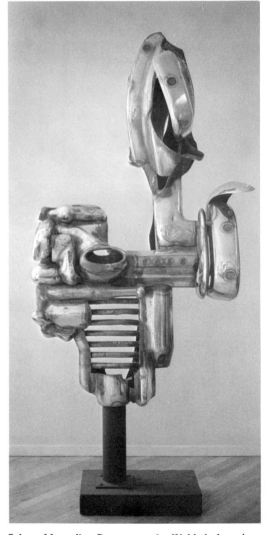

Seley: *Masculine Presence*. 1961. Welded chromium-plated steel automobile bumpers and grill, 7'2⅞" x 48"

Mallary: *In Flight*. 1957. Relief of wood, dust, sand, synthetic polymer resin on painted plywood, 43¹/₂″ x 6′7⁵/₈″ x 4³/₈″

Ortiz: *Archeological Find, 3*. 1961. Burnt mattress, 6′2⁷/₈″ x 41¹/₄″ x 9³/₈″

Mallary: *Phoenix*. 1960. Relief of cardboard and synthetic resins with sand over wood supports, 7′10¹/₂″ x 6′7¹/₂″

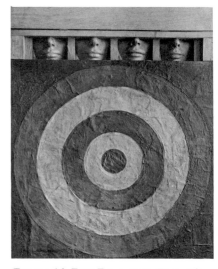

Target with Four Faces. 1955. Encaustic on newspaper over canvas, 26 x 26", surmounted by four plaster faces in a wood box, 3³/₄" high, with hinged front

Green Target. 1955. Encaustic on newspaper over canvas, 60 x 60"

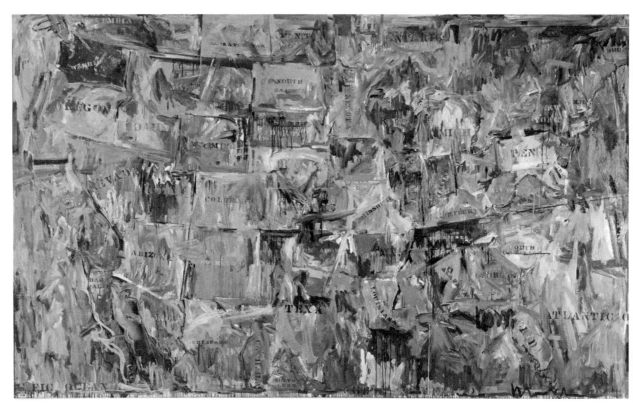

Map. 1961. Oil, 6'6" x 10'3¹/₈"

Johns: *White Numbers*. 1957. Encaustic on canvas, 34 x 28⅛"

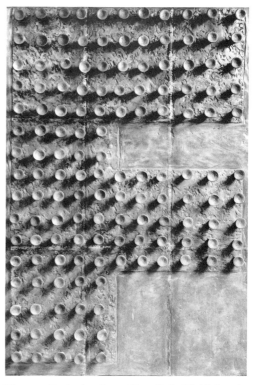

Chryssa: *Projection Letter F*. 1958–60. Welded and cast aluminum relief, 68⅜ x 46⅛ x 2½"

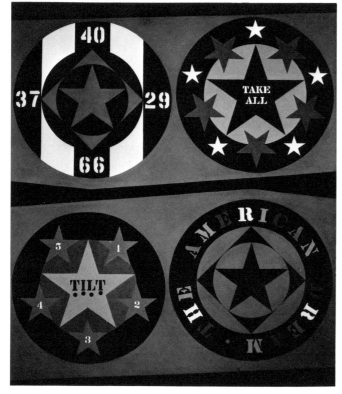

Indiana: *The American Dream, I*. 1961. Oil, 6' x 60⅛"

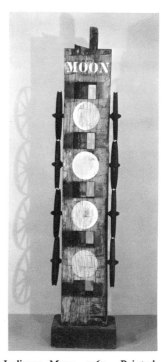

Indiana: *Moon*. 1960. Painted wood, iron-rimmed wheels, 6'6" high

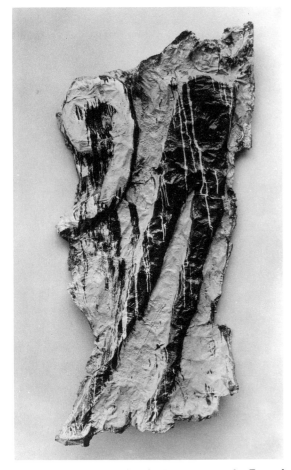

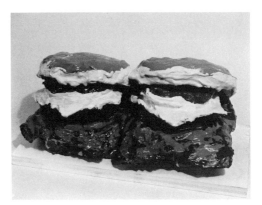

Oldenburg: *Two Cheeseburgers, with Everything (Dual Hamburgers)*. 1962. Painted plaster, 7 x 14³/₄ x 8⁵/₈″

Oldenburg: *Red Tights with Fragment 9*. 1961. Enamel paint on plaster-covered cloth over wire frame, 69⁵/₈ x 34¹/₄ x 8³/₄″

Thiebaud: *Cut Meringues*. 1961. Oil, 16 x 20″

Blosum: *Time Expired*. 1962. Oil, 37¹/₂ x 27⁷/₈″

Wesselmann: *The Great American Nude, 2.* 1961. Gesso, enamel,
oil, and collage, 59⁵/₈ x 47¹/₂″

right: Warhol: *Gold Marilyn Monroe.* 1962. Synthetic polymer
paint, silkscreened, and oil, 6′11¹/₄″ x 57″

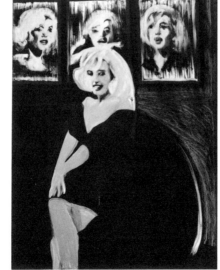

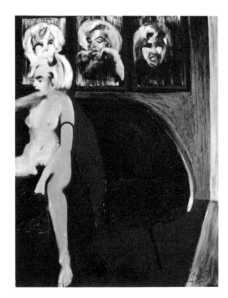

Gill: *Marilyn.* 1962. Triptych. Oil, each panel 48 x 35⁷/₈″

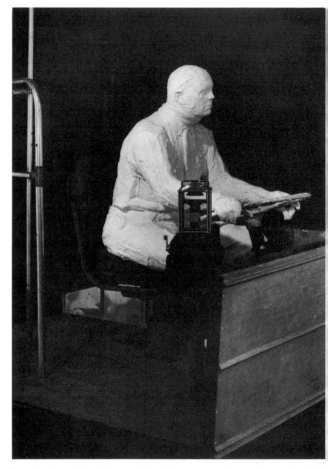

Marisol: *The Family*. 1962. Painted wood and other materials in three sections, 6′10⅝″ x 65½″

Segal: *The Bus Driver*. 1962. Plaster, wood, metal, and rubber platform, 5⅛″ x 51⅝″ x 6′3⅝″; figure, 53½″ high

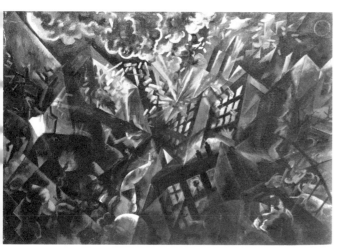

Grosz: *Explosion*. 1917. Oil, 18⁷/₈ x 26⁷/₈″

Manessier: *Figure of Pity*. 1944–45. Oil, 57³/₄ x 38¹/₄″

Baruchello: *Exit from the Great Accolade*. 1963. Oil, 25 x 24³/₄″

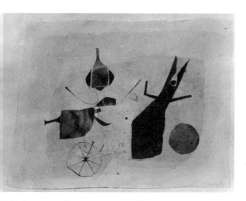

Bissier: *6 July 1959*. 1959. Oil and tempera, 8¹/₄ x 11¹/₄″

Masson: *Battle of a Bird and a Fish*. 1927. Oil, 39³/₈ x 25³/₄″

Graham: *Elinor Graham*. 1943. Oil, 20¹/₈ x 16″

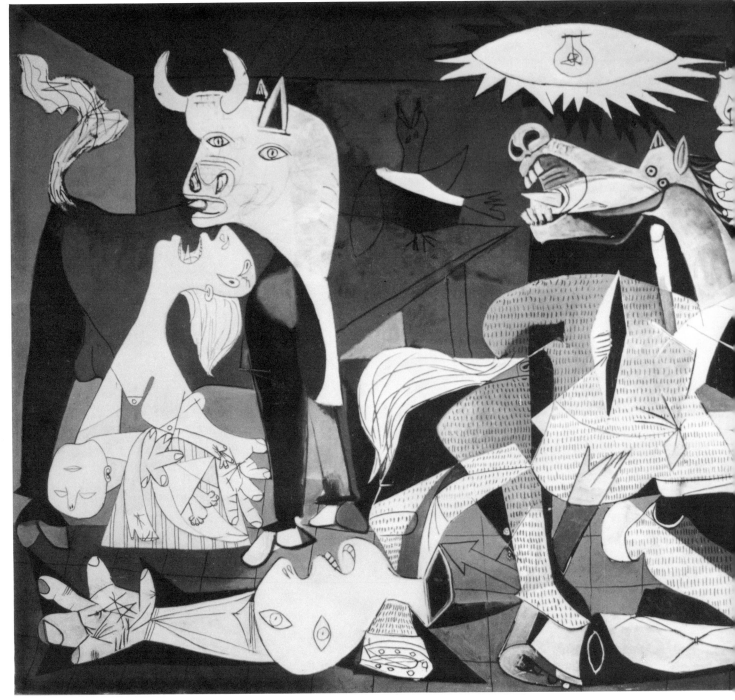

Guernica. May–early June 1937. Oil, 11′5¹/₂″ x 25′5³/₄″

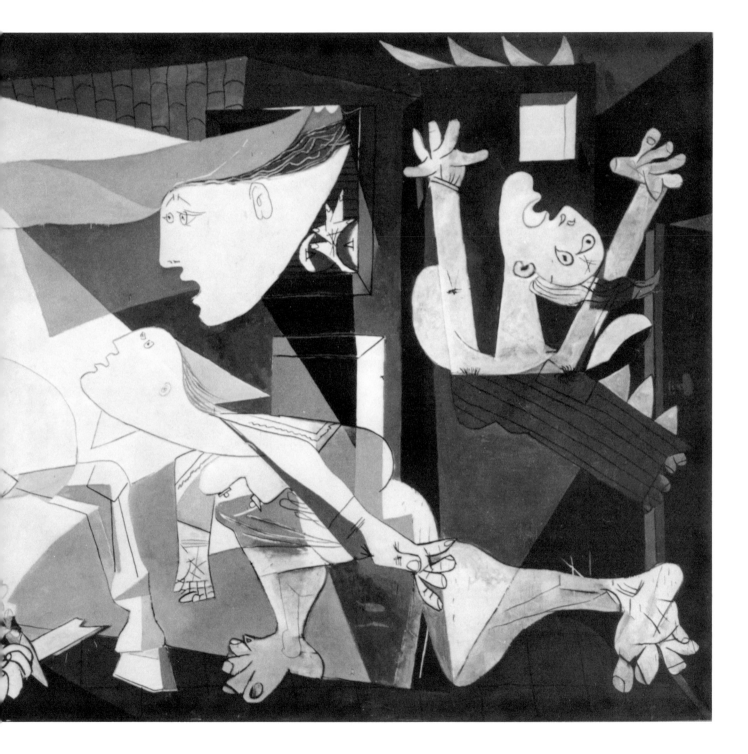

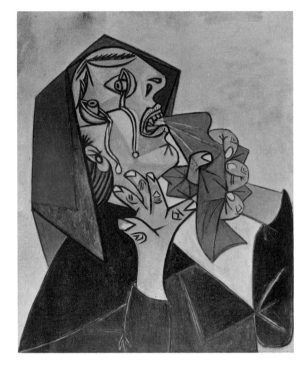

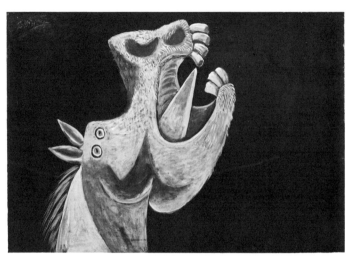

Horse's Head. May 2, 1937. Oil, 25¹/₂ x 36¹/₄"

left: Weeping Woman with Handkerchief. October 17, 1937. Oil, 36¹/₄ x 28⁵/₈"

All works on this page are studies for *Guernica*

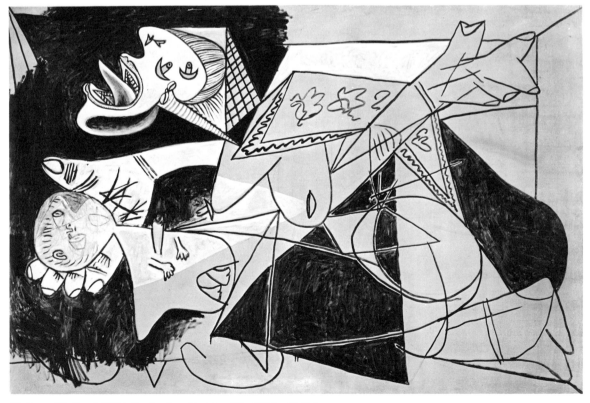

Mother with Dead Child. September 26, 1937. Oil, 51¹/₄" x 6'4³/₄"

PART II ACQUISITIONS OF 1964 THROUGH JUNE 1967

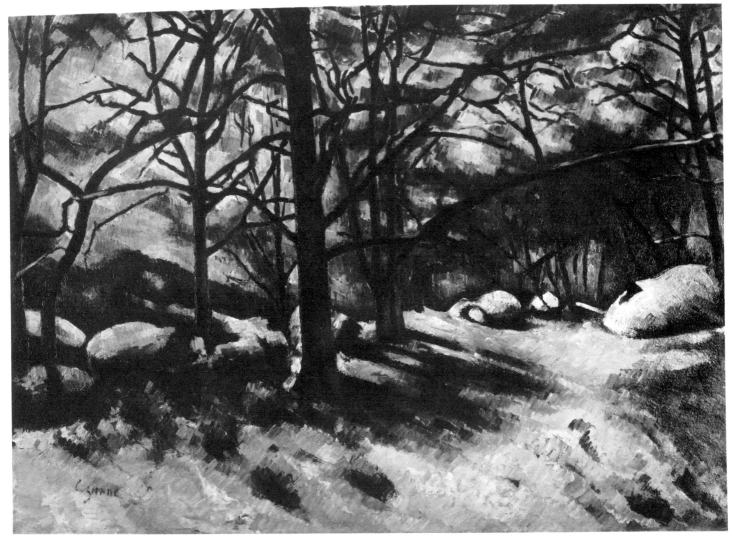

Melting Snow, Fontainebleau. c. 1879. Oil, 29 x 39⅝", irregular

Butterflies. 1910. Oil, 29¹/₈ x 21¹/₂"

Eilshemius: *The Hudson at Yonkers*. 1911? Oil, 15 x 20″

Wallis: *Rough Sea*. Oil and pencil, 8³/₈ x 11¹/₄″

Eilshemius: *Mosque near Biskra*. c. 1915? Oil, 30¹/₂ x 20¹/₄″

Eilshemius: *The Demon of the Rocks*. 1901. Oil, 20 x 15¹/₈″

Kubin: *As Day Flies So Goes the Night*. c. 1900–03? Gouache, wash, brush and ink, 13 x 10³/₄″

Eberz: *Stage*. 1916. Oil, 9¼ x 11⅞"

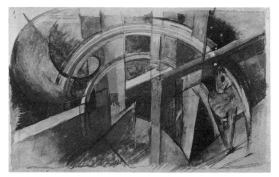

Marc: **Blue Horse with Rainbow**. 1913. Watercolor, gouache, and pencil, 6⅜ x 10⅛"

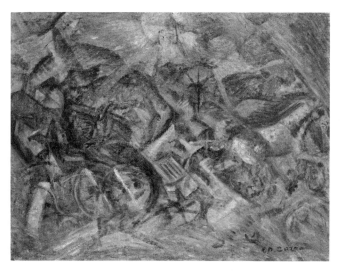

Carrà: *Jolts of a Cab*. 1911. Oil, 20⅝ x 26½"

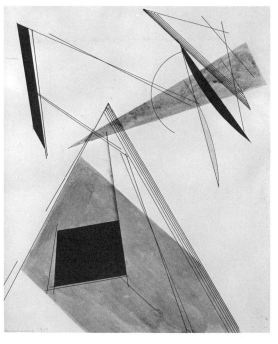

Rodchenko: *Composition*. 1919. Watercolor and ink, 14⅝ x 11½"

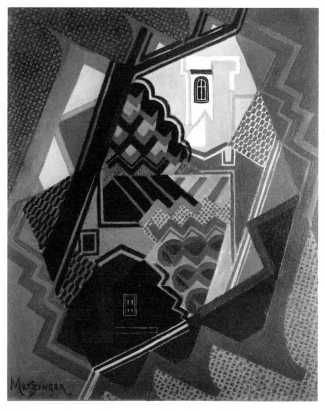

Metzinger: *Composition*. 1919? Oil, 31⅞ x 25⅝"

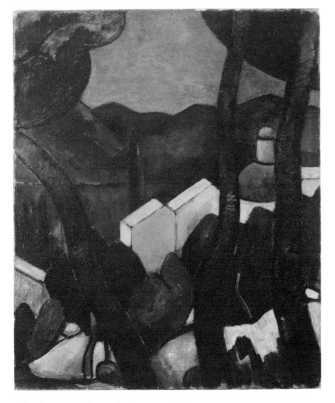

Martigues. 1908–09. Oil, 32 x 25⁵/₈″

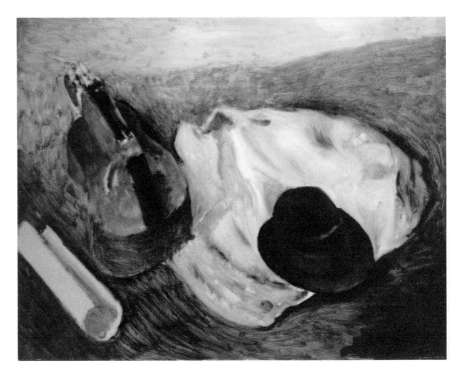

Still Life with a Blue Hat. 1912. Oil, 28³/₈ x 35⁷/₈″

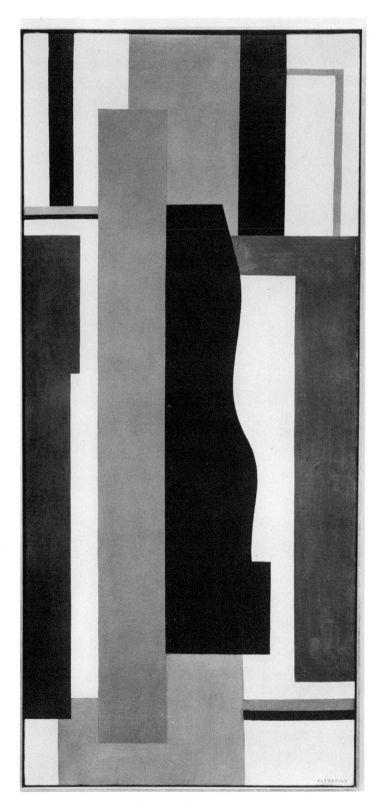

Project for a cinematic mural. Three of a
series of seven studies. 1939–40.
Gouache, pencil, pen and ink, 20 x 15"

Mural Painting. 1924. Oil, 71 x 31¹/₄"

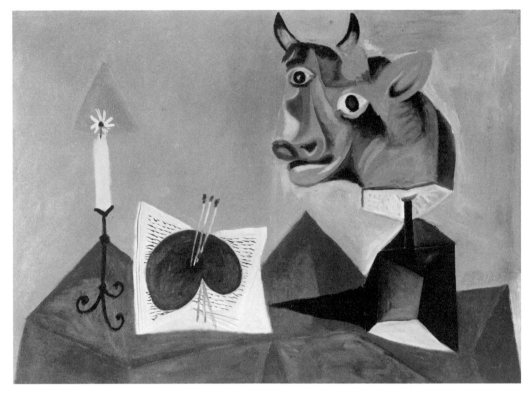

Still Life with Red Bull's Head. 1938. Oil and enamel, 38¹/₈ x 51″

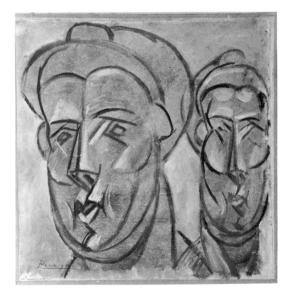

Two Heads. 1909. Oil, 13³/₄ x 13¹/₄″

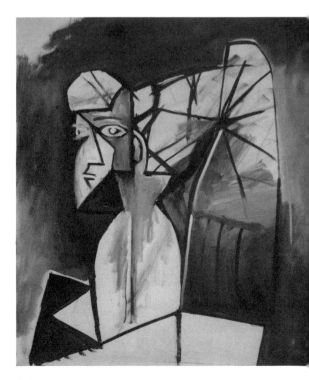

Sylvette. 1954. Oil, 28³/₄ x 23⁵/₈″

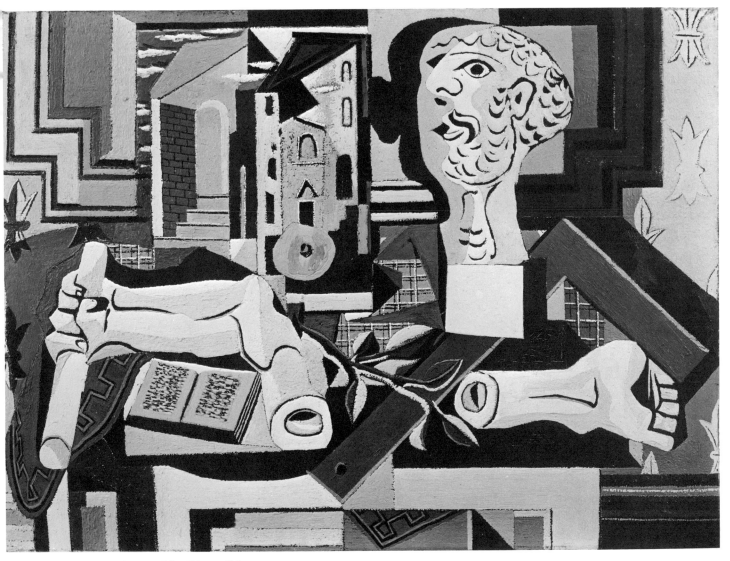

Studio with Plaster Head. 1925. Oil, 38⅝ x 51⅝"

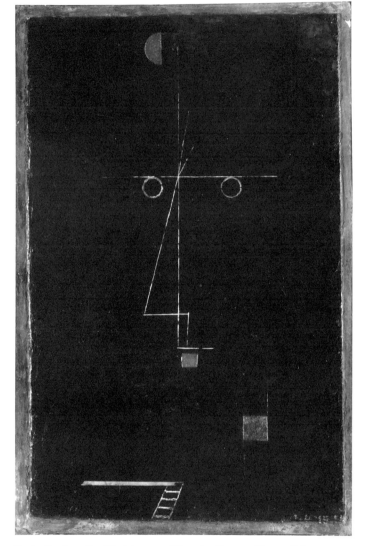

Portrait of an Equilibrist. 1927. Oil and collage, 24⁷/₈ x 15³/₄"

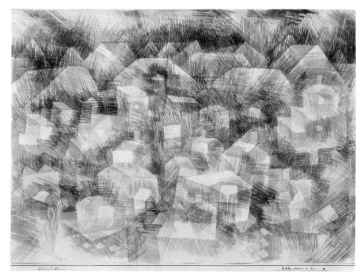

Early Morning in Ro. . . . 1925. Watercolor, 14⁵/₈ *x* 20¹/₈"

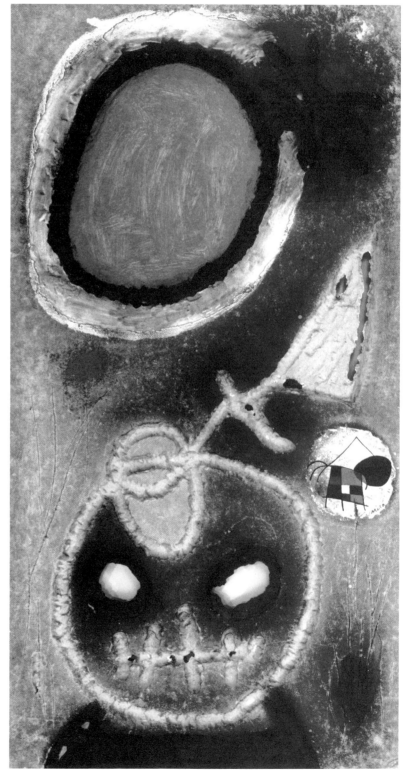

Person, Woman, Bird, Star at Sunset. 1953. Oil and gesso, 42¹/₂ x 21¹/₂″

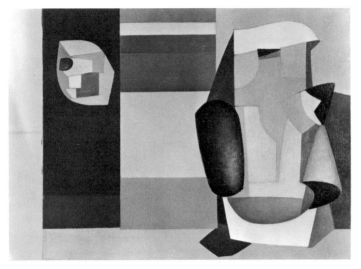

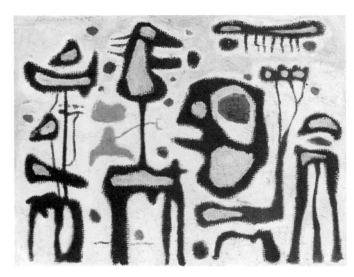

Hélion: *Composition*. 1938. Oil, 13¹/₈ x 16″

Baumeister: *African Play, IV*. 1942. Oil, 14¹/₈ x 18¹/₈″

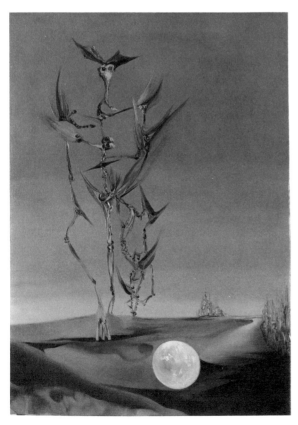

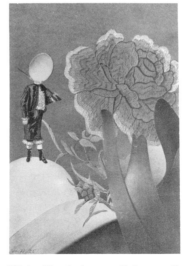

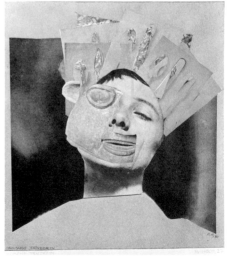

Paalen: Study for *Totem Landscape of My Childhood*. 1937. Oil, 21⁷/₈ x 15¹/₈″

Höch: *Watched*. 1925. Collage, 10⁷/₈ x 7³/₈″

Höch: *Indian Dancer (from an Ethnographic Museum)*. 1930. Collage, 10¹/₈ x 8⁷/₈″

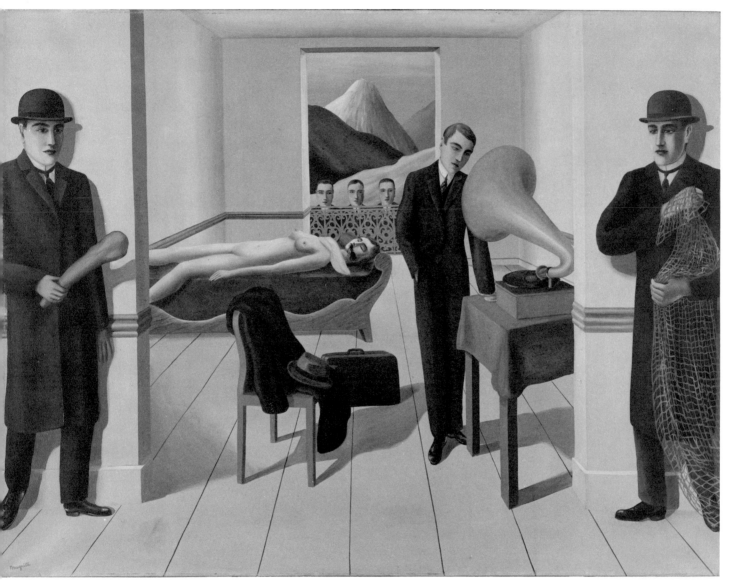

The Menaced Assassin. 1926. Oil, 59¼″ x 6′4⅞″

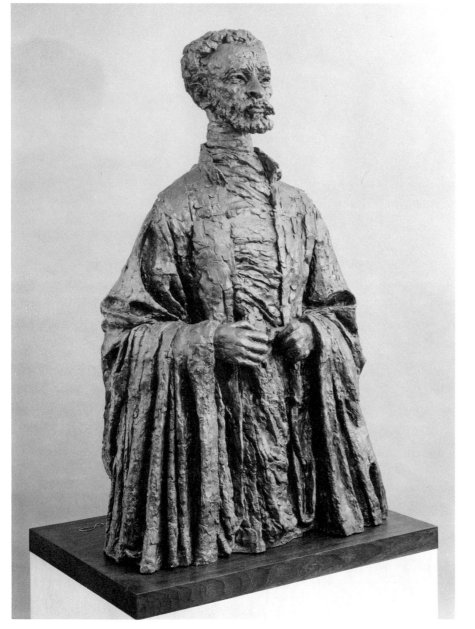

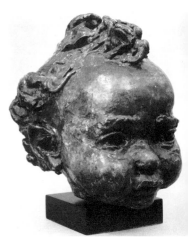

Leda (with Coxcomb). 1940. Tinted plaster, 8¹/₈ x 7¹/₄ x 7¹/₄″

Haile Selassie. 1936. Tinted plaster, 46¹/₄ x 27³/₄ x 17″

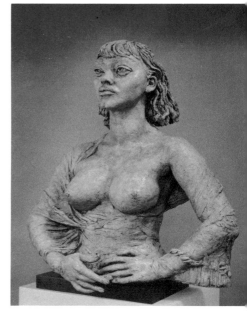

Isobel. 1933. Tinted plaster, 27⁷/₈ x 26¹/₂ x 18″

Paul Robeson. 1928. Bronze, 13¹/₂″ high

Robert Flaherty. 1933. Tinted plaster, 12¹/₂ x 8³/₈ x 11¹/₈″

Rosalyn Tureck. 1956. Tinted plaster, 12¹/₂ x 10¹/₈ x 10⁷/₈″

Pandit Nehru. 1946. Tinted plaster, 11⁵/₈ x 7¹/₈ x 9¹/₈″

413

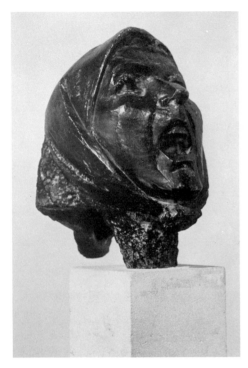

Gonzalez: *Head of the Montserrat, II.* 1942.
Bronze, 12³/₈ x 7³/₄ x 11¹/₈″

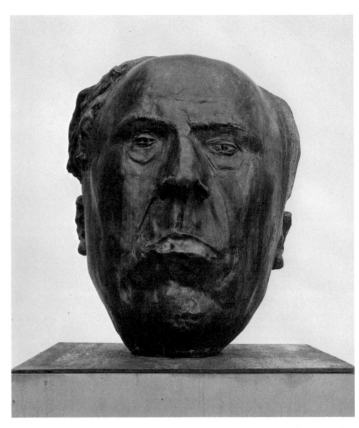

Serrano: *Head of Antonio Machado.* 1965. Bronze, 26 x 20⁷/₈ x 24⁵/₈″

Giacometti: Six untitled miniature figures. c. 1945. Plaster held upright by metal pins inserted
in plaster bases, 1³/₄ to 4¹/₂″ high

Giacometti: Untitled miniature figure. c
1945. Plaster, metal pin, 4¹/₂″ high

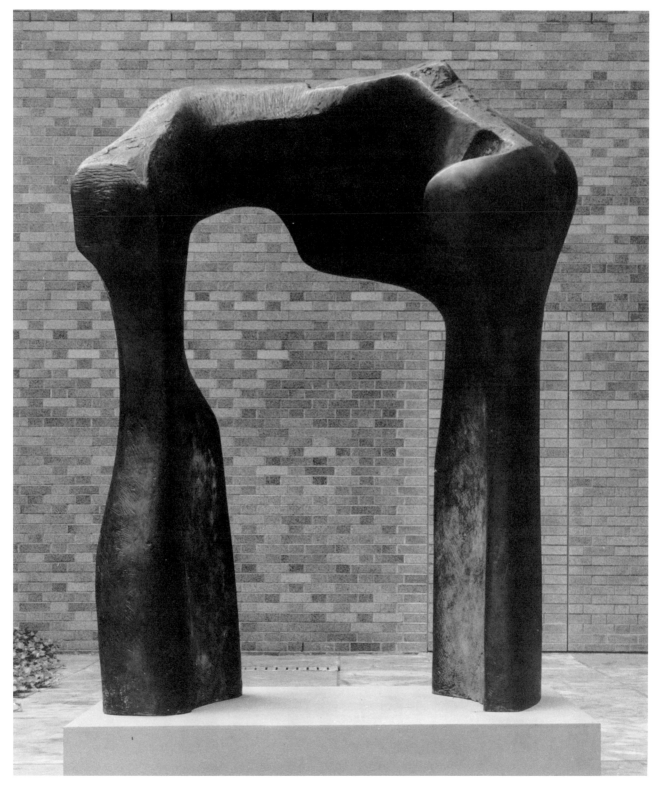

Large Torso: Arch. 1962–63. Bronze, 6'6¹/₈" x 59¹/₈" x 51¹/₄"

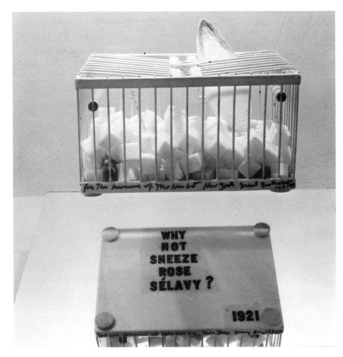

Duchamp: *Why Not Sneeze Rose Sélavy?* 1964. Replica of 1921 original. Painted metal birdcage, white marble blocks, thermometer, cuttlebone, 4⁷/₈ x 8³/₄ x 6³/₈"

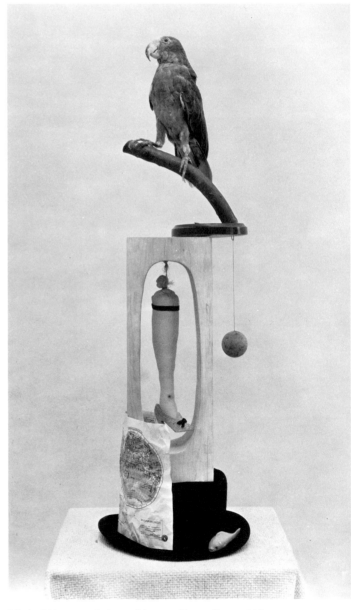

Miró: *Object*. 1936. Assemblage, 31⁷/₈ x 11⁷/₈ x 10¹/₄"

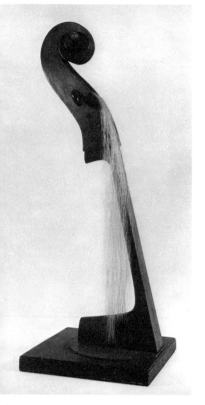

Man Ray: *Indestructible Object* (or *Object to Be Destroyed*). 1964. Replica of 1923 original. Metronome with cutout photograph of eye on pendulum, 8⅞ x 4⅜ x 4⅝"

Man Ray: *Cadeau*. c. 1958. Replica of 1921 original. Painted flatiron with metal tacks, 6⅛ x 3⅝ x 4½"

Man Ray: *Emak Bakia*. 1962. Replica of 1926 original. Cello fingerboard and scroll with horsehair, 29¼ x 5¾ x 10¾"

Cornell: *Object "Beehive."* 1934. Wood box containing diagram, pins, thimbles, copper screen, cardboard disc, etc., 3⅝" high, 7¾" diameter

Biederman: *Relief, New York.* 1936. Casein on wood, with metal, nails, and string, 33⅜ x 6¾ x 5⅞"

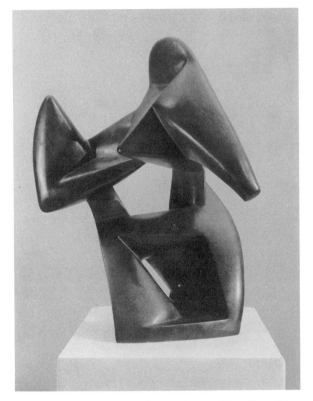

Archipenko: *Boxing*. 1914. Bronze (cast 1966), 23¹/₄ x 18¹/₄ x 15⁷/₈″

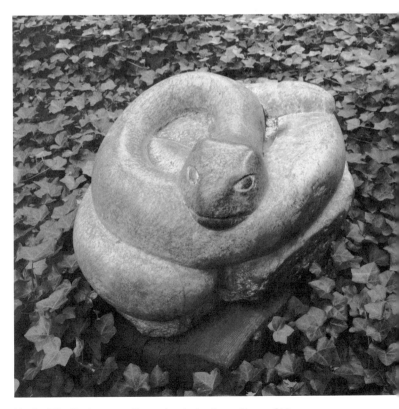

Vagis: *The Snake*. 1942. Stone (gneiss), 18 x 27⁵/₈ x 20⁷/₈″

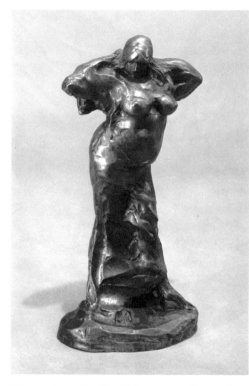

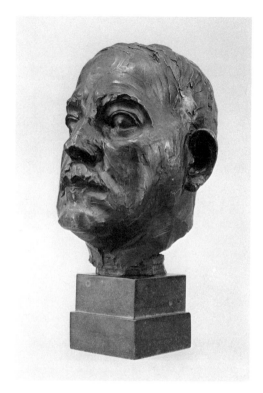

Woman Arranging Her Hair. 1910–12. Bronze (cast 1963), 10^1/$_2$ x 5^1/$_8$ x 2^3/$_4$″

Henry McBride. 1928. Bronze, 13^5/$_8$ x 10^1/$_8$ x 11^1/$_8$″

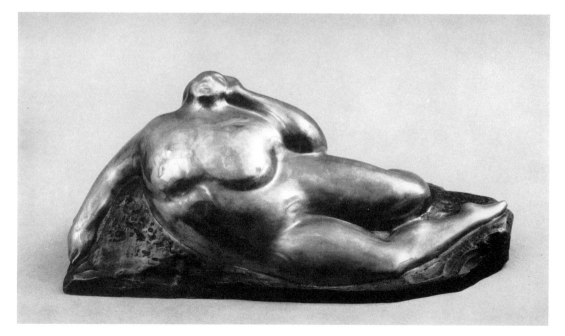

The Mountain. 1924. Bronze (cast 1964), 7^1/$_2$ x 19^3/$_8$ x 9^1/$_2$″

Josephine Baker. 1927–29. Iron-wire construction, 39 x 22³/₈ x 9³/₄″

Cow. 1929. Wire and wood construction, 3¹/₂ x 8¹/₈ x 4″

Soda Fountain. 1928. Iron-wire construction, 10

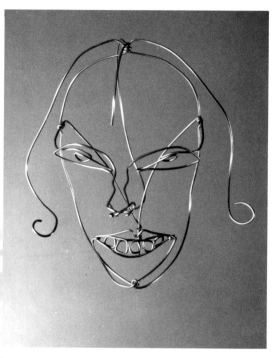

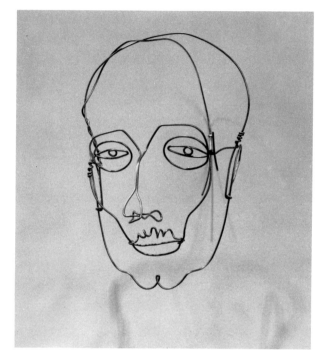

Marion Greenwood. 1929–30. Brass-wire construction, 12⁵/₈ x 11¹/₈ x 11³/₈″

Portrait of a Man. 1929–30. Brass-wire construction, 12⁷/₈ x 8³/₄ x 13¹/₂″

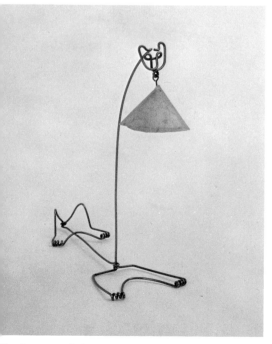

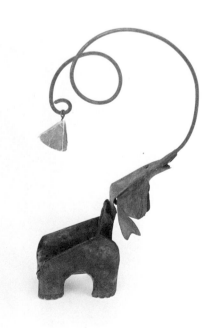

Cat Lamp. 1928. Iron-wire and paper construction, 8³/₄ x 10¹/₈ x 3¹/₈″

Elephant Chair with Lamp. 1928. Galvanized sheet steel, iron-wire, lead, cloth, and painted-paper construction, 7⁷/₈ x 3¹/₂ x 4¹/₈″

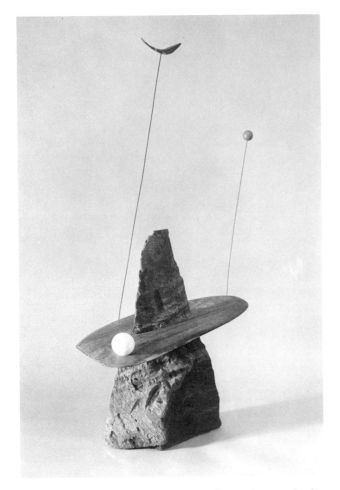

Gibraltar. 1936. Construction of lignum vitae, walnut, steel rods, and painted wood, 51⁷/₈ x 24¹/₄ x 11³/₈"

Shark Sucker. 1930. Wood, 10³/₄ x 30⁷/₈ x 10¹/₄"

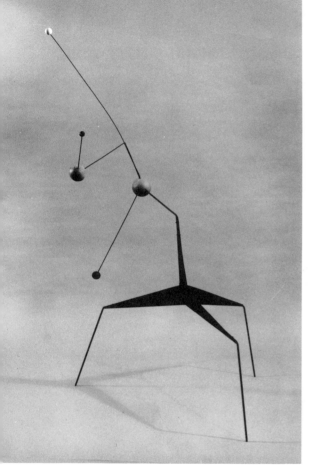

Morning Star. 1943. Stabile: painted sheet steel and steel wire, painted and unpainted wood, 6′4³/₄″ x 48³/₈″ x 45³/₄″

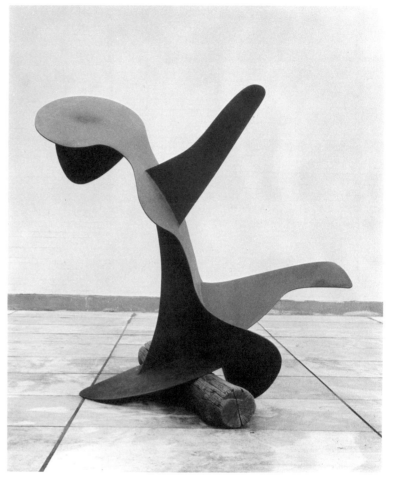

Whale, II. 1964. Replica of 1937 original. Standing stabile: painted sheet steel, supported by a log of wood, 68 x 69¹/₂ x 45³/₈″

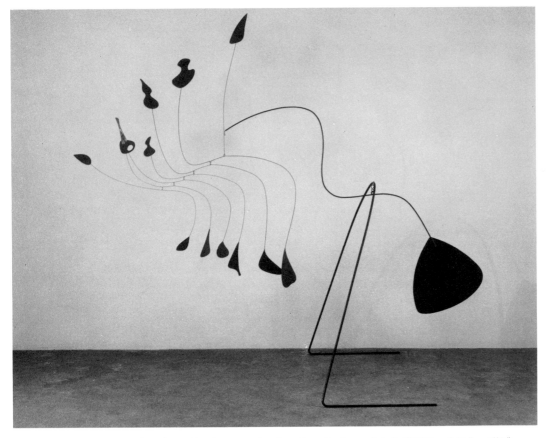

Spider. 1939. Standing mobile: sheet aluminum, steel rod, and steel wire, painted, 6'8¹/₂" x 7'4¹/₂" x 36¹/₂"

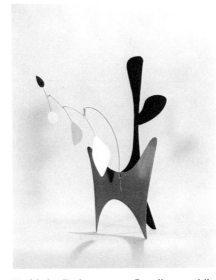

Untitled. Early 1940s. Standing mobile: sheet aluminum and steel wire, painted, 14⁵/₈ x 9 x 10⁷/₈"

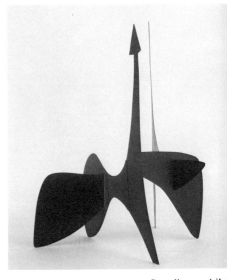

Model for *Teodelapio.* 1962. Standing stabile sheet aluminum, painted, 23³/₄ x 15¹/₄ x 15³/₄"

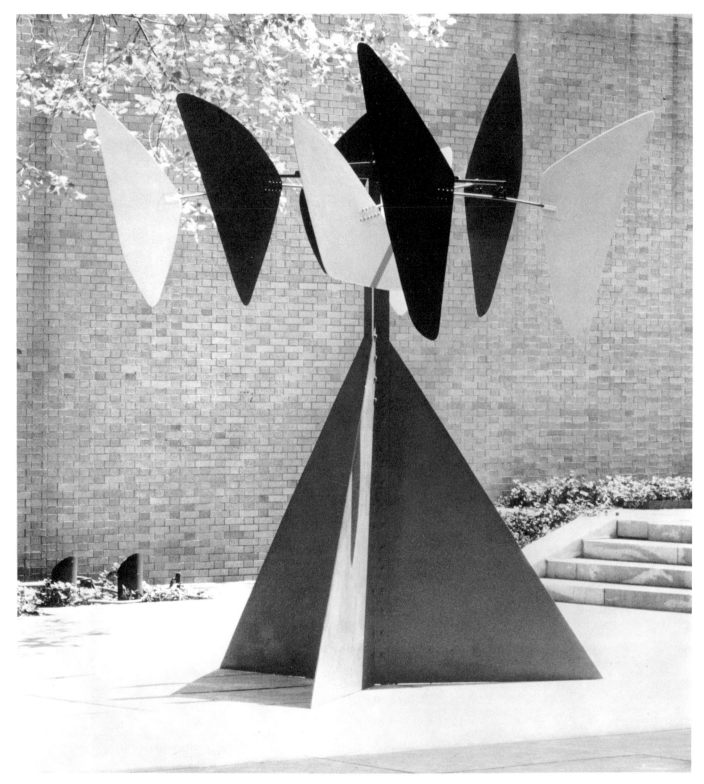

Sandy's Butterfly. 1964. Standing mobile: stainless sheet steel and iron rods, painted, 12′8″ x 9′2″ x 8′7″

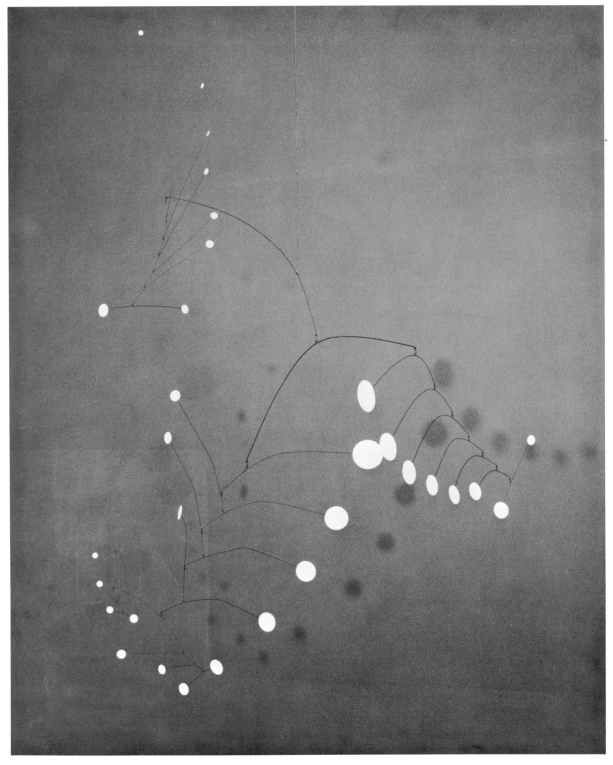

Snow Flurry, I. 1948. Hanging mobile: sheet steel and steel wire, painted, 7′10″ x 6′10¼″

Hartley: *Maine Mountains, Autumn*. c. 1909. Oil, 12¹/₈ x 12¹/₈″

Stella: *First Light*. c. 1928. Oil, 16¹/₄ x 16¹/₄″

Sparhawk-Jones: *Startled Woman*. c. 1956? Oil, 19 x 26¹/₈″

Ruin by the Sea. 1930. Oil, 27 x 43³/₈″

Uprising. 1910. Oil, 41¹/₈ x 37⁵/₈″

Manhattan, I. 1940. Oil, 39⁵/₈ x 31⁷/₈"

Davis: *Salt Shaker.* 1931. Oil, 49⁷/₈ x 32″

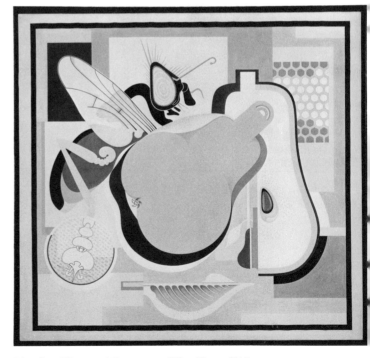

Murphy: *Wasp and Pear.* 1927. Oil, 36³/₄ x 38⁵/₈″

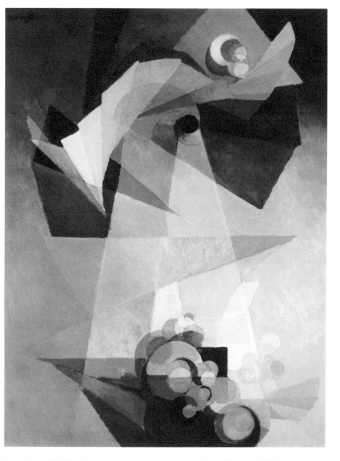

Macdonald-Wright: *Embarkation*. 1962. Oil, 48¼ x 36⅛″

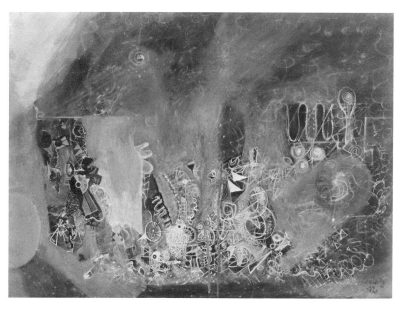

Tobey: *The Void Devouring the Gadget Era*. 1942. Tempera, 21⅞ x 30″

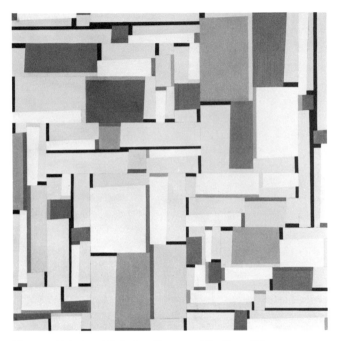

Glarner: *Relational Painting, 85*. 1957. Oil, 48 x 46¹/₈″

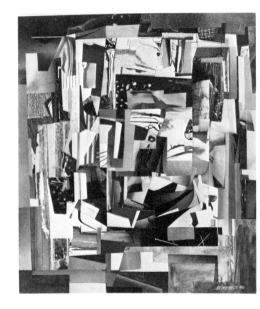

Reinhardt: *Collage, 1940*. 1940. Collage, 15³/₄ x 13¹/₈″

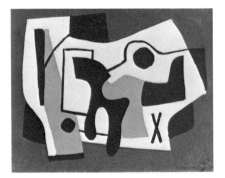

Reinhardt: Study for a painting. 1938. Gouache, 4 x 5″

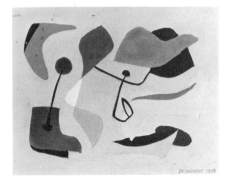

Reinhardt: Study for a painting. 1939. Gouache, 4 x 5″

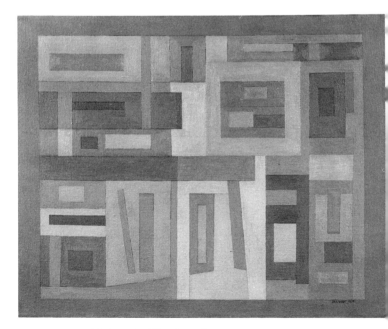

Reinhardt: Untitled. 1938. Oil, 16 x 20″

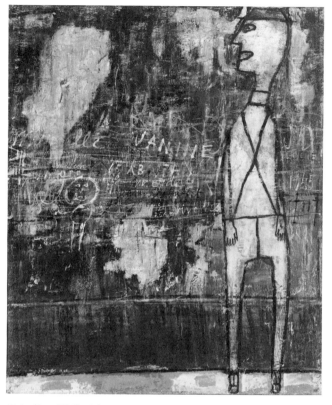

Dubuffet: *Wall with Inscriptions*. 1945. Oil, 39³/₈ x 31⁷/₈″

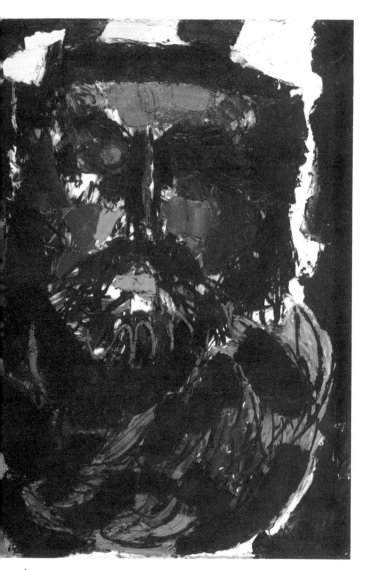

el: *Étienne-Martin*. 1956. Oil, 6′4⁷/₈″ x 51¹/₄″

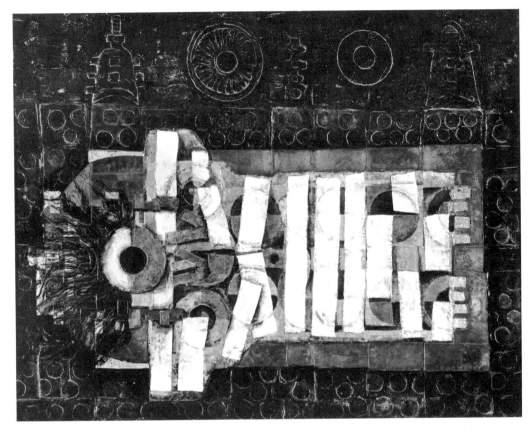

French: *The Princess*. 1965. Enamel and gold leaf, copper panels, and burlap collage, 48¹/₄ x 60″

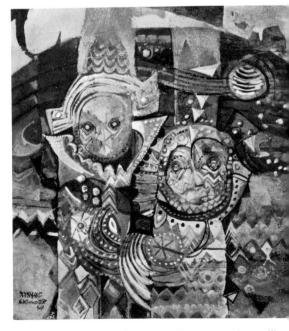

Skunder: *Ju-Ju's Wedding*. 1964. Tempera and metallic
on cut and torn cardboard, 21¹/₈ x 20″

Colville: *Skater*. 1964. Synthetic polymer paint, 44¹/₂ x 27¹/₂″

Pistoletto: *Man with Yellow Pants*. 1964. Collage with oil and pencil on polished stainless steel, 6′6⁷/₈″ x 39³/₈″

López García: *The Apparition*. 1963. Oil on wood relief, 21¹/₂ x 31⁵/₈ x 5³/₈″

Vieira da Silva: *The City*. 1950–51. Oil, 38³/₈ x 51"

Gujral: *Outpost*. 1962. Oil and mixed mediums, 33¹/₈ x 44³/₈"

Salahi: *The Mosque*. 1964. Oil, 12¹/₈ x 18¹/₈"

Lowry: *Ships near Cumberland Coast*. 1963. Oil, 11⁷/₈ x 19¹/₄"

Shalom of Safed: *Noah's Ark*. 1965. Synthetic polymer paint on paper, 26¹/₂ x 18⁷/₈"

Burt: *The Old House Endures*. 1966. Synthetic polymer paint, with collage of corrugated cardboard and cloth, 47³/₈ x 47³/₈"

Mishaan: *Maya*. 1965. Collage of casein-painted newspaper and synthetic polymer paint, 40¼ x 60″

Dechar: *Pears*. 1966. Oil, 54⅛″ x 6′1¼″

Daybreak. 1962. Oil, 57¼" x 6'1¼"

Lichtenstein: *Flatten—Sand Fleas!* 1962. Synthetic polymer paint and oil, 34¹/₈ x 44¹/₈″

Warhol: *Campbell's Soup.* 1965. Oil silkscreened on canvas, 36¹/₈ x 24″

Warhol: *Campbell's Soup.* 1965. Oil silkscreened on canvas, 36¹/₈ x 24¹/₈″

Highway U.S. 1, Number 5. 1962. Synthetic polymer paint, 70″ x 6′9½″

Kraa: Untitled. 1964. Oil, 15¹/₈ x 15"

Copley: *Think*. 1964. Oil, 25⁵/₈ x 32"

Benedit: *Pullet*. 1963. Oil and enamel, 31¹/₂ x 23³/₄"

Martínez: *Colored Incomprehension*. 1964. Pen and colored inks, and colored pencils, 11³/₈ x 16³/₈"

Nilsson: *The Pink Suit*. 1965. Watercolor, 9⁷/₈ x
⁷/₈″

Porter: *Flowers by the Sea*. 1965. Oil, 20 x 19¹/₂″

Markman: *Family Circle*. 1965. Synthetic polymer paint, 48⁷/₈ x 56¹/₂″

Kitaj: *The Ohio Gang*. 1964. Oil and crayon, 6'1/8" x 6'1/4"

Johnson: *Freedom Now, Number 1.*
1963–64. Pitch on canvas with assemblage, 53⁷/₈ x 55³/₈ x 7¹/₂"

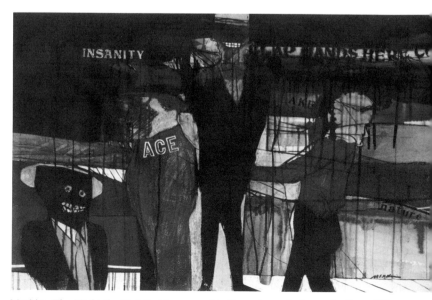

Merkin: *The Night the Nut Got Loose*. 1965. Gouache and charcoal, 26 x 39³/₄"

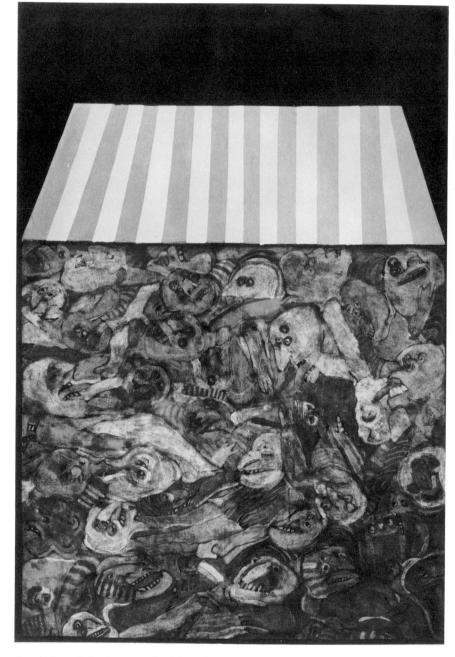

Seguí: *Box of Gentlemen*. 1964. Oil, 6'4⁷/₈" x 51³/₈"

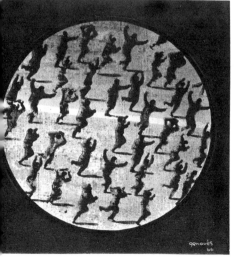

novés: *Micrography*. 1966. Oil, 10¹/₈ x 9³/₈"

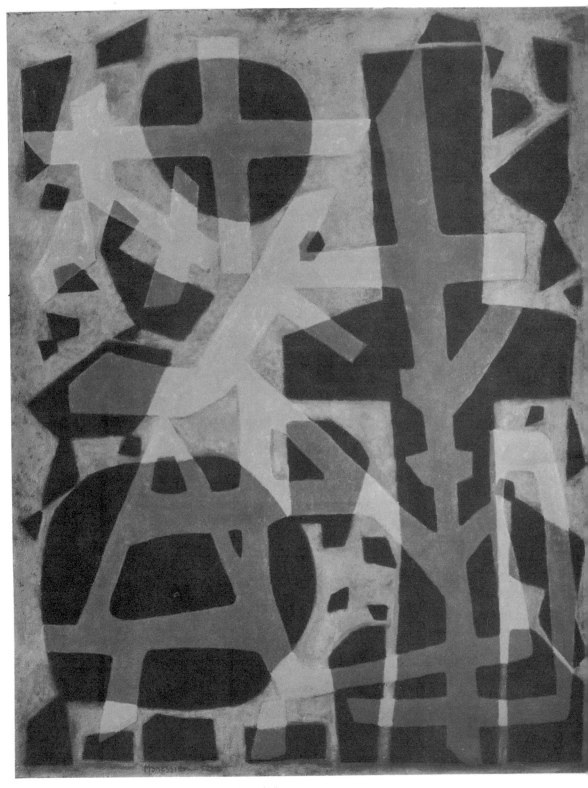

For the Feast of Christ the King. 1952. Oil, 6'7" x 59⅛"

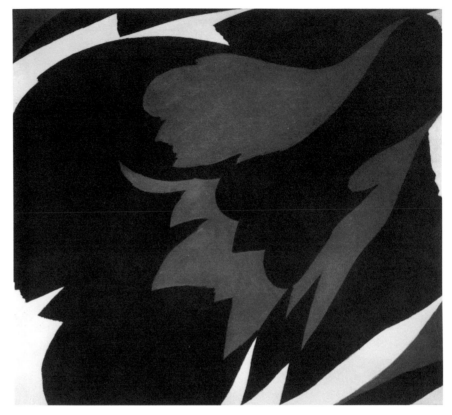

Youngerman: *Black, Red, and White.* 1962. Oil, 6'3⅝" x 6'11"

Haubensak: Study for *Mauresque.* 1965. Synthetic
polymer paint, 24³/₈ x 19⅝"

Sills: *Landlocked*. 1960. Oil, 51³/₄ x 68¹/₄″

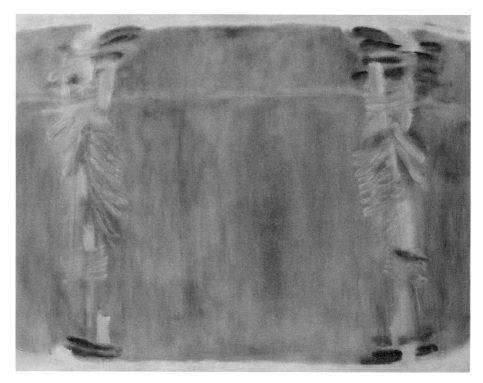

Messagier: *June Crossing*. 1956. Oil, 58⁷/₈″ x 6′4³/₈″

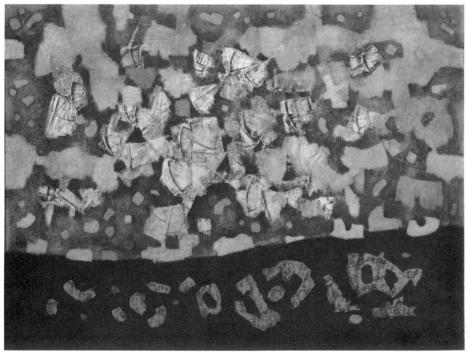

Ardon: *Amulet for a Yellow Landscape*. 1966. Oil and tempera, 38$^{1}/_{8}$ x 50$^{3}/_{4}$"

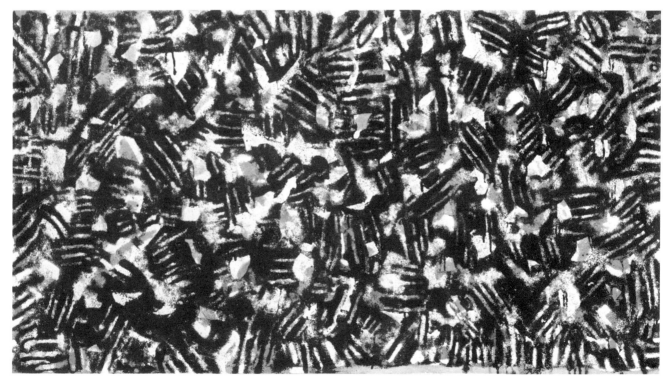

Vasiri: Untitled. 1962. Sand and synthetic polymer paint, 39$^{3}/_{8}$ x 71"

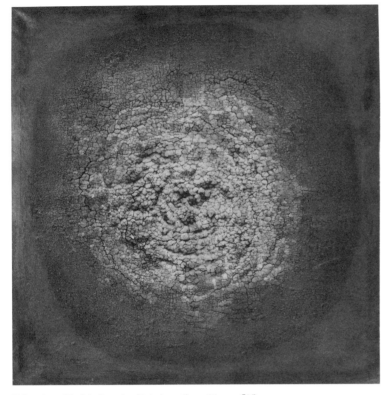

Grigorian: Untitled. 1963. Dried earth, 33¹/₂ x 31⁷/₈″

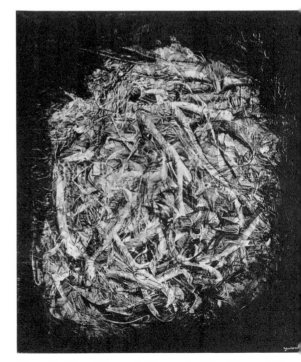

Yacoubi: *King Solomon's Ring*. 1963. Oil, 28³/₄ x 23¹/₂″

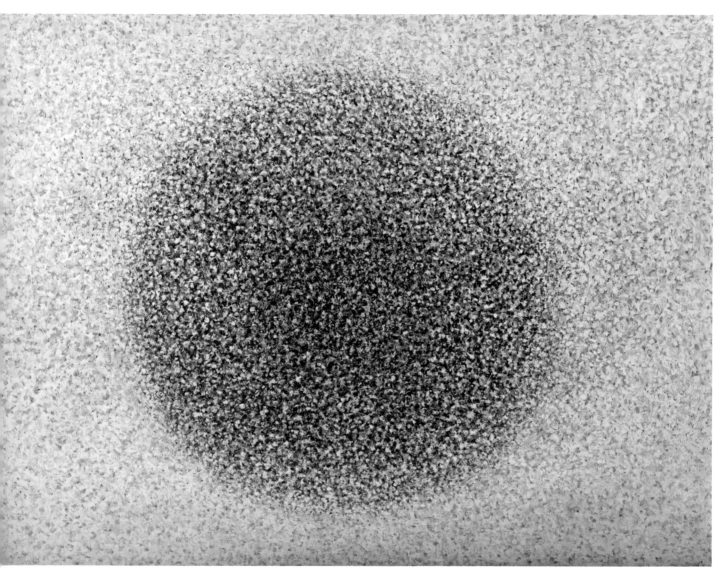

adiance. 1962–63. Oil and metallic paint, 6'1/8" x 8'1/4"

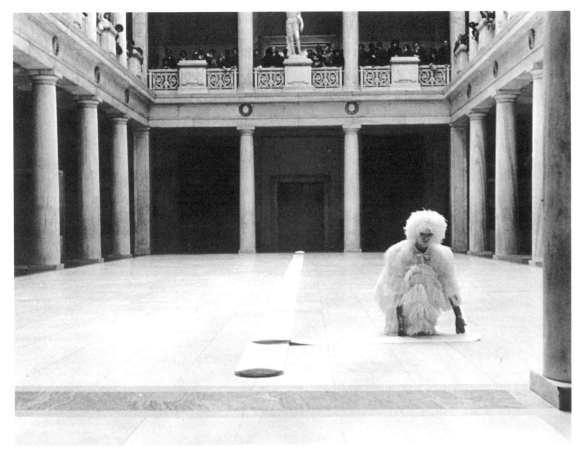

Untitled Object (Rivet Continuity). 1962–64. Japanese handmade white flax paper in seventy-five sections connected by rivets; 12″ x 500′. In performance at Carnegie Institute, Pittsburgh, October 25, 1965

Untitled Object (A Mile-Long Paper Walk). 1962–64. Japanese handmade white flax paper; folded, 36 x 36 x 3″

Untitled Object (Runcible). 1962–64. Japanese handmade white flax paper, 18″ cube

Performance of *Untitled Object* (below) in the temple of Shokukuji Monastery, Kyoto, Japan, July 21, 1964

Untitled Object. 1962–64. Crayon on Japanese handmade white flax paper; folded, 12 x 12 x 3³/₄″

The Tree. 1964. Oil and pencil, 6 x 6′

The Wild. 1950. Oil, 7′11³/₄″ x 1⁵/₈″

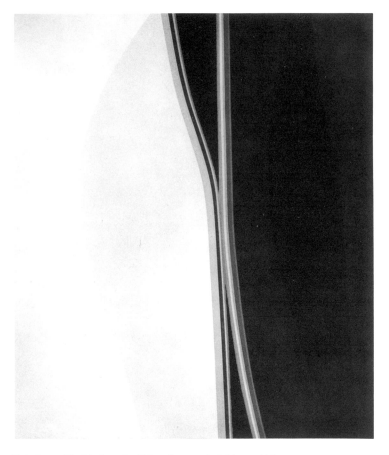

Feitelson: Untitled. 1964. Oil and enamel, 60¼ x 50¼"

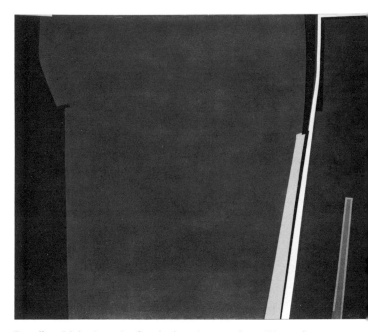

Douaihy: *Majestic*. 1965. Synthetic polymer paint, 46¼ x 54"

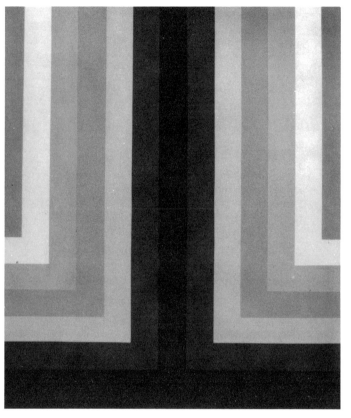

Mehring: *Nova*. 1965. Synthetic polymer paint, 7′7/8″ x 70¹/8″

Denny: *Folded*. 1965. Oil, 6′11⁷/8 x 6′

Krushenick: *The Red Baron*. 1967. Synthetic polymer paint, 8'1/8" x 6'3¼"
at top, 65¼" at bottom

Paternosto: *Duino*. 1966. Oil, 6'6¾" x 51³/8", and 6'6¹/8" x 51

Anthracite Minuet. 1966. Synthetic polymer paint, 7′9¹/₈″ x 7′7¹/₈″

Town: *Optical Number 9.* 1964. Oil and synthetic polymer paint, 60 x 60″

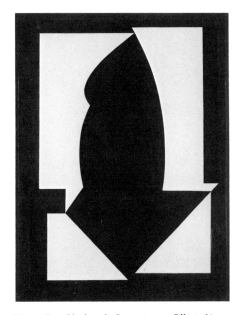

Vasarely: *Yarkand, I.* 1952–53. Oil, 39¹/₂ x 28³/₄″

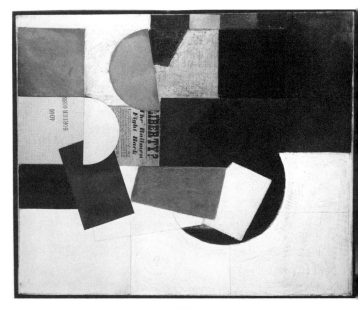

Pasmore: *Square Motif in Brown, White, Black, Blue, and Ochre.* 1948–5, Collage and oil, 25 x 30″

Dorazio: *Hand of Mercy*. 1963. Oil, 64¹/₈ x 51³/₈"

Quinte: *Blue Field, III*. 1963. Oil, 51¹/₂ x 39⁵/₈"

Sage: *The Great Impossible*. 1961. Watercolor, ink, and collage with convex lenses, 12⅝ x 9⅜″

Johnson: *Caged*. 1959. Collage with gouache and watercolor, 10½ x 7⅜″

Scliar: *Pear and Cherry*. 1965. Synthetic polymer paint and collage, 11 x 7″

Day: *Across the Lethe*. 1962. Oil and collage of photographs and playbills, 60 x 50⅛"

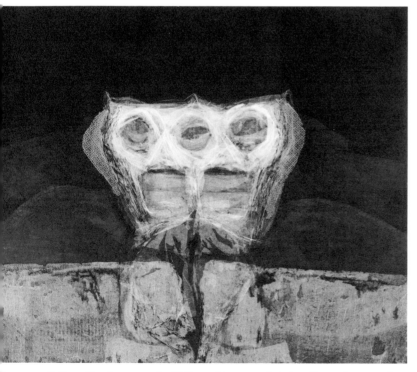

Farreras: *Collage Number 242*. 1965. Collage of tempera-tinted and burned papers, 60 x 50⅛"

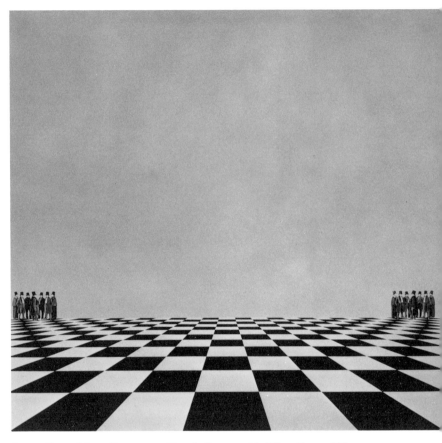

Stern: *Seven Minus Twenty-one Equals Seven*. 1966. Oil, 50¼ x 50⅛″

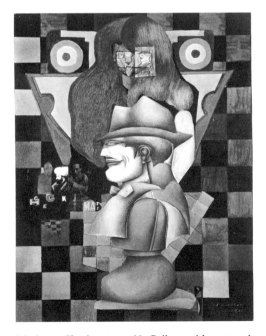

Lindner: *Checkmate*. 1966. Collage with watercolor, pencil, crayon, pastel, brush and ink, 23⅞ x 18″

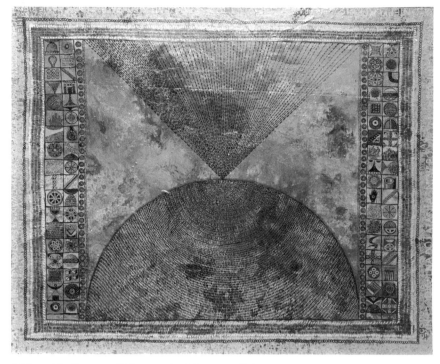

Makowski: *Separate Objects*. 1963. Oil, 32 x 39³/₈"

Al-Kazi: *Conception*. 1962. Gouache and gold spray
paint, 30¹/₂ x 20¹/₂"

465

Khakhar: *Kali*. 1965. Enamel and metallic papers, 68¹/₄ x 60″

Marsicano: *She*. 1959. Oil, 60⁵/₈ x 52¹/₈″

Israel: Untitled. 1964. Oil, 30¹/₈ x 22¹/₄″

Rodríguez-Larrain: *Birth of a Personage*. 1965. Oil and tempera, 6′6³/₄″ x 56″

Fernández: Untitled. 1964. Oil, 49 x 48⁵/₈″

Voices of Silence. 1962. Oil, 55¼″ x 6′7″

Tyapushkin: *Emotional Sign*. 1965. Oil and tempera mixed with sawdust, 51¼ x 39⅝″

Nemukhin: *Cards on a Marquetry Table*. 1966. Oil, tempera, and collage, 43⅜ x 35⅛″

Varazi: *Bleeding Buffalo*. 1963. Cloth trousers, glue, oil paint, wood boards, 25⅛ x 14⅞ x 4⅜″

Plavinsky: *Coelacanth*. 1965. Oil and synthetic polymer paint over small pieces of cardboard and wood shavings, 39⅜ x 59⅛″

Yamaguchi: *Taku*. 1961. Oil, 35⁷/₈ x 35³/₄″

Domoto: *Solution of Continuity, 24*. 1964. Oil, 63⁵/₈ x 51¹/₈″

Tanaka: Untitled. 1964. Synthetic polymer paint, 10′11¼″ x 7′4¾″

Tadasky: *B-171*. 1964. Synthetic polymer paint, 15⅛ x 15⅛″

Inokuma: *Subway*. 1966. Oil, 6'8¹/₄" x 50³/₈"

Mukai: Untitled. 1963. Oil, string, and canvas, 6'³/₈" x 53⁷/₈"

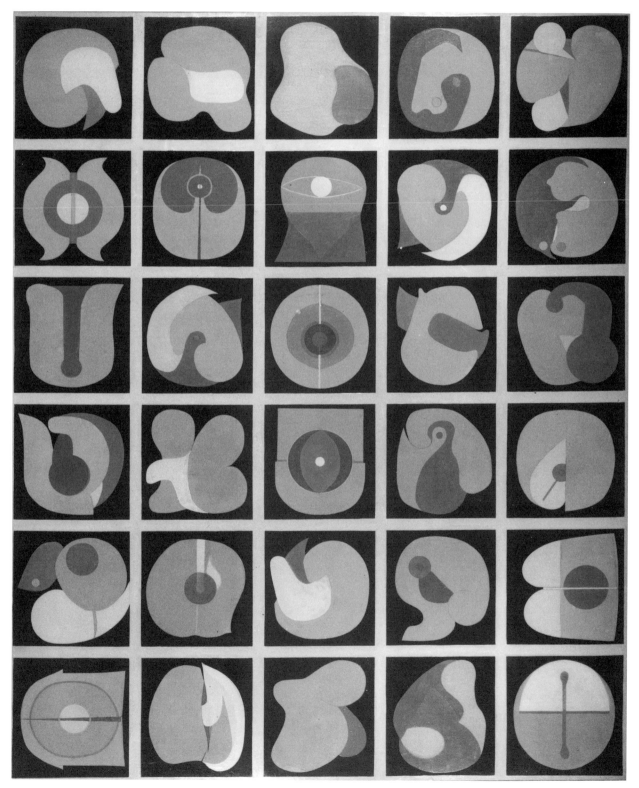

Untitled 1964, New York. 1964. Oil, 8′4¹/₂″ x 6′6¹/₈″

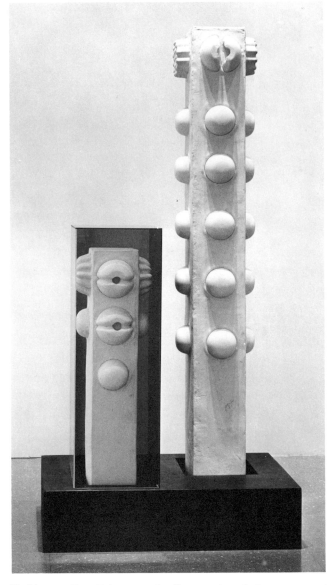

Niizuma: *Castle of the Eye*. 1964. Marble
18¹/₂ x 15³/₄ x 8″

Yoshimura: *Two Columns*. 1964. Construction of plaster on wood
and composition board, recessed in wood base, one column in a
plexiglass vitrine, 6′2¹/₄″ x 36″ x 18″

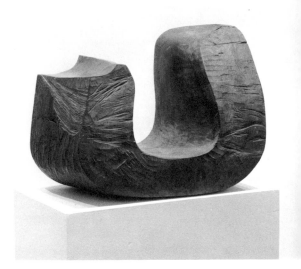

Eguchi: *Monument, Number 4*. 1964. Cherry, 17³/₄ x 21³/₄ x 13¹/₂

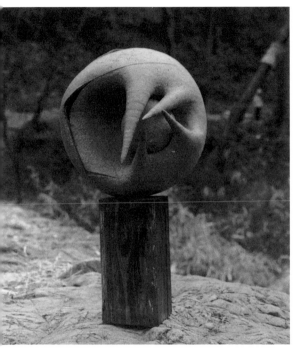

Yagi: *A Cloud Remembered*. 1962. Ceramic, 9 x 8 x 10"

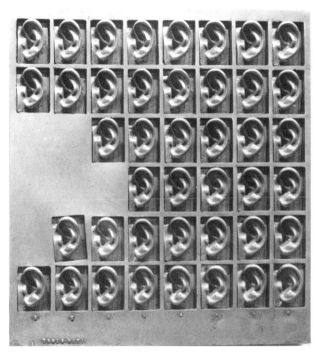

Miki: *Untitled (Ears)*. 1964. Cast aluminum relief, 21³/₈ x 19 x 1¹/₂"

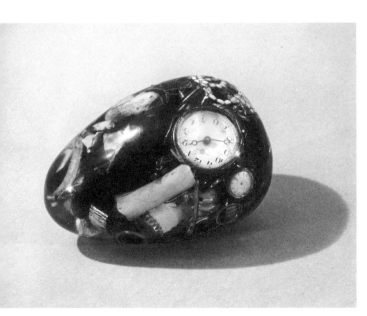

Nakanishi: *Compact Object*. 1962. Assemblage, 5⁵/₈ x 8³/₈"

Kikuhata: *Roulette: Number Five*. 1964. Assemblage, 42¹/₈ x 25³/₈ x 8¹/₂"

Kienholz: *The Friendly Grey Computer—Star Gauge Model #54*. 1965. Motor-driven assemblage, 40 x 39¹/₈ x 24¹/₂″

Gentils: *Berlin-Leipzig*. 1963. Assemblage, 53¹/₂ x 44³/₈ x 16³/₄″

Tinguely: Fragment from *Homage to New York*. 1960. Painted metal, 6′8¹/₄″ x 29⁵/₈″ x 7′3⁷/₈″

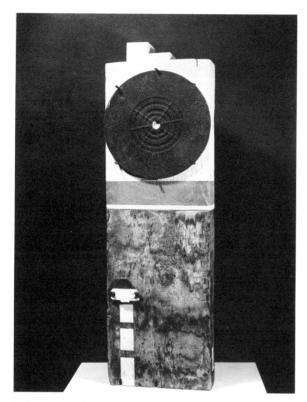

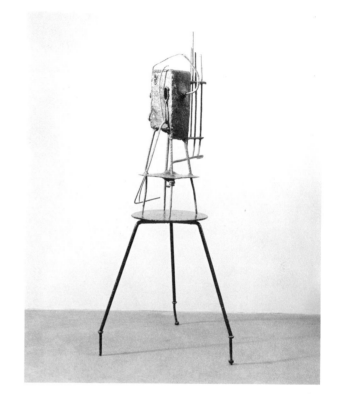

Indiana: *French Atomic Bomb*. 1959–60. Assemblage: poly-chromed wood beam and metal, 38⅝ x 11⅝ x 4⅞"

Butler: *The Box*. 1953. Iron, welded and painted, 47⅛ x 17¼ x 16¾"

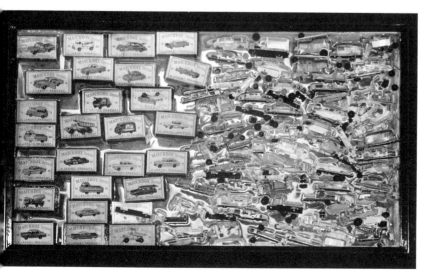

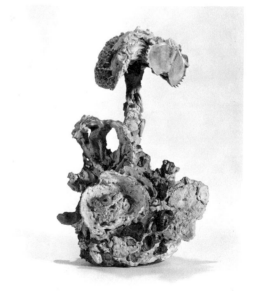

Arman: *Collection*. 1964. Assemblage: split toy automobiles and matchboxes embedded in polyester in a case, 16⅞ x 27¾ x 2⅞"

Vail: *Bottle*. 1945. Glass bottle and stopper en-crusted with shells, glass, barnacles, coral, and metal, 13¾ x 8⅞ x 5⅝"

477

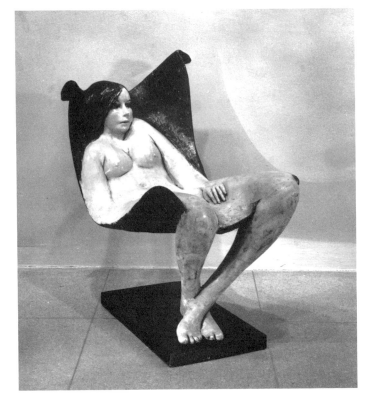

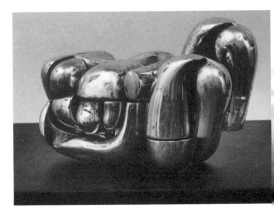

Berrocal: *Maria of the O*. 1964. Bronze, 4¹/₈ x 6¹/₄ x 3″

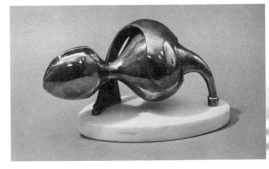

Baker: *644*. 1963. Bronze (cast 1964), 4¹/₂ x 8³/₄ x 4″

Gallo: *Girl in Sling Chair*. 1964. Polyester resin, 36³/₄ x 23 x 33³/₄″

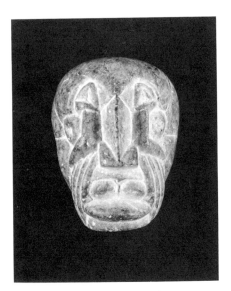

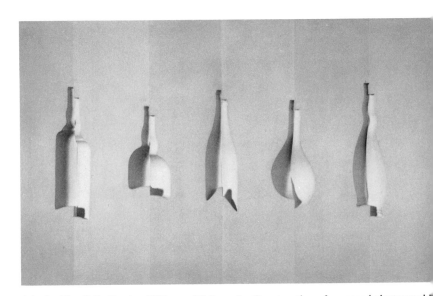

Mapanda: *Little Mask*. 1964. Stone (steatite), 4³/₄ x 3⁵/₈ x 2⁵/₈″

Adzak: *Five Split Bottles: White on White*. 1965. Construction of recessed plaster mold and oil on canvas, 28³/₄ x 45⁵/₈ x 2⁷/₈″

Study from Falling Man Series. 1964. Sixteen plaster figures in compartmented wood box, 48 x 32³/₄ x 6³/₄″

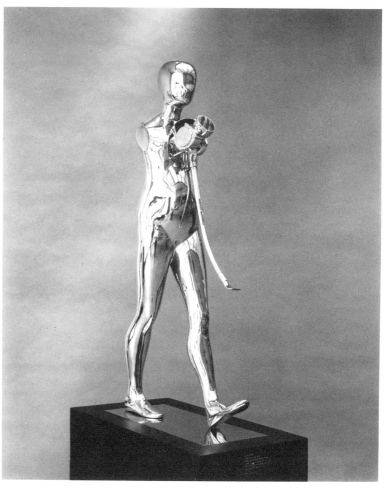

Study from Falling Man Series: Walking Man. 1964. Chromium-plated bronze (cast 1965), 58⁵/₈ x 11³/₈ x 26¹/₂″, on chrome base recessed in marble base 6 x 20¹/₈ x 35¹/₈″

Study from Falling Man Series. 1964. Chromium figure, lying on miniature automobile chassis, in plexiglass case, 6⁷/₈ x 15³/₄ x 6¹/₈″

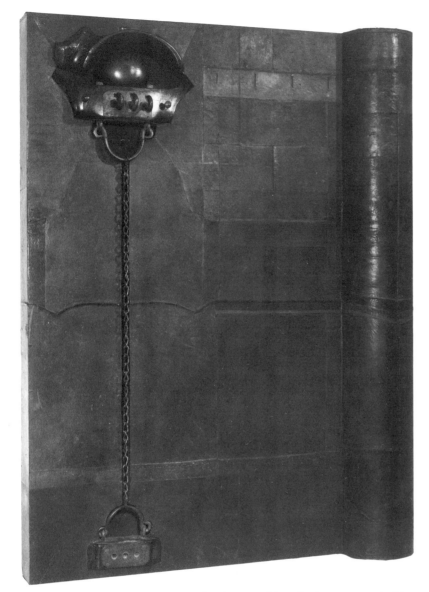

Kalinowski: *The Gate of the Executed*. 1963. Assemblage: leather over wood with a chain, 6'6³/₄" x 58¹/₂" x 11⁵/₈"

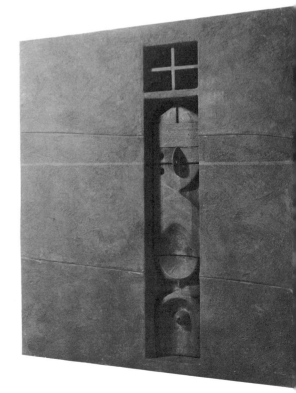

Bonevardi: *Figure, I*. 1964. Synthetic polymer paint joined canvas, with construction of wood and string, 25¹/₈ 21³/₄ x 2¹/₈"

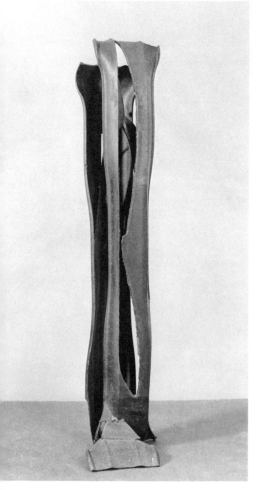

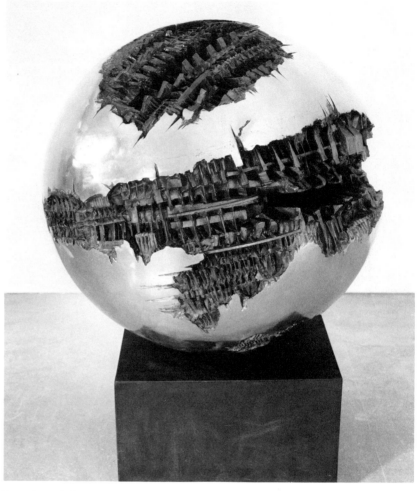

Orion: *High Night, II*. 1963. Welded iron, 6'2" high

Pomodoro: *Sphere, I*. 1963. Bronze, 44³/4" diameter

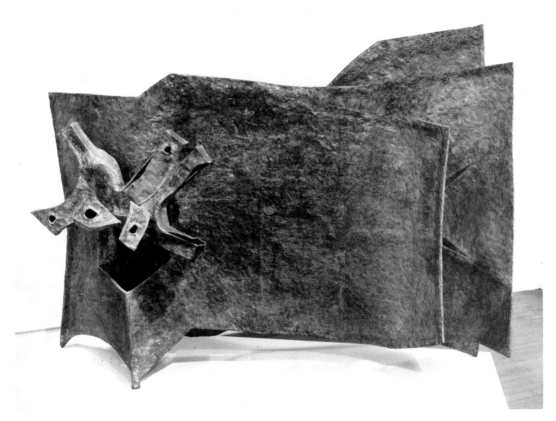

Lipton: *Manuscript*. 1961. Brazed bronze on metal alloy, 60³/₈″ x 7′1¹/₈″ x 37¹/₈″

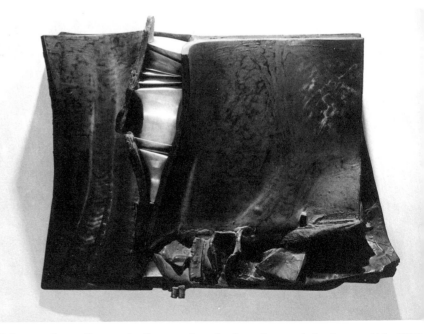

Bolomey: *Ocean Game*. 1964. Construction of polyurethane and aluminum, 52¹/₂″ x 6′1¹/₄″ x 28¹/₄″

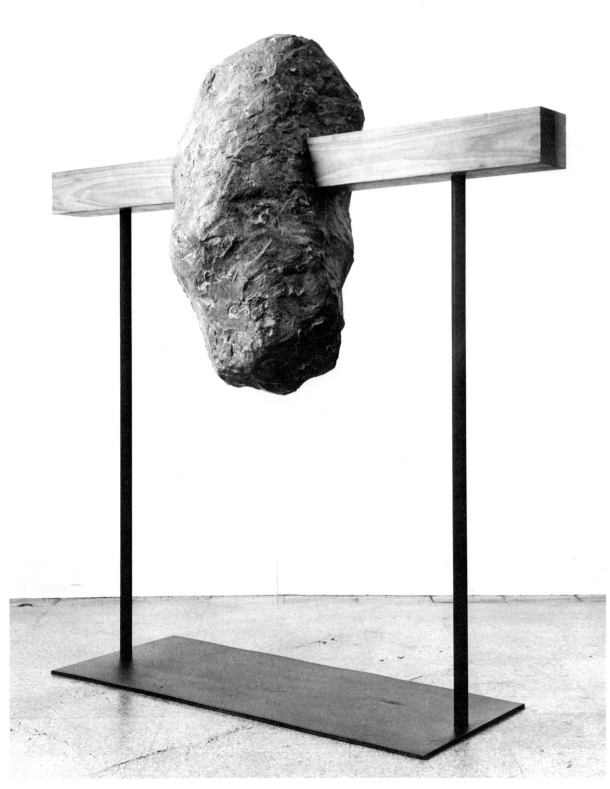

Stone of Spiritual Understanding. 1962. Bronze suspended on square wood bar set on metal supports, 52¼ x 48 x 16″

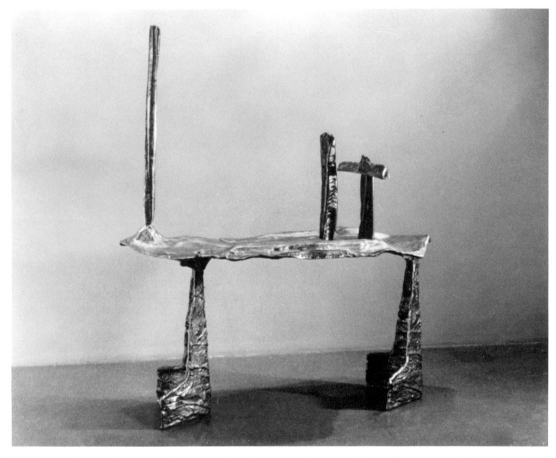

Kiesler: *Landscape—Marriage of Heaven and Earth*. 1961–62. Bronze and silver plate (cast 1964), 6′1/2″ x 63¹/8″ x 27″

Nakian: *The Burning Walls of Troy*. 1957. Terra cotta, 8¹/8 x 11⁵/8 x 5³/8″

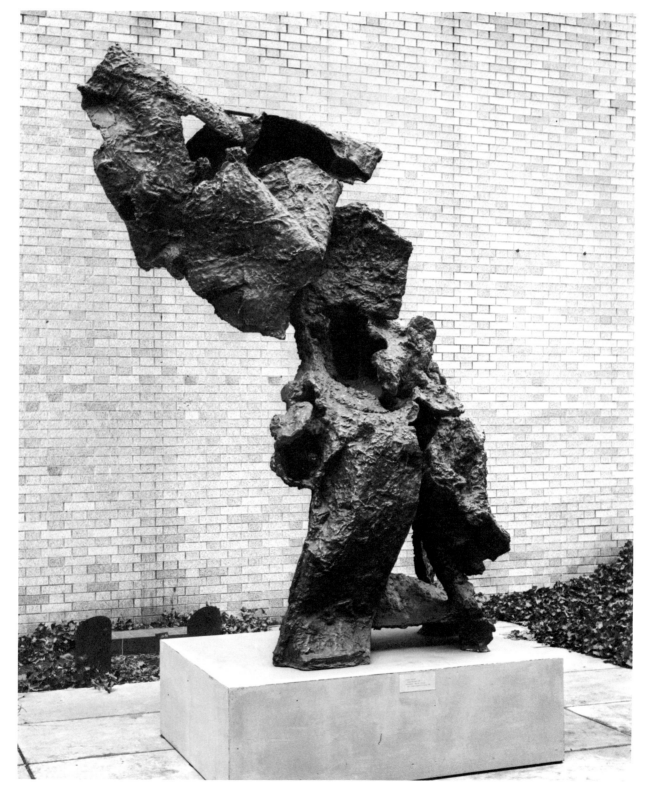

Hiroshima. 1965–66. Bronze (cast 1967–68), 9′3³/₄″ x 6′2³/₄″ x 45¹/₄″

Bauermeister: *Progressions*. 1963. Pebbles and sand on plywood, 51¼ x 47⅜ x 4¾"

Stazewski: *Colored Relief*. 1963. Oil on relief construction, 19¾ x 32¾ x 2⅞"

Haese: *Caravan*. 1965. Construction of clockwork parts, brass screening, and wire, 11¹/₈ x 15¹/₂ x 11¹/₂"

Haese: *In Tibet*. 1964. Construction of clockwork parts, brass screening, and wire, 19¹/₂ x 9¹/₄ x 4¹/₄"

Feeley: *Errai (Model for a Park Structure)*. 1965. Construction of enamel on composition board, 24³/₈ x 25¹/₂ x 25¹/₂"

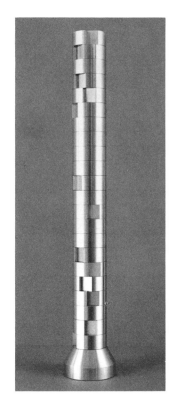

Comtois: *Column Number 4*.
1967. Aluminum, 24³/₈″ high

B. and F. Baschet: *Glass Trombone*. 1958. Steel, glass and metal rods, aluminum,
brass, and cord, 65 x 36 x 23³/₈″

Eielson: *White Quipus*. 1964. Knotted cloth and tempera, 37¹/₂ x 59¹/₈″

Kauffman: *Red-Blue*. 1964. Synthetic polymer paint on vacuum-formed plexiglass, 7′5⁵/₈″ x 45¹/₂″ x 5¹/₈″

Paolozzi: *Lotus*. 1964. Welded aluminum, 7′5¹/₈″ high

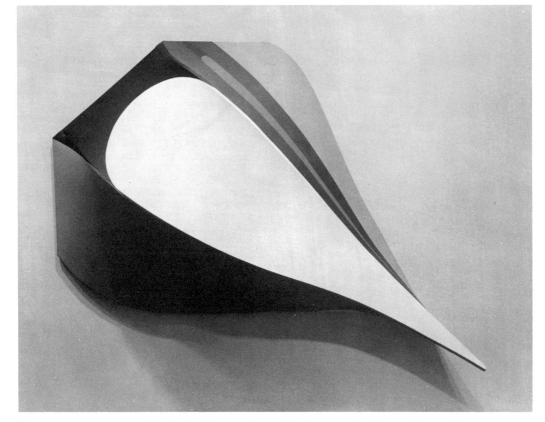

Hinman: *Poltergeist*. 1964. Synthetic polymer paint on shaped canvas, 8′2³/₄″ x 61⁷/₈″ x 16³/₈″

Tippett: *Item 34, 1964, Spiral IV*. 1964. Synthetic polymer paint, 67³/₄ x 67³/₄ x 4″

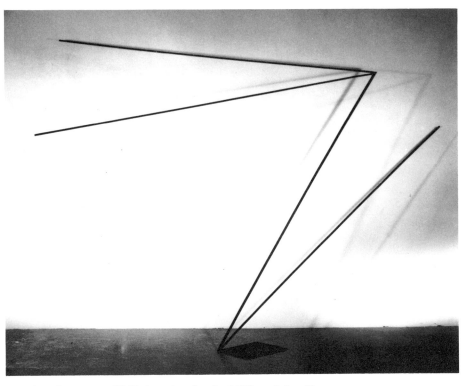

Baertling: *Sirur*. 1959. Welded steel, painted, 9′2¹/₂″ x 12′4″ x 58″

Lenk: *Stratification 44D, II*. 1969. Construction of plexi-glass disks, 32¹/₄ x 12¹/₄ x 13¹/₂″

Baertling: *Agriaki*. 1959. Oil, 6′5″ x 38¹/₂″

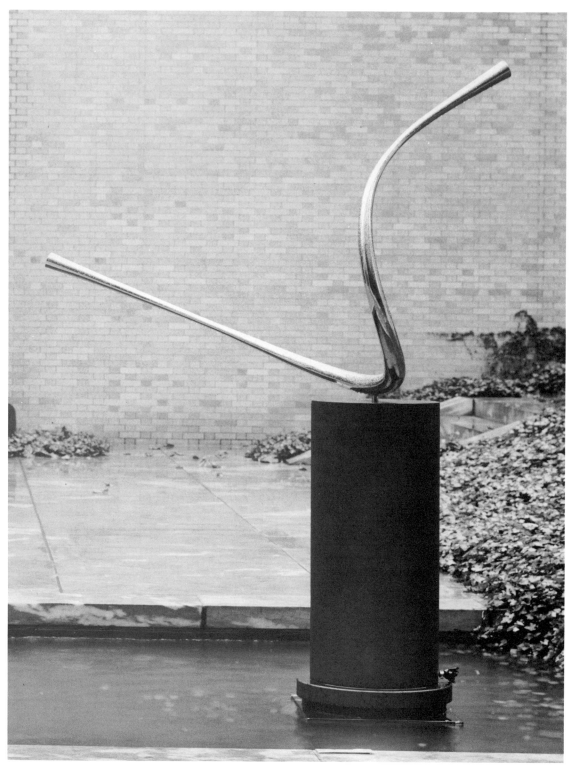

Steel Century Two (Construction 73). 1960–65. Stainless steel, 54¹/₈″ x 10′5³/₄″, on painted steel base with motor, 47″ high, 24¹/₄″ diameter

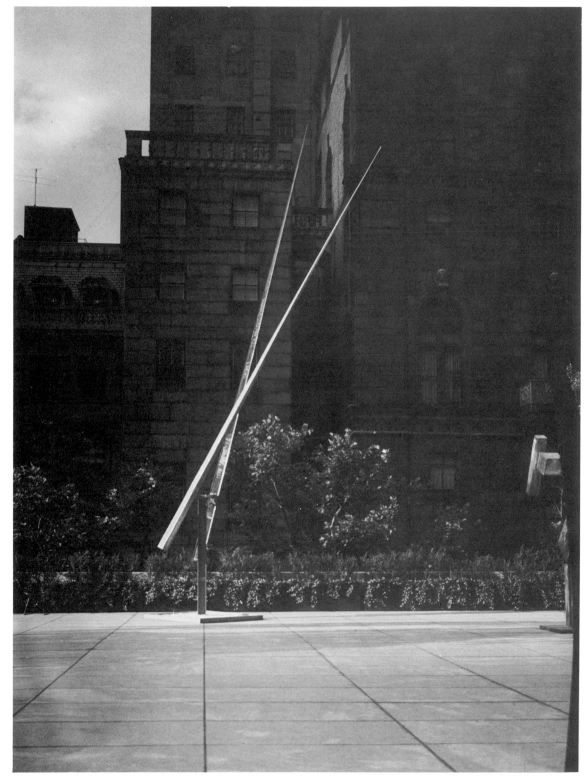

Two Lines—Temporal I. 1964. Two stainless steel mobile blades on painted steel base, 35′2⅜″ high

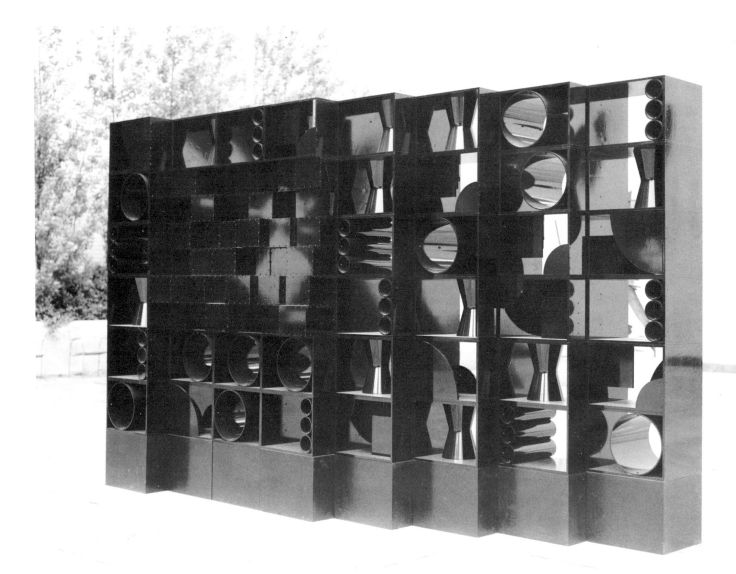

Atmosphere and Environment, I. 1966. Construction of enameled aluminum, 6′6¼″ x 12′³/₈″ x 48¹/₂″

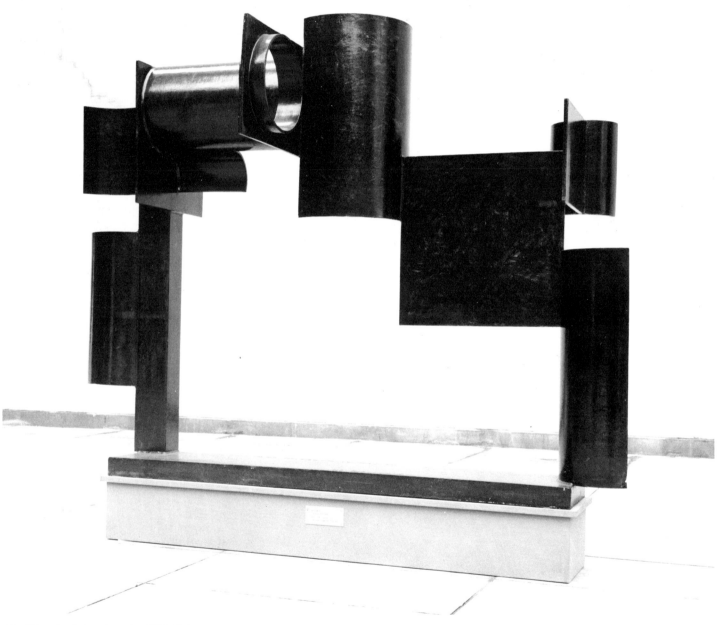

Zig, III. 1961. Painted steel, 7'8¾" high

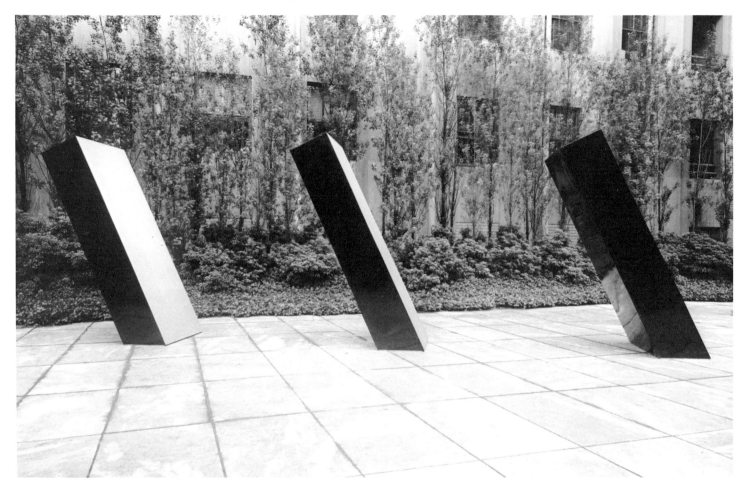

Bladen: Untitled. 1966–67. Painted and burnished aluminum in three identical parts, each 10′ x 48″ x 24″

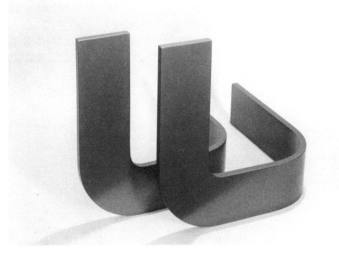

DeLap: *Tango Tangles, II*. 1966. Lacquered plastic in two identical parts, each 13 x 3½ x ½″

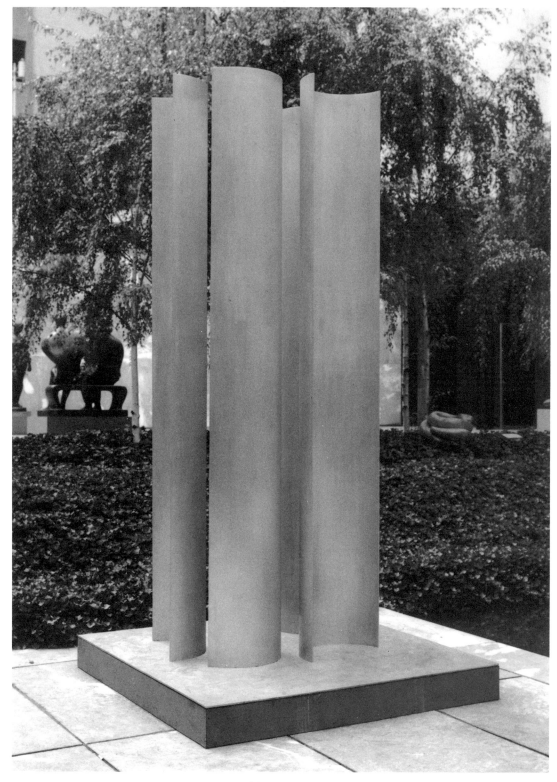

Temple, I. 1963–64. Burnished aluminum, 9′2³/₈″ high

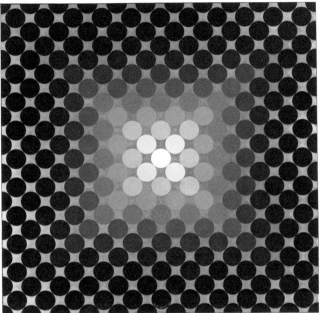

Vasarely: *CTA-104-E*. 1965. Synthetic polymer and metallic paint, 31³/₈ x 31³/₈"

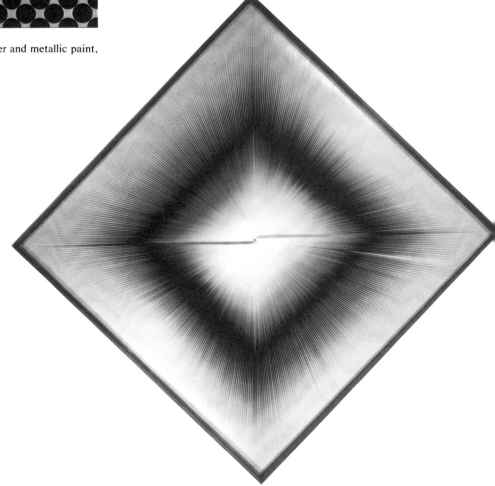

Costa: *Visual Dynamics*. 1963. Polyethylene, diagonal measurements, 56⁵/₈ x 56⁵/₈"

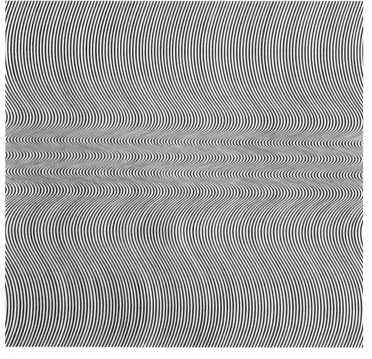

Riley: *Current*. 1964. Synthetic polymer paint, 58³/₈ x 58⁷/₈″

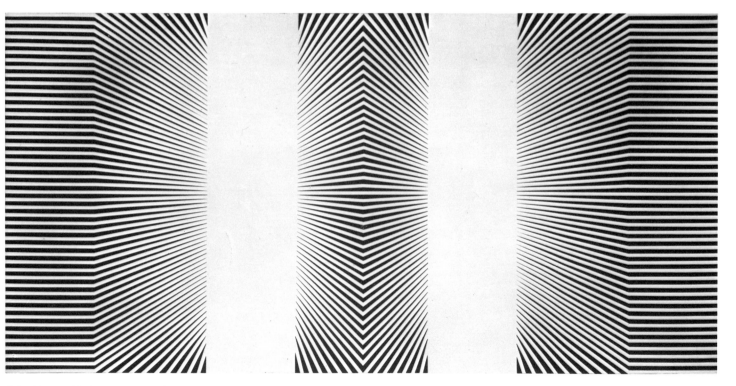

Schmidt: Untitled. 1965. Synthetic polymer paint, 48¹/₈″ x 8′¹/₈″

Tadasky: *A-101*. 1964. Synthetic polymer paint, 52 x 52″

Fangor: *Number 17*. 1963. Oil, 39¹/₂ x 39¹/₂″

Bengston: *Gregory*. 1961. Lacquer and synthetic enamel, 48¹/₈ x 48¹/₈″

Šutej: *Bombardment of the Optic Nerve, II.* 1963. Tempera and pencil, 6'7" diameter

Cunningham: *Equivocation.* 1964. Synthetic polymer paint, 26 x 26"

Hinterreiter: *Op. 134.* 1961. Mixed mediums, 15³/₈ x 13⁷/₈"

Le Parc: *Instability through Movement of the Spectator*. 1962–64. Synthetic polymer paint on wood and polished aluminum in painted wood box, 28⁵/8 x 57¹/8 x 36¹/2″

Celentano: *Flowing Phalanx*. 1965. Synthetic polymer paint, 34¹/8 x 46¹/8″

Group N: *Unstable Perception*. 1963. Metal rods and metal cylinders on wood, 17⁷/₈ x 18 x 3¹/₄″

Alviani: *Surface with Vibrating Texture*. 1964. Brushed aluminum, 33 x 33″

Zammitt: Untitled. 1966. Laminated synthetic polymer, 5³/₄ x 15¹/₄ x 4¹/₄″

Magariños D.: *Object: Light-Form Variations*. 1965. Synthetic polymer paint on glass squares, 11⁵/₈ x 11¹/₂ x 1³/₄″

Zehringer: *Number 2, 1964.* 1964. Plexiglass with background of painted plastic, 31⁵/₈ x 31⁵/₈ x 1¹/₂″

Uecker: *White Field.* 1964. Nails projecting from canvas-covered board, painted, 34³/₈ x 34³/₈ x 2³/₄″

Polesello: Untitled. 1966. Synthetic polymer paint airbrushed on paper, 39³/₈ x 25¹/₂″

Wells: Model for detail of ceiling relief in the donor' apartment, Buenos Aires. 1966. Enamel on paper, 3¹/₄ x 18⁷/₈ x 19¹/₈″

Sihvonen: *Duplex*. 1963. Oil, 56¹/₈ x 52″

MacEntyre: *Generative Painting: Black, Red, Orange*. 1965. Oil, 64³/₄ x 59″

Cruz-Diez: *Physichromie, 114*. 1964. Synthetic polymer paint on wood panel and on parallel cardboard strips interleaved with projecting plastic strips, 28 x 56¹/₄″

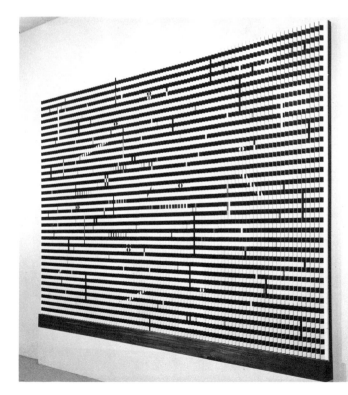

Double Metamorphosis, II. 1964. Oil on corrugated aluminum, 8′10″ x
3′2¼″. Viewed from three angles, opposite, above, and right.

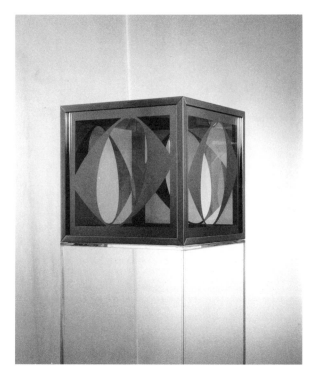

Bell: *Glass Sculpture Number 10.* 1964. Partially silvered glass with chromium frame, 10³/₈″ cube

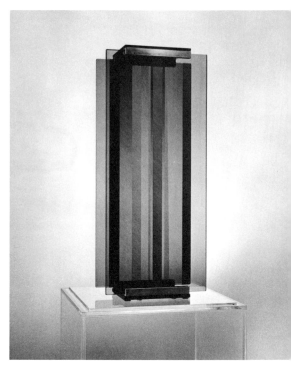

Olson: *Optochromi H 12-4.* 1965. Glass with polarization and birefringence sheets, 16⁵/₈ x 6³/₄ x 4″

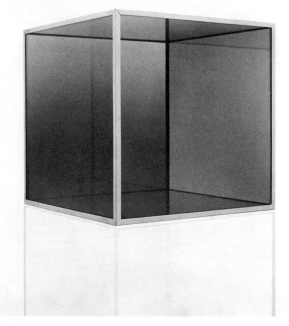

Bell: *Shadows.* 1967. Partially silvered glass with chromium frame, 14¹/₄″ cube

Mallory: Untitled. 1966. Motor-driven construction with mercury sealed in plastic, 19³/₄ x 19³/₄ x 8″

Mari: *Dynamic Optical Deformation of a Cube in a Sphere.* 1958–63. Transparent polyester resin, 4″ diameter

Boriani: *Magnetic Surface.* 1959. Construction with iron filings and foam rubber on plastic background, with magnets and motor, in a glass-covered cylinder, 22³/₄″ diameter, 2⁷/₈″ deep

Soto: *Olive and Black.* 1966. Flexible mobile metal strips suspended in front of two plywood panels painted with synthetic polymer paint, 61¹/₂ x 42¹/₄ x 12¹/₂″

Machlin: *Space Box.* 1963. Painted aluminum, 6 x 17⁵/₈ x 5″

Mack: *Silver Dynamo*. 1964. Motor-driven wheel covered with sheet aluminum in a glass-covered, aluminum-lined box, 60 x 60 x 7″

Colombo: *Pulsating Structuralization*. 1959. Motor-driven relief construction of plastic-foam blocks in a wood box, 36½ x 36½ x 9¼″

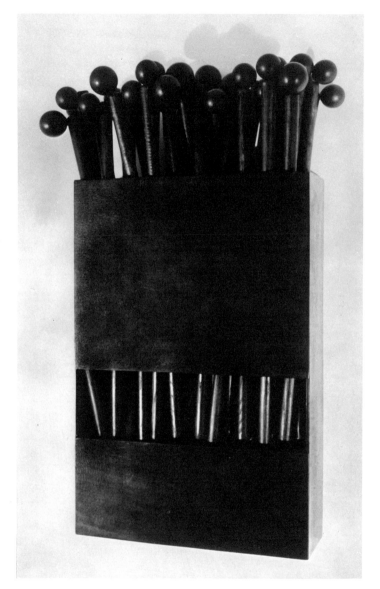

,914 *White Points*. 1964. Motor-driven construction of plas-
ic-tipped nylon wires in wood panel, 39¹/₄ x 19⁵/₈ x 4³/₄″

31 Rods Each with a Ball. 1964. Motor-driven wood construction with cork
and nylon wire, 39³/₄″ high

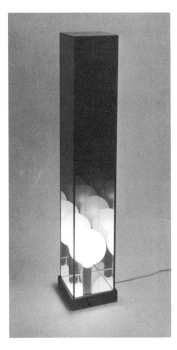

Landsman: Untitled. 1967. Construction of coated glass with electric light bulb, 37¹/₈ x 6³/₄ x 6³/₄″

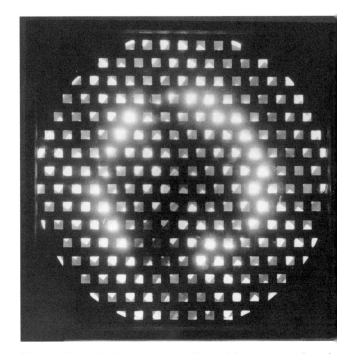

Varisco: *Dynamic Lattice A*. 1962. Motor-driven construction wit plexiglass, cardboard lattices, and light in a wood box, 20¹ x 20¹/₄ x 5⁷/₈″

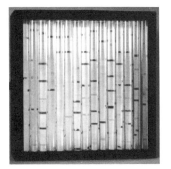

far left: Landi: *Geometrical Kinetic Variations*. 1963. Motor-driven construction of water-filled plexiglass tubes, painted metal rollers with strips of colored cloth tape, in a box, 19³/₄ x 19³/₄ x 5³/₄″

left: Levi: *Binal Lantana*. 1965. White formica box with painted perforated metal screens and fluorescent lights, 36³/₄ x 39⁵/₈ x 8¹/₂″

Seawright: *Eight*. 1966. Construction with sound, 6³/₈ x 44 x 6″

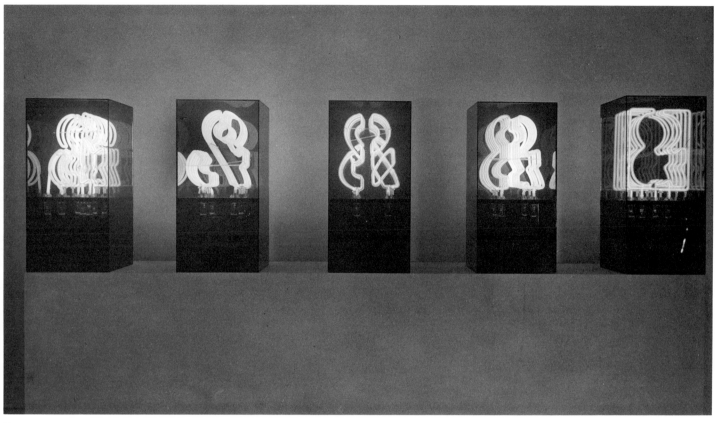

Five Variations on the Ampersand. 1966. Neon-light constructions in tinted plexiglass vitrines; one, 30³/₄ x 14¹/₄ x 12³/₈″; four, 29¹/₂ x 14¹/₄ x 12³/₈″

Lumia Suite, Op. 158. 1963–64. Projected light on translucent screen, 6 x 8'. Four variations of the *Suite*

Lumia Suite, Op. 158, variation

Lumia Suite, Op. 158, variation

Lumia Suite, Op. 158, variation

Microtemps 11. 1965. Motor-driven construction of steel, duraluminum, and plexiglass, in illuminated wood stage, 24^1/$_8$ x 35^1/$_4$ x 23^3/$_4$". *Above*, at rest; *below*, in motion

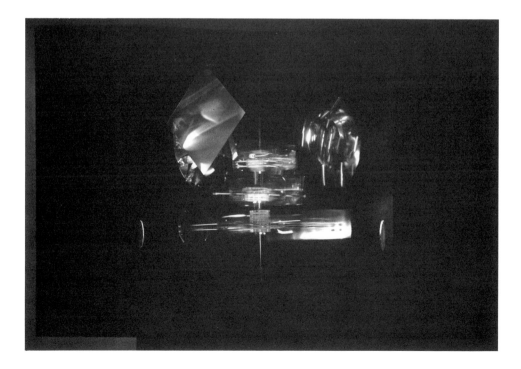

CATALOG

OF PAINTING AND SCULPTURE IN THE MUSEUM OF MODERN ART

JUNE 1967

LISTED ARE the paintings and sculptures in the Museum's collection in June of 1967, with the addition of the Sidney and Harriet Janis Collection, announced in June, and a few works already commissioned or selected before the end of June and acquired in the autumn. The Catalog is arranged alphabetically by artist, and the works of each artist appear in chronological order. The number to the left of a title refers to the page on which the work is reproduced. The date of a work is enclosed in parentheses if it is not inscribed by the artist on the work itself. The date for a sculpture in bronze refers to the original version in plaster or clay; wherever possible, the date of casting is also supplied.

Dimensions are given in feet and inches and in centimeters. Height precedes width; a third dimension, depth, is given for sculptures and constructions. Measurements are also given for bases made or designed by the sculptor. Watercolors, gouaches, temperas, caseins, pastels, and collages are works on paper,

for which sheet sizes are provided, unless otherwise specified.

The Museum accession number indicates the year in which a work was acquired; for example, 396.41 is the number assigned to the three-hundred-ninety-sixth work acquired in 1941. For extended loans the first two digits indicate the year of the loan, for example, E.L. 63.103.

The words "by exchange" in the credit line indicate that the work was acquired in exchange for one previously owned by the Museum. The credit line for the work previously owned is retained for the newly acquired work.

References to reproductions in other Museum publications appear in abbreviated form following the entry. The key to these abbreviations appears on pages 611 ff.

Many of the artists included in this list are represented in the collection by works in other mediums; these are noted through 1963 at the end of an artist's listing.

ABE, Shiro (pen name: Suichiku). Japanese, born 1900.

DELIGHT OF A PEACEFUL LIFE. (c.1953) Two-panel screen, brush and ink, each sheet 53⅝ x 26¾″ (136.2 x 68 cm). Japanese House Fund. 278.54. Repr. *Suppl. V*, p. 29.

ADLER, Jankel. Polish, 1895–1949. Worked in Germany and Great Britain.

199 TWO RABBIS. 1942. Oil on canvas, 33⅞ x 44⅛″ (86 x 112.1 cm). Gift of Sam Salz. 1.49. Repr. *Suppl. I*, p. 16.

ADZAK, Roy (Royston Wright Adzak). British, born 1927.

478 FIVE SPLIT BOTTLES: WHITE ON WHITE. 1965. Construction of oil on canvas with recessed plaster molds, 28¾ x 45⅝ x 2⅞″ (73 x 115.8 x 7.2 cm). Gift of Mr. and Mrs. A. M. Sachs. 93.67.

AFRO (Afro Basaldella). Italian, born 1912.

THE YELLOW BOOK. 1952. Oil and tempera on canvas, 50 x 59¾″ (127 x 151.7 cm). Gift of Mr. and Mrs. Joseph Pulitzer, Jr. 251.57. Repr. *Suppl. VII*, p. 17.

350 BOY WITH TURKEY. 1954. Oil on canvas, 49⅛ x 59″ (124.5 x 149.8 cm). Gift of Mr. and Mrs. Gordon Bunshaft. 321.60. Repr. *Suppl. X*, p. 38.

AGAM (Yaacov Agam). Israeli, born 1928. Works in Israel and Paris.

506– DOUBLE METAMORPHOSIS, II. 1964. Oil on corrugated aluminum,
507 in eleven parts, 8′10″ x 13′2¼″ (269.2 x 401.8 cm). Gift of Mr. and Mrs. George M. Jaffin. 104.65a–k. Repr. in color, *Responsive Eye*, p. 28.

ALBERS, Josef. American, born Germany. 1888–1976. To U.S.A. 1933.

Study for HOMAGE TO THE SQUARE: NIGHT SHADES. 1956. Oil on composition board, 23⅞ x 23⅞″ (60.7 x 60.7 cm). Gift of Mrs. Bliss Parkinson. 275.61. Repr. *Suppl. XI*, p. 22.

141 Study for HOMAGE TO THE SQUARE: EARLY RISING A. 1961. Oil on composition board, 24 x 24″ (60.9 x 60.9 cm). Gift of Mrs. Bliss Parkinson. 276.61. Repr. *Suppl. XI*, p. 22.

141 HOMAGE TO THE SQUARE: SILENT HALL. 1961. Oil on composition board, 40 x 40″ (101.8 x 101.8 cm). Dr. and Mrs. Frank Stanton Fund. 293.61. Repr. *Suppl. XI*, p. 23.

HOMAGE TO THE SQUARE: BROAD CALL. 1967, fall. Oil on composition board, 48 x 48″ (121.9 x 121.9 cm). The Sidney and Harriet Janis Collection (fractional gift). 664.67. Repr. *Janis*, p. 137; in color, *Invitation*, p. 34.

Also, prints, furniture, Bauhaus lettering set, and other design objects.

ALBRIGHT, Ivan Le Lorraine. American, born 1897.

244 WOMAN. (1928) Oil on canvas, 33 x 22″ (83.8 x 55.9 cm). Given anonymously. 228.48. Repr. *Suppl. I*, p. 24.

244 THE ARTIST'S FATHER. (1935) Bronze (cast 1952), 15″ (38.1 cm) high. Gift of Earle Ludgin. 172.52. *Note*: the subject is Adam Emory Albright.

Also, prints.

ALCOPLEY, L. (Alfred Lewin Copley). American, born Germany 1910. To U.S.A. 1937.

314 "SPIRITUS UBI VULT SPIRAT," 24 [*The Wind Bloweth Where It Listeth*]. 1962. Watercolor and ink, 26¾ x 22⅞″ (67.9 x 58 cm). Larry Aldrich Foundation Fund. 225.62. Repr. *Suppl. XII*, p. 22.

Also, a poster.

ALECHINSKY, Pierre. Belgian, born 1927. Lives in Paris.

355 VANISHED IN SMOKE [*Parti en fumée*]. 1962. Distemper and India ink on paper mounted on canvas, 59⅝ x 58¼″ (151.5 x 147.7 cm). Gertrud A. Mellon Fund. 70.63.

Also, a drawing and prints.

ALFARO SIQUEIROS. See SIQUEIROS.

AL-KAZI, Munira. Kuwaiti, born 1939. To England 1957–58.

465 CONCEPTION. 1962. Gouache and gold spray paint, 30½ x 20½″ (77.5 x 51.9 cm). Frances Keech Fund. 119.65.

ALVIANI, Getulio. Italian, born 1939.

503 SURFACE WITH VIBRATING TEXTURE [*Superficie a testura vibratile LL 36 Q 14 x 14 inv.*] (1964) Brushed aluminum on composition board, 33 x 33″ (83.6 x 83.6 cm). Larry Aldrich Foundation Fund. 105.65.

ANDERSON, John S. American, born 1928.

SHELTER. (1962) Wood, 50½ x 25¼″ (128.3 x 63.8 cm). Larry Aldrich Foundation Fund. 308.62. Repr. *Suppl. XII*, p. 25.

ANGUIANO, Raúl. Mexican, born 1915.

210 LA LLORONA. 1942. Oil on canvas, 23⅝ x 29⅝″ (60 x 75.2 cm). Inter-American Fund. 622.42. Repr. *Ptg. & Sc.*, p. 182.

Also, prints, posters, and broadsides.

ANUSZKIEWICZ, Richard J. American, born 1930.

373 FLUORESCENT COMPLEMENT. 1960. Oil on canvas, 36 x 32¼″ (91.5 x 82 cm). Larry Aldrich Foundation Fund. 355.60. Repr. *Suppl. X*, p. 54; *Amer. 1963*, p. 8.

RADIANT GREEN. 1965. Synthetic polymer paint on composition board, 16 x 16″ (40.4 x 40.5 cm). The Sidney and Harriet Janis Collection (fractional gift). 1770.67. Repr. *Janis*, p. 139.

APPEL, Karel. Dutch, born 1921. To Paris 1950.

355 CHILD WITH BIRDS. 1950. Oil on canvas, 39½ x 39¾″ (100.4 x 101 cm). Mr. and Mrs. William B. Jaffe Fund. 327.55. Repr. *Suppl. V*, p. 23.

433 ÉTIENNE-MARTIN. 1956. Oil on canvas, 6′4⅞″ x 51¼″ (195.1 x 130.1 cm). Purchase. 183.66. Repr. in color, *Invitation*, p. 65. *Note*: Henri Étienne-Martin is the French sculptor.

Also, a drawing.

ARCHIPENKO, Alexander. American, born Ukraine. 1887–1964. Worked in Paris 1908–21. To U.S.A. 1923.

418 BOXING. 1914. Bronze (cast 1966), 23¼ x 18¼ x 15⅞″ (59.1 x 46.3 x 40.3 cm). Given anonymously. 567.66. Repr. *What Is Mod. Sc.*, p. 51; *Archipenko*, back cover.

104 WOMAN COMBING HER HAIR. (1915) Bronze, 13¾″ (35 cm) high. Acquired through the Lillie P. Bliss Bequest. 581.43. Repr. *Ptg. & Sc.*, p. 267; *What Is Mod. Sc.*, p. 43.

104 GLASS ON A TABLE. (1920) Wood and plaster relief, painted, 16⅛ x 13″ (41 x 33 cm). Katherine S. Dreier Bequest. 141.53.

104 WHITE TORSO. (c. 1920, after a marble of 1916) Silvered bronze, 18½″ (47.1 cm) high. Gift of Mr. and Mrs. Murray Thompson. 277.61. Repr. *Suppl. XI*, p. 16.

Also, prints.

ARDON (Ardon-Bronstein), Mordecai. Israeli, born Poland 1896. Worked in Germany. To Israel 1933.

290 THE TENTS OF JUDEA. (1950) Oil and tempera on composition board, 31⁷/₈ x 39³/₈" (80.9 x 100 cm). Gift of Miss Belle Kogan. 37.52.

449 AMULET FOR A YELLOW LANDSCAPE. 1966. Oil and tempera on canvas, 38¹/₈ x 50³/₄" (96.8 x 128.7 cm). Gift of Mr. and Mrs. George M. Jaffin. 173.67.

ARIZA, Gonzalo. Colombian, born 1912.

217 SAVANNA. (1942) Oil on canvas, 19³/₈ x 19¹/₄" (49.2 x 48.9 cm). Inter-American Fund. 633.42. Repr. *Ptg. & Sc.*, p. 176.

Also, an oil in the Study Collection.

ARMAN (Armand Fernandez; Armand Pierre Arman). American, born France 1928. To U.S.A. 1963.

477 COLLECTION. (1964) Assemblage: split toy automobiles and matchboxes embedded in polyester in a case, 16⁷/₈ x 27³/₄ x 2⁷/₈" (42.8 x 70.5 x 7.3 cm). Promised gift and extended loan from Mr. and Mrs. William N. Copley. E.L.65.391.

ARMITAGE, Kenneth. British, born 1916.

296 FAMILY GOING FOR A WALK. (1951) Bronze, 29 x 31" (73.7 x 78.8 cm). Acquired through the Lillie P. Bliss Bequest. 1.53. Repr. *Suppl. IV*, p. 40.

Also, prints.

ARP, Jean (originally, Hans). French, born Alsace. 1887–1966. Lived in Switzerland 1959–66.

166 COLLAGE WITH SQUARES ARRANGED ACCORDING TO THE LAW OF CHANCE. (1916–17) Collage of colored papers, 19¹/₈ x 13⁵/₈" (48.6 x 34.6 cm). Purchase. 457.37. Repr. *Arp*, p. 37; *Assemblage*, p. 35.

166 BIRDS IN AN AQUARIUM. (c. 1920) Painted wood relief, 9⁷/₈ x 8" (25.1 x 20.3 cm). Purchase. 232.37. Repr. *Ptg. & Sc.*, p. 277; *Masters*, p. 140; *Arp*, p. 38.

166 MOUNTAIN, TABLE, ANCHORS, NAVEL. (1925) Oil on cardboard with cutouts, 29⁵/₈ x 23¹/₂" (75.2 x 59.7 cm). Purchase. 77.36. Repr. *Ptg. & Sc.*, p. 214; in color, *Fantastic Art* (3rd), opp. p. 146; *Arp*, p. 43; in color, *Invitation*, p. 88.

167 TWO HEADS. (1927) Oil and string on canvas, 13³/₄ x 10⁵/₈" (35 x 27 cm). Purchase. 74.36. Repr. *Fantastic Art* (3rd), p. 146.

167 LEAVES AND NAVELS. (1929) Oil and string on canvas, 13³/₄ x 10³/₄" (35 x 27.3 cm). Purchase. 1647.40. Repr. *Arp*, p. 51.

167 TWO HEADS. (1929) Painted wood relief, 47¹/₄ x 39¹/₄" (120 x 99.7 cm). Purchase. 82.36. Repr. *Fantastic Art* (3rd), p. 148; *Arp*, p. 53.

168 OBJECTS ARRANGED ACCORDING TO THE LAW OF CHANCE *or* NAVELS. (1930) Varnished wood relief, 10³/₈ x 11¹/₈" (26.3 x 28.3 cm). Purchase. 79.36. Repr. *Fantastic Art* (3rd), p. 146; *Arp*, p. 51.

168 LEAVES AND NAVELS, I. (1930) Painted wood relief, 39³/₄ x 31³/₄" (100.9 x 80.6 cm). Purchase. 75.36. Repr. *Fantastic Art* (3rd), p. 147; *Arp*, p. 56.

MAN AT A WINDOW. (1930) Oil and cord on canvas, 31³/₄ x 27¹/₄" (80.5 x 69.2 cm). The Sidney and Harriet Janis Collection (fractional gift). 575.67. Repr. *Janis*, p. 59. *Note*: also called *Head of a Man*.

CONSTELLATION. (1932) Painted wood relief, 11³/₄ x 13¹/₈ x 2³/₈" (29.6 x 33.1 x 6 cm). The Sidney and Harriet Janis Collection (fractional gift). 576.67. Repr. *Janis*, p. 60.

CONSTELLATION WITH FIVE WHITE AND TWO BLACK FORMS: VARIATION 2. (1932) Painted wood relief, 27⁵/₈ x 33¹/₂ x 1¹/₂" (70.1 x 85.1 x 3.6 cm). The Sidney and Harriet Janis Collection (fractional gift). 577.67. Repr. *Janis*, p. 61.

HUMAN CONCRETION. (1935) Original plaster, 19¹/₂ x 18³/₄" (49.5 x 47.6 cm). Gift of the Advisory Committee. 4.37. Repr. *Ptg. & Sc.*, p. 279; *Masters*, p. 140; *Arp*, p. 65; *What Is Mod. Sc.*, p. 60.

168 HUMAN CONCRETION. Replica of above (4.37), cast stone, 1949. Cast authorized and approved by artist. Purchase. 328.49.

169 RELIEF. (1938–39, after a relief of 1934–35) Wood, 19¹/₂ x 19⁵/₈" (49.5 x 49.8 cm). Gift of the Advisory Committee (by exchange). 336.39. Repr. *Ptg. & Sc.*, p. 278; *What Is Mod. Sc.*, p. 117. *Note*: the original relief (which warped) was in wood, painted white.

169 FLORAL NUDE. (1957) Marble, 47¹/₄" (120 cm) high, 10¹/₂" (26.5 cm) diameter at base. Mrs. Simon Guggenheim Fund. 129.61. Repr. *Suppl. XI*, cover.

PRE-ADAMITE DOLL [*Poupée préadamite*]. (1964) Marble, 19¹/₄ x 13 x 13" (48.7 x 32.9 x 32.9 cm), on marble base, 4³/₈" high x 11¹/₈" diameter (11 x 28 cm). The Sidney and Harriet Janis Collection (fractional gift). 578.67. Repr. *Janis*, p. 63.

Also, a drawing, prints, a poster, illustrated books, and a rug designed by the artist.

ASSETTO, Franco. Italian, born 1911.

DARK SEAL. 1958. Oil, partly in low relief, on canvas, 35¹/₂ x 39³/₈" (90.1 x 100 cm). G. David Thompson Fund. 1.59. Repr. *Suppl. IX*, p. 17.

ATHERTON, John. American, 1900–1952.

288 CHRISTMAS EVE. 1941. Oil on canvas, 30¹/₄ x 35" (76.8 x 88.9 cm). Purchase. 136.42. Repr. *Ptg. & Sc.*, p. 173.

CONSTRUCTION. (1942) Gouache on cardboard, 9 x 11⁷/₈" (22.9 x 30.2 cm). Abby Aldrich Rockefeller Fund. 137.42.

Also, posters.

ATLAN, Jean-Michel. French, born Algeria. 1913–1960.

REALM. (1957) Pastel, 9⁷/₈ x 12³/₄" (25 x 32.3 cm). Benjamin Scharps and David Scharps Fund. 81.58. Repr. *Suppl. VIII*, p. 19.

AULT, George. American, 1891–1949.

228 NEW MOON, NEW YORK. 1945. Oil on canvas, 28 x 20" (71.1 x 50.8 cm). Gift of Mr. and Mrs. Leslie Ault. 132.57. Repr. *Suppl. VII*, p. 12.

AUSTIN, Darrel. American, born 1907.

CATAMOUNT. (1940) Oil on canvas, 20 x 24" (50.8 x 61 cm). Abby Aldrich Rockefeller Fund. 312.41. Repr. *Ptg. & Sc.*, p. 174.

AVERY, Milton. American, 1893–1965.

239 THE DESSERT. (1939) Oil on canvas, 28¹/₈ x 36¹/₈" (71.4 x 91.8 cm). Gift of Mr. and Mrs. Roy R. Neuberger. 130.51. Repr. *Suppl. III*, p. 20. *Note*: at the table, upper left, are David Burliuk with wine glass in hand, his wife Marussia beside him; to her left, Wallace Putnam, in whose studio the gathering took place; in right foreground, the wife of the artist. The man at the left has not been identified.

239 SEA GRASSES AND BLUE SEA. 1958. Oil on canvas, 60⅛″ x 6′ ⅜″ (152.7 x 183.7 cm). Gift of friends of the artist. 649.59. Repr. *Suppl. IX*, p. 20; in color, *Invitation*, p. 117.

AWA TSIREH (Alfonso Roybal). American Indian, Pueblo of San Ildefonso, New Mexico. 1900–1955.

235 GREEN CORN CEREMONY. (c. 1935) Gouache, 19¼ x 27¾″ (48.9 x 70.5 cm). Abby Aldrich Rockefeller Fund. 330.39. Repr. *Ptg. & Sc.*, p. 158; in color, *Indian Art* (2nd), p. 194.

BACCI, Edmondo. Italian, born 1913.

350 INCIDENT 13R. (1953) Tempera on canvas, 32¾ x 56¼″ (83.1 x 142.9 cm). Purchase. 253.56. Repr. *Suppl. VI*, p. 30.

BACON, Francis. British, born 1909.

266 PAINTING. (1946) Oil and tempera on canvas, 6′5⅞″ x 52″ (197.8 x 132.1 cm). Purchase. 229.48. Repr. *Suppl. I*, p. 17; in color, *Masters*, p. 169; in color, *Invitation*, p. 107.

267 DOG. (1952) Oil on canvas, 6′6¼″ x 54¼″ (198.7 x 137.8 cm). William A. M. Burden Fund. 408.53. Repr. *New Decade*, p. 62.

267 NUMBER VII FROM EIGHT STUDIES FOR A PORTRAIT. (1953) Oil on canvas, 60 x 46⅛″ (152.3 x 117 cm). Gift of Mr. and Mrs. William A. M. Burden. 254.56. Repr. *Suppl. VI*, p. 29. *Note*: a variation on the painting *Innocent X* by Velázquez.

BADEN, Mowry Thacher. American, born 1936.

282 THE GATE. 1960. Oil on canvas, 6′6″ x 6′3″ (198.2 x 190.5 cm). Larry Aldrich Foundation Fund. 356.60. Repr. *Suppl. X*, p. 29.

BADI, Aquiles. Argentine, born 1894.

SCHOOL TABLEAU, SAN MARTÍN'S BIRTHDAY. (1935) Tempera, 15 x 19½″ (38.1 x 49.5 cm). Inter-American Fund. 636.42. Repr. *Latin-Amer. Coll.*, p. 30.

Also, works in the Study Collection.

BAER, Martin. American, 1894–1961.

PARROT TULIPS. 1939. Oil and tempera on canvas, 16 x 13″ (40.7 x 33 cm). Gift of Mrs. Simon Guggenheim. 467.41.

BAERTLING, Olle. Swedish, born 1911.

491 AGRIAKI. 1959. Oil on canvas, 6′5″ x 38½″ (195.4 x 97 cm). Gift of Galerie Denise René. 495.64.

491 SIRUR. (1959) Welded steel, painted, 9′2½″ x 12′4″ x 58″ (280.6 x 375.5 x 147.3 cm); iron base 19⅜ x 14″ (49.1 x 35.4 cm). Gift of Mr. and Mrs. Leif Sjöberg. 496.64a–d.

BAIZERMAN, Eugenie. American, born Poland. 1899–1949. To U.S.A. 1913.

ACTRESS DRESSING. 1945. Oil on canvas, 45⅝ x 34″ (115.7 x 86.3 cm). Gift of Mr. and Mrs. Ralph F. Colin. 108.61. Repr. *Suppl. XI*, p. 20. *Note*: the subject is said to be the actress Irene Worth.

BAKER, George P. American, born 1931.

478 644. 1963. Bronze (cast 1964), 4½ x 8¾ x 4″ (11.4 x 22.1 x 9.9 cm). Larry Aldrich Foundation Fund. 114.66.

BALLA, Giacomo. Italian, 1871–1958.

116 STREET LIGHT [*Lampada—Studio di luce*]. 1909. Oil on canvas, 68¾ x 45¼″ (174.7 x 114.7 cm). Hillman Periodicals Fund. 7.54. Repr. *Suppl. V*, p. 14; in color, *Futurism*, p. 26; in color, *Invitation*, p. 96.

116 SPEEDING AUTOMOBILE. 1912. Oil on wood, 21⅞ x 27⅛″ (55.6 x 68.9 cm). Purchase. 271.49. Repr. *20th-C. Italian Art*, pl. 29; *The Machine*, p. 54.

116 SWIFTS: PATHS OF MOVEMENT + DYNAMIC SEQUENCES. 1913. Oil on canvas, 38⅛ x 47¼″ (96.8 x 120 cm). Purchase. 272.49. Repr. *20th-C. Italian Art*, pl. 27; *Futurism*, p. 63.

117 COMPOSITION. (c.1914?) Distemper on canvas, 32 x 26⅜″ (81.3 x 67 cm) (sight). Gift of Mr. and Mrs. Arnold H. Maremont. 357.60b. On reverse: *Spring*. 357.60a. Repr. *Suppl. X*, p. 20.

117 SPRING. (c. 1916) Oil on canvas, 32 x 26⅜″ (81.3 x 67 cm) (sight). Gift of Mr. and Mrs. Arnold H. Maremont. 357.60a. On reverse: *Composition*. 357.60b. Repr. *Suppl. X*, p. 20.

BALTHUS (Baltusz Klossowski de Rola). French, born 1908.

193 ANDRÉ DERAIN. 1936. Oil on wood, 44⅜ x 28½″ (112.7 x 72.4 cm). Acquired through the Lillie P. Bliss Bequest. 67.44. Repr. *Ptg. & Sc.*, p. 188.

193 JOAN MIRÓ AND HIS DAUGHTER DOLORES. 1937–38. Oil on canvas, 51¼ x 35″ (130.2 x 88.9 cm). Abby Aldrich Rockefeller Fund. 398.38. Repr. *Ptg. & Sc.*, p. 189; in color, *20th-C. Portraits*, opp. p. 102; *Balthus*, p. 15; in color, *Invitation*, p. 63.

Also, drawings.

BANGERT, Colette. American, born 1934.

FLATLAND FIELDS. 1961. Synthetic polymer paint on paper, 22¼ x 30½″ (56.3 x 77.4 cm). Gift of Harold W. Bangert. 278.61. Repr. *Suppl. XI*, p. 33.

BARELA, Patrocino. American, 1908–1964.

CORONATION OF THE VIRGIN. (1936) Wood relief, 20½ x 11″ (52.1 x 27.9 cm). Extended loan from the United States WPA Art Program. E.L.38.3051. Repr. *New Horizons*, no. 241.

11 THE TWELVE APOSTLES. (1936) Wood relief, 11½ x 61″ (29.2 x 154.9 cm). Extended loan from the United States WPA Art Program. E.L.44.1992.

Also, other carvings on extended loan.

BARKER, Walter William. American, born Germany 1921.

I-CHING SERIES. 1962. Watercolor, ink, and gouache, 19⅝ x 13¼″ (49.8 x 33.7 cm). Gift of Mr. and Mrs. Joseph Pulitzer, Jr. 396.63.

340 I-CHING SERIES, 5. 1963. Oil and chalk on canvas, 7′1⅛″ x 64⅛″ (213.8 x 163 cm). Gift of Mr. and Mrs. Morton D. May. 395.63.

BARLACH, Ernst. German, 1870–1938.

43 HEAD (DETAIL, WAR MONUMENT, GÜSTROW CATHEDRAL). (1927) Bronze, 13½″ (34.3 cm) high. Gift of Edward M. M. Warburg. 521.41. Repr. *Ptg. & Sc.*, p. 248.

43 SINGING MAN. (1928) Bronze, 19½ x 21⅞ x 14⅛″ (49.5 x 55.3 x 35.9 cm). Abby Aldrich Rockefeller Fund. 656.39. Repr. *Ptg. & Sc.*, p. 249.

Also, a drawing, prints, and illustrated books.

BARNES, Matthew Rackham. American, born Scotland. 1880–1951. To U.S.A. 1904.

243 HIGH PEAK. 1936. Oil on canvas, 36¼ x 42⅛″ (92.1 x 107 cm). Acquired through the Lillie P. Bliss Bequest. 745.43. Repr. *Romantic Ptg.*, p. 111.

BARNET, Will. American, born 1911.

368 GOLDEN TENSION. 1959–60. Oil and gold leaf on canvas, 64 x 39⁷/₈" (162.5 x 101.2 cm). Gift of Dr. Jack M. Greenbaum. 22.60. Repr. *Suppl. X*, p. 43.

Also, a print.

BARUCHELLO, Gianfranco. Italian, born 1924.

395 EXIT FROM THE GREAT ACCOLADE [*Uscita dalla grande accolade*]. 1963. Oil on canvas, 25 x 24³/₄" (63.3 x 62.9 cm). Gift of Cordier & Ekstrom, Inc. 588.63.

Also, a drawing.

BASALDÚA, Héctor. Argentine, born 1895.

EXPRESO VILLALONGA (EL CALLE). 1937. Tempera on cardboard, 12¹/₄ x 18³/₄" (31.1 x 47.6 cm). Inter-American Fund. 641.42. Repr. *Latin-Amer. Coll.*, p. 30.

Also, a painting in the Study Collection.

BASCHET, Bernard, born 1917, and François, born 1920, French.

488 GLASS TROMBONE. (1958) Steel, glass and metal rods, aluminum, brass, and cord, 65 x 36 x 23³/₈" (165 x 91.4 x 59.2 cm). Gift of Daphne Hellman Shih. 115.66. *Note*: Bernard Baschet is the sound engineer and François the sculptor.

BASKIN, Leonard. American, born 1922.

302 MAN WITH A DEAD BIRD. (1951–56) Walnut, 64 x 18¹/₂" (162.5 x 46.9 cm). A. Conger Goodyear Fund. 25.57. Repr. *Suppl. VII*, p. 24; *New Images*, p. 34.

302 SEATED BIRDMAN. (1961) Bronze, 35³/₄ x 15⁷/₈ x 20¹/₂" (90.5 x 40.3 x 52 cm). Gift of Mr. and Mrs. Herman D. Shickman. 112.62. Repr. *Suppl. XII*, p. 16.

Also, a drawing, a block for a woodcut, prints, illustrated books, and a record album cover.

BAUCHANT, André. French, 1873–1958.

8 THE PROCLAMATION OF AMERICAN INDEPENDENCE. 1926. Oil on canvas, 30 x 46⁵/₈" (76.2 x 118.4 cm). Inscribed: *Washington Procured Independence for the United States 4 Juili 1776. Libertas Americana. Lexington April, 19th 1775. Comitia Americana 17 Mars 1776.* Gift of Mme Eve Daniel and Mme Sibylle Cournand in memory of their mother, Mme Jeanne Bucher. 301.47. Repr. *Masters Pop. Ptg.*, no. 3. *Note*: represented, left to right, are Rochambeau, Franklin, Washington, and Lafayette.

8 CLEOPATRA'S BARGE [*Cléopâtre allant trouver Antoine à Tarse*]. 1939. Oil on canvas, 32 x 39³/₈" (81.3 x 100 cm). Abby Aldrich Rockefeller Fund. 649.39. Repr. *Ptg. & Sc.*, p. 17.

BAUERMEISTER, Mary. American, born Germany 1934. To U.S.A. 1962. Works in U.S.A. and Germany.

486 PROGRESSIONS. 1963. Pebbles and sand on four plywood panels, 51¹/₄ x 47³/₈ x 4³/₄" (130.1 x 120.4 x 12 cm). Matthew T. Mellon Foundation Fund. 254.64.

BAUMEISTER, Willi. German, 1889–1955.

139 COMPOSITION. (1922) Gouache and crayon, 12³/₄ x 8⁵/₈" (32.4 x 21.9 cm). Katherine S. Dreier Bequest. 142.53.

410 AFRICAN PLAY, IV. 1942. Oil on composition board, 14¹/₈ x 18¹/₈" (35.7 x 45.9 cm). Gift of Mr. and Mrs. F. Taylor Ostrander. 568.66.

139 ARU 6. 1955. Oil on composition board, 51¹/₄ x 39¹/₄" (129.9 x 99.5 cm). Given anonymously. 9.56. Repr. *Suppl. VI*, p. 17.

Also, drawings, prints, and posters.

BAYER, Herbert. American, born Austria 1900. To U.S.A. 1938.

141 IMAGE WITH GREEN MOON. 1961. Synthetic polymer paint on canvas, 16¹/₄ x 16¹/₄" (41 x 41 cm). Given anonymously. 267.63.

Also, a drawing, poster, and other graphic art.

BAZAINE, Jean. French, born 1904.

345 THE FLAME AND THE DIVER. 1953. Oil on canvas, 6'4³/₄" x 51" (194.8 x 129.5 cm). Given anonymously. 1.57. Repr. *Suppl. VII*, p. 19.

Also, a poster.

BAZIOTES, William. American, 1912–1963.

332 DWARF. 1947. Oil on canvas, 42 x 36¹/₈" (106.7 x 91.8 cm). A. Conger Goodyear Fund. 229.47. Repr. *Ptg. & Sc.*, p. 227; in color, *New Amer. Ptg.*, p. 21.

332 POMPEII. 1955. Oil on canvas, 60 x 48" (152.4 x 121.9 cm). Mrs. Bertram Smith Fund. 189.55. Repr. *Suppl. VI*, p. 23; *New Amer. Ptg.*, p. 23.

BEARDEN, Romare. American, born 1914.

HE IS ARISEN. (1945) Watercolor and India ink, 26 x 19³/₈" (66 x 49.2 cm). Advisory Committee Fund. 158.45.

338 THE SILENT VALLEY OF SUNRISE. (1959) Oil and casein on canvas, 58¹/₈ x 42" (147.5 x 106.5 cm). Given anonymously. 113.60. Repr. *Suppl. X*, p. 37.

BEASLEY, Bruce. American, born 1939.

CHORUS. (1960) Welded iron, 10¹/₂ x 14³/₄ x 9³/₄" (26.6 x 37.5 x 24.7 cm). Gift of Mr. and Mrs. Frederick R. Weisman. 1.62. Repr. *Suppl. XII*, p. 22.

BEAUCHAMP, Robert. American, born 1923.

283 Untitled. 1962. Oil on canvas, 67" x 6'10" (170.2 x 208.2 cm). Larry Aldrich Foundation Fund. 226.62. Repr. *Suppl. XII*, p. 26.

BECKMANN, Max. German, 1884–1950. Worked in Amsterdam 1936–47; in U.S.A. 1947–50.

72 THE DESCENT FROM THE CROSS. 1917. Oil on canvas, 59¹/₂ x 50³/₄" (151.2 x 128.9 cm). Curt Valentin Bequest. 328.55. Repr. *Suppl. V*, p. 12; *Beckmann*, p. 28.

72 FAMILY PICTURE. 1920. Oil on canvas, 25⁵/₈ x 39³/₄" (65.1 x 100.9 cm). Gift of Abby Aldrich Rockefeller. 26.35. Repr. *Ptg. & Sc.*, p. 83; in color, *Beckmann*, p. 34. *Note*: represented, left to right, are the artist, his first wife, Minna Beckmann-Tube, his mother-in-law, Frau Tube, his wife's sister, Anne Marie Tube, a servant (reading newspaper); in foreground, his son, Peter Beckmann.

72 THE PRODIGAL SON. (1921) Series of four paintings: THE PRODIGAL SON AMONG COURTESANS, THE PRODIGAL SON AMONG SWINE, THE RETURN OF THE PRODIGAL, THE FEAST OF THE PRODIGAL. Gouache and watercolor with pencil underdrawing on parchment, 14¹/₄ to 14¹/₂ x 11³/₄" (36.1 to 36.9 x 29.9 cm). Purchase. 263–266.39.

72 SELF-PORTRAIT WITH A CIGARETTE. 1923. Oil on canvas, 23³/₄ x 15⁷/₈" (60.2 x 40.3 cm). Gift of Dr. and Mrs. F. H. Hirschland. 255.56. Repr. *Suppl. VI*, p. 16; *Beckmann*, p. 37.

73 DEPARTURE. (1932–33) Oil on canvas; triptych, center panel 7'³/₄" x 45³/₈" (215.3 x 115.2 cm); side panels each 7'³/₄" x 39¹/₄" (215.3 x

99.7 cm). Given anonymously (by exchange). 6.42.1–.3. Repr. *Ptg. & Sc.*, p. 82; in color, *Masters*, p. 63; in color, *Beckmann*, pp. 59–60; in color, *Invitation*, pp. 104–05. *Note*: in his studio notebook the artist recorded the titles and dates of the three panels. All were begun in Frankfort about May 1932 and finished in Berlin late in 1933. See *Beckmann*, p. 55. Left panel: THE CASTLE [*Das Schloss*] finished 31 Dec. 1933. Center panel: THE HOMECOMING [*Die Heimkehr*] finished 15 Nov. 1933. Right panel: THE STAIR-CASE [*Die Treppe*] finished 4 Nov. 1933.

73 SELF-PORTRAIT. (1936) Bronze (cast 1951), 14$^{1/2}$″ (36.8 cm) high. Gift of Curt Valentin. 506.51.

73 STILL LIFE WITH CANDLES. 1949. Oil on canvas, 35 x 55$^{7/8}$″ (88.9 x 141.9 cm). Purchase. 2.50. Repr. *Suppl. II*, p. 17.

Also, drawings, prints, illustrated books, and a poster.

BELL, Larry. American, born 1939.

508 GLASS SCULPTURE NUMBER 10. (1964) Partially silvered glass with chromium frame, 10$^{3/8}$″ (26.2 cm) cube. Promised gift and extended loan from Mr. and Mrs. William N. Copley. E.L.65.392.

508 SHADOWS. (1967) Partially silvered glass with chromium frame, 14$^{1/4}$″ (36.1 cm) cube. Gift of the artist. 116.67.

BELLING, Rudolf. German, 1886–1972. In Istanbul 1937–65.

139 SCULPTURE. (1923) Bronze, partly silvered, 18$^{7/8}$ x 7$^{3/4}$ x 8$^{1/2}$″ (48 x 19.7 x 21.5 cm). A. Conger Goodyear Fund. 246.56. Repr. *Suppl. VI*, p. 16; *German Art of 20th C.*, p. 174; *What Is Mod. Sc.*, p. 46.

ALFRED FLECHTHEIM. (1927) Bronze, 7$^{1/2}$″ (19 cm) high, at base, 4$^{3/4}$″ (12 cm) diameter. Gift of Curt Valentin. 3.50.

Also, a print.

BELLMER, Hans. German, born Upper Silesia (now Poland). 1902–1975. To France 1938.

DOLL. (1936) Painted aluminum (cast 1965), 19$^{1/8}$ x 10$^{5/8}$ x 14$^{7/8}$″ (48.5 x 26.9 x 37.6 cm), on bronze base, 7$^{1/2}$ x 8 x 8″ (18.8 x 20.3 x 20.1 cm). The Sidney and Harriet Janis Collection (fractional gift). 579.67. Repr. *Janis*, p. 69.

BELLOWS, George Wesley. American, 1882–1925.

234 UNDER THE ELEVATED. Watercolor, 5$^{3/4}$ x 8$^{7/8}$″ (14.6 x 22.5 cm). Gift of Abby Aldrich Rockefeller. 27.35.

Also, prints.

BEMAN, Roff. American, 1891–1940.

CORNFIELD AFTER RAIN. 1938. Oil on canvas, 30 x 40″ (76.2 x 101.6 cm). Extended loan from the United States WPA Art Program. E.L.39.1781.

234 BRUMMITT'S CORNFIELD. 1939. Oil on canvas, 24$^{1/4}$ x 36$^{1/4}$″ (61.6 x 92.1 cm). Extended loan from the United States WPA Art Program. E.L.39.1780. Repr. *Romantic Ptg.*, p. 116.

BENDER, C. Whitney. American, born 1929.

HUMID DAY. (1946) Gouache on cardboard, 15$^{5/8}$ x 21$^{5/8}$″ (39.7 x 54.9 cm). Purchase. 1.48.

BENEDIT, Luis Fernando. Argentine, born 1937.

442 PULLET. 1963. Oil and enamel on canvas, 31$^{1/2}$ x 23$^{3/4}$″ (80 x 60.2 cm). Inter-American Fund. 255.64.

BENGSTON, Billy Al. American, born 1934.

500 GREGORY. 1961. Lacquer and synthetic enamel on composition

board, 48$^{1/8}$ x 48$^{1/8}$″ (122 x 122 cm). Larry Aldrich Foundation Fund. 628.65.

BENNETT, Rainey. American, born 1907.

FARM FIELDS. 1938. Watercolor, 21$^{3/4}$ x 30″ (55.2 x 76.2 cm). Purchase. 567.39.

Also, two watercolors in the Study Collection.

BEN-SHMUEL, Ahron. American, born 1903.

256 PUGILIST. (1929) Black granite, 21″ (53.3 cm) high. Gift of Nelson A. Rockefeller. 172.34. Repr. *Ptg. & Sc.*, p. 262.

TORSO OF A BOY. 1930. Stone (diabase), 28$^{3/4}$″ (73 cm) high. Given anonymously. 314.41. Repr. *Ptg. & Sc.* (I), p. 24.

SEATED WOMAN. 1932. Granite, 14$^{3/4}$″ (37.5 cm) high. Gift of Edward M. M. Warburg. 150.34. Repr. *Modern Works*, no. 158.

BENTON, Thomas Hart. American, 1889–1975.

234 HOMESTEAD. (1934) Tempera and oil on composition board, 25 x 34″ (63.5 x 86.4 cm). Gift of Marshall Field (by exchange). 6.38. Repr. *Ptg. & Sc.*, p. 157.

Also, a print and a poster; an oil in the Study Collection.

BEN-ZION. American, born Ukraine 1897. To U.S.A. 1920.

DE PROFUNDIS: IN MEMORY OF THE MASSACRED JEWS OF NAZI EUROPE (from a series of 14). (1943) Gouache and ink, 24 x 19″ (61 x 48.3 cm). Given anonymously. 2.44.

Also, prints.

BÉRARD, Christian. French, 1902–1949.

194 JEAN COCTEAU. 1928. Oil on canvas, 25$^{5/8}$ x 21$^{1/4}$″ (65.1 x 54 cm). Abby Aldrich Rockefeller Fund. 25.40. Repr. *Ptg. & Sc.*, p. 185.

194 PROMENADE. 1928. Oil on canvas, 16$^{1/8}$ x 10$^{5/8}$″ (41 x 27 cm). Purchase. 194.42. Repr. *Ptg. & Sc.*, p. 185.

194 ON THE BEACH (DOUBLE SELF-PORTRAIT). 1933. Oil on canvas, 31$^{7/8}$ x 46″ (80.8 x 116.7 cm). Gift of James Thrall Soby. 23.60. Repr. *Suppl. X*, p. 23; *Soby Collection*, p. 27.

Also, a drawing.

BERDECIO, Roberto. Bolivian, born 1913. Has worked in Mexico and U.S.A.

214 THE CUBE AND THE PERSPECTIVE. 1935. Duco airbrushed on steel panel mounted on wood, 30 x 26″ (76.2 x 66 cm). Gift of Leigh Athearn. 315.41. Repr. *Latin-Amer. Coll.*, p. 33.

BERMAN, Eugene. American, born Russia. 1899–1972. In France 1919–39; in U.S.A. 1939–56; in Italy 1956–72.

194 WINTER. 1929. Oil on canvas, 36$^{1/8}$ x 28$^{3/4}$″ (91.8 x 73 cm). Gift of Richard Blow. 209.37. Repr. *Ptg. & Sc.*, p. 186.

194 THE GOOD SAMARITAN. 1930. Oil on canvas, 36$^{1/4}$ x 28$^{7/8}$″ (92.1 x 73.3 cm). Gift of Mr. and Mrs. Edward M. M. Warburg. 256.56. Repr. *Suppl. VI*, p. 21.

195 SLEEPING FIGURES, STATUE, CAMPANILE. 1932. Oil on canvas, 36$^{1/4}$ x 28$^{3/4}$″ (92.1 x 73 cm). Gift of Philip L. Goodwin. 120.45. Repr. *Ptg. & Sc.*, p. 186.

195 THE GATES OF THE CITY, NIGHTFALL. 1937. Oil on canvas, 30$^{1/4}$ x 40$^{1/4}$″ (76.8 x 102.2 cm). Gift of James Thrall Soby. 224.47. Repr. *Ptg. & Sc.*, p. 187.

ICARE. Three designs for scenery for the ballet produced by the Ballets Russes de Monte Carlo, London, 1938. Gouache, 8$^{1/2}$ x

$11^{1}/8''$; $7^{7}/8 \times 10^{3}/4''$; $10^{1}/8 \times 17^{7}/8''$ (21.6 x 28.3 cm; 20 x 27.2 cm; 25.6 x 45.3 cm). Gift of the artist. 61.42.1–.3. Theatre Arts Collection.

DEVIL'S HOLIDAY. Twelve gouache designs for the ballet produced by the Ballets Russes de Monte Carlo, New York, 1939. Six designs for costumes, $11^{7}/8 \times 15^{7}/8''$ to 8 x 5″ (30.2 x 40.3 to 20.3 x 12.7 cm); six designs for scenery, $12^{5}/8 \times 14^{7}/8''$ to $9^{3}/8 \times 12^{1}/2''$ (32.1 x 37.8 to 23.8 x 31.7 cm). 59.42.1–.11, gift of Paul Magriel; 109.46, gift of Briggs W. Buchanan. Theatre Arts Collection. Design for scenery (59.42.8) repr. *Masters*, p. 182.

GISELLE. Six designs for scenery for the ballet, 1940, unproduced. Gouache, various sizes, $14^{1}/2 \times 22''$ to $4^{7}/8 \times 7^{3}/8''$ (36.8 x 55.9 to 12.4 x 18.7 cm). Gift of Paul Magriel. 60.42.1–.6. Theatre Arts Collection.

NUAGES. Design for costume for the ballet, 1940, not used. Gouache, $8^{7}/8 \times 11''$ (22.5 x 27.9 cm). Gift of Paul Magriel. 62.42. Theatre Arts Collection.

Also, a drawing, prints, an illustrated book, and a poster.

BERMAN, Leonid. See LEONID.

BERMÚDEZ, Cundo. Cuban, born 1914.

THE BALCONY. (1941) Oil on canvas, 29 x $23^{1}/8''$ (73.7 x 58.7 cm). Gift of Edgar Kaufmann, Jr. 644.42. Repr. *Latin-Amer. Coll.*, p. 53. *Note*: the Museum owns one watercolor and eleven ink studies for this painting.

287 BARBER SHOP. 1942. Oil on canvas, $25^{1}/8 \times 21^{1}/8''$ (63.8 x 53.7 cm). Inter-American Fund. 68.44. Repr. *Bulletin*, vol. XI, no. 5, 1944, p. 10.

Also, drawings and a watercolor in the Study Collection.

BERMÚDEZ, José Ygnacio. Cuban, born 1922.

382 MICROFLORA. 1956. Collage of paper with charcoal, pencil, tempera, $19^{3}/4 \times 25^{1}/2''$ (50.2 x 64.7 cm). Inter-American Fund. 557.56. Repr. *Suppl. VI*, p. 35.

Also, a drawing.

BERNARD, Émile. French, 1868–1941.

29 BRIDGE AT ASNIÈRES. 1887. Oil on canvas, $18^{1}/8 \times 21^{3}/8''$ (45.9 x 54.2 cm). Grace Rainey Rogers Fund. 113.62. Repr. *Suppl. XII*, p. 5; in color, *Post-Impress.* (2nd), p. 61.

Also, prints.

BERROCAL, Miguel Ortiz. Spanish, born 1933. Lives in France and Italy.

478 MARIA OF THE O. (1964) Bronze, in seven demountable parts, $4^{1}/8 \times 6^{1}/4 \times 3''$ (10.3 x 15.8 x 7.5 cm). Purchase. 126.65a–g.

BIANCO, Pamela. American, born Great Britain 1906. To U.S.A. 1921.

315 POMEGRANATE. 1957–59. Oil and gold leaf on canvas, $30^{1}/8 \times 24''$ (76.3 x 60.9 cm). Larry Aldrich Foundation Fund. 109.61. Repr. *Suppl. XI*, p. 44.

BIEDERMAN, Charles. American, born 1906.

417 RELIEF, NEW YORK. (1936) Casein on wood with metal, nails, and string, $33^{3}/8 \times 6^{3}/4 \times 5^{7}/8''$ (84.7 x 17.1 x 14.9 cm). Gift of A. Conger Goodyear. 70.36.

BIGAUD, Wilson. Haitian, born 1931.

9 MURDER IN THE JUNGLE. (1950) Oil on composition board, $23^{7}/8 \times 29^{3}/4''$ (60.6 x 75.6 cm). Inter-American Fund. 2.51. Repr. *Suppl. III*, p. 24.

Also, a print.

BISCHOFF, Elmer. American, born 1916.

280 GIRL WADING. 1959. Oil on canvas, $6'10^{5}/8'' \times 67^{3}/4''$ (209.8 x 172 cm). Blanchette Rockefeller Fund. 1.60. Repr. *Suppl. X*, p. 26.

BISSIER, Julius. German, 1893–1965. Lived in Switzerland.

395 6 JULY 1959. 1959. Oil and tempera on canvas, $8^{1}/4 \times 11^{1}/4''$ (21 x 28.5 cm). Gertrud A. Mellon Fund. 397.63.

BISSIÈRE, Roger. French, 1888–1964.

193 RED AND BLACK. 1952. Oil and egg tempera on canvas, $42^{1}/2 \times 26^{3}/4''$ (107.9 x 67.8 cm). Gift of Miss Darthea Speyer. 515.61. Repr. *Suppl. XI*, p. 16.

192 RED BIRD ON BLACK. 1953. Oil and egg tempera on canvas, 40 x $19^{5}/8''$ (101.4 x 49.7 cm). Gift of Mr. and Mrs. Werner E. Josten. 713.59. Repr. *Suppl. IX*, p. 16.

Also, a poster.

BITTLEMAN, Arnold. American, born 1933.

COLLAGE WITH A LEAF. (1957) Oil with collage of leaves on paper, $30^{1}/8 \times 22^{7}/8''$ (76.2 x 58.2 cm). Purchase. 108.58.

BLADEN, Ronald. American, born Canada 1918. To U.S.A. 1939.

496 Untitled. (1966–67; first made in wood, 1965) Painted and burnished aluminum in three identical parts, each 10' x 48″ x 24″ (305 x 122 x 61 cm), spaced 9'4″ (284 cm) apart; overall length 28'4″ (864 cm). James Thrall Soby Fund. 69.67a–c. Repr. *What Is Mod. Sc.*, p. 108.

BLANCO. See RAMOS BLANCO.

BLATAS, Arbit. American, born Lithuania 1908. Worked in Paris. To U.S.A. 1940.

THREE CHILDREN. (1938) Oil on canvas, $39^{1}/4 \times 13^{5}/8''$ (99.7 x 34.6 cm). Gift of the French Art Galleries, Inc. 12.40.

BLOOM, Hyman. American, born Latvia 1913. To U.S.A. 1920.

CHRISTMAS TREE. 1939. Oil on canvas, 52 x 31″ (132.1 x 78.8 cm). Extended loan from the United States WPA Art Program. E.L.41.2312.

273 THE SYNAGOGUE. (c. 1940) Oil on canvas, $65^{1}/4 \times 46^{3}/4''$ (165.7 x 118.7 cm). Acquired through the Lillie P. Bliss Bequest. 611.43. Repr. *Ptg. & Sc.*, p. 171.

273 THE BRIDE. (1941) Oil on canvas, $20^{1}/8 \times 49^{7}/8''$ (51.1 x 126.7 cm). Purchase. 7.42. Repr. *Romantic Ptg.*, p. 99.

Also, a drawing in the Study Collection.

BLOSUM, Vern. American, born 1936.

392 TIME EXPIRED. 1962. Oil on canvas, $37^{1}/2 \times 27^{7}/8''$ (95.1 x 70.7 cm). Larry Aldrich Foundation Fund. 71.63.

BLOW, Sandra. British, born 1925.

WINTER. (1956) Oil, sawdust, gauze on composition board, 36 x $60^{1}/8''$ (91.5 x 152.6 cm). Purchase. 257.56. Repr. *Suppl. VI*, p. 30.

BLUEMNER, Oscar Florianus. American, 1867–1938.

223 THE EYE OF FATE. (1927) Watercolor, $13^{3}/8 \times 10''$ (33.8 x 25.3 cm). Gift of James Graham and Sons. 78.60. Repr. *Suppl. X*, p. 21.

223 SUN STORM. (1927) Watercolor, 10 x $13^{1}/4''$ (25.3 x 33.5 cm). Gift of James Graham and Sons. 79.60. Repr. *Suppl. X*, p. 21.

BLUME, Peter. American, born Russia 1906. To U.S.A. 1911.

245　THE BOAT. (1929) Oil on canvas, 20¹/₈ x 24¹/₈″ (51.1 x 61.3 cm). Gift of Mrs. Sam A. Lewisohn. 39.52. Repr. *Suppl. IV*, p. 30.

Study for PARADE. 1929. Oil on cardboard, 20¹/₄ x 14″ (51.4 x 35.6 cm). Gift of Abby Aldrich Rockefeller. 30.35. Repr. *La Pintura*, p. 109.

244　PARADE. 1930. Oil on canvas, 49¹/₄ x 56³/₈″ (125.1 x 143.2 cm). Gift of Abby Aldrich Rockefeller. 29.35. Repr. *Ptg. & Sc.*, p. 133.

MONK. Study for THE ETERNAL CITY. (1937) Oil on paper, 9⁷/₈ x 9¹/₂″ (25.1 x 24.1 cm). Given anonymously. 121.45.

245　THE ETERNAL CITY. 1937 (1934–37. Dated on painting 1937). Oil on composition board, 34 x 47⁷/₈″ (86.4 x 121.6 cm). Mrs. Simon Guggenheim Fund. 574.42. Repr. *Ptg. & Sc.*, p. 152; in color, *Masters*, p. 161; in color, *Invitation*, p. 106. *Note*: the Museum also owns four pencil studies for this painting.

245　LANDSCAPE WITH POPPIES. (1939) Oil on canvas, 18 x 25¹/₈″ (45.7 x 63.8 cm). Gift of Abby Aldrich Rockefeller. 391.41. Repr. *Ptg. & Sc.*, p. 162.

Also, drawings.

BLUMENSCHEIN, Ernest Leonard. American, 1874–1960.

235　JURY FOR TRIAL OF A SHEEPHERDER FOR MURDER. (1936) Oil on canvas, 46¹/₄ x 30″ (117.5 x 76.2 cm). Abby Aldrich Rockefeller Fund. 300.38. Repr. *Art in Our Time*, no. 142.

BOCCACCI, Marcello. Italian, born 1914.

COMPOSITION—FIGURES AND LANDSCAPE. (1952) Gouache and pastel, 8⁵/₈ x 33¹/₄″ (21.9 x 84.5 cm). Gift of Mr. and Mrs. David M. Solinger. 29.53.

BOCCIONI, Umberto. Italian, 1882–1916.

118　THE CITY RISES. (1910) Oil on canvas, 6′6¹/₂″ x 9′10¹/₂″ (199.3 x 301 cm). Mrs. Simon Guggenheim Fund. 507.51. Repr. *Suppl. IV*, p. 20; in color, *Masters*, p. 99; *Futurism*, p. 37. *Note*: the left-hand third of *The City Rises* was damaged by fire in 1958 and has been partially repainted with pigment in a vinyl medium over discolored original oil paint. The Museum owns the final composition study, in black crayon, for this painting.

118　THE LAUGH. (1911) Oil on canvas, 43³/₈ x 57¹/₄″ (110.2 x 145.4 cm). Gift of Herbert and Nannette Rothschild. 656.59. Repr. *Suppl. IX*, p. 11; in color, *Futurism*, p. 40. *Note*: the Museum owns a pencil drawing related to this painting but probably a study for an earlier version of the same subject.

119　THE RIOT. (1911 or after) Oil on canvas, 19⁷/₈ x 19⁷/₈″ (50.5 x 50.5 cm). Gift of Herbert and Nannette Rothschild. 252.57. Repr. *Suppl. VII*, p. 7; *Futurism*, p. 34. *Note*: two ink drawings, dated 18 April 1911, are apparently studies for this painting and are reproduced in *Futurism*, p. 34.

119　DEVELOPMENT OF A BOTTLE IN SPACE. (1912) Silvered bronze (cast 1931), 15 x 12⁷/₈ x 23³/₄″ (38.1 x 32.7 x 60.3 cm). Aristide Maillol Fund. 230.48. Repr. *20th-C. Italian Art*, pl. 12; *Futurism*, p. 92; *Rosso*, p. 62. *Note*: variously titled by the artist *Sviluppo di una bottiglia nello spazio mediante la forma (Natura morta)*, and *Sviluppo di una bottiglia nello spazio (Natura morta)*.

DYNAMISM OF A SOCCER PLAYER [*Dinamismo di un footballer*]. (1913) Oil on canvas, 6′4¹/₈″ x 6′7¹/₈″ (193.2 x 201 cm). The Sidney and Harriet Janis Collection (fractional gift). 580.67. Repr. *Futurism*, p. 89; in color, *Janis*, p. 23; in color, *Invitation*, p. 55.

119　UNIQUE FORMS OF CONTINUITY IN SPACE. (1913) Bronze (cast 1931), 43⁷/₈ x 34⁷/₈ x 15³/₄″ (111.2 x 88.5 x 40 cm). Acquired through the Lillie P. Bliss Bequest. 231.48. Repr. *Masters*, p. 101;

Futurism, p. 95; *What Is Mod. Sc.*, p. 49. *Note*: the Museum owns a large charcoal study for this sculpture, entitled by the artist *Muscular Dynamism*, and a pencil study.

Also, drawings.

BOLOMEY, Roger. American, born 1918.

482　OCEAN GAME. 1964. Construction of polyurethane and aluminum on a wood frame, 52¹/₂″ x 6′1¹/₄″ x 28¹/₄″ (133.2 x 183.4 x 71.7 cm). Gift of Dr. Rosemary Lenel. 382.66.

BOLOTOWSKY, Ilya. American, born Russia 1907. To U.S.A. 1923.

364　WHITE CIRCLE. (1958) Oil on canvas, about 60³/₄″ (154.3 cm) diameter. Gift of N. E. Waldman. 24.60. Repr. *Suppl. X*, p. 51.

BOMBOIS, Camille. French, 1883–1970.

9　BEFORE ENTERING THE RING. (1930–35) Oil on canvas, 23⁵/₈ x 28³/₄″ (60 x 73 cm). Abby Aldrich Rockefeller Fund. 662.39. Repr. *Ptg. & Sc.*, p. 18.

BONEVARDI, Marcelo. Argentine, born 1929. To U.S.A. 1958.

480　FIGURE, I. 1964. Synthetic polymer paint on joined canvas, with construction of wood and string, 25¹/₈ x 21³/₄ x 2¹/₈″ (63.7 x 55 x 5.2 cm). Inter-American Fund. 650.64.

BONNARD, Pierre. French, 1867–1947.

32　THREE PANELS OF A SCREEN. (1894–96) Oil on brown twill lined with canvas, each panel about 65³/₄ x 20″ (167 x 50.8 cm). Gift of Mr. and Mrs. Allan D. Emil. 2.55.1–.3. Repr. *Suppl. V*, p. 6. *Note*: the screen originally had four panels.

33　LUNCHEON. (c. 1927) Oil on canvas, 16¹/₄ x 24¹/₂″ (41.3 x 62.2 cm). Given anonymously. 453.37. Repr. *Ptg. & Sc.*, p. 38; in color, *Bonnard* (1948), p. 99.

33　THE BREAKFAST ROOM. (c. 1930–31) Oil on canvas, 62⁷/₈ x 44⁷/₈″ (159.6 x 113.8 cm). Given anonymously. 392.41. Repr. *Ptg. & Sc.*, p. 39; *Bonnard* (1948), p. 109; in color, *Masters*, p. 39; *Bonnard*, p. 81; in color, *Invitation*, p. 27.

Also, prints, posters, a screen, music sheets, illustrated books, and album covers.

BONTECOU, Lee. American, born 1931.

Untitled. 1959. Relief construction of welded steel, wire, cloth, 58¹/₈ x 58¹/₂ x 17³/₈″ (147.5 x 148.5 x 44 cm). Gift of Mr. and Mrs. Arnold H. Maremont. 2.60. Repr. *Suppl. X*, p. 42; *Amer. 1963*, p. 13.

363　Untitled. 1961. Relief construction of welded steel, wire, canvas, 6′8¹/₄″ x 7′5″ x 34³/₄″ (203.6 x 226 x 88 cm). Kay Sage Tanguy Fund. 398.63. Repr. *Amer. 1963*, p. 16.

Also, drawings and prints.

BOOTH, Cameron. American, born 1892.

STREET IN STILLWATER. (1936) Gouache, 15³/₄ x 22³/₄″ (40 x 57.8 cm). Extended loan from the United States WPA Art Program. E.L.39.1865. Repr. *New Horizons*, no. 124.

BORDUAS, Paul-Émile. Canadian, 1905–1960. Worked in Paris from 1955.

349　MORNING CANDELABRA [*Lampadaires du matin*]. 1948. Oil on canvas, 32¹/₄ x 43″ (81.9 x 109.2 cm). Gift of the Passedoit Gallery. 263.54. Repr. *Suppl. V*, p. 27.

LA GUIGNOLÉE. 1954. Watercolor, 22 x 30¹/₄″ (55.9 x 76.8 cm). Purchase. 3.55.

BORÈS, Francisco. Spanish, born 1898. Lives in Paris.

192 THE FITTING [*L'Essayage—Souvenir imaginaire*]. 1934. Oil on canvas, 6'3³/4" x 7'2³/4" (184.8 x 220.4 cm). Purchase. 2.49. Repr. *Suppl. I*, p. 12.

BORIANI, Davide. Italian, born 1936.

509 MAGNETIC SURFACE. (1959) Construction with iron filings and foam rubber on plastic background, with magnets and motor, in a glass-covered cylinder, 22³/4" diameter, 2⁷/8" deep (57.6 x 7.2 cm). Gift of the Olivetti Company of Italy. 1231.64.

BOTERO, Fernando. Colombian, born 1932. In U.S.A. since 1961.

284 MONA LISA, AGE TWELVE. 1959. Oil and tempera on canvas, 6'11¹/8" x 6'5" (211 x 195.5 cm). Inter-American Fund. 279.61. Repr. *Suppl. XI*, p. 52; in color, *Invitation*, p. 61.

BOTKIN, Henry. American, born 1896.

PALMA. (1963) Cloth collage and chalk on composition board, 14³/4 x 18¹/2" (37.2 x 46.9 cm). Gift of Carroll Carstairs (by exchange). 256.64.

BOUCHÉ, René Robert. American, born Czechoslovakia. 1905–1963. Worked in Western Europe. To U.S.A. 1941.

262 GEORGES BRAQUE. 1957. Oil on canvas, 45¹/8 x 34" (114.5 x 86.4 cm). Gift of Mrs. Albert D. Lasker. 60.61. Repr. *Suppl. X*, p. 25.

Also, a drawing.

BOURDELLE, Émile-Antoine. French, 1861–1929.

39 BEETHOVEN. (1901) Bronze, head, 15⁵/8" (39.6 cm) high, cast with base, 11³/8" (28.9 cm) high. Inscribed on base: *Moi je suis Bacchus qui pressure pour les hommes le nectar délicieux— Beethoven.* Gift of Mrs. Maurice L. Stone in memory of her husband. 714.59. Repr. *Suppl. IX*, p. 7.

39 BEETHOVEN, TRAGIC MASK. 1901. Bronze, 30¹/2" (77.4 cm) high. Grace Rainey Rogers Fund. 280.61. Repr. *Suppl. XI*, p. 10; *What Is Mod. Sc.*, p. 36.

Also, a drawing.

BOURGEOIS, Louise. American, born France 1911. To U.S.A. 1938.

303 SLEEPING FIGURE. (1950) Balsa wood, 6'2¹/2" (189.2 cm) high. Katharine Cornell Fund. 3.51. Repr. *Suppl. III*, p. 7.

SLEEPING FIGURE, II. (1959) Bronze, 6'3¹/4" (191.1 cm) high. Purchase. 153.62. Variant of *Sleeping Figure*, 1950, listed above, 3.51.

BRANCUSI, Constantin. French, born Rumania. 1876–1957. To Paris 1904.

Dating and other difficult details depend largely on the definitive catalog *Brancusi*, New York, 1968, by Sidney Geist; his catalog number is included in each entry. Athena Tacha Spear has also been of generous assistance. A group of the Museum's Brancusi sculptures is reproduced in color in *Masters*, p. 125.

108 DOUBLE CARYATID. (1908?) Limestone, 29⁵/8" (75.2 cm) high. Middle section of pedestal of *Magic Bird*, 144.53a. Katherine S. Dreier Bequest. 144.53c. *Geist* 41. Repr. *Suppl. IV*, p. 8.

108 MAGIC BIRD [*Pasarea Maiastra*]. Version I (1910) White marble, 22" (55.9 cm) high; on three-part limestone pedestal, 70" (177.8 cm) high, of which the middle section is the *Double Caryatid*, listed above (144.53c). Katherine S. Dreier Bequest. 144.53a–d. *Geist* 61. Repr. *Suppl. IV*, p. 8. *Note*: in the Rumanian title, *pasarea* means bird, *maiastra* means magic (or master). Geist quotes Brancusi's reference to a Rumanian folk tale: "Prince

Charming was in search of Ilena Cosinzene. The master bird is the bird that spoke and showed the way to Prince Charming."

108 MLLE POGANY. Version I (1913) after a marble of 1912. Bronze, 17¹/4" (43.8 cm) high. Acquired through the Lillie P. Bliss Bequest. 2.53. *Geist* 74a. Repr. *Suppl. IV*, p. 21. *Note*: this first bronze cast was purchased in 1953 from the subject, Mlle Margit Pogany, who commissioned it in 1910.

108 THE NEWBORN. Version I (1915) close to the marble of 1915. Bronze, 5³/4 x 8¹/4" (14.6 x 21 cm). Acquired through the Lillie P. Bliss Bequest. 605.43. *Geist* 87a. Repr. *Ptg. & Sc.*, p. 276.

110 SOCRATES. (1923) Wood, 51¹/4" (130 cm) high. Mrs. Simon Guggenheim Fund. 187.56. *Geist* 143. Repr. *Suppl. VI*, p. 1.

110 THE COCK. Version I (1924) Walnut, 47⁵/8" (121 cm) high, including cylindrical base 11¹/2" (29.2 cm) high. Inscribed: *A Audrey Chadwick. C. Brancusi Paris.* Gift of LeRay W. Berdeau. 620.59. *Geist* 151. Repr. *Bulletin*, Fall 1958, p. 15.

108 BIRD IN SPACE. (1928?) Bronze (unique cast), 54" (137.2 cm) high. Given anonymously. 153.34. *Geist* 171, tenth of sixteen variations from 1923 to 1941 and depending on *Geist* 162, 1925. Repr. *Ptg. & Sc.*, p. 275.

109 FISH. 1930. Gray marble, 21 x 71" (53.3 x 180.3 cm); on three-part pedestal of one marble and two limestone cylinders, 29¹/8" (74 cm) high. (Similar to much smaller marble *Fish*, 1922.) Acquired through the Lillie P. Bliss Bequest. 695.49. *Geist* 177. Repr. *Suppl. II*, p. 31.

110 BLOND NEGRESS. 1933. Version II, after a marble of 1928. Bronze, 15³/4" (40 cm) high; on four-part pedestal of marble, limestone, and two wood sections (carved by the artist), 55¹/2" (141 cm) high. The Philip L. Goodwin Collection. 97.58a–e. *Geist* 182a. Repr. *Bulletin*, Fall 1958, on cover and p. 5.

Also, a drawing.

BRAQUE, Georges. French, 1882–1963.

92 ROAD NEAR L'ESTAQUE. (1908) Oil on canvas, 23³/4 x 19³/4" (60.3 x 50.2 cm). Given anonymously (by exchange). 103.43. Repr. *Ptg. & Sc.*, p. 86.

92 MAN WITH A GUITAR. (1911) Oil on canvas, 45³/4 x 31⁷/8" (116.2 x 80.9 cm). Acquired through the Lillie P. Bliss Bequest. 175.45. Repr. *Ptg. & Sc.*, p. 87; *Gris*, p. 22; in color, *Masters*, p. 72.

92 SODA. (1911) Oil on canvas, 14¹/4" (36.2 cm) diameter. Acquired through the Lillie P. Bliss Bequest. 8.42. Repr. *Ptg. & Sc.*, p. 86.

93 GUITAR. (1913–14) Gesso on canvas with pasted paper, pencil, charcoal, and chalk, 39¹/4 x 25⁵/8" (99.7 x 65.1 cm). Acquired through the Lillie P. Bliss Bequest. 304.47. Repr. *Braque*, p. 61.

93 OVAL STILL LIFE [*Le Violon*]. (1914) Oil on canvas, 36³/8 x 25³/4" (92.4 x 65.4 cm). Gift of the Advisory Committee. 210.35. Repr. *Ptg. & Sc.*, p. 96.

93 THE TABLE. 1928. Oil on canvas, 70³/4 x 28³/4" (179.7 x 73 cm). Acquired through the Lillie P. Bliss Bequest. 520.41. Repr. *Ptg. & Sc.*, p. 103; in color, *Braque*, p. 109; in color, *Invitation*, p. 51.

94 BEACH AT DIEPPE. 1928. Oil on canvas, 10³/4 x 18¹/8" (27.3 x 46 cm). Abby Aldrich Rockefeller Fund. 272.39.

94 WOMAN WITH A MANDOLIN. 1937. Oil on canvas, 51¹/4 x 38¹/4" (130.2 x 97.2 cm). Mrs. Simon Guggenheim Fund. 2.48. Repr. *Suppl. I*, p. 9; in color, *Masters*, p. 94; *Braque*, p. 129; in color, *Invitation*, p. 73.

Also, a drawing, prints, illustrated books, a copper plate for an etching, posters, and a film on the artist.

BRATBY, John Randall. British, born 1928.

269 NELL AND JEREMY SANDFORD. 1957. Oil on composition board, 6′5⁷/₈″ x 7′8¹/₈″ (197.7 x 234 cm). Gift of Mr. and Mrs. Robert W. Dowling. 2.59. Repr. *Suppl. IX*, p. 29.

BRAUNER, Victor. Rumanian, 1903–1966. To Paris 1930.

 NUDE AND SPECTRAL STILL LIFE [*La Vie intérieure*]. (1939) Oil on canvas, 36¹/₈ x 28⁵/₈″ (91.7 x 72.6 cm). The Sidney and Harriet Janis Collection (fractional gift). 581.67. Repr. *Janis*, p. 73.

 TALISMAN. 1943. Tallow on wood, 6³/₈ x 10⁷/₈″ (15.9 x 27.4 cm). The Sidney and Harriet Janis Collection (fractional gift). 582.67. Repr. *Dada, Surrealism*, p. 136; *Janis*, p. 73.

182 PROGRESSION PANTACULAIRE. 1948. Encaustic on cardboard, 19³/₄ x 27¹/₂″ (50.2 x 69.8 cm). Gift of D. and J. de Menil. 331.49. Repr. *Suppl. II*, p. 14.

 Also, part of a *cadavre exquis* and an illustration; a painting and assemblage in the Study Collection.

BRECHT, George. American, born 1926.

386 REPOSITORY. (1961) Assemblage: wall cabinet containing pocket watch, tennis ball, thermometer, plastic and rubber balls, baseball, plastic persimmon, "Liberty" statuette, wood puzzle, tooth brushes, bottle caps, house number, pencils, preserved worm, pocket mirror, light bulbs, keys, hardware, coins, photographs, playing cards, postcard, dollar bill, page from Thesaurus, 40³/₈″ x 10¹/₂ x 3¹/₈″ (102.6 x 26.7 x 7.7 cm). Larry Aldrich Foundation Fund. 281.61. Repr. *Assemblage*, p. 155.

BREININ, Raymond. American, born Russia 1909. To U.S.A. 1924.

 DESERTED FARM. 1936. Gouache, 18 x 26¹/₄″ (45.7 x 66.7 cm). Extended loan from the United States WPA Art Program. E.L.39.1832. Repr. *New Horizons*, no. 126.

 LONESOME FARM. 1936. Gouache, 20¹/₈ x 30″ (50.9 x 76.2 cm). Extended loan from the United States WPA Art Program. E.L.39.1834. Repr. *Ptg. & Sc.*, p. 172.

 WHITE HOUSE. 1938. Oil on canvas, 30 x 40¹/₈″ (76.2 x 101.9 cm). Extended loan from the United States WPA Art Program. E.L.39.1856. Repr. *Amer. 1942*, p. 27.

 ONE MORNING. (c. 1939) Gouache, 16⁵/₈ x 27⁵/₈″ (42.2 x 70.2 cm). Abby Aldrich Rockefeller Fund. 568.39. Repr. *Amer. 1942*, p. 26.

 Also, other paintings on extended loan.

BRETON, André. French, 1896–1966.

182 POEM-OBJECT. 1941. Assemblage mounted on drawing board: carved wood bust of man, oil lantern, framed photograph, toy boxing gloves, 18 x 21 x 4³/₈″ (45.8 x 53.2 x 10.9 cm). Inscribed in gouache and oil: *ces terrains vagues/où j'erre/vaincu par l'ombre/et la lune/accrochée à la maison de mon coeur.* Kay Sage Tanguy Bequest. 197.63. Repr. *Assemblage*, p. 67.

 Also, drawings and part of a *cadavre exquis*.

BRÔ, René (René Brault). French, born 1930.

291 SPRING BLOSSOMS. (1962) Oil and egg tempera on canvas, 25¹/₂ x 31⁷/₈″ (64.7 x 81 cm). Acquired through the Lillie P. Bliss Bequest. 228.62. Repr. *Suppl. XII*, p. 27.

BRODIE, Gandy. American, 1925–1975.

289 BROKEN BLOSSOM. (1960) Oil on canvas, 25⁵/₈ x 36³/₈″ (65.1 x 92.3 cm). Purchase and exchange. 110.61. Repr. *Suppl. XI*, p. 46.

BROOK, Alexander. American, born 1898.

240 GEORGE BIDDLE PLAYING THE FLUTE. (1929) Oil on canvas,

40³/₈ x 30¹/₄″ (102.6 x 76.8 cm). Gift of Abby Aldrich Rockefeller. 38.35. Repr. *20th-C. Portraits*, p. 96.

 Also, a drawing and prints.

BROOKS, James. American, born 1906.

332 QUALM. 1954. Oil on canvas, 61 x 57¹/₈″ (154.9 x 144.9 cm). Gift of Mrs. Bliss Parkinson. 247.56. Repr. *12 Amer.*, p. 17; *New Amer. Ptg.*, p. 25.

BROWN, Joan. American, born 1938.

 THANKSGIVING TURKEY. 1959. Oil on canvas, 47⁷/₈ x 47⁷/₈″ (121.5 x 121.5 cm). Larry Aldrich Foundation Fund. 80.60. Repr. *Suppl. X*, p. 35.

BRZOZOWSKI, Tadeusz. Polish, born 1918.

 PRETZELS. (1959) Oil on canvas, 51¹/₄ x 50″ (130.1 x 127 cm). Gift of Mr. and Mrs. Arthur S. Freeman. 116.62. Repr. *Suppl. XII*, p. 20.

 Also, a print.

BUCHHOLZ, Erich. German, 1891–1972.

139 FORCES [*Kräfte*]. 1921. Oil on canvas, 7′7¹/₄″ x 53¹/₄″ (231.6 x 135.2 cm). Gift of Herbert and Nannette Rothschild. 261.56. Repr. *Suppl. VI*, p. 17.

BUFFET, Bernard. French, born 1928.

 SELF-PORTRAIT. 1948. Oil on canvas, 6′10¹/₄″ x 40⁵/₈″ (209 x 103.2 cm). Purchase. 131.51. Repr. *Suppl. III*, p. 19.

289 STILL LIFE WITH FISH, II. 1949. Oil on canvas, 16³/₈ x 33¹/₂″ (41.6 x 85.1 cm). Mrs. Cornelius J. Sullivan Fund. 85.50. Repr. *Suppl. II*, p. 16.

 Also, a drawing and prints.

BURCHFIELD, Charles. American, 1893–1967.

 THE CITY. 1916. Watercolor, 13³/₈ x 19³/₈″ (34 x 49.2 cm). Gift of Abby Aldrich Rockefeller. 42.35.

 ROGUES' GALLERY. 1916. Watercolor, 13¹/₂ x 19⁵/₈″ (34.3 x 49.9 cm). Gift of Abby Aldrich Rockefeller. 44.35. Repr. *Burchfield*, no. 4.

242 GARDEN OF MEMORIES. 1917. Crayon and watercolor, 25³/₄ x 22¹/₂″ (65.4 x 57.1 cm). Gift of Abby Aldrich Rockefeller (by exchange). 2.36. Repr. *Burchfield*, no. 25.

 INSECTS AT TWILIGHT. 1917. Watercolor, 14 x 19³/₄″ (35.6 x 50.2 cm). Gift of Abby Aldrich Rockefeller (by exchange). 3.36.

242 THE FIRST HEPATICAS. 1917–18. Watercolor, 21¹/₂ x 27¹/₂″ (54.6 x 69.8 cm). Gift of Abby Aldrich Rockefeller. 43.35. Repr. *Ptg. & Sc.*, p. 163.

242 THE NIGHT WIND. 1918. Watercolor and gouache, 21¹/₂ x 21⁷/₈″ (54.4 x 55.5 cm). Gift of A. Conger Goodyear. 359.60. Repr. *Burchfield*, no. 26; *Suppl. X*, p. 21.

242 THE INTERURBAN LINE. 1920. Watercolor, 14³/₄ x 20³/₄″ (37.5 x 52.7 cm). Gift of Abby Aldrich Rockefeller (by exchange). 4.36. Repr. *Ptg. & Sc.*, p. 159.

242 PIPPIN HOUSE, EAST LIVERPOOL, OHIO. (1920) Watercolor, 26 x 19³/₈″ (66 x 49.2 cm). Gift of Mr. and Mrs. Alex L. Hillman. 235.50. Repr. *Suppl. II*, p. 24.

242 RAILROAD GANTRY. (1920) Watercolor, 18 x 24⁵/₈″ (45.7 x 62.6 cm). Given anonymously. 2.30. Repr. *Ptg. & Sc.*, p. 159.

BURLE MARX, Roberto. Brazilian, born 1909.

Detail 5 of Plan for Quadricentennial Gardens, Ibirapuera Park, São Paulo, Brazil. 1953. Gouache, 43 x 52¹/₈″ (109.2 x 132.4 cm). Inter-American Fund. 243.54. Repr. *Suppl. V*, p. 35.

Also, garden designs in the Study Collection.

BURLIN, Paul. American, 1886–1969.

236 FALLEN ANGEL. (1943) Oil on canvas, 13 x 16¹/₈″ (32.8 x 40.8 cm). Purchase. 104.43. Repr. *Ptg. & Sc.*, p. 234.

BURRA, Edward John. British, born 1905.

196 BAL DES PENDUS. (1937) Watercolor, 61¹/₈ x 44⁷/₈″ (155.2 x 114 cm). Purchase. 233.48. Repr. *Suppl. I*, p. 15.

BURRI, Alberto. Italian, born 1915.

376 SACKCLOTH 1953. (1953) Burlap, sewn, patched, and glued, over canvas, 33⁷/₈ x 39³/₈″ (86 x 100 cm). Mr. and Mrs. David M. Solinger Fund. 542.54. Repr. *Suppl. V*, p. 23.

BURT, Michael. Paraguayan, born 1931.

437 THE OLD HOUSE ENDURES [*La Vieja casona permanece*]. 1966. Synthetic polymer paint, with collage of corrugated cardboard and cloth on canvas, 47³/₈ x 47³/₈″ (120.3 x 120.3 cm). Inter-American Fund. 2099.67.

BURY, Pol. Belgian, born 1922. To France 1961.

511 1,914 WHITE POINTS. 1964. Motor-driven construction of plastic-tipped nylon wires in wood panel, 39¹/₄ x 19⁵/₈ x 4³/₄″ (99.6 x 49.7 x 12.1 cm). Philip Johnson Fund. 566.64.

511 31 RODS EACH WITH A BALL. 1964. Motor-driven wood construction with cork and nylon wire, 39³/₄″ (100.9 cm) high, including wood box, 29³/₄ x 19¹/₂ x 6¹/₂″ (75.4 x 49.5 x 16.4 cm). Elizabeth Bliss Parkinson Fund. 565.64.

BUTLER, Horacio A. Argentine, born 1897.

EL CAMELOTE: TIGRE. (1941) Oil on canvas, 32 x 39″ (81.3 x 99.1 cm). Inter-American Fund. 653.42. Repr. *Latin-Amer. Coll.*, p. 26.

Also, a theatre design.

BUTLER, Reg (Reginald Cotterell Butler). British, born 1913.

295 THE UNKNOWN POLITICAL PRISONER (PROJECT FOR A MONUMENT). (1951–53) Welded bronze, brass wire and sheet, 17³/₈″ (44.1 cm) high, on limestone base, 2³/₄ x 7¹/₂ x 7¹/₄″ (7 x 19 x 18.4 cm). Saidie A. May Fund. 410.53. Repr. *Masters*, p. 159; *New Images*, p. 42; *What Is Mod. Sc.*, p. 124. *Note*: replica made by the artist to replace the original, damaged after winning first prize in international competition for a monument to The Unknown Political Prisoner, London, 1953.

295 ORACLE. (1952) Cast shell bronze welded to forged bronze armature, 33¹/₂ x 6'1″ (85.1 x 185.4 cm). Purchase. 409.53. Repr. *Suppl. IV*, p. 41; *New Decade*, p. 67.

295 WOMAN STANDING. (1952) Welded bronze and brass sheet and wire, 18¹/₂″ (47 cm) high. Acquired through the Lillie P. Bliss Bequest. 3.53. *Note*: the Museum owns a sheet of studies for this sculpture.

477 THE BOX. (1953) Iron, welded and painted, 47¹/₈ x 17¹/₄ x 16³/₄″ (119.5 x 43.6 x 42.4 cm). William P. Jones O'Connor Fund. 184.66.

295 GIRL. (1953–54) Cast shell bronze (cast 1955), 68³/₈″ (173.7 cm) high. A. Conger Goodyear Fund. 558.56. Repr. *Suppl. VI*, p. 27.

Also, drawings and prints.

BYARS, James Lee. American, born 1932. Worked in Japan.

When the four works below were given, the artist wished to be anonymous and to have the works remain untitled. He has since titled the works and given permission for his name to be used.

453 UNTITLED OBJECT. (1962–64) Crayon on Japanese handmade white flax paper, hinged and folded; unfolded, 12″ x 210'9″ (30.3 cm x 64.23 m); folded, 12 x 12 x 3³/₄″ (30.3 x 30.3 x 9.5 cm). Given anonymously. 47.65.

452 UNTITLED OBJECT (A MILE-LONG PAPER WALK). (1962–64) Japanese handmade white flax paper, hinged and folded; unfolded, 36″ x 300' (91.4 cm x 91.44 m), ending in a circle, 9' (274 cm) in diameter; folded, 36 x 36 x 3″ (91 x 91 x 7.6 cm). Given anonymously. 255.66.

452 UNTITLED OBJECT (RIVET CONTINUITY). (1962–64) Japanese handmade white flax paper, in seventy-five sections, ends of each section rounded, overlapped, and joined with rivets; unfolded, 12″ x 500' (30.4 cm x 152.4 m); folded, 12″ x 6' x 4″ (30.4 x 179.7 x 10.1 cm). Given anonymously. 380.66. *Note*: the artist says that this object can form various shapes, such as a circle, star, or triangle.

453 UNTITLED OBJECT (RUNCIBLE). (1962–64) Japanese handmade white flax paper; a 50' (15.24 m) square, divided into thirty-two parallel strips, attached by paper hinges to a single strip at right angles, forming a comb shape; each strip reverse-folds in 18″ (45.6 cm) squares, the whole object stacking into an 18″ (45.6 cm) cube. Given anonymously. 381.66.

CADMUS, Paul. American, born 1904.

248 GREENWICH VILLAGE CAFETERIA. (1934) Oil on canvas, 25¹/₂ x 39¹/₂″ (64.8 x 100.3 cm). Extended loan from the United States Public Works of Art Project. E.L.34.1508. Repr. *Ptg. & Sc.*, p. 144.

Also, a drawing and prints.

CALCAGNO, Lawrence. American, born 1916.

FROZEN RIVER. 1960. Oil on canvas, 52¹/₈ x 48¹/₈″ (132.4 x 122.1 cm). Gift of Mr. and Mrs. William Unger. 111.61. Repr. *Suppl. XI*, p. 32.

CALDER, Alexander. American, 1898–1976. Lived in France and U.S.A.

420 JOSEPHINE BAKER. (1927–29) Iron-wire construction, 39 x 22³/₈ x 9³/₄″ (99 x 56.6 x 24.5 cm). Gift of the artist. 841.66. Repr. *Salute to Calder*, p. 9. *Note*: the sculptor made five or six versions, inspired by the American dancer popular in Paris.

421 CAT LAMP. (1928) Iron-wire and paper construction, 8³/₄ x 10¹/₈ x 3¹/₈″ (22 x 25.6 x 7.7 cm). Gift of the artist. 846.66. Repr. *Salute to Calder*, p. 11.

421 ELEPHANT CHAIR WITH LAMP. (1928) Galvanized sheet steel, iron wire, lead, cloth, and painted-paper construction, 7⁷/₈ x 3¹/₂ x 4¹/₈″ (19.7 x 8.9 x 10.3 cm). Gift of the artist. 845.66. Repr. *Salute to Calder*, p. 11.

257 THE HORSE. (1928) Walnut, 15¹/₂ x 34³/₄″ (39.4 x 88.3 cm). Acquired through the Lillie P. Bliss Bequest. 747.43. Repr. *Ptg. & Sc.*, p. 264; *Salute to Calder*, p. 6.

257 THE HOSTESS. (1928) Wire construction, 11¹/₂″ (29.2 cm) high. Gift of Edward M. M. Warburg. 319.41. Repr. *Salute to Calder*, p. 7.

420 SODA FOUNTAIN. (1928) Iron-wire construction, 10³/₄″ (27.3 cm) high, on wood base, 1⁵/₈ x 5¹/₂ x 3¹/₂″ (4 x 13.9 x 8.7 cm). Gift of the artist. 844.66. Repr. *Salute to Calder*, p. 7.

257 SOW. (1928) Wire construction, 7¹/₂ x 17″ (19.5 x 43.2 cm). Gift of the artist. 5.44. Repr. *Ptg. & Sc.*, p. 264; *Salute to Calder*, p. 8.

257 COW. (1929) Wire construction, 6¹/₂ x 16″ (16.5 x 40.7 cm). Gift of Edward M. M. Warburg. 318.41a–d. Repr. *Salute to Calder*, p. 6.

420 COW. (1929) Wire and wood construction, 3¹/₂ x 8¹/₈ x 4″ (8.9 x 20.5 x 9.9 cm), on wood base, 2 x 6 x 5³/₄″ (5.2 x 15 x 14.5 cm). Gift of Edward M. M. Warburg. 499.41. Repr. *Salute to Calder*, p. 8.

421 MARION GREENWOOD. (1929–30) Brass-wire construction, 12⁵/₈ x 11¹/₈ x 11³/₈″ (31.9 x 28.1 x 28.8 cm). Gift of the artist. 842.66. Repr. *Salute to Calder*, p. 10. *Note*: the subject was an American painter.

421 PORTRAIT OF A MAN. (1929–30) Brass-wire construction, 12⁷/₈ x 8³/₄ x 13¹/₂″ (32.5 x 22.2 x 34.2 cm). Gift of the artist. 843.66.

422 SHARK SUCKER. (1930) Wood, 10³/₄ x 30⁷/₈ x 10¹/₄″ (27.1 x 78.3 x 25.9 cm). Gift of the artist. 389.66. Repr. *Calder* (2nd), p. 20; *Salute to Calder*, p. 26.

258 A UNIVERSE. (1934) Motor-driven mobile: painted iron pipe, wire, and wood with string, 40¹/₂″ (102.9 cm) high. Gift of Abby Aldrich Rockefeller (by exchange). 163.34. Repr. *Calder* (2nd), p. 31; *The Machine*, p. 150; *Salute to Calder*, p. 12.

422 GIBRALTAR. (1936) Construction of lignum vitae, walnut, steel rods, and painted wood, 51⁷/₈ x 24¹/₄ x 11³/₈″ (131.7 x 61.3 x 28.7 cm). Gift of the artist. 847.66a–b. Repr. *Calder* (2nd), p. 36; *Salute to Calder*, p. 14.

259 WHALE. (1937) Standing stabile: painted sheet steel, supported by a log of wood, 68 x 69¹/₂ x 45³/₈″ (172.8 x 176.5 x 115 cm). Gift of the artist. 319.50. Repr. *Suppl. III*, p. 6; *Masters*, p. 146. *Note*: replaced by the artist; see *Whale, II*, 1.65.

258 LOBSTER TRAP AND FISH TAIL. (1939) Hanging mobile: painted steel wire and sheet aluminum, about 8′6″ x 9′6″ (260 x 290 cm). Commissioned by the Advisory Committee for the stairwell of the Museum. 590.39a–d. Repr. *Ptg. & Sc.*, p. 290; *Masters*, p. 147; *Salute to Calder*, p. 4; *What Is Mod. Sc.*, p. 76.

424 SPIDER. (1939) Standing mobile: sheet aluminum, steel rod, and steel wire, painted, 6′8¹/₂″ x 7′4¹/₂″ x 36¹/₂″ (203.5 x 224.5 x 92.6 cm). Gift of the artist. 391.66a–c. Repr. *Salute to Calder*, p. 18.

424 UNTITLED. (Early 1940s) Standing mobile: sheet aluminum and steel wire, painted, 14⁵/₈ x 9 x 10⁷/₈″ (37.1 x 22.8 x 27.5 cm). Kay Sage Tanguy Bequest. 1122.64. Repr. *Salute to Calder*, p. 31.

258 CONSTELLATION WITH RED OBJECT. (1943) Painted wood and steel wire construction, 25¹/₂ x 12¹/₂″ (31.8 x 64.8 cm). James Thrall Soby Fund. 746.43. Repr. *Ptg. & Sc.*, p. 291; *Salute to Calder*, p. 20.

423 MORNING STAR. (1943) Stabile: painted sheet steel and steel wire, painted and unpainted wood, 6′4³/₄″ x 48³/₈ x 45³/₄″ (194.8 x 122.8 x 116 cm). Gift of the artist. 848.66. Repr. *Calder* (2nd), p. 57; *Salute to Calder*, p. 15.

259 MAN-EATER WITH PENNANTS. (1945) Standing mobile: painted steel rods and sheet iron, 14′ x about 30′ (425 x 915 cm). Commissioned for the Sculpture Garden. Purchase. 150.45. Repr. *Ptg. & Sc.*, p. 291; *Salute to Calder*, p. 19.

426 SNOW FLURRY, I. 1948. Hanging mobile: sheet steel and steel wire, painted, 7′10″ x 6′10¹/₄″ (238.7 x 208.8 cm). Gift of the artist. 390.66a–c. Repr. *Salute to Calder*, p. 17.

260 . BLACK WIDOW. 1959. Standing stabile: painted sheet steel, 7′8″ x 14′3″ x 7′5″ (233.3 x 434.1 x 226.2 cm). Mrs. Simon Guggenheim Fund. 557.63. Repr. *Salute to Calder*, p. 23.

424 Model for TEODELAPIO. (1962) Standing stabile: painted sheet aluminum, 23³/₄ x 15¹/₄ x 15³/₄″ (60.3 x 38.7 x 39.8 cm). Gift of the artist. 392.66. Repr. *Salute to Calder*, cover. *Note*: the final work, standing over 60 feet high, was made for the Festival of Two

Worlds, Spoleto, Italy, 1962. Teodelapio, A.D., 601–653 was a Duke of Spoleto.

425 SANDY'S BUTTERFLY. 1964. Standing mobile: stainless sheet steel and iron rods, painted, 12′8″ x 9′2″ x 8′7″ (386 x 279 x 261 cm), at base 9′3″ x 7′6″ x 7′2″ (282 x 229 x 218 cm). Gift of the artist. 849.66a–b. Repr. *Salute to Calder*, p. 21.

423 WHALE, II. (1964. Replica of 1937 original). Standing stabile: painted sheet steel, supported by a log of wood, 68 x 69¹/₂ x 45³/₈″ (172.8 x 176.5 x 115 cm). Gift of the artist (by exchange). 1.65. Repr. *Salute to Calder*, p. 5; *What Is Mod. Sc.*, p. 62. *Note*: the original version was on view in the Sculpture Garden from 1941 to 1963. It suffered damage from the weather, and Calder replaced it in 1964 with a replica in heavier steel.

Also, prints, an illustration, jewelry, and candelabrum; a wire construction, drawings, a poster design, and a templet for a stabile in the Study Collection.

CALLERY, Mary. American, born 1903. Lives in Paris.

304 HORSE. (1942) Bronze, 49¹/₈ x 34³/₈″ (124.6 x 87.2 cm), base 37¹/₄″ (94.4 cm) diameter. Purchase. 256.44. Repr. *Ptg. & Sc.*, p. 265.

CAMPBELL, Jewett. American, born 1912.

243 REFLECTED GLORY. (1939) Oil on canvas, 16¹/₈ x 20″ (41 x 50.8 cm). Purchase. 139.42.

 THE SKATERS. (1940) Oil on canvas, 17 x 14″ (43.2 x 35.6 cm). Abby Aldrich Rockefeller Fund. 140.42.

CAMPENDONK, Heinrich. German, 1889–1957. To the Netherlands 1933.

71 MYSTICAL CRUCIFIXION. (1926–28?) Oil on glass, 17¹/₂ x 15″ (44.5 x 38.1 cm). Katherine S. Dreier Bequest. 146.53. Repr. *Suppl. IV*, p. 17.

Also, prints.

CAMPIGLI, Massimo. Italian, 1895–1971. In Paris 1919–39.

198 Design for mosaic floor of Teatro Metropolitano, Rome. (1943) Gouache and oil on paper, 32¹/₄ x 33¹/₈″ (81.9 x 84.3 cm). Gift of Eric Estorick. 471.53. Repr. *Suppl. V*, p. 19.

Also, prints and an illustrated book.

CAMPOLI, Cosmo. American, born 1922.

303 BIRTH. (1958) Bronze, 37¹/₄ x 49³/₄″ (94.5 x 126.3 cm). Purchase. 715.59. Plaster model for bronze repr. *New Images*, p. 47.

CANADÉ, Vincent. American, born Italy. 1879–1961. To U.S.A. 1892.

10 SELF-PORTRAIT. (c. 1926) Oil on canvas, 18⁵/₈ x 14″ (47.3 x 35.6 cm). Gift of Abby Aldrich Rockefeller (by exchange). 5.36.

Also, prints.

CAPOGROSSI, Giuseppe. Italian, 1900–1972.

 COMPOSITION. (1953) Gouache, 13³/₄ x 19⁵/₈″ (35 x 49.9 cm). Alfred Flechtheim Fund. 8.54.

368 SECTION 4. 1953. Oil on canvas, 7′1⁷/₈″ x 38⁵/₈″ (218.1 x 98.1 cm). Blanchette Rockefeller Fund. 149.55. Repr. *New Decade*, p. 88.

Also, a print.

CARDOSO JUNIOR, José Bernardo. Brazilian, born Portugal. 1861–1947.

 STILL LIFE WITH VIEW OF THE BAY OF GUANABARA. 1937. Oil on paper, 21¹/₄ x 29¹/₂″ (54 x 74.9 cm). Inter-American Fund. 656.42. Repr. *Latin-Amer. Coll.*, p. 40.

CARLES, Arthur B. American, 1882–1952.

229 COMPOSITION, III. (1931–32) Oil on canvas, 51³/₈ x 38³/₄″ (130.5 x 98.4 cm). Gift of Leopold Stokowski. 393.41.

CARRÀ, Carlo. Italian, 1881–1966.

120 FUNERAL OF THE ANARCHIST GALLI. (1911) Oil on canvas, 6′6¹/₄″ x 8′6″ (198.7 x 259.1 cm). Acquired through the Lillie P. Bliss Bequest. 235.48. Repr. *Masters*, p. 98; in color, *Futurism*, p. 31.

403 JOLTS OF A CAB [*Sobbalzi di fiacre*]. (1911) Oil on canvas, 20⁵/₈ x 26¹/₂″ (52.3 x 67.1 cm). Gift of Herbert and Nannette Rothschild. 1007.65. Repr. *Futurism*, p. 53.

Also, prints.

CARREÑO, Mario. Chilean, born Cuba 1913. Worked in U.S.A. 1939–41, 1944–51.

287 TORNADO. 1941. Oil on canvas, 31 x 41″ (78.8 x 104.1 cm). Inter-American Fund. 657.42. Repr. *Ptg. & Sc.*, p. 181.

VASE OF FLOWERS. 1943. Duco on composition board, 41 x 31″ (104.1 x 78.8 cm). Inter-American Fund. 70.44.

Also, a drawing.

CARRIÈRE, Eugène. French, 1849–1906.

28 MATERNITY. (c. 1892) Oil on canvas, 37³/₄ x 45³/₄″ (95.9 x 116.2 cm). Given anonymously. 580.42.

Also, prints.

CARTER, Clarence H. American, born 1904.

235 JANE REED AND DORA HUNT. 1941. Oil on canvas, 36 x 45″ (91.4 x 114.3 cm). Purchase. 334.42. Repr. *Ptg. & Sc.*, p. 160.

Also, a print.

CARVALHO, Flavio de R. Brazilian, born 1899.

215 THE POET PABLO NERUDA. 1947. Oil over gesso on canvas, 39³/₈ x 30⁷/₈″ (100 x 78.3 cm). Inter-American Fund. 134.57. Repr. *Suppl. VII*, p. 13.

Also, drawings.

CASHWAN, Samuel. American, born Ukraine 1900. To U.S.A. c. 1907.

TORSO. (1936) Limestone, 23³/₄ x 15 x 6³/₄″ (60.3 x 38 x 17.2 cm). Extended loan from the United States WPA Art Program. E.L.41.2386. Repr. *Amer. 1942*, pp. 32–33.

CASSINARI, Bruno. Italian, born 1912.

262 THE MOTHER. 1948. Oil on canvas, 47¹/₂ x 29³/₄″ (120.6 x 75.6 cm). Mrs. Cornelius J. Sullivan Fund. 274.49. Repr. *20th-C. Italian Art*, pl. 97.

CASTEL, Moshe Elazar. Israeli, born 1909.

318 POETRY OF CANAAN, I. 1963. Mixed mediums on canvas, 64 x 51³/₈″ (162.4 x 130.4 cm). Gift of Mr. and Mrs. David Kluger. 1008.65. Repr. *Art Israel*, p. 28.

CASTELLANOS, Julio. Mexican, 1905–1947.

210 THE AUNTS. (1933) Oil on canvas, 60⁷/₈ x 48³/₄″ (154.6 x 123.8 cm). Inter-American Fund. 1.43. Repr. *Latin-Amer. Coll.*, p. 74.

210 THE ANGEL KIDNAPPERS [*Los Robachicos*]. (1943) Oil on canvas, 22⁵/₈ x 37³/₈″ (57.5 x 94.9 cm). Inter-American Fund. 6.44. Repr. *Ptg. & Sc.*, p. 182.

Also, prints.

CELENTANO, Francis. American, born 1928.

502 FLOWING PHALANX. 1965. Synthetic polymer paint on canvas, 34¹/₈ x 46¹/₈″ (86.5 x 117.1 cm). Larry Aldrich Foundation Fund. 112.66.

CERVANTEZ, Pedro L. American, born 1915.

CROQUET GROUND. (1936) Oil on composition board, 19³/₄ x 28³/₄″ (50.2 x 73 cm). Extended loan from the United States WPA Art Program. E.L.39.1858. Repr. *Masters Pop. Ptg.*, no. 104.

PANHANDLE LUMBER COMPANY. 1937. Oil on composition board, 17¹/₂ x 24″ (44.5 x 61 cm). Extended loan from the United States WPA Art Program. E.L.39.1859. Repr. *Masters Pop. Ptg.*, no. 106.

CÉSAR (César Baldaccini). French, born 1921.

377 TORSO. (1954) Welded iron, 30³/₈ x 23³/₈ x 27¹/₈″ (77.1 x 59.4 x 68.8 cm). Blanchette Rockefeller Fund. 25.60. Repr. *Suppl. X*, p. 31; *New Images*, p. 51; *What Is Mod. Sc.*, p. 16.

377 SCULPTURE PICTURE. (1956) Welded iron relief, 30¹/₈ x 39³/₄ x 8″ (76.3 x 100.8 x 20.2 cm). Gift of G. David Thompson. 114.60. Repr. *Suppl. X*, p. 32.

377 GALACTIC INSECT. 1956. Welded iron, 19⁷/₈ x 37″ (50.5 x 94 cm). Gift of G. David Thompson. 3.59. Repr. *Suppl. IX*, p. 30.

377 THE YELLOW BUICK. (1961) Compressed automobile, 59¹/₂ x 30³/₄ x 24⁷/₈″ (151.1 x 77.7 x 63.5 cm). Gift of Mr. and Mrs. John Rewald. 294.61. Repr. *Suppl. XI*, p. 37; *The Machine*, p. 185.

Also, a drawing.

CÉZANNE, Paul. French, 1839–1906.

Dating and titles of the following works have been checked with John Rewald, who is preparing a new catalog of Cézanne's paintings and, in collaboration with Adrien Chappuis, of his watercolors.

400 MELTING SNOW, FONTAINEBLEAU. (c. 1879) Oil on canvas, 29 x 39⁵/₈″ (73.5 x 100.7 cm), irregular. Gift of André Meyer. 373.61. Repr. *Suppl XI*, p. 9.

12 L'ESTAQUE. (1883–85) Oil on canvas, 23⁷/₈ x 27³/₄″ (60.6 x 70.5 cm). Mrs. Sam A. Lewisohn Bequest. 264.54. Repr. *Suppl. V*, p. 4.

12 THE BATHER. (c. 1885) Oil on canvas, 50 x 38¹/₈″ (127 x 96.8 cm). Lillie P. Bliss Collection. 1.34. Repr. *Ptg. & Sc.*, p. 27; in color, *Masters*, p. 23; in color, *Invitation*, p. 29.

13 THE BRIDGE AT GARDANNE. (1885–86) Watercolor, 8¹/₈ x 12¹/₄″ (20.6 x 31.1 cm). Lillie P. Bliss Collection. 6.34a. Repr. *Ptg. & Sc.*, p. 23. On reverse: *View of Gardanne*, pencil, 6.34b.

13 BATHERS. (1885–90) Watercolor and pencil, 5 x 8¹/₈″ (12.7 x 20.6 cm). Lillie P. Bliss Collection. 2.34. Repr. *Bliss, 1934*, no. 12.

14 STILL LIFE WITH APPLES. (1895–98) Oil on canvas, 27 x 36¹/₂″ (68.6 x 92.7 cm). Lillie P. Bliss Collection. 22.34. Repr. *Ptg. & Sc.*, p. 25; in color, *Masters*, p. 20; in color, *Invitation*, p. 30.

13 ROCKS AT LE CHÂTEAU NOIR. (Previous title: *Rocky Ridge*.) (1895–1900) Watercolor and pencil, 12¹/₂ x 18³/₄″ (31.7 x 47.6 cm). Lillie P. Bliss Collection. 21.34. Repr. *Ptg. & Sc.*, p. 26.

13 FOLIAGE. (1895–1900) Watercolor and pencil, 17⁵/₈ x 22³/₈″ (44.8 x 56.8 cm). Lillie P. Bliss Collection. 9.34a. Repr. *Bliss, 1934*, no. 21a. On reverse: *Study of Trees*, watercolor, 9.34b.

13 STUDY OF TREES. (1895–1900) Watercolor, 17⁵/₈ x 22³/₈″ (44.8 x 56.8 cm). Lillie P. Bliss Collection. 9.34b. On reverse: *Foliage*, watercolor, 9.34a.

13 HOUSE AMONG TREES. (c. 1900) Watercolor, 11 x 17$^{1/8}$" (27.9 x 43.5 cm). Lillie P. Bliss Collection. 15.34. Repr. *Ptg. & Sc.*, p. 26.

14 PINES AND ROCKS. (c. 1900) Oil on canvas, 32 x 25$^{3/4}$" (81.3 x 65.4 cm). Lillie P. Bliss Collection. 16.34. Repr. *Ptg. & Sc.*, p. 29; in color, *Masters*, p. 21; in color, *Invitation*, p. 31.

15 ORANGES. (1902–06) Oil on canvas, 23$^{7/8}$ x 28$^{7/8}$" (60.6 x 73.3 cm). Lillie P. Bliss Collection. 18.34. Repr. *Ptg. & Sc.*, p. 28.

15 LE CHÂTEAU NOIR. (1904–06) Oil on canvas, 29 x 36$^{3/4}$" (73.6 x 93.2 cm). Gift of Mrs. David M. Levy. 137.57. Repr. *Suppl. X*, p. 7; in color, *Levy Collection*, cover.

Also, a drawing and prints.

CHADWICK, Lynn. British, born 1914.

360 BALANCED SCULPTURE. (1952) Wrought iron, 19$^{1/2}$ x 11$^{7/8}$ x 7$^{3/4}$" (49.5 x 30 x 19.6 cm). Purchase. 7.53. Repr. *Suppl. IV*, p. 40. *Note*: the Museum owns a sheet of studies for this sculpture.

361 INNER EYE. (1952) Wrought iron with glass cullet, 7'6$^{1/2}$" x 42$^{1/2}$" x 30$^{1/4}$" (230 x 107.9 x 76.7 cm). A. Conger Goodyear Fund. 150.55. Repr. *New Decade*, p. 72.

Also, a drawing.

CHAGALL, Marc. French, born Russia 1887. To France 1923. In U.S.A. 1941–48.

150 I AND THE VILLAGE. 1911. Oil on canvas, 6'3$^{5/8}$" x 59$^{5/8}$" (192.1 x 151.4 cm). Mrs. Simon Guggenheim Fund. 146.45. Repr. *Ptg. & Sc.*, p. 210; in color, *Masters*, p. 132; in color, *Invitation*, p. 53. *Note*: at right is a profile of the artist, facing left.

VASLAW NIJINSKY. Study of the dancer in the ballet *Spectre de la Rose*. (1911) Watercolor, oval 8$^{3/8}$ x 5$^{1/4}$" (21.3 x 13.3 cm). Gift of Edward M. M. Warburg. 507.41. Theatre Arts Collection.

151 CALVARY. 1912. Oil on canvas, 68$^{3/4}$" x 6'3$^{3/4}$" (174.6 x 192.4 cm). Acquired through the Lillie P. Bliss Bequest. 276.49. Repr. *Suppl. I*, p. 4.

152 BIRTHDAY [*L'Anniversaire*]. (1915) Oil on cardboard, 31$^{3/4}$ x 39$^{1/4}$" (80.6 x 99.7 cm). Acquired through the Lillie P. Bliss Bequest. 275.49. Repr. *Suppl. I*, p. 7; in color, *Masters*, p. 133; *Paintings from MoMA*, p. 67. *Note*: this is the original version. A second version, 31$^{7/8}$ x 39$^{3/8}$", painted in Paris about 1923, is in The Solomon R. Guggenheim Museum, New York. The artist and Bella Rosenfeld, his betrothed, are the subjects. The birthday was the artist's. The Museum owns a pencil study for this painting.

153 HOMAGE TO GOGOL. Design for curtain (not executed) for Gogol festival, Hermitage Theater, Petrograd (Leningrad). 1917. Watercolor, 15$^{1/2}$ x 19$^{3/4}$" (39.4 x 50.2 cm). Acquired through the Lillie P. Bliss Bequest. 71.44.

152 OVER VITEBSK. 1915–20 (after a painting of 1914). Oil on canvas, 26$^{3/8}$ x 36$^{1/2}$" (67 x 92.7 cm). Acquired through the Lillie P. Bliss Bequest. 277.49. Repr. *Suppl. I*, p. 5. *Note*: this is the second version. The first, painted in 1914, 27$^{1/2}$ x 35$^{1/2}$", is in the Ayala and Sam Zacks Collection, Toronto.

153 TIME IS A RIVER WITHOUT BANKS [*Le Temps n'a point de rives*]. 1930–39. Oil on canvas, 39$^{3/8}$ x 32" (100 x 81.3 cm). Given anonymously. 612.43. Repr. *Ptg. & Sc.*, p. 211; in color, *Chagall*, opp. p. 64.

ALEKO. Sixty-seven gouache, watercolor, and pencil designs for the ballet produced by the Ballet Theatre, Mexico City and New York. (1942) Four designs for scenery, 15$^{1/4}$ x 22$^{1/2}$" to 15 x 20$^{7/8}$" (38.7 x 57.1 to 38.1 x 53 cm); forty-eight designs for costumes, 14$^{3/4}$ x 22$^{1/8}$" to 10$^{1/2}$ x 8$^{1/2}$" (37.5 x 56.2 to 26.7 x 21.6 cm); fifteen designs for choreography, 16 x 11$^{7/8}$" to 7$^{5/8}$ x 10$^{3/8}$" (40.7 x 30.2 to

19.4 x 26.3 cm). Acquired through the Lillie P. Bliss Bequest. 137.45.1–67. Theatre Arts Collection. Design for scenery (137.45.3) repr. *Masters*, p. 182.

Also, drawings, prints, illustrated books, and posters.

CHAMBERLAIN, John. American, born 1927.

388 ESSEX. (1960) Automobile body parts and other metal, relief, 9' x 6'8" x 43" (274.3 x 203.2 x 109.2 cm). Gift of Mr. and Mrs. Robert C. Scull and Purchase. 282.61. Repr. in color, *Assemblage*, p. 138.

CHANG DAI-CHIEN. Chinese, born 1899.

316 LOTUS. 1961. Brush and ink on paper, 70$^{3/4}$ x 38$^{1/4}$" (179.6 x 96.9 cm) mounted on a silk scroll. Gift of Dr. Kuo Yu-Shou. 295.61. Repr. *Suppl. XI*, p. 17.

CHARLOT, Jean. American, born France 1898. To U.S.A. 1929. Worked in Mexico. Lives in Hawaii.

LANDSCAPE, MILPA ALTA. 1924. Oil on canvas, 11 x 14" (27.9 x 35.6 cm). Gift of Abby Aldrich Rockefeller (by exchange). 217.37.

WOMAN LIFTING REBOZO. 1935. Oil on canvas, 25$^{1/8}$ x 30" (63.8 x 76.2 cm). Given anonymously (by exchange). 468.41. Repr. *Ptg. & Sc.*, p. 176.

Also, a drawing, prints, and illustrated books; a drawing in the Study Collection.

CHAVEZ, Edward. American, born 1917.

COLT. (c. 1939) Gouache, 17$^{7/8}$ x 21$^{1/2}$" (45.4 x 54.6 cm). Abby Aldrich Rockefeller Fund. 569.39.

CHIMES, Thomas. American, born 1921.

Study for THE INNER WORLD. (1961) Oil on canvas, 9$^{1/4}$ x 10$^{5/8}$" (23.6 x 26.9 cm). Larry Aldrich Foundation Fund. 283.61. Repr. *Suppl. XI*, p. 51.

314 CRUCIFIX. (1961) Oil on canvas, 36 x 36" (91.5 x 91.5 cm). Larry Aldrich Foundation Fund. 198.63.

Also, a drawing.

DE CHIRICO, Giorgio. Italian, born Greece 1888. Worked in Paris 1911–15, 1925–39.

154 THE ANXIOUS JOURNEY. 1913. Oil on canvas, 29$^{1/4}$ x 42" (74.3 x 106.7 cm). Acquired through the Lillie P. Bliss Bequest. 86.50. Repr. *Suppl. II*, p. 6; *de Chirico*, p. 181; *The Machine*, p. 64.

154 THE DELIGHTS OF THE POET. (1913) Oil on canvas, 27$^{3/8}$ x 34" (69.5 x 86.4 cm). Acquired through the Lillie P. Bliss Bequest. 525.41. Repr. *Ptg. & Sc.*, p. 192; *de Chirico*, p. 171.

154 THE NOSTALGIA OF THE INFINITE. (1913–14? Dated on painting 1911) Oil on canvas, 53$^{1/4}$ x 25$^{1/2}$" (135.2 x 64.8 cm). Purchase. 87.36. Repr. *Ptg. & Sc.*, p. 191; in color, *Masters*, p. 134; *de Chirico*, p. 53; in color, *Invitation*, p. 85.

155 THE EVIL GENIUS OF A KING. (1914–15) Oil on canvas, 24 x 19$^{3/4}$" (61 x 50.2 cm). Purchase. 112.36. Repr. *Ptg. & Sc.*, p. 193; in color, *Fantastic Art* (3rd), opp. p. 120; *de Chirico*, p. 99.

155 THE DOUBLE DREAM OF SPRING. 1915. Oil on canvas, 22$^{1/8}$ x 21$^{3/8}$" (56.2 x 54.3 cm). Gift of James Thrall Soby. 138.57. Repr. *de Chirico*, p. 212; *Suppl. VII*, p. 7; *Soby Collection*, p. 36; *Dada, Surrealism*, p. 79.

EVANGELICAL STILL LIFE. 1916. Oil on canvas, 31$^{3/4}$ x 28$^{1/8}$" (80.5 x 71.4 cm), irregular. The Sidney and Harriet Janis Collection (fractional gift). 583.67. Repr. *Modern Works*, no. 57; *Cubism*, p. 175; *de Chirico*, p. 221; in color, *Janis*, p. 51.

155 THE GREAT METAPHYSICIAN. 1917. Oil on canvas, 41⅛ x 27½″ (104.5 x 69.8 cm). The Philip L. Goodwin Collection. 98.58. Repr. in color, *de Chirico*, p. 133; *Bulletin*, Fall 1958, p. 7.

155 THE SACRED FISH. (1919) Oil on canvas, 29½ x 24⅜″ (74.9 x 61.9 cm). Acquired through the Lillie P. Bliss Bequest. 333.49. Repr. *Suppl. II*, p. 7; in color, *de Chirico*, p. 155.

Also, a drawing and prints; paintings in the Study Collection.

CHOKAI, Seiji. Japanese, born 1902.

289 GOURDS. (1950) Oil on canvas, 25⅝ x 21″ (65.1 x 53.4 cm). Blanchette Rockefeller Fund. 110.58. Repr. *Suppl. VIII*, p. 19.

CHRYSSA (Chryssa Vardea Mavromichali). American, born Greece 1933. To U.S.A. 1954.

391 PROJECTION LETTER F. (1958–60) Welded and cast aluminum relief, 68⅜ x 46⅛ x 2½″ (173.7 x 117 x 6.3 cm). Gift of Joseph H. Konigsberg. 97.61. Repr. *Suppl. XI*, p. 51; *Amer. 1963*, p. 23.

513 FIVE VARIATIONS ON THE AMPERSAND. (1966) Neon-light constructions in tinted-plexiglass vitrines; one, 30¾ x 14¼ x 12⅜″ (78.1 x 36.2 x 31.3 cm); four, 29½ x 14¼ x 12⅜″ (74.8 x 36.2 x 31.3 cm). Gift of D. and J. de Menil. 393.66.1–.5.

Also, a print.

CLERK, Pierre. Canadian, born U.S.A. 1928.

PAINTING, II. 1955. Oil on canvas, 31½ x 37⅜″ (79.8 x 94.9 cm). Purchase. 234.56. Repr. *Suppl. VI*, p. 31.

CLOAR, Carroll. American, born 1913.

276 AUTUMN CONVERSION. (1953) Tempera on composition board, 20⅛ x 26⅛″ (51.1 x 66.4 cm). Gift of Mr. and Mrs. Edward F. Kook. 502.53. Repr. *Suppl. V*, p. 32.

Also, prints.

COHEN, Bernard. British, born 1933.

372 MUTATION WHITSUN SERIES 2. (1960) Oil and enamel on canvas, 54⅜ x 66¼″ (138 x 168 cm). Philip Johnson Fund. 360.60. Repr. *Suppl. X*, p. 47.

COHEN, George. American, born 1919.

386 ANYBODY'S SELF-PORTRAIT. (1953) Assemblage: framed square mirror mounted on painted composition board, 9⅝″ (24.3 cm) diameter, with two oval mirrors, plastic doll's torso, legs, and arms, painted doll's eyes with fiber lashes in anchovy tin can, small metal hand, nail heads, screw eyes, hooks, string, and cloth. Larry Aldrich Foundation Fund. 284.61. Repr. *Assemblage*, p. 112.

COLEMAN, Glenn O. American, 1887–1932.

234 JEFFERSON MARKET COURTHOUSE. (1929 or before) Gouache, 12½ x 15″ (31.5 x 38 cm) (composition). Given anonymously. 123.40.

ANGELO'S PLACE. (1929) Oil on canvas, 25¼ x 34¼″ (64.1 x 87 cm). Gift of Abby Aldrich Rockefeller. 47.35.

Study for CHERRY HILL. (Before 1931) Gouache, 10⅝ x 7⅞″ (27 x 20 cm). Given anonymously (by exchange). 7.36.

Also, prints.

COLLA, Ettore. Italian, 1899–1968.

378 CONTINUITY. (1951) Welded construction of five iron wheels, 7′11⅝″ x 56″ (242.8 x 142.2 cm). Purchase. 285.61. Repr. *Assemblage*, p. 148.

COLOMBO, Gianni. Italian, born 1937.

510 PULSATING STRUCTURALIZATION. (1959) Motor-driven relief construction of 174 plastic-foam blocks in a wood box, 36½ x 36½ x 9¼″ (92.5 x 92.5 x 23.5 cm). Gift of the Olivetti Company of Italy. 1232.64.

COLQUHOUN, Robert. British, 1914–1962.

268 TWO SCOTSWOMEN. (1946) Oil on canvas, 48⅜ x 36″ (122.9 x 91.4 cm). Mrs. Wendell T. Bush Fund. 236.48. Repr. *Suppl. I*, p. 14.

Also, a drawing, prints, and an illustrated book.

COLVILLE, Alex. Canadian, born 1920.

435 SKATER. 1964. Synthetic polymer paint on composition board, 44½ x 27½″ (113 x 69.8 cm). Gift of R. H. Donnelley Erdman (by exchange). 372.65.

COMTOIS, Ulysses. Canadian, born 1931.

291 FROM EAST TO WEST. 1961. Oil on canvas, 24 x 30″ (60.9 x 76.4 cm). Gift of the Women's Committee of the Art Gallery of Toronto. 374.61. Repr. *Suppl. XI*, p. 54.

488 COLUMN NUMBER 4. (1967) Aluminum, 24⅜″ (61.6 cm) high, at base 3¾″ (9.3 cm) diameter. Gift of Mrs. Bernard F. Gimbel. 2100.67.

CONGDON, William. American, born 1912. Works in Italy.

290 PIAZZA, VENICE, 12. 1952. Oil on composition board, 49 x 56″ (124.5 x 142.2 cm). Gift of Peggy Guggenheim. 334.52. Repr. *Suppl. IV*, p. 33.

CONNER, Bruce. American, born 1933.

387 THE BOX. (1960) Assemblage: wax figure, suitcase, tin cans, shredded nylon, etc., in wooden box, 32¼ x 20⅜ x 35¼″ (81.7 x 51.7 x 89.3 cm). Larry Aldrich Foundation Fund. 112.61. Repr. *Suppl. XI*, p. 40.

Also, films.

CONSAGRA, Pietro. Italian, born 1920.

360 CONVERSATION BEFORE THE MIRROR. 1957. Bronze relief, 56 x 40⅞″ (142.2 x 103.8 cm), attached to wood base. Gift of G. David Thompson. 81.60. Repr. *Suppl. X*, p. 33; *What Is Mod. Sc.*, p. 121.

CONSTABLE, William H. Australian, born 1906.

DESIGN FOR AN ABORIGINAL BALLET, II. (1939) Gouache, 15⅝ x 20¾″ (39.7 x 52.7 cm). Purchase. 526.41. Theatre Arts Collection.

COOK, Howard. American, born 1901.

MORNING AT HONDO. (1941) Watercolor, 13½ x 27¼″ (34.3 x 69.3 cm). Abby Aldrich Rockefeller Fund. 141.42.

Also, drawings and prints.

COPLEY, William N. American, born 1919.

442 THINK. 1964. Oil on canvas, 25⅝ x 32″ (65.1 x 81 cm). Gift of Miss Jeanne Reynal. 1233.64.

CORBETT, Edward. American, 1919–1971.

NUMBER 11. 1951. Chalk, 36 x 24⅛″ (91.4 x 61.3 cm). Katharine Cornell Fund. 44.52. Repr. *15 Amer.*, p. 7.

NUMBER 15. 1951. Chalk and casein, 28 x 15″ (71.1 x 38.1 cm). Purchase. 43.52. Repr. *15 Amer.*, p. 6.

LEJOS DE SOCORRO. 1957. Oil, enamel and bronze paint on canvas, 48 x 50″ (122.1 x 127.1 cm). Gift of Philip Johnson. 255.57. Repr. *Suppl. VII*, p. 16.

CORINTH, Lovis. German, 1858–1925.

35 SELF-PORTRAIT. 1924. Oil on canvas, 39³⁄₈ x 31⁵⁄₈″ (100 x 80.3 cm). Gift of Curt Valentin. 320.50. Repr. *Suppl. III*, p. 8; in color, *German Art of 20th C.*, p. 72.

Also, prints, illustrated books, and a music sheet.

CORNELL, Joseph. American, 1903–1972.

417 OBJECT "BEEHIVE." 1934. Cylindrical, covered wood box painted red, 3⁵⁄₈″ (9.2 cm) high, 7³⁄₄″ (19.7 cm) diameter, containing on bottom a printed diagram, cut from a book, of Heaven, Hell, the stars, and planets; seven pins protrude through bottom of box, six in a circle, one in center, each supporting a brass thimble; around each of six outer pins is a cutout cardboard circle in a different color; all covered by a circular piece of copper screen supported on brads driven through the side of the box and by a cardboard disk covered with a photoengraving and pierced by seven octagonal holes. Gift of James Thrall Soby. 473.53.

312 TAGLIONI'S JEWEL CASKET. 1940. Wood box containing glass ice cubes, jewelry, etc., 4³⁄₄ x 11⁷⁄₈ x 8¹⁄₄″ (12 x 30.2 x 21 cm). Gift of James Thrall Soby. 474.53. Repr. *Masters*, p. 145; *Soby Collection*, p. 40.

312 CENTRAL PARK CARROUSEL, IN MEMORIAM. (1950) Construction in wood, mirror, wire netting, and paper, 20¹⁄₄ x 14¹⁄₂ x 6³⁄₄″ (51.4 x 36.8 x 17.1 cm). Katharine Cornell Fund. 5.51. Repr. *Suppl. III*, p. 21.

CORPORA, Antonio. Italian, born Tunis 1909.

350 DIVIDED HOUR. 1958. Oil on canvas, 57¹⁄₂ x 44⁷⁄₈″ (145.9 x 113.8 cm). Given anonymously. 4.60. Repr. *Suppl. X*, p. 38.

COSTA, Toni. Italian, born 1935.

498 VISUAL DYNAMICS. 1963. Polyethylene on wood, diagonal measurements, 56⁵⁄₈ x 56⁵⁄₈″ (143.7 x 143.7 cm). Larry Aldrich Foundation Fund. 45.65. Repr. *Responsive Eye*, p. 51.

COUGHTRY, Graham. Canadian, born 1931.

280 RECLINING FIGURE. (1961) Oil on canvas, 52³⁄₄ x 51″ (134.3 x 129.7 cm). Gift of Emilio del Junco. 375.61. Repr. *Suppl. XI*, p. 56.

COVERT, John. American, 1882–1960.

225 EX ACT. 1919. Oil on relief of plywood and cardboard, 23¹⁄₄ x 25¹⁄₄″ (59 x 64.1 cm). Katherine S. Dreier Bequest. 147.53. Repr. *Suppl. IV*, p. 15.

DE CREEFT, José. American, born Spain 1884. To U.S.A. 1929.

256 SATURNIA. (1939) Hammered lead relief, 61 x 38″ (154.9 x 96.5 cm). Gift of Mrs. George E. Barstow. 591.39. Repr. *Ptg. & Sc.*, p. 258.

CREMONINI, Leonardo. Italian, born 1925.

ENAMORED TOMCAT. 1952. Oil on canvas, 23¹⁄₈ x 17³⁄₄″ (58.7 x 45.1 cm). Purchase. 5.55.

Also, a drawing.

CRIPPA, Roberto. Italian, born 1921.

376 COMPOSITION. 1959. Bark mounted on plywood coated with

paint, sawdust, and plastic glue, 6′6⁷⁄₈″ x 6′6⁷⁄₈″ (200.3 x 200.3 cm). Gift of Alexandre Iolas. 376.61. Repr. *Suppl. XI*, p. 38.

Also, a print.

CRISTIANO, Renato. Italian, born 1926.

314 REASON AND INSTINCT—SUN AND MOON. (1958) Oil on canvas, applied with feet and hands, 36³⁄₈ x 32⁷⁄₈″ (92.3 x 83.5 cm). Purchase. 667.59. Repr. *Suppl. IX*, p. 17.

CROSS, Henri Edmond. French, 1856–1910.

23 LANDSCAPE WITH FIGURES. (c. 1905) Watercolor, 9⁵⁄₈ x 13³⁄₈″ (24.4 x 34 cm). Gift of Abby Aldrich Rockefeller. 234.40.

23 WOODLAND IN PROVENCE. (1906–07) Oil on paper mounted on canvas, 21³⁄₄ x 17¹⁄₄″ (55.3 x 43.8 cm). Gift of Abby Aldrich Rockefeller. 182.35.

Also, prints.

CRUZ-DIEZ, Carlos. Venezuelan, born 1923. In Paris since 1960.

505 PHYSICHROMIE, 114. 1964. Synthetic polymer paint on wood panel and on parallel cardboard strips interleaved with projecting plastic strips (or blades), 28 x 56¹⁄₄″ (71.1 x 142.8 cm). Inter-American Fund. 284.65.

CUIXART, Modest. Spanish, born 1925.

353 PAINTING. 1958. Latex and synthetic polymer paint with metallic powders on canvas, 7′4⁵⁄₈″ x 51¹⁄₄″ (225 x 130.1 cm). Gift of Mr. and Mrs. Alex L. Hillman. 26.60. Repr. *New Spanish Ptg. & Sc.*, p. 20; *Suppl. X*, p. 34.

CULWELL, Ben L. American, born 1918.

DEATH BY BURNING. (c. 1942) Watercolor and gouache, 12¹⁄₈ x 9⁵⁄₈″ (30.8 x 24.4 cm). Purchase. 4.47. Repr. *14 Amer.*, p. 19.

310 MEN FIGHTING AND STARS IN THE SOLOMONS. (1942) Watercolor and gouache, 8 x 8″ (20.3 x 20.3 cm). Purchase. 5.47. Repr. *14 Amer.*, p. 18.

CUNNINGHAM, Ben (Benjamin Frazier Cunningham). American, 1904–1975.

501 EQUIVOCATION. 1964. Synthetic polymer paint on composition board, 26 x 26″ (65.9 x 65.9 cm). Larry Aldrich Foundation Fund. 106.65. Repr. *Responsive Eye*, p. 27.

CUSHING, Lily. American, 1909–1969.

MAIN STREET, SAUGERTIES. (1938) Gouache on cardboard, 18¹⁄₂ x 26¹⁄₈″ (47 x 66.4 cm). Given anonymously. 319.39.

DALI, Salvador. Spanish, born 1904. Active in Paris and New York.

ILLUMINED PLEASURES. (1929) Oil and collage on composition board, 9³⁄₈ x 13³⁄₄″ (23.8 x 34.7 cm). The Sidney and Harriet Janis Collection (fractional gift). 584.67. Repr. *Modern Works*, no. 60; *Fantastic Art*, p. 156; *Dali*, p. 34; *Dada, Surrealism*, p. 109; in color, *Janis*, p. 53.

183 THE PERSISTENCE OF MEMORY [*Persistance de la mémoire*]. 1931. Oil on canvas, 9¹⁄₂ x 13″ (24.1 x 33 cm). Given anonymously. 162.34. Repr. *Ptg. & Sc.*, p. 200; in color, *Masters*, p. 145; *Dali* (2nd), opp. p. 38; *Dada, Surrealism*, p. 111; in color, *Invitation*, p. 86.

183 PORTRAIT OF GALA [*L'Angélus de Gala*]. 1935. Oil on wood, 12³⁄₄ x 10¹⁄₂″ (32.4 x 26.7 cm). Gift of Abby Aldrich Rockefeller. 298.37. Repr. *Ptg. & Sc.*, p. 201. *Note*: Gala is the wife of the artist.

183 IMPERIAL VIOLETS [*Violettes impériales*]. 1938. Oil on canvas, 39¼ x 56⅛" (99.7 x 142.5 cm). Gift of Edward James. 527.41. Repr. *Dali* (2nd), p. 65.

Also, drawings, prints, an illustrated book, and a film.

DALSTROM, Gustaf Oscar. American, born Sweden 1893. To U.S.A. 1900.

 CITY BUILDINGS. 1935. Oil on composition board, 26¾ x 32¼" (68 x 81.9 cm). Purchase. 570.39.

DALWOOD, Hubert. British, born 1924.

362 LARGE OBJECT. (1959) Cast aluminum, welded, 28⅞ x 34⅛ x 27⅞" (73.2 x 86.5 x 70.8 cm). Gift of G. David Thompson. 61.61. Repr. *Suppl. XI*, p. 49.

DAMIAN, Horia. French, born Rumania 1922.

354 RED FORM ON RED BACKGROUND. 1960. Mixed mediums on canvas, 57½ x 51⅛" (145.9 x 129.8 cm). Given anonymously. 113.61. Repr. *Suppl. XI*, p. 49.

DAMIANI, Jorge. Uruguayan, born Italy 1931.

284 AGONY. 1956. Oil on canvas, 6'4½" x 47¼" (194.3 x 120 cm). Inter-American Fund. 114.58. Repr. *Suppl. VIII*, p. 14.

 NUMBER XIV. 1960. Plastic cement with sand on composition board, 40 x 24" (101.5 x 60.8 cm). Inter-American Fund. 62.61. Repr. *Suppl. XI*, p. 30.

DAPHNIS, Nassos. American, born Greece 1914. To U.S.A. 1930.

 NUMBER 5-58. 1958. Synthetic polymer paint on canvas, 64⅛ x 43" (162.7 x 109.2 cm). Blanchette Rockefeller Fund. 4.59. Repr. *Suppl. IX*, p. 19.

D'ARCANGELO, Allan. American, born 1930.

441 HIGHWAY U.S. 1, NUMBER 5. 1962. Synthetic polymer paint on canvas, 70" x 6'9½" (177.6 x 207 cm). Gift of Mr. and Mrs. Herbert Fischbach. 383.66.

DARIÉ, Sandú. Cuban, born Rumania 1908.

 COMPOSITION IN RED. (1946) Gouache, ink, and wax, 11¼ x 14¼" (28.6 x 36.2 cm). Gift of Miss Renée Spodheim. 5.50.

DAVIDSON, Jo. American, 1883–1952.

251 LA PASIONARIA (DOLORES IBARRURI). 1938. Bronze, 20½ x 21⅜" (52.1 x 54.1 cm). The purchase money, subscribed by Trustees and friends of the Museum, was given by the artist to a fund for assisting European refugee artists in 1941. 320.41. Repr. *Ptg. & Sc.*, p. 260.

DAVIE, Alan. British, born 1920.

348 PAINTING. (1955) Oil on composition board, 60 x 48⅛" (152.2 x 122 cm). Gift of Mr. and Mrs. Allan D. Emil. 188.56. Repr. *Suppl. VI*, p. 31.

DAVIES, Arthur B. American, 1862–1928.

 THE WINE PRESS. (1918) Oil on canvas, 32¼ x 24¼" (81.9 x 61.6 cm). Lillie P. Bliss Collection. 31.34. Repr. *Bliss, 1934*, pl. 23.

36 ITALIAN LANDSCAPE. (1925) Oil on canvas, 26⅛ x 40⅛" (66.4 x 101.9 cm). Lillie P. Bliss Collection. 30.34. Repr. *Ptg. & Sc.*, p. 164.

Also, prints and a tapestry designed by the artist.

DAVIS, Emma Lu. American, born 1905.

257 COSMIC PRESENCE. (1934) Wood, painted, 8 x 66¼ x 15¼" (23 x 168.3 x 38.7 cm). Purchase. 9.42. Repr. *Ptg. & Sc.*, p. 288.

 CHINESE RED ARMY SOLDIER. (1936) Walnut, 9¾" (24.8 cm) high. Abby Aldrich Rockefeller Fund. 142.42. Repr. *Ptg. & Sc.*, p. 261; *Amer. 1942*, p. 48.

DAVIS, Gene. American, born 1920.

459 ANTHRACITE MINUET. (1966) Synthetic polymer paint on canvas, 7'9⅛" x 7'7⅛" (236.4 x 231.3 cm). Purchase and Larry Aldrich Foundation Fund. 94.67.

DAVIS, James Edward. American, born 1901.

 TRANSPARENCY. 1944. Translucent pigment on two sheets of cellulose acetate, 14 x 20⅛" (35.6 x 51.1 cm) each, attached to plywood panel 20 x 30" (50.8 x 76.2 cm). Purchase. 2.45.

Also, films and photographs.

DAVIS, Stuart. American, 1894–1964.

230 THE FRONT PAGE. 1912. Watercolor, 11 x 15" (27.9 x 38.1 cm). Purchase. 116.46.

230 LUCKY STRIKE. (1921) Oil on canvas, 33¼ x 18" (84.5 x 45.7 cm). Gift of The American Tobacco Company, Inc. 132.51. Repr. *Suppl. III*, p. 16.

230 EGG BEATER, V. 1930. Oil on canvas, 50⅛ x 32¼" (127.3 x 81.9 cm). Abby Aldrich Rockefeller Fund. 122.45. Repr. *Ptg. & Sc.*, p. 127; in color, *Davis*, opp. p. 22.

230 SUMMER LANDSCAPE. 1930. Oil on canvas, 29 x 42" (73.7 x 106.7 cm). Purchase. 30.40. Repr. *Davis*, p. 21.

430 SALT SHAKER. (1931) Oil on canvas, 49⅞ x 32" (126.5 x 81.2 cm). Gift of Edith Gregor Halpert. 543.54. Repr. *Davis*, p. 25; *Abstract Ptg. & Sc.*, p. 104.

 NEW YORK WATERFRONT. (1938) Gouache, 12 x 15⅞" (30.5 x 40.3 cm). Given anonymously. 583.42.

 Study for HOT STILL-SCAPE. 1940. Oil on canvas, 9 x 12" (22.9 x 30.5 cm). Given anonymously. 469.41.

230 VISA. 1951. Oil on canvas, 40 x 52" (101.6 x 132.1 cm). Gift of Mrs. Gertrud A. Mellon. 9.53. Repr. *Suppl. IV*, p. 32; *Lettering*, p. 20; in color, *Masters*, p. 117; *Paintings from MoMA*, p. 50; in color, *Invitation*, p. 126.

Also, drawings, prints, and a rug designed by the artist.

DAY, John. American, born 1932.

463 ACROSS THE LETHE. 1962. Oil and collage of photographs and playbills on canvas, 60 x 50⅛" (152.4 x 127.3 cm). Gift of the artist through the Ford Foundation Purchase Program. 567.64.

DECHAR, Peter. American, born 1942.

438 PEARS. (1966) Oil on canvas, 54⅛" x 6'¼" (137.5 x 183.4 cm). Larry Aldrich Foundation Fund. 728.66.

DEGAS, Hilaire-Germain-Edgar. French, 1834–1917.

18 AT THE MILLINER'S. (c. 1882) Pastel, 27⅝ x 27¾" (70.2 x 70.5 cm). Gift of Mrs. David M. Levy. 141.57. Repr. *Bulletin*, Fall 1958, p. 22; *Suppl. X*, p. 8; *Levy Collection*, p. 17; in color, *Impress.* (4th), p. 446; in color, *Invitation*, p. 14. *Note*: the young woman trying on the hat is the American painter Mary Cassatt.

18 DANCERS. (c. 1899) Pastel, 37¼ x 31¾" (94.6 x 80.6 cm). Gift of

William S. Paley. 470.41. Repr. *Ptg. & Sc.*, p. 30; in color, *Impress.* (4th), p. 567.

Also, prints.

DEHN, Adolf. American, 1895–1968.

FLORIDA SYMPHONY. 1939. Watercolor, 19³/₈ x 28³/₈″ (49.2 x 72.1 cm). Abby Aldrich Rockefeller Fund. 571.39. Repr. *Ptg. & Sc.*, p. 158.

BUTTE, UTAH. 1940. Watercolor, 18³/₈ x 26¹/₂″ (46.7 x 67.3 cm). Abby Aldrich Rockefeller Fund (by exchange). 245.40.

Also, a drawing, prints, and a poster.

DEHNER, Dorothy. American, born 1908.

FROM JAPAN. 1951. Watercolor, pen and ink, 18¹/₈ x 22⁷/₈″ (46 x 58.1 cm). Purchase. 10.53.

305 DECISION AT KNOSSOS. (1957) Bronze, 3¹/₈ x 4⁷/₈ x 3″ (7.8 x 12.3 x 7.6 cm). Purchase. 5.59. Repr. *Suppl. IX*, p. 37.

Also, a poster design in the Study Collection.

DeLAP, Tony. American, born 1927.

496 TANGO TANGLES, II. 1966. Lacquered plastic in two identical L-shaped movable parts; each, 13 x 3¹/₂ x ¹/₂″ (32.9 x 8.7 x 1.1 cm). Larry Aldrich Foundation Fund. 2.67a–b.

DELAUNAY, Robert. French, 1885–1941.

WINDOWS [*Les Fenêtres*]. 1912. Encaustic on canvas, 31¹/₂ x 27⁵/₈″ (79.9 x 70 cm). The Sidney and Harriet Janis Collection (fractional gift). 586.67. Repr. in color, *Janis*, p. 19.

126 SIMULTANEOUS CONTRASTS: SUN AND MOON [*Soleils, lune, simultané 2*]. (1913. Dated on painting 1912) Oil on canvas, 53″ (134.5 cm) diameter. Mrs. Simon Guggenheim Fund. 1.54. Repr. in color, *Masters*, p. 77; *Paintings from MoMA*, p. 53; in color, *Invitation*, p. 33. *Note*: also called *Sun Disks*.

126 DISKS. (1930–33) Oil on cardboard, 23⁵/₈ x 23¹/₂″ (60 x 59.8 cm). Gift of Judge and Mrs. Henry Epstein. 256.57. Repr. *Suppl. VII*, p. 11.

126 RHYTHM WITHOUT END. (1935) Gouache, brush and ink, 10⁵/₈ x 8¹/₄″ (27 x 21 cm). Given anonymously. 34.36.

Also, drawings, prints, and an illustrated book.

DELAUNAY-TERK, Sonia. French, born Ukraine 1885.

126 Decoration for *La Prose du Transsibérien et de la Petite Jehanne de France*, by Blaise Cendrars. 1913. Gouache and ink on printed text, scroll, 6′9¹/₂″ x 13⁷/₈″ (207 x 35.3 cm). Purchase. 133.51.

126 PORTUGUESE MARKET. 1915. Oil and wax on canvas, 35⁵/₈ x 35⁵/₈″ (90.5 x 90.5 cm). Gift of Theodore R. Racoosin. 191.55. Repr. *Suppl. VI*, p. 20.

Also, a print.

DELVAUX, Paul. Belgian, born 1897.

181 THE ENCOUNTER [*La Rencontre*]. 1938. Oil on canvas, 35⁵/₈ x 47¹/₂″ (90.5 x 120.5 cm). Kay Sage Tanguy Bequest. 326.63.

181 PHASES OF THE MOON [*Les Phases de la lune*]. 1939. Oil on canvas, 55 x 63″ (139.7 x 160 cm). Purchase. 504.51. Repr. *Suppl. IV*, p. 31; in color, *Invitation*, p. 93.

Also, a drawing.

DEMUTH, Charles. American, 1883–1935.

226 STROLLING. 1912. Watercolor and pencil, 8¹/₂ x 5¹/₈″ (21.6 x 13

cm). Gift of Abby Aldrich Rockefeller. 60.35. Repr. *Demuth*, p. 22.

226 FLOWERS. 1915. Watercolor and pencil, 8¹/₂ x 11″ (21.6 x 27.9 cm). Gift of Abby Aldrich Rockefeller. 55.35.

227 NANA, SEATED LEFT, AND SATIN AT LAURE'S RESTAURANT. Illustration for *Nana* by Zola. 1916. Watercolor and pencil, 8¹/₂ x 11″ (21.6 x 27.9 cm). Gift of Abby Aldrich Rockefeller. 52.35. Repr. *Demuth*, p. 38.

THE SHINE. 1916. Watercolor and pencil, 7³/₄ x 10¹/₄″ (19.7 x 26 cm). Gift of James W. Barney. 165.34.

226 EIGHT O'CLOCK. 1917. Watercolor and pencil, 7⁷/₈ x 10¹/₈″ (20 x 25.7 cm). Gift of Abby Aldrich Rockefeller. 54.35.

226 VAUDEVILLE. 1917. Watercolor and pencil, 8 x 10¹/₂″ (20.3 x 26.7 cm). Katharine Cornell Fund. 87.50. Repr. *Demuth*, p. 29.

226 VAUDEVILLE MUSICIANS. 1917. Watercolor and pencil, 13 x 8″ (33 x 20.3 cm). Abby Aldrich Rockefeller Fund. 148.45. Repr. *Ptg. & Sc.*, p. 73.

227 "AT A HOUSE IN HARLEY STREET." One of five illustrations for *The Turn of the Screw* by Henry James. 1918. Watercolor and pencil, 8 x 11″ (20.3 x 27.9 cm). Gift of Abby Aldrich Rockefeller. 56.35. Repr. *Ptg. & Sc.*, p. 72.

226 DANCING SAILORS. 1918. Watercolor and pencil, 7⁷/₈ x 9⁷/₈″ (20 x 25.1 cm) (sight). Abby Aldrich Rockefeller Fund. 147.45. Repr. *Ptg. & Sc.*, p. 72.

226 EARLY HOUSES, PROVINCETOWN. 1918. Watercolor and pencil, 14 x 10″ (35.6 x 25.4 cm). Gift of Philip L. Goodwin. 3.49. Repr. *Demuth*, p. 64.

226 VAUDEVILLE DANCERS. 1918. Watercolor and pencil, 8 x 11¹/₂″ (20.3 x 29.2 cm). Purchase. 149.45.

226 ACROBATS. 1919. Watercolor and pencil, 13 x 7⁷/₈″ (33 x 20 cm). Gift of Abby Aldrich Rockefeller. 51.35. Repr. *Bulletin*, vol. II, no. 8, 1935, p. 2; in color, *Masters*, p. 115; *Demuth*, frontispiece. *Note*: the Museum owns a pencil study for this watercolor.

227 STAIRS, PROVINCETOWN. 1920. Gouache and pencil on cardboard, 23¹/₂ x 19¹/₂″ (59.7 x 49.5 cm). Gift of Abby Aldrich Rockefeller. 59.35. Repr. *Ptg. & Sc.*, p. 109.

227 IN THE KEY OF BLUE. (c. 1920) Gouache, pencil, and crayon, 19¹/₂ x 15¹/₂″ (49.5 x 39.4 cm). Gift of Abby Aldrich Rockefeller. 57.35.

EGGPLANT AND TOMATOES. 1926. Watercolor and pencil, 14¹/₈ x 20″ (35.8 x 50.9 cm). The Philip L. Goodwin Collection. 99.58. Repr. *Bulletin*, Fall 1958, p. 6.

227 CORN AND PEACHES. 1929. Watercolor and pencil, 13³/₄ x 19³/₄″ (35 x 50.2 cm). Gift of Abby Aldrich Rockefeller. 53.35.

Also, a drawing.

DENIS, Maurice. French, 1870–1943.

28 THE PITCHER. (1890–95?) Oil and sand on paper mounted on canvas, 17³/₄ x 9¹/₂″ (45.1 x 24.1 cm). Gift of A. M. Adler and Norman Hirschl. 282.58. Repr. *Suppl. VIII*, p. 6. *Note*: attribution to Denis seems probable but has been questioned.

28 ON THE BEACH OF TRESTRIGNEL. 1898. Oil on cardboard, 27⁵/₈ x 39³/₈″ (70 x 99.8 cm). Grace Rainey Rogers Fund. 1.64.

Also, prints, design for wallpaper, and an illustration.

DENNY, Robyn. British, born 1930.

457 FOLDED. 1965. Oil on canvas, 6′11⁷/₈″ x 6′ (213 x 182.8 cm). Blanchette Rockefeller Fund. 116.66.

DERAIN, André. French, 1880–1954.

Several titles and dates have been revised in consultation with Mme Derain (1964) and D.-H. Kahnweiler (1965).

60 POPLARS. (c. 1900) Oil on canvas, 16¼ x 12⅞″ (41.3 x 32.7 cm). Bequest of Anna Erickson Levene in memory of her husband, Dr. Phoebus Aaron Theodor Levene. 128.47.

60 FISHING BOATS, COLLIOURE. (1905) Oil on canvas, 15⅛ x 18¼″ (38.2 x 46.3 cm). The Philip L. Goodwin Collection. 100.58. Repr. *Bulletin*, Fall 1958, p. 6.

BACCHIC DANCE. (1906) Watercolor and pencil, 19½ x 25½″ (49.5 x 64.8 cm). Gift of Abby Aldrich Rockefeller. 61.35.

60 L'ESTAQUE. (1906) Oil on canvas, 13⅞ x 17¾″ (35.3 x 45.1 cm). Acquired through the Lillie P. Bliss Bequest. 6.51. Repr. *Suppl. III*, p. 10.

60 LONDON BRIDGE. (1906) Oil on canvas, 26 x 39″ (66 x 99.1 cm). Gift of Mr. and Mrs. Charles Zadok. 195.52. Repr. *Suppl. IV*, p. 18; in color, *Masters*, p. 46; in color, *Invitation*, p. 114.

60 MME DERAIN IN GREEN. (Previous title: *Woman in a Green Dress.*) (1907) Oil on canvas, 28¾ x 23⅝″ (73 x 60 cm). Given anonymously. 143.42.

61 LANDSCAPE NEAR CASSIS. (1907) Oil on canvas, 18⅛ x 21⅝″ (46 x 54.9 cm). Mrs. Wendell T. Bush Fund. 278.49. Repr. *Suppl. I*, p. 5.

404 MARTIGUES. (1908–09) Oil on canvas, 32 x 25⅝″ (81.2 x 65.1 cm). Mrs. George Hamlin Shaw and Loula D. Lasker Funds. 1234.64.

404 STILL LIFE WITH A BLUE HAT. (1912) Oil on canvas, 28⅜ x 35⅞″ (72 x 91.1 cm). Gift of Mr. and Mrs. Justin K. Thannhauser in honor of Alfred H. Barr, Jr. 174.67.

61 VALLEY OF THE LOT AT VERS. (1912) Oil on canvas, 28⅞ x 36¼″ (73.3 x 92.1 cm). Abby Aldrich Rockefeller Fund. 262.39. Repr. *Ptg. & Sc.*, p. 50.

61 WINDOW AT VERS. (Previous title: *The Window on the Park.*) (1912) Oil on canvas, 51½ x 35¼″ (130.8 x 89.5 cm). Abby Aldrich Rockefeller Fund, purchased in memory of Mrs. Cornelius J. Sullivan. 631.39. Repr. *Ptg. & Sc.*, p. 51.

61 ITALIAN WOMAN. (Previous title: *Mourning Woman.*) (1913) Oil on canvas, 35⅞ x 28¾″ (91.1 x 73 cm). Gift of Dr. Alfred Gold. 31.47.

62 MME DERAIN. (Previous title: *Head of a Woman.*) (1920) Oil on canvas, 14¾ x 9¼″ (37.5 x 23.6 cm). Lillie P. Bliss Collection. 44.34. Repr. *Ptg. & Sc.*, p. 52.

62 TORSO. (c. 1921) Oil on cardboard, 30 x 21⅜″ (76.2 x 54.3 cm). Purchase (by exchange). 1638.40.

62 THREE TREES. (1923?) Oil on canvas, 36 x 32⅛″ (91.4 x 81.6 cm). Gift of Mr. and Mrs. Sam A. Lewisohn. 302.47. Repr. *Ptg. & Sc.*, p. 53. *Note*: according to Mme Derain, subject is near Les Lecques or St.-Cyr-sur-Mer, Côte d'Azur.

62 LANDSCAPE, PROVENCE. (Previous title: *Landscape.*) (c. 1926) Oil on canvas, 23½ x 28⅝″ (59.7 x 72.7 cm). Given anonymously. 454.37.

62 LANDSCAPE, SOUTHERN FRANCE. (1927–28) Oil on canvas, 31½ x 38″ (80 x 96.5 cm). Lillie P. Bliss Collection. 45.34. Repr. *Bliss*, 1934, no. 36.

62 NIGHT PIECE WITH MUSICAL INSTRUMENTS. Oil on canvas, 9⅛ x 15⅜″ (23.3 x 39 cm). Gift of William H. Weintraub. 679.54. Repr. *Suppl. V*, p. 35.

Also, drawings, prints, a theatre design, and illustrated books; a book jacket in the Study Collection.

DESPIAU, Charles. French, 1874–1946.

42 YOUNG PEASANT GIRL. (1909) Pewter (cast 1929), 11½″ (29.2 cm) high. Gift of Abby Aldrich Rockefeller. 618.39. Repr. *Bulletin*, vol. XI, no. 4, 1944, p. 9.

DOMINIQUE. (1926) Original plaster, 21¾″ (55.2 cm) high. Gift of Abby Aldrich Rockefeller. 617.39. Repr. *Ptg. & Sc.*, p. 241. *Note*: the subject is Mlle Dominique Jeanès.

42 ADOLESCENCE. (1921–28?) Bronze, 25⅛″ (63.8 cm) high. Gift of Frank Crowninshield. 615.43. Repr. *Bulletin*, vol. XI, no. 4, 1944, p. 6. *Note*: alternate title, *Diana*.

42 PORTRAIT HEAD. Original plaster, 18¼ x 17″ (46.3 x 43 cm). Gift of Abby Aldrich Rockefeller. 620.39. Repr. *Ptg. & Sc.*, p. 241.

42 ANTOINETTE SCHULTE. (1934) Bronze, 19″ (48.2 cm) high. Gift of Miss Antoinette Schulte. 394.62. Repr. *Suppl. XII*, p. 12.

42 ASSIA. (1938) Bronze, 6′3¾″ (184.8 cm) high. Gift of Mrs. Simon Guggenheim. 334.39. Repr. *Ptg. & Sc.*, p. 243; *Masters*, p. 45; *What Is Mod Sc.*, p. 10.

42 ANNE MORROW LINDBERGH. (1939) Bronze, 15½″ (39.4 cm) high. Gift of Colonel and Mrs. Charles A. Lindbergh. 1654.40. Repr. *20th-C. Portraits*, p. 109.

Also, drawings and a print.

DESVALLIÈRES, Georges. French, 1861–1950.

28 NOTRE DAME. (c. 1905?) Oil and charcoal on cardboard, 40½ x 28½″ (102.9 x 72.4 cm). Gift of John Hay Whitney. 18.49.

DICKINSON, Edwin. American, born 1891.

239 COTTAGE PORCH, PEAKED HILL. 1932. Oil on canvas, 26⅛ x 30⅛″ (66.4 x 76.3 cm). Grace Rainey Rogers Fund. 98.61. Repr. *Suppl. XI*, p. 18.

238 COMPOSITION WITH STILL LIFE. 1933–37. Oil on canvas, 8′1″ x 6′5¾″ (246.4 x 197.5 cm). Gift of Mr. and Mrs. Ansley W. Sawyer. 173.52. Repr. *Romantic Ptg.*, p. 123; in color, *Invitation*, p. 102.

Also, a drawing.

DICKINSON, Preston. American, 1891–1930.

229 PLUMS ON A PLATE. (1926) Oil on canvas, 14 x 20″ (35.6 x 50.8 cm). Gift of Abby Aldrich Rockefeller. 2.31. Repr. *Ptg. & Sc.*, p. 132.

STILL LIFE. 1926. Pastel, 21 x 14″ (53.3 x 35.6 cm). Gift of Abby Aldrich Rockefeller. 63.35.

229 HARLEM RIVER. (Before 1928) Oil on canvas, 16⅛ x 20¼″ (41 x 51.4 cm). Gift of Abby Aldrich Rockefeller. 62.35.

DILLER, Burgoyne. American, 1906–1965.

CONSTRUCTION. 1938. Painted wood construction, 14⅝ x 12½ x 2⅝″ (37 x 31.9 x 6.7 cm). Gift of Mr. and Mrs. Armand P. Bartos. 4.58. Repr. *Suppl. VIII*, p. 18.

364 FIRST THEME. (1942) Oil on canvas, 42 x 42″ (106.6 x 106.6 cm). Gift of Silvia Pizitz. 6.59. Repr. *Suppl. IX*, p. 18. *Note*: the title *First Theme* supersedes the previous title *Composition*.

DINE, Jim. American, born 1935.

FIVE FEET OF COLORFUL TOOLS. 1962. Oil on canvas surmounted by a board on which thirty-two tools hang from hooks; overall, 55⅝ x 60¼ x.4⅜″ (141.2 x 152.9 x 11 cm). The Sidney and Harriet Janis Collection (fractional gift). 587.67a–gg. Repr. *Janis*, p. 151.

DIX, Otto. German, 1891–1969.

201 CAFÉ COUPLE. 1921. Watercolor and pencil, 20 x 16⅛″ (50.8 x 41 cm). Purchase. 124.45. Repr. *Ptg. & Sc.*, p. 142.

201 CAFÉ. 1922. Watercolor, pen and ink, 19¼ x 14⅜″ (48.9 x 36.5 cm). Gift of Samuel A. Berger. 7.55.

201 SELF-PORTRAIT. 1922. Watercolor and pencil, 19⅜ x 15½″ (49.2 x 39.3 cm). Gift of Richard L. Feigen. 142.57. Repr. *Suppl. VII*, p. 21.

201 DR. MAYER-HERMANN. 1926. Oil and tempera on wood, 58¾ x 39″ (149.2 x 99.1 cm). Gift of Philip Johnson. 3.32. Repr. *Ptg. & Sc.*, p. 190; in color, *Invitation*, p. 60. *Note*: the subject is Dr. Wilhelm Mayer-Hermann, a prominent Berlin throat specialist who died in New York in 1945.

201 CHILD WITH DOLL. 1928. Oil and tempera on wood, 29¼ x 15¼″ (74.3 x 38.7 cm). Gift of Abby Aldrich Rockefeller. 65.35. Repr. *German Art of 20th C.*, p. 89. *Note*: the child is Nelly Thaesler-Dix, daughter of the artist.

Also, drawings and prints.

DLUGOSZ, Louis. American, born 1916.

HENRY. (1938) Terra cotta, 12½″ (31.7 cm) high. Purchase. 247.40. *Note*: the subject is a brother of the artist.

DMITRIENKO, Pierre. French, 1925–1974.

THE COUPLE. 1965. Oil on paper, 22 x 28⅞″ (55.7 x 73.2 cm). Gift of Carl van der Voort. 185.66.

VAN DOESBURG, Theo (C. E. M. Küpper). Dutch, 1883–1931.

138 COMPOSITION (THE COW). 1916. Gouache, 15⅝ x 22¾″ (39.7 x 57.8 cm). Purchase. 226.48. A study for the oil, no. 225.48. Repr. *Cubism*, pl. 144.

138 COMPOSITION (THE COW). (1916–17) Oil on canvas, 14¾ x 25″ (37.5 x 63.5 cm). Purchase. 225.48. Repr. *Cubism*, pl. 144; *Suppl. I*, p. 18; *de Stijl*, pp. 6 (detail), 9; in color, *Masters*, p. 217. *Note*: the Museum owns eight pencil studies for this painting.

138 RHYTHM OF A RUSSIAN DANCE. 1918. Oil on canvas, 53½ x 24¼″ (135.9 x 61.6 cm). Acquired through the Lillie P. Bliss Bequest. 135.46. Repr. *Ptg. & Sc.*, p. 116; *de Stijl*, pp. 6 (detail), 10; in color, *Masters*, p. 217; in color, *Invitation*, p. 38.

138 COLOR CONSTRUCTION: PROJECT FOR A PRIVATE HOUSE (in collaboration with Cornelis van Eesteren). (1922) Gouache and ink, 22½ x 22½″ (57.1 x 57.1 cm). Edgar Kaufmann, Jr., Fund. 149.47. Architecture Collection. Repr. *de Stijl*, p. 6 (detail), cover; in color, *Masters*, p. 217.

SIMULTANEOUS COUNTER-COMPOSITION. (1929–30). Oil on canvas, 19¾ x 19⅝″ (50.1 x 49.8 cm). The Sidney and Harriet Janis Collection (fractional gift). 588.67. Repr. *Cubism*, pl. 156; in color, *Janis*, p. 35.

Also, drawings.

DOMINGUEZ, Oscar. French, born Spain. 1906–1957. To Paris 1927.

182 NOSTALGIA OF SPACE [*Nostalgie de l'espace*]. 1939. Oil on canvas, 28¾ x 36⅛″ (73 x 91.8 cm). Gift of Peggy Guggenheim. 174.52. *Note*: also called *La Formule*.

Also, a drawing and an illustration.

DOMOTO, Hisao. Japanese, born 1928. In Paris 1955–67.

470 SOLUTION OF CONTINUITY, 24. 1964. Oil on canvas, 63⅝ x 51⅛″ (161.6 x 129.8 cm). Promised gift and extended loan from Mr. and

Mrs. David Kluger. E.L.70.1281. Repr. *New Jap. Ptg. & Sc.*, p. 75.

DONATI, Enrico. American, born Italy 1909. Worked in France. To U.S.A. 1934.

311 ST. ELMO'S FIRE. 1944. Oil on canvas, 36½ x 28½″ (92.7 x 72.4 cm). Given anonymously. 129.47. Repr. *Ptg. & Sc.*, p. 230.

INSCRIPTION 4062 B.C. (1962) Oil and sand on canvas, 60 x 50″ (152.5 x 126.9 cm). Gift of Mr. and Mrs. Gilbert W. Kahn. 73.62. Repr. *Suppl. XII*, p. 21.

Also, an illustration.

VAN DONGEN, Kees (Cornelis T. M. van Dongen). French, born the Netherlands. 1877–1968. To France 1897.

63 MODJESKO, SOPRANO SINGER. (1908) Oil on canvas, 39⅜ x 32″ (100 x 81.3 cm). Gift of Mr. and Mrs. Peter A. Rübel. 192.55. Repr. *Suppl. VI*, p. 10; in color, *Invitation*, p. 19. *Note*: Modjesko was a female impersonator well known in Paris *cafés concerts*.

63 MLLE BORDENAVE. (1925) Oil on canvas, 28¾ x 19¾″ (73 x 50.2 cm). Given anonymously. 244.54. Repr. *Suppl. V*, p. 8.

Also, a print.

DORAZIO, Piero. Italian, born 1927.

374 RELIEF. 1953. Painted wood and celluloid in frame, 17 x 21½ x 5⅛″ (43 x 54.8 x 13 cm). Given anonymously. 286.61. Repr. *Suppl. XI*, p. 25.

461 HAND OF MERCY [*Mano della clemenza*]. 1963. Oil on canvas, 64⅛ x 51⅜″ (162.6 x 130.3 cm). Bertram F. and Susie Brummer Foundation Fund. 107.65.

Also, a drawing.

DORCÉLY, Roland. Haitian, born 1930. Works in Paris.

289 WHEN TO RELAX? [*A Quand la détente?*]. 1958. Tempera on composition board, 36 x 49¼″ (91.5 x 125 cm). Gift of Edna and Keith Warner. 115.58. Repr. *Suppl. VIII*, p. 20.

DORIANI, William. American, born 1891.

FLAG DAY. (1935) Oil on canvas, 12¼ x 38⅝″ (31.1 x 98 cm). The Sidney and Harriet Janis Collection (fractional gift). 589.67. Repr. *Janis*, p. 87.

DOS PRAZERES, Heitor. Brazilian, 1902–1966.

ST. JOHN'S DAY. 1942. Oil on oilcloth, 25½ x 31¾″ (64.8 x 80.6 cm). Inter-American Fund. 773.42. Repr. *Latin-Amer. Coll.*, p. 40.

DOUAIHY, Saliba. American, born Lebanon 1915. To U.S.A. 1955.

456 MAJESTIC. 1965. Synthetic polymer paint on canvas, 46¼ x 54″ (117.3 x 137.1 cm). Gift of Y. K. Bedas. 384.66.

DOVE, Arthur G. American, 1880–1946.

223 GRANDMOTHER. (1925) Collage of shingles, needlepoint, page from the Concordance, pressed flowers and ferns, 20 x 21¼″ (50.8 x 54 cm). Gift of Philip L. Goodwin (by exchange). 636.39. Repr. *Ptg. & Sc.*, p. 222; *Assemblage*, p. 43; in color, *Invitation*, p. 59.

223 THE INTELLECTUAL. (1925) Assemblage: magnifying glass, bone, moss, bark and a scale glued or nailed on varnished cloth, mounted on wood panel, 17 x 7⅛″ (43 x 18.2 cm). The Philip L. Goodwin Collection. 101.58. Repr. *Bulletin*, Fall 1958, p. 8.

223 PORTRAIT OF ALFRED STIEGLITZ. (1925) Assemblage: camera lens, photographic plate, clock and watch springs, and steel wool, on cardboard, 15⁷/₈ x 12¹/₈″ (40.3 x 30.8 cm). Purchase. 193.55. Repr. *Suppl. VI*, p. 21.

223 WILLOWS. (1940) Oil on gesso on canvas, 25 x 35″ (63.5 x 88.9 cm). Gift of Duncan Phillips. 471.41. Repr. *Ptg. & Sc.*, p. 222.

DREIER, Katherine S. American, 1877–1952.

225 ABSTRACT PORTRAIT OF MARCEL DUCHAMP. 1918. Oil on canvas, 18 x 32″ (45.7 x 81.3 cm). Abby Aldrich Rockefeller Fund. 279.49. Repr. *Suppl. I*, p. 20.

DROSTE, Karl-Heinz. German, born 1931.

362 RELIEF XIII/60 VADASA II. (1960) Bronze, 23¹/₂ x 18¹/₄″ (59.6 x 46.2 cm). Gift of Mr. and Mrs. Clarence C. Franklin. 268.63.

DRUMMOND, Sally Hazelet. American, born 1924.

HUMMINGBIRD. 1961. Oil on canvas, 12 x 12″ (30.4 x 30.4 cm). Larry Aldrich Foundation Fund. 229.62. Repr. *Amer. 1963*, p. 29.

DU BOIS, Guy Pène. American, 1884–1958.

234 AMERICANS IN PARIS. 1927. Oil on canvas, 28³/₄ x 36³/₈″ (73 x 92.4 cm). Given anonymously. 66.35. Repr. *Ptg. & Sc.*, p. 157.

DUBUFFET, Jean. French, born 1901.

Loreau refers to the definitive *Catalogue des travaux de Jean Dubuffet*, edited by Max Loreau, Paris; 25 volumes published to date (1976).

263 SNACK FOR TWO [*Casse-croûte à deux*]. (1945) Oil on canvas, 29¹/₈ x 24¹/₈″ (74 x 61.2 cm). From the Mirobolus, Macadam et Cie/Hautes Pâtes series. Gift of Mrs. Saidie A. May. 280.49. *Loreau II*, 31. Repr. *Suppl. I*, p. 13.

433 WALL WITH INSCRIPTIONS. 1945. Oil on canvas, 39³/₈ x 31⁷/₈″ (99.7 x 81 cm). From the Walls series. Mr. and Mrs. Gordon Bunshaft Fund. 186.66. *Loreau I*, 445.

263 HENRI MICHAUX, JAPANESE ACTOR. 1946. Mixed mediums on canvas, 51¹/₂ x 38³/₈″ (130.8 x 97.3 cm). From the More Beautiful Than They Think: Portraits series. Gift of Mr. and Mrs. Gordon Bunshaft. 309.62. Repr. *Suppl. XII*, p. 16.

HIGH HEELS. 1946. Oil and sand on canvas, 25⁵/₈ x 21¹/₂″ (65.1 x 54.3 cm). From the Mirobolus, Macadam et Cie/Hautes Pâtes series. The Sidney and Harriet Janis Collection (fractional gift). *Loreau II*, 152. 590.67. Repr. *Janis*, p. 101.

263 JOË BOUSQUET IN BED. (1947) Oil emulsion in water on canvas, 57⁵/₈ x 44⁷/₈″ (146.3 x 114 cm). From the More Beautiful Than They Think: Portraits series. Mrs. Simon Guggenheim Fund. 114.61. *Loreau III*, 116. Repr. *Suppl. XI*, p. 42; *Dubuffet*, p. 33. Note: the subject is a French poet who was paralyzed in World War I and lived bedridden for over three decades in Narbonne. He died in 1950.

PORTRAIT OF HENRI MICHAUX. 1947. Oil on canvas, 51¹/₂ x 38³/₈″ (130.7 x 97.3 cm). Inscribed on reverse: *Portrait of Henri Michaux*; on stretcher: *Michaux gros cerne crême*. From the More Beautiful Than They Think: Portraits series. The Sidney and Harriet Janis Collection (fractional gift). 591.67. *Loreau III*, 112. Repr. *Janis*, p. 101.

CORPS DE DAME: BLUE SHORT CIRCUIT [*Court-circuit bleu*]. 1951 (February). Oil on canvas, 46¹/₈ x 35¹/₄″ (117 x 89.4 cm). From the Corps de Dames series. The Sidney and Harriet Janis Collection (fractional gift). 593.67. *Loreau VI*, 118. Repr. in color, *Janis*, p. 103; in color, *Invitation*, p. 130.

TABLE AUX SOUVENIRS. 1951 (March). Oil and sand on canvas, 32¹/₈ x 39¹/₂″ (81.5 x 100.2 cm). From the Landscaped Tables series. The Sidney and Harriet Janis Collection (fractional gift). 592.67. *Loreau VII*, 20. Repr. *Janis*, p. 107.

FAÇADE. 1951 (June). Watercolor on gesso on paper, 9⁷/₈ x 13″ (25 x 32.9 cm). From the Barren Landscapes series. The Sidney and Harriet Janis Collection (fractional gift). 1772.67. Repr. *Janis*, p. 105.

264 WORK TABLE WITH LETTER. 1952. Oil paint in Swedish putty on composition board, 35⁵/₈ x 47⁷/₈″ (90.5 x 121.6 cm). From the Landscaped Tables series. Gift of Mr. and Mrs. Ralph F. Colin. 46.52. *Loreau VII*, 138. Repr. *Suppl. IV*, p. 32; *Dubuffet*, p. 70.

264 THE COW WITH THE SUBTILE NOSE. 1954. Oil and enamel on canvas, 35 x 45³/₄″ (88.9 x 116.1 cm). From the Cows, Grass, Foliage series. Benjamin Scharps and David Scharps Fund. 288.56. *Loreau X*, 109. Repr. *Suppl. VI*, p. 24; *Dubuffet*, p. 99.

263 BLACK COUNTRYSIDE [*Terres noires*]. (1955) Assemblage: cut-and-pasted paper with ink transfer on paper, 25¹/₂ x 23¹/₈″ (64.8 x 58.7 cm). From the Second Series of Imprint Assemblages. Gift of Mr. and Mrs. Donald H. Peters. 12.56.

264 BEARD OF UNCERTAIN RETURNS. 1959. Oil on canvas, 45³/₄ x 35¹/₈″ (116.1 x 89.2 cm). From the Beards series. Mrs. Sam A. Lewisohn Fund. 63.61. *Loreau XV*, 85. Repr. *Suppl. XI*, p. 43; *Dubuffet*, p. 147.

BOTANICAL ELEMENT: BAPTISM OF FIRE [*Baptême du feu*]. 1959 (September). Assemblage of leaves on paper, 21⁵/₈ x 27¹/₈″ (54.9 x 68.9 cm). From the Botanical Elements series. The Sidney and Harriet Janis Collection (fractional gift). 594.67. Repr. *Janis*, p. 109.

265 BUSINESS PROSPERS. 1961. Oil on canvas, 65″ x 7′2⁵/₈″ (165.1 x 220 cm). From the Paris Circus series. Mrs. Simon Guggenheim Fund. 115.62. *Loreau XIX*, 55. Repr. *Dubuffet*, p. 161; *Suppl. XII*, p. 17; in color, *Invitation*, p. 125.

Design for jacket of *The Work of Jean Dubuffet* by Peter Selz, The Museum of Modern Art, New York, 1962. (1961) Gouache, 9⁵/₈ x 27¹/₈″ (24.5 x 68.9 cm). Commissioned by the Museum. Gift of the artist. 117.62. Repr. in color, *Dubuffet* jacket.

Also, prints, illustrated books, and posters.

DUCHAMP, Marcel. American, born France. 1887–1968. In U.S.A. 1915–18, 1920–23, 1942–68.

156 LANDSCAPE. 1911. Oil on canvas, 18¹/₄ x 24¹/₈″ (46.3 x 61.3 cm). Katherine S. Dreier Bequest. 148.53. Repr. *Suppl. IV*, p. 10.

156 THE PASSAGE FROM VIRGIN TO BRIDE. 1912 (Munich, July–August). Oil on canvas, 23³/₈ x 21¹/₄″ (59.4 x 54 cm). Inscribed, lower left: *Le Passage de la vierge à la mariée*. Purchase. 174.45. Repr. *Ptg. & Sc.*, p. 91; in color, *Masters*, p. 136; *Dada, Surrealism*, p. 13; in color, *Invitation*, p. 56.

156 3 STOPPAGES ÉTALON. 1913–14. Assemblage: three threads glued to three painted canvas strips, 5¹/₄ x 47¹/₄″ (13.3 x 120 cm), each mounted on a glass panel, 7¹/₄ x 49³/₈ x ¹/₄″ (18.4 x 125.4 x .6 cm); three wood slats, 2¹/₂ x 43 x ¹/₈″ (6.2 x 109.2 x .2 cm), 2¹/₂ x 47 x ¹/₈″ (6.1 x 119.4 x .2 cm), and 2¹/₂ x 43¹/₄ x ¹/₈″ (6.3 x 109.7 x .2 cm), shaped along one edge to match the curves of the threads; the whole fitted into a wood box, 11¹/₈ x 50⁷/₈ x 9″ (28.2 x 129.2 x 22.7 cm). Inscribed on reverse: *Un mètre de fil droit, horizontal, tombé d'un mètre de haut. 3 Stoppages étalon; appartenant à Marcel Duchamp. 1913–14*. Katherine S. Dreier Bequest. 149.53. Repr. *Suppl. IV*, p. 10; *Masters*, p. 137. Note: stoppages étalon may be translated "standard stoppages" but *stoppage* in French means both the action of "stopping" and the action of sewing together a torn or cut cloth with a thread.

157 TO BE LOOKED AT (FROM THE OTHER SIDE OF THE GLASS) WITH ONE EYE, CLOSE TO, FOR ALMOST AN HOUR. 1918. Oil paint, silver leaf, lead wire, and magnifying lens on glass (cracked), $19^{1}/2$ x $15^{5}/8''$ (49.5 x 39.7 cm), mounted between two panes of glass in a standing metal frame, $20^{1}/8$ x $16^{1}/4$ x $1^{1}/2''$ (51 x 41.2 x 3.7 cm), on painted wood base $1^{7}/8$ x $17^{7}/8$ x $4^{1}/2''$ (4.8 x 45.3 x 11.4 cm); overall height 22" (55.8 cm). Inscribed: *A regarder (l'autre côté du verre) d'un oeil, de prés, pendant presque une heure.* Katherine S. Dreier Bequest. 150.53. Repr. *Suppl. IV*, p. 11; in color, *Invitation*, p. 147.

157 FRESH WIDOW. 1920. Miniature French window, painted wood frame and eight panes of glass covered with black leather, $30^{1}/2$ x $17^{5}/8''$ (77.5 x 44.8 cm), on wood sill, $3/4$ x 21 x 4" (1.9 x 53.4 x 10.2 cm). Inscribed: *Fresh Widow Copyright Rose Selavy 1920.* Katherine S. Dreier Bequest. 151.53. Repr. *Suppl. IV*, p. 11; *Assemblage*, p. 44. *Note: Fresh Widow* is, of course, a pun and so is *Sélavy* if pronounced *c'est la vie.*

157 MONTE CARLO BOND. 1924. Photocollage on colored lithograph, $12^{1}/4$ x $7^{3}/4''$ (31.1 x 19.7 cm). Gift of the artist. 3.39. *Note*: framed in the roulette wheel, above the center, is a cutout photograph of the artist, his face wreathed in soapsuds. Man Ray took the photograph.

BOX IN A VALISE [*Boîte-en-valise*]. (1935–41) Leather valise containing miniature replicas, photographs, and color reproductions of works by Duchamp, 16 x 15 x 4" (40.7 x 38.1 x 10.2 cm). Inscribed at time of acquisition: *Marcel Duchamp New York Jan. 1943* and stamped with the Museum's name in gold. James Thrall Soby Fund. 67.43.1–70. *Note*: Number IX of a deluxe edition of twenty, completed in 1941. The artist assembled the contents of this "portable museum" between 1935 and 1940.

BICYCLE WHEEL. (1951. Third version, after lost original of 1913). Assemblage: metal wheel, $25^{1}/2''$ (63.8 cm) diameter, mounted on painted wood stool, $23^{3}/4''$ (60.2 cm) high; overall, $50^{1}/2''$ (128.3 cm) high. The Sidney and Harriet Janis Collection (fractional gift). 595.67. Repr. *Assemblage*, p. 46; *Janis*, p. 49.

WEDGE OF CHASTITY [*Coin de chasteté*]. 1954. Plaster in two sections, partly painted, $2^{3}/4$ x $3^{7}/8$ x $2^{1}/2''$ (6.9 x 10 x 6.1 cm). Inscribed: *Pour Sacha Maruchess très cordialement.* Gift of Mr. and Mrs. Solomon Ethe. 154.62a–b.

416 WHY NOT SNEEZE ROSE SÉLAVY? 1964. Replica of 1921 original. Painted metal birdcage containing 151 white marble blocks, thermometer, and piece of cuttlebone; cage, $4^{7}/8$ x $8^{3}/4$ x $6^{3}/8''$ (12.3 x 22.1 x 16 cm). Inscribed lower edge: *For the Museum of Modern Art New York Marcel Duchamp/1964;* on bottom: *Why/not/sneeze/Rose/Sélavy?/1921.* Gift of Galleria Schwarz. 1123.64a–e. Repr. *Dada, Surrealism*, p. 16.

Also, a drawing, "rotoreliefs," a poster, a film, and designs for chessmen.

DUCHAMP-VILLON, Raymond. French, 1876–1918.

102 BAUDELAIRE. 1911. Bronze, $15^{3}/4''$ (40 cm) high. Alexander M. Bing Bequest. 5.60. Repr. *Suppl. X*, p. 18.

102 THE LOVERS. (1913) Original plaster relief, $27^{1}/2$ x 46 x $6^{1}/2''$ (69.8 x 116.8 x 16.3 cm). Purchase. 258.39. Repr. *Ptg. & Sc.*, p. 268; *What Is Mod. Sc.*, p. 114.

102 THE HORSE. 1914. Bronze (cast c. 1930–31), 40 x $39^{1}/2$ x $22^{3}/8''$ (101.6 x 100.1 x 56.7 cm). Van Gogh Purchase Fund. 456.37. This cast was made after the sculptor's death by his brother Jacques Villon and the sculptor Albert Pommier, who enlarged the original model according to the sculptor's instructions. Repr. *Ptg. & Sc.*, p. 269; *Masters*, p. 79; *What Is Mod. Sc.*, p. 50.

DUFY, Raoul. French, 1877–1953.

M.L. refers to *Raoul Dufy,* volume 1, by Maurice Laffaille, Geneva, 1972.

64 ANGLERS AT SUNSET. (1907) Oil on canvas, $21^{3}/8$ x $25^{5}/8''$ (54.3 x 65.1 cm). Gift of Mr. and Mrs. Charles Zadok. 11.53. *M.L.* 156 (*Coup de vent*). Repr. *Suppl. IV*, p. 19.

64 SAILBOAT AT SAINTE-ADRESSE. (1912) Oil on canvas, $34^{7}/8$ x $45^{5}/8''$ (88.6 x 115.9 cm). Gift of Mr. and Mrs. Peter A. Rübel. 476.53. *M.L.* 320 (*Le Casino de Sainte-Adresse au Pêcheur*). Repr. in color, *Masters*, p. 48.

65 THE PALM. 1923. Watercolor and gouache, $19^{3}/4$ x 25" (50.2 x 63.5 cm). Gift of Mrs. Saidie A. May. 140.34. Repr. *Ptg. & Sc.*, p. 54.

64 THE POET FRANÇOIS BERTHAULT. (1925) Oil on paper over canvas, 32 x $25^{5}/8''$ (81.3 x 65.1 cm). Gift of Mr. and Mrs. Peter A. Rübel. 544.54. Repr. *Suppl. V*, p. 8.

64 WINDOW AT NICE. (c. 1929) Oil on canvas, $21^{5}/8$ x $18^{1}/8''$ (54.9 x 46 cm). Gift of Mrs. Gilbert W. Chapman. 267.54. Repr. *Suppl. V*, p. 8.

NICE. 1936. Watercolor and gouache, $20^{1}/2$ x $29^{7}/8''$ (51.8 x 75.9 cm). Gift of Fania Marinoff Van Vechten in memory of Carl Van Vechten. 374.65.

Also, a drawing, prints, posters, a broadside, and illustrations; a watercolor in the Study Collection.

DURCHANEK, Ludvik. American, born Austria 1902, of Czech parentage. To U.S.A. 1927.

302 FURY. (1958) Welded sheet bronze, $30^{3}/4''$ (78 cm) high. Blanchette Rockefeller Fund. 116.58 Repr. *Suppl. VIII*, p. 16.

DŽAMONJA, Dušan. Yugoslavian, born 1928.

379 METALLIC SCULPTURE. (1959) Welded iron nails with charred wood core, $16^{3}/8''$ high, 10" diameter (41.5 x 25.4 cm). Philip Johnson Fund. 2.61. Repr. *Suppl. XI*, p. 41.

Also, a drawing.

EBERZ, Josef. German, 1880–1942.

403 STAGE [*Bühne*]. 1916. Oil on cardboard, $9^{1}/4$ x $11^{7}/8''$ (23.4 x 30.1 cm). Gift of Richard L. Feigen. 729.66.

VAN EESTEREN, Cornelis. See van DOESBURG.

EGAS, Camilo. Ecuadorian, 1899–1962. To U.S.A. 1930.

217 DREAM OF ECUADOR. 1939. Oil on canvas, 20 x 25" (50.8 x 63.5 cm). Inter-American Fund. 3.45. Repr. *Ptg. & Sc.*, p. 141.

EGUCHI, Shyu. Japanese, born 1932.

474 MONUMENT, NUMBER 4 [*Kuwagata*]. (1964) Cherry wood, $17^{3}/4$ x $21^{3}/4$ x $13^{1}/2''$ (44.9 x 55.1 x 34.1 cm). Purchase. 602.65. Repr. *New Jap. Ptg. & Sc.*, p. 83.

EIELSON, Jorge. Peruvian, born 1924. In Italy since 1952.

488 WHITE QUIPUS. (1964) Knotted cloth and tempera on canvas, $37^{1}/2$ x $59^{1}/8''$ (95 x 150.2 cm). Inter-American Fund. 108.65. *Note*: quipus were knotted cords used by the Inca Indians to record facts and events. Color and knots had specific meanings.

EILSHEMIUS, Louis Michel. American, 1864–1941.

36 AFTERNOON WIND. 1899. Oil on canvas, 20 x 36" (50.8 x 91.4 cm). Given anonymously. 394.41. Repr. *Ptg. & Sc.*, p. 164.

402 THE DEMON OF THE ROCKS. 1901. Oil on cardboard, 20 x $15^{1}/8''$ (50.6 x 38.3 cm). Gift of Fania Marinoff Van Vechten in memory of Carl Van Vechten. 285.65.

402 THE HUDSON AT YONKERS. (1911?) Oil on cardboard, 15 x 20″ (37.9 x 50.8 cm). Gift of Fania Marinoff Van Vechten in memory of Carl Van Vechten. 286.65.

36 IN THE STUDIO. (c. 1911) Oil on cardboard, 22⅛ x 13¾″ (56.2 x 35 cm). Gift of Abby Aldrich Rockefeller. 67.35.

SAMOA. 1911. Oil on cardboard, 10 x 8″ (25.4 x 20.3 cm). The Sidney and Harriet Janis Collection (fractional gift). 596.67. Repr. *Janis*, p. 81.

DANCING NYMPHS. (1914) Oil on composition board, 20⅛ x 20¼″ (51 x 51.2 cm). The Sidney and Harriet Janis Collection (fractional gift). 597.67. Repr. *Janis*, p. 81. *Note*: the canvas is signed "Elshemus"; the artist signed his name variously as Elshemus, Eilshemius, and Eilsemus.

NYMPH. (1914) Oil on composition board, 20⅛ x 19¾″ (51 x 50.2 cm). The Sidney and Harriet Janis Collection (fractional gift). 598.67. Repr. *Janis*, p. 81. *Note*: signed "Elshemus."

402 MOSQUE NEAR BISKRA. (c. 1915?) Oil on cardboard, 30½ x 20¼″ (77.4 x 51.3 cm). Gift of Fania Marinoff Van Vechten in memory of Carl Van Vechten. 287.65.

Also, a drawing.

ENGMAN, Robert. American, born 1927.

371 A STUDY IN GROWTH. (1958) Plastic-coated stainless steel, 19½″ (49.3 cm) high. Larry Aldrich Foundation Fund. 27.60. Repr. *Suppl. X*, p. 51.

Also, a sculpture in the Study Collection.

ENRÍQUEZ, Carlos. Cuban, 1901–1957.

LANDSCAPE WITH WILD HORSES. 1941. Oil on composition board, 17½ x 23⅝″ (44.5 x 60 cm). Gift of Dr. C. M. Ramírez Corría. 604.42. Repr. *Latin-Amer. Coll.*, p. 50.

ENSOR, James. Belgian, 1860–1949.

27 TRIBULATIONS OF ST. ANTHONY [*Les Tribulations de St. Antoine*]. 1887. Oil on canvas, 46⅜ x 66″ (117.8 x 167.6 cm). Purchase. 1642.40. Repr. *Ptg. & Sc.*, p. 34; in color, *Masters*, p. 35.

27 MASKS CONFRONTING DEATH [*Masques devant la mort*]. 1888. Oil on canvas, 32 x 39½″ (81.3 x 100.3 cm). Mrs. Simon Guggenheim Fund. 505.51. Repr. *Suppl. IV*, p. 19; in color, *Invitation*, p. 20.

Also, prints, including etchings colored by hand, posters, and menus.

EPSTEIN, Jacob. British, born U.S.A. 1880–1959. To England 1905.

114 NAN SEATED. (1911) Bronze, 18½″ (47 cm) high, at base, 13 x 5⅞″ (33 x 14.9 cm). Gift of Mrs. Frank Altschul in memory of her father, Philip J. Goodhart. 4.49. Repr. *Suppl. I*, p. 28. *Note*: Nan Condron, a gypsy, was a professional model.

114 MOTHER AND CHILD. (1913) Marble, 17¼ x 17″ (43.8 x 43.1 cm). Gift of A. Conger Goodyear. 5.38. Repr. *Ptg. & Sc.*, p. 270.

114 THE ROCK DRILL. (1913–14) Bronze (cast 1962), 28 x 26″ (71 x 66 cm) on wood base, 12″ (30.5 cm) diameter. Mrs. Simon Guggenheim Fund. 155.62. Repr. *Suppl. XII*, p. 1; *The Machine*, p. 65. *Note*: the original plaster version of this sculpture was mounted on an actual rock drill and so exhibited.

413 PAUL ROBESON. (1928) Bronze, 13½″ (34.2 cm) high. Gift of Fania Marinoff Van Vechten in memory of Carl Van Vechten. 288.65. *Note*: the subject of this unfinished portrait is the singer.

115 ORIEL ROSS. (1932) Bronze, 26¼ x 17″ (66.7 x 43 cm). Gift of

Edward M. M. Warburg. 2.33. Repr. *Ptg. & Sc.*, p. 252; *What Is Mod Sc.*, p. 28. *Note*: Epstein's third portrait of this model who was an actress and later married Earl Paulett.

413 ROBERT FLAHERTY. (1933) Tinted plaster, 12½ x 8⅜ x 11⅛″ (31.7 x 21.1 x 28 cm). Gift of Lady Kathleen Epstein on behalf of the artist's estate. 187.66. *Note*: the subject is the American documentary-film master.

412 ISOBEL. (1933) Tinted plaster, 27⅞ x 26½ x 18″ (70.6 x 67.1 x 45.6 cm). Gift of Lady Kathleen Epstein on behalf of the artist's estate. 188.66. *Note*: Epstein's second portrait of Isobel Nicholas, an art student, later a painter and ballet set designer.

412 HAILE SELASSIE. (1936) Tinted plaster, 46¼ x 27¾ x 17″ (117.5 x 70.5 x 43.1 cm). Gift of Lady Kathleen Epstein on behalf of the artist's estate. 189.66. *Note*: the subject is the deposed Emperor of Ethiopia.

412 LEDA (WITH COXCOMB). (1940) Tinted plaster, 8⅛ x 7¼ x 7¼″ (20.5 x 18.3 x 18.3 cm). Gift of Lady Kathleen Epstein on behalf of the artist's estate. 190.66. *Note*: Epstein's fourth portrait of his granddaughter, Leda Hornstein.

413 PANDIT NEHRU. (1946) Tinted plaster, 11⅝ x 7⅛ x 9⅛″ (29.5 x 18 x 23.1 cm). Gift of Lady Kathleen Epstein on behalf of the artist's estate. 191.66. *Note*: study for a bust completed in 1949. Jawaharlal Nehru was Prime Minister of India.

115 RECLINING NUDE TURNING. (1946) Bronze, 5½ x 21¾ x 12¾″ (14 x 55.3 x 32.4 cm). Gift of Dr. and Mrs. Arthur Lejwa in memory of Leon Chalette. 82.58. Repr. *Suppl. VIII*, p. 6.

115 RECLINING NUDE STRETCHING. (1946) Bronze, 4 x 28¼ x 7″ (10.1 x 71.6 x 17.6 cm). Gift of Dr. and Mrs. Arthur Lejwa in memory of Leon Chalette. 603.59. Repr. *Suppl. IX*, p. 10. *Note*: the model for this and the preceding sculpture was Betty Peters who kept a lodging house in the East End of London.

413 ROSALYN TURECK. (1956) Tinted plaster, 12½ x 10⅛ x 10⅞″ (31.6 x 25.6 x 27.6 cm). Gift of Lady Kathleen Epstein on behalf of the artist's estate. 192.66. *Note*: the subject is the well-known concert pianist.

ERNST, Jimmy. American, born Germany 1920. To U.S.A. 1938.

311 THE FLYING DUTCHMAN. 1942. Oil on canvas, 20 x 18⅛″ (50.8 x 46 cm). Purchase. 68.43. Repr. *Ptg. & Sc.*, p. 230.

311 A TIME FOR FEAR. 1949. Oil on canvas, 23⅞ x 20″ (60.6 x 50.8 cm). Katharine Cornell Fund. 73.50. Repr. *Abstract Ptg. & Sc.*, p. 121.

Also, a drawing in the Study Collection.

ERNST, Max. French, born Germany. 1891–1976. To France 1922; in U.S.A. 1941–50.

162 THE GRAMINEOUS BICYCLE GARNISHED WITH BELLS THE DAPPLED FIRE DAMPS AND THE ECHINODERMS BENDING THE SPINE TO LOOK FOR CARESSES. (Cologne, 1920 or 1921) Botanical chart altered with gouache, 29¼ x 39¼″ (74.3 x 99.7 cm). Inscribed: *la bicyclette graminée garnie de grelots les grisous grivelés et les échinodermes courbants l'échine pour quêter des caresses*. Purchase. 279.37. Repr. *Fantastic Art* (3rd), p. 163.

162 THE HAT MAKES THE MAN. (Cologne, 1920) Collage, pencil, ink, and watercolor, 14 x 18″ (35.6 x 45.7 cm). Inscribed: *bedeckt-samiger stapelmensch nacktsamiger wasserformer* ("*edel-former*") *Kleidsame nervatur. auch! umpressnerven!* (*c'est le chapeau qui fait l'homme*) (*le style c'est le tailleur*). Purchase. 242.35. Repr. *Ptg. & Sc.*, p. 213.

162 THE LITTLE TEAR GLAND THAT SAYS TIC TAC. 1920. Gouache on wallpaper, 14¼ x 10″ (36.2 x 25.4 cm). Inscribed: *la petite*

fistule lacrimale qui dit tic tac. Purchase. 238.35. Repr. *Masters,* p. 138; *The Machine,* p. 125.

162 STRATIFIED ROCKS, NATURE'S GIFT OF GNEISS LAVA ICELAND MOSS 2 KINDS OF LUNGWORT 2 KINDS OF RUPTURES OF THE PERINEUM GROWTHS OF THE HEART (B) THE SAME THING IN A WELL-POLISHED BOX SOMEWHAT MORE EXPENSIVE. (1920) Anatomical engraving altered with gouache and pencil, 6 x 8¹/₈″ (15.2 x 20.6 cm). Inscribed: *schichtgestein naturgabe aus gneis lava isländisch moos 2 sorten lungenkraut 2 sorten dammriss herzgewächse (b) dasselbe in fein poliertem kästchen etwas teurer.* Purchase. 280.37.

162 WOMAN, OLD MAN AND FLOWER [*Weib, Greis und Blume*]. (1923–24) Oil on canvas, 38 x 51¹/₄″ (96.5 x 130.2 cm). Purchase. 264.37. Repr. *Ptg. & Sc.,* p. 194; *Ernst,* p. 27.

162 TWO CHILDREN ARE THREATENED BY A NIGHTINGALE. (1924) Oil on wood with wood construction, 27¹/₂ x 22¹/₂ x 4¹/₂″ (69.8 x 57.1 x 11.4 cm). Inscribed: *2 enfants sont menacés par un rossignol.* Purchase. 256.37. Repr. *Fantastic Art* (3rd), p. 165; in color, *Ernst,* frontispiece; in color, *Invitation,* p. 87.

BIRDS. (1926) Oil on sandpaper over canvas, 8¹/₈ x 10³/₈″ (20.6 x 26.2 cm). The Sidney and Harriet Janis Collection (fractional gift). 599.67. Repr. *Janis,* p. 71.

163 FOREST [*Forêt et soleil*]. (1926) Oil on canvas, 28³/₄ x 36¹/₄″ (73 x 92.1 cm). Purchase. 237.35. Repr. *Ptg. & Sc.,* p. 214.

163 TWO SISTERS. 1926. Oil and "frottage" with black lead on canvas, 39¹/₂ x 28³/₄″ (100.3 x 73 cm). Gift of Mme Helena Rubinstein. 411.53. Repr. *Suppl. V,* p. 18.

163 THE SEA. (1928) Painted plaster on canvas, 22 x 18¹/₂″ (55.9 x 47 cm). Purchase. 85.36. Repr. *Ernst,* p. 36.

163 FOREST, SUN, BIRDS. (1928–29?) Oil on paper, 25¹/₂ x 19⁵/₈″ (64.6 x 49.8 cm). Gift of Mme Helena Rubinstein. 412.53.

163 BIRDS ABOVE THE FOREST. (1929) Oil on canvas, 31³/₄ x 25¹/₄″ (80.6 x 64.1 cm). Katherine S. Dreier Bequest. 154.53. Repr. *Suppl. IV,* p. 13; *Ernst,* p. 35.

BUTTERFLIES. (1931 or 1933) Collage, oil, gouache, and pencil, 19³/₄ x 25³/₄″ (50.2 x 65.4 cm). Purchase. 240.35.

164 LES ASPERGES DE LA LUNE [*Lunar Asparagus*]. (1935) Plaster, 65¹/₄″ (165.7 cm) high. Purchase. 273.37. Repr. *Ptg. & Sc.,* p. 292; *What Is Mod. Sc.,* p. 55.

164 THE NYMPH ECHO [*La Nymphe Écho*]. 1936. Oil on canvas, 18¹/₄ x 21³/₄″ (46.3 x 55.2 cm). Purchase. 262.37. Repr. in color, *Fantastic Art* (3rd), opp. p. 168.

165 NATURE AT DAYBREAK. 1938. Oil on canvas, 31⁷/₈ x 39³/₈″ (80.9 x 100 cm). Gift of Samuel A. Berger. 8.55. Repr. *Suppl. V,* p. 18.

165 NAPOLEON IN THE WILDERNESS. (1941) Oil on canvas, 18¹/₄ x 15″ (46.3 x 38.1 cm). Acquired by exchange. 12.42. Repr. *Ptg. & Sc.,* p. 195; *Ernst,* p. 42.

164 THE KING PLAYING WITH THE QUEEN. (1944) Bronze (cast 1954, from original plaster), 38¹/₂″ (97.8 cm) high, at base 18³/₄ x 20¹/₂″ (47.7 x 52.1 cm). Gift of D. and J. de Menil. 330.55. Repr. *Suppl. VI,* p. 19; *Ernst,* p. 50.

165 MUNDUS EST FABULA. 1959. Oil on canvas, 51¹/₄ x 64″ (130.1 x 162.5 cm). Gift of the artist. 116.61. Repr. *Ernst,* p. 49; *Suppl. XI,* p. 14.

Also, collages, drawings, prints, technical engravings altered by hand, illustrated books, and posters; a collage of color reproductions in the Study Collection.

EROL (Erol Akyavash). Turkish, born 1932. In U.S.A. 1950–60.

318 THE GLORY OF THE KINGS. (1959?) Oil on canvas, 48″ x 7'1¹/₄″ (121.8 x 214 cm). Gift of Mr. and Mrs. L. M. Angeleski. 130.61. Repr. *Suppl. XI,* p. 35.

ETROG, Sorel. Israeli, born Rumania 1933. Lives in Canada.

297 RITUAL DANCER. (1960–62) Bronze, 56¹/₄″ (142.6 cm) high. Gift of Mr. and Mrs. Samuel J. Zacks. 327.63. *Note:* the Museum owns a pencil study for this sculpture.

Also, a drawing.

EURICH, Richard. British, born 1903.

THE NEW FOREST. 1939. Oil on canvas, 25 x 30¹/₈″ (63.5 x 76.5 cm). Gift of the American Academy and National Institute of Arts and Letters Fund, through the American British Art Center. 584.42.

ÈVE, Jean. French, born 1900.

THE CATHEDRAL AT MANTES. 1930. Oil on canvas, 18¹/₈ x 21¹/₂″ (46 x 54.6 cm). Gift of Mr. and Mrs. Peter A. Rübel. 615.51.

EVERGOOD, Philip. American, 1901–1973.

248 DON'T CRY, MOTHER. (1938–44) Oil on canvas, 26 x 18″ (66 x 45.7 cm). Purchase. 120.44. Repr. *Ptg. & Sc.,* p. 146.

Also, prints.

EYÜBOĞLU. See RAHMI.

FAHLSTRÖM, Öyvind. Swedish, born Brazil. 1928–1976. In Sweden 1939–61; to U.S.A. 1961.

EDDIE (SYLVIE'S BROTHER) IN THE DESERT. (1966) Variable collage: fifteen movable serigraphed paper cutouts over serigraphed cutouts pasted on painted wood panel, 35¹/₄ x 50¹/₂″ (89.5 x 128.1 cm). The Sidney and Harriet Janis Collection (fractional gift). 600.67. Repr. *Janis,* p. 147.

FANGOR, Wojciech. Polish, born 1922. Worked in Great Britain, Germany, France; to U.S.A. 1966.

500 NUMBER 17. 1963. Oil on burlap, 39¹/₂ x 39¹/₂″ (100.1 x 100.1 cm). Gift of Beatrice Perry, Inc. 46.65. Repr. *Responsive Eye,* p. 29.

FARRERAS, Francisco. Spanish, born 1927.

463 COLLAGE NUMBER 242. 1965. Collage of tempera-tinted and burned papers over wood, 60 x 70¹/₈″ (152.4 x 178.1 cm). Gift of Dr. Andres J. Escoruela. 503.65.

FAUSETT, Dean. American, born 1913.

291 DERBY VIEW. (1939) Oil tempera on canvas, 24¹/₈ x 40″ (61.3 x 101.6 cm). Purchased from the Southern Vermont Artists' Exhibition at Manchester with a fund given anonymously. 1643.40. Repr. *What Is Mod. Ptg.* (9th), p. 6.

FAUTRIER, Jean. French, 1898–1964.

192 FLOWERS. (c. 1927) Oil on canvas, 25⁵/₈ x 21¹/₄″ (65.1 x 54 cm). Gift of A. Conger Goodyear. 530.41.

Also, a print.

FAZZINI, Pericle. Italian, born 1913.

292 THE SIBYL. 1947. Bronze, 37¹/₄″ (94.6 cm) high, at base 24⁵/₈ x 11⁵/₈″ (62.6 x 29.5 cm). Gift of D. and J. de Menil. 333.52. Repr. *Suppl. IV,* p. 37; *Masters,* p. 172.

FEELEY, Paul. American, 1910–1966.

487 ERRAI (MODEL FOR A PARK STRUCTURE). (1965) Construction of enamel on composition board, 24³/₈ x 25¹/₂ x 25¹/₂" (61.8 x 64.7 x 64.7 cm). Larry Aldrich Foundation Fund. 587.66.

FEININGER, Lyonel. American, 1871–1956. In Germany 1887–1936; returned to U.S.A. 1937.

428 UPRISING [*Émeute*]. 1910. Oil on canvas, 41¹/₈ x 37⁵/₈" (104.4 x 95.4 cm). Gift of Julia Feininger. 257.64.

THE DISPARAGERS. 1911. Watercolor, pen and ink, 9¹/₂ x 12³/₈" (24.1 x 31.4 cm). Acquired through the Lillie P. Bliss Bequest. 477. 53. Repr. *Feininger-Hartley*, p. 21.

220 VIADUCT. 1920. Oil on canvas, 39³/₄ x 33³/₄" (100.9 x 85.7 cm). Acquired through the Lillie P. Bliss Bequest. 259.44. Repr. *Ptg. & Sc.*, p. 108; in color, *Invitation*, p. 115.

220 THE STEAMER ODIN, II. 1927. Oil on canvas, 26¹/₂ x 39¹/₂" (67.3 x 100.3 cm). Acquired through the Lillie P. Bliss Bequest. 751.43. Repr. *Ptg. & Sc.*, p. 109; in color, *Feininger-Hartley*, opp. p. 32; *Masters*, p. 113; *German Art of 20th C.*, p. 110.

428 RUIN BY THE SEA. 1930. Oil on canvas, 27 x 43³/₈" (68.4 x 110 cm). Inscribed on stretcher: *Ruine am Meere I (Kirche bei Hoff, Ostsee)*. Purchased with funds provided by Julia Feininger, Mr. and Mrs. Richard K. Weil, and Mr. and Mrs. Ralph F. Colin. 593.66. Repr. in color, *Feininger-Ruin*, cover; p. 17. *Note*: the Museum also has twenty-three watercolors and drawings of the same subject dating from 1928 to 1935, gift of Julia Feininger, and two drawings of 1953, one a gift and one an extended loan from Mr. and Mrs. Walter Bareiss.

220 GLASSY SEA. 1934. Watercolor, pen and ink, charcoal, 13³/₈ x 19" (34 x 48.3 cm). Given anonymously (by exchange). 258.44.

220 RUIN BY THE SEA, II. 1934. Watercolor, pen and ink, 12 x 18¹/₂" (30.2 x 47 cm). Gift of Julia Feininger. 99.63.

220 DAWN. 1938. Watercolor, pen and ink, 12¹/₂ x 19" (31.7 x 48.3 cm). Purchase. 501.41. Repr. *Feininger-Hartley*, p. 36.

429 MANHATTAN, I. 1940. Oil on canvas, 39⁵/₈ x 31⁷/₈" (100.5 x 80.9 cm). Gift of Julia Feininger. 259.64.

220 CHURCH ON THE CLIFF, I. 1953. Charcoal, wash, pen and ink, 12⁵/₈ x 19¹/₄" (32 x 48.8 cm). Gift of Mr. and Mrs. Walter Bareiss. 344.63.

CHURCH ON THE CLIFF, III. 1953. Charcoal, wash, pen and ink, 12⁵/₈ x 19¹/₈" (32 x 48.5 cm). Extended loan from Mr. and Mrs. Walter Bareiss, E.L.63.607.

Also, drawings, prints, and comic strips.

FEININGER, Theodore Lux. American, born Germany 1910. To U.S.A. 1936.

288 GHOSTS OF ENGINES. 1946. Oil on canvas, 20¹/₈ x 24" (51.1 x 61 cm). Gift of the Griffis Foundation. 309.47.

Also, photographs.

FEITELSON, Lorser. American, born 1898.

369 MAGICAL SPACE FORMS. 1955. Oil on canvas, 6' x 60" (183 x 152.4 cm). Inscribed: *Homage to Piero della Francesca and Michelangelo*. Gift of Thomas McCray. 156.62. Repr. *Suppl. XII*, p. 23.

456 Untitled. 1964. Oil and enamel on canvas, 60¹/₄ x 50¹/₄" (152.9 x 127.5 cm). Gift of Craig Ellwood. 766.65.

FERBER, Herbert. American, born 1906.

356 JACKSON POLLOCK. 1949. Lead, 17⁵/₈ x 30" (44.8 x 76.2 cm). Purchase. 51.49. Repr. *Suppl. I*, p. 20.

356 HOMAGE TO PIRANESI, I. 1962–63. Welded and brazed sheet

copper and brass tubing, 7'7¹/₄" x 48³/₄" x 48" (231.8 x 123.8 x 121.7 cm). Given anonymously. 594.63.

FERGUSON, Duncan. American, born Shanghai 1901.

CAT. (1928) Bronze, 7³/₈ x 13¹/₂ x 8" (18.7 x 34.3 x 20.1 cm). Gift of Abby Aldrich Rockefeller. 613.39.

Also, a sculpture in the Study Collection.

FERNÁNDEZ, Agustín. Cuban, born 1928. In Paris 1960–68. Lives in Puerto Rico.

288 STILL LIFE AND LANDSCAPE. (1956) Oil on canvas, 48 x 55¹/₈" (122 x 140 cm). Inter-American Fund. 118.58. Repr. *Suppl. VIII*, p. 17.

467 Untitled. 1964. Oil on canvas, 49 x 48⁵/₈" (124.2 x 123.4 cm). Inter-American Fund. 504.65.

FERNÁNDEZ-MURO, José Antonio. Argentine, born Spain 1920. To U.S.A. 1962.

341 SILVERED CIRCLE [*Círculo azogado*]. 1962. Oil on aluminum paper over canvas, 68¹/₈ x 50" (173 x 126.8 cm). Gift of Emilio del Junco. 174.63.

FERREIRA. See REYES FERREIRA.

FERREN, John. American, 1905–1970.

365 COMPOSITION. 1937. Etched and colored plaster with intaglio, 11⁷/₈ x 9¹/₈" (30.2 x 23.2 cm). Gift of the Advisory Committee (by exchange). 498.41. Repr. *Ptg. & Sc.*, p. 119.

Also, a rug designed by the artist.

FETT, William. American, born 1918.

LANDSCAPE OF MICHOACAN. 1942. Watercolor, 13³/₄ x 19⁷/₈" (35 x 50.5 cm). Gift of James Thrall Soby. 69.43.

FIENE, Ernest. American, born Germany. 1894–1965. To U.S.A. 1912.

VENICE, I. (1932) Oil on wood, 7³/₄ x 11¹/₄" (19.7 x 28.6 cm). Given anonymously. 130.40.

Also, prints; and a drawing in the Study Collection.

FIGARI, Pedro. Uruguayan, 1861–1938.

212 CREOLE DANCE. (1925?) Oil on cardboard, 20¹/₂ x 32" (52.1 x 81.3 cm). Gift of the Honorable and Mrs. Robert Woods Bliss. 8.43. Repr. *Ptg. & Sc.*, p. 175.

FISCHER, Ida E. American, born Austria. 1883–1956. To U.S.A. 1892.

381 FLORIDA BARK. (1951) Assemblage: plaster and cement on composition board, with bark, shells, corks, etc., 16 x 12" (40.7 x 30.5 cm). Gift of the American Abstract Artists. 9.55.

FIUME, Salvatore. Italian, born 1915.

291 ISLAND OF STATUES. 1948. Oil on canvas, 28 x 36¹/₄" (71.1 x 92.1 cm). Purchase. 281.49. Repr. *20th-C. Italian Art*, pl. 105.

FLANNAGAN, John B. American, 1898–1942.

254 TRIUMPH OF THE EGG, I. (1937) Granite, 12 x 16" (35 x 40.7 cm). Purchase. 296.38. Repr. *Flannagan*, frontispiece; *Ptg. & Sc.*, p. 266.

Also, drawings.

FOLLETT, Jean. American, born 1917.

387 MANY-HEADED CREATURE. (1958) Assemblage: light switch,

cooling coils, window screen, nails, faucet knob, mirror, twine, cinders, etc., on wood panel, 24 x 24″ (61 x 61 cm). Larry Aldrich Foundation Fund. 296.61. Repr. *Assemblage*, p. 124.

FONTANA, Lucio. Italian, born Argentina. 1899–1968.

360 CRUCIFIXION. 1948. Ceramic, 19$\frac{1}{8}$″ (48.6 cm) high. Purchase. 335.49.

360 SPATIAL CONCEPT: EXPECTATIONS. (1959) Synthetic polymer paint on burlap, slashed, 39$\frac{3}{8}$ x 32$\frac{1}{8}$″ (100 x 81.5 cm). Philip Johnson Fund. 413.60. Repr. *Suppl. X*, p. 46.

Also, a drawing, a print, and a poster.

FORBES, Donald. American, 1905–1951.

MILLSTONE. (1936) Oil on canvas, 26$\frac{1}{4}$ x 36″ (66.7 x 91.4 cm). Extended loan from the United States WPA Art Program. E.L.39.1771. Repr. *Romantic Ptg.*, p. 99.

FORNER, Raquel. Argentine, born 1902.

213 DESOLATION. 1942. Oil on canvas, 36$\frac{7}{8}$ x 28$\frac{7}{8}$″ (93.7 x 72.7 cm). Inter-American Fund. 697.42. Repr. *Latin-Amer. Coll.*, p. 25.

MOONS. (1957) Brush, pen and colored inks, 15$\frac{7}{8}$ x 21$\frac{7}{8}$″ (40.3 x 55.7 cm). Inter-American Fund. 257.57. Repr. *Suppl. VII*, p. 23.

FRANCIS, Sam (Samuel Lewis Francis). American, born 1923. Worked chiefly in France, 1950–60.

337 BIG RED. (1953) Oil on canvas, 10′ x 6′4$\frac{1}{4}$″ (303.2 x 194 cm). Gift of Mr. and Mrs. David Rockefeller. 5.58. Repr. in color, *12 Amer.*, p. 22; *New Amer. Ptg.*, p. 29.

BLACK IN RED. (1953) Oil on canvas, 6′5″ x 51$\frac{1}{4}$″ (195.6 x 130.2 cm). Blanchette Rockefeller Fund. 194.55. Repr. *Suppl. VI*, p. 34; *New Amer. Ptg.*, p. 30.

336 PAINTING. (1958) Watercolor, 27$\frac{1}{8}$ x 40$\frac{1}{8}$″ (68.7 x 101.7 cm). Udo M. Reinach Estate. 28.60. Repr. *Suppl. X*, p. 36.

Also, prints.

FRANKENTHALER, Helen. American, born 1928.

TROJAN GATES. (1955) Duco on canvas, 6′ x 48$\frac{7}{8}$″ (182.9 x 124.1 cm). Gift of Mr. and Mrs. Allan D. Emil. 189.56. Repr. *Suppl. VI*, p. 34.

337 JACOB'S LADDER. 1957. Oil on canvas, 9′5$\frac{3}{8}$″ x 69$\frac{7}{8}$″ (287.9 x 177.5 cm). Gift of Hyman N. Glickstein. 82.60. Repr. *Suppl. X*, p. 36; in color, *Invitation*, p. 140.

Also, prints.

FRENCH, Leonard. Australian, born 1928.

434 THE PRINCESS. (1965) Enamel and gold leaf, copper panels, and burlap collage on burlap mounted on composition board, 48$\frac{1}{4}$ x 60″ (122.4 x 152.2 cm). Gift of Mr. and Mrs. David Rockefeller. 104.66.

FREUD, Lucian. British, born Germany 1922.

269 WOMAN WITH A DAFFODIL. 1945. Oil on canvas, 9$\frac{3}{8}$ x 5$\frac{5}{8}$″ (23.8 x 14.3 cm). Purchase. 12.53. Repr. *Suppl. IV*, p. 31.

269 GIRL WITH LEAVES. (1948) Pastel, 18$\frac{7}{8}$ x 16$\frac{1}{2}$″ (47.9 x 41.9 cm). Purchase. 240.48. Repr. *Suppl. I*, p. 15. *Note*: the subject is Kitty, the daughter of Sir Jacob Epstein and the former wife of the painter.

269 PORTRAIT OF A WOMAN. (1949) Oil on canvas, 16$\frac{1}{8}$ x 12″ (41 x 30.5 cm). Gift of Lincoln Kirstein. 546.54. Repr. *Suppl. V*, p. 32.

Note: the subject is a London neighbor who had been bombed out during the war.

DEAD MONKEY. (1950) Pastel, 8$\frac{3}{8}$ x 14$\frac{1}{4}$″ (21.3 x 36.2 cm). Gift of Lincoln Kirstein. 547.54.

FRIEDMAN, Arnold. American, 1879–1946.

SNOWSCAPE. 1926. Oil on canvas, 36$\frac{1}{4}$ x 42″ (92.1 x 106.7 cm). Gift of Mr. and Mrs. Sam A. Lewisohn. 320.39. Repr. *Amer. Ptg. & Sc.*, no. 35.

222 SAWTOOTH FALLS. (1945) Oil on canvas, 36$\frac{1}{8}$ x 29$\frac{7}{8}$″ (91.8 x 75.9 cm). Purchase Fund and gift of Dr. Nathaniel S. Wollf (by exchange). 119.46. Repr. *Ptg. & Sc.*, p. 223.

Also, prints.

FRIESZ, Othon. French, 1879–1949.

65 LANDSCAPE WITH FIGURES (BATHERS). 1909. Oil on canvas, 25$\frac{5}{8}$ x 32″ (65.1 x 81.3 cm). Gift of Mrs. Saidie A. May. 5.35. Repr. *Ptg. & Sc.*, p. 56.

STANDING NUDE. 1929. Watercolor, 20$\frac{1}{8}$ x 17$\frac{7}{8}$″ (51 x 32.5 cm). Gift of Mrs. Saidie A. May. 17.32.

THE GARDEN. 1930. Oil on canvas, 23$\frac{5}{8}$ x 28$\frac{3}{4}$″ (60 x 73 cm). Gift of Mrs. Saidie A. May. 16.32.

GABO, Naum. American, born Russia 1890. Worked in Germany, Paris, England. To U.S.A. 1946.

133 HEAD OF A WOMAN. (c. 1917–20, after a work of 1916) Construction in celluloid and metal, 24$\frac{1}{2}$ x 19$\frac{1}{4}$″ (62.2 x 48.9 cm). Purchase. 397.38. Repr. *Ptg. & Sc.*, p. 272.

133 SPIRAL THEME. (1941) Construction in plastic, 5$\frac{1}{2}$ x 13$\frac{1}{4}$ x 9$\frac{3}{8}$″ (14 x 33.6 x 23.7 cm), on base 24″ (61 cm) square. Advisory Committee Fund. 7.47. Repr. *Ptg. & Sc.*, p. 273; *Masters*, p. 127; *What Is Mod. Sc.*, p. 67. *Note*: an earlier version, 5$\frac{3}{8}$″ (13.7 cm) high, is in the Tate Gallery, London.

133 Project for sculptures (never executed) for lobby of the Esso Building, Rockefeller Center, New York, N.Y. (1949) Four plastic and metal sculpture maquettes installed in two architectural models: 51st Street entrance, one wall sculpture, 8$\frac{3}{4}$ x 7$\frac{1}{4}$″ (22.2 x 18.4 cm); 52nd Street entrance, one wall sculpture, 6$\frac{1}{2}$ x 9″ (16.5 x 22.9 cm); two sculptures over revolving doors, each 3″ (7.6 cm) high. Gift of the artist. 13.53.1, 14.53.1–.3. Repr. *Suppl. IV*, p. 43.

Also, a print.

GAITONDE, Vasudeo S. Indian, born 1924.

351 PAINTING, 4. 1962. Oil on canvas, 40 x 49$\frac{7}{8}$″ (101.6 x 126.6 cm). Gift of Mrs. Joseph James Akston. 1.63.

GALI, Zvi. Israeli, 1924–1961.

THE BAKER'S DREAM. (1956) Encaustic on plywood, 52$\frac{5}{8}$ x 17$\frac{1}{2}$″ (133.6 x 44.4 cm). Purchase. 119.58. Repr. *Suppl. VIII*, p. 23.

GALLATIN, A. E. American, 1881–1952.

364 FORMS AND RED. 1949. Oil on canvas, 30 x 23″ (76.2 x 58.4 cm). Purchase (by exchange). 134.51. Repr. *Abstract Ptg. & Sc.*, p. 80.

GALLO, Frank. American, born 1933.

478 GIRL IN SLING CHAIR. 1964. Polyester resin, 36$\frac{3}{4}$ x 23 x 33$\frac{3}{4}$″ (93.1 x 58.3 x 85.6 cm), at base 13$\frac{5}{8}$ x 24″ (34.4 x 60.8 cm). Purchase. 1235.64.

GALVÁN. See GUERRERO GALVÁN.

GARGALLO, Pablo. Spanish, 1881–1934. Worked in Paris.

104 PICADOR. (1928) Wrought iron, $9^3/8$ x $13^1/2''$ (24.7 x 34.2 cm). Gift of A. Conger Goodyear. 151.34. Repr. *Art in Our Time*, no. 309.

GASPARO, Oronzo. American, born Italy. 1903–1969. To U.S.A. 1916.

 ITALIOPA. 1936. Gouache, $19^1/2$ x $14^1/2''$ (49.5 x 36.8 cm). Purchase. 76.39. Repr. *La Pintura*, p. 127.

GATCH, Lee. American, 1902–1968.

 BATTLE WAGON. (1946) Oil on canvas, $14^1/8$ x $28^1/8''$ (35.9 x 71.4 cm). Gift of Mrs. Charles Suydam Cutting. 336.49. Repr. *Suppl. II*, p. 22

241 RAINBOW RAMPAGE. (1950) Oil on canvas, 28 x 40" (71.1 x 101.6 cm). Gift of Mr. and Mrs. Roy R. Neuberger. 7.51.

GAUDIER-BRZESKA, Henri. French, 1891–1915. Worked in England.

115 BIRDS ERECT. (1914) Limestone, $26^5/8$ x $10^1/4$ x $12^3/8''$ (67.6 x 26 x 31.4 cm). Gift of Mrs. W. Murray Crane. 127.45. Repr. *Ptg. & Sc.*, p. 270.

 Also, drawings.

GAUGUIN, Paul. French, 1848–1903. In Tahiti and the Marquesas Islands, 1891–93, 1895–1903.

24 STILL LIFE WITH THREE PUPPIES. 1888. Oil on wood, $36^1/8$ x $24^5/8''$ (91.8 x 62.6 cm). Mrs. Simon Guggenheim Fund. 48.52. Repr. *Suppl. IV*, p. 1; *Art Nouveau*, p. 48; in color, *Masters*, p. 31; *Post-Impress.* (2nd), p. 199; in color, *Invitation*, p. 15.

24 THE MOON AND THE EARTH [*Hina Te Fatou*]. 1893. Oil on burlap, 45 x $24^1/2''$ (114.3 x 62.2 cm). Lillie P. Bliss Collection. 50.34. Repr. *Ptg. & Sc.*, p. 32; *Post-Impress.* (2nd), p. 531.

 Also, prints.

GEGO (Gertrude Goldschmidt). Venezuelan, born Germany 1912.

371 SPHERE. (1959) Welded brass and steel, painted, 22" (55.7 cm) diameter, on three points, $8^5/8$ x $7^1/2$ x $7^1/8''$ (21.8 x 19 x 18 cm) apart. Inter-American Fund. 115.60. Repr. *Suppl. X*, p. 50.

GENOVÉS, Juan. Spanish, born 1930.

445 MICROGRAPHY. 1966. Oil on canvas, $10^1/8$ x $9^3/8''$ (25.6 x 23.6 cm). Purchase. 594.66.

GENTILS, Vic. Belgian, born Great Britain 1919.

476 BERLIN-LEIPZIG. 1963. Assemblage: piano parts, piano stool, velvet, felt, and metal, in a frame with folding doors, $53^1/2$ x $44^3/8$ x $16^3/4''$ (135.8 x 112.5 x 42.5 cm). Advisory Committee Fund. 1236.64. *Note*: the title and material for this work came from two pianos, one made in Berlin and the other in Leipzig.

GERSTEIN, Noemí. Argentine, born 1910.

 YOUNG GIRL. (1959) Brass rods soldered with silver, $25^3/4''$ (65.4 cm) high. Inter-American Fund. 3.61. Repr. *Suppl. XI*, p. 26.

GIACOMETTI, Alberto. Swiss, 1901–1966. To Paris 1922.

184 WOMAN WITH HER THROAT CUT [*Femme égorgée*]. 1932. Bronze (cast 1949), 8 x $34^1/2$ x 25" (20.3 x 87.6 x 63.5 cm). Purchase. 696.49. Repr. *Suppl. I*, p. 27; *Giacometti*, p. 38; *Dada, Surrealism*, p. 118.

184 THE PALACE AT 4 A.M. (1932–33) Construction in wood, glass, wire, string, 25 x $28^1/4$ x $15^3/4''$ (63.5 x 71.8 x 40 cm). Purchase.

90.36. Repr. *Ptg. & Sc.*, p. 294; *Masters*, p. 150; *Giacometti*, p. 45; *Dada, Surrealism*, p. 119; *What Is Mod. Sc.*, p. 75.

414 Six untitled miniature figures in plaster held upright by metal pins inserted in plaster bases. (c. 1945) Gift of Mr. and Mrs. Thomas B. Hess. 730.66–735.66.

 Figure I. 1" (2.5 cm) high, on base $3^1/2$ x 2 x $2^1/8''$ (8.9 x 5 x 5.2 cm). 730.66.

 Figure II. $1^1/2''$ (3.9 cm) high, on base $2^1/4$ x $1^3/4$ x $1^3/4''$ (5.6 x 4.3 x 4.2 cm). 731.66.

 Figure III. $3/4''$ (2.1 cm) high, on base $1^3/8$ x $1^1/2$ x $1^5/8''$ (3.3 x 3.8 x 4.1 cm). 732.66.

 Figure IV. $7/8''$ (2.2 cm) high, on base $7/8$ x $1^1/2$ x $1^1/8''$ (2.1 x 3.6 x 2.9 cm). 733.66.

 Figure V. $1^1/4''$ (3.2 cm) high, on base 1 x $1^1/2$ x $1^1/4''$ (2.5 x 3.7 x 3.1 cm). 734.66.

 Figure VI. 1" (2.4 cm) high, on base $5/8$ x $1/2$ x $1/2''$ (1.6 x 1.2 x 1.2 cm). 735.66. Repr. *Giacometti*, p. 47 (Figures I and II). *Note*: bronze casts of these figures are in the Study Collection.

185 MAN POINTING. 1947. Bronze, $70^1/2''$ (179 cm) high, at base 12 x $13^1/4''$ (30.5 x 33.7 cm). Gift of Mrs. John D. Rockefeller 3rd. 678.54. Repr. *Sc. of 20th C.*, p. 210; *New Images*, pp. 69, 72; *Giacometti*, p. 49, detail in color, p. 41; *What Is Mod. Sc.*, p. 11.

184 CITY SQUARE [*La Place*]. (1948) Bronze, $8^1/2$ x $25^3/8$ x $17^1/4''$ (21.6 x 64.5 x 43.8 cm). Purchase. 337.49. Repr. *Suppl. II*, p. 26; *Giacometti*, p. 56.

 THREE MEN WALKING, I. (1948–49) Bronze, $28^1/2$ x 16 x $16^3/8''$ (72.2 x 40.5 x 41.5 cm) including base, $10^5/8$ x $7^3/4$ x $7^3/4''$ (27 x 19.6 x 19.6). The Sidney and Harriet Janis Collection (fractional gift). 601.67. Repr. *Janis*, p. 111.

184 THE ARTIST'S MOTHER. 1950. Oil on canvas, $35^3/8$ x 24" (89.9 x 61 cm). Acquired through the Lillie P. Bliss Bequest. 15.53. Repr. *Suppl. IV*, p. 29; *New Images*, p. 74; *Giacometti*, p. 80. *Note*: the sitter is Annetta Giacometti.

185 CHARIOT. (1950) Bronze, 57 x 26 x $26^1/8''$ (144.8 x 65.8 x 66.2 cm). Purchase. 8.51. Repr. *Suppl. III*, p. 5; *Masters*, p. 151; *Giacometti*, p. 61.

185 DOG. (1951) Bronze (cast 1957), 18" (45.7 cm) high, at base 39 x $6^1/8''$ (99 x 15.5 cm). A. Conger Goodyear Fund. 120.58. Repr. *Suppl. VIII*, p. 1; *Giacometti*, p. 62.

 ANNETTE. 1962. Oil on canvas, $36^3/8$ x $28^7/8''$ (92.3 x 73.2 cm). The Sidney and Harriet Janis Collection (fractional gift). 603.67. Repr. *Janis*, p. 113.

 Also, prints, an illustration, and a poster.

GIACOMETTI, Augusto. Swiss, 1877–1947.

127 COLOR ABSTRACTION. (1903?) Pastel cutout mounted on paper, $5^7/8$ x $5^1/2''$ (14.7 x 14 cm) irregular. Gift of Ernst Beyeler. 414.60. Repr. *Suppl. X*, p. 14.

 Also, a poster.

GILIOLI, Emile. French, born 1911.

374 SKY AND SEA. (1956) Crystal, $10^1/2''$ (26.6 cm) high. Gift of Louis Carré. 121.58. Repr. *Suppl. VIII*, p. 18.

GILL, James F. American, born 1934.

393 MARILYN. 1962. Oil on composition board, triptych, each panel 48 x $35^7/8''$ (122 x 91 cm). Gift of D. and J. de Menil. 72.63a-c. *Note*: the subject is the actress, Marilyn Monroe.

 WOMAN IN STRIPED DRESS. 1962. Color crayon on gesso on

composition board, 40 x 30″ (101.4 x 76.2 cm). Larry Aldrich Foundation Fund. 2.63.

GLARNER, Fritz. American, born Switzerland. 1899–1972. In U.S.A. 1936–71. To Switzerland 1971.

364 RELATIONAL PAINTING. 1947–48. Oil on canvas. 43¹⁄₈ x 42¹⁄₄″ (109.5 x 107.3 cm). Purchase. 52.49. Repr. *Suppl. I*, p. 19.

364 RELATIONAL PAINTING, TONDO 37. 1955. Oil on composition board, 19″ (48 cm) diameter. Gift of Mr. and Mrs. Armand P. Bartos. 264.56. Repr. *Suppl. VI*, p. 22.

432 RELATIONAL PAINTING, 85. 1957. Oil on canvas, 48 x 46¹⁄₈″ (121.8 x 116.9 cm). Given anonymously. 736.66.

Also, prints and a poster.

GLASCO, Joseph. American, born 1925.

303 MAN WALKING. (1955) Bronze, 17¹⁄₂″ (44.4 cm) high. Purchase (by exchange). 190.56. Repr. *Suppl. VI*, p. 32.

Also, a drawing.

GLEIZES, Albert. French, 1881–1953.

100 COMPOSITION. 1922. Gouache, 3¹⁄₂ x 2³⁄₄″ (8.9 x 7 cm) (sight). Gift of A. E. Gallatin. 461.37.

Also, prints and an illustration.

GLENNY, Anna. American, born 1888.

MRS. WOLCOTT. (1930) Bronze, 15¹⁄₂″ (39.4 cm) high. Gift of A. Conger Goodyear. 25.35. Repr. *Amer. Ptg. & Sc.*, no. 130. *Note*: Frances Wolcott is the wife of Josiah Oliver Wolcott, Senator from Delaware.

VAN GOGH, Vincent. Dutch, 1853–1890. To France 1886.

25 THE STARRY NIGHT. (1889) Oil on canvas, 29 x 36¹⁄₄″ (73.7 x 92.1 cm). Acquired through the Lillie P. Bliss Bequest. 472.41. Repr. *Ptg. & Sc.*, p. 33; in color, *Masters*, p. 29; *Post-Impress.* (2nd), p. 345; *Paintings from MoMA*, frontispiece; in color, *Invitation*, p. 16.

25 HOSPITAL CORRIDOR AT SAINT RÉMY. (1889) Gouache and watercolor, 24¹⁄₈ x 18⁵⁄₈″ (61.3 x 47.3 cm). Abby Aldrich Rockefeller Bequest. 242.48. Repr. *Suppl. I*, p. 2; in color, *Masters*, p. 27; *Post-Impress.* (2nd), p. 325.

Also, a drawing and prints.

GOLUB, Leon. American, born 1922.

282 TORSO, III. 1960. Oil and lacquer on canvas, 63¹⁄₈ x 39¹⁄₄″ (160.2 x 99.6 cm). Edward Joseph Gallagher 3rd Memorial Collection. 117.61. Repr. *Suppl. XI*, p. 48.

Also, a print.

GONTCHAROVA, Natalie. Russian, 1881–1962. To Paris 1915.

131 LANDSCAPE, 47. 1912. Oil on canvas, 21¹⁄₂ x 18³⁄₈″ (54.6 x 46.7 cm). Gift of the artist. 84.36.

LE COQ D'OR. Design for scenery for the ballet produced by the Ballets Russes, Paris, 1914. Gouache, watercolor, touches of pencil on cardboard, 18³⁄₈ x 24¹⁄₄″ (46.7 x 61.6 cm). Acquired through the Lillie P. Bliss Bequest. 305.47. Theatre Arts Collection. Repr. *Masters*, p. 182.

Also, watercolors in the Study Collection.

GONZALEZ, Julio. Spanish, 1876–1942. To Paris 1900.

111 HEAD. (1935?) Wrought iron, 17³⁄₄ x 15¹⁄₄″ (45.1 x 38.7 cm).

Purchase. 266.37. Repr. *Ptg. & Sc.*, p. 284; *Masters*, p. 90; *What Is Mod. Sc.*, p. 24.

HEAD (Study for sculpture). 1936. Gouache, crayon, pen and ink on pasted paper, 11 x 7¹⁄₂″ (27.9 x 18.9 cm). Gift of Dr. and Mrs. Arthur Lejwa. 787.63. *Note*: related to *Head*, 266.37.

111 TORSO. (c. 1936) Hammered and welded iron, 24³⁄₈″ (61.9 cm) high. Gift of Mr. and Mrs. Samuel A. Marx. 191.56. Repr. *Suppl. VI*, p. 18; *Gonzalez*, p. 38.

111 WOMAN COMBING HER HAIR. (1936) Wrought iron, 52 x 23¹⁄₂ x 24⁵⁄₈″ (132.1 x 59.7 x 62.4 cm). Mrs. Simon Guggenheim Fund. 16.53. Repr. *Suppl. IV*, p. 27; *Masters*, p. 91; *What Is Mod. Sc.*, p. 83.

111 STANDING WOMAN. (c. 1941) Watercolor, brush, pen and ink, 12¹⁄₂ x 9⁵⁄₈″ (31.8 x 24.3 cm) (irregular). Gift of the James S. and Marvelle W. Adams Foundation. 235.56. Repr. *Suppl. VI*, p. 19.

414 HEAD OF THE MONTSERRAT, II. (1942) Bronze, 12³⁄₈ x 7³⁄₄ x 11¹⁄₈″ (31.3 x 19.6 x 28.1 cm). Gift of Mrs. Harry Lynde Bradley. 937.65. Repr. *Gonzalez*, p. 41 (another cast).

Also, a drawing and a print.

GONZÁLEZ GOYRI, Roberto. Guatemalan, born 1924.

305 WOLF'S HEAD. (1950) Bronze, 11″ (28 cm) high. Inter-American Fund. 331.55. Repr. *Suppl. VI*, p. 32.

GOODMAN, Sidney. American, born 1936.

285 FIND A WAY. (1961) Oil on canvas, 37³⁄₄ x 61″ (95.7 x 154.7 cm). Gift of Dr. Abraham Melamed. 157.62. Repr. *Figure U.S.A.*

Also, a drawing and a print.

GOODNOUGH, Robert. American, born 1917.

338 LAOCOÖN. 1958. Oil and charcoal on canvas, 66³⁄₈ x 54¹⁄₈″ (168.4 x 137.5 cm). Given anonymously. 9.59. Repr. *Suppl. IX*, p. 27.

Also, prints.

GORKY, Arshile (Vosdanig Manoog Adoian). American, born Turkish Armenia. 1904–1948. To U.S.A. 1920.

308 COMPOSITION: HORSE AND FIGURES. 1928. Oil on canvas, 34¹⁄₄ x 43³⁄₈″ (87 x 110.2 cm). Gift of Bernard Davis in memory of the artist. 237.50.

308 Study for a mural for Administration Building, Newark Airport, New Jersey. (1935–36) Gouache, 13⁵⁄₈ x 29⁷⁄₈″ (34.6 x 75.9 cm). Extended loan from the United States WPA Art Program. E.L.39.1811. *Note*: the ten mural panels called *Aviation: Evolution of Forms under Aerodynamic Limitations*, oil on canvas, 1530 square feet, were installed at Newark Airport but later destroyed.

308 ARGULA. (1938) Oil on canvas, 15 x 24″ (38.1 x 61 cm). Gift of Bernard Davis. 323.41. Repr. *Ptg. & Sc.* (I), p. 42.

309 GARDEN IN SOCHI. (1941) Oil on canvas, 44¹⁄₄ x 62¹⁄₄″ (112.4 x 158.1 cm). Purchase Fund and gift of Mr. and Mrs. Wolfgang S. Schwabacher (by exchange). 335.42. Repr. *14 Amer.*, p. 20; *Ptg. & Sc.*, p. 225; *Gorky*, p. 27.

308 BULL IN THE SUN. (1942) Gouache, 18¹⁄₂ x 24³⁄₄″ (47 x 62.9 cm). Gift of George B. Locke. 4.57. Design for a rug in the collection of The Museum of Modern Art. Repr. *Suppl. VII*, p. 20.

GOOD HOPE ROAD, II. 1945. Oil on canvas, 25¹⁄₂ x 32⁵⁄₈″ (64.7 x 82.7 cm). The Sidney and Harriet Janis Collection (fractional gift). 604.67. Repr. *Janis*, p. 115. *Note*: also called *Pastoral*.

Study for SUMMATION. 1946. Pencil and colored crayon on

paper, 18$^{1}/_{2}$ x 24$^{3}/_{8}$" (47 x 61.8 cm). The Sidney and Harriet Janis Collection (fractional gift). 605.67. Repr. *Janis*, p. 115.

309 AGONY. 1947. Oil on canvas, 40 x 50$^{1}/_{2}$" (101.6 x 128.3 cm). A. Conger Goodyear Fund. 88.50. Repr. *Suppl. II*, p. 21; *Gorky*, p. 41; in color, *Masters*, p. 175; *New Amer. Ptg.*, p. 35; *Paintings from MoMA*, p. 75; in color, *Invitation*, p. 41.

Also, drawings, a print, and a rug designed by the artist.

GOTO, Joseph. American, born Hawaii of Japanese parents, 1920. To U.S.A. 1947.

359 ORGANIC FORM, I. (1951) Welded steel in two parts, 11'4$^{1}/_{4}$" (346.1 cm) high, two-part base, 3 x 15$^{3}/_{8}$ x 12" (7.6 x 39.1 x 35 cm). Purchase. 175.52. Repr. *Suppl. IV*, p. 39.

GOTTLIEB, Adolph. American, 1903–1974.

333 VOYAGER'S RETURN. 1946. Oil on canvas, 37$^{7}/_{8}$ x 29$^{7}/_{8}$" (96.2 x 75.9 cm). Gift of Mr. and Mrs. Roy R. Neuberger. 175.46. Repr. *Ptg. & Sc.*, p. 226.

333 UNSTILL LIFE, III. (1954–56) Oil on canvas, 6'8" x 15'5$^{1}/_{4}$" (203 x 470.5 cm). Given anonymously. 415.60. Repr. *Suppl. X*, p. 40.

333 BLAST, I. (1957) Oil on canvas, 7'6" x 45$^{1}/_{8}$" (228.7 x 114.4 cm). Philip Johnson Fund. 6.58. Repr. *Suppl. VIII*, p. 11; in color, *Invitation*, p. 143.

GOURGUE, Enguérrand. Haitian, born 1930.

9 MAGIC TABLE. (1947) Oil on cardboard, 17 x 20$^{3}/_{4}$" (43.2 x 52.7 cm). Inter-American Fund. 244.48.

Also, a print.

GOYRI. See GONZÁLEZ GOYRI.

GRAHAM, John (Ivan Dabrowsky). American, born Ukraine. 1886–1961. To U.S.A. 1920.

395 ELINOR GRAHAM. 1943. Oil on canvas, 20$^{1}/_{8}$ x 16" (50.9 x 40.7 cm). Gift of Mr. and Mrs. Georges E. Seligmann. 558.63. *Note*: the subject is the third wife of the artist.

GRANELL, Eugene F. Spanish, born 1912. To U.S.A. 1950.

310 THE LAST HAITIAN NIGHT OF KING CHRISTOPHE. 1960. Oil on canvas, 30$^{1}/_{8}$ x 42$^{1}/_{8}$" (76.3 x 107 cm). Gift of Mr. and Mrs. Raymond J. Braun. 100.62. Repr. *Suppl. XII*, p. 30.

GRAVES, Morris. American, born 1910.

274 MESSAGE III, MESSAGE IV, MESSAGE VI, MESSAGE VII. (1937) Tempera and wax on paper; III and IV, 12 x 15$^{1}/_{2}$" (30.5 x 39.4 cm); VI and VII, 12 x 16$^{1}/_{2}$" (30.5 x 41.9 cm). Extended loans from the United States WPA Art Program. E.L.39.1813–.1816. VI, repr. *Amer. 1942*, p. 52. *Note*: *Message IV* is illustrated.

274 BIRD SINGING IN THE MOONLIGHT. (1938–39) Gouache, 26$^{3}/_{4}$ x 30$^{1}/_{8}$" (68 x 76.5 cm). Purchase. 14.42. Repr. *Ptg. & Sc.*, p. 229.

IN THE MOONLIGHT. (1938–39) Gouache and watercolor, 25 x 30$^{1}/_{8}$" (63.5 x 76.5 cm). Purchase. 20.42.

274 SNAKE AND MOON. (1938–39) Gouache and watercolor, 25$^{1}/_{2}$ x 30$^{1}/_{4}$" (64.8 x 76.8 cm). Purchase. 25.42. Repr. *Amer. 1942*, p. 55.

275 BLIND BIRD. (1940) Gouache, 30$^{1}/_{8}$ x 27" (76.5 x 68.6 cm). Purchase. 15.42. Repr. in color, *Masters*, p. 164; *Romantic Ptg.*, frontispiece.

NESTLING. (1940) Gouache and watercolor, 26$^{3}/_{4}$ x 30" (68 x 76.2 cm). Purchase. 22.42.

FLEDGLING. (1940) Gouache and watercolor, 10$^{3}/_{8}$ x 21$^{3}/_{4}$" (26.3 x 55.2 cm). Purchase. 145.42.

274 LITTLE-KNOWN BIRD OF THE INNER EYE. (1941) Gouache, 20$^{3}/_{4}$ x 36$^{5}/_{8}$" (52.7 x 93 cm). Purchase. 21.42. Repr. *Amer. 1942*, p. 56.

274 OWL OF THE INNER EYE. (1941) Gouache, 20$^{3}/_{4}$ x 36$^{5}/_{8}$" (52.7 x 93 cm). Purchase. 23.42. Repr. *Ptg. & Sc.*, p. 229.

274 UNNAMED BIRD OF THE INNER EYE. (1941) Gouache, 22 x 39" (55.9 x 99.1 cm). Purchase. 26.42.

WOODPECKERS. (1941) Gouache and watercolor, 31 x 26" (78.8 x 66 cm). Purchase. 27.42.

BAT DANCING FOR A SLUG. (1943) Watercolor, 24 x 29$^{7}/_{8}$" (61 x 75.9 cm). Given anonymously. 83.50.

275 JOYOUS YOUNG PINE. (1944) Watercolor and gouache, 53$^{5}/_{8}$ x 27" (136.2 x 68.6 cm). Purchase (by exchange). 138.45.

275 THE INDIVIDUAL STATE OF THE WORLD. 1947. Gouache, 30$^{1}/_{4}$ x 24$^{7}/_{8}$" (76.8 x 63.2 cm). A. Conger Goodyear Fund. 3.48. Repr. *Suppl. I*, p. 23.

Also, drawings.

GREENE, Balcomb. American, born 1904.

365 THE ANCIENT FORM. (1940) Oil on canvas, 20 x 30" (50.8 x 76.2 cm). Purchase. 326.41. Repr. *Ptg. & Sc.*, p. 120.

272 EXECUTION (FIRST VERSION). (1948) Oil on canvas, 39$^{7}/_{8}$ x 29$^{7}/_{8}$" (101.3 x 75.9 cm). Katharine Cornell Fund. 6.50. Repr. *Suppl. II*, p. 23.

GREENE, Gertrude. American, 1911–1956.

364 WHITE ANXIETY. 1943–44. Painted wood relief construction on composition board, 41$^{3}/_{4}$ x 32$^{7}/_{8}$" (105.8 x 83.3 cm). Gift of Balcomb Greene. 658.59. Repr. *Suppl. IX*, p. 18.

GRIGORIAN, Marcos. Iranian, born Russia 1924. To U.S.A. 1962.

450 Untitled. 1963. Dried earth on canvas, 33$^{1}/_{2}$ x 31$^{7}/_{8}$" (84.9 x 80.9 cm). Gift of Dr. and Mrs. Alex J. Gray. 48.65.

GRIPPE, Peter. American, born 1912.

305 THE CITY. (1942) Terra cotta, 9$^{1}/_{2}$ x 11$^{1}/_{8}$ x 16" (24.1 x 28.3 x 40.7 cm). Given anonymously. 20.43. Repr. *Ptg. & Sc.*, p. 289.

Also, prints.

GRIS, Juan (José Victoriano González). Spanish, 1887–1927. To France 1906.

90 STILL LIFE. 1911. Oil on canvas, 23$^{1}/_{2}$ x 19$^{3}/_{4}$" (59.7 x 50.2 cm). Acquired through the Lillie P. Bliss Bequest. 502.41. Repr. *Gris*, p. 16.

90 GUITAR AND FLOWERS. (1912) Oil on canvas, 44$^{1}/_{8}$ x 27$^{5}/_{8}$" (112.1 x 70.2 cm). Bequest of Anna Erickson Levene in memory of her husband, Dr. Phoebus Aaron Theodor Levene. 131.47. Repr. *Ptg. & Sc.*, p. 90; *Gris*, p. 19; in color, *Masters*, p. 73.

91 VIOLIN AND ENGRAVING. 1913, April. Oil and collage on canvas, 25$^{5}/_{8}$ x 19$^{5}/_{8}$" (65.2 x 50.3 cm). Bequest of Anna Erickson Levene in memory of her husband, Dr. Phoebus Aaron Theodor Levene. 133.47. Repr. *Ptg. & Sc.*, p. 92; *Gris*, p. 25.

90 GUITAR AND PIPE. (1913) Oil on canvas, 25$^{1}/_{2}$ x 19$^{3}/_{4}$" (64.8 x 50.2 cm). Gift of the Advisory Committee. 211.35. Repr. *Cubism*, fig. 68; *Gris*, p. 24.

90 GRAPES AND WINE. 1913, October. Oil on canvas, 36$^{1}/_{4}$ x 23$^{5}/_{8}$" (92.1 x 60 cm). Bequest of Anna Erickson Levene in memory of her husband, Dr. Phoebus Aaron Theodor Levene. 132.47. Repr. *Ptg. & Sc.*, p. 93.

91 BREAKFAST. (1914) Pasted paper, crayon, and oil on canvas, 31$^{7}/_{8}$

x 23½" (80.9 x 59.7 cm). Acquired through the Lillie P. Bliss Bequest. 248.48. Repr. *Suppl. I*, p. 8; *Assemblage*, p. 20; in color, *Masters*, p. 76; *Gris*, p. 40; in color, *Invitation*, p. 50.

91 FRUIT DISH, GLASS, AND NEWSPAPER. 1916, July. Oil on wood, 21⅝ x 15" (54.9 x 38.1 cm). Gift of Abby Aldrich Rockefeller. 70.35. Repr. *Ptg. & Sc.*, p. 98; *Gris*, p. 65.

91 THE CHESSBOARD. 1917, March. Oil on wood, 28¾ x 39⅜" (73 x 100 cm). Purchase. 5.39. Repr. *Ptg. & Sc.*, p. 99; *Gris*, p. 75.

Also, drawings, prints, and illustrated books.

GROPPER, William. American, born 1897.

248 THE SENATE. (1935) Oil on canvas, 25⅛ x 33⅛" (63.8 x 84.2 cm). Gift of A. Conger Goodyear. 108.36. Repr. *Ptg. & Sc.*, p. 150.

Also, prints.

GROSS, Chaim. American, born Austria 1904. To U.S.A. 1921.

254 HANDLEBAR RIDERS. (1935) Lignum vitae, 41¼" (104.7 cm) high, at base 10½ x 11½" (26.7 x 29.2 cm). Gift of A. Conger Goodyear. 156.37. Repr. *Ptg. & Sc.*, p. 261. *Note*: the Museum owns an ink study for this sculpture.

Also, a drawing.

GROSS, Michael. Israeli, born 1920.

SMALL FIGURE ON BLUE. (1964) Casein on composition board, 19¾ x 15⅞" (50.1 x 40.3 cm). Gift of Mr. and Mrs. George M. Jaffin. 2.65. Repr. *Art Israel*, p. 37.

GROSSER, Maurice. American, born 1903.

THE PUSHCART. 1942. Oil on canvas, 19⅛ x 26⅛" (48.6 x 66.4 cm). Gift of Briggs W. Buchanan. 575.43.

GROSZ, George. American, 1893–1959. Born and died in Germany. In U.S.A. 1932–59.

395 EXPLOSION. (1917) Oil on composition board, 18⅞ x 26⅞" (47.8 x 68.2 cm). Gift of Mr. and Mrs. Irving Moskovitz. 780.63.

200 METROPOLIS. 1917. Oil on cardboard, 26¾ x 18¾" (68 x 47.6 cm). Purchase. 136.46. Repr. *Ptg. & Sc.*, p. 142.

200 THE ENGINEER HEARTFIELD. (1920) Watercolor and collage of pasted postcard and halftone, 16½ x 12" (41.9 x 30.5 cm). Gift of A. Conger Goodyear. 176.52. Repr. *Suppl. IV*, p. 28; *Masters*, p. 139; *The Machine*, p. 114; in color, *Invitation*, p. 57. *Note*: John Heartfield was a close friend of the artist and a fellow-dadaist in Berlin just after World War I. He died in 1968.

200 REPUBLICAN AUTOMATONS. (1920) Watercolor, 23⅝ x 18⅝" (60 x 47.3 cm). Advisory Committee Fund. 120.46. Repr. *Ptg. & Sc.*, p. 213.

METHUSELAH. (1922) Watercolor, bronze paint, pen and ink, 20¾ x 16¼" (52.6 x 41.1 cm). Mr. and Mrs. Werner E. Josten Fund. 143.57. Repr. *Suppl. VII*, p. 7. *Note*: costume design for the title role in the play, *Methusalem*, by Ivan Goll. Apparently Grosz's designs were not used. The play was produced by William Dieterle, Dramatisches Theater, Berlin, 1924, with décor and costumes by Hannes Boht.

200 THE POET MAX HERRMANN-NEISSE. 1927. Oil on canvas, 23⅜ x 29⅛" (59.4 x 74 cm). Purchase. 49.52. Repr. *Suppl. IV*, p. 28. *Note*: the Museum owns an ink study for this painting.

200 SELF-PORTRAIT WITH A MODEL. 1928. Oil on canvas, 45½ x 29¾" (115.6 x 75.6 cm). Gift of Mr. and Mrs. Leo Lionni. 548.54.

200 PUNISHMENT. (1934) Watercolor, 27½ x 20½" (69.8 x 52.1 cm). Gift of Mr. and Mrs. Erich Cohn. 169.34. Repr. *Ptg. & Sc.*, p. 143.

Also, drawings and prints.

GROUP N. An Italian group, located in Padua and exhibiting anonymously, comprising Alberto Biasi, Ennio Chiggio, Toni Costa, Edoardo Landi, and Manfredo Massironi; disbanded in 1964.

503 UNSTABLE PERCEPTION. (1963) Metal rods and eighteen metal cylinders on wood mount, 17⅞ x 18 x 3¼" (45.3 x 45.5 x 8.2 cm). Gift of the Olivetti Company of Italy. 1238.64. Repr. *Responsive Eye*, p. 4.

GUAYASAMÍN (Oswaldo Guayasamín Calero). Ecuadorian, born 1919.

MY BROTHER. 1942. Oil on wood, 15⅞ x 12¾" (40.3 x 32.4 cm). Inter-American Fund. 699.42. Repr. *Latin-Amer. Coll.*, p. 55.

Also, a drawing in the Study Collection.

GUDNASON. See SVAVAR GUDNASON.

GUERRERO GALVÁN, Jesús. Mexican, born 1910.

211 THE CHILDREN. 1939. Oil on canvas, 53¾ x 43¼" (136.5 x 109.8 cm). Inter-American Fund. 2.43. Repr. *Latin-Amer. Coll.*, p. 73. *Note*: the Museum owns a pencil study for this painting.

Also, drawings.

GUERRESCHI, Giuseppe. Italian, born 1929.

THE SHUTTERS. 1956. Oil on canvas, 70⅞ x 43" (179.9 x 109.2 cm). Gift of Mrs. Saul S. Sherman. 26.57. Repr. *Suppl. VII*, p. 19.

GUEVARA. See HERRERA GUEVARA.

GUGLIELMI, O. Louis. American, born Cairo, of Italian parents. 1906–1956. To U.S.A. 1914.

244 WEDDING IN SOUTH STREET. (1936) Oil on canvas, 30 x 24" (76.2 x 61 cm). Extended loan from the United States WPA Art Program. E.L.38.3041. Repr. *Ptg. & Sc.*, p. 161.

ISAAC WALTON IN BROOKLYN. (1937) Oil on composition board, 29¾ x 23⅞" (75.6 x 60.6 cm). Extended loan from the United States WPA Art Program. E.L.39.1792.

Also, other paintings on extended loan and a poster.

GUIDO, Alfredo. Argentine, born 1892.

213 STEVEDORES RESTING. (1938) Tempera on wood, 21⅛ x 18⅛" (53.7 x 46 cm) (sight). Inter-American Fund. 702.42. Repr. *Ptg. & Sc.*, p. 175.

Also, prints.

GUIGNARD, Alberto da Veiga. Brazilian, 1895–1962.

215 OURO PRETO: ST. JOHN'S EVE. 1942. Oil on plywood, 31½ x 23⅝" (80 x 60 cm). Commissioned through the Inter-American Fund. 10.43. Repr. *Latin-Amer. Coll.*, p. 38. *Note*: the Museum owns an ink study for this painting.

Also, a drawing.

GUJRAL, Satish. Indian, born 1925.

436 OUTPOST. 1962. Oil and mixed mediums on canvas, 33⅛ x 44⅜" (83.9 x 112.6 cm). Gift of Dr. and Mrs. Samuel Rosen. 452.64.

GUSTON, Philip. American, born 1913.

334 PAINTING. 1954. Oil on canvas, 63¼ x 60⅛" (160.6 x 152.7 cm). Gift of Philip Johnson. 7.56. Repr. *Suppl. V*, p. 21; *New Amer. Ptg.*, p. 41.

334 THE CLOCK. 1956–57. Oil on canvas, 6'4" x 64⅛" (193.1 x 163

cm). Gift of Mrs. Bliss Parkinson. 659.59. Repr. *New Amer. Ptg.*, p. 42.

GUTTUSO, Renato. Italian, born 1912.

279 MELON EATERS. 1948. Oil on canvas, 35 x 45⁵/₈" (88.9 x 115.9 cm). Purchase (by exchange). 689.49. Repr. *Suppl. II*, p. 16.

279 LAVA QUARRY. 1957. Oil on canvas, 57⁵/₈ x 45" (146.8 x 114.3 cm). Gift of Mrs. Joseph James Akston. 310.62. Repr. *Suppl. XII*, p. 14.

279 ORANGE GROVE AT NIGHT. (1957) Oil on canvas, 55³/₈" x 7'6⁵/₈" (140.6 x 230.2 cm). Blanchette Rockefeller Fund. 85.58. Repr. *Suppl. VIII*, p. 13.

Also, drawings; an oil in the Study Collection.

GYSIN, Brion. American, born Great Britain 1916. Lives in Paris.

A TRIP FROM HERE TO THERE. (1958) Ink and gouache, 31'6⁵/₈" (961.7 cm) long, folded to fit between covers, 11¹/₂ x 8" (29.1 x 20.3 cm). Larry Aldrich Foundation Fund. 230.62. Detail repr. *Suppl. XII*, p. 36.

Also, drawings.

HADZI, Dimitri. American, born 1921.

362 HELMET, I. 1958. Bronze, 13¹/₈" (33.2 cm) high. Mr. and Mrs. William B. Jaffe Fund. 604.59. Repr. *Suppl. IX*, p. 33.

Also, a print.

HAESE, Günter. German, born 1924.

487 IN TIBET. (1964) Construction of clockwork parts, brass screening, and wire, 19¹/₂ x 9¹/₄ x 4¹/₄" (49.5 x 23.5 x 10.3 cm). Blanchette Rockefeller Fund. 1125.64.

487 CARAVAN. (1965) Construction of clockwork parts, brass screening, and wire, 11¹/₈ x 15¹/₂ x 11¹/₂" (28.2 x 39.4 x 29 cm). Gift of Mr. and Mrs. C. Gerald Goldsmith. 595.66.

HAGUE, Raoul. American, born Constantinople of Armenian parents, 1905. To U.S.A. 1921.

OHAYO WORMY BUTTERNUT. (1947–48) Butternut, 66¹/₂" (168.9 cm) high, attached to base 3¹/₂ x 18 x 11⁷/₈" (8.9 x 45.7 x 30.2 cm). Katharine Cornell Fund. 248.56. Repr. *12 Amer.*, p. 47; *What Is Mod. Sc.*, p. 17.

358 PLATTEKILL WALNUT. (1952) Walnut, 35⁵/₈ x 27³/₄ x 22⁵/₈" (90.5 x 70.4 x 57.4 cm). Elizabeth Bliss Parkinson Fund. 249.56. Repr. *12 Amer.*, p. 50.

HAJDU, Etienne. French, born Rumanian Transylvania, of Hungarian parents, 1907.

299 SOLDIERS IN ARMOR. (1953) Sheet copper relief, repoussé, 38¹/₂" x 6'5¹/₄" (97.8 x 196.2 cm). A. Conger Goodyear Fund. 152.55. Repr. *New Decade*, p. 23.

298 WHITE HEAD. 1958. Marble, 30¹/₂ x 13⁷/₈" (77.3 x 35.2 cm). Gift of The Four Seasons. 122.58. Repr. *Suppl. IX*, p. 30.

Also, a print.

HALLER, Hermann. Swiss, 1880–1950.

STANDING GIRL. (c. 1926) Bronze, 14" (35.6 cm) high. Gift of Mrs. Saidie A. May. 13.30. Repr. *Modern Works*, no. 169.

HAMBLETT, Theora. American, born 1895.

10 THE VISION. (1954) Oil on composition board, 17⁷/₈ x 48" (45.4 x 121.9 cm). Gift of Albert Dorne. 10.55. Repr. *Suppl. V*, p. 33.

HANSEN, Robert. American, born 1924.

314 MAN-MEN: MIRROR. 1959. Lacquer on composition board, 46¹/₈" x 6' (116.7 x 182.7 cm). Larry Aldrich Foundation Fund. 74.62. Repr. *Figure U.S.A.*

HANSON, Joseph Mellor. British, 1900–1963. To U.S.A. 1939.

NOCTURNAL ENCOUNTERS. 1949. Oil on canvas, 35¹/₈ x 45³/₈" (89.2 x 115.2 cm). Given anonymously. 89.50. Repr. *Suppl. II*, p. 22.

HARE, David. American, born 1917.

305 CRAB. (1951) Welded bronze, 23¹/₄" (59 cm) high, on three points, 9 x 7¹/₂ x 7¹/₄" (22.9 x 19 x 18.4 cm) apart. Purchase. 136.51. Repr. *Suppl. III*, p. 7.

305 SUNSET, I. (1953) Stone and painted wire, 19¹/₄" (48.8 cm) high. Fund given in memory of Philip L. Goodwin. 669.59. Repr. *Suppl. IX*, p. 34.

Also, an illustration and a photograph.

HARKAVY, Minna R. American, born Estonia 1895.

255 AMERICAN MINER'S FAMILY. 1931. Bronze, 27" (68.6 cm) high, at base 23 x 19³/₄" (58.4 x 50.2 cm). Abby Aldrich Rockefeller Fund. 303.38. Repr. *Ptg. & Sc.*, p. 263.

HART, George Overbury ("Pop"). American, 1868–1933.

THE HUDSON. 1925. Watercolor and ink, 17¹/₄ x 23¹/₄" (43.8 x 59 cm). Given anonymously. 73.35.

FRUIT PACKERS, TEHUANTEPEC. 1927. Watercolor and ink, 17¹/₄ x 23¹/₄" (43.8 x 59 cm). Gift of Abby Aldrich Rockefeller. 71.35.

236 THE MERRY-GO-ROUND, OAXACA. 1927. Watercolor, 17¹/₄ x 23¹/₄" (43.8 x 59 cm). Gift of Abby Aldrich Rockefeller. 75.35. Repr. *Art in Our Time*, no. 209.

ORCHESTRA AT COCK FIGHT, MEXICO. 1928. Watercolor and pastel, 17⁵/₈ x 23⁵/₈" (44.8 x 60 cm). Given anonymously. 76.35. Repr. *Ptg. & Sc.*, p. 165.

HORSE SALE, FEZ: TRYING THE HORSES. 1929. Watercolor, 17¹/₄ x 23¹/₂" (43.8 x 59.7 cm). Given anonymously. 72.35.

THE SULTAN'S MESSENGER, FEZ. 1929. Watercolor and pastel, 16³/₈ x 22³/₈" (41.6 x 56.8 cm). Given anonymously. 79.35.

Also, drawings and prints; and an oil and a drawing in the Study Collection.

HARTIGAN, Grace. American, born 1922.

THE PERSIAN JACKET. 1952. Oil on canvas, 57¹/₂ x 48" (146 x 121.9 cm). Gift of George Poindexter. 413.53. Repr. *12 Amer.*, p. 54.

RIVER BATHERS. 1953. Oil on canvas, 69³/₈" x 7'4³/₄" (176.2 x 225.5 cm). Given anonymously. 11.54. Repr. *Suppl. V*, p. 26; in color, *12 Amer.*, opp. p. 53.

336 SHINNECOCK CANAL. 1957. Oil on canvas, 7'6¹/₂" x 6'4" (229.8 x 193 cm). Gift of James Thrall Soby. 6.60. Repr. *Soby Collection*, p. 46.

Also, prints.

HARTLEY, Marsden. American, 1877–1943.

BIRCH GROVE, AUTUMN. (c. 1909) Oil on cardboard, 12¹/₈ x 12¹/₈" (30.6 x 30.6 cm). Lee Simonson Bequest. 335.67.

427 MAINE MOUNTAINS, AUTUMN. (c. 1909) Oil on cardboard, 12¹/₈ x 12¹/₈" (30.6 x 30.6 cm). Lee Simonson Bequest. 448.67.

222　BOOTS. (1941) Oil on gesso composition board, 28¹/₈ x 22¹/₄″ (71.4 x 56.5 cm). Purchase. 146.42. Repr. *Ptg. & Sc.*, p. 166; *Masters*, p. 118.

222　EVENING STORM, SCHOODIC, MAINE. 1942. Oil on composition board, 30 x 40″ (76.2 x 101.6 cm). Acquired through the Lillie P. Bliss Bequest. 66.43. Repr. *Ptg. & Sc.*, p. 167.

Also, a print.

HARTUNG, Hans. French, born Germany 1904. In Paris since 1935.

344　PAINTING. 1948. Oil on canvas, 38¹/₄ x 57¹/₂″ (97.2 x 146 cm). Gift of John L. Senior, Jr. 50.52. Repr. *Suppl. IV*, p. 35.

Also, prints.

HAUBENSAK, Pierre. Swiss, born 1935. Lives in Ibiza.

447　Study for MAURESQUE. 1965. Synthetic polymer paint on paper, 24³/₈ x 19⁵/₈″ (61.9 x 49.9 cm). Gift of Carl van der Voort. 193.66.

HAYDEN, Henri. French, born Poland. 1883–1970. To Paris 1907.

100　STILL LIFE. (1917) Gouache and charcoal, 16³/₄ x 14″ (42.4 x 35.5 cm). Gift of Mr. and Mrs. Sidney Elliott Cohn. 361.60. Repr. *Suppl. X*, p. 17.

HAYES, David V. American, born 1931.

304　BEAST. (1957) Forged steel, 20³/₈ x 21¹/₈″ (53.6 x 51.7 cm). Blanchette Rockefeller Fund. 605.59. Repr. *Recent Sc. U.S.A. Note*: the Museum owns an ink study for this sculpture.

Also, a drawing and a print.

HAYTER, Stanley William. British, born 1901. In Paris 1926–39; U.S.A. 1939–50; Paris since 1950.

HAND SCULPTURE. (1940) Plaster, 15¹/₄″ (38.8 cm) high. Given anonymously. 519.41.

Also, prints, an illustrated book, and a copper plate for an engraving.

HECKEL, Erich. German, 1883–1970.

70　SEATED MAN (SELF-PORTRAIT). 1909. Oil on canvas, 27³/₄ x 23⁷/₈″ (70.4 x 60.5 cm). Gift of G. David Thompson. 10.59. Repr. *Suppl. IX*, p. 10.

70　FISHING. 1912. Oil on canvas, 32¹/₂ x 37″ (82.5 x 94 cm). Gift of Philip Johnson. 414.53. Repr. *Suppl. V*, p. 11.

TWO NUDES ON THE BEACH. 1912. Watercolor, ink, and charcoal, 10³/₄ x 12″ (27.3 x 30.5 cm) (irregular). Gift of Samuel A. Berger. 11.55.

AUTUMN DAY. 1922. Watercolor, 18¹/₄ x 23¹/₄″ (46.3 x 59 cm). Given anonymously. 82.35.

Also, a drawing and prints.

HEDRICK, Wally. American, born 1928.

AROUND PAINTING. 1957. Oil on circular canvas, about 69³/₄″ (177 cm) diameter. Larry Aldrich Foundation Fund. 717.59. Repr. *16 Amer.*, p. 15.

HEILIGER, Bernhard. German, born 1915.

298　ERNST REUTER. (1954) Bronze (cast 1958), 15⁷/₈″ (40.1 cm) high. Matthew T. Mellon Foundation Fund. 123.58. Repr. *Suppl. VIII*, p. 16. *Note*: Dr. Ernst Reuter was first postwar Mayor of Berlin in 1946, Western Sector Mayor, 1948. He died in 1953.

Also, a drawing and prints.

HÉLION, Jean. French, born 1904.

142　EQUILIBRIUM. 1934. Oil on canvas, 10³/₄ x 13³/₄″ (27.3 x 35 cm). Acquired through the Lillie P. Bliss Bequest. 389.42. Repr. *Ptg. & Sc.*, p. 119.

COMPOSITION. 1936. Oil on canvas, 39¹/₄ x 31⁷/₈″ (99.7 x 80.9 cm). Gift of the Advisory Committee. 76.36. Repr. *Ptg. & Sc. (I)*, p. 46.

410　COMPOSITION. (1938) Oil on canvas, 13¹/₈ x 16″ (33.2 x 40.4 cm). Kay Sage Tanguy Bequest. 1126.64.

Also, a print.

HEPWORTH, Barbara. British, 1903–1975.

143　DISKS IN ECHELON. (1935) Padouk wood, 12¹/₄″ (31.1 cm) high, attached to base 19³/₈ x 8⁷/₈″ (49.1 x 22.5 cm). Gift of W. B. Bennet. 80.36. Repr. *Ptg. & Sc.*, p. 274.

143　HELIKON. (1948) Portland stone, 24¹/₄″ (61.6 cm) high, attached to base 12¹/₈″ (30.8 cm) square. Gift of Curt Valentin. 155.53. Repr. *Suppl. IV*, p. 39.

143　HOLLOW FORM (PENWITH). (1955–56) Lagos wood, partly painted, 35³/₈ x 25⁷/₈ x 25⁵/₈″ (89.8 x 65.7 x 64.8 cm) attached to base 35⁷/₈ x 23¹/₂″ (91.1 x 59.7 cm). Gift of Dr. and Mrs. Arthur Lejwa. 7.60. Repr. *Suppl. X*, p. 45.

HERBIN, Auguste. French, 1882–1960.

COMPOSITION ON THE WORD "VIE," 2. 1950. Oil on canvas, 57¹/₂ x 38¹/₄″ (145.8 x 97.1 cm). The Sidney and Harriet Janis Collection (fractional gift). 606.67. Repr. in color, *Janis*, p. 135.

HERRERA GUEVARA, Luis. Chilean, 1891–1945.

214　SNOW STORM AT THE UNIVERSITY. 1941. Oil on canvas, 24 x 27⁵/₈″ (61 x 70.2 cm). Inter-American Fund. 707.42. Repr. *Latin-Amer. Coll.*, p. 41.

Also, an oil in the Study Collection.

HIDAI, Nankoku. Japanese, born 1912.

WORK 59–42. 1959. Brush and ink on paper, 9 x 6⁷/₈″ (22.8 x 17.2 cm), mounted on silk scroll, 29⁷/₈ x 10³/₄″ (75.9 x 27.3 cm). Elizabeth Bliss Parkinson Fund. 6.61. Repr. *Suppl. XI*, p. 35.

WORK 60 B. 1960. Brush and ink on paper mounted on plywood, 6⁷/₈ x 9″ (17.3 x 22.8 cm). Mr. and Mrs. Donald B. Straus Fund. 4.61.

WORK 60 C. 1960. Brush and ink on paper mounted on plywood, 9 x 6⁵/₈″ (22.9 x 16.8 cm). Mr. and Mrs. Donald B. Straus Fund. 5.61.

WORK 60 D. 1960. Brush and ink on paper mounted on plywood, 9 x 6⁵/₈″ (22.9 x 16.8 cm). Mr. and Mrs. Donald B. Straus Fund. 118.61. Repr. *Suppl. XI*, p. 35.

317　WORK 63–14–3. 1963. Brush and ink on paper mounted on cardboard, 59⁵/₈ x 47³/₈″ (151.2 x 120.2 cm). Gift of Dr. Frederick Baekeland. 196.64.

HIGGINS, Edward. American, born 1930.

THE OUTSIDE OF A SOLDIER. 1958. Welded steel and plaster, 24³/₈ x 21⁵/₈ x 15³/₈″ (61.8 x 54.9 x 38.9 cm). Larry Aldrich Foundation Fund. 11.59. Repr. *Recent Sc. U.S.A.*

363　DOUBLE PORTRAIT—TORSOS. (1960) Steel and epoxy, 16¹/₄ x 17 x 7³/₄″ (41.2 x 43.1 x 19.6 cm). Larry Aldrich Foundation Fund. 116.60. Repr. *Suppl. X*, p. 43; *Amer. 1963*, p. 35. *Note*: the subjects are the artist and his wife.

HILER, Hilaire. American, 1898–1966.

POUTER PIGEONS. 1930. Gouache, 14³/₄ x 18″ (37.5 x 45.7 cm). Gift of Abby Aldrich Rockefeller. 83.35. Repr. *La Pintura*, p. 131.

HILLSMITH, Fannie. American, born 1911.

288 LIQUOR STORE WINDOW. 1946. Oil tempera and sand on canvas, 32 x 34¹/₈″ (81.3 x 86.7 cm). Purchase. 307.47.

Also, a print.

HINMAN, Charles. American, born 1932.

490 POLTERGEIST. 1964. Synthetic polymer paint on shaped canvas over wood framework, 8′2³/₄″ x 61⁷/₈″ x 16³/₈″ (250.7 x 156.9 x 41.5 cm). Larry Aldrich Foundation Fund. 3.65.

HINTERREITER, Hans. Swiss, born 1902. Lives in Ibiza.

501 OP. 134. 1961. Mixed mediums, 15³/₈ x 13⁷/₈″ (39 x 35.1 cm). Gift of the artist. 251.66.

HIRSCH, Joseph. American, born 1910.

248 TWO MEN. 1937. Oil on canvas, 18¹/₈ x 48¹/₄″ (46 x 122.5 cm). Abby Aldrich Rockefeller Fund. 572.39. Repr. *Ptg. & Sc.*, p. 150.

439 DAYBREAK. (1962) Oil on canvas, 57¹/₄″ x 6′1/₄″ (145.4 x 183.5 cm). Purchase and anonymous gift. 1261.64.

Also, prints and a poster.

HIRSHFIELD, Morris. American, born Russian Poland. 1872–1946. To U.S.A. 1890.

ANGORA CAT. (1937–39. Dated on canvas 1937). Oil on canvas, 22¹/₈ x 27¹/₄″ (56.1 x 69.1 cm). The Sidney and Harriet Janis Collection (fractional gift). 607.67. Repr. *Janis*, p. 90.

BEACH GIRL. (1937–39. Dated on canvas 1937) Oil on canvas, 36¹/₄ x 22¹/₄″ (91.8 x 56.3 cm). The Sidney and Harriet Janis Collection (fractional gift). 2097.67. Repr. *Janis*, p. 89.

LION. 1939. Oil on canvas, 28¹/₄ x 40¹/₄″ (71.5 x 102 cm). The Sidney and Harriet Janis Collection (fractional gift). 608.67. Repr. *Janis*, p. 90.

10 GIRL IN A MIRROR. 1940. Oil on canvas, 40¹/₈ x 22¹/₄″ (101.9 x 56.5 cm). Purchase. 327.41. Repr. *Bulletin*, vol. IX, no. 2, 1941, p. 6.

10 TIGER. 1940. Oil on canvas, 28 x 39⁷/₈″ (71.1 x 101.3 cm). Abby Aldrich Rockefeller Fund. 328.41. Repr. *Ptg. & Sc.*, p. 22.

INSEPARABLE FRIENDS. 1941. Oil on canvas, 60¹/₈ x 40¹/₈″ (152.6 x 101.9 cm). The Sidney and Harriet Janis Collection (fractional gift). 609.67. Repr. in color, *Janis*, p. 91; in color, *Invitation*, p. 77.

GIRL WITH PIGEONS. 1942. Oil on canvas, 30 x 40¹/₈″ (76.1 x 101.7 cm). The Sidney and Harriet Janis Collection (fractional gift). 610.67. Repr. *Janis*, p. 92.

PARLIAMENTARY BUILDINGS. 1946. Oil on canvas, 36¹/₈ x 28″ (91.7 x 71.1 cm). The Sidney and Harriet Janis Collection (fractional gift). 611.67. Repr. *Janis*, p. 92. *Note*: also called *Sacré Coeur*.

HÖCH, Hannah. German, born 1889.

159 Untitled. 1925. Collage, 9³/₄ x 7⁵/₈″ (24.5 x 19.2 cm). Gift of Miss Rose Fried. 3.63.

410 WATCHED. 1925. Collage, 10⁷/₈ x 7³/₈″ (27.5 x 18.5 cm). Joseph G. Mayer Foundation Fund, in memory of René d'Harnoncourt. 2634.67.

410 INDIAN DANCER (FROM AN ETHNOGRAPHIC MUSEUM). 1930.

Collage, 10¹/₈ x 8⁷/₈″ (25.7 x 22.4 cm). Frances Keech Fund. 569.64. *Note*: the principal element is a photograph of the actress, Marie Falconetti, from the film of 1928, *The Passion of Joan of Arc*.

159 Untitled. 1945. Collage, 13¹/₂ x 12¹/₈″ (34 x 30.7 cm). Gift of Miss Rose Fried. 4.63.

WITH SEAWEED. (1950) Collage, 13⁵/₈ x 9⁷/₈″ (34.6 x 25 cm). Gift of Miss Rose Fried. 5.63.

Also, a print.

VAN HOEYDONCK, Paul. Belgian, born 1925.

Untitled. 1960. Synthetic polymer paint on composition board, 23⁵/₈ x 23¹/₄″ (60 x 59 cm). Purchase. 416.60.

HOFER, Carl. German, 1878–1955.

71 MAN WITH A MELON. (1926) Oil on canvas, 42¹/₄ x 28⁷/₈″ (107.3 x 73.3 cm). Purchase. 284.49. Repr. *Suppl. I*, p. 11.

Also, a drawing, prints, an illustrated book, and a poster; an oil in the Study Collection.

HOFMANN, Hans. American, born Germany. 1880–1966. To U.S.A. 1932.

321 AMBUSH. 1944. Oil on paper, 24 x 19″ (61 x 48.3 cm). Purchase. 51.52.

321 DELIGHT. 1947. Gesso and oil on canvas, 50 x 40″ (126.9 x 101.6 cm). Gift of Mr. and Mrs. Theodore S. Gary. 2.56. Repr. *Suppl. VI*, p. 23.

321 MEMORIA IN AETERNUM. 1962. Oil on canvas, 7′ x 6′1/₈″ (213.3 x 183.2 cm). Gift of the artist. 399.63. Dedicated to Arthur Carles, Arshile Gorky, Jackson Pollock, Bradley Walker Tomlin, Franz Kline. Repr. *Hofmann*, p. 55; in color, *Invitation*, p. 133.

HONEGGER, Gottfried. Swiss, born 1917.

370 HENCEFORTH. 1959. Oil over cardboard collage on canvas, 25 x 25″ (63.5 x 63.5 cm). Gift of Mr. and Mrs. Peter A. Rübel. 29.60. Repr. *Suppl. X*, p. 54.

HOPPER, Edward. American, 1882–1967.

232 CORNER SALOON. (1913) Oil on canvas, 24 x 29″ (61 x 73.7 cm). Abby Aldrich Rockefeller Fund. 329.41. Repr. *Ptg. & Sc.*, p. 154.

232 HOUSE BY THE RAILROAD. (1925) Oil on canvas, 24 x 29″ (61 x 73.7 cm). Given anonymously. 3.30. Repr. *Ptg. & Sc.*, p. 155; in color, *Masters*, p. 111.

232 MRS. ACORN'S PARLOR. (1926) Watercolor, 14 x 20″ (35.6 x 50.8 cm). Gift of Abby Aldrich Rockefeller. 87.35.

232 BOX FACTORY, GLOUCESTER. (1928) Watercolor, 14 x 20″ (35.6 x 50.8 cm). Gift of Abby Aldrich Rockefeller. 85.35. Repr. *Hopper*, no. 47.

232 NIGHT WINDOWS. (1928) Oil on canvas, 29 x 34″ (73.7 x 86.4 cm). Gift of John Hay Whitney. 248.40. Repr. *Ptg. & Sc.*, p. 156.

233 NEW YORK MOVIE. (1939) Oil on canvas, 32¹/₄ x 40¹/₈″ (81.9 x 101.9 cm). Given anonymously. 396.41. Repr. *Ptg. & Sc.*, p. 155.

233 GAS. (1940) Oil on canvas, 26¹/₄ x 40¹/₄″ (66.7 x 102.2 cm). Mrs. Simon Guggenheim Fund. 577.43. Repr. *Ptg. & Sc.*, p. 156; in color, *Romantic Ptg.*, opp. p. 38; in color, *Invitation*, p. 121.

Also, prints.

HORD, Donal. American, born 1902.

MEXICAN BEGGAR. (1938) Columbia marble, 12⁵/₈ x 7⁷/₈ x 6¹/₄″

(31.9 x 19.9 x 15.8 cm). Extended loan from the United States WPA Art Program. E.L.41.2383. Repr. *Amer. 1942*, p. 73.

HOSIASSON, Philippe. French, born Ukraine 1898.

347 RED AND BLACK. 1956. Oil on canvas, 57⅞ x 45¼″ (146.8 x 114.9 cm). Benjamin Scharps and David Scharps Fund. 289.56. Repr. *Suppl. VI*, p. 25.

HOYER, Thorvald Arenst. American, born Denmark. 1872–1949. To U.S.A. c. 1915.

INSIDE A BARN. 1937. Oil on canvas, 30⅛ x 24⅛″ (76.5 x 61.3 cm). Extended loan from the United States WPA Art Program. E.L.39.1775. Repr. *Masters Pop. Ptg.*, no. 128.

HUGHES, Toni. American, born 1907.

CHILDREN ON THE BEACH. 1940. Construction in plumber's hanger iron, galvanized wire cloth, screening, with various ornaments, 24½″ (62.2 cm) high, on base 24⅛ x 7½″ (61.3 x 9.1 cm). Purchase. 397.41.

HULTBERG, John. American, born 1922.

315 TILTED HORIZON. 1955. Oil on canvas, 54⅛ x 6'4⅛″ (137.4 x 193.2 cm). Gift of Dr. and Mrs. Daniel E. Schneider. 286.58. Repr. *Suppl. VIII*, p. 13.

Also, a print.

HUNT, Edward C. ("Pa"). American, 1870–1934.

PETER HUNT'S ANTIQUE SHOP. (1930–34) Oil on canvas, 20 x 30⅛″ (50.8 x 76.5 cm). Abby Aldrich Rockefeller Fund. 645.39. Repr. *Masters Pop. Ptg.*, no. 134.

HUNT, Richard. American, born 1935.

363 ARACHNE. (1956) Welded steel, 30″ (76 cm) high, base, 18½″ (45.9 cm) diameter. Purchase. 5.57. Repr. *Suppl. VII*, p. 15; *Hunt*, front cover.

IKEDA, Fumio (pen name: Suijō). Japanese, born 1912.

317 WHITE PATH. (c. 1953) Brush and ink, 25¾ x 54⅜″ (65.4 x 138.1 cm). Japanese House Fund. 279.54.

INDIANA, Robert. American, born 1928.

477 FRENCH ATOMIC BOMB. 1959–60. Assemblage: polychromed wood beam and metal, 38⅝ x 11⅝ x 4⅞″ (98 x 29.5 x 12.3 cm). Gift of Arne Ekstrom. 1127.64.

391 MOON. 1960. Assemblage: wood beam with iron-rimmed wheels and white paint, 6'6″ (198.1 cm) high, on base 5 x 17⅛ x 10¼″ (12.7 x 43.5 x 26 cm). Philip Johnson Fund. 288.61. Repr. *Assemblage*, p. 141; *Amer. 1963*, p. 41.

391 THE AMERICAN DREAM, I. 1961. Oil on canvas, 6' x 60⅛″ (183 x 152.7 cm). Larry Aldrich Foundation Fund. 287.61. Repr. *Suppl. XI*, p. 50; *Amer. 1963*, p. 39.

Also, a drawing and a poster.

INOKUMA, Genichiro. Japanese, born 1902. To U.S.A. 1955.

472 SUBWAY. 1966. Oil on canvas, 6'8¼″ x 50⅜″ (203.8 x 127.8 cm). Blanchette Rockefeller Fund. 95.67.

IPOUSTEGUY, Jean. French, born 1920.

299 DAVID AND GOLIATH. 1959. Bronze, two figures in four parts: *David*, 47⅞ x 24¼ x 25″ (121.4 x 61.4 x 63.3 cm); *Goliath* (in

three sections), 30⅜ x 53¾ x 29½″ (76.9 x 136.5 x 74.8 cm). Matthew T. Mellon Foundation Fund. 6.63.1–.2a–c.

ISENBURGER, Eric. American, born Germany 1902. To U.S.A. 1941.

GIRL WITH A CAT. 1939. Oil on canvas, 39⅝ x 32″ (100.6 x 81.3 cm). Gift of Albert D. Lasker. 538.41.

ISRAEL, Marvin. American, born 1924.

467 Untitled. 1964. Oil on paper, 30⅛ x 22¼″ (76.3 x 56.5 cm). Larry Aldrich Foundation Fund. 194.66.

JACOB, Max. French, 1876–1944.

THREE FIGURES. 1928. Gouache, 13⅞ x 12¼″ (35.3 x 31.1 cm). Given anonymously. 88.35.

Also, a print.

JARVAISE, James. American, born 1925.

338 HUDSON RIVER SCHOOL SERIES, 32. 1957. Oil on composition board, 60⅛ x 48″ (152.5 x 121.9 cm). Larry Aldrich Foundation Fund. 8.60. Repr. *Suppl. X*, p. 35.

JAWLENSKY, Alexey. Russian, 1864–1941. Worked in Germany and Switzerland.

66 HEAD. (c. 1910?) Oil on canvas over cardboard, 16⅛ x 12⅞″ (41 x 32.7 cm). Acquired through the Lillie P. Bliss Bequest. 415.53. Repr. *Suppl. V*, p. 36.

MEDITATION: YELLOW HEAD. 1936. Oil on cloth-textured paper, 9¾ x 7⅜″ (24.8 x 18.5 cm). The Sidney and Harriet Janis Collection (fractional gift). 612.67. Repr. *Janis*, p. 45.

Also, prints.

JEANNERET. See LE CORBUSIER.

JENKINS, Paul. American, born 1923.

PHENOMENA JUNCTION RED. 1963. Synthetic polymer paint on canvas, 67 x 47¼″ (170.3 x 120 cm). Promised gift and extended loan from Mr. and Mrs. David Kluger. E.L.64.83.

342 PHENOMENA YELLOW STRIKE. 1963–64. Synthetic polymer paint on canvas, 60⅛ x 39⅞″ (152.6 x 101.3 cm). Promised gift and extended loan from Mr. and Mrs. David Kluger. E.L.64.84.

JENSEN, Alfred J. American, born Guatemala of Danish parents, 1903. To U.S.A. 1934.

372 CLOCKWORK IN THE SKY. 1959. Oil on canvas, 6' x 46⅛″ (182.7 x 117 cm). Gift of Henry Luce, III. 117.60. Repr. *Suppl. X*, p. 48.

JESPERS, Oscar. Belgian, born 1887.

202 TEMPTATION OF ST. ANTHONY. (1934) Limestone, 17½ x 56¼″ (44.5 x 142.8 cm). A. Conger Goodyear Fund. 121.46. Repr. *Ptg. & Sc.*, p. 250.

JOHN, Gwen. British, 1876–1939.

34 GIRL WITH BARE SHOULDERS. (1909–10?) Oil on canvas, 17⅛ x 10¼″ (43.4 x 26 cm). A. Conger Goodyear Fund. 124.58. Repr. *Suppl. VIII*, p. 6. *Note:* Fenella Lovell, who posed for Gwen John in Paris before 1911, was probably the model for this painting as well as for the *Nude Girl* in the Tate Gallery, London.

GIRL WITH A BLUE SCARF. Oil on canvas, 16¼ x 13″ (41.1 x 33 cm). Gift of Nelson A. Sears in memory of Mrs. Millicent A. Rogers. 400.63.

JOHNS, Jasper. American, born 1930.

390 GREEN TARGET. 1955. Encaustic on newspaper over canvas, 60 x 60″ (152.4 x 152.4 cm). Richard S. Zeisler Fund. 9.58. Repr. *Suppl. VIII*, p. 20; *16 Amer.*, p. 27.

390 TARGET WITH FOUR FACES. (1955) Encaustic on newspaper over canvas, 26 x 26″ (66 x 66 cm) surmounted by four tinted plaster faces in wood box with hinged front. Box, closed, 3³/₄ x 26 x 3¹/₂″ (9.5 x 66 x 8.9 cm). Overall dimensions with box open, 33⁵/₈ x 26 x 3″ (85.3 x 66 x 7.6 cm). Gift of Mr. and Mrs. Robert C. Scull. 8.58. Repr. *Suppl. VIII*, p. 20; *16 Amer.*, p. 26; in color, *Invitation*, p. 101.

391 WHITE NUMBERS. 1957. Encaustic on canvas, 34 x 28¹/₈″ (86.5 x 71.3 cm). Elizabeth Bliss Parkinson Fund. 10.58. Repr. *Suppl. VIII*, p. 20; *16 Amer.*, p. 24; *Art of the Real*, p. 20.

390 MAP. (1961) Oil on canvas, 6′6″ x 10′3¹/₈″ (198.2 x 307.7 cm). Fractional gift of Mr. and Mrs. Robert C. Scull. 277.63.

0 THROUGH 9. 1961. Aluminum relief (cast 1966), 26 x 19⁷/₈ x ⁷/₈″ (66 x 50.2 x 2.2 cm), irregular. The Sidney and Harriet Janis Collection (fractional gift). 613.67. Repr. *Janis*, p. 149.

Also, prints, a poster, and a stone for a lithograph.

JOHNSON, Daniel LaRue. American, born 1938.

444 FREEDOM NOW, NUMBER 1. 1963–64. Pitch on canvas with assemblage including "Freedom Now" button, broken doll, hacksaw, mousetrap, flexible tube, wood, 53⁷/₈ x 55³/₈ x 7¹/₂″ (136.6 x 140.5 x 18.9 cm). Given anonymously. 4.65.

JOHNSON, Lester F. American, born 1919.

282 THREE HEADS WITH THE WORD "BLACK." 1962. Oil on canvas, 60¹/₄″ x 6′6¹/₈″ (153 x 198.5 cm). Larry Aldrich Foundation Fund. 73.63.

JOHNSON, Ray. American, born 1927.

462 CAGED. (1959) Collage with gouache and watercolor, 10¹/₂ x 7³/₈″ (26.6 x 18.7 cm). Larry Aldrich Foundation Fund. 289.65.

JOHNSTON, Ynez. American, born 1920.

DARK JUNGLE. (1950) Casein on cardboard, 23⁷/₈ x 18¹/₂″ (60.6 x 47 cm). Katharine Cornell Fund. 10.51.

Also, a print.

JONSON, Sven. Swedish, born 1902.

THEME AND VARIATIONS, II. 1954. Watercolor, 16 x 13″ (40.7 x 32.8 cm). Gift of Carl Magnus Berger. 13.56. Repr. *Suppl. VI*, p. 36.

JULES, Mervin. American, born 1912.

THE LITTLE PRESSER. (1943) Oil on composition board, 11¹/₂ x 11⁵/₈″ (29.2 x 29.5 cm). Purchase. 617.43.

Also, a print.

JUNYER, Joan. American, born Spain (Catalonia) 1904. To U.S.A. 1941.

THREE PAINTINGS IN SCULPTURE. (1954) Enameled steel, 6³/₈″ (16.2 cm), 5¹/₂″ (13.9 cm), and 6¹/₂″ (16.6 cm) high. Blanchette Rockefeller Fund. 6.57, 7.57, 8.57. Repr. *Suppl. VII*, p. 15.

Also, a drawing, and a print; a poster in the Study Collection.

KABAK, Robert. American, born 1930.

FIRES. (1956) Casein on gesso on composition board, 11³/₄ x 36″ (29.8 x 91.3 cm). Purchase. 236.56. Repr. *Suppl. VI*, p. 30.

KAHLO, Frida. Mexican, 1910–1954.

210 SELF-PORTRAIT WITH CROPPED HAIR. 1940. Oil on canvas, 15³/₄ x 11″ (40 x 27.9 cm). Gift of Edgar Kaufmann, Jr. 3.43. Repr. *Ptg. & Sc.*, p. 181.

KAHN, Wolf. American, born Germany 1927. To U.S.A. 1940.

IN THE HARBOR OF PROVINCETOWN. (1956) Pastel, 10⁷/₈ x 13⁷/₈″ (27.6 x 35.2 cm). Purchase. 560.56. Repr. *Suppl. VI*, p. 33.

Also, a drawing.

KALINOWSKI, Horst Egon. German, born 1924. To Paris 1952.

MAY NIGHT. 1961. Collage of gouache, velvet, metal thread, 12¹/₂ x 22¹/₈″ (32 x 56.2 cm). Philip Johnson Fund. 297.61. Repr. *Suppl. XI*, p. 39.

480 THE GATE OF THE EXECUTED [*La Porte des suppliciés*]. 1963. Assemblage: leather over wood with a chain and other metal and wood parts, 6′6³/₄″ x 58¹/₂″ x 11⁵/₈″ (200 x 148.6 x 29.5 cm). Philip Johnson Fund. 1129.64.

Also, a print.

KANDINSKY, Wassily. Russian, 1866–1944. Worked in Germany and France.

122 CHURCH AT MURNAU. (1909) Oil on cardboard, 19¹/₈ x 27¹/₂″ (48.6 x 69.8 cm). Purchase. 321.50. Repr. *Suppl. II*, p. 10.

121 PICTURE WITH AN ARCHER. (1909) Oil on canvas, 69 x 57″ (175.2 x 144.7 cm). Fractional gift of Mrs. Bertram Smith. 619.59. Repr. *Suppl. VIII*, p. 5.

122 SKETCH, 14. 1913. Watercolor, 9¹/₂ x 12¹/₂″ (24.1 x 31.7 cm). Katherine S. Dreier Bequest. 159.53. *Note*: according to Will Grohmann in *Kandinsky: Life and Work*, this watercolor is a study for one of several works in oil on glass of 1911 entitled *The Last Judgment*.

122 Study for PAINTING WITH WHITE FORM. 1913. Watercolor and ink, 10⁷/₈ x 15″ (27.6 x 38.1 cm). Katherine S. Dreier Bequest. 157.53. Repr. *Suppl. IV*, p. 12.

122 WATERCOLOR (NUMBER 13). 1913. Watercolor, 12⁵/₈ x 16¹/₈″ (32.1 x 41 cm). Katherine S. Dreier Bequest. 158.53.

123 PANEL (3). 1914. Oil on canvas, 64 x 36¹/₄″ (162.5 x 92.1 cm). Mrs. Simon Guggenheim Fund. 2.54. Repr. in color, *Masters*, p. 120; *German Art of 20th C.*, p. 71; *Paintings from MoMA*, p. 52; in color, *Invitation*, p. 40. *Note*: this and the following, 3.54, are two of four canvases commissioned as a mural ensemble for a New York apartment. The other two canvases are in the collection of the Solomon R. Guggenheim Museum, New York. *Panel (3)* is sometimes called *Summer*.

123 PANEL (4). 1914. Oil on canvas, 64 x 31¹/₂″ (162.5 x 80 cm). Mrs. Simon Guggenheim Fund. 3.54. Repr. in color, *Masters*, p. 120; *Paintings from MoMA*, p. 52; in color, *Invitation*, p. 40. *Note*: see note to *Panel (3)*, above. *Panel (4)* is sometimes called *Spring*.

122 Untitled. 1915. Watercolor, 13¹/₄ x 9″ (33.7 x 22.9 cm). Gift of Abby Aldrich Rockefeller. 89.35. Repr. *Ptg. & Sc.*, p. 203.

123 BLACK RELATIONSHIP [*Schwarze Beziehung*]. 1924. Watercolor, 14¹/₂ x 14¹/₄″ (36.8 x 36.2 cm). Acquired through the Lillie P. Bliss Bequest. 341.49. Repr. *Suppl. II*, p. 10. *Note*: formerly listed as *The Black Circle*.

123 BLUE (NUMBER 393). 1927. Oil on cardboard, 19½ x 14½″ (49.5 x 36.8 cm). Katherine S. Dreier Bequest. 160.53.

LIGHTLY TOUCHING [*Leicht berührt*]. 1931. Oil on cardboard, 27⅝ x 19¼″ (69.9 x 48.8 cm). The Sidney and Harriet Janis Collection (fractional gift). 614.67. Repr. *Janis*, p. 43. *Note*: also called *Leicht gebunden*.

Also, a drawing, prints, illustrated books, and posters.

KANE, John. American, born Scotland. 1860–1934. To U.S.A. 1880.

HOMESTEAD. (c. 1929?) Oil on canvas, 24 x 27″ (61 x 68.6 cm). Gift of Abby Aldrich Rockefeller. 90.35. Repr. *Masters Pop. Ptg.*, no. 148.

7 SELF-PORTRAIT. (1929) Oil on canvas over composition board, 36⅛ x 27⅛″ (91.8 x 68.9 cm). Abby Aldrich Rockefeller Fund. 6.39. Repr. *Ptg. & Sc.*, p. 21; in color, *Masters*, p. 17; in color, *Invitation*, p. 64.

THE CAMPBELLS ARE COMING. (1932) Oil and gold paint on paper over composition board, 20 x 16⅛″ (50.8 x 40.8 cm). Inscribed: *Cambells are/comeing/John Kane*, over previous inscription, *Scotch Piper/by/John Kane*. The Sidney and Harriet Janis Collection (fractional gift). 615.67. Repr. *Janis*, p. 83.

7 SCOTCH DAY AT KENNYWOOD. 1933. Oil on canvas, 19⅞ x 27⅛″ (50.5 x 68.9 cm). Gift of Mr. and Mrs. Albert Lewin. 504.53. Repr. *Suppl. V*, p. 33.

7 THROUGH COLEMAN HOLLOW UP THE ALLEGHENY VALLEY. Oil on canvas, 30 x 38⅝″ (76.2 x 98.1 cm). Given anonymously. 400.41. Repr. *Ptg. & Sc.*, p. 20.

KANTOR, Morris. American, born Russia. 1896–1974. To U.S.A. 1911.

241 SOUTH TRURO CHURCH. 1934. Oil on canvas, 24⅛ x 27″ (61.3 x 68.6 cm). Gift of Abby Aldrich Rockefeller (by exchange). 11.36.

Also, prints.

KARFIOL, Bernard. American, born Hungary. 1886–1952.

236 SEATED NUDE. (1929) Oil on canvas, 40 x 30″ (101.6 x 76.2 cm). Gift of Abby Aldrich Rockefeller. 4.30. Repr. *Ptg. & Sc.*, p. 75.

FISHING VILLAGE. (1932) Watercolor, 10 x 14¾″ (25.4 x 37.5 cm). Given anonymously (by exchange). 12.36.

Also, drawings; and works in the Study Collection.

KATZMAN, Herbert. American, born 1923.

THE SEINE. (1949) Oil on canvas, 37¼ x 63″ (94.6 x 160 cm). Gift of Mr. and Mrs. Hugo Kastor. 52.52. Repr. *Suppl. IV*, p. 33.

KAUFFMAN, Craig (Robert Craig Kauffman). American, born 1932.

489 RED-BLUE. 1964. Synthetic polymer paint on vacuum-formed plexiglass, 7′5⅝″ x 45½″ x 5⅛″ (227.4 x 115.4 x 13 cm). Larry Aldrich Foundation Fund. 603.65.

KAWASHIMA, Takeshi. Japanese, born 1930. To U.S.A. 1963.

473 UNTITLED 1964, NEW YORK. 1964. Oil on canvas, center panel of a triptych, 8′4½″ x 6′6⅛″ (255.1 x 203.3 cm). Junior Council Fund. 604.65. Repr. in color, *New Jap. Ptg. & Sc.*, p. 20.

KELDER, Toon. Dutch, born 1894.

MASKER. (1952–53) Iron wire, 23½″ (59.6 cm) high, at base 12¼ x 9″ (30.9 x 22.8 cm). Gift of Dr. H. B. G. Casimir. 145.57. Repr. *Suppl. VII*, p. 15.

KELLY, Ellsworth. American, born 1923.

369 RUNNING WHITE. 1959. Oil on canvas, 7′4″ x 68″ (223.6 x 172.7 cm). Purchase. 9.60. Repr. *Suppl. X*, p. 53.

SPECTRUM, III. 1967. Oil on canvas in thirteen parts; overall, 33¼″ x 9′ ⅝″ (84.3 x 275.7 cm). The Sidney and Harriet Janis Collection (fractional gift). 336.67. Repr. in color, *Janis*, p. 141.

KEMENY, Zoltan. Swiss, born Hungary. 1907–1965. Lived in Paris and Zurich.

376 SHADOW OF THE MIRACLE. (1957) Copper T-sections mounted on wood, 33⅝ x 21⅞″ (85.3 x 55.5 cm). Gift of G. David Thompson. 12.59. Repr. *Suppl. IX*, p. 32.

KHAKHAR, Bhupen P. Indian, born 1934.

466 KALI. 1965. Enamel and metallic papers on plywood, 68¼ x 60″ (173.3 x 152.2 cm). Grace M. Mayer Fund. 2311.67.

KIENBUSCH, William. American, born 1914.

381 NEW ENGLAND COLLAGE, II. (1947) Cedar shingles, asphalt roofing, tar paper, etc., nailed to painted board, 21⅛ x 26⅝″ (53.7 x 67.6 cm). Purchase. 249.48. Repr. *Suppl. I*, p. 22.

LOW TIDE. 1950. Casein and ink, 22½ x 31″ (57.1 x 78.8 cm). Katharine Cornell Fund. 137.51. Repr. *Abstract Ptg. & Sc.*, p. 99.

KIENHOLZ, Edward. American, born 1927.

476 THE FRIENDLY GREY COMPUTER—STAR GAUGE MODEL #54. (1965) Motor-driven assemblage: aluminum painted rocking chair, metal case, two instrument boxes with dials, plastic case containing yellow and blue lights, panel with numbers, bell, "rocker switch," pack of index cards, directions for operation, light switch, telephone receiver, doll's legs, 40 x 39⅛ x 24½″ (101.3 x 99.2 x 62.1 cm) on aluminum sheet 48⅛ x 36″ (122 x 91.5 cm). Gift of Jean and Howard Lipman. 605.65. Repr. *The Machine*, p. 190. *Note*: computer should answer one question at a time.

KIERZKOWSKI, Bronislaw. Polish, born 1924.

376 TEXTURED COMPOSITION, 150. 1958. Cement and perforated metal strips on board, 20⅜ x 26¼″ (51.8 x 66.7 cm). Purchase. 272.61. Repr. *15 Polish Ptrs.*, p. 30.

KIESLER, Frederick J. American, born Austria. 1890–1965. To U.S.A. 1926.

484 LANDSCAPE—MARRIAGE OF HEAVEN AND EARTH. (1961–62) Bronze and silver plate (cast 1964), 6′1½″ x 63⅛″ x 27″ (184 x 160.1 x 68.5 cm). Kay Sage Tanguy Fund. 675.65a–f.

KIKUHATA, Mokuma. Japanese, born 1935.

475 ROULETTE: NUMBER FIVE. (1964) Assemblage: wood boards, sheet metal with circular cutouts, cans, iron pipe, baseball, pencil, enamel paint, etc., 42⅛ x 25⅜ x 8½″ (107 x 64.5 x 21.6 cm). Daphne Hellman Shih Fund. 606.65. Repr. in color, *New Jap. Ptg. & Sc.*, p. 18.

KINGMAN, Dong. American, born 1911.

FROM MY ROOF. 1941. Watercolor, 18¾ x 28½″ (47.6 x 72.4 cm). Gift of Albert M. Bender. 401.41. Repr. *La Pintura*, p. 136.

KIRCHNER, Ernst Ludwig. German, 1880–1938.

Donald E. Gordon has corrected some dates and titles.

69 EMMY FRISCH. (1907–08) Oil on canvas, 59⅛ x 28⅞″ (150 x 73.4

cm). Gift of William S. Rubin. 9.57. Repr. *Suppl. VI*, p. 14. *Note*: Fräulein Frisch later married the painter Karl Schmidt-Rottluff.

68 STREET, DRESDEN. (1908. Dated on painting 1907) Oil on canvas, 59$^1/4$″ x 6′6$^7/8$″ (150.5 x 200.4 cm). Purchase. 12.51. Repr. *Suppl. III*, p. 9; in color, *Invitation*, p. 124. *Note*: on the reverse, a painting of a group of women bathers done about 1912. In 1960 when the canvas was damaged in shipment and it was necessary to line it, fiberglass was used instead of linen in order to avoid obliterating the painting on the back. It is somewhat dimmed but remains visible. Will Grohmann (1954) identified the street as König-Johannstrasse, Dresden.

69 STREET, BERLIN. (1913) Oil on canvas, 47$^1/2$″ x 35$^7/8$″ (120.6 x 91.1 cm). Purchase. 274.39. Repr. *Ptg. & Sc.*, p. 79; in color, *German Art of 20th C.*, p. 40. *Note*: Will Grohmann (1954) identified the street as Friedrichstrasse, Berlin.

69 ARTILLERYMEN. (1915) Oil on canvas, 55$^1/4$ x 59$^3/8$″ (140.3 x 150.8 cm). Gift of Mr. and Mrs. Morton D. May. 15.56. Repr. *German Art of 20th C.*, p. 43.

68 SAND HILLS IN ENGADINE. (1917–18) Oil on canvas, 33$^3/4$ x 37$^1/2$″ (85.7 x 95.2 cm). Purchase. 285.49. Repr. *Suppl. I*, p. 10.

Also, drawings, prints, and illustrated books; a drawing in the Study Collection.

KITAJ, R. B. (Ronald Brooks Kitaj). American, born 1932. Lives in London.

444 THE OHIO GANG. (1964) Oil and crayon on canvas, 6′1$^1/8$″ x 6′1$^1/4$″ (183.1 x 183.5 cm). Philip Johnson Fund. 109.65.

KJARVAL, Jóhannes Sveinsson. Icelandic, born 1885.

199 LAVA AT BESSASTADIR. (1947–54) Oil on canvas, 29$^5/8$ x 37$^5/8$″ (75.2 x 95.4 cm). Given in memory of Holger Cahill. 289.61. Repr. *Suppl. XI*, p. 19.

KLEE, Paul. German, 1879–1940. Born and died in Switzerland.

144 STILL LIFE WITH FOUR APPLES. (1909) Oil on paper mounted on composition board, 13$^1/2$ x 11$^1/8$″ (34.3 x 28.2 cm). Gift of Mr. and Mrs. Peter A. Rübel. 27.57. Repr. *Suppl. VII*, p. 3.

144 WITH THE RED X [*Mit dem roten X*]. 1914. Watercolor, 6$^1/4$ x 4$^1/4$″ (15.9 x 10.8 cm). Katherine S. Dreier Bequest. 162.53.

144 LAUGHING GOTHIC [*Lachende Gotik*]. 1915. Watercolor, 10$^1/4$ x 5$^3/8$″ (26 x 13.6 cm). Purchase. 91.50. Repr. *Suppl. II*, p. 14.

144 DEMON ABOVE THE SHIPS [*Dämon über den Schiffen*]. 1916. Watercolor, pen and ink, 9 x 7$^7/8$″ (22.9 x 20 cm). Acquired through the Lillie P. Bliss Bequest. 122.44. Repr. *Ptg. & Sc.*, p. 204; in color, *Klee, 1945*, opp. p. 24.

144 INTRODUCING THE MIRACLE [*Vorführung des Wunders*]. 1916. Tempera, pen and ink on canvas, 10$^3/8$ x 8$^7/8$″ (26.4 x 22.4 cm). Fractional gift of Allan Roos, M.D., and B. Mathieu Roos. 395.62. Repr. *Suppl. XII*, p. 11.

144 CHRISTIAN SECTARIAN [*Christlicher Sectierer*]. 1920. Watercolor on transfer drawing, 10$^1/8$ x 6$^5/8$″ (25.7 x 16.8 cm). James Thrall Soby Fund. 121.44. Repr. *Ptg. & Sc.*, p. 205. *Note*: *Sectierer* for *Sektierer* is the artist's spelling.

145 THE END OF THE LAST ACT OF A DRAMA [*Schluss des letzten Aktes eines Dramas*]. 1920. Watercolor on transfer drawing, 8$^1/8$ x 11$^3/8$″ (20.6 x 28.8 cm). Promised gift and extended loan from Allan Roos, M.D., and B. Mathieu Roos. E.L.62.1390. Repr. *Suppl. XII*, p. 11.

146 THE ANGLER [*Der Angler*]. 1921. Watercolor, pen and ink, 18$^7/8$ x 12$^3/8$″ (47.6 x 31.2 cm). John S. Newberry Collection. 64.61. Repr. *Suppl. XI*, p. 14.

147 THE ARROW BEFORE THE TARGET [*Der Pfeil vor dem Ziel*]. 1921. Watercolor on transfer drawing, 8$^3/4$ x 12$^3/8$″ (22.2 x 31.3 cm). John S. Newberry Collection. 376.60. Repr. *Suppl. X*, p. 16.

146 DYING PLANTS [*Sterbende Pflanzen*]. 1922. Watercolor, pen and ink, 19$^1/8$ x 12$^5/8$″ (48.5 x 32.2 cm) (composition). The Philip L. Goodwin Collection. 102.58. Repr. *Bulletin*, Fall 1958, p. 8.

145 FLOWERS IN THE WIND [*Blumen im Wind*]. 1922. Watercolor, pen and ink, 6$^5/8$ x 5$^3/8$″ (16.8 x 13.6 cm). Katherine S. Dreier Bequest. 164.53.

148 GOOD FISHING PLACE [*Guter Fischplatz*]. 1922. Watercolor, pen and ink, 10$^1/2$ x 16$^1/8$″ (26.7 x 41 cm) (without margins). Katherine S. Dreier Bequest. 165.53.

147 SCHERZO WITH THIRTEEN [*Das Scherzo mit der Dreizehn*]. 1922. Watercolor, pen and ink, 8$^3/4$ x 11$^7/8$″ (22.2 x 30.2 cm). Purchase. 139.51. Repr. *Suppl. III*, p. 14.

146 TWITTERING MACHINE [*Zwitscher-Maschine*]. 1922. Watercolor, pen and ink, 16$^1/4$ x 12″ (41.3 x 30.5 cm) (without margins). Purchase. 564.39. Repr. *Ptg. & Sc.*, p. 207; in color, *Masters*, p. 129; *Klee, 1945*, frontispiece; *The Machine*, p. 127.

145 URN COLLECTION [*Urnensammlung*]. 1922. Watercolor on transfer drawing, 10$^7/8$ x 8$^1/2$″ (27.6 x 21.6 cm). Katherine S. Dreier Bequest. 163.53. Repr. *Suppl. IV*, p. 16.

145 VILLAGE IN THE FIELDS [*Das Dorf im Grünen*]. 1922. Oil on cardboard, 17$^7/8$ x 20$^1/8$″ (45.4 x 51.1 cm). Katherine S. Dreier Bequest. 169.53. Repr. *Suppl. IV*, p. 17.

145 VOCAL FABRIC OF THE SINGER ROSA SILBER [*Das Vokaltuch der Kammersängerin Rosa Silber*]. (1922) Gouache and gesso on canvas, 20$^1/4$ x 16$^3/8$″ (51.4 x 41.6 cm) (irregular). Gift of Mr. and Mrs. Stanley Resor. 13.55. Repr. *Private Colls.*, p. 8.

146 GIRL WITH DOLL CARRIAGE [*Mädchen mit Puppenwagen*]. 1923. Watercolor, pen and ink, 15$^3/8$ x 8$^3/8$″ (39 x 21.3 cm) (without margins). Purchase. 13.51. Repr. *Suppl. III*, p. 14.

148 INTOXICATION [*Rausch*]. 1923. Watercolor, pen and ink, 9$^5/8$ x 12$^1/4$″ (24.2 x 31 cm). John S. Newberry Collection. 377.60. Repr. *Suppl. X*, p. 16.

ACTOR'S MASK [*Schauspielermaske*]. 1924. Oil on canvas mounted on board, 14$^1/2$ x 13$^3/8$″ (36.7 x 33.8 cm). The Sidney and Harriet Janis Collection (fractional gift). 616.67. Repr. *Klee, 1930*, no. 12; *Klee, 1945*, p. 41; in color, *Janis*, p. 39; in color, *Invitation*, p. 21.

147 FLOWER GARDEN [*Blumengarten*]. 1924. Watercolor and gouache, 14$^7/8$ x 8$^3/8$″ (37.8 x 21.3 cm) (without margins). Katherine S. Dreier Bequest. 166.53. Repr. *Suppl. IV*, p. 16.

147 HERON [*Reiher*]. 1924. Mixed mediums, waxed, on paper, 13$^5/8$ x 7$^1/4$″ (34.6 x 18.4 cm) (without margins). Katherine S. Dreier Bequest. 167.53.

147 OLD CITY ARCHITECTURE [*Alte Stadtarchitektur*]. 1924. Watercolor, pen and ink, 9$^7/8$ x 7$^1/4$″ (25.1 x 18.4 cm) (without margins). Katherine S. Dreier Bequest. 168.53.

408 EARLY MORNING IN RO . . . [*Früher Morgen in Ro . . .*]. 1925. Watercolor, 14$^5/8$ x 20$^1/8$″ (37 x 50.9 cm). Gift of Mrs. Gertrud A. Mellon. 1262.64.

149 OLD CEMETERY [*Alter Friedhof*]. 1925. Mixed mediums on paper over cardboard, 14$^3/8$ x 19″ (36.4 x 48.3 cm). Gift of Mr. and Mrs. Albert Lewin. 287.58. Repr. *Suppl. VIII*, p. 7.

148 SLAVERY [*Sklaverei*]. 1925. Gouache and printing ink, 10 x 14″ (25.4 x 35.6 cm). Gift of Abby Aldrich Rockefeller. 96.35. Repr. *Ptg. & Sc.*, p. 206.

148 AROUND THE FISH [*Um den Fisch*]. 1926. Oil on canvas, 18$^3/8$ x

25¹/₈″ (46.7 x 63.8 cm). Abby Aldrich Rockefeller Fund. 271.39. Repr. *Ptg. & Sc.*, p. 209.

148 PASTORALE [*Pastorale, K10*]. 1927. Tempera on canvas mounted on wood, 27¹/₄ x 20⁵/₈″ (69.3 x 52.4 cm). Abby Aldrich Rockefeller Fund and exchange. 157.45. Repr. *Ptg. & Sc.*, p. 208.

408 PORTRAIT OF AN EQUILIBRIST [*Artistenbildnis*]. 1927. Oil and collage on cardboard over wood with painted plaster border, 24⁷/₈ x 15³/₄″ (63.2 x 40 cm). Mrs. Simon Guggenheim Fund. 195.66. Repr. *Klee*, 1930, cover (simplified zinc cut).

IN THE GRASS [*Im Gras*]. (1930) Oil on canvas, 16⁵/₈ x 20³/₄″ (42.1 x 52.5 cm). The Sidney and Harriet Janis Collection (fractional gift). 617.67. Repr. *Cubism*, p. 181; *Klee*, 1945, p. 46; *Janis*, p. 41.

149 THE MOCKER MOCKED [*Oder der verspottete Spötter*]. (1930) Oil on canvas, 17 x 20⁵/₈″ (43.2 x 52.4 cm). Gift of J. B. Neumann. 637.39. Repr. *Ptg. & Sc.*, p. 209.

149 EQUALS INFINITY [*Gleich Unendlich*]. 1932. Oil on canvas mounted on wood, 20¹/₄ x 26⁷/₈″ (51.4 x 68.3 cm). Acquired through the Lillie P. Bliss Bequest. 90.50. Repr. *Suppl. II*, p. 13; in color, *Masters*, p. 131; in color, *Invitation*, p. 99.

149 LETTER GHOST [*Geist eines Briefes*]. (1937) Watercolor, gouache, and ink on newspaper, 13 x 19¹/₄″ (33 x 48.9 cm). Purchase. 8.39. Repr. *Ptg. & Sc.*, p. 205.

149 SPRING IS COMING [*Es wird Grünen*]. 1939. Gouache and watercolor, 8¹/₈ x 11⁵/₈″ (20.6 x 29.5 cm). Alexander M. Bing Bequest. 10.60. Repr. *Suppl. X*, p. 17.

Also, drawings, lithographs with watercolor, an illustrated book, and postcards.

KLEIN, Yves. French, 1928–1962.

BLUE MONOCHROME. 1961. Oil on cotton cloth over plywood, 6′4⁷/₈″ x 55¹/₈″ (195.1 x 140 cm). The Sidney and Harriet Janis Collection (fractional gift). 618.67. Repr. in color, *Janis*, p. 133.

KLIMT, Gustav. Austrian, 1862–1918.

35 THE PARK. (1910 or earlier) Oil on canvas, 43¹/₂ x 43¹/₂″ (110.4 x 110.4 cm). Gertrud A. Mellon Fund. 10.57. Repr. *Suppl. VII*, p. 5. *Note*: has also been dated 1903.

Also, drawings.

KLINE, Franz. American, 1910–1962.

330 CHIEF. (1950) Oil on canvas, 58³/₈″ x 6′1¹/₂″ (148.3 x 186.7 cm). Gift of Mr. and Mrs. David M. Solinger. 2.52. Repr. *Suppl. IV*, p. 35.

TWO HORIZONTALS. 1954. Oil on canvas, 31¹/₈ x 39¹/₄″ (79.1 x 99.5 cm). The Sidney and Harriet Janis Collection (fractional gift). 619.67. Repr. *Janis*, p. 125.

LE GROS. 1961. Oil on canvas, 41³/₈ x 52⁵/₈″ (105 x 133.8 cm). The Sidney and Harriet Janis Collection (fractional gift). 620.67. Repr. *Janis*, p. 125.

Also, a print.

KNAPP, Stefan. British, born Poland 1921.

VERDURE. (1950) Vitreous enamel on steel, 61⁷/₈ x 35³/₈ x ⁷/₈″ (150.7 x 89.6 x 2.3 cm). Gift of Harold Kovner. 258.57. Repr. *Suppl. VII*, p. 18.

KNATHS, Karl. American, 1891–1971.

229 GIORGIONE BOOK. (1941) Oil on canvas, 40 x 20″ (101.6 x 50.8 cm). Gift of John S. Newberry. 140.44. Repr. *Art in Prog.*, p. 83.

KOBZDEJ, Aleksander. Polish, 1920–1972.

352 CONFLICT. 1959. Casein and oil on paper mounted on canvas, 39¹/₄ x 28³/₄″ (99.4 x 73 cm). Blanchette Rockefeller Fund. 83.60. Repr. *15 Polish Ptrs.*, p. 35; *Suppl. X*, p. 39.

KOENIG, Fritz. German, born 1924.

297 CAMARGUE, X. (1958) Bronze, 3 x 17¹/₄ x 15³/₈″ (7.6 x 43.8 x 39 cm). Matthew T. Mellon Foundation Fund. 119.61. Repr. *Suppl. XI*, p. 46. *Note*: the Museum owns an ink study for this sculpture.

Also, a drawing.

KOERNER, Henry. American, born Austria 1915. To U.S.A. 1938.

276 ROSE ARBOR. (1947) Oil on composition board, 27³/₄ x 35″ (70.5 x 88.9 cm). Gift of John Hay Whitney. 5.48. Repr. *Bulletin*, vol. XV, no. 4, 1948, p. 10. *Note*: the Museum owns an ink study for this painting.

Also, posters; a drawing in the Study Collection.

KOHN, Gabriel. American, 1910–1975.

TILTED CONSTRUCTION. (1959) Laminated wood, 27¹/₈″ (68.8 cm) high, at base 18¹/₂ x 12⁵/₈″ (46.7 x 31.9 cm). Philip Johnson Fund. 606.59. Repr. *Suppl. IX*, p. 33; *Amer. 1963*, p. 49.

369 ACROTERE. (1960) Laminated wood, 35¹/₄ x 31 x 22¹/₄″ (90.3 x 80.7 x 56.4 cm). Given anonymously (by exchange). 559.63. Repr. *Amer. 1963*, p. 51.

KOKOSCHKA, Oskar. British subject, born Austria of Austrian-Czech parents, 1886. Worked in Germany and Czechoslovakia. To England 1938. Lives in Switzerland.

74 NUDE BENDING FORWARD. (c. 1907) Watercolor, chalk, pen and ink, pencil, 17³/₄ x 12¹/₄″ (45.1 x 31.1 cm) (irregular). Rose Gershwin Fund. 549.54.

74 HANS TIETZE AND ERICA TIETZE-CONRAT. (1909) Oil on canvas, 30¹/₈ x 53⁵/₈″ (76.5 x 136.2 cm). Abby Aldrich Rockefeller Fund. 651.39. Repr. *Ptg. & Sc.*, p. 80; in color, *Masters*, p. 66; *German Art of 20th C.*, p. 74; in color, *Invitation*, p. 62.

74 SELF-PORTRAIT. (1913) Oil on canvas, 32¹/₈ x 19¹/₂″ (81.6 x 49.5 cm). Purchase. 26.40. Repr. *Ptg. & Sc.*, p. 81.

75 SEATED WOMAN. 1921. Watercolor, 27³/₄ x 20³/₈″ (70.5 x 51.7 cm). Gift of Myrtil Frank. 53.52.

74 TIGLON. (1926) Oil on canvas, 38 x 51″ (96.5 x 129.6 cm). Benjamin Scharps and David Scharps Fund. 237.56. Repr. *Suppl. VI*, p. 15.

75 PORT OF HAMBURG. (1951) Oil on canvas, 35³/₄ x 47¹/₂″ (90.8 x 120.5 cm). Rose Gershwin Fund. 14.56. Repr. *Suppl. VI*, p. 15.

Also, drawings, prints, a poster, and illustrated books; a gouache in the Study Collection.

KOLBE, Georg. German, 1877–1947.

STANDING GIRL. (c. 1920) Bronze, 16¹/₄″ (41.3 cm) high. Gift of Abby Aldrich Rockefeller. 612.39.

43 GRIEF. (1921) Bronze, 15³/₄ x 22″ (40 x 55.9 cm). Gift of Edward M. M. Warburg. 9.39. Repr. *Ptg. & Sc.*, p. 245.

Also, drawings and a print.

KOMAN, Ilhan. Turkish, born 1921. Lives in Sweden.

378 MY COUNTRY'S SUN [*Le Soleil de mon pays*]. (1957) Antique

wrought iron, reconstructed, 66⅛″ x 6′4⅛″ (168 x 193.2 cm). Philip Johnson Fund. 13.59. Repr. *Suppl. IX*, p. 35.

DE KOONING, Elaine. American, born 1920.

BULLFIGHT. (1960) Gouache, 19⅜ x 24⅝″ (49.2 x 62.6 cm). Larry Aldrich Foundation Fund. 120.61. Repr. *Suppl. XI*, p. 33.

DE KOONING, Willem. American, born the Netherlands 1904. To U.S.A. 1926.

331 PAINTING. (1948) Enamel and oil on canvas, 42⅝″ x 56⅛″ (108.3 x 142.5 cm). Purchase. 238.48. Repr. *Suppl. I*, p. 21; *New Amer. Ptg.*, p. 54; *de Kooning*, p. 57.

331 WOMAN, I. (1950–52) Oil on canvas, 6′3⅞″ x 58″ (192.7 x 147.3 cm). Purchase. 478.53. Repr. *New Images*, p. 91; in color, *Masters*, p. 177; *New Amer. Ptg.*, p. 53; *de Kooning*, p. 91, detail in color, p. 90; in color, *Invitation*, p. 131.

331 WOMAN, II. (1952) Oil on canvas, 59 x 43″ (149.9 x 109.3 cm). Gift of Mrs. John D. Rockefeller 3rd. 332.55. Repr. *Suppl. VI*, p. 29; *de Kooning*, p. 92.

SEPTEMBER MORN. (1958) Oil on canvas, 62⅞ x 49⅜″ (159.5 x 125.7 cm). The Sidney and Harriet Janis Collection (fractional gift). 621.67. Repr. *Janis*, p. 121.

A TREE IN NAPLES. (1960) Oil on canvas, 6′8¼″ x 70⅛″ (203.7 x 178.1 cm). The Sidney and Harriet Janis Collection (fractional gift). 622.67. Repr. *Janis*, p. 121. *Note*: also called *A Tree Grows in Naples*.

WOMAN, XI. (1961) Oil and pastel on paper mounted on canvas, 29 x 22⅜″ (73.5 x 56.6 cm). The Sidney and Harriet Janis Collection (fractional gift). 623.67. Repr. *Janis*, p. 123.

Also, a print.

KOPMAN, Benjamin. American, born Russia. 1887–1965. To U.S.A. 1903.

236 HEAD. 1929. Oil on canvas, 22⅞ x 18⅛″ (58.1 x 46 cm). Given anonymously. 97.35.

THE RUIN. (1930) Oil on canvas, 25⅝ x 36⅜″ (65.1 x 92.4 cm). Given anonymously. 98.35. Repr. *Ptg. & Sc.*, p. 166.

LANDSCAPE WITH FIGURE. 1963. Oil on canvas, 42 x 50″ (106.5 x 126.9 cm). Gift of G. David Thompson. 589.63.

KRAA, Kirsten. American, born Germany of Danish parents, 1941. To U.S.A. 1956.

442 Untitled. (1964) Oil on canvas, 15⅛ x 15″ (38.2 x 38.1 cm). Larry Aldrich Foundation Fund. 260.64.

KRAJCBERG, Frans. Brazilian, born Poland 1921.

352 PAINTING, I. 1957. Oil on canvas, 36⅛ x 28¾″ (91.6 x 73 cm). Inter-American Fund. 125.58. Repr. *Suppl. VIII*, p. 17.

KRASNOPEVTSEV, Dimitri Mikhailovich. Russian, born 1925.

BOTTLES PLANTED IN THE GROUND. 1966. Oil on composition board, 20⅞ x 17¾″ (52.8 x 45.1 cm). Purchase. 2102.67.

KRICKE, Norbert. German, born 1922.

374 PLANE OF RODS [*Flächenbahn*]. (1960) Stainless steel welded with silver, 8¾ x 28⅛″ (22.1 x 71.4 cm). Purchase. 121.61. Repr. *Suppl. XI*, p. 26.

KRIESBERG, Irving. American, born 1919.

RED SHEEP. 1951. Tempera on composition board, 48 x 42″ (121.9 x 106.7 cm). Gift of Mr. and Mrs. Hugo Kastor. 140.51.

Also, a print.

KROHG, Per. Norwegian, born 1889. Works in Paris.

RAIN. (Before 1933) Gouache, 11¼ x 15½″ (28.6 x 39.4 cm). Given anonymously. 99.35.

KRUSHENICK, Nicholas. American, born 1929.

458 THE RED BARON. 1967. Synthetic polymer paint on shaped canvas, 8′1⅛″ x 6′3¼″ at top, 65¼″ at bottom (244.2 x 191.1, 165.7 cm). Larry Aldrich Foundation Fund. 117.67.

KUBIN, Alfred. Austrian, 1877–1959.

402 AS DAY FLIES SO GOES THE NIGHT. (c. 1900–03) Gouache, wash, brush and ink, 13 x 10¾″ (32.9 x 27.2 cm). John S. Newberry Collection. 599.64.

THE LAST KING. (c. 1900–03) Wash, brush, pen and ink, 14⅝ x 11⅛″ (37.1 x 28.2 cm). John S. Newberry Collection. 603.64.

KUHN, Walt. American, 1880–1949.

JEANNETTE. 1928. Oil on canvas, 30 x 25″ (76.2 x 63.5 cm). Lillie P. Bliss Collection. 79.34. Repr. *Bliss, 1934*, no. 42.

236 APPLES IN THE HAY. 1932. Oil on canvas, 30 x 40″ (76.2 x 101.6 cm). Given anonymously (by exchange). 14.36. Repr. *Ptg. & Sc.*, p. 65.

Also, drawings and prints.

KUNIYOSHI, Yasuo. American, born Japan. 1889–1953. To U.S.A. 1906.

240 SELF-PORTRAIT AS A GOLF PLAYER. (1927) Oil on canvas, 50¼ x 40¼″ (127.6 x 102.2 cm). Abby Aldrich Rockefeller Fund. 293.38. Repr. *Ptg. & Sc.*, p. 76.

240 UPSIDE DOWN TABLE AND MASK. 1940. Oil on canvas, 60⅛ x 35½″ (152.7 x 90.2 cm). Acquired through the Lillie P. Bliss Bequest. 125.44. Repr. *Ptg. & Sc.*, p. 77.

Also, drawings and prints.

KUPFERMAN, Lawrence. American, born 1909.

LOW TIDE SEASCAPE. 1947. Gouache, 23¼ x 29″ (59 x 73.7 cm). Purchase. 308.47.

Also, prints.

KUPKA, František (*or Frank*). Czech, 1871–1957. To France 1895.

124 GIRL WITH A BALL. (c. 1908) Pastel, 24½ x 18¾″ (62.2 x 47.5 cm). Gift of Mr. and Mrs. František Kupka. 567.56.

124 THE FIRST STEP. (1910–13? Dated on painting 1909) Oil on canvas, 32¾ x 51″ (83.2 x 129.6 cm). Hillman Periodicals Fund. 562.56. Repr. in color, *Invitation*, p. 32.

124 MME KUPKA AMONG VERTICALS. (1910–11). Oil on canvas, 53⅜ x 33⅝″ (135.5 x 85.3 cm). Hillman Periodicals Fund. 563.56. *Note*: the subject is Eugénie Kupka, the wife of the artist.

125 THE MUSICIAN FOLLOT. (1911? Dated on painting 1910) Oil on canvas, 28½ x 26⅛″ (72.4 x 66.3 cm). Hillman Periodicals Fund. 564.56.

124 OVAL MIRROR. (1911? Dated on painting 1910) Oil on canvas, 42⅝ x 34⅞″ (108.3 x 88.6 cm). Hillman Periodicals Fund. 565.56. *Note*: titled and dated by Kupka for his retrospective exhibition, Prague, in 1946: *Oval Mirror*, 1911. Previous title: *The Mirror*.

125 RED AND BLUE DISKS. (1911? Dated on painting 1911–12) Oil on canvas, 39³/₈ x 28³/₄″ (100 x 73 cm). Purchase. 141.51. Repr. *Suppl. IV*, p. 21. *Note*: titled and dated by Kupka for his retrospective exhibition, Prague, in 1946: *Red and Blue Disks (Origin of the Fugue)*, 1911.

125 FUGUE IN TWO COLORS: AMORPHA. (1912) Twenty-seven studies for the large painting exhibited in the Salon d'Automne, Paris, 1912, and now in the National Gallery, Prague. Tempera, brush and ink, largest 16³/₈ x 18⁵/₈″ (41.6 x 47.3 cm), smallest 4³/₈ x 4⁷/₈″ (11.1 x 12.2 cm). Gift of Mr. and Mrs. František Kupka. 569.56.1–.10; 569.56.13–.29. *Note*: although these studies are reproduced as a group, one, no. 569.56.1, is also shown separately.

125 VERTICAL PLANES (STUDY). (1912? Dated on painting 1911). Oil on canvas, 25⁵/₈ x 18¹/₄″ (65.1 x 46.2 cm). Gift of Alfred H. Barr, Jr. 566.56. *Note*: titled and dated by Kupka for his retrospective exhibition, Prague, in 1946: *Preliminary Study for the Vertical Planes*, 1911. The final composition was completed in 1913. Previous title: *Curving Verticals*.

125 Replica (1946) of FUGUE IN TWO COLORS: AMORPHA, 1912. Gouache, India ink, and pencil, 9 x 9⁵/₈″ (22.9 x 24.3 cm). Gift of the artist. 147.57.

125 Replica (1946) of VERTICAL PLANES, 1912–13. Watercolor, gouache, and pencil, 11¹/₄ x 6⁵/₈″ (28.5 x 16.8 cm). Gift of the artist. 149.57.

125 Replica (1946) of SOLO OF A BROWN STROKE, 1913. Watercolor, gouache, and pencil, 5¹/₄ x 8¹/₂″ (13.2 x 21.4 cm). Gift of the artist. 148.57.

Also, 520 items in the Study Collection, including eight crayon and pencil studies after *Girl with a Ball*; twelve gouache, pastel, and pencil studies for *Fugue in Two Colors: Amorpha*; a number of pastel, crayon, and pencil studies for *Chromatique Chaude*; and a watercolor replica (1947) of *Animated Lines*, 1919–21.

KURELEK, William. Canadian, born 1927.

286 HAILSTORM IN ALBERTA. (1961) Oil on composition board, 27¹/₄ x 19″ (69.3 x 48.2 cm). Gift of the Women's Committee of the Art Gallery of Toronto. 380.61. Repr. *Suppl. XI*, p. 54.

LACHAISE, Gaston. American, born France. 1882–1935. To U.S.A. 1906.

419 WOMAN ARRANGING HER HAIR. (1910–12) Bronze (cast 1963), 10¹/₂ x 5¹/₈ x 2³/₄″ (26.4 x 13 x 6.8 cm). Given anonymously (by exchange). 253.66.

HEAD. (After 1920?) Granite, 8¹/₂″ (21.6 cm) high. Given anonymously. 608.39.

252 WOMAN WALKING. 1922. Bronze, 18¹/₂″ (47 cm) high, at base 6¹/₂ x 5³/₈″ (16.5 x 13.7 cm). Gift of Abby Aldrich Rockefeller. 635.39. Repr. *20th-C. Portraits*, p. 86.

252 EGYPTIAN HEAD. 1923. Bronze, 13″ (33 cm) high. Gift of Abby Aldrich Rockefeller. 606.39. Another cast repr. *Living Amer.*, no. 105.

419 THE MOUNTAIN. (1924) Bronze (cast 1964), 7¹/₂ x 19³/₈ x 9¹/₂″ (19 x 49.2 x 24 cm). Given anonymously (by exchange). 252.66.

252 FLOATING FIGURE. (1927) Bronze (cast 1935), 51³/₄″ x 8′ (131.4 x 243.9 cm). Given anonymously in memory of the artist. 3.37. Repr. *Ptg. & Sc.*, p. 254; *Masters*, p. 108.

DANCER. 1928. Bronze, 10³/₄ x 9¹/₄″ (27.3 x 23.3 cm). Gift of Abby Aldrich Rockefeller. 605.39.

252 JOHN MARIN. 1928. Bronze, 12¹/₂″ (31.7 cm) high. Gift of Abby Aldrich Rockefeller. 154.34. Repr. *Ptg. & Sc.*, p. 253.

419 HENRY McBRIDE. 1928. Bronze, 13⁵/₈ x 10¹/₈ x 11¹/₈″ (34.5 x 25.6 x 28.1 cm). Gift of Maximilian H. Miltzlaff. 246.66. *Note*: the subject was for thirty-seven years the knowledgeable and genial art critic for the *New York Sun*.

WOMAN STANDING. (1932) Plaster, 22¹/₂ x 12″ (57.1 x 30.5 cm). Gift of Abby Aldrich Rockefeller. 603.39. Original plaster of 604.39.

WOMAN STANDING. 1932. Bronze, 22¹/₄ x 11⁷/₈″ (56.5 x 30.1 cm). Gift of Abby Aldrich Rockefeller. 604.39. Bronze cast of 603.39.

253 STANDING WOMAN. 1932. Bronze, 7′4″ x 41¹/₈″ x 19¹/₈″ (223.6 x 104.3 x 48.4 cm). Mrs. Simon Guggenheim Fund. 251.48. Repr. *Ptg. & Sc.*, p. 255; *Masters*, p. 109.

DYNAMO MOTHER. 1933. Bronze, 11¹/₈ x 17³/₄ x 7¹/₂″ (28.3 x 45.1 x 19 cm). Gift of Edward M. M. Warburg. 406.41.

253 KNEES. (1933) Marble, 19″ (48.3 cm) high, at base 13¹/₄ x 9¹/₂″ (33.6 x 24 cm). Gift of Mr. and Mrs. Edward M. M. Warburg. 3.56. Repr. *Suppl. VI*, p. 18; *Lachaise*, no. 54.

EDWARD M. M. WARBURG. (1933) Plaster, 14¹/₂″ (36.8 cm) high. Gift of Edward M. M. Warburg. 239.50. Alabaster version repr. *Lachaise*, no. 52.

253 TORSO. 1934. Plaster, 45 x 41¹/₄″ (114.3 x 104.7 cm). Gift of Edward M. M. Warburg. 160.34. Repr. *Lachaise*, no. 40. *Note*: torso of the *Standing Woman* of 1932, 251.48.

Also, drawings.

LA FRESNAYE, Roger de. French, 1885–1925.

101 THE CONQUEST OF THE AIR. 1913. Oil on canvas, 7′8⁷/₈″ x 6′5″ (235.9 x 195.6 cm). Mrs. Simon Guggenheim Fund. 222.47. Repr. *Ptg. & Sc.*, p. 95; in color, *Masters*, p. 75; in color, *Invitation*, p. 52. *Note*: the two figures are said to be the artist and his brother Henri, director of the Nieuport airplane factory.

101 STILL LIFE [*Nature morte à la bouteille, pipe, et pot à tabac*]. (1913–14) Oil on canvas, 28⁵/₈ x 36¹/₈″ (72.7 x 91.8 cm). Gift of Abby Aldrich Rockefeller. 124.40. Repr. *Ptg. & Sc.*, p. 94.

Also, drawings and a print.

LAM, Wifredo. Cuban, born 1902. Worked in France, Spain, and Italy from 1923. Lives in France.

MOTHER AND CHILD. 1939. Gouache, 41 x 29¹/₄″ (104.1 x 74.3 cm). Purchase. 652.39.

306 SATAN. 1942. Gouache, 41⁷/₈ x 34″ (106.4 x 86.4 cm). Inter-American Fund. 710.42. Repr. *Latin-Amer. Coll.*, p. 52.

306 THE JUNGLE. 1943. Gouache on paper mounted on canvas, 7′10¹/₄″ x 7′6¹/₂″ (239.4 x 229.9 cm). Inter-American Fund. 140.45. Repr. *Ptg. & Sc.*, p. 235; in color, *Masters*, p. 167; in color, *Invitation*, p. 81.

Also, prints and an illustration.

LANDAU, Jacob. American, born 1917.

284 CINNA THE POET. (1959) Watercolor, 27¹/₄ x 40³/₈″ (69.1 x 102.5 cm). Larry Aldrich Foundation Fund. 158.62. Repr. *Figure U.S.A.*

Also, a print.

LANDI, Edoardo. Italian, born 1937.

512 GEOMETRICAL KINETIC VARIATIONS. (1963) Motor-driven construction of water-filled plexiglass tubes, painted metal rollers with strips of colored cloth tape, in a box, 19³/₄ x 19³/₄ x 5³/₄″ (50 x 50 x 14.5 cm). Gift of the Olivetti Company of Italy. 1237.64. *Note*: made while the artist was a member of Group N, Padua.

LANDSMAN, Stanley. American, born 1930.

512 Untitled. (1967) Construction of coated glass with electric light bulb, 37⅛ x 6¾ x 6¾″ (94.2 x 16.9 x 16.9 cm). Larry Aldrich Foundation Fund. 96.67.

LANDUYT, Octave. Belgian, born 1922.

271 PURIFICATION BY FIRE. 1957. Oil on composition board, 47⅞ x 35⅞″ (121.7 x 91 cm). Philip Johnson Fund. 128.58. Repr. *Suppl. VIII*, p. 14.

271 ESSENTIAL SURFACE, EYE. (1960) Oil on canvas, 51⅜ x 63⅛″ (130.5 x 160.3 cm). Philip Johnson Fund. 122.61 . Repr. *Suppl. XI*, p. 45.

 Also, a drawing.

LANSKOY, André. French, born Russia. 1902–1976. To Paris 1921.

346 EXPLOSION. 1958. Oil on canvas, 57½ x 38¼″ (146 x 97.2 cm). Gift of Louis Carré. 362.60. Repr. *Suppl. X*, p. 37.

LARCHE, Raoul François. French, 1860–1912.

38 LOÏE FULLER, THE DANCER. (c. 1900) Bronze, 18⅛″ (45.7 cm) high (wired for use as a table lamp). Gift of Anthony Russo. 266.63. Repr. *Suppl. XII*, p. 36.

LARIONOV, Michael. Russian, 1881–1964. To Paris 1915.

131 RAYONIST COMPOSITION: DOMINATION OF RED. (1912–13. Dated on painting 1911) Oil on canvas, 20¾ x 28½″ (52.7 x 72.4 cm). Gift of the artist. 36.36.

131 RAYONIST COMPOSITION: HEADS. (1912–13. Dated on painting 1911) Oil on paper, 27¼ x 20½″ (69.3 x 52.1 cm). Gift of the artist. 37.36.

131 RAYONIST COMPOSITION NUMBER 8. (1912–13) Tempera, 20 x 14¾″ (50.8 x 37.5 cm). Gift of the artist. 40.36.

131 RAYONIST COMPOSITION NUMBER 9. (1913) Tempera, 10⅜ x 18″ (26.3 x 45.7 cm). Gift of the artist. 41.36.

131 SPIRAL. 1915. Tempera, 30⅝ x 21¼″ (77.8 x 54 cm). Gift of the artist. 38.36.

 RENARD. Three watercolor designs made in 1921 for the ballet produced by Ballets Russes de Monte Carlo, 1922. Two designs for costumes, 20 x 13¾″ (50.8 x 35 cm); one for scenery, 20½ x 25¼″ (52.1 x 64.1 cm). Gift of the artist. 42.36.1–.3. Theatre Arts Collection.

 Also, a painting in the Study Collection.

LASSAW, Ibram. American, born Egypt, of Russian parents, 1913. To U.S.A. 1921.

357 KWANNON. 1952. Welded bronze with silver, 6′ x 43″ (182.9 x 109.2 cm). Katharine Cornell Fund. 196.52. Repr. *Suppl. IV*, p. 38; *What Is Mod. Sc.*, p. 79.

LATASTER, Ger. Dutch, born 1920.

355 THREATENED GAME. 1956. Oil on composition board, 48 x 68″ (121.9 x 172.7 cm). Gift of G. David Thompson. 14.59. Repr. *Suppl. IX*, p. 21.

 Also, a print.

LATHAM, John. British, born Rhodesia (modern-day Zambia) 1921.

380 SHEM. 1958. Assemblage: hessian-covered door, with books, scrap metals, various paints, plasters, and cements, 8′4½″ x 46″ x 12½″ (255.2 x 116.8 x 31.7 cm). Philip Johnson Fund. 298.61. Repr. *Assemblage*, p. 123.

LAUFMAN, Sidney. American, born 1891.

 THE WOODYARD. (1932) Oil on canvas, 25¾ x 32″ (65.4 x 81.3 cm). Given anonymously. 336.41. Repr. *Ptg. & Sc.*, p. 74.

LAURENCIN, Marie. French, 1883–1956.

 THE BLUE PLUME. Pastel, pencil, watercolor, 9⅝ x 7⅝″ (24.5 x 19.4 cm). Gift of Mrs. Meredith Hare. 137.34.

 Also, drawings, prints, and an illustrated book.

LAURENS, Henri. French, 1885–1954.

103 HEAD. (1918) Wood construction, painted, 20 x 18¼″ (50.8 x 46.3 cm). Van Gogh Purchase Fund. 263.37. Repr. *Ptg. & Sc.*, p. 271; *Masters*, p. 78; *What Is Mod. Sc.*, p. 45.

103 GUITAR. (1920) Terra cotta, 14¼″ (36.2 cm) high, at base 4¾ x 3⅝″ (10.2 x 9.2 cm). Gift of Curt Valentin. 303.47.

 HEAD OF A BOXER. (1920) Stone relief, polychrome, 9¾ x 9⅞″ (24.8 x 25.1 cm). Gift of Mrs. Marie L. Feldhaeusser. 240.50.

103 SEATED WOMAN. (1926) Terra cotta, 14½″ (36.8 cm) high, at base 8 x 7¼″ (20.3 x 18.4 cm). Gift of Lucien Lefebvre-Foinet. 258.37.

103 MERMAID. (1937) Bronze, 10″ (25.5 cm) high. Gift of Mr. and Mrs. Walter Bareiss. 571.56. Repr. *Suppl. VI*, p. 19.

 Also, prints, illustrated books, and posters.

LAURENT, Robert. American, born France. 1890–1970. To U.S.A. 1902.

254 AMERICAN BEAUTY. (c. 1933) Alabaster, 12¼″ (31.1 cm) high, at base 6¾ x 7⅜″ (17.1 x 18.7 cm). Abby Aldrich Rockefeller Fund. 124.46. Repr. *Ptg. & Sc.*, p. 259.

LAWRENCE, Jacob. American, born 1917.

278 THE MIGRATION OF THE NEGRO. (1940–41) Series of thirty, tempera and gesso on composition board, 18 x 12″ (45.7 x 30.5 cm) and 12 x 18″ (30.5 x 45.7 cm). Gift of Mrs. David M. Levy. 28.42.1–.30. There are in all sixty panels in this series: the thirty odd numbers in the Phillips Collection, Washington, D.C., the thirty even numbers in The Museum of Modern Art. Nos. 28.42.5 and 28.42.6 are reproduced here. Nos. 28.42.11, 28.42.26, and 28.42.29 are repr. *Ptg. & Sc.*, p. 151. Nos. 28.42.24 and 28.42.29 are in color, *Invitation*, p. 113.

278 SEDATION. 1950. Casein, 31 x 22⅞″ (78.8 x 58.1 cm). Gift of Mr. and Mrs. Hugo Kastor. 15.51. Repr. *Suppl. III*, p. 22.

LEBDUSKA, Lawrence. American, 1894–1966.

 MONASTERY FARM, RHODE ISLAND. (1936) Oil on rubberized cloth, 28¼ x 38″ (71.8 x 96.5 cm). Abby Aldrich Rockefeller Fund. 632.39. Repr. *Masters Pop. Ptg.*, no. 157.

LEBENSTEIN, Jan. Polish, born 1930. To Paris 1959.

352 AXIAL FIGURE, 110. 1961. Oil on canvas, trapezoid, 7′1½″ x 46¾″ at top, 31½″ at bottom (217.2 x 118.8 x 80 cm). Blanchette Rockefeller Fund. 273.61. Repr. *15 Polish Ptrs.*, p. 41.

 Also, drawings.

LEBRUN, Rico. American, born Italy. 1900–1964. To U.S.A. 1924.

272 FIGURE IN RAIN. 1949. Duco on canvas over composition board, 48 x 30⅛″ (121.9 x 76.5 cm). Gift of Mrs. Robert Woods Bliss. 102.50. Repr. *Suppl. II*, p. 25.

 DOBLE DISPARATE. 1958. Oil and casein on plywood, 7′5⅝″ x

45¹/₈″ (214.7 x 114.5 cm). Extended loan from Mr. and Mrs. Frank S. Wyle. E.L.61.92. Repr. *New Images*, p. 98.

Also, a drawing and a print.

LE CORBUSIER (Charles-Édouard Jeanneret). French, born Switzerland. 1887–1965. To Paris 1917.

142 STILL LIFE. 1920. Oil on canvas, 31⁷/₈ x 39¹/₄″ (80.9 x 99.7 cm). Van Gogh Purchase Fund. 261.37. Repr. *Ptg. & Sc.*, p. 123; *Masters*, p. 219.

Also, architectural models and designs, furniture, posters, and an illustrated book.

LEE, Ung-no. Korean, born 1904.

 MOUNTAINS. (1957) Brush and colored inks, 18³/₄ x 22⁵/₈″ (47.5 x 57.3 cm) mounted on cloth scroll, 39³/₄ x 28¹/₂″ (101 x 72.4 cm). Blanchette Rockefeller Fund. 96.58.

316 SAILING. (1957) Brush and colored inks, 50 x 12⁵/₈″ (127 x 32 cm) mounted on cloth scroll, 71⁵/₈ x 17⁷/₈″ (182 x 45.3 cm). Blanchette Rockefeller Fund. 95.58. Repr. *Suppl. VIII*, p. 23.

 COMPOSITION. (1959?) Brush and colored inks, 13³/₄ x 18″ (34.8 x 45.6 cm). Gift of the artist. 119.60.

LE FAUCONNIER, Henri Victor Gabriel. French, 1881–1946.

100 THE HUNTSMAN. (1912) Oil on canvas, 62¹/₄ x 46³/₈″ (158.1 x 117.8 cm). Gift of Mr. and Mrs. Leo Lionni. 505.53. Repr. *Suppl. V*, p. 16.

LÉGER, Fernand. French, 1881–1955. In U.S.A. 1940–45.

 BRIDGE. (1908?) Oil on canvas, 36¹/₂ x 28⁵/₈″ (92.7 x 72.6 cm). The Sidney and Harriet Janis Collection (fractional gift). 624.67. Repr. *Janis*, p. 5. *Note*: also called *Paysage* and *Composition # 1*.

95 CONTRAST OF FORMS. 1913. Oil on canvas, 39¹/₂ x 32″ (100.3 x 81.1 cm). The Philip L. Goodwin Collection. 103.58. Repr. *Bulletin*, Fall 1958, p. 9.

95 EXIT THE BALLETS RUSSES. 1914. Oil on canvas, 53³/₄ x 39¹/₂″ (136.5 x 100.3 cm). Gift of Mr. and Mrs. Peter A. Rübel (partly by exchange). 11.58. Repr. *Bulletin*, Fall 1958, p. 26; in color *Invitation*, p. 66. *Note*: according to the former owner, Leonid Massine, the title of the picture was given by the artist.

97 VERDUN: THE TRENCH DIGGERS. 1916. Watercolor, 14¹/₈ x 10³/₈″ (35.9 x 26.3 cm). Frank Crowninshield Fund. 142.44.

 BARGEMAN. (1918) Oil on canvas, 18¹/₈ x 21⁷/₈″ (45.8 x 55.5 cm). The Sidney and Harriet Janis Collection (fractional gift). 625.67. Repr. *Janis*, p. 7.

95 PROPELLERS. 1918. Oil on canvas, 31⁷/₈ x 25³/₄″ (80.9 x 65.4 cm). Katherine S. Dreier Bequest. 171.53. Repr. *Suppl. IV*, p. 9; *The Machine*, p. 140.

95 THE CITY (STUDY). 1919. Oil on canvas, 36¹/₄ x 28³/₈″ (92.1 x 72.1 cm). Acquired through the Lillie P. Bliss Bequest. 178.52. Repr. *Suppl. IV*, p. 23; *Léger*, p. 28. *Note*: study for *The City*, 1919, Philadelphia Museum of Art, A. E. Gallatin Collection.

 ANIMATED LANDSCAPE [*Paysage animé, 1ᵉʳ état*]. 1921. Oil on canvas, 19⁷/₈ x 25³/₈″ (50.4 x 64.4 cm). The Sidney and Harriet Janis Collection (fractional gift). 626.67. Repr. *Janis*, p. 7.

96 THREE WOMEN [*Le Grand déjeuner*]. 1921. Oil on canvas, 6′1¹/₄″ x 8′3″ (183.5 x 251.5 cm). Mrs. Simon Guggenheim Fund. 189.42. Repr. *Ptg. & Sc.*, p. 124; *Léger*, p. 31; in color, *Masters*, p. 85; *Art in Prog.*, opp. p. 74; *Paintings from MoMA*, p. 44; in color, *Invitation*, p. 71.

 SKATING RINK. Costume design for the ballet produced by Ballet

Suédois, Paris. (1922) Watercolor and pencil, 12³/₈ x 9¹/₂″ (31.4 x 24.1 cm). W. Alton Jones Foundation Fund. 270.54. Theatre Arts Collection.

405 MURAL PAINTING. 1924. Oil on canvas, 71 x 31¹/₄″ (180.3 x 79.2 cm). Given anonymously. 49.65. Repr. *Léger*, p. 39.

97 STILL LIFE. 1924. Oil on canvas, 36¹/₄ x 23⁵/₈″ (92 x 60 cm). Hillman Periodicals Fund. 246.54. Repr. *Suppl. V*, p. 16.

97 THE BALUSTER. 1925. Oil on canvas, 51 x 38¹/₄″ (129.5 x 97.2 cm). Mrs. Simon Guggenheim Fund. 179.52. Repr. *Suppl. IV*, p. 24.

97 COMPASS AND PAINT TUBES. 1926. Gouache, 10¹/₂ x 14¹/₄″ (26.7 x 36.2 cm). Gift of Edward M. M. Warburg. 407.41. Repr. *Mod. Art in Your Life*, p. 24.

97 UMBRELLA AND BOWLER. 1926. Oil on canvas, 50¹/₄ x 38³/₄″ (130.1 x 98.2 cm). A. Conger Goodyear Fund. 650.59. Repr. *Suppl. IX*, p. 13.

 Design for a mural. (1938) Gouache and watercolor, 4¹/₄ x 7¹/₄″ (10.7 x 18.2 cm). Gift of the Advisory Committee. 135.47. *Note*: a miniature mural painting for the model of the *Suspended House* designed by Paul Nelson.

405 Project for a cinematic mural (never executed) for the lobby of the International Building, Rockefeller Center, New York. (1939–40) Seven paintings, key studies for a proposed moving mural, to be projected on a marble wall. Gouache, pencil, pen and ink on cardboard; five, 20 x 15″ (50.7 x 38 cm); two, 20 x 16″ (50.7 x 40.5 cm). Given anonymously. 737–743.66. Nos. 737.66, 741.66, and 742.66 are reproduced here.

 BLUE DECORATION. 1941. Oil on canvas, 70 x 48″ (177.8 x 121.9 cm). Gift of Mr. and Mrs. Gerald Murphy. 98.50.

98 RED DECORATION. 1941. Oil on canvas, 70 x 48″ (177.8 x 121.9 cm). Gift of Mr. and Mrs. Gerald Murphy. 97.50.

98 THE DIVERS, II [*Les Plongeurs*]. 1941–42. Oil on canvas, 7′6″ x 68″ (228.6 x 172.8 cm). Mrs. Simon Guggenheim Fund. 333.55. Repr. *Suppl. VI*, p. 12.

 TWO DIVERS [*Les Plongeurs*]. 1942. Oil on canvas, 50 x 58¹/₈″ (127 x 147.6 cm). The Sidney and Harriet Janis Collection (fractional gift). 627.67. Repr. *Léger*, p. 54; in color, *Janis*, p. 9.

98 MECHANICAL FRAGMENT. 1943–44. Oil on canvasboard, 24 x 19⁷/₈″ (60.8 x 50.4 cm). Gift of Mr. and Mrs. Donald H. Peters. 259.57. Repr. *Suppl. VII*, p. 11. *Note*: a larger version, of the same date, was in the G. David Thompson collection, Pittsburgh.

99 THREE MUSICIANS. 1944 (after a drawing of 1924–25; dated on canvas 24–44). Oil on canvas, 68¹/₂ x 57¹/₄″ (174 x 145.4 cm). Mrs. Simon Guggenheim Fund. 334.55. Repr. *Léger*, p. 65; *Suppl. VI*, p. 13.

99 BIG JULIE [*La Grande Julie*]. 1945. Oil on canvas, 44 x 50¹/₈″ (111.8 x 127.3 cm). Acquired through the Lillie P. Bliss Bequest. 141.45. Repr. *Ptg. & Sc.*, p. 131; *Léger*, p. 67; in color, *Masters*, p. 96; in color, *Invitation*, p. 129.

99 LANDSCAPE WITH YELLOW HAT. 1952. Oil on canvas, 36¹/₄ x 28⁷/₈″ (92.2 x 73.4 cm). Gift of Mr. and Mrs. David M. Solinger. 292.58. Repr. *Suppl. VIII*, p. 8.

Also, drawings, prints, a film, illustrated books, and posters.

LEHMBRUCK, Wilhelm. German, 1881–1919.

44 STANDING WOMAN. (1910) Bronze (cast in New York, 1916–17, from an original plaster), 6′3¹/₈″ (190.8 cm) high, base 20¹/₂″ (52 cm) diameter. Given anonymously. 6.30. Repr. *Ptg. & Sc.*, p. 244.

44 TORSO. (1910–11) Cast stone, 27³/₄″ (70.5 cm) high, at base 10 x 7¹/₂″ (25.4 x 19 cm). Gift of Abby Aldrich Rockefeller. 602.39. Repr. *Ptg. & Sc.*, p. 245.

44 BUST OF A WOMAN. (c. 1911) Cast stone, 19³/₈ x 19″ (49.2 x 48.2 cm). Gift of Abby Aldrich Rockefeller. 601.39. *Note*: bust of the *Kneeling Woman*, 268.39.

45 KNEELING WOMAN. (1911) Cast stone, 69¹/₂″ (176.5 cm) high, at base 56 x 27″ (142.2 x 68.6 cm). Abby Aldrich Rockefeller Fund. 268.39. Repr. *Ptg. & Sc.*, p. 246; *Masters*, p. 65.

45 STANDING YOUTH. (1913) Cast stone, 7′8″ (233.7 cm) high, at base 36 x 26³/₄″ (91.5 x 68 cm). Gift of Abby Aldrich Rockefeller. 68.36. Repr. *Ptg. & Sc.*, p. 247; *Masters*, p. 65; *What Is Mod. Sc.*, p. 37.

Also, drawings and prints.

LEKAKIS, Michael. American, born 1907.

358 PTISIS (SOARING). (1957–62) Oak, 34⁷/₈ x 25¹/₂ x 15³/₄″ (88.4 x 64.6 x 40 cm), on pine base 12 x 11³/₈ x 11″ (30.3 x 28.7 x 27.8 cm) and mahogany pedestal, 41⁷/₈ x 10⁵/₈ x 10¹/₈″ (106.2 x 27 x 25.6 cm). Gift of the artist through the Ford Foundation Purchase Program. 74.63. Repr. *Amer. 1963*, p. 57.

LENCH, Stanley. British, born 1934.

POLA NEGRI. (1958) Gouache, 30 x 21⁷/₈″ (76 x 55.5 cm). Purchase. 129.58.

LENK, Thomas (Kaspar-Thomas Lenk). German, born 1933.

491 STRATIFICATION 44D, II [*Schichtung*]. 1969. Construction of plexiglass disks, 32¹/₄ x 12¹/₄ x 13¹/₂″ (81.9 x 31.1 x 34.1 cm). Gertrud A. Mellon Fund (by exchange). 506.69. *Note*: original sculpture of 1966, acquired in 1967, was damaged beyond repair. The artist made this piece, differing slightly from the original, to replace it.

LEONID (Leonid Berman). American, born Russia. 1896–1976. Worked in France. To U.S.A. 1946.

195 SHRIMP FISHERMEN. 1937. Oil on canvas, 21¹/₄ x 31³/₄″ (54 x 80.6 cm). Gift of James Thrall Soby. 578.43. Repr. *Ptg. & Sc.*, p. 184.

195 MALAMOCCO. 1948. Oil on canvas, 36 x 28″ (91.4 x 71.1 cm). Purchase. 10.50. Repr. *Suppl. II*, p. 25.

LE PARC, Julio. Argentine, born 1928. To Paris 1958.

375 DOUBLE CONCURRENCE—CONTINUOUS LIGHT, 2. (1961) Black wood box, 21 x 19³/₄ x 5⁵/₈″ (53.4 x 50 x 14.1 cm) with illuminated aperture 7⁷/₈ x 8″ (20 x 20.2 cm) in which fifty-four plastic squares, 1¹/₂ x 1¹/₂″ (3.6 x 3.6 cm), are suspended from eighteen nylon threads; mirror backing, 11⁷/₈ x 16″ (30.1 x 40.4 cm), two reflectors, three sets of interchangeable pierced metal screens, two glass filters. Philip Johnson Fund. 199.63a–l.

375 CONTINUOUS INSTABILITY—LIGHT. (1962) Two-part construction: painted wood screen, 43¹/₂″ (110.5 cm) diameter, recessed in cylinder, 15″ (38 cm) deep; projection apparatus in wood box, 19⁵/₈ x 9 x 9″ (49.9 x 23 x 23 cm), including electric bulb, dangling aluminum blades, and four interchangeable pierced metal screens. Heat of bulb sets apparatus in motion. Inter-American Fund. 312.62. Repr. *Suppl. XII*, p. 34.

502 INSTABILITY THROUGH MOVEMENT OF THE SPECTATOR. 1962–64. Synthetic polymer paint on wood and polished aluminum in painted wood box, 28⁵/₈ x 57¹/₈ x 36¹/₂″ (72.6 x 145 x 92.8 cm). Inter-American Fund. 110.65.

LEPPER, Robert. American, born 1906.

ORB AND INSTRUMENT. 1961. Iron and other metals, 50⁷/₈″ (129.2 cm) high, wood base 2⁵/₈ x 16⁷/₈ x 9¹/₂″ (6.6 x 42.9 x 24.1 cm). Gift of the artist. 571.64.

LEPRI, Stanislao. Italian, born 1910.

BANQUET. 1945. Tempera on plywood, 18¹/₂ x 23⁵/₈″ (47 x 60 cm). Gift of D. and J. de Menil. 343.49. Repr. *20th-C. Italian Art*, pl. 104.

LESLIE, Alfred. American, born 1927.

THE SECOND TWO-PANEL HORIZONTAL. 1958. Oil on canvas, each panel, 66″ x 6′ (167.6 x 182.8 cm). Larry Aldrich Foundation Fund. 718.59a–b. Repr. *16 Amer.*, p. 36.

LEVEE, John. American, born 1924. Lives in Paris.

PAINTING. 1954. Oil on canvas, 63⁷/₈ x 51¹/₈″ (162 x 129.8 cm). Gift of Mr. and Mrs. Jack I. Poses. 192.56. Repr. *Suppl. VI*, p. 31.

OCTOBER 1, 1958. 1958. Oil on canvas, 28³/₄ x 39³/₈″ (73 x 100 cm). Gift of Joseph H. Hazen. 671.59. Repr. *Suppl. IX*, p. 38.

Also, a drawing and a print.

LEVI, Josef. American, born 1938.

512 BINAL LANTANA. 1965. White formica box with painted perforated metal screens and fluorescent lights, 36³/₄ x 39⁵/₈ x 8¹/₂″ (93.1 x 100.5 x 21.4 cm). Larry Aldrich Foundation Fund. 105.66.

LEVI, Julian E. American, born 1900.

237 PORTRAIT OF SUBA. 1944. Oil on canvas, 28¹/₈ x 19⁷/₈″ (71.4 x 50.5 cm). Purchase and exchange. 262.44. Repr. *Ptg. & Sc.*, p. 74. *Note*: the subject is the artist, Miklos Suba.

Also, a print.

LEVINE, Jack. American, born 1915.

248 THE FEAST OF PURE REASON. (1937) Oil on canvas, 42 x 48″ (106.7 x 121.9 cm). Extended loan from the United States WPA Art Program. E.L.38.2926. Repr. *Ptg. & Sc.*, p. 145.

249 THE STREET. (1938) Oil tempera and oil on canvas, 59¹/₂″ x 6′11″ (151.1 x 210.8 cm). Extended loan from the United States WPA Art Program. E.L.41.2378. Repr. *Amer. 1942*, p. 88.

249 THE PASSING SCENE. (1941) Oil on composition board, 48 x 29³/₄″ (121.9 x 75.6 cm). Purchase. 133.42. Repr. *Ptg. & Sc. (I)*, p. 55.

249 ELECTION NIGHT. (1954) Oil on canvas, 63¹/₈″ x 6′¹/₂″ (160.3 x 184.1 cm). Gift of Joseph H. Hirshhorn. 153.55. Repr. *Private Colls.*, p. 8; in color, *Invitation*, p. 109.

Also, a print and posters.

LEWIS, Wyndham. British, born U.S.A. 1884–1957.

FIGURE. 1912. Watercolor and ink, 10³/₄ x 6³/₄″ (27.3 x 17.1 cm). Gift of Victor S. Riesenfeld. 197.55.

142 ROMAN ACTORS. (1934) Watercolor, gouache, and ink, 15¹/₈ x 22¹/₈″ (38.4 x 56.2 cm). Francis E. Brennan Fund. 14.54. Repr. *Fantastic Art* (3rd), p. 215.

A HAND OF BANANAS. (c. 1938) Gouache, watercolor, pencil, ink, 8 x 7¹/₈″ (20.3 x 18.1 cm). Purchase. 408.41.

LEWITIN, Landès. American, born Cairo, of Rumanian parents. 1892–1966. To U.S.A. 1916. In Paris 1928–39.

381 INNOCENCE IN A LABYRINTH. (1940) Collage of colored photoengravings, 8¹/₂ x 17¹/₂″ (21.6 x 44.5 cm). Purchase. 6.48. Repr. *Assemblage*, p. 160.

310 KNOCKOUT. (1955–59) Oil and ground glass on composition board, 23⁷/₈ x 17⁷/₈″ (60.6 x 45.4 cm). Promised gift and extended loan from Royal S. Marks. E.L.63.1108. Repr. *16 Amer.*, p. 39.

Also, a drawing.

LIAUTAUD, Georges. Haitian, born 1899.

THE GOAT WITH TWO HEADS. (1961) Wrought iron, 16¹/₈ x 9¹/₄ x 8¹/₂″ (40.9 x 23.3 x 21.5 cm). Inter-American Fund. 76.62. Repr. *Suppl. XII*, p. 37.

LIBERMAN, Alexander. American, born Ukraine 1912. To U.S.A. 1941.

373 CONTINUOUS ON RED. 1960. Oil on circular canvas, approximately 6′8″ (203 cm) diameter. Gift of Mr. and Mrs. Fernand Leval. 381.61. Repr. *Suppl. X*, p. 52; in color, *Responsive Eye*, p. 25.

373 PASSAGE. (1960) Enamel on metal with marble base, 9¹/₄ x 6¹/₄ x 5¹/₂″ (23.4 x 15.8 x 14 cm). Gift of Mr. and Mrs. Jan Mitchell. 84.60. Repr. *Suppl. X*, p. 52.

497 TEMPLE, I. 1963–64. Burnished aluminum, 9′2³/₈″ (279.9 cm) high, base ³/₈ x 60 x 60″ (.9 x 152.4 x 152.4 cm). Given in memory of Fernand Leval by his wife and children. 449.67a–e.

Also, a drawing, prints, and photographs.

LICHTENSTEIN, Roy. American, born 1923.

440 FLATTEN—SAND FLEAS! 1962. Synthetic polymer paint and oil on canvas, 34¹/₈ x 44¹/₈″ (86.7 x 111.8 cm). Inscribed on painting: *Thung! Flatten—Sand Fleas*. Philip Johnson Fund. 106.66. Repr. *What Is Mod. Ptg.*, p. 45. *Note*: composition is based on a panel in a comic strip.

MODERN PAINTING WITH BOLT. (1966) Synthetic polymer paint and oil partly silkscreened on canvas, 68¹/₄ x 68³/₈″ (173.2 x 173.5 cm). The Sidney and Harriet Janis Collection (fractional gift). 666.67. Repr. *Janis*, p. 153.

LINDNER, Richard. American, born Germany 1901. To U.S.A. 1941.

312 THE MEETING. 1953. Oil on canvas, 60″ x 6′ (152.4 x 182.9 cm). Given anonymously. 75.62. Repr. *Amer. 1963*, p. 61. *Note*: an assembly of characters from the artist's childhood in Munich and later life in New York. Foreground: left to right, the photographer Evelyn Hofer, King Ludwig II of Bavaria, the family cook, the cat Florian, the artist Saul Steinberg. Background: the artist's sister Lizzi as a child, the artist with his aunt Else Bornstein, and the painter Hedda Sterne (then Mrs. Steinberg).

312 THE MIRROR. 1958. Oil and encaustic on canvas, 39³/₈ x 25⁵/₈″ (100 x 65 cm). Given in memory of Dr. Hermann Vollmer. 65.61. Repr. *Suppl. XI*, p. 44; *Amer. 1963*, p. 63.

CONSTRUCTION. (1962) Assemblage: plastic mask, printed paper and cloth on painted wood panel, 11⁷/₈ x 13 x 3³/₄″ (29.9 x 33 x 9.5 cm). Philip Johnson Fund. 7.63.

464 CHECKMATE. 1966. Collage with watercolor, pencil, crayon, pastel, brush and ink, 23⁷/₈ x 18″ (60.6 x 45.7 cm). John S. Newberry Fund. 370.66. *Note*: the man in the photograph is Marcel Duchamp, to whom the watercolor is dedicated.

Also, a drawing.

LIPCHITZ, Jacques. American, born Lithuania. 1891–1973. In France 1909–41. To U.S.A. 1941.

105 MAN WITH A GUITAR. 1915. Limestone, 38¹/₄″ (97.2 cm) high, at base 7³/₄ x 7³/₄″ (19.7 x 19.7 cm). Mrs. Simon Guggenheim Fund (by exchange). 509.51. Repr. *Masters*, p. 78; *What Is Mod. Sc.*, p. 44.

105 GERTRUDE STEIN. (1920) Bronze, 13³/₈″ (34 cm) high. Fund given by friends of the artist. 9.63. Repr. *Four Amer. in Paris*, p. 158.

105 SEATED MAN. (1925) Bronze, 13¹/₂ x 12″ (34.3 x 30.2 cm). Purchase. 658.39. Repr. *Ptg. & Sc.*, p. 280; *Lipchitz*, p. 46.

106 FIGURE. 1926–30. Bronze (cast 1937), 7′1¹/₄″ x 38⁵/₈″ (216.6 x 98.1 cm). Van Gogh Purchase Fund. 214.37. Repr. *Ptg. & Sc.*, p. 281; *Masters*, p. 86.

105 RECLINING NUDE WITH GUITAR. (1928) Black limestone, 16³/₈″ (41.6 cm) high, at base 27⁵/₈ x 13¹/₂″ (70.3 x 34.3 cm). Promised gift and extended loan from Mrs. John D. Rockefeller 3rd. E.L.55.1865. Repr. *Lipchitz*, pp. 50–51; *Sc. of 20th C.*, p. 140; *What Is Mod. Sc.*, p. 21.

106 SONG OF THE VOWELS. 1931. Terra cotta, 14¹/₂ x 10¹/₂″ (36.8 x 26.4 cm). Gift of the artist. 257.37. Repr. *Ptg. & Sc.*, p. 280.

SONG OF THE VOWELS. (1931) Bronze (cast 1962, from terra cotta original), 14⁵/₈ x 10″ (37 x 25.2 cm). Gift of the artist. 8.63.

107 THE RAPE OF EUROPA, II. (1938) Bronze, 15¹/₄ x 23¹/₈″ (38.7 x 58.7 cm). Given anonymously. 193.42. Repr. *Ptg. & Sc.*, p. 282.

THE RAPE OF EUROPA, IV. 1941. Chalk, gouache, brush and ink, 26 x 20″ (66 x 50.8 cm). Purchase. 154.42. Repr. *Lipchitz*, p. 63. *Note*: study for the sculpture, *Rape of Europa, IV*.

107 THE RAPE OF EUROPA, IV. 1941. Gouache, watercolor, brush and ink, 18³/₄ x 13⁵/₈″ (47.6 x 34.6 cm). Gift of Philip L. Goodwin. 6.49. *Note*: study for the sculpture, *Rape of Europa, IV*.

106 BLOSSOMING. (1941–42) Bronze, 21¹/₂ x 16¹/₂″ (54.6 x 41.8 cm). Given anonymously. 619.43. Repr. *Ptg. & Sc.*, p. 282.

107 MOTHER AND CHILD, II. (1941–45) Bronze, 50 x 51″ (127 x 129.5 cm). Mrs. Simon Guggenheim Fund (by exchange). 508.51. Repr. *Suppl. III*, p. 4; *Masters*, p. 95. *Note*: the Museum owns a watercolor and ink study for this sculpture.

Also, a drawing and prints.

LIPPOLD, Richard. American, born 1915.

367 VARIATION NUMBER 7: FULL MOON. (1949–50) Brass rods, nickel-chromium and stainless steel wire, 10 x 6′ (305 x 183 cm). Mrs. Simon Guggenheim Fund. 241.50. Repr. *Suppl. II*, p. 1; *Masters*, p. 181; *What Is Mod. Sc.*, p. 78.

Also, a drawing and a film.

LIPTON, Seymour. American, born 1903.

357 SANCTUARY. (1953) Nickel-silver over steel, 29¹/₄ x 25″ (74.3 x 63.5 cm). Blanchette Rockefeller Fund. 550.54. Repr. *Suppl. V*, p. 31. *Note*: the Museum owns a crayon study for this sculpture.

482 MANUSCRIPT. (1961). Brazed bronze on monel metal, 60³/₈″ x 7′1¹/₈″ x 37¹/₈″ (153.3 x 213.7 x 94.2 cm). Mrs. Simon Guggenheim Fund. 530.65.

Also, a drawing.

LISSITZKY, El (Lazar Markovich Lissitzky). Russian, 1890–1941. In Germany 1921–23, 1925–28.

130 PROUN 19D. (1922?) Gesso, oil, collage, etc., on plywood, 38³/₈ x 38¹/₄″ (97.5 x 97.2 cm). Katherine S. Dreier Bequest. 172.53. Repr. *Suppl. IV*, p. 15.

130 PROUN COMPOSITION. (c. 1922) Gouache and ink, 19³/₄ x 15³/₄″ (50.2 x 40 cm). Gift of Curt Valentin. 338.41. Repr. *Ptg. & Sc.*, p. 115.

PROUN GK. (c. 1922–23) Gouache, 26 x 19³/₄″ (66 x 50.2 cm). Extended loan. E.L.35.780.

Also, prints and posters.

LITWAK, Israel. American, born Ukraine. 1867–? To U.S.A. 1903.

6 DOVER, NEW JERSEY. 1947. Oil on canvas, 22 x 32″ (55.9 x 81.3 cm). Gift of Dr. F. H. Hirschland. 53.49.

LOPEZ, José Dolores. American, c. 1880–c. 1939.

11 ADAM AND EVE AND THE SERPENT. (c. 1930) Cottonwood; tree 24⅞″ (63.2 cm) high; figures 13″ and 14″ (33 and 35.6 cm) high; garden 8½ x 21¼″ (21.6 x 54 cm). Gift of Mrs. Meredith Hare. 106.43a–d. Repr. *Ptg. & Sc.*, p. 296.

LÓPEZ GARCÍA, Antonio. Spanish, born 1936.

435 THE APPARITION. 1963. Oil on wood relief, 21½ x 31⅝ x 5⅜″ (54.5 x 80.2 x 13.6 cm). Gift of the Staempfli Gallery. 290.65.

LOUIS, Morris. American, 1912–1962.

343 Untitled. (1959) Synthetic polymer paint on canvas, 11′7¼″ x 7′7¼″ (353.7 x 231.5 cm). Grace Rainey Rogers Fund. 560.63.

343 THIRD ELEMENT. 1962. Synthetic polymer paint on canvas, 7′1¾″ x 51″ (207.5 x 129.5 cm). Blanchette Rockefeller Fund. 200.63. Repr. in color, *Invitation*, p. 141.

LOVE, Jim. American, born 1927.

379 FIGURE. (1959) Assemblage: welded steel and cast iron with brush, 16″ (40.6 cm) high. Larry Aldrich Foundation Fund. 299.61. Repr. *Suppl. XI*, p. 39.

LOWRY, L. S. (Laurence Stephen Lowry). British, 1887–1976.

437 SHIPS NEAR CUMBERLAND COAST. 1963. Oil on composition board, 11⅞ x 19¼″ (30.1 x 48.7 cm). Blanchette Rockefeller Fund. 572.64.

LOZANO. See RODRÍGUEZ LOZANO.

LUNDQUIST, Evert. Swedish, born 1904.

199 POTTERY, NUMBER 9. (1949) Oil on canvas, 46⅛ x 41⅜″ (117 x 105 cm). Gift of Mrs. G. P. Raymond. 123.61. Repr. *Suppl. XI*, p. 21.

LURÇAT, Jean. French, 1892–1966.

192 ENCHANTED ISLE. (c. 1928) Oil on canvas, 15¼ x 24⅛″ (38.7 x 61.3 cm). Gift of Bernard Davis. 339.41.

 Also, prints, illustrated books, and a rug designed by the artist.

LYTLE, Richard. American, born 1935.

 ICARUS DESCENDED. (1958) Oil on canvas, 62⅜ x 70¼″ (158.4 x 178.3 cm). Elizabeth Bliss Parkinson Fund. 130.58. Repr. *Suppl. VIII*, p. 10; *16 Amer.*, p. 45.

MacBRYDE, Robert. British, born 1913.

268 WOMAN IN A RED HAT. (1947) Oil on canvas, 50 x 28½″ (127 x 72.4 cm). Acquired through the Lillie P. Bliss Bequest. 253.48. Repr. *Suppl. I*, p. 14.

 Also, prints.

MACDONALD-WRIGHT, Stanton. American, 1890–1973. In France 1907–16.

 STILL LIFE SYNCHROMY. 1913. Oil on canvas, 20 x 20″ (50.8 x 50.8 cm). Given anonymously. 347.49.

224 SYNCHROMY. (1917) Oil on canvas, 31 x 24″ (78.8 x 61 cm). Given anonymously. 346.49. Repr. *Suppl. II*, p. 11.

 SYNCHROMY IN BLUE. (c. 1917–18) Oil on canvas, 26¼ x 20⅛″

(66.4 x 51.1 cm). The Sidney and Harriet Janis Collection (fractional gift). 629.67. Repr. *Janis*, p. 21.

 TRUMPET FLOWERS. 1919. Oil on canvas, 18⅛ x 13⅛″ (45.8 x 33.2 cm). The Sidney and Harriet Janis Collection (fractional gift). 630.67. Repr. *Janis*, p. 21.

431 EMBARKATION. 1962. Oil on plywood, 48¼ x 36⅛″ (122.3 x 91.5 cm). Gift of Mr. and Mrs. Walter Nelson Pharr. 120.65.

MacENTYRE, Eduardo A. Argentine, born 1929.

505 GENERATIVE PAINTING: BLACK, RED, ORANGE. 1965. Oil on canvas, 64¾ x 59″ (164.9 x 150.4 cm). Inter-American Fund. 3.67.

McEWEN, Jean. Canadian, born 1923.

 OCHRE CELL. 1961. Oil on canvas, 30 x 30″ (76.2 x 76.2 cm). Gift of the Women's Committee of the Art Gallery of Toronto. 383.61. Repr. *Suppl. XI*, p. 55.

349 PLUMB LINE IN YELLOW. 1961. Oil on canvas, 60¼ x 60⅛″ (152.8 x 152.7 cm). Gift of Mr. and Mrs. Samuel J. Zacks. 2.62. Repr. *Suppl. XII*, p. 21.

McFADDEN, Elizabeth. American, born 1912.

 BANNERS OF THE SUN. 1955. Collage of fabric and paper on corrugated cardboard, 18¼ x 16⅛″ (46.4 x 40.7 cm). Purchase. 576.56. Repr. *Suppl. VI*, p. 22.

McGARRELL, James. American, born 1930.

285 REST IN AIR. 1958. Oil on composition board, 47⅞ x 59⅝″ (121.5 x 151.4 cm). Larry Aldrich Foundation Fund. 12.60. Repr. *New Images*, p. 105; *Suppl. X*, p. 27.

 Also, prints.

MACHLIN, Sheldon. American, 1918–1975.

509 SPACE BOX. (1963) Painted aluminum, 6 x 17⅝ x 5″ (15.2 x 44.6 x 12.7 cm). Larry Aldrich Foundation Fund. 111.65.

MacIVER, Loren. American, born 1909.

243 SHACK. (1934) Oil on canvas, 20⅛ x 24″ (51.1 x 61 cm). Gift of Abby Aldrich Rockefeller. 399.38. Repr. *Art in Our Time*, no. 136.

 YELLOW SEASON. (1938) Oil on canvas, 30⅛ x 36⅛″ (76.5 x 91.8 cm). Extended loan from the United States WPA Art Program. E.L.39.1777.

243 HOPSCOTCH. (1940) Oil on canvas, 27 x 35⅞″ (68.6 x 91.1 cm). Purchase. 1649.40. Repr. *Masters*, p. 160.

243 RED VOTIVE LIGHTS. (1943) Oil on wood, 20 x 25⅝″ (50.8 x 65.1 cm). James Thrall Soby Fund. 4.45. Repr. *Ptg. & Sc.*, p. 170.

 Also, a print; other oils and a drawing on extended loan; and a gouache in the Study Collection.

MACK, Heinz. German, born 1931.

510 SILVER DYNAMO. 1964. Motor-driven wheel covered with sheet aluminum in a glass-covered, aluminum-lined box, 60 x 60 x 7″ (152.4 x 152.4 x 17.4 cm). Elizabeth Bliss Parkinson Fund. 1239.64.

MACKE, August. German, 1887–1914.

71 SUSANNA AND THE ELDERS. 1913. Colored inks, 9⅛ x 9⅞″ (23.2 x 25 cm). Gift of Mr. and Mrs. Walter Bareiss. 573.56. Repr. *Suppl. VI*, p. 14.

71 LADY IN A PARK. 1914. Oil on canvas, 38½ x 23¼″ (97.8 x 58.9

cm). Gift of the Henry Pearlman Foundation. 16.56. Repr. *Suppl. VI*, p. 14.

Also, drawings and a print.

McNEIL, George. American, born 1908.

334 CONSTANZA. 1958. Oil on composition board, 47⁷/₈ x 47⁷/₈" (121.6 x 121.6 cm). Larry Aldrich Foundation Fund. 17.59. Repr. *Suppl. IX*, p. 20.

McWILLIAM, Frederick Edward. British, born 1909.

296 LAZARUS, II. (1955) Bronze, 38⁵/₈" (98 cm) high, at base 7¹/₂" (18.9 cm) diameter. Gift of Dr. and Mrs. Arthur Lejwa. 557.56. Repr. *Suppl. VI*, p. 27.

Also, a drawing and a monotype.

MAGALHÃES, Aloisio. Brazilian, born 1927.

LANDSCAPE. 1956. Gouache, pen and ink, 12⁷/₈ x 19⁵/₈" (32.6 x 49.8 cm). Inter-American Fund. 13.57. Repr. *Suppl. VII*, p. 22.

Also, books and graphics.

MAGARIÑOS D., Victor. Argentine, born 1924.

Untitled. (c. 1964) Felt pen with colored inks on paper, 10¹/₄ x 12¹/₂" (25.8 x 31.7 cm). Given anonymously. 588.66.

Untitled. (c. 1964) Watercolor, felt pens with colored inks on paper, 10¹/₈ x 12¹/₂" (25.7 x 31.7 cm). Inter-American Fund. 589.66.

Untitled. (c. 1964) Felt pens with colored inks and gouache on paper, 10¹/₈ x 12⁵/₈" (25.7 x 31.8 cm). Inter-American Fund. 590.66.

Untitled. (c. 1964) Felt pens with colored inks and oil on paper, 10¹/₈ x 12¹/₂" (25.6 x 31.7 cm). Inter-American Fund. 591.66.

Untitled. (c. 1964) Felt pens with colored inks on paper, 10¹/₈ x 12¹/₂" (25.7 x 31.7 cm). Inter-American Fund. 592.66.

503 OBJECT: LIGHT-FORM VARIATIONS. 1965. Synthetic polymer paint on thirty-six glass squares projecting at right angles from painted composition board, 11⁵/₈ x 11¹/₂ x 1³/₄" (29.3 x 29.1 x 4.4 cm). Inter-American Fund. 4.67.

MAGRITTE, René. Belgian, 1898–1967.

411 THE MENACED ASSASSIN [*L'Assassin menacé*]. (1926) Oil on canvas, 59¹/₄ x 6'4⁷/₈" (150.4 x 195.2 cm). Kay Sage Tanguy Fund. 247.66. Repr. *Magritte*, p. 10.

180 THE FALSE MIRROR [*Le Faux miroir*]. (1928) Oil on canvas, 21¹/₄ x 31⁷/₈" (54 x 80.9 cm). Purchase. 133.36. Repr. *Ptg. & Sc.*, p. 199; *Magritte*, p. 25; in color, *Invitation*, p. 95.

180 THE VOICE OF SPACE [*La Voix des airs*]. (1928) Oil on canvas, 25¹/₂ x 19⁵/₈" (64.8 x 49.9 cm). Purchase. 83.36. Repr. *Ptg. & Sc.*, p. 199.

THE PALACE OF CURTAINS, III [*Le Palais des rideaux*]. (1928–29) Oil on canvas, 32 x 45⁷/₈" (81.2 x 116.4 cm). The Sidney and Harriet Janis Collection (fractional gift). 631.67. Repr. *Magritte*, p. 24; *Janis*, p. 57.

180 PORTRAIT [*Le Portrait*]. (1935) Oil on canvas, 28⁷/₈ x 19⁷/₈" (73.3 x 50.2 cm). Gift of Kay Sage Tanguy. 574.56. Repr. *Suppl. VI*, p. 20; in color, *Magritte*, frontispiece.

180 THE EMPIRE OF LIGHT, II [*L'Empire des lumières, II*]. 1950. Oil on canvas, 31 x 39" (78.8 x 99.1 cm). Gift of D. and J. de Menil. 16.51. Repr. *Suppl. III*, p. 15; in color, *Magritte*, p. 50.

180 MEMORY OF A VOYAGE [*Souvenir de voyage*]. 1955. Oil on canvas, 63⁷/₈ x 51¹/₄" (162.2 x 130.2 cm). Gift of D. and J. de

Menil. 607.59. Repr. *Suppl. IX*, p. 14; *Magritte*, p. 53. *Note*: the subject is Marcel Lecomte, the Belgian poet.

Also, a drawing and magazine covers.

MAILLOL, Aristide. French, 1861–1944.

40 THE MEDITERRANEAN. (1902–05) Bronze, 41" (104.1 cm) high, at base 45 x 29³/₄" (114.3 x 75.6 cm). Gift of Stephen C. Clark. 173.53. Repr. *Masters*, p. 43; *Sc. of 20th C.*, pp. 72–74; *What Is Mod. Sc.*, p. 39.

40 DESIRE. (1906–08) Tinted plaster relief, 46⁷/₈ x 45" (119.1 x 114.3 cm). Gift of the artist. 7.30. Repr. *Ptg. & Sc.*, p. 238; *What Is Mod. Sc.*, p. 115. *Note*: plaster made from the original mold in 1925 and approved by the sculptor.

HEAD OF FLORA. (1910–11) Bronze, 14³/₄" (37.5 cm) high. Given anonymously. 599.39.

40 SUMMER. (1910–11) Tinted plaster, 64" (162.5 cm) high, at base 13¹/₄ x 11³/₄" (33.6 x 29.8 cm). Gift of the artist. 9.30. Repr. *Ptg. & Sc.*, p. 237. *Note*: plaster made from the original mold in 1925 and approved by the sculptor.

41 TORSO OF A WOMAN. (c. 1925) Bronze, 40" (101.6 cm) high, at base 10¹/₂ x 10¹/₂" (26.7 x 26.7 cm). Sam A. Lewisohn Bequest. 3.52. Repr. *Suppl. IV*, p. 6.

40 SEATED FIGURE. (c. 1930?) Terra cotta, 9" (22.9 cm) high, at base 2³/₈ x 5³/₈" (6 x 13.7 cm). Gift of Mrs. Saidie A. May. 391.42. Repr. *Ptg. & Sc.*, p. 241.

41 THE RIVER. (Begun 1938–39, completed 1943) Lead, 53³/₄ x 7'6" (136.5 x 228.6 cm), at base, 67 x 27³/₄" (170.1 x 70.4 cm). Mrs. Simon Guggenheim Fund. 697.49. Repr. *Suppl. I*, p. 26; *Masters*, p. 44.

Also, drawings, prints, illustrated books, and a magazine cover; two bronzes in the Study Collection.

MAKOWSKI, Zbigniew. Polish, born 1930.

465 SEPARATE OBJECTS. 1963. Oil on canvas, 32 x 39³/₈" (81.3 x 100 cm). Gift of Mr. and Mrs. Maurice A. Lipschultz. 112.65.

Untitled. 1964. Watercolor and ink, 4¹/₄ x 3³/₄" (10.8 x 9.5 cm). Gift of Mr. and Mrs. Irwin Hersey. 630.65.

MALEVICH, Kasimir. Russian, 1878–1935. In Germany 1927.

Exact dating of Malevich's Suprematist paintings is difficult to determine, as is the precise way they should be hung and reproduced; the same painting may appear in photographs of Malevich exhibitions during his lifetime right side up, upside down, or sideways.

128 WOMAN WITH WATER PAILS: DYNAMIC ARRANGEMENT. 1912. Oil on canvas, 31⁵/₈ x 31⁵/₈" (80.3 x 80.3 cm). 815.35. Repr. *Ptg. & Sc.*, p. 107.

128 PRIVATE OF THE FIRST DIVISION. 1914. Oil on canvas with collage of postage stamp, thermometer, etc., 21¹/₈ x 17⁵/₈" (53.7 x 44.8 cm). 814.35.

128 SUPREMATIST COMPOSITION: AIRPLANE FLYING. 1914. Oil on canvas, 22⁷/₈ x 19" (58.1 x 48.3 cm). Purchase. 248.35. Repr. *Ptg. & Sc.*, p. 113; *Mod. Art in Your Life*, p. 20. *Note*: dated 1914 on back of canvas. Exhibited Petrograd, December 1915. There is documentary evidence that the ill., p. 128, is right side up and somewhat less evidence that it is upside down.

128 SUPREMATIST COMPOSITION: RED SQUARE AND BLACK SQUARE. (1914 or 1915?) Oil on canvas, 28 x 17¹/₂" (71.1 x 44.5 cm). 816.35. Repr. *Cubism*, fig. 113; in color, *Invitation*, p. 36. *Note*: exhibited in Petrograd, December 1915, as shown on p. 128. Early editions of *Cubism* show large black square below.

129 SUPREMATIST COMPOSITION. Oil on canvas, 31⁵/₈ x 31⁵/₈″ (80.3 x 80.3 cm). 818.35. *Note*: a related pencil drawing by the artist is dated 1914–15 but the painting may date from a year or two later.

129 SUPREMATIST COMPOSITION. (1916–17?) Oil on canvas, 38¹/₂ x 26¹/₈″ (97.8 x 66.4 cm). 819.35. Repr. *Ptg. & Sc.*, p. 114.

129 SUPREMATIST COMPOSITION: WHITE ON WHITE. (1918?) Oil on canvas, 31¹/₄ x 31¹/₄″ (79.4 x 79.4 cm). 817.35. Repr. *Ptg. & Sc.*, p. 113. *Note*: just how this painting should be hung and reproduced is problematic: a photograph of a Malevich exhibition, probably Moscow, 1920, shows the painting hung with the square near the lower left-hand corner. It is hung in the Museum galleries with the square near the upper right-hand corner.

Also, drawings, didactic charts, and in the Design Collection, two porcelain saucers, one on extended loan, painted by Malevich's pupils.

MALLARY, Robert. American, born 1917.

389 IN FLIGHT. 1957. Relief of wood, dust, sand, synthetic polymer resin on painted plywood, 43¹/₂ x 6′7⁵/₈ x 4³/₈″ (110.4 x 202.2 x 11.1 cm). Larry Aldrich Foundation Fund. 15.59. Repr. *Recent Sc. U.S.A.*; *16 Amer.*, p. 49.

389 PHOENIX. 1960. Relief of cardboard and synthetic resins with sand over wood supports, 7′10¹/₂″ x 6′7¹/₂″ (240 x 202 cm). Gift of Allan Stone. 269.63.

Also, a poster and a broadside.

MALLORY, Ronald. American, born 1935.

508 Untitled. 1966. Motor-driven construction with mercury sealed in plastic, 19³/₄ x 19³/₄ x 8″ (50.2 x 50.2 x 20.3 cm). Larry Aldrich Foundation Fund. 196.66. *Note*: one clockwise revolution occurs every two minutes.

MANESSIER, Alfred. French, born 1911.

395 FIGURE OF PITY [*Grande figure de pitié*]. 1944–45. Oil on canvas, 57³/₄ x 38¹/₄″ (146.7 x 97.2 cm). Gift of Mr. and Mrs. Charles Zadok. 590.63. Repr. *New Decade*, p. 27.

EVOCATION OF THE ENTOMBMENT. 1948. Watercolor, 3¹/₈ x 11″ (8 x 27.9 cm). Mrs. Cornelius J. Sullivan Fund. 255.48.

344 NOCTURNAL MOVEMENTS [*Mouvements nocturnes*]. 1948. Oil on canvas, 31⁷/₈ x 39³/₄″ (81 x 101 cm). Gift of Mrs. Alfred A. Knopf. 479.53.

446 FOR THE FEAST OF CHRIST THE KING. 1952. Oil on canvas, 6′7″ x 59¹/₈″ (200.5 x 150 cm). Abby Aldrich Rockefeller Fund. 197.66. Repr. *New Decade*, p. 30.

Also, prints.

MANOLO (Manuel Martínez Hugué). Spanish, 1872–1945. Worked in Paris.

43 STANDING NUDE. (1912) Bronze, 9³/₈″ (23.8 cm) high, at base 4¹/₂ x 4″ (11.4 x 10.2 cm) (irregular). Given anonymously. 597.39.

43 GRAPE HARVESTER. (1913) Bronze, 17³/₄″ (45 cm) high, at base 7 x 6″ (17.8 x 15.3 cm). Gift of Dr. and Mrs. Arthur Lejwa. 260.57. Repr. *Suppl. VII*, p. 8.

Also, prints.

MAN RAY. American, 1890–1976. Lived in Paris.

225 THE ROPE DANCER ACCOMPANIES HERSELF WITH HER SHADOWS. 1916. Oil on canvas, 52″ x 6′1³/₈″ (132.1 x 186.4 cm). Gift of G. David Thompson. 33.54. Repr. *Abstract Ptg. & Sc.*, p. 57; in color, *Invitation*, p. 45.

225 ADMIRATION OF THE ORCHESTRELLE FOR THE CINEMATO-GRAPH. 1919. Gouache, wash, and ink, airbrushed, 26 x 21¹/₂″ (66 x 54.6 cm). Gift of A. Conger Goodyear. 231.37. Repr. *Ptg. & Sc.*, p. 212.

417 CADEAU [*Gift*]. (c. 1958. Replica of 1921 original) Painted flatiron with row of thirteen tacks, heads glued to bottom, 6¹/₈ x 3⁵/₈ x 4¹/₂″ (15.3 x 9 x 11.4 cm). James Thrall Soby Fund. 249.66. Repr. *Dada, Surrealism*, p. 35 (original); *Object Transformed*, p. 28. *Note*: one of five or six replicas made before 1963. In 1963, the artist produced, signed, and numbered ten additional copies.

417 EMAK BAKIA. 1962. Replica of 1926 original. Cello fingerboard and scroll with horsehair, 29¹/₄ x 5³/₄ x 10³/₄″ (74.2 x 14.5 x 27.1 cm) on wood base in two parts, 1⁵/₈ x 11 x 11¹/₈″ (4.2 x 27.9 x 28.2 cm). Kay Sage Tanguy Fund. 5.67. *Note*: Emak Bakia is the name of the Basque villa where the artist worked on the film of the same name, 1927.

417 INDESTRUCTIBLE OBJECT (or OBJECT TO BE DESTROYED). 1964. Replica of 1923 original. Metronome with cutout photograph of eye on pendulum, 8⁷/₈ x 4³/₈ x 4⁵/₈″ (22.5 x 11 x 11.6 cm). James Thrall Soby Fund. 248.66a–e. Repr. *Assemblage*, p. 49; *The Machine*, p. 153 (other replicas). *Note*: the original *Object to Be Destroyed* was destroyed in 1957, then remade in 1958 with the title *Indestructible Object*. "Since 1940, I made a replica from time to time, in all about five examples. These including the one you have I consider originals bearing the original eye." One hundred replicas were produced in 1965.

Also, drawings, photographs, films, an illustration, a poster, magazine covers, and a chess set; an altered photograph and a chess table in the Study Collection.

MANSO, Leo. American, born 1914.

381 ASCENT 3. (1962) Collage of painted fabric on cardboard, 26 x 12⁵/₈″ (65.9 x 32.1 cm) (composition). Gift of Mr. and Mrs. Sidney Elliott Cohn. 12.63.

EARTH 2. (1962) Collage of painted fabric and paper on cardboard, 23 x 20″ (58.3 x 50.6 cm). Gift of Dr. and Mrs. Ronald Neschis. 13.63.

MANZÙ, Giacomo. Italian, born 1908.

292 PORTRAIT OF A LADY. (1946) Bronze (cast 1955), 59¹/₄ x 23¹/₄ x 44³/₈″ (150.5 x 59 x 112.5 cm). A. Conger Goodyear Fund. 193.56. Repr. *Suppl. VI*, p. 26; another cast, *20th-C. Italian Art*, pl. 125. *Note*: the subject is Mrs. Alice Lampugnani.

Also, a print and an illustrated book.

MAPANDA, Kumberai. Rhodesian, Shona tribe, born c. 1940.

478 LITTLE MASK. (1964) Stone (steatite), 4³/₄ x 3⁵/₈ x 2⁵/₈″ (11.8 x 9.2 x 6.4 cm). Katherine S. Dreier Fund. 2103.67.

MARC, Franz. German, 1880–1916.

403 BLUE HORSE WITH RAINBOW. (1913) Watercolor, gouache, and pencil, 6³/₈ x 10¹/₈″ (16.2 x 25.7 cm). John S. Newberry Collection. 2.64.

MARCA-RELLI, Conrad. American, born 1913.

382 SLEEPING FIGURE. 1953–54. Collage of painted canvas, 52¹/₈″ x 6′5⁵/₈″ (132.4 x 197.3 cm). Mr. and Mrs. Walter Bareiss Fund. 337.55. Repr. *Suppl. VI*, p. 23.

MARCHAND, André. French, born 1907.

THE KNIFE. Oil on canvas, 18¹/₈ x 21⁵/₈″ (46 x 54.9 cm). Gift of Mrs. Sam A. Lewisohn. 55.52.

MARCKS, Gerhard. German, born 1889.

203 THE RUNNERS. (1924) Bronze, $7^3/4''$ (19.6 cm) high, at base $7^7/8$ x $2^1/4''$ (20 x 5.7 cm). Gift of Abby Aldrich Rockefeller. 625.39. Repr. *Ptg. & Sc.*, p. 248.

203 CRUCIFIX. (1948) Bronze, 23 x $18^5/8''$ (58.5 x 47.1 cm), on wood cross $27^5/8$ x $21^7/8''$ (72 x 55.5 cm). Gift of Mrs. John D. Rockefeller 3rd. 338.55. Repr. *Suppl. VI*, p. 18.

203 FREYA. (1949) Bronze, $66^5/8''$ (169.2 cm) high, at base $19^1/2$ x $16^7/8''$ (49.5 x 42.9 cm). Gift of Curt Valentin. 271.54. Repr. *Suppl. V*, p. 13.

203 AMAZON. (1949–50) Bronze, 26" (66 cm) high, at base $5^1/4$ x $5^1/4''$ (13.4 x 13.4 cm). Gift of Curt Valentin. 17.51. Repr. *Suppl. III*, p. 21.

Also, a drawing, prints, and illustrated books.

MARCOUSSIS, Louis. Polish, 1883–1941. To France 1903.

100 STILL LIFE WITH ZITHER. 1919. Watercolor, oil, ink, and pencil on paper, $16^3/4$ x $9^1/2''$ (42.5 x 24.1 cm). Katherine S. Dreier Bequest. 174.53.

Also, a drawing, prints, illustrated books, and a rug designed by the artist.

MARGULES, De Hirsh. American, born Rumania. 1899–1965. To U.S.A. 1899.

PORTUGUESE DOCK, GLOUCESTER. 1936. Watercolor, $14^5/8$ x $22^7/8''$ (37.2 x 58.1 cm). Gift of A. Conger Goodyear (by exchange). 107.36. Repr. *La Pintura*, p. 138.

MARI, Enzo. Italian, born 1932.

509 DYNAMIC OPTICAL DEFORMATION OF A CUBE IN A SPHERE. (1958–63) Transparent polyester resin, 4" (10.1 cm) diameter. Larry Aldrich Foundation Fund. 501.65. Repr. *Responsive Eye*, p. 50.

MARIA (Maria Martins). Brazilian, 1910–1973. In U.S.A. 1939–1948.

313 CHRIST. (1941) Jacaranda wood, $7'10^1/2''$ (240 cm) high, base 20" (50.8 cm) diameter. Gift of Nelson A. Rockefeller. 558.41. Repr. *Ptg. & Sc. (I)*, p. 58.

313 THE IMPOSSIBLE, III. (1946) Bronze, $31^1/2$ x $32^1/2''$ (80 x 82.5 cm). Purchase. 138.46. Repr. *Ptg. & Sc.*, p. 293.

313 THE ROAD; THE SHADOW; TOO LONG, TOO NARROW. (1946) Bronze, $56^1/2$ x $71^3/4$ x $23^3/8''$ (143.4 x 179.7 x 59.4 cm). Brazil Fund. 573.64.

Also, an illustration.

MARIANO (Mariano Rodríguez). Cuban, born 1912.

THE COCK. 1941. Oil on canvas, $29^1/4$ x $25^1/8''$ (74.3 x 63.8 cm). Gift of the Comisión Cubana de Cooperación Intelectual. 30.42. Repr. *Latin-Amer. Coll.*, p. 52.

FIGURES IN A LANDSCAPE. 1942. Watercolor, 23 x 28" (58.4 x 71.1 cm). Inter-American Fund. 718.42.

MARIN, John. American, 1870–1953. In Paris 1905–10.

221 LOWER MANHATTAN. 1920. Watercolor, $21^7/8$ x $26^3/4''$ (55.4 x 68 cm). The Philip L. Goodwin Collection. 104.58. Repr. in color, *Art in Prog.*, opp. p. 52; *Bulletin*, Fall 1958, p. 10.

221 CAMDEN MOUNTAIN ACROSS THE BAY. 1922. Watercolor, $17^1/4$ x $20^1/2''$ (43.8 x 52.1 cm). Gift of Abby Aldrich Rockefeller (by exchange). 16.36. Repr. *Ptg. & Sc.*, p. 70.

221 LOWER MANHATTAN (COMPOSING DERIVED FROM TOP OF WOOLWORTH). 1922. Watercolor and charcoal with paper cutout attached with thread, $21^5/8$ x $26^7/8''$ (54.9 x 68.3 cm). Acquired through the Lillie P. Bliss Bequest. 143.45. Repr. *Ptg. & Sc.*, p. 71; in color, *Masters*, p. 114; in color, *Invitation*, p. 123.

221 BUOY, MAINE. 1931. Watercolor, $14^3/4$ x $19^1/4''$ (37.5 x 48.9 cm). Gift of Philip L. Goodwin. 170.34. Repr. *Ptg. & Sc.*, p. 70.

Also, prints.

MARINI, Marino. Italian, born 1901.

293 LAMBERTO VITALI. (1945) Bronze (cast 1949), 9" (22.9 cm) high. Acquired through the Lillie P. Bliss Bequest. 694.49. Repr. *Suppl. II*, p. 28. *Note*: the subject is a Milanese businessman, art critic, and collector.

293 HORSE AND RIDER. (1947) Bronze, 64 x 62" (162.6 x 157.5 cm), at base 29 x $16^3/4''$ (73.7 x 42.6 cm). Promised gift and extended loan from Mrs. John D. Rockefeller 3rd. E.L.55.1867. Repr. *20th-C. Italian Art*, pl. 119.

292 HORSE AND RIDER. (1947–48). Bronze, $38^1/4$ x $26^7/8''$ (97.2 x 68.1 cm), at base $17^1/2$ x 12" (44.5 x 30.5 cm). Acquired through the Lillie P. Bliss Bequest. 256.48. Repr. *Masters*, p. 172; *20th-C. Italian Art*, pl. 120.

293 MIRACLE. (1953–54) Bronze, $7'11^1/2''$ x 6'1" x $54^7/8''$ (242.5 x 185.2 x 139.2 cm). Mrs. Simon Guggenheim Fund. 77.62. Repr. *Suppl. XII*, p. 40.

293 CURT VALENTIN. (1954) Bronze, $9^1/8''$ (23.2 cm) high. Gift of the artist. 17.55. Repr. *Suppl. V*, p. 13.

Also, drawings and prints.

MARISOL (Marisol Escobar). Venezuelan, born Paris 1930. To U.S.A. 1950.

394 THE FAMILY. (1962) Painted wood and other materials in three sections, $6'10^5/8''$ x $65^1/2''$ (209.8 x 166.3 cm). Advisory Committee Fund. 231.62a-c. Repr. *Amer. 1963*, p. 71. *Note*: *The Family* is based on a castoff photograph found among wastepaper near the artist's studio. Names are unknown.

PORTRAIT OF SIDNEY JANIS SELLING PORTRAIT OF SIDNEY JANIS BY MARISOL, BY MARISOL. (1967–68) Mixed mediums on wood, 69 x $61^1/2$ x $21^5/8''$ (175.2 x 156.2 x 54.8 cm). The Sidney and Harriet Janis Collection (fractional gift). 2356.67. Repr. *Janis*, p. 169.

Also, a drawing.

MARKMAN, Ronald. American, born 1931.

443 FAMILY CIRCLE. (1965) Synthetic polymer paint on canvas, $48^7/8$ x $56^1/2''$ (124 x 143.4 cm). Larry Aldrich Foundation Fund. 107.66.

MARSH, Reginald. American, 1898–1954.

234 IN FOURTEENTH STREET. 1934. Egg tempera on composition board, $35^7/8$ x $39^3/4''$ (91.1 x 101 cm). Gift of Mrs. Reginald Marsh. 262.57. Repr. *Suppl. VII*, p. 12.

Also, prints; and photographs in the Study Collection.

MARSICANO, Nicholas. American, born 1914.

466 SHE. (1959) Oil on canvas, $60^5/8$ x $52^1/8''$ (153.8 x 132.2 cm). Gift of Larry Aldrich. 938.65.

MARTIN, Agnes. American, born Canada 1912. To U.S.A. 1933.

454 THE TREE. 1964. Oil and pencil on canvas, 6 x 6' (182.8 x 182.8 cm). Larry Aldrich Foundation Fund. 5.65.

MARTIN, Fletcher. American, born 1904.

TROUBLE IN FRISCO. 1938. Oil on canvas, 30 x 36″ (76.2 x 91.4 cm). Abby Aldrich Rockefeller Fund. 10.39. Repr. *Amer. 1942*, p. 99.

Also, a poster.

MARTIN, Phillip John. British, born 1927.

348 PAINTING, POSITANO. 1953. Enamel on paper, mounted on canvas, 59 x 39″ (149.9 x 99.1 cm). Given anonymously. 247.54. Repr. *Suppl. V*, p. 27.

Also, a print.

MARTÍNEZ, Ricardo. Argentine, born 1923.

442 COLORED INCOMPREHENSION. 1964. Pen and colored inks, and colored pencils on newspaper, 11³/₈ x 16³/₈″ (28.9 x 41.4 cm). Inter-American Fund. 261.64.

MARTÍNEZ PEDRO, Luis. Cuban, born 1910.

AT THE BEACH OF JIBACOA. 1946. Watercolor and gouache on cardboard, 12¹/₂ x 9³/₈″ (31.7 x 23.8 cm). Inter-American Fund. 14.47.

368 COMPOSITION 13. 1957. Oil on canvas, 58¹/₈ x 38″ (147.5 x 96.5 cm). Gift of Mr. and Mrs. Joseph Cantor. 672.59. Repr. *Suppl. IX*, p. 19.

Also, a drawing.

MARTINI, Arturo. Italian, 1889–1947.

202 DAEDALUS AND ICARUS. (1934–35) Bronze, 24 x 9⁵/₈″ (61 x 24.3 cm). Aristide Maillol Fund. 345.49. Repr. *20th-C. Italian Art*, pl. 116.

MARX. See BURLE MARX.

MASSON, André. French, born 1896. In U.S.A. 1941–46.

395 BATTLE OF A BIRD AND A FISH. (1927) Oil on canvas, 39³/₈ x 25³/₄″ (100 x 65.2 cm). Gift of Richard L. Feigen. 591.63.

176 BATTLE OF FISHES. (1927) Sand, gesso, oil, pencil, and charcoal on canvas, 14¹/₄ x 28³/₄″ (36.2 x 73 cm). Purchase. 260.37. Repr. *Ptg. & Sc.*, p. 218.

176 ANIMALS DEVOURING THEMSELVES. (1928) Pastel, 28³/₄ x 45³/₄″ (73 x 116.2 cm). Purchase. 256.35. Repr. *Fantastic Art* (3rd), p. 183.

176 STREET SINGER. 1941. Pastel and collage of paper, leaf, and dragonfly wings, 23¹/₂ x 17¹/₂″ (59.7 x 44.5 cm). Purchase. 158.42. Repr. *Ptg. & Sc.*, p. 218.

177 LEONARDO DA VINCI AND ISABELLA D'ESTE. 1942. Oil on canvas, 39⁷/₈ x 50″ (101.3 x 127 cm). Given anonymously. 72.43. Repr. *Ptg. & Sc.*, p. 219.

177 MEDITATION ON AN OAK LEAF. 1942. Tempera, pastel, and sand on canvas, 40 x 33″ (101.6 x 83.8 cm). Given anonymously. 84.50. Repr. *Suppl. II*, p. 15.

177 WEREWOLF. (1944) Pastel, brush and ink, 18 x 24″ (45.7 x 61 cm). Acquired through the Lillie P. Bliss Bequest. 126.44.

177 ATTACKED BY BIRDS. 1956. Oil and sand on canvas, 29⁵/₈ x 35¹/₂″ (75 x 90.1 cm). Gift of Mr. and Mrs. Allan D. Emil. 270.63.

Also, drawings, prints, ballet designs, posters, illustrated books, and a copper plate for a drypoint.

MASTROIANNI, Umberto. Italian, born 1910.

292 SOLOMON. 1958. Bronze, 26³/₄ x 21″ (67.9 x 53.2 cm). Given anonymously. 11.60. Repr. *Suppl. X*, p. 30.

MATARÉ, Ewald. German, 1887–1965.

202 COW. (1924) Bronze, 6⁷/₈ x 13¹/₈″ (17.5 x 33.1 cm). Gift of Mrs. Heinz Schultz. 101.62. Repr. *Suppl. XII*, p. 12.

Also, prints.

MATHIEU, Georges. French, born 1921.

PAINTING. 1947. Oil and gesso on plywood, 62⁷/₈ x 47¹/₄″ (159.7 x 120 cm). Gift of G. David Thompson. 660.59. Repr. *Suppl. IX*, p. 21.

347 MONTJOIE SAINT DENIS! 1954. Oil on canvas, 12′3⁵/₈″ x 35¹/₂″ (375 x 90.2 cm). Gift of Mr. and Mrs. Harold Kaye. 198.55. Repr. *Suppl. V*, p. 27. *Note*: the title is a medieval French battle cry.

Also, drawings.

MATISSE, Henri. French, 1869–1954.

48 STILL LIFE. (1899?) Oil on canvas, 18¹/₈ x 15″ (46 x 38.1 cm). Gift of A. Conger Goodyear. 7.49. Repr. *Matisse*, p. 301.

48 THE SERF. (1900–03) Bronze, 37³/₈″ (92.3 cm) high, at base 12 x 13″ (30.3 x 33 cm). Mr. and Mrs. Sam Salz Fund. 553.56. Repr. *Suppl. VI*, p. 8; another cast, *Matisse*, p. 305; *Four Amer. in Paris*, pl. 13; *Sc. of Matisse*, p. 10.

MUSIC (SKETCH). (1907, summer) Oil on canvas, 29 x 24″ (73.4 x 60.8 cm). Gift of A. Conger Goodyear in honor of Alfred H. Barr, Jr. 78.62. Repr. *Suppl. XII*, p. 7; in color, *Matisse*, p. 79; *Four Amer. in Paris*, pl. 12. *Note*: study for the large composition now at the Hermitage, Leningrad.

48 RECLINING NUDE, I. (1907) Bronze, 13¹/₂ x 19³/₄″ (34.3 x 50.2 cm). Acquired through the Lillie P. Bliss Bequest. 143.51. Repr. *Suppl. III*, p. 5; *Matisse*, p. 337; *What Is Mod. Sc.*, p. 18; *Four Amer. in Paris*, pl. 16; *Sc. of Matisse*, p. 19.

48 SEATED FIGURE, RIGHT HAND ON GROUND. (1908) Bronze, 7¹/₂ x 5″ (19 x 12.6 cm). Abby Aldrich Rockefeller Fund. 198.52. Another cast repr. *Matisse*, p. 366; *Sc. of Matisse*, p. 21.

49 DANCE (FIRST VERSION). (1909, early) Oil on canvas, 8′6¹/₂″ x 12′9¹/₂″ (259.7 x 390.1 cm). Gift of Nelson A. Rockefeller in honor of Alfred H. Barr, Jr. 201.63. Repr. *Matisse*, p. 360; in color, *Invitation*, p. 42. *Note*: the second version, of 1910, is at the Hermitage, Leningrad.

50 BATHER. (1909, summer) Oil on canvas, 36¹/₂ x 29¹/₈″ (92.7 x 74 cm). Gift of Abby Aldrich Rockefeller. 17.36. Repr. *Ptg. & Sc.*, p. 40; in color, *Matisse*, p. 161.

48 LA SERPENTINE. (1909) Bronze, 22¹/₄″ (56.5 cm) high, at base 11 x 7¹/₂″ (28 x 19 cm). Gift of Abby Aldrich Rockefeller. 624.39. Repr. *Ptg. & Sc.*, p. 250; *Matisse*, p. 367; *Sc. of Matisse*, p. 24, cover.

Series of four reliefs:

52 THE BACK, I. 1909. Bronze, 6′2³/₈″ x 44¹/₂″ x 6¹/₂″ (188.9 x 113 x 16.5 cm). Mrs. Simon Guggenheim Fund. 4.52. Repr. *Masters*, p. 51; *Matisse*, p. 313 (with wrong date); *Sc. of Matisse*, p. 26.

52 THE BACK, II. (1913) Bronze, 6′2¹/₄″ x 47⁵/₈″ x 6″ (188.5 x 121 x 15.2 cm). Mrs. Simon Guggenheim Fund. 240.56. Repr. *Suppl. VI*, p. 8; *Sc. of Matisse*, p. 27.

53 THE BACK, III. (1916–17) Bronze, 6′2¹/₂″ x 44″ x 6″ (189.2 x 111.8 x 15.2 cm). Mrs. Simon Guggenheim Fund. 5.52. Repr. *Masters*, p. 51; *Matisse*, p. 458 (wrongly entitled *The Back, II*); *Sc. of Matisse*, p. 28.

53 THE BACK, IV. (1930) Bronze, 6'2" x 44¼" x 6" (188 x 112.4 x 15.2 cm). Mrs. Simon Guggenheim Fund. 6.52. Repr. *Masters*, p. 51; plaster, *Matisse*, p. 459 (wrongly entitled *The Back, III*); *What Is Mod. Sc.*, p. 116; *Sc. of Matisse*, p. 29.

Series of five portraits of Jeannette (Jeanne Vaderin, a young woman who in 1910 was living in the Paris suburb of Clamart near Matisse's home):

52 JEANNETTE, I (Jeanne Vaderin, 1st state). (1910–13) Bronze, 13" (33 cm) high. Acquired through the Lillie P. Bliss Bequest. 7.52. Repr. *Masters*, p. 50; another cast, *Matisse*, p. 368; *Sc. of Matisse*, p. 30.

52 JEANNETTE, II (Jeanne Vaderin, 2nd state). (1910–13) Bronze, 10³/₈" (26.2 cm) high. Gift of Sidney Janis. 383.55. Repr. *Suppl. VI*, p. 9; another cast, *Matisse*, p. 369; *Sc. of Matisse*, p. 30.

53 JEANNETTE, III (Jeanne Vaderin, 3rd state). (1910–13) Bronze, 23³/₄" (60.3 cm) high. Acquired through the Lillie P. Bliss Bequest. 8.52. Repr. *Masters*, p. 50; another cast, *Matisse*, p. 369; *Sc. of Matisse*, p. 30.

53 JEANNETTE, IV (Jeanne Vaderin, 4th state). (1910–13) Bronze, 24¹/₈" (61.3 cm) high. Acquired through the Lillie P. Bliss Bequest. 9.52. Repr. *Masters*, p. 50; another cast, *Matisse*, p. 370; *Sc. of Matisse*, p. 31.

53 JEANNETTE, V (Jeanne Vaderin, 5th state). (1910–13) Bronze, 22⁷/₈" (58.1 cm) high. Acquired through the Lillie P. Bliss Bequest. 10.52. Repr. *Masters*, p. 50; another cast, *Matisse*, p. 371; *Sc. of Matisse*, p. 31.

50 GOLDFISH AND SCULPTURE. (1911) Oil on canvas, 46 x 39⁵/₈" (116.2 x 100.5 cm). Gift of Mr. and Mrs. John Hay Whitney. 199.55. Repr. *Private Colls.*, p. 7; in color, *Matisse*, p. 165.

51 THE RED STUDIO. (1911) Oil on canvas, 71¼" x 7'2¼" (181 x 219.1 cm). Mrs. Simon Guggenheim Fund. 8.49. Repr. *Suppl. I*, p. 6; in color, *Masters*, p. 49; *Matisse*, p. 162; in color, *Invitation*, p. 74.

50 THE BLUE WINDOW. (1911, autumn) Oil on canvas, 51½ x 35⁵/₈" (130.8 x 90.5 cm). Abby Aldrich Rockefeller Fund. 273.39. Repr. *Ptg. & Sc.*, p. 41; in color, *Matisse*, p. 167.

54 GOURDS. 1916 (summer). Oil on canvas, 25⁵/₈ x 31⁷/₈" (65.1 x 80.9 cm). Mrs. Simon Guggenheim Fund. 109.35. Repr. *Ptg. & Sc.*, p. 42.

55 THE MOROCCANS. (1916) Oil on canvas, 71³/₈" x 9'2" (181.3 x 279.4 cm). Gift of Mr. and Mrs. Samuel A. Marx. 386.55. Repr. in color, *Matisse*, p. 172; *Paintings from MoMA*, p. 25; *School of Paris*, p. 15; in color, *Invitation*, p. 116.

56 PIANO LESSON. (1916) Oil on canvas, 8'1½" x 6'11³/₄" (245.1 x 212.7 cm). Mrs. Simon Guggenheim Fund. 125.46. Repr. *Ptg. & Sc.*, p. 43; in color, *Masters*, p. 52; *Matisse*, p. 175; in color, *Invitation*, p. 69.

54 THE ROSE MARBLE TABLE. (1917) Oil on canvas, 57½ x 38¼" (146 x 97 cm). Mrs. Simon Guggenheim Fund. 554.56. Repr. *Matisse*, p. 407; *Suppl. VI*, p. 9.

57 INTERIOR WITH A VIOLIN CASE. (1918–19, winter) Oil on canvas, 28³/₄ x 23⁵/₈" (73 x 60 cm). Lillie P. Bliss Collection. 86.34. Repr. *Ptg. & Sc.*, p. 45; *Matisse*, p. 423.

57 TIARI. (1930) Bronze, 8" (20.3 cm) high. A. Conger Goodyear Fund. 154.55. Repr. *Matisse*, p. 461; *What Is Mod Sc.*, p. 23; *Sc. of Matisse*, p. 40. Note: tiari (French, *tiaré*) is a Tahitian flower.

57 VENUS IN A SHELL, I. (1930) Bronze, 12¼ x 7¼ x 8¹/₈" (31 x 18.3 x 20.6 cm). Gift of Pat and Charles Simon. 417.60. Repr. *Suppl. X*, p. 15; another cast, *Matisse*, p. 461; *Sc. of Matisse*, p. 42.

57 LEMONS AGAINST A FLEUR-DE-LIS BACKGROUND. 1943, March.

Oil on canvas, 28⁷/₈ x 24¼" (73.4 x 61.3 cm). Loula D. Lasker Bequest. 382.61. Repr. *Matisse*, p. 489; *Suppl. XI*, p. 13.

58 Maquettes for a set of red and yellow liturgical vestments designed for the Chapel of the Rosary of the Dominican Nuns of Vence. (c. 1950) Gouache on paper, cut and pasted.
Chasuble, front: 52½" x 6'6¹/₈" (133.3 x 198.4 cm); back: 50½" x 6'6½" (128.2 x 199.4 cm).
Stole: 49 x 7½" (124.5 x 19 cm) (design).
Maniple: 17 x 8³/₈" (43.2 x 21.2 cm) (design).
Chalice Veil: 20¼ x 20¼" (51.5 x 51.5 cm).
Burse: 10 x 8³/₄" (25.4 x 22.2 cm).
Acquired through the Lillie P. Bliss Bequest. 176.53.1–.6. *Note*: the Museum also owns a set of silk vestments made after the above maquettes, and four other chasubles, green, black, violet, and white, without the minor vestments.

59 Design for jacket of *Matisse: His Art and His Public* by Alfred H. Barr, Jr., The Museum of Modern Art, New York, 1951. (1951) Gouache on paper, cut and pasted, 10⁵/₈ x 16⁷/₈" (27 x 42.9 cm). Commissioned by the Museum. 418.53. Repr. in color, *Matisse*, jacket.

Design for cover of *Exhibition: H. Matisse*, introduction by Alfred H. Barr, Jr., The Museum of Modern Art, New York, 1951. (1951) Gouache on paper, cut and pasted, 10⁵/₈ x 15³/₄" (27 x 40 cm). Commissioned by the Museum. 419.53. Repr. in color, *Matisse*, cover.

59 NUIT DE NOËL. 1952. Maquette for stained glass window commissioned by *Life*, 1952. Gouache on paper, cut and pasted, 10'7" x 53½" (312.8 x 135.9 cm). Gift of Time Inc. 421.53.1–.5. Repr. in color, *Last Works of Matisse*, pl. J. *Note*: the window made after the above maquette is also owned by the Museum. Gift of Time Inc.

Also, drawings, prints, monotypes, illustrated books, posters, a stained glass window, and a rug designed by the artist.

MATTA (Sebastian Antonio Matta Echaurren). Chilean, born 1912. In U.S.A. 1939–48. Lives in Paris.

PAYSAGE FLAMMIFÈRE. (1940) Crayon and pencil on paper, 18¹/₈ x 22½" (45.8 x 57.1 cm). The Sidney and Harriet Janis Collection (fractional gift). 632.67. Repr. *Janis*, p. 75.

306 LISTEN TO LIVING [*Écoutez vivre*]. 1941. Oil on canvas, 29½ x 37³/₈" (74.9 x 94.9 cm). Inter-American Fund. 33.42. Repr. *Ptg. & Sc.*, p. 221; in color, *Masters*, p. 166.

306 THE HANGED MAN. (1942) Oil on canvas, 38¼ x 51¼" (97.2 x 130.2 cm). Gift of Charles E. Merrill. 579.43. Repr. *Matta*, p. 14.

307 LE VERTIGE D'ÉROS. (1944) Oil on canvas, 6'5" x 8'3" (195.6 x 251.5 cm). Given anonymously. 65.44. Repr. *Ptg. & Sc.*, p. 220; in color, *Matta*, p. 22; in color, *Invitation*, p. 91.

307 THE SPHERICAL ROOF AROUND OUR TRIBE (REVOLVERS). (1952) Tempera on canvas, 6'6⁵/₈" x 9'7⁷/₈" (199.7 x 294.5 cm). Gift of D. and J. de Menil. 16.54. Repr. *Suppl. V*, p. 22; *Matta*, p. 31.

Untitled. (1958?) Oil on canvas, 44⁷/₈ x 57½" (113.8 x 146 cm). Gift of Mr. and Mrs. David Kluger. 720.59. Repr. *Suppl. IX*, p. 22.

Also, drawings, prints, and an illustrated book.

MAUNY, Jacques. French, born 1892.

IN PORT. (Before 1932) Oil on cardboard, 11³/₄ x 11³/₄" (29.8 x 29.8 cm). Given anonymously. 112.35.

PICASSO. (Before 1932) Gouache, 10³/₈ x 13⁷/₈" (26.1 x 35.1 cm). Given anonymously. 114.35.

MAURER, Alfred. American, 1868–1932.

219 SELF-PORTRAIT. (c. 1927) Oil on composition board, 21½ x 18″ (54.6 x 45.7 cm). Bertram F. and Susie Brummer Foundation Fund. 290.61. Repr. *Suppl. XI*, p. 11.

MECHAU, Frank A. American, 1903–1946.

235 DANGERS OF THE MAIL. (1935) Study for mural in Post Office Department Building, Washington, D.C., 1937. Oil, tempera, and pencil on paper, 25 x 54½″ (63.5 x 138.4 cm). Gift of A. Conger Goodyear. 101.36. Repr. *Ptg. & Sc.*, p. 165.

PONY EXPRESS. (1935) Study for mural in Post Office Department Building, Washington, D.C., 1937. Oil on paper, 25 x 54½″ (63.5 x 138.4 cm). Gift of A. Conger Goodyear. 100.36. Repr. *La Pintura*, p. 83.

MEHRING, Howard. American, born 1931.

457 NOVA. 1965. Synthetic polymer paint on canvas, 7′7⅞″ x 70⅛″ (215.5 x 178 cm). Gift of Mr. and Mrs. Eugene M. Schwartz. 254.66.

MÉRIDA, Carlos. Guatemalan, born 1891. Lives in Mexico.

214 TEMPO IN RED MAJOR. 1942. Wax crayon, 17⅞ x 24″ (45.4 x 61 cm). Inter-American Fund. 738.42. Repr. *Ptg. & Sc.*, p. 224.

Also, prints.

MERKIN, Richard. American, born 1938.

444 THE NIGHT THE NUT GOT LOOSE. (1965) Gouache and charcoal on paper over cardboard, 26 x 39¾″ (65.8 x 100.9 cm). Larry Aldrich Foundation Fund. 385.66.

MERRILD, Knud. American, born Denmark. 1894–1954. To U.S.A. 1921.

HERMA. 1935. Gesso-wax on paper, 10½ x 8½″ (26.7 x 21.6 cm). Purchase. 75.39. Repr. *Amer. 1942*, p. 110.

310 ARCHAIC FORM. 1936. Gesso-wax and pencil on paper, 10½ x 8¾″ (26.7 x 22.2 cm). Purchase. 73.39. Repr. *Amer. 1942*, p. 111; *Ptg. & Sc.*, p. 224.

SYNTHESIS. (c. 1936) Gesso-wax on paper, 10 x 9¼″ (25.4 x 23.6 cm). Purchase. 74.39. Repr. *Amer. 1942*, p. 109.

310 PERPETUAL POSSIBILITY. 1942. Enamel on canvas over composition board, 20 x 16⅛″ (50.8 x 41.1 cm). Gift of Mrs. Knud Merrild. 85.60.

CHAIN REACTION. 1947. Oil on canvas over composition board, 17½ x 13½″ (44.5 x 34.3 cm). Gift of Alexander M. Bing. 144.51. Repr. *Suppl. III*, p. 17.

MESSAGIER, Jean. French, born 1920.

448 JUNE CROSSING [*Traversée de juin*]. 1956. Oil on canvas, 58⅞″ x 6′4⅜″ (149.5 x 193.9 cm). Promised gift and extended loan from Mr. and Mrs. David Kluger. E.L.64.272.

METZINGER, Jean. French, 1883–1956.

100 LANDSCAPE. (1912–14?) Oil on canvas, 28¾ x 36¼″ (73 x 92.1 cm). Gift of T. Catesby Jones. 410.41.

100 STILL LIFE WITH LAMP. (1916) Oil on canvas mounted on composition board, 32 x 23⅞″ (81.2 x 60.5 cm). Gift of Mr. and Mrs. Harry Lewis Winston. 412.60. Repr. *Suppl. X*, p. 19.

403 COMPOSITION. (1919?) Oil on canvas, 31⅞ x 25⅝″ (81 x 64.9 cm). Gift of Mr. and Mrs. A. M. Adler. 1240.64.

Also, an illustration.

MEZA, Guillermo. Mexican, born 1917.

287 DEMONSTRATION. (1942) Oil on canvas, 19¾ x 39⅜″ (50.2 x 100 cm). Gift of Sam A. Lewisohn (by exchange). 739.42. Repr. *Ptg. & Sc.*, p. 179.

Also, drawings and a print.

MIKI, Tomio. Japanese, born 1937.

475 UNTITLED (EARS). (1964) Cast aluminum relief, 21⅜ x 19 x 1½″ (54.3 x 48.2 x 3.7 cm). Philip Johnson Fund. 607.65. Repr. *New Jap. Ptg. & Sc.*, p. 108.

MIKUS, Eleanore. American, born 1927.

TABLET NUMBER 84. 1964. Synthetic polymer paint on composition-board sections, 51⅝ x 35⅞″ (131.1 x 90.9 cm). Gift of Louise Nevelson. 505.65.

MILIÁN, Raúl. Cuban, born 1914.

COMPOSITION. (1951) Colored inks, 15 x 11″ (38 x 27.9 cm). Gift of Emilio del Junco. 183.52.

Untitled. 1959. Watercolor and ink, 14⅞ x 11″ (37.7 x 27.9 cm). Gift of Emilio del Junco. 86.60.

Untitled. 1959. Watercolor and ink, 15 x 11″ (38 x 27.9 cm). Gift of Emilio del Junco. 87.60.

Untitled. 1960. Watercolor and ink, 15 x 11″ (38 x 27.9 cm). Gift of Emilio del Junco. 88.60. Repr. *Suppl. X*, p. 57.

MILLARES, Manolo. Spanish, born 1926.

378 COMPOSITION 9. (1957) Whiting and lampblack on burlap and string, 27⅝ x 53¼″ (70.2 x 135.3 cm). Blanchette Rockefeller Fund. 134.58. Repr. *Suppl. VIII*, p. 15.

MILNE, David Brown. Canadian, 1882–1953.

217 SUNBURST OVER THE CATSKILLS. 1917. Watercolor, 15⅛ x 21¾″ (38.4 x 55.2 cm). Gift of Douglas M. Duncan. 384.61. Repr. *Suppl. XI*, p. 53.

Also, a print.

MINGUZZI, Luciano. Italian, born 1911.

304 DOG AMONG REEDS. (1951) Bronze, 27⅛ x 21″ (68.9 x 53.3 cm). Aristide Maillol Fund. 20.53. Repr. *Suppl. IV*, p. 37.

MINNE, George. Belgian, 1867–1941.

38 KNEELING YOUTH. (1898) Original plaster, 31⅜″ (79.6 cm) high, at base 6¾ x 12⅝″ (17.1 x 32 cm). Gift of Mr. and Mrs. Samuel Josefowitz. 232.62. Repr. *Suppl. XII*, p. 4; bronze cast, *Art Nouveau*, p. 72. *Note*: five replicas in marble were commissioned about 1902 by the architect Henry van de Velde for a fountain in Karl Osthaus's Folkwang Museum at Hagen, later moved to Essen.

MIRÓ, Joan. Spanish, born 1893. In Paris 1919–40.

Dupin refers to the catalog *Joan Miró: Life and Work*, by Jacques Dupin, New York, 1962.

170 TABLE WITH GLOVE. 1921. Oil on canvas, 46 x 35¼″ (116.8 x 89.5 cm). Gift of Armand G. Erpf. 18.55. *Dupin* 72. Repr. *Private Colls.*, p. 7; *Miró* (1959), p. 30; in color, *Miró* (1973), p. 17. *Note*: former title, *Glove and Newspaper*.

170 THE CARBIDE LAMP. 1922–23. Oil on canvas, 15 x 18″ (38.1 x 45.7 cm). Purchase. 12.39. *Dupin* 80. Repr. *Ptg. & Sc.*, p. 126; *Miró* (1973), p. 18.

170 THE EAR OF GRAIN. 1922–23. Oil on canvas, 14⁷/₈ x 18¹/₈″ (37.8 x 46 cm). Purchase. 11.39. *Dupin* 81. Repr. *Ptg. & Sc.*, p. 126; *Miró* (1959), p. 34; *Miró* (1973), p. 19.

170 THE HUNTER (CATALAN LANDSCAPE). 1923–24. Oil on canvas, 25¹/₂ x 39¹/₂″ (64.8 x 100.3 cm). Purchase. 95.36. *Dupin* 84. Repr. *Ptg. & Sc.*, p. 215; in color, *Masters*, p. 142; *Miró* (1959), p. 39; in color, *Miró* (1973), p. 23; in color, *Invitation*, p. 90.

171 BLUE PAINTING. 1926. Oil on canvas, 23¹/₂ x 28³/₄″ (59.7 x 73 cm). Katherine S. Dreier Bequest. 178.53. *Dupin* 167.

170 PERSON THROWING A STONE AT A BIRD. 1926. Oil on canvas, 29 x 36¹/₄″ (73.7 x 92.1 cm). Purchase. 271.37. *Dupin* 172. Repr. *Ptg. & Sc.*, p. 215; in color, *Fantastic Art* (3rd), opp. p. 184; in color, *Miró* (1973), p. 36.

171 DUTCH INTERIOR, I. 1928. Oil on canvas, 36¹/₈ x 28³/₄″ (91.8 x 73 cm). Mrs. Simon Guggenheim Fund. 163.45. *Dupin* 234. Repr. *Ptg. & Sc.*, p. 216; in color, *Miró* (1959), p. 57; in color, *Miró* (1973), p. 42, foldout; in color, *Invitation*, p. 72. *Note*: as basis for this painting the artist, according to Walter Erben in *Joan Miró*, New York, 1959, used a picture postcard of *The Lute Player* by H. M. Sorgh (Dutch painter, 1611?–1670), which he had bought at the Rijksmuseum in Amsterdam in 1928.

171 PORTRAIT OF A LADY IN 1820. 1929. Oil on canvas, 45³/₄ x 35¹/₈″ (116.2 x 89.2 cm). Purchase. 653.39. *Dupin* 240.

172 RELIEF CONSTRUCTION. 1930. Wood and metal, 35⁷/₈ x 27⁵/₈″ (91.1 x 70.2 cm). Purchase. 259.37. *Dupin*, p. 232. Repr. *Ptg. & Sc.*, p. 278; *Miró* (1959), p. 64; *Miró* (1973), p. 53.

171 OBJECT. 1931. Assemblage: painted wood, steel, string, bone, and a bead, 15³/₄″ (40 cm) high, at base 8¹/₄ x 4³/₄″ (21 x 12 cm). Gift of Mr. and Mrs. Harold X. Weinstein. 7.61. Repr. *Suppl. XI*, p. 36; *Miró* (1973), p. 55.

172 DRAWING-COLLAGE. 1933. Collage and charcoal drawing on green paper with three postcards, sandpaper, and four engravings, 42¹/₂ x 28³/₈″ (107.8 x 72.1 cm). Kay Sage Tanguy Bequest. 328.63. Repr. *Miró* (1973), p. 61.

173 PAINTING. 1933. Oil on canvas, 68¹/₂″ x 6′5¹/₄″ (174 x 196.2 cm). Gift of the Advisory Committee (by exchange). 229.37. *Dupin* 336. Repr. *Ptg. & Sc.*, p. 217; in color, *Masters*, p. 143; *Miró* (1959), p. 73; in color, *Miró* (1973), p. 59; in color, *Invitation*, p. 89. *Note*: formerly titled *Composition*.

172 ROPE AND PEOPLE, I. 1935. Oil on cardboard mounted on wood, with coil of rope, 41¹/₄ x 29³/₈″ (104.7 x 74.6 cm). Gift of the Pierre Matisse Gallery. 71.36. *Dupin* 408. Repr. *Fantastic Art* (3rd), p. 187; *Miró* (1959), p. 76; in color, *Miró* (1973), p. 69.

416 OBJECT. (1936) Assemblage: stuffed parrot on wood perch, stuffed silk stocking with velvet garter and doll's paper shoe suspended in a hollow wood frame, derby hat, hanging cork ball, celluloid fish, and engraved map, 31⁷/₈ x 11⁷/₈ x 10¹/₄″ (81 x 30.1 x 26 cm). Gift of Mr. and Mrs. Pierre Matisse. 940.65a–c. Repr. *Miró*, p. 77; *Assemblage*, p. 63; *Dada*, p. 147; *What Is Mod. Sc.*, p. 95; in color, *Miró* (1973), p. 71. *Note*: the original map disintegrated and the fish disappeared; both have been replaced. Also called *Poetic Object*.

172 THE BEAUTIFUL BIRD REVEALING THE UNKNOWN TO A PAIR OF LOVERS. 1941. Gouache and oil wash, 18 x 15″ (45.7 x 38.1 cm). Acquired through the Lillie P. Bliss Bequest. 7.45. *Dupin* 558. Repr. *Ptg. & Sc.*, p. 218; *Miró* (1959), p. 105; in color, *Miró* (1973), p. 80.

174– MURAL PAINTING. (1950–51) Oil on canvas, 6′2³/₄″ x 19′5³/₄″
175 (188.8 x 593.8 cm). Mrs. Simon Guggenheim Fund. 592.63. *Dupin* 775. Repr. *Miró* (1959), pp. 130–131; in color, *Miró* (1973), p. 86, foldout. *Note*: commissioned by Harvard University for Harkness Commons Dining Room, Graduate Center, and later replaced by a ceramic replica.

409 PERSON, WOMAN, BIRD, STAR AT SUNSET. 1953. Oil and gesso on gouged and burnt composition board, 42¹/₂ x 21¹/₂″ (107.9 x 54.6 cm). Kay Sage Tanguy Fund. 198.66. *Dupin* 821 (called *Painting on Masonite*). Repr. *Miró* (1959), p. 142; *Assemblage*, p. 63; *Miró* (1973), p. 93.

Design for jacket of *Joan Miró* by James Thrall Soby, The Museum of Modern Art, New York, 1959. (1958) Watercolor, brush and ink, 9⁵/₈ x 17³/₄″ (24.4 x 45 cm). Commissioned by the Museum. Gift of the artist. 721.59. Repr. *Suppl. IX*, p. 15; in color, *Miró* (1959), jacket.

Also, drawings, prints, posters, illustrated books, a wood block, and a rug designed by the artist; an oil and drawings in the Study Collection.

MISHAAN, Rodolfo (Rodolfo Mishaan Pinto). Guatemalan, born 1924. Lives in U.S.A.

438 MAYA. (1965) Collage of casein-painted newspaper and synthetic polymer paint on matboard, 40¹/₄ x 60″ (102.2 x 152.4 cm). Larry Aldrich Foundation Fund. 199.66.

MITCHELL, Joan. American, born 1926.

336 LADYBUG. (1957) Oil on canvas, 6′5⁷/₈″ x 9′ (197.9 x 274 cm). Purchase. 385.61. Repr. *Suppl. XI*, p. 31.

MODEL, Evsa. American, born Russia 1900. Worked in France. To U.S.A. 1938.

OPEN DOOR. (1942) Oil on canvas, 65¹/₈ x 43″ (165.4 x 109.2 cm). Purchase. 390.42.

MODIGLIANI, Amedeo. Italian, 1884–1920. To France 1906.

112 CARYATID. (c. 1914) Limestone, 36¹/₄″ (92.1 cm) high, at base 16³/₈ x 16⁷/₈″ (41.6 x 42.9 cm). Mrs. Simon Guggenheim Fund. 145.51. Repr. *Suppl. III*, p. 3; *Masters*, p. 104; *Modigliani* (3rd), p. 20.

113 HEAD. (1915?) Limestone, 22¹/₄ x 5 x 14³/₄″ (56.5 x 12.7 x 37.4 cm). Gift of Abby Aldrich Rockefeller in memory of Mrs. Cornelius J. Sullivan. 593.39. Repr. *Ptg. & Sc.*, p. 251.

113 BRIDE AND GROOM. (1915–16) Oil on canvas, 21³/₄ x 18¹/₄″ (55.2 x 46.3 cm). Gift of Frederic Clay Bartlett. 339.42. Repr. *Ptg. & Sc.*, p. 60; in color, *Modigliani* (3rd), p. 25.

112 ANNA ZBOROWSKA. (1917) Oil on canvas, 51¹/₄ x 32″ (130.2 x 81.3 cm). Lillie P. Bliss Collection. 87.34. Repr. *Ptg. & Sc.*, p. 61; *Modigliani* (3rd), p. 51.

113 RECLINING NUDE [*Le Grand nu*]. (c. 1919) Oil on canvas, 28¹/₂ x 45⁷/₈″ (72.4 x 116.5 cm). Mrs. Simon Guggenheim Fund. 13.50. Repr. *Suppl. II*, p. 3; in color, *Masters*, p. 105; *Modigliani* (3rd), p. 49; *Paintings from MoMA*, p. 31; in color, *Invitation*, p. 78.

Also, drawings.

MOHOLY-NAGY, László. American, born Hungary. 1895–1946. In Germany 1921–34; U.S.A. 1937–46.

140 NICKEL CONSTRUCTION. (1921) Nickel-plated iron, welded, 14¹/₈″ (35.6 cm) high, base 6⁷/₈ x 9³/₈″ (17.5 x 23.8 cm). Gift of Mrs. Sibyl Moholy-Nagy. 17.56. Repr. *Suppl. VI*, p. 17; *The Machine*, p. 136.

140 Z II. 1925. Oil on canvas, 37⁵/₈ x 29⁵/₈″ (95.4 x 75.1 cm). Gift of Mrs. Sibyl Moholy-Nagy. 18.56. Repr. *Suppl. VI*, p. 16.

SPACE MODULATOR L3. (1936) Oil on perforated zinc and composition board, with glass-headed pins, 17¹/₄ x 19¹/₈″ (43.8 x 48.6 cm). Purchase. 223.47. Repr. *Ptg. & Sc.*, p. 115.

Untitled. 1942. Oil on clear plastic, 23¹/₈ x 18¹/₈″ (58.7 x 46 cm). Gift of Mrs. Katharine Kuh. 526.61. Repr. *Suppl. XI*, p. 22.

141 DOUBLE LOOP. 1946. Plexiglass, 16¼ x 22¼ x 17½" (41.1 x 56.5 x 44.5 cm). Purchase. 195.56. Repr. *Suppl. VI*, p. 17.

Also, a drawing, prints, posters, and photographs.

MOLINARI, Guido. Canadian, born 1933.

372 YELLOW ASYMMETRY. 1959. Synthetic polymer paint on canvas, 48 x 60" (122 x 152.1 cm). Gift of Mr. and Mrs. Monroe Geller. 75.63.

MONDRIAN, Piet. Dutch, 1872–1944. Worked in Paris 1912–14, 1919–38; in New York 1940–44.

134 MILL BY THE WATER. (c. 1905) Oil on canvas mounted on cardboard, 11⅞ x 15" (30.2 x 38.1 cm). Purchase. 243.50. Repr. *Suppl. II*, p. 8. Note: formerly titled and dated *Landscape with Mill* (before 1905).

RED AMARYLLIS WITH BLUE BACKGROUND. (c. 1907) Watercolor, 18⅜ x 13" (46.5 x 33 cm). The Sidney and Harriet Janis Collection (fractional gift). 1773.67. Repr. *Janis*, p. 25.

134 BLUE FAÇADE (COMPOSITION 9). (1913–14) Oil on canvas, 37½ x 26⅝" (95.2 x 67.6 cm). Gift of Mr. and Mrs. Armand P. Bartos. 153.57. Repr. *Suppl. VII*, p. 10.

134 COMPOSITION IN BROWN AND GRAY. (1913–14) Oil on canvas, 33¾ x 29¾" (85.7 x 75.6 cm). Purchase. 242.50. Repr. *Suppl. II*, p. 8.

134 COLOR PLANES IN OVAL. (1914?) Oil on canvas, 42⅜ x 31" (107.6 x 78.8 cm). Purchase. 14.50. Repr. *Suppl. II*, p. 9; *de Stijl*, pp. 6 (detail), 7.

COMPOSITION, V. 1914. Oil on canvas, 21⅝ x 33⅝" (54.8 x 85.3 cm). The Sidney and Harriet Janis Collection (fractional gift). 633.67. Repr. in color, *Janis*, p. 27; in color, *Invitation*, p. 49. Note: also called *Façade, 5*.

135 PIER AND OCEAN. 1914. Charcoal and white watercolor on buff paper, 34⅝ x 44" (87.9 x 111.2 cm); oval composition 33 x 40" (83.8 x 101.6 cm). Mrs. Simon Guggenheim Fund. 34.42. Repr. *Mondrian*, p. 6.

COMPOSITION WITH COLOR PLANES, V. 1917. Oil on canvas, 19⅜ x 24⅛" (49 x 61.2 cm). The Sidney and Harriet Janis Collection (fractional gift). 1774.67. Repr. *Janis*, p. 28; in color, *Invitation*, p. 49.

135 COMPOSITION C. 1920. Oil on canvas, 23¾ x 24" (60.3 x 61 cm). Acquired through the Lillie P. Bliss Bequest. 257.48. Repr. *Suppl. I*, p. 18; in color, *Masters*, p. 217.

135 COMPOSITION. 1921. Oil on canvas, 29⅞ x 20⅝" (76 x 52.4 cm). Gift of John L. Senior, Jr. 154.57. Repr. *Suppl. VII*, p. 10.

136 COMPOSITION. 1925. Oil on canvas, 15⅞ x 12⅝" (40.3 x 32.1 cm). Gift of Philip Johnson. 486.41. Repr. *Mod. Art in Your Life*, p. 10.

136 PAINTING, I. 1926. Oil on canvas; diagonal measurements, 44¾ x 44" (113.7 x 111.8 cm). Katherine S. Dreier Bequest. 179.53. Repr. *Suppl. IV*, p. 14; *Mondrian*, p. 10; *Masters*, p. 122.

COMPOSITION, I. 1931. Oil on canvas, 19⅞ x 19⅞" (50.4 x 50.3 cm). The Sidney and Harriet Janis Collection. 634.67. Repr. *Janis*, p. 31. Note: also called *Composition in Red and Blue*.

COMPOSITION. 1933. Oil on canvas, 16¼ x 13⅛" (41.2 x 33.3 cm). The Sidney and Harriet Janis Collection (fractional gift). 635.67. Repr. *Modern Works*, no. 118; *Mondrian*, p. 11; *Janis*, p. 31. Note: also called *Composition in White, Blue and Red; Composition (Red and Blue); Composition with Blue and Red*. The painting appears on the easel of George Segal's sculpture *Portrait of Sidney Janis with Mondrian Painting*.

136 COMPOSITION IN WHITE, BLACK, AND RED. 1936. Oil on canvas,

40¼ x 41" (102.2 x 104.1 cm). Gift of the Advisory Committee. 2.37. Repr. *Ptg. & Sc.*, p. 117; *Mondrian*, cover.

COMPOSITION WITH BLUE SQUARE, II. 1936–42. Oil on canvas, 24½ x 23⅞" (62.1 x 60.4 cm). The Sidney and Harriet Janis Collection. 636.67. Repr. *Janis*, p. 32. Note: also called *Composition; Composition II with Blue; Composition II with Blue Square; N:12 Blue Square*.

COMPOSITION IN YELLOW, BLUE, AND WHITE, I. 1937. Oil on canvas, 22½ x 21¾" (57.1 x 55.2 cm). The Sidney and Harriet Janis Collection (fractional gift). 637.67. Repr. *Janis*, p. 32.

COMPOSITION IN RED, BLUE, AND YELLOW. 1937–42. Oil on canvas, 23¾ x 21⅞" (60.3 x 55.4 cm). The Sidney and Harriet Janis Collection (fractional gift). 638.67. Repr. *Janis*, p. 33.

137 BROADWAY BOOGIE WOOGIE. 1942–43. Oil on canvas, 50 x 50" (127 x 127 cm). Given anonymously. 73.43. Repr. *Ptg. & Sc.*, p. 118; *Mondrian*, p. 14; in color, *Masters*, p. 123; in color, *Invitation*, p. 39.

137 VICTORY BOOGIE WOOGIE. (1943–44, unfinished) Oil on canvas with colored tape and paper; diagonal measurements, 70¼ x 70¼" (178.4 x 178.4 cm). Extended loan from Mr. and Mrs. Burton Tremaine. E.L.49.2415. Repr. *Mondrian*, p. 16.

Also, a drawing.

MONET, Claude. French, 1840–1926.

19 POPLARS AT GIVERNY, SUNRISE. (1888) Oil on canvas, 29⅛ x 36½" (74 x 92.7 cm). Gift of Mr. and Mrs. William B. Jaffe. 617.51. Repr. *Suppl. IV*, p. 18; in color, *Masters*, p. 19; *Post-Impress.* (2nd), p. 17.

21 WATER LILIES. (c. 1920) Oil on canvas, 6'6½" x 19'7½" (199.5 x 599 cm). Mrs. Simon Guggenheim Fund. 712.59. Repr. *Suppl. X*, pp. 6–7.

20–21 WATER LILIES. (c. 1920) Oil on canvas; triptych, each section 6'6" x 14' (200 x 425 cm). Mrs. Simon Guggenheim Fund. 666.59.1–.3. Repr. *Monet*, pp. 44–45; *Suppl. IX*, pp. 4–5, 40 (detail); two panels in color, *Invitation*, pp. 24–25.

19 WATER LILIES. (c. 1920) Oil on canvas, 51½" x 6'7" (130.7 x 200.7 cm). Gift of Mme Katia Granoff. 13.60. Repr. *Suppl. X*, p. 12.

19 THE JAPANESE FOOTBRIDGE. (c. 1920–22) Oil on canvas, 35¼ x 45⅞" (89.5 x 116.3 cm). Grace Rainey Rogers Fund. 242.56. Repr. *Suppl. VI*, p. 7.

MONTENEGRO, Roberto. Mexican, born 1885.

MAYA WOMEN. (1926) Oil on canvas, 31½ x 27½" (80 x 69.8 cm). Gift of Nelson A. Rockefeller. 560.41. Repr. *Latin-Amer. Coll.*, p. 68.

MOORE, Henry. British, born 1898.

H.M. refers to the catalog *Henry Moore, Sculpture and Drawings*, London; vol. 1, 1921–48, 4th ed., 1957, edited by David Sylvester; vol. 2, 1949–54, 2nd ed., 1965, and vol. 3, 1955–64, 1965, both edited by Alan Bowness.

186 TWO FORMS. (1934) Pynkado wood, 11 x 17¾" (27.9 x 45.1 cm) on irregular oak base, 21 x 12½" (53.3 x 31.7 cm). Sir Michael Sadler Fund. 207.37. *H.M.* 153. Repr. *Ptg. & Sc.*, p. 285; *Moore*, p. 36; *Cubism*, fig. 223; *What Is Mod. Sc.*, p. 60.

186 MOTHER AND CHILD. (1938) Elmwood, 30⅜ x 13⅞ x 15½" (77.2 x 35.2 x 39.2 cm). Acquired through the Lillie P. Bliss Bequest. 21.53. *H.M.* 194. Repr. *Suppl. IV*, p. 36.

186 RECLINING FIGURE. (1938) Cast lead, 5¾ x 13" (14.6 x 33 cm). Purchase. 630.39. *H.M.* 192. Repr. *Ptg. & Sc.*, p. 287; *Moore*, p. 49.

186 THE BRIDE. (1939–40) Cast lead and copper wire, 9³⁄₈ x 4¹⁄₈″ (23.8 x 10.3 cm). Acquired through the Lillie P. Bliss Bequest. 15.47. *H.M.* 213. Repr. *Ptg. & Sc.*, p. 287.

188 SCULPTURE AND RED ROCKS. 1942. Crayon, wash, pen and ink, 19¹⁄₈ x 14¹⁄₄″ (48.6 x 36.2 cm). Gift of Philip L. Goodwin. 9.49.

188 SEATED FIGURES, II. 1942. Crayon, wash, pen and ink, 22⁵⁄₈ x 18¹⁄₈″ (57.5 x 46 cm). Acquired through the Lillie P. Bliss Bequest. 74.43. *H.M.* 245. Repr. *Ptg. & Sc. (I) Suppl.*, p. 11.

IDEAS FOR TWO-FIGURE SCULPTURE. 1944. Crayon, pen and ink, pencil, watercolor, 8⁷⁄₈ x 6⁷⁄₈″ (22.5 x 17.5 cm). Purchase. 176.46. Repr. in color, *Moore*, frontispiece.

186 FAMILY GROUP. (1945) Bronze, 9³⁄₈″ (23.8 cm) high, at base 8¹⁄₂ x 5¹⁄₈″ (21.6 x 13 cm). Acquired through the Lillie P. Bliss Bequest. 16.47. *H.M.* 259. Repr. *Ptg. & Sc.*, p. 286. *Note*: working model for large *Family Group, H.M.* 269.

187 FAMILY GROUP. (1948–49) Bronze (cast 1950), 59¹⁄₄ x 46¹⁄₂″ (150.5 x 118 cm), at base 45 x 29⁷⁄₈″ (114.3 x 75.9 cm). A. Conger Goodyear Fund. 146.51. *H.M.* 269. Repr. *Suppl. III*, p. 1.

188 SEATED FIGURE. (1952–53) Terra cotta, 40³⁄₄ x 19 x 19⁷⁄₈″ (103.4 x 48 x 50.5 cm). Gift of G. David Thompson. 14.63. *H.M.* 347. *Note*: the former title, *Queen*, is incorrect though this figure very closely resembles the group *King and Queen, H.M.* 350, of about the same date.

188 Study for sculpture on Time-Life Building, London. (1952–53) Bronze, 15 x 38⁷⁄₈″ (38.1 x 98.7 cm). Gift of Time Inc. 18.54. Repr. *Suppl. V*, p. 30. *Note*: cast of working model for "screen," c. 10 x 26′, *H.M.* 344.

189 RECLINING FIGURE, II. (1960) Bronze, in two parts, a) 50 x 34⁵⁄₈ x 29¹⁄₄″ (127 x 87.7 x 74.2 cm); b) 36⁵⁄₈ x 55¹⁄₄ x 41¹⁄₈″ (93 x 140.2 x 104.4 cm); overall length 8′3″ (251.6 cm). Given in memory of G. David Thompson, Jr., by his father. 131.61a–b. *H.M.* 458. Repr. *Suppl. XI*, p. 15.

415 LARGE TORSO: ARCH. (1962–63) Bronze, 6′6¹⁄₈″ x 59¹⁄₈″ x 51¹⁄₄″ (198.4 x 150.2 x 130.2 cm). Mrs. Simon Guggenheim Fund. 608.65. *H.M.* 159–62.

Also, drawings, prints, an illustrated book, and a film on the artist.

MOPP, Maximilian (Max Oppenheimer). American, born Austria. 1885–1954. To U.S.A. 1939.

159 THE WORLD WAR. (1916) Oil on canvas, 21 x 17⁵⁄₈″ (53.3 x 44.8 cm). Given anonymously. 504.41.

Also, prints and a poster.

MORALES SEQUEIRA, Armando. Nicaraguan, born 1927. To U.S.A. 1960.

SPOOK TREE. (1956) Oil on canvas, 51¹⁄₄ x 22⁵⁄₈″ (130 x 57.9 cm). Inter-American Fund. 14.57. Repr. *Suppl. VII*, p. 16.

MORANDI, Giorgio. Italian, 1890–1964.

198 STILL LIFE. 1916. Oil on canvas, 32¹⁄₂ x 22⁵⁄₈″ (82.5 x 57.5 cm). Acquired through the Lillie P. Bliss Bequest. 286.49. Repr. *Masters*, p. 103.

198 STILL LIFE. 1938. Oil on canvas, 9¹⁄₂ x 15⁵⁄₈″ (24.1 x 39.7 cm). Purchase. 688.49. Repr. *Suppl. II*, p. 17.

Also, prints.

MORENO, Rafael. Cuban, born Spain. 1887–1955.

THE FARM. (1943) Oil on canvas, 39″ x 6′6¹⁄₈″ (99.1 x 198.4 cm). Inter-American Fund. 12.44.

MORGAN, Maud. American, born 1903.

MUSICAL SQUASH. (1942) Oil on canvas, 15⁷⁄₈ x 26¹⁄₈″ (40.3 x 66.4 cm). Gift of Mrs. Kenneth Simpson. 593.42.

MORITA, Yasuji. Japanese, 1912–1960.

THE WIND MAN. (c. 1953) Brush and ink, 53¹⁄₂ x 27¹⁄₂″ (135.9 x 69.8 cm). Japanese House Fund. 272.54.

MOSKOWITZ, Robert. American, born 1935.

387 Untitled. 1961. Oil on canvas, with part of window shade, 24 x 30″ (61 x 76 cm). Larry Aldrich Foundation Fund. 300.61. Repr. *Assemblage*, p. 161.

MOSKOWITZ, Shalom. See SHALOM OF SAFED.

MOTHERWELL, Robert. American, born 1915.

329 PANCHO VILLA, DEAD AND ALIVE. 1943. Gouache and oil with collage on cardboard, 28 x 35⁷⁄₈″ (71.1 x 91.1 cm). Purchase. 77.44. Repr. *Ptg. & Sc.*, p. 231; in color, *Motherwell*, p. 14.

328 WESTERN AIR. 1946–47. Oil on canvas, 6′ x 54″ (182.9 x 137.2 cm). Purchase (by exchange). 75.50. Repr. *Contemp. Ptrs.*, p. 72; *Motherwell*, p. 13.

328 PERSONAGE, WITH YELLOW OCHRE AND WHITE. 1947. Oil on canvas, 6′ x 54″ (182.8 x 137 cm). Gift of Mr. and Mrs. Samuel M. Kootz. 15.57. Repr. *Suppl. VII*, p. 20; *New Amer. Ptg.*, p. 57; *Motherwell*, p. 24.

328 THE VOYAGE. (1949) Oil and tempera on paper mounted on composition board, 48″ x 7′10″ (122 x 238.8 cm). Gift of Mrs. John D. Rockefeller 3rd. 339.55. Repr. *Suppl. VI*, p. 40; in color, *New Amer. Ptg.*, p. 69; *Motherwell*, p. 27.

329 ELEGY TO THE SPANISH REPUBLIC, 54. (1957–61) Oil on canvas, 70″ x 7′6¹⁄₄″ (178 x 229 cm). Given anonymously. 132.61. Repr. *Suppl. XI*, p. 64; *Motherwell*, p. 44.

Also, prints.

DE MOULPIED, Deborah. American, born 1933.

371 FORM 7. (1960) Polystyrene, 12¹⁄₄ x 14¹⁄₄ x 11¹⁄₂″ (31 x 36.2 x 29 cm). Larry Aldrich Foundation Fund. 66.61. Repr. *Suppl. XI*, p. 27.

MUCCINI, Marcello. Italian, born 1926.

287 BULL. (1948) Duco on plywood, 13 x 28¹⁄₄″ (33 x 71.8 cm). Purchase. 287.49. Repr. *20th-C. Italian Art*, pl. 98.

Also, prints.

MUELLER, Otto. German, 1874–1930.

71 BATHERS. (c. 1920) Oil on burlap, 27⁵⁄₈ x 35³⁄₄″ (70.2 x 90.8 cm). Gift of Samuel A. Berger. 19.55. Repr. *Suppl. V*, p. 10.

Also, prints.

MUKAI, Shuji. Japanese, born 1939.

472 Untitled. (1963) Oil, string, and canvas on wood, 6′3⁄₈″ x 53⁷⁄₈″ (183.6 x 136.8 cm). Purchase. 609.65. Repr. *New Jap. Ptg. & Sc.*, p. 111.

MUKAROBGWA, Thomas. Rhodesian, born 1924.

DYING PEOPLE IN THE BUSH. (1962) Oil on cardboard mounted on composition board, 23¹⁄₄ x 36¹⁄₄″ (59 x 91.9 cm). Gift of Mr. and Mrs. Walter Hochschild. 331.63. Repr. *Suppl. XII*, p. 33.

RIVER COMING IN THE MIDDLE OF THE BUSH. (1962) Oil on cardboard mounted on composition board, 23³/₈ x 36¹/₈″ (59.3 x 91.7 cm). Gift of Mr. and Mrs. Walter Hochschild. 330.63. Repr. *Suppl. XII*, p. 33.

9 VERY IMPORTANT BUSH. (1962) Oil on cardboard mounted on composition board, 23¹/₂ x 36¹/₄″ (59.6 x 92 cm). Gift of Mr. and Mrs. Walter Hochschild. 329.63.

VIEW YOU SEE IN THE MIDDLE OF A TREE. (1962) Oil on composition board, 23⁷/₈ x 23⁷/₈″ (60.4 x 60.4 cm). Gift of Mr. and Mrs. Walter Hochschild. 332.63. Repr. *Suppl. XII*, p. 33.

MÜLLER, Jan. American, born Germany. 1922-1958.

283 FAUST, I. (1956) Oil on canvas, 68¹/₈″ x 10′ (173 x 304.7 cm). Purchase. 16.57. Repr. *Suppl. VII*, p. 16.

MÜLLER, Robert. Swiss, born 1920. To Paris 1950.

361 EX-VOTO. (1957) Forged iron, 6′11⁷/₈″ (213 cm) high, at base 13⁷/₈ x 14³/₄″ (33.8 x 37.9 cm). Philip Johnson Fund. 18.59. (Purchased in 1957.) Repr. *Suppl. IX*, p. 31.

MULLICAN, Lee (Alva Lee Mullican). American, born 1919.

312 PRESENCE. (1955) Painted wood construction, 36¹/₈ x 17³/₈″ (91.5 x 44.1 cm). Mr. and Mrs. Roy R. Neuberger Fund. 19.56. Repr. *Suppl. VI*, p. 32.

MUNSELL, Richard. American, born 1909.

POSING FOR THE FIRST TIME. (1939) Oil and tempera on canvas, 17¹/₂ x 8¹/₄″ (44.5 x 21 cm). Purchase. 340.41.

MURCH, Walter Tandy. American, born Canada. 1907-1967. To U.S.A. 1929.

CLOCK. 1965. Mixed mediums on cardboard, 28¹/₈ x 22¹/₄″ (71.4 x 56.3 cm). Larry Aldrich Foundation Fund. 250.66.

MÜRITOGLU, Zühtü. Turkish, born 1906.

379 THE UNKNOWN POLITICAL PRISONER. (1956) Wood and iron, 53³/₄″ (136.4 cm) high, at base 15¹/₄ x 11³/₈″ (38.6 x 28.9 cm). Purchase. 135.58. Repr. *Suppl. VIII*, p. 18. *Note*: variant of the model submitted by the artist to the international competition for a monument to The Unknown Political Prisoner, London, 1953.

MURPHY, Gerald. American, 1888-1964.

430 WASP AND PEAR. (1927) Oil on canvas, 36³/₄ x 38⁵/₈″ (93.3 x 97.9 cm). Gift of Archibald MacLeish. 1130.64.

MUSE, Isaac Lane. American, born 1906.

COMPOSITION WITH BIRD AND SHELLS. 1941. Watercolor, 13 x 20¹/₄″ (33 x 51.4 cm). Gift of Mrs. Wallace M. Scudder. 77.43.

MUSIC, Antonio Zoran. Italian, born Gorizia 1909.

DALMATIAN SCENE. 1951. Oil on canvas, 21³/₈ x 28³/₄″ (54.3 x 73 cm). Purchase. 22.53.

Also, prints.

NADELMAN, Elie. American, born Poland. 1882-1946. Worked in Paris 1904-14. To U.S.A. 1914.

250 STANDING FEMALE NUDE. (c. 1909) Bronze, 21³/₄″ (55.2 cm) high, at base 5³/₄ x 5¹/₂″ (14.6 x 14 cm). Aristide Maillol Fund. 261.48. Repr. *Nadelman*, p. 13.

250 STANDING BULL. (1915) Bronze, 6⁵/₈ x 11¹/₄″ (16.8 x 28.6 cm). Gift of Mrs. Elie Nadelman. 225.47. Repr. *Nadelman*, p. 23.

250 MAN IN THE OPEN AIR. (c. 1915) Bronze, 54¹/₂″ (138.4 cm) high, at base 11³/₄ x 21¹/₂″ (29.9 x 54.6 cm). Gift of William S. Paley (by exchange). 259.48. Repr. *Masters*, p. 106; *Nadelman*, p. 25. *Note*: the Museum owns a watercolor and ink study for this sculpture.

250 WOUNDED BULL. (1915) Bronze, 5⁷/₈ x 11¹/₂″ (14.7 x 29.2 cm). Gift of Mrs. Elie Nadelman. 226.47. Repr. *Ptg. & Sc.*, p. 253; *Nadelman*, p. 22.

250 WOMAN AT THE PIANO. (c. 1917) Wood, stained and painted, 35¹/₈″ (89.2 cm) high, at base including piano, 21¹/₂ x 8¹/₂″ (54.5 x 21.5 cm). The Philip L. Goodwin Collection. 105.58. Repr. *Nadelman*, p. 30; *Bulletin*, Fall 1958, p. 11.

251 MAN IN A TOP HAT. (c. 1927) Painted bronze, 26 x 14⁷/₈″ (66 x 37.6 cm). Abby Aldrich Rockefeller Fund. 260.48. Repr. *Nadelman*, p. 43.

251 WOMAN WITH A POODLE. (c. 1934) Terra cotta, 11³/₄ x 21¹/₂″ (29.8 x 54.5 cm). Purchase. 263.48.

251 HEAD OF A WOMAN. (c. 1942) Rose marble, 15⁵/₈″ (39.7 cm) high. Gift of William S. Paley (by exchange). 262.48. Repr. *Nadelman*, p. 41.

251 FIGURE. (c. 1945) Plaster, 11″ (27.9 cm) high. Aristide Maillol Fund. 264.48.

Also, drawings and prints.

NAGARE, Masayuki. Japanese, born 1923.

358 RECEIVING. (1959-60) Stone (gabbro), 9³/₄ x 28³/₄″ (24.7 x 73 cm). Gift of Mrs. John D. Rockefeller 3rd. 121.60. Repr. *Suppl. X*, p. 46.

NAGWARABA. Australian contemporary. Headman of the Labara clan, west coast of Groote Eylandt, northeast Australia.

11 TWO SNAKES. (1955) Colored clays over charcoal on eucalyptus bark, about 22 x 36³/₈″ (55.9 x 92.3 cm). Purchase. 290.58. Repr. *Suppl. IX*, p. 15.

NAKAMURA, Kazuo. Canadian, born 1926.

368 INNER CORE 2. 1960-61. Oil on canvas, 42 x 31″ (106.6 x 78.7 cm). Blanchette Rockefeller Fund. 386.61. Repr. *Suppl. XI*, p. 55.

NAKANISHI, Natsuyuki. Japanese, born 1935.

475 COMPACT OBJECT. (1962) Assemblage: bones, watch and clock parts, bead necklace, hair, eggshell, lens, and other manufactured objects embedded in polyester, egg-shaped, 5⁵/₈ x 8³/₈″ (14.3 x 21.2 cm). Frank Crowninshield Fund. 610.65. Repr. *New Jap. Ptg. & Sc.*, p. 99; in color, p. 18.

NAKIAN, Reuben. American, born 1897.

256 YOUNG CALF. (1927) Georgia pink marble, 15 x 11¹/₂″ (38.1 x 29.2 cm). Purchase. 297.38. Repr. *Art in Our Time*, no. 298; *Nakian*, p. 40.

256 "POP" HART. (1932) Tinted plaster, 17″ (43.2 cm) high. Gift of Abby Aldrich Rockefeller. 3.33. Repr. *Ptg. & Sc.*, p. 260; *Nakian*, p. 41.

256 HARRY L. HOPKINS. 1934. Tinted plaster, 17¹/₂″ (44.4 cm) high, on two bases 9¹/₂″ (24.1 cm) high. Gift of Charles Abrams. 401.63. Repr. *Nakian*, p. 41.

HARRY L. HOPKINS. 1934. Bronze (cast 1963), 26³/₈″ (67 cm) high including bases cast together with head. Gift of Charles Abrams. 202.63.

484 THE BURNING WALLS OF TROY. (1957) Terra cotta, 8¹/₈ x 11⁵/₈ x 5³/₈″ (20.6 x 29.5 x 13.6 cm). Gift of Wilder Green in memory of Frank O'Hara. 394.66. Repr. *Nakian*, p. 19.

357 ROCK DRAWING. (1957) Terra cotta, 10 x 14¼ x 6″ (25.3 x 36.1 x 15.2 cm). Fund given in memory of Philip L. Goodwin. 19.59. Repr. *Suppl. IX*, p. 15; *Nakian*, p. 27.

357 Study for THE RAPE OF LUCRECE. (1958) Terra cotta, 9¼ x 16 x 4¼″ (23.5 x 40.6 x 10.6 cm) (irregular). Gift of the artist in memory of Holger Cahill. 363.60. Repr. *Suppl. X*, p. 30; *Nakian*, p. 27.

485 HIROSHIMA. 1965–66. Bronze (cast 1967–68), 9′3¾″ x 6′2¾″ x 45¼″ (283.8 x 189.8 x 114.3 cm). Mrs. Simon Guggenheim Fund. 1514.68. Repr. *Nakian*, p. 46 (work in progress).

NDANDARIKA, Joseph. Rhodesian, born 1944.

286 BUSHMEN RUNNING FROM THE RAIN. (1962) Oil on composition board, 48¼ x 48″ (122.5 x 121.8 cm). Gift of Mr. and Mrs. Walter Hochschild. 333.63. Repr. *Suppl. XII*, p. 32.

NEEL, Alice. American, born 1908.

262 DAVID. (1963) Oil on canvas, 34 x 20⅛″ (86.4 x 51 cm). Larry Aldrich Foundation Fund. 561.63. *Note*: portrait of David Brody, the son of an old friend of the artist.

NEGRET, Edgar. Colombian, born 1920.

374 SIGN FOR AN AQUARIUM (MODEL). (1954) Painted iron, 4⅜ x 13½″ (11.2 x 34 cm), 3½″ (8.8 cm) diameter at base. Inter-American Fund. 551.54. Repr. *Suppl. V*, p. 37.

NEMUKHIN, Vladimir Nikolaevich. Russian, born 1925.

469 CARDS ON A MARQUETRY TABLE. 1966. Oil, tempera, and collage of playing cards on canvas, 43⅜ x 35⅛″ (110 x 89 cm). Purchase. 2104.67.

NEVELSON, Louise. American, born Ukraine 1900. To U.S.A. 1905.

385 SKY CATHEDRAL. (1958) Assemblage: wood construction painted black, 11′3½″ x 10′¼″ x 18″ (343.9 x 305.4 x 45.7 cm). Gift of Mr. and Mrs. Ben Mildwoff. 136.58. Repr. *Suppl. VIII*, p. 24; *16 Amer.*, p. 57; *What Is Mod. Sc.*, p. 119.

384 HANGING COLUMN (from *Dawn's Wedding Feast*). (1959) Assemblage: wood construction painted white, 6′ x 6⅝″ (182.8 x 16.7 cm). Blanchette Rockefeller Fund. 14.60. Repr. *Suppl. X*, p. 60.

384 HANGING COLUMN (from *Dawn's Wedding Feast*). (1959) Assemblage: wood construction painted white, 6′ x 10⅛″ (182.8 x 25.7 cm). Blanchette Rockefeller Fund. 15.60. Repr. *Suppl. X*, p. 60.

494 ATMOSPHERE AND ENVIRONMENT, I. (1966) Construction of enameled aluminum, 6′6¼″ x 12′⅜″ x 48½″ (198.6 x 366.7 x 123 cm). Mrs. Simon Guggenheim Fund. 386.66.

NEWALL, Albert. British, born 1920. Lives in South Africa.

MARINE OBJECT. 1955. Ink and pastel, 13¼ x 18¼″ (33.6 x 46.2 cm). Gift of the artist. 20.56. Repr. *Suppl. VI*, p. 33.

NEWMAN, Barnett. American, 1905–1970.

366 ABRAHAM. 1949. Oil on canvas, 6′10¾″ x 34½″ (210.2 x 87.7 cm). Philip Johnson Fund. 651.59. Repr. *New Amer. Ptg.*, p. 62; *Newman*, p. 59.

THE VOICE. (1950) Egg tempera and enamel on canvas, 8′⅛″ x 8′9½″ (244.1 x 268 cm). The Sidney and Harriet Janis Collection (fractional gift). 1.68. Repr. *Newman*, p. 68; *Janis*, p. 131.

455 THE WILD. (1950) Oil on canvas, 7′11¾″ x 1⅝″ (243 x 4.1 cm). Promised gift and extended loan from The Kulicke Family. E.L.66.937. Repr. *Newman*, pp. 72, 74.

NICHOLSON, Ben. British, born 1894. To Switzerland 1958.

143 PAINTED RELIEF. 1939. Synthetic board mounted on plywood, painted, 32⅞ x 45″ (83.5 x 114.3 cm). Gift of H. S. Ede and the artist (by exchange). 1645.40. Repr. *Ptg. & Sc.*, p. 274; *What Is Mod. Sc.*, p. 118.

Also, prints and a poster.

NICOLAO, Tereza. Brazilian, born 1928.

290 SHANTY TOWN, I [*Favela, I*]. 1957. Oil on plywood, 26⅞ x 38⅞″ (68.1 x 98.5 cm). Inter-American Fund. 137.58. Repr. *Suppl. VIII*, p. 15.

NIIZUMA, Minoru. Japanese, born 1930. To U.S.A. 1959.

474 CASTLE OF THE EYE. 1964. Marble, 18½ x 15¾ x 8″ (47.1 x 39.9 x 20.1 cm). Blanchette Rockefeller Fund. 611.65a–b. Repr. *New Jap. Ptg. & Sc.*, p. 78.

NILSSON, Gladys. American, born 1940.

443 THE PINK SUIT. (1965) Watercolor, 9⅞ x 9⅛″ (24.9 x 23.2 cm). Larry Aldrich Foundation Fund. 676.65.

NOGUCHI, Isamu. American, born 1904. Works principally in U.S.A., Japan, and Italy.

300 PORTRAIT OF MY UNCLE. 1931. Terra cotta, 12½″ (31.7 cm) high. Gift of Edward M. M. Warburg. 244.50. Repr. *Amer. Ptg. & Sc.*

300 CAPITAL. (1939) Georgia marble, 16 x 24 x 24″ (40.7 x 61 x 61 cm). Gift of Miss Jeanne Reynal. 561.41. Repr. *Ptg. & Sc.*, p. 289.

BIG BOY. 1952. Karatsu ware, 7⅞ x 6⅞″ (18.7 x 17.4 cm). A. Conger Goodyear Fund. 20.55.

300 EVEN THE CENTIPEDE. (1952) Kasama ware in eleven pieces, each approximately 18″ (46 cm) wide, mounted on wood pole 14′ (425 cm) high. A. Conger Goodyear Fund. 1.55a–k. Repr. *Suppl. V*, p. 31.

300 BIRD C (MU). (1952–58) Greek marble, 22¾ x 8⅛″ (57.8 x 20.5 cm). In memory of Robert Carson, architect (given anonymously). 418.60. Repr. *Suppl. X*, p. 44.

300 WOMAN. (1957) Iron, 14⅜ x 18¼ x 8⅝″ (36.5 x 46.3 x 21.9 cm). Purchase. 419.60. Repr. *Suppl. X*, p. 44.

483 STONE OF SPIRITUAL UNDERSTANDING. 1962. Bronze suspended on square wood bar set on metal supports, 52¼ x 48 x 16″ (132.6 x 121.9 x 40.4 cm). Gift of the artist. 574.64a–c.

Also, a poster, a lamp, and a table.

NOLAN, Sidney. Australian, born 1917.

268 AFTER GLENROWAN SIEGE (Second Ned Kelly series). (1955) Enamel on composition board, 48 x 36″ (121.9 x 91.5 cm). Benjamin Scharps and David Scharps Fund. 340.55. Repr. *Suppl. VI*, p. 28.

FIGURES AND FOREST. (1958) Alizarin dye on paper, 12 x 10″ (30.4 x 25.4 cm). Blanchette Rockefeller Fund. 138.58. Repr. *Suppl. VIII*, p. 17.

NOLDE, Emil (Emil Hansen). Danish, born North Schleswig, Germany, later part of Denmark. 1867–1956. Worked in Germany.

Dr. Martin Urban, Director of the Ada and Emil Nolde Foundation, has corrected some dates.

67 CHRIST AMONG THE CHILDREN. (1910) Oil on canvas, 34⅛ x 41⅞″ (86.8 x 106.4 cm). Gift of Dr. W. R. Valentiner. 341.55. Repr. *Art in Our Time*, no. 125; *Nolde*, p. 20; in color, *German Art of 20th C.*, p. 33; in color, *Invitation*, p. 22.

PAPUAN HEAD. 1914. Watercolor, 19⁷/₈ x 14³/₄″ (50.4 x 37.5 cm). Gift of Mr. and Mrs. Eugene Victor Thaw. 279.58.

67 RUSSIAN PEASANTS. (1915) Oil on canvas, 29 x 35¹/₂″ (73.4 x 90 cm). Matthew T. Mellon Foundation Fund. 19.54. Repr. *Suppl. V*, p. 10.

67 FLOWERS. (c. 1915?) Oil on burlap, 26¹/₄ x 33¹/₄″ (66.6 x 84.5 cm). Gift of Mr. and Mrs. Werner E. Josten. 555.56. Repr. in color, *German Art of 20th C.*, p. 36.

66 ISLANDER. (1920–21) Watercolor, 18¹/₂ x 13³/₄″ (47 x 34.9 cm). Gertrud A. Mellon Fund. 21.55.

66 AMARYLLIS AND ANEMONE. (c. 1930) Watercolor, 13³/₄ x 18³/₈″ (35 x 46.7 cm). Gift of Philip L. Goodwin. 10.49. Repr. *Suppl. I*, p. 11.

66 MAGICIANS. (1931–35) Watercolor, 20¹/₈ x 14³/₈″ (51.1 x 36.5 cm). Purchase. 654.39. Repr. *Ptg. & Sc.*, p. 78.

Also, a drawing, prints, and a poster.

NTIRO, Sam Joseph. Tanzanian, born 1923. Lives in Uganda.

286 MEN TAKING BANANA BEER TO BRIDE BY NIGHT. 1956. Oil on canvas, 16¹/₈ x 20″ (40.9 x 50.8 cm). Elizabeth Bliss Parkinson Fund. 122.60. Repr. *Suppl. X*, p. 24.

OBIN, Philomé. Haitian, born 1892.

9 INSPECTION OF THE STREETS. 1948. Oil on composition board, 24 x 24″ (61 x 61 cm). Inter-American Fund. 268.48.

OBREGÓN, Alejandro. Colombian, born Spain 1920.

290 SOUVENIR OF VENICE. (1953) Oil on canvas, 51¹/₄ x 38¹/₈″ (130.2 x 96.8 cm). Inter-American Fund. 22.55. Repr. *Suppl. V*, p. 25.

OCAMPO, Miguel. Argentine, born 1922.

NUMBER 166. 1957. Gouache, 17¹/₄ x 12¹/₈″ (43.6 x 30.8 cm), composition. Inter-American Fund. 90.58.

373 NUMBER 172. 1957. Oil on canvas, 21¹/₄ x 31⁷/₈″ (54 x 81 cm). Inter-American Fund. 89.58. Repr. *Suppl. VIII*, p. 22.

O'CONOR, Roderic. Irish, 1860–1940. Worked in France.

34 THE GLADE. 1892. Oil on canvas, 36¹/₄ x 23¹/₂″ (92 x 59.6 cm). Acquired through the Lillie P. Bliss Bequest. 270.56. Repr. *Suppl. VI*, p. 6.

OELZE, Richard. German, born 1900.

182 EXPECTATION [*Erwartung*]. 1935–36. Oil on canvas, 32¹/₈ x 39⁵/₈″ (81.6 x 100.6 cm). Purchase. 27.40. Repr. *Ptg. & Sc.*, p. 202.

Also, drawings.

O'GORMAN, Juan. Mexican, born 1905.

211 THE SAND MINES OF TETELPA. 1942. Tempera on composition board, 22¹/₄ x 18″ (56.5 x 45.7 cm). Gift of Edgar Kaufmann, Jr. 751.42. Repr. *Ptg. & Sc.*, p. 178.

OKADA, Kenzo. American, born Japan 1902. To U.S.A. 1950.

368 NUMBER 3. 1953. Oil on canvas, 65¹/₈ x 57⁷/₈″ (165.4 x 147 cm). Given anonymously. 248.54. Repr. *Suppl. V*, p. 28.

Also, a drawing.

O'KEEFFE, Georgia. American, born 1887.

228 EVENING STAR, III. (1917) Watercolor, 9 x 11⁷/₈″ (22.7 x 30.2 cm). Mr. and Mrs. Donald B. Straus Fund. 91.58. Repr. *Suppl. VIII*, p. 8.

228 LAKE GEORGE WINDOW. 1929. Oil on canvas, 40 x 30″ (101.6 x 76.2 cm). Acquired through the Richard D. Brixey Bequest. 144.45. Repr. *Ptg. & Sc.*, p. 129; *Art of the Real*, p. 12; in color, *Invitation*, p. 97.

Also, drawings.

OLDENBURG, Claes. American, born Sweden 1929. To U.S.A. 1936.

392 RED TIGHTS WITH FRAGMENT 9. (1961) Muslin soaked in plaster over wire frame, painted with enamel, 69⁵/₈ x 34¹/₄ x 8³/₄″ (176.7 x 87 x 22.2 cm). Gift of G. David Thompson. 387.61. Repr. *Suppl. XI*, p. 48; *Amer. 1963*, p. 77; in color, *Oldenburg*, p. 78.

PASTRY CASE, I. 1961–62. Enamel paint on nine plaster sculptures in glass showcase, 20³/₄ x 30¹/₈ x 14³/₄″ (52.7 x 76.5 x 37.3 cm). The Sidney and Harriet Janis Collection (fractional gift). 639.67a–dd. Repr. in color, *Oldenburg*, p. 89; in color, *Janis*, p. 159. *Note*: also called *Case of Pastries and Sundaes*.

392 TWO CHEESEBURGERS, WITH EVERYTHING (DUAL HAMBURGERS). 1962. Burlap soaked in plaster, painted with enamel, 7 x 14³/₄ x 8⁵/₈″ (17.8 x 37.5 x 21.8 cm). Philip Johnson Fund. 233.62. Repr. *Amer. 1963*, p. 78; in color, *Oldenburg*, p. 84.

GIANT SOFT FAN. (1966–67) Construction of vinyl filled with foam rubber, wood, metal, and plastic tubing; fan, 10′ x 58⁷/₈ x 61⁷/₈″ (305 x 149.5 x 157.1 cm), variable; plus cord and plug, 24′3¹/₄″ (739.6 cm). The Sidney and Harriet Janis Collection (fractional gift). 2098.67. Repr. *Oldenburg*, p. 134; *Janis*, pp. 160–161. *Note*: also called *Giant Black Vinyl Soft Fan*.

Also, a drawing and a poster.

OLITSKI, Jules. American, born Russia 1922. To U.S.A. 1924.

342 CLEOPATRA FLESH. 1962. Synthetic polymer paint on canvas, 8′8″ x 7′6″ (264.2 x 228.3 cm). Gift of G. David Thompson (by exchange). 262.64.

OLIVEIRA, Nathan. American, born 1928.

280 STANDING MAN WITH STICK. 1959. Oil on canvas, 68⁷/₈ x 60¹/₄″ (174.8 x 153 cm). Gift of Joseph H. Hirshhorn. 609.59. Repr. in color, *New Images*, p. 112.

Also, a print.

OLSON, Eric H. Swedish, born 1909.

508 OPTOCHROMI H 12-4. 1965. Glass with polarization and birefringence sheets, 16⁵/₈ x 6³/₄ x 4″ (42 x 17.2 x 10 cm). Gift of Mr. and Mrs. Leif Sjöberg (by exchange). 182.66. *Note*: the artist states: "Each glass plane is made into a lamellar glass, which contains polarizing film and a double refractive film."

OPPENHEIM, Meret. Swiss, born Berlin 1913.

182 OBJECT [*Le Déjeuner en fourrure*]. (1936) Fur-covered cup, saucer, and spoon; cup, 4³/₈″ (10.9 cm) diameter; saucer, 9³/₈″ (23.7 cm) diameter; spoon, 8″ (20.2 cm) long; overall height 2⁷/₈″ (7.3 cm). Purchase. 130.46a–c. Repr. *Fantastic Art* (3rd), p. 192; *Assemblage*, p. 60; *Dada, Surrealism*, p. 143.

OPPER, John. American, born 1908.

PAINTING. (1960) Oil on canvas, 69¹/₄ x 42″ (175.8 x 106.7 cm). Gift of Mrs. Leo Simon. 388.61. Repr. *Suppl. XI*, p. 24.

ORION, Ezra. Israeli, born 1934.

481 HIGH NIGHT, II. (1963) Welded iron, 6′2″ (187.9 cm) high, at base 14 x 13³/₈″ (35.5 x 34.2 cm). Gift of Mr. and Mrs. George M. Jaffin. 6.65. Repr. *Art Israel*, p. 60.

ORLANDO, Felipe. Cuban, born 1911.

WOMAN WASHING. (1943) Gouache, 15⅜ x 11¼" (39 x 28.6 cm). Inter-American Fund. 78.44.

Also, prints.

OROZCO, José Clemente. Mexican, 1883–1949. In U.S.A. 1917–18, 1927–34, 1940, 1945–46.

204 THE SUBWAY. (1928) Oil on canvas, 16⅛ x 22⅛" (41 x 56.2 cm). Gift of Abby Aldrich Rockefeller. 203.35. Repr. *Latin-Amer. Coll.*, p. 58.

204 PEACE. (1930) Oil on canvas, 30¼ x 48¼" (76.8 x 122.5 cm). Given anonymously. 467.37.

205 ZAPATISTAS. 1931. Oil on canvas, 45 x 55" (114.3 x 139.7 cm). Given anonymously. 470.37. Repr. *Ptg. & Sc.*, p. 137; in color, *Invitation*, p. 111.

204 BARRICADE. (1931) Oil on canvas, 55 x 45" (139.7 x 114.3 cm). Given anonymously. 468.37. Repr. *Ptg. & Sc.*, p. 136. *Note:* variant of the fresco (1924) in the National Preparatory School, Mexico City.

204 THE CEMETERY. (1931) Oil on canvas, 27 x 39⅞" (68.6 x 101.3 cm). Given anonymously. 469.37. Repr. *Latin-Amer. Coll.*, p. 58.

205 DIVE BOMBER AND TANK. 1940. Fresco, 9 x 18' (275 x 550 cm), on six panels, 9 x 3' (275 x 91.4 cm) each. Commissioned through the Abby Aldrich Rockefeller Fund. 1630.40.1–.6. Repr. *Ptg. & Sc.*, p. 135.

205 SELF-PORTRAIT. 1940. Oil and gouache on cardboard, 20¼ x 23¾" (51.4 x 60.3 cm). Inter-American Fund. 605.42. Repr. *Latin-Amer. Coll.*, p. 61.

Also, drawings and prints.

ORTIZ, Ralph. American, born 1934.

389 ARCHEOLOGICAL FIND, 3. (1961) Burnt mattress, 6'2⅞" x 41¼" x 9⅜" (190 x 104.5 x 23.7 cm). Gift of Mrs. Francis Douglas Kane. 76.63. Repr. *Object Transformed*, p. 23.

ORTMAN, George. American, born 1926.

372 TRIANGLE. (1959) Collage of painted canvas on composition board with nine plaster inserts, 49⅝ x 49⅞ x 3¾" (126 x 126.6 x 9.5 cm). Larry Aldrich Foundation Fund. 364.60. Repr. *Suppl. X*, p. 47.

Also, a print.

ORTVAD, Erik. Danish, born 1917.

Untitled. 1945. Watercolor, 13 x 15⅞" (33 x 40.3 cm). Gift of the artist. 64.47.

Also, drawings in the Study Collection.

OSAWA, Gakyù. Japanese, 1890–1953.

317 THE DEEP POOL. (c. 1953) Brush and ink, 26⅞ x 54⅜" (68.3 x 138.1 cm). Japanese House Fund. 273.54. Repr. *Suppl. V*, p. 28.

OSSAYE, Roberto. Guatemalan, 1927–1954.

289 PITAHAYA. 1953. Oil on canvas, 12⅞ x 18¾" (32.7 x 47.5 cm). Given in memory of the artist by Mrs. Roberto Ossaye and her daughter Maria del Carmen Ossaye. 17.57. Repr. *Suppl. VII*, p. 20.

OSSORIO, Alfonso. American, born the Philippines 1916. To U.S.A. 1929.

SUM, 2. 1959. Assemblage: synthetic resin with miscellaneous materials on composition board, 7'11¾" x 48" (243.2 x 121.8 cm). Given anonymously. 3.62. Repr. *Suppl. XII*, p. 18.

OSVER, Arthur. American, born 1912.

MELANCHOLY OF A ROOFTOP. (1942) Oil on canvas, 48 x 24" (121.9 x 61 cm). Purchase. 340.42. Repr. *Ptg. & Sc.*, p. 172.

OTERO, Alejandro. Venezuelan, born 1921. Worked in Paris 1945–52, 1960–64.

371 COLOR-RHYTHM, I [*Coloritmo I*]. 1955. Duco on plywood, 6'6¾" x 19" (200.1 x 48.2 cm). Inter-American Fund. 21.56. Repr. *Suppl. VI*, p. 33.

OUDOT, Roland. French, born 1897.

LOISETTE. 1929. Oil on canvas, 28¾ x 23⅝" (73 x 60 cm). Gift of A. Conger Goodyear. 563.41.

OZENFANT, Amédée. French, 1886–1966. In U.S.A. 1938–55.

142 THE VASES [*Les Vases; Dorique*]. 1925. Oil on canvas, 51⅜ x 38⅜" (130.5 x 97.5 cm). Acquired through the Lillie P. Bliss Bequest. 164.45. Repr. *Ptg. & Sc.*, p. 125.

Also, a drawing and a print.

PAALEN, Wolfgang. Austrian, 1905–1959. Worked in Paris and Mexico.

410 Study for TOTEM LANDSCAPE OF MY CHILDHOOD. 1937. Oil on canvas, 21⅞ x 15⅛" (55.3 x 38.3 cm). Kay Sage Tanguy Bequest. 1131.64.

182 Untitled. 1938. Colored inks, 21¾ x 28½" (55.1 x 72.2 cm). Gift of Mrs. Milton Weill. 80.62. Repr. *Suppl. XII*, p. 22.

FUMAGE. (1944–45?) Oil and candle soot on paper, 18¾ x 10¼" (47.6 x 26 cm) (irregular). Gift of Samuel A. Berger. 23.55.

Also, drawings.

PACENZA, Onofrio A. Argentine, born 1902.

213 END OF THE STREET. 1936. Oil on canvas, 33⅜ x 41⅜" (84.8 x 105.1 cm). Inter-American Fund. 212.42.

Also, an oil in the Study Collection.

PANCETTI, José. Brazilian, born 1903.

SELF-PORTRAIT. 1941. Oil on canvas, 32 x 24" (81.3 x 60.8 cm). Inter-American Fund. 765.42. Repr. *Latin-Amer. Coll.*, p. 39.

PANNAGGI, Ivo. Italian, born 1901. Lives in Norway.

198 MY MOTHER READING THE NEWSPAPER. (c. 1922) Oil on canvas on composition board, 11⅛ x 10¼" (28.3 x 26 cm). Gift of Mario da Silva. 510.51.

Also, a collage in the Study Collection, and a poster.

PAOLOZZI, Eduardo. British, born 1924.

STUDY FOR SCULPTURE. 1950. Watercolor, 22 x 30" (55.9 x 76.2 cm). Mrs. Wendell T. Bush Fund. 182.53.

COMPOSITION. 1951. Collage of cut and pasted serigraphs printed in dye, 20½ x 26⅞" (52.1 x 68.3 cm). Purchase. 183.53.

296 SCULPTURE. (1951) Cast concrete, 9⅜ x 18¼ x 11¼" (23.8 x 46.3 x 28.6 cm). Purchase. 181.53. Repr. *Suppl. IV*, p. 41.

296 JASON. (1956) Bronze, 66⅛" (167.8 cm) high, at base 14¾ x 11¼" (37.5 x 28.6 cm). Blanchette Rockefeller Fund. 661.59. (Purchased in 1957.) Repr. *New Images*, p. 119.

489 LOTUS. (1964) Welded aluminum, 7'5¹/₈" (226.1 cm) high, at base 36³/₈ x 36¹/₈" (92.3 x 91.6 cm). Gift of G. David Thompson. 291.65.

Also, a print.

PAPSDORF, Fred. American, born 1887.

FLOWERS IN A VASE. 1940. Oil on canvas, 18¹/₄ x 14¹/₄" (46.3 x 36.2 cm). Purchase. 249.40. Repr. *Amer. Realists*, p. 48.

PAREDES, Diógenes. Ecuadorian, born 1910.

217 THRESHERS. 1942. Tempera on cardboard, 20¹/₂ x 19⁵/₈" (52.1 x 49.9 cm). Inter-American Fund. 766.42. Repr. *Latin-Amer. Coll.*, p. 55.

PARK, David. American, 1911–1960.

280 GROUP OF FIGURES. 1960. Watercolor, 11¹/₂ x 14¹/₂" (29.2 x 36.9 cm). Larry Aldrich Foundation Fund. 15.63.

RICHARD DIEBENKORN. 1960. Watercolor, 14⁵/₈ x 11³/₄" (37.1 x 29.7 cm). Larry Aldrich Foundation Fund. 16.63.

PARKER, Raymond. American, born 1922.

341 Untitled. 1960. Oil on canvas, 71⁷/₈" x 7'2" (182.5 x 218.4 cm). Gift of Mr. and Mrs. Samuel M. Kootz. 31.60. Repr. *Suppl. X*, p. 41.

PARKER, Robert Andrew. American, born 1927.

BOSNIA 1911. 1954. Watercolor and ink, 18 x 11⁷/₈" (45.7 x 30.2 cm). Katharine Cornell Fund. 21.54.

CAMILLE PISSARRO AS A YOUNG MAN. 1954. Watercolor and ink, 12¹/₄ x 17¹/₄" (31.1 x 43.8 cm). Katharine Cornell Fund. 20.54.

PASCIN, Jules. American, born Bulgaria. 1885–1930. Worked in Europe and North Africa. In U.S.A., Cuba, and Mexico 1914–20. Died in Paris.

GIRLS ON BENCH. Watercolor, pen and ink, 9¹/₂ x 10¹/₈" (23.5 x 25.6 cm). Given anonymously. 122.35.

SEATED GIRL. Watercolor and pencil, 12¹/₄ x 8¹/₂" (31.1 x 21.6 cm). Gift of A. Conger Goodyear. 22.54.

PICNICKERS. (1914–15) Watercolor, pen and ink, 7³/₈ x 11¹/₈" (18.6 x 28 cm). Given anonymously. 123.35.

CAB IN HAVANA. (1914–20) Watercolor, pen and ink, 7¹/₂ x 9⁵/₈" (18.8 x 24.4 cm). Gift of Abby Aldrich Rockefeller. 121.35.

PORT OF HAVANA. (1914–20) Watercolor and pencil, 4⁷/₈ x 7¹/₂" (12.2 x 19 cm). Given anonymously. 124.35.

191 SOCRATES AND HIS DISCIPLES MOCKED BY COURTESANS. (c. 1921) Oil, gouache, and crayon on paper mounted on canvas, 61¹/₄" x 7'2" (155.6 x 218.5 cm). Given anonymously in memory of the artist. 307.38. Repr. *Ptg. & Sc.*, p. 64.

191 RECLINING MODEL. (c. 1925) Oil on canvas, 28³/₄ x 36¹/₄" (73 x 92.1 cm). Gift of A. Conger Goodyear. 564.41.

Also, drawings, prints, sketchbook with 166 drawings, illustrated book, and menus.

PASMORE, Victor. British, born 1908.

460 SQUARE MOTIF IN BROWN, WHITE, BLACK, BLUE, AND OCHRE. (1948–53) Collage and oil on canvas, 25 x 30" (63.5 x 76.1 cm). Gift of Mr. and Mrs. Allan D. Emil. 1241.64.

PATERNOSTO, César. Argentine, born 1931. To U.S.A. 1967.

458 DUINO. 1966. Oil on shaped canvas in two parts, 6'6³/₄" x 51³/₈" (200 x 130.4 cm), and 6'6¹/₈" x 51" (198.4 x 129.5 cm). Inter-American Fund. 450.67a–b.

PECHSTEIN, Max. German, 1881–1955.

MAX RAPHAEL. (c. 1910) Watercolor, 22⁵/₈ x 18³/₈" (57.3 x 46.7 cm). Gift of Mr. and Mrs. Eugene Victor Thaw. 22.56.

Also, prints and an illustrated book; a watercolor in the Study Collection.

PEDERSEN, Carl-Henning. Danish, born 1913.

THE HAPPY WORLD. 1943. Watercolor, pen and ink, 16¹/₄ x 11³/₄" (41.3 x 29.9 cm). Gift of the artist. 70.47.

WINGED MAN. 1944. Watercolor, pen and ink, 12⁵/₈ x 15⁵/₈" (32.1 x 39.7 cm). Gift of the artist. 71.47.

TOWN AT NIGHT. 1945. Watercolor, 10¹/₈ x 6⁵/₈" (25.7 x 16.8 cm). Gift of the artist. 72.47.

LIGHT BLUE WORLD BIRD. 1945. Gouache, watercolor, pen and ink, 9⁷/₈ x 8¹/₂" (25 x 21.6 cm). Gift of the artist. 73.47.

354 THE YELLOW STAR. 1952. Oil and pencil on canvas, 48⁷/₈ x 40¹/₂" (124 x 102.8 cm). Gift of G. David Thompson. 8.61. Repr. *Suppl. XI*, p. 21.

Also, a drawing; and works in the Study Collection.

PEDRO. See MARTÍNEZ PEDRO.

PELÁEZ DEL CASAL, Amelia. Cuban, 1897–1968.

216 STILL LIFE IN RED. 1938. Oil on canvas, 27¹/₄ x 33¹/₂" (69.3 x 85.1 cm). Inter-American Fund. 162.42. Repr. *Latin-Amer. Coll.*, p. 49.

216 FISHES. 1943. Oil on canvas, 45¹/₂ x 35¹/₈" (115.6 x 89.2 cm). Inter-American Fund. 80.44. Repr. *Ptg. & Sc.*, p. 130.

GIRLS. 1943. Watercolor, 25 x 27⁵/₈" (63.5 x 70.2 cm). Inter-American Fund. 81.44.

Also, a drawing.

PEREIRA, Irene Rice. American, 1907–1971.

SHADOWS WITH PAINTING. (1940) Outer surface, oil on glass, 1¹/₄" (3.2 cm) in front of inner surface, gouache on cardboard, 15 x 12¹/₈" (38.1 x 30.8 cm). Gift of Mrs. Marjorie Falk. 348.41.

365 WHITE LINES. 1942. Oil on vellum with marble dust, sand, etc., 25⁷/₈ x 21⁷/₈" (65.7 x 55.6 cm). Gift of Edgar Kaufmann, Jr. 341.42. Repr. *Ptg. & Sc.*, p. 122.

Also, a drawing and a print.

PÉRI, László. Hungarian, born 1889. Worked in Germany 1921–33. To London 1933.

139 IN FRONT OF THE TABLE. (1922) Tempera on cardboard, 25¹/₄ x 34" (64.1 x 86.4 cm) (irregular). Katherine S. Dreier Bequest. 184.53.

PERLIN, Bernard. American, born 1918.

277 THE LOVERS. 1946. Gouache, 30 x 37³/₄" (76.2 x 95.9 cm). Purchase. 269.48. Repr. *Suppl. I*, p. 23.

Also, a poster.

PETITJEAN, Hippolyte. French, 1854–1929.

LANDSCAPE WITH ROAD. Watercolor, 12¹/₂ x 18⁵/₈" (31.6 x 47.2 cm). Gift of Mr. and Mrs. A. M. Adler. 782.63.

PETO, John Frederick. American, 1854–1907.

36 OLD TIME LETTER RACK. (Previous title: *Old Scraps*.) 1894. Oil on canvas, 30 x 25¹/₈" (76.2 x 63.8 cm). Gift of Nelson A.

Rockefeller. 29.40. Repr. *Art in Our Time*, no. 43. *Note*: former-ly attributed to Harnett, titled *Old Scraps*, and dated 1879–80. Removal of the lining canvas in 1967 revealed the inscription "Old Time Letter Rack/11.94/John F. Peto/Artist/Island Heights/N.J."

PETTORUTI, Emilio. Argentine, born 1895. Lives in Paris.

213 THE VERDIGRIS GOBLET. 1934. Oil on canvas, 21⁵/₈ x 18¹/₈″ (54.9 x 46 cm). Inter-American Fund. 4.43. Repr. *Latin-Amer. Coll.*, p. 24.

PEVSNER, Antoine. French, born Russia. 1886–1962. To Paris 1923.

132 ABSTRACT FORMS. 1913? (1923?) Encaustic on wood, 17¹/₄ x 13¹/₂″ (43.8 x 34.3 cm). Gift of the artist. 35.36. *Note*: dated 1913 by artist, 1923 by his brother, Alexei Pevsner.

132 BUST. (1923–24) Construction in metal and celluloid, 20⁷/₈ x 23³/₈″ (53 x 59.4 cm). Purchase. 396.38. Repr. *Ptg. & Sc.*, p. 272.

132 TORSO. (1924–26) Construction in plastic and copper, 29¹/₂ x 11⁵/₈″ (74.9 x 29.4 cm). Katherine S. Dreier Bequest. 185.53. Repr. *Suppl. IV*, p. 12.

132 DEVELOPABLE COLUMN. 1942. Brass and oxidized bronze, 20³/₄″ (52.7 cm) high, base 19³/₈″ (49.2 cm) diameter. Purchase. 15.50. Repr. *Suppl. II*, p. 19; *Masters*, p. 126; *What Is Mod. Sc.*, p. 70.

PEYRONNET, Dominique-Paul. French, 1872–1943.

8 THE FERRYMAN OF THE MOSELLE. (c. 1934) Oil on canvas, 35 x 45⁵/₈″ (88.9 x 115.9 cm). Abby Aldrich Rockefeller Fund. 664.39. Repr. *Ptg. & Sc.*, p. 19.

PFRIEM, Bernard. American, born 1916.

338 RED RISING UP. 1960. Oil on canvas, 57¹/₂ x 45″ (145.8 x 114.2 cm). Larry Aldrich Foundation Fund. 124.61. Repr. *Suppl. XI*, p. 32.

Also, a drawing.

PICABIA, Francis. French, 1879–1953. Active in New York and Barcelona, 1913–17.

158 I SEE AGAIN IN MEMORY MY DEAR UDNIE [*Je revois en souvenir ma chère Udnie*]. (1914, perhaps begun 1913) Oil on canvas, 8′2¹/₂″ x 6′6¹/₄″ (250.2 x 198.8 cm). Hillman Periodicals Fund. 4.54. Repr. *Suppl. V*, p. 15; *Dada, Surrealism*, p. 25; in color, *Invitation*, p. 44.

Also, a drawing and a print.

PICASSO, Pablo. Spanish, 1881–1973. To France 1904.

Zervos refers to *Pablo Picasso*, volumes I through XXVIII by Christian Zervos, Editions "Cahiers d'Art," Paris, 1932–74.

76 BROODING WOMAN. (1904–05) Watercolor, 10⁵/₈ x 14¹/₂″ (26.7 x 36.6 cm). Gift of Mr. and Mrs. Werner E. Josten. 4.56a. *Zervos, I*, no. 231. Repr. *Picasso 75th Anniv.*, p. 19; in color, *Picasso in MoMA*, p. 27. On reverse: THREE CHILDREN. (1903–04) Watercolor, 14¹/₂ x 10⁵/₈″ (36.6 x 26.7 cm). 4.56b. *Zervos, I*, no. 218. Repr. *Suppl. VI*, p. 11; *Picasso in MoMA*, p. 26.

76 TWO NUDES. (1906, late) Oil on canvas, 59⁵/₈ x 36⁵/₈″ (151.3 x 93 cm). Gift of G. David Thompson in honor of Alfred H. Barr, Jr. 621.59. *Zervos, I*, no. 366. Repr. *Picasso 50* (3rd), p. 52; *Picasso 75th Anniv.*, p. 31; *Bulletin*, Fall 1958, p. 36; in color, *Picasso in MoMA*, p. 39.

HEAD (Study for *Les Demoiselles d'Avignon*). (1906, late) Watercolor, 8⁷/₈ x 6⁷/₈″ (22.4 x 17.5 cm). John S. Newberry Collection. 383.60. *Zervos, II*, no. 10. Repr. *Suppl. X*, p. 15; *Picasso in MoMA*, p. 42.

76 HEAD OF A MAN (Study for *Les Demoiselles d'Avignon*). (1907, early) Watercolor, 23³/₄ x 18¹/₂″ (60.3 x 47 cm). A. Conger Goodyear Fund. 14.52. *Zervos, VI*, no. 977. Repr. *Suppl. IV*, p. 22; *Picasso in MoMA*, p. 43.

77 LES DEMOISELLES D'AVIGNON. (1907) Oil on canvas, 8′ x 7′8″ (243.9 x 233.7 cm). Acquired through the Lillie P. Bliss Bequest. 333.39. *Zervos, II*, no. 18. Repr. *Ptg. & Sc.*, p. 85; in color, *Masters*, p. 69; *Picasso 50* (3rd), opp. p. 54; in color, *Picasso in MoMA*, p. 41; in color, *Invitation*, p. 47.

76 BATHERS IN A FOREST. 1908. Watercolor and pencil on paper over canvas, 18³/₄ x 23¹/₈″ (47.5 x 58.7 cm) (sight). Hillman Periodicals Fund. 28.57. Repr. *Picasso 75th Anniv.*, p. 36; *Suppl. VII*, p. 8; *Picasso in MoMA*, p. 46.

78 FRUIT DISH. (1909, early spring) Oil on canvas, 29¹/₄ x 24″ (74.3 x 61 cm). Acquired through the Lillie P. Bliss Bequest. 263.44. *Zervos, II*, no. 121. Repr. *Ptg. & Sc.*, p. 84; *Picasso in MoMA*, p. 55.

78 HEAD. (1909, spring) Gouache, 24 x 18″ (61 x 45.7 cm). Gift of Mrs. Saidie A. May. 12.30. *Zervos, II*, no. 148. Repr. *Picasso 50* (3rd), p. 66; *Picasso in MoMA*, p. 59.

406 TWO HEADS. (1909, summer) Oil on canvas, 13³/₄ x 13¹/₄″ (34.9 x 33.6 cm). A. Conger Goodyear Fund. 197.64. *Zervos, II**, no. 162; *Picasso in MoMA*, p. 58. *Note*: the original canvas (14 x 26³/₈″) with three heads was cut sometime after leaving the artist's studio. The Museum owns the right-hand part; the left-hand part is in a New York private collection.

78 STILL LIFE WITH LIQUEUR BOTTLE. (1909, summer) Oil on canvas, 32¹/₈ x 25³/₄″ (81.6 x 65.4 cm). Mrs. Simon Guggenheim Fund. 147.51. *Zervos, II*, no. 173. Repr. *Suppl. III*, p. 12; in color, *Picasso in MoMA*, p. 63.

78 WOMAN'S HEAD. (1909, fall) Bronze, 16¹/₄″ (41.3 cm) high. Purchase. 1632.40. *Zervos, II***, no. 573. Repr. *Ptg. & Sc.*, p. 267; *Picasso 50* (3rd), p. 69; *Nadelman*, p. 15; *What Is Mod. Sc.*, p. 42; *Sc. of Picasso*, p. 56; *Picasso in MoMA*, p. 61. *Note*: the subject is Fernande Olivier, companion of the artist, 1904–12.

79 WOMAN IN A CHAIR. (1909, late) Oil on canvas, 28³/₄ x 23⁵/₈″ (73 x 60 cm). Gift of Mr. and Mrs. Alex L. Hillman. 23.53. *Zervos, II*, no. 215. Repr. *Suppl. IV*, p. 22; *Picasso in MoMA*, p. 65.

79 "MA JOLIE." (1911–12, winter) Oil on canvas, 39³/₈ x 25³/₄″ (100 x 65.4 cm). Acquired through the Lillie P. Bliss Bequest. 176.45. *Zervos, II*, no. 244. Repr. *Ptg. & Sc.*, p. 88; *Lettering*, p. 24; in color, *Picasso in MoMA*, p. 69; in color, *Invitation*, p. 48. *Note*: also entitled *Woman with a Zither* or *Woman with a Guitar*.

79 VIOLIN AND GRAPES. (1912, summer or early fall) Oil on canvas, 20 x 24″ (50.6 x 61 cm). Mrs. David M. Levy Bequest. 32.60. *Zervos, II*, no. 350. Repr. *Suppl. X*, p. 11; *Levy Collection*, p. 28; in color, *Picasso in MoMA*, p. 77. *Note*: sometimes mistakenly reproduced vertically.

78 MAN WITH A HAT. (1912, December) Charcoal, ink, pasted paper, 24¹/₂ x 18⁵/₈″ (62.2 x 47.3 cm). Purchase. 274.37. *Zervos, II***, no. 398. Repr. *Ptg. & Sc.*, p. 97; in color, *Picasso in MoMA*, p. 78.

HEAD. (1913, spring) Collage, pen and ink, pencil, and watercolor on paper, 17 x 11³/₈″ (43 x 28.8 cm) (irregular). The Sidney and Harriet Janis Collection (fractional gift). 640.67. *Zervos, II***, no. 403. Repr. *Picasso in MoMA*, p. 80; *Janis*, p. 11.

GLASS, GUITAR, AND BOTTLE. (1913, spring) Oil, pasted paper, gesso, and pencil on canvas, 25³/₄ x 21¹/₈″ (65.4 x 53.6 cm). The Sidney and Harriet Janis Collection (fractional gift). 641.67. *Zervos, II***, no. 419. Repr. *Cubism*, p. 81; *Picasso 50* (3rd), p. 82; *Picasso in MoMA*, p. 81; *Janis*, p. 12. *Note*: also called *Still Life with a Guitar*; *La Table*; *Guitar and Glass*.

80 CARD PLAYER. (1913–14, winter) Oil on canvas, 42¹/₂ x 35¹/₄″ (108 x 89.5 cm). Acquired through the Lillie P. Bliss Bequest. 177.45. *Zervos, II***, no. 466. Repr. *Ptg. & Sc.*, p. 89; in color, *Picasso in MoMA*, p. 87.

79 PIPE, GLASS, BOTTLE OF RUM. 1914, March. Pasted paper, pencil, gouache, on cardboard, 15³/₄ x 20³/₄″ (40 x 52.7 cm). Gift of Mr. and Mrs. Daniel Saidenberg. 287.56. Repr. *Picasso 75th Anniv.*, p. 43; *Picasso in MoMA*, p. 92.

80 GREEN STILL LIFE. 1914 (summer) Oil on canvas, 23¹/₂ x 31¹/₄″ (59.7 x 79.4 cm). Lillie P. Bliss Collection. 92.34. *Zervos, II***, no. 485. Repr. *Ptg. & Sc.*, p. 97; in color, *Picasso in MoMA*, p. 94.

GLASS, NEWSPAPER, AND BOTTLE. (1914, fall) Oil and sand on canvas, 14¹/₄ x 24¹/₈″ (36 x 61.2 cm). The Sidney and Harriet Janis Collection (fractional gift). 642.67. *Zervos, II***, no. 531. Repr. *Picasso in MoMA*, p. 96; *Janis*, p. 12. *Note*: also called *Still Life*.

80 GLASS OF ABSINTH. (1914) Painted bronze with silver sugar strainer, 8¹/₂ x 6¹/₂″ (21.6 x 16.4 cm); diameter at base, 2¹/₂″ (6.4 cm). Gift of Mrs. Bertram Smith. 292.56. *Zervos, II***, no. 584. Repr. *Picasso 75th Anniv.*, p. 46; in color, *Sc. of Picasso*, frontispiece; in color, *Picasso in MoMA*, p. 95.

80 HARLEQUIN. 1915 (late) Oil on canvas, 6′1¹/₄″ x 41³/₈″ (183.5 x 105.1 cm). Acquired through the Lillie P. Bliss Bequest. 76.50. *Zervos, II***, no. 555. Repr. *Suppl. II*, p. 4; in color, *Picasso in MoMA*, p. 99.

81 PIERROT. 1918. Oil on canvas, 36¹/₂ x 28³/₄″ (92.7 x 73 cm). Sam A. Lewisohn Bequest. 12.52. *Zervos, III*, no. 137. Repr. *Suppl. IV*, p. 6; in color, *Picasso in MoMA*, p. 102.

80 SEATED WOMAN. (1918) Gouache, 5¹/₂ x 4¹/₂″ (14 x 11.4 cm). Gift of Abby Aldrich Rockefeller. 127.35. *Zervos, III*, no. 207; *Picasso in MoMA*, p. 106.

GUITAR. (1919, early) Oil, charcoal, and pinned paper on canvas, 7′1″ x 31″ (216 x 78.8 cm). Gift of A. Conger Goodyear. 384.55. *Zervos, II***, no. 570. Repr. *Suppl. VI*, p. 11; *Picasso 50* (3rd), p. 93; in color, *Picasso in MoMA*, p. 105.

81 SLEEPING PEASANTS. 1919. Tempera, watercolor, and pencil, 12¹/₄ x 19¹/₄″ (31.1 x 48.9 cm). Abby Aldrich Rockefeller Fund. 148.51. *Zervos, III*, no. 371. Repr. *Suppl. III*, p. 13; in color, *Masters*, p. 80; in color, *Picasso in MoMA*, p. 109.

81 THE RAPE. 1920. Tempera on wood, 9³/₈ x 12⁷/₈″ (23.8 x 32.6 cm). The Philip L. Goodwin Collection. 106.58. *Zervos, IV*, no. 109. Repr. *Picasso 50* (3rd), p. 117; *Picasso 75th Anniv.*, p. 55; *Bulletin*, Fall 1958, p. 10; in color, *Picasso in MoMA*, p. 111.

81 TWO WOMEN. 1920. Pastel and pencil, 27¹/₈ x 20¹/₈″ (68.8 x 51 cm). Gift of Mr. and Mrs. David Rockefeller. 593.63. *Zervos, IV*, no. 58.

83 THREE MUSICIANS. 1921 (summer) Oil on canvas, 6′7″ x 7′3³/₄″ (200.7 x 222.9 cm). Mrs. Simon Guggenheim Fund. 55.49. *Zervos, IV*, no. 331. Repr. *Suppl. I*, p. 1; in color, *Masters*, p. 83; *Paintings from MoMA*, p. 37; in color, *Picasso in MoMA*, p. 113; in color, *Invitation*, p. 70.

82 THREE WOMEN AT THE SPRING. 1921 (summer) Oil on canvas, 6′8¹/₄″ x 68¹/₂″ (203.9 x 174 cm). Gift of Mr. and Mrs. Allan D. Emil. 332.52. *Zervos, IV*, no. 322. Repr. *Suppl. IV*, p. 25; in color, *Picasso in MoMA*, p. 115. *Note*: also titled *Fontainebleau* and *La Fontaine*.

84 STILL LIFE WITH A CAKE. 1924, May. Oil on canvas, 38¹/₂ x 51¹/₂″ (97.8 x 130.8 cm). Acquired through the Lillie P. Bliss Bequest. 190.42. *Zervos, V*, no. 185. Repr. *Ptg. & Sc.*, p. 102; in color, *Picasso in MoMA*, p. 119.

407 STUDIO WITH PLASTER HEAD. 1925 (summer) Oil on canvas, 38⁵/₈ x 51⁵/₈″ (97.9 x 131.1 cm). Purchase. 116.64. *Zervos, V*, no.

445. Repr. *Picasso 50* (3rd), p. 139; in color, *Picasso in MoMA*, p. 121.

SEATED WOMAN. 1926, December. Oil on canvas, 8³/₄ x 5″ (22.2 x 12.5 cm). The Sidney and Harriet Janis Collection (fractional gift). 643.67. *Zervos, VII*, no. 60. Repr. *Picasso in MoMA*, p. 124; *Janis*, p. 15.

85 SEATED WOMAN. 1927. Oil on wood, 51¹/₈ x 38¹/₄″ (129.9 x 96.8 cm). Fractional gift of James Thrall Soby. 516.61. *Zervos, VII*, no. 77. Repr. *Picasso 50* (3rd), p. 148; *Picasso 75th Anniv.*, p. 64; *Suppl. XI*, p. 12; in color, *Soby Collection*, frontispiece; in color, *Picasso in MoMA*, p. 125.

84 THE STUDIO. 1927–28. Oil on canvas, 59″ x 7′7″ (149.9 x 231.2 cm). Gift of Walter P. Chrysler, Jr. 213.35. *Zervos, VII*, no. 142. Repr. *Ptg. & Sc.*, p. 105; in color, *Masters*, p. 87; in color, *Picasso in MoMA*, p. 129.

PAINTER AND MODEL. 1928. Oil on canvas, 51¹/₈ x 64¹/₄″ (129.8 x 163 cm). The Sidney and Harriet Janis Collection (fractional gift). 644.67. *Zervos, VII*, no. 143. Repr. *Cubism*, pl. 88; *Picasso 50* (3rd), p. 156; in color, *Picasso in MoMA*, p. 131; in color, *Janis*, p. 17; in color, *Invitation*, p. 75. *Note*: also called *Artist and Model*; *The Painter with His Models*; *Abstraction*.

85 BATHER AND CABIN. 1928, August 9. Oil on canvas, 8¹/₂ x 6¹/₄″ (21.5 x 15.8 cm) (painted area). Hillman Periodicals Fund. 342.55. *Zervos, VII*, no. 211. Repr. *Picasso 75th Anniv.*, p. 65; *Picasso in MoMA*, p. 132.

85 SEATED BATHER. (1930, early) Oil on canvas, 64¹/₄ x 51″ (163.2 x 129.5 cm). Mrs. Simon Guggenheim Fund. 82.50. *Zervos, VII*, no. 306. Repr. *Suppl. II*, p. 5; in color, *Picasso in MoMA*, p. 133.

86 GIRL BEFORE A MIRROR. 1932, March 14. Oil on canvas, 64 x 51¹/₄″ (162.3 x 130.2 cm). Gift of Mrs. Simon Guggenheim. 2.38. *Zervos, VII*, no. 379. Repr. *Ptg. & Sc.*, p. 106; in color, *Masters*, p. 89; *Picasso 50* (3rd), frontispiece; *Paintings from MoMA*, cover; in color, *Picasso in MoMA*, p. 139; in color, *Invitation*, p. 76.

396– GUERNICA. (1937, May–early June) Oil on canvas, 11′5¹/₂″ x
397 25′5³/₄″ (349.3 x 776.6 cm). Extended loan. E.L.39.1095. *Zervos, IX*, no. 65. Repr. *Picasso 50* (3rd), p. 207; *Picasso 75th Anniv.*, pp. 76–77; *Picasso in MoMA*, p. 237.

Also on extended loan, fifty-eight studies for, and postscripts after, the *Guernica* in various mediums, including the following seven oil paintings:

398 HORSE'S HEAD. 1937, May 2. Oil on canvas, 25¹/₂ x 36¹/₄″ (64.8 x 92 cm). E.L.39.1093.7. *Zervos, IX*, no. 11. Repr. *Picasso 75th Anniv.*, p. 75.

WEEPING HEAD. 1937, June 15. Oil, color crayon, and pencil on canvas, 21⁵/₈ x 18¹/₈″ (54.9 x 46 cm). E.L.39.1093.26. *Zervos, IX*, no. 54.

WEEPING HEAD WITH HANDKERCHIEF. 1937, June 22. Oil on canvas, 21⁵/₈ x 18¹/₈″ (54.9 x 46 cm). E.L.39.1093.38. *Zervos, IX*, no. 52.

MOTHER WITH DEAD CHILD. 1937, June 22. Oil, color crayon, and pencil on canvas, 21⁵/₈ x 18¹/₈″ (54.9 x 46 cm). E.L.39.1093.27. *Zervos, IX*, no. 49.

398 MOTHER WITH DEAD CHILD. 1937, September 26. Oil on canvas, 51¹/₄″ x 6′4³/₄″ (130.1 x 194.9 cm). E.L.39.1093.58. *Zervos, IX*, no. 69.

WEEPING HEAD WITH HANDKERCHIEF. 1937, October 13. Oil and ink on canvas, 21⁵/₈ x 18¹/₈″ (54.9 x 46 cm). E.L.39.1093.37.

398 WEEPING WOMAN WITH HANDKERCHIEF. 1937, October 17. Oil on canvas, 36¹/₄ x 28⁵/₈″ (92 x 72.5 cm). E.L.39.1093.41. *Zervos, IX*, no. 77.

406 STILL LIFE WITH RED BULL'S HEAD. 1938, November 26. Oil and enamel on canvas, 38⅛ x 51" (96.7 x 129.6 cm). Promised gift and extended loan from Mr. and Mrs. William A. M. Burden. E.L.63.292. *Zervos, IX*, no. 239. Repr. *Picasso 75th Anniv.*, p. 81; in color, *Picasso in MoMA*, p. 153.

87 NIGHT FISHING AT ANTIBES. (1939, August) Oil on canvas, 6'9" x 11'4" (205.8 x 345.4 cm). Mrs. Simon Guggenheim Fund. 13.52. *Zervos, IX*, no. 316. Repr. *Suppl. IV*, p. 26; in color, *Masters*, p. 93; in color, *Picasso in MoMA*, p. 157.

86 HEAD. 1940, March 3. Oil on paper mounted on canvas, 25½ x 18⅛" (64.5 x 46 cm). Gift of Mr. and Mrs. Gordon Bunshaft. 264.57. *Zervos, X*, no. 374. Repr. *Picasso 50* (3rd), p. 224; *Suppl. VII*, p. 8.

86 HEAD OF A WOMAN. 1945, February 27. Oil on paper mounted on canvas, 25⅝ x 19⅞" (65.2 x 50.2 cm). Gift of Mr. and Mrs. Joseph H. Hazen. 385.55. *Zervos, XIV*, no. 85. Repr. *Suppl. VI*, p. 11.

88 PREGNANT WOMAN. (1950) Bronze (cast 1955), 41¼" (104.8 cm) high, at base 7⅝ x 6¼" (19.3 x 15.8 cm). Gift of Mrs. Bertram Smith. 271.56. Repr. *Picasso 75th Anniv.*, p. 102; *Sc. of Picasso*, p. 125; *Picasso in MoMA*, p. 173.

88 SHE-GOAT. (1950) Bronze (cast 1952), after found objects, 46⅜ x 56⅜" (117.7 x 143.1 cm), base 41⅛ x 28⅛" (104.4 x 71.4 cm). Mrs. Simon Guggenheim Fund. 611.59. Repr. *Suppl. IX*, p. 1; *Sc. of Picasso*, p. 126; *Picasso in MoMA*, p. 174.

88 BABOON AND YOUNG. 1951. Bronze (cast 1955), after found objects, 21" (53.3 cm) high, base 13¼ x 6⅞" (33.3 x 17.3 cm). Mrs. Simon Guggenheim Fund. 196.56. Repr. *Picasso 75th Anniv.*, p. 103; *Sc. of Picasso*, p. 134; *Picasso in MoMA*, p. 175.

87 HEAD OF A WOMAN. (1951) Bronze (cast 1955), 21⅛" (53.6 cm) high, at base 14⅛ x 7⅜" (35.7 x 18.8 cm). Benjamin Scharps and David Scharps Fund. 273.56. Repr. *Picasso 75th Anniv.*, p. 102; *Sc. of Picasso*, p. 130; *Picasso in MoMA*, p. 175.

87 GOAT SKULL AND BOTTLE. (1951–52) Painted bronze (cast 1954), 31 x 37⅝ x 21½" (78.8 x 95.3 x 54.5 cm). Mrs. Simon Guggenheim Fund. 272.56. Repr. *Picasso 75th Anniv.*, p. 103; *Sc. of Picasso*, p. 132; *Picasso in MoMA*, p. 177.

406 SYLVETTE. 1954 (spring) Oil on canvas, 28¾ x 23⅝" (72.9 x 59.8 cm). Gift of Mrs. Marya Bernard in memory of her husband, Dr. Bernard Bernard. 1263.64. *Zervos, XVI*, no. 314. *Note*: the subject was Mlle Sylvette David.

89 STUDIO IN A PAINTED FRAME. 1956, April 2. Oil on canvas, 35 x 45⅝" (88.8 x 115.8 cm). Gift of Mr. and Mrs. Werner E. Josten. 29.57. *Zervos, XVII*, no. 58. Repr. *Picasso 75th Anniv.*, p. 113; *Suppl. VII*, p. 9; *Picasso in MoMA*, p. 179.

89 WOMAN BY A WINDOW. 1956, June 11. Oil on canvas, 63¾ x 51¼" (162 x 130 cm). Mrs. Simon Guggenheim Fund. 30.57. *Zervos, XVII*, no. 120. Repr. *Picasso 75th Anniv.*, p. 114; *Suppl. VII*, p. 1; in color, *Picasso in MoMA*, p. 181. *Note*: the subject is Jacqueline Roque, subsequently Mme Picasso.

89 HEAD OF A FAUN. 1956. Painting on tile, 8 x 8" (20.3 x 20.3 cm). Philip Johnson Fund. 275.56. Repr. *Suppl. VI*, p. 10; *Picasso in MoMA*, p. 178.

89 BEARDED FAUN. 1956. Painting on tile, 8 x 8" (20.3 x 20.3 cm). Philip Johnson Fund. 274.56. Repr. *Suppl. VI*, p. 10; *Picasso in MoMA*, p. 178.

Also, drawings, prints, a copper plate for an etching, posters, illustrated books, magazine covers, a rug designed by the artist, and a film on the artist.

PICKENS, Alton. American, born 1917.

278 THE BLUE DOLL. 1942. Oil on canvas 42⅞ x 35" (108.9 x 88.9 cm). James Thrall Soby Fund. 622.43. Repr. *Ptg. & Sc.*, p. 147.

278 CARNIVAL. 1949. Oil on canvas, 54⅝ x 40⅜" (138.7 x 102.6 cm). Gift of Lincoln Kirstein. 511.51. Repr. *Suppl. IV*, p. 30.

Also, a drawing and prints.

PICKETT, Joseph. American, 1848–1918.

6 MANCHESTER VALLEY. (1914–18?) Oil with sand on canvas, 45½ x 60⅝" (115.4 x 153.7 cm). Gift of Abby Aldrich Rockefeller. 541.39. Repr. *Ptg. & Sc.*, p. 13; in color, *Masters*, p. 16; in color, *Invitation*, p. 118.

PIENE, Otto. German, born 1928.

PURE ENERGY [*La Force pure, I*]. 1958. Oil on canvas, 39½ x 31½" (100.2 x 80 cm). Gertrud A. Mellon Fund. 420.60. Repr. *Suppl. X*, p. 59.

PIGNON, Édouard. French, born 1905.

270 OSTEND. 1948. Watercolor, 20½ x 27½" (52.1 x 69.8 cm). Mrs. Cornelius J. Sullivan Fund. 270.48. Repr. *Suppl. I*, p. 13.

Also, prints.

PILARAME, Feramarze. Iranian, born 1936.

319 LAMINATIONS [*Les Lames*]. (1962) Gouache and metallic paint, 6'5⅞" x 32⅝" (197.7 x 82.7 cm). Elizabeth Bliss Parkinson Fund. 313.62. *Note*: *Lames* may also be translated as *Blades*.

PIPER, John. British, born 1903.

270 CWN TRYFAN ROCK. (1950) Oil on canvas, 25⅛ x 30" (63.8 x 76.2 cm). Purchase. 19.51. Repr. *Suppl. III*, p. 20.

END OF THE GLYDER MOUNTAIN. (1950) Gouache, 22⅝ x 27⅝" (57.5 x 70.2 cm). Gift of Curt Valentin. 322.50.

Also, prints and illustrated books.

PIRANDELLO, Fausto. Italian, born 1899.

198 WOMEN'S QUARTERS [*Gineceo*]. (1950) Oil on cardboard, 28¼ x 34⅛" (71.7 x 86.6 cm). Gift of Mrs. Joseph James Akston. 314.62. Repr. *Suppl. XII*, p. 13.

PISTOLETTO, Michelangelo. Italian, born 1933.

435 MAN WITH YELLOW PANTS. 1964. Collage with oil and pencil on polished stainless steel, 6'6⅞" x 39⅜" (200.3 x 100 cm). Blanchette Rockefeller Fund. 292.65. Repr. *Object Transformed*, p. 34. *Note*: the subject is Gian Enzo Sperone, of the gallery in Turin.

PIZZINATO, Armando. Italian, born 1910.

MAY DAY. 1948. Oil on plywood, 31⅜ x 45½" (79.7 x 115.6 cm). Gift of Peggy Guggenheim. 185.52.

PLAVINSKY, Dimitri Petrovich. Russian, born 1937.

468 VOICES OF SILENCE. (1962) Oil on canvas, 55¼" x 6'7" (139.8 x 200.5 cm). Purchase. 2105.67.

469 COELACANTH. 1965. Oil and synthetic polymer paint on canvas with small pieces of cardboard and wood shavings beneath paint, 39⅜ x 59⅛" (99.7 x 150.1 cm). Purchase. 2106.67.

POLAK, Marcel. Dutch, born 1902. To France 1948.

THE SHADOW. 1954. Collage of paper with watercolor and pastel,

8¹/₈ x 6⁷/₈″ (20.5 x 17.5 cm) (irregular). Alfred Flechtheim Fund. 277.56.

CHRISTMAS. 1954–55. Collage of paper with watercolor, gouache, and ink, 8⁷/₈ x 6³/₄″ (22.6 x 17 cm) (irregular). Purchase. 276.56. Repr. *Suppl. VI*, p. 22.

POLESELLO, Rogelio. Argentine, born 1939.

504 Untitled. 1966. Synthetic polymer paint airbrushed on paper, 39³/₈ x 25¹/₂″ (99.9 x 64.8 cm). Gift of Emilio del Junco (by exchange). 6.67.

POLIAKOFF, Serge. French, born Russia. 1906–1969. To Paris 1923.

346 COMPOSITION. (1956) Oil on burlap, 38¹/₈ x 51¹/₄″ (96.7 x 130.2 cm). Gift of M. Knoedler & Company. 579.56. Repr. *Suppl. VI*, p. 24.

POLLOCK, Jackson. American, 1912–1956.

322 THE SHE-WOLF. 1943. Oil, gouache, and plaster on canvas, 41⁷/₈ x 67″ (106.4 x 170.2 cm). Purchase. 82.44. Repr. *Ptg & Sc.*, p. 231; *Pollock, 1967*, p. 86; in color, *Invitation*, p. 83.

322 PAINTING. 1945. Mixed mediums on paper, 30⁵/₈ x 22³/₈″ (77.7 x 57 cm). Blanchette Rockefeller Fund. 13.58. Repr. *Suppl. VIII*, p. 9.

322 PAINTING. (1945?) Gouache on plywood, 23 x 18⁷/₈″ (58.4 x 47.8 cm). Gift of Monroe Wheeler. 415.58. Repr. *Suppl. VIII*, p. 9; *Pollock, 1967*, p. 37.

FREE FORM. 1946. Oil on canvas, 19¹/₄ x 14″ (48.9 x 35.5 cm). The Sidney and Harriet Janis Collection (fractional gift). 645.67. Repr. *Janis*, p. 119.

324 FULL FATHOM FIVE. 1947. Oil on canvas with nails, tacks, buttons, key, coins, cigarettes, matches, etc., 50⁷/₈ x 30¹/₈″ (129.2 x 76.5 cm). Gift of Peggy Guggenheim. 186.52. Repr. *Suppl. IV*, p. 34; *Pollock, 1967*, p. 96.

323 NUMBER 1, 1948. 1948. Oil on canvas, 68″ x 8′8″ (172.7 x 264.2 cm). Purchase. 77.50. Repr. *Suppl. II*, p. 20; *Pollock*, p. 22; in color, *Masters*, p. 178; *Pollock, 1967*, p. 47.

322 NUMBER 12. 1949. Oil on paper mounted on composition board, 31 x 22¹/₂″ (78.8 x 57.1 cm). Gift of Edgar Kaufmann, Jr. 15.52. Repr. *Pollock, 1967*, p. 102.

324 NUMBER 5. (1950) Oil on canvas, 53³/₄ x 39″ (136.5 x 99.1 cm). Gift of Mr. and Mrs. Walter Bareiss. 155.57. Repr. *Suppl. VII*, p. 18.

324 PAINTING. (1953–54) Oil and gouache on paper, 15³/₄ x 20¹/₂″ (40 x 52.1 cm). On reverse: brush drawing in black and red ink. Gift of Mr. and Mrs. Ira Haupt. 263.57a–b. Repr. *Suppl. VIII*, p. 9.

WHITE LIGHT. 1954. Oil, enamel, and aluminum paint on canvas, 48¹/₄ x 38¹/₄″ (122.4 x 96.9 cm). The Sidney and Harriet Janis Collection (fractional gift). 337.67. Repr. *Pollock, 1967*, p. 128; *Janis*, p. 119.

Also, drawings.

POMODORO, Arnaldo. Italian, born 1926.

481 SPHERE, I. (1963) Bronze, 44³/₄ (113.5 cm) diameter, on base ¹/₂″ (1.2 cm) high, 7³/₈″ (18.5 cm) diameter. Mrs. Simon Guggenheim Fund. 1242.64.

POMPON, François. French, 1855–1933.

DUCK. Bronze, 7¹/₄″ (18.4 cm) high, at base 4¹/₄″ (10.8 cm) diameter (irregular). Gift of Abby Aldrich Rockefeller. 594.39.

PONCE DE LEÓN, Fidelio. Cuban, 1895–1949.

216 TWO WOMEN. 1934. Oil on canvas, 39¹/₄ x 39³/₈″ (99.7 x 100 cm). Gift of Dr. C. M. Ramírez Corría. 606.42. Repr. *Ptg. & Sc.*, p. 180.

Also, drawings.

POONS, Larry. American, born Japan 1937. To U.S.A. 1938.

373 NIGHT ON COLD MOUNTAIN. (1962) Synthetic polymer paint and dye on canvas, 6′8″ x 6′8″ (203.1 x 203.1 cm). Larry Aldrich Foundation Fund. 271.63.

POPOVA, Lyubov Sergeievna. Russian, 1889–1924.

131 ARCHITECTONIC PAINTING. 1917. Oil on canvas, 31¹/₂ x 38⁵/₈″ (80 x 98 cm). Philip Johnson Fund. 14.58. Repr. *Suppl. X*, p. 50.

PORTER, Fairfield. American, 1907–1975.

443 FLOWERS BY THE SEA. 1965. Oil on composition board, 20 x 19¹/₂″ (50.6 x 49.5 cm). Larry Aldrich Foundation Fund. 200.66.

PORTINARI, Cândido. Brazilian, 1903–1962.

215 MORRO. (1933) Oil on canvas, 44⁷/₈ x 57³/₈″ (114 x 145.7 cm). Abby Aldrich Rockefeller Fund. 663.39. Repr. *Art in Our Time*, no. 152a.

215 SCARECROW. 1940. Oil on canvas, 51¹/₂ x 64″ (130.8 x 162.5 cm). Abby Aldrich Rockefeller Fund. 361.41. Repr. *Art in Prog.*, p. 104.

Also, drawings, monotypes, and prints.

PORTOCARRERO, René. Cuban, born 1912.

MYTHOLOGICAL PERSONAGE. 1945. Gouache, 37¹/₄ x 27³/₄″ (94.6 x 70.5 cm). Inter-American Fund. 166.45.

Also, a sketchbook of twenty-five watercolors and ink drawings.

POUSETTE-DART, Richard. American, born 1916.

330 NUMBER 11: A PRESENCE. (1949) Oil on canvas, 25¹/₈ x 21¹/₈″ (63.8 x 53.7 cm). Katharine Cornell Fund. 100.50. Repr. *Abstract Ptg. & Sc.*, p. 137.

451 RADIANCE. 1962–63. Oil and metallic paint on canvas, 6′ ¹/₈″ x 8′ ¹/₄″ (183.3 x 244.2 cm). Gift of Susan Morse Hilles. 453.64.

PRAZERES. See DOS PRAZERES.

PRENDERGAST, Maurice. American, born Newfoundland. 1859–1924.

CAMPO VITTORIO EMANUELE, SIENA. (1898) Watercolor, 11¹/₄ x 13³/₄″ (28.6 x 35 cm). Gift of Abby Aldrich Rockefeller. 131.35.

37 FESTIVAL, VENICE. (1898) Watercolor, 16⁵/₈ x 14″ (42.2 x 35.6 cm). Gift of Abby Aldrich Rockefeller. 133.35.

37 THE LAGOON, VENICE. 1898. Watercolor, 11¹/₈ x 15³/₈″ (28.3 x 39 cm). Acquired through the Lillie P. Bliss Bequest. 168.45.

37 THE EAST RIVER. 1901. Watercolor, 13³/₄ x 19³/₄″ (35 x 50.2 cm). Gift of Abby Aldrich Rockefeller. 132.35. Repr. *Ptg. & Sc.*, p. 66; in color, *La Pintura*, p. 144.

37 APRIL SNOW, SALEM. (1906–07) Watercolor, 14³/₄ x 21⁵/₈″ (37.5 x 54.9 cm). Gift of Abby Aldrich Rockefeller. 129.35. Repr. *Ptg. & Sc.*, p. 66.

LANDSCAPE. Watercolor and pastel, 14¹/₂ x 18″ (36.8 x 45.7 cm). Given anonymously. 134.35.

37 ACADIA. (1922) Oil on canvas, 31³/₄ x 37¹/₂″ (80.6 x 95.2 cm). Abby Aldrich Rockefeller Fund. 167.45. Repr. *Ptg. & Sc.*, p. 67; in color, *Masters*, p. 37.

Also, monotypes.

PRÉVERT, Jacques. French, born 1900.

THE WINDOW OF ISIS. (1957) Collage on photograph, 14¼ x 11⅝" (36.3 x 29.6 cm). Gift of James Thrall Soby. 291.61. Repr. *Suppl. XI*, p. 36.

Also, part of a *cadavre exquis*.

PRINNER, Antoine. French, born Hungary 1902. To France 1927.

298 EVOCATION [*L'Appelée*]. (1952) Bronze, 48" (122 cm) high, at base 13⅝ x 18¾" (34.7 x 47.5 cm). Blanchette Rockefeller Fund. 31.57. Repr. *Suppl. VI*, p. 27.

Also, a print and an illustrated book.

PURVES-SMITH, Charles Roderick. Australian, 1913–1949.

KANGAROO HUNT. 1939. Oil on canvas, 25½ x 36½" (64.8 x 92.7 cm). Purchase. 567.41.

PUTNAM, Wallace. American, born 1899.

SHEEP ON A CLIFF. (1952) Oil on composition board, 16⅛ x 30⅜" (41 x 77.2 cm). Given anonymously. 552.54. Repr. *Suppl. V*, p. 32.

QUINTE, Lothar. German, born 1923.

461 BLUE FIELD, III. 1963. Oil on canvas, 51½ x 39⅝" (130.5 x 100.4 cm). Gertrud A. Mellon Fund. 50.65.

QUIRT, Walter. American, 1902–1968.

248 BURIAL. 1934. Oil on gesso on composition board, 6⅜ x 7¾" (16.2 x 19.7 cm). Given anonymously. 401.38. Repr. *Ptg. & Sc.*, p. 149.

THE TRANQUILLITY OF PREVIOUS EXISTENCE. (1941) Oil on canvas, 24⅛ x 32" (61.3 x 81.3 cm). Purchase. 163.42. Repr. *Art in Prog.*, p. 96.

RABKIN, Leo. American, born 1919.

THE RED VISIT. (1960) Watercolor, 38⅛ x 24⅞" (96.8 x 63.1 cm) (irregular). Larry Aldrich Foundation Fund. 365.60. Repr. *Suppl. X*, p. 34.

RAHMI, Bedri (Bedri Rahmi Eyüboğlu). Turkish, born 1913.

318 THE CHAIN. 1962. Synthetic polymer paint on burlap, 14⅛ x 47⅝" (35.8 x 121 cm) (irregular). Gift of the Honorable Turgut Menemencioğlu. 234.62. Repr. *Suppl. XII*, p. 30.

RAMÍREZ, Eduardo (Eduardo Ramírez Villamizar). Colombian, born 1922.

BLACK AND WHITE. 1956. Gouache, 25⅞ x 32⅝" (65.6 x 82.9 cm). Inter-American Fund. 580.56. Repr. *Suppl. VI*, p. 33.

374 HORIZONTAL WHITE RELIEF. 1961. Synthetic polymer paint on cardboard, 11 x 24⅜ x 1¾" (28 x 61.8 x 4.5 cm). Gift of Silvia Pizitz. 562.63.

RAMOS BLANCO, Teodoro. Cuban, born 1902.

216 OLD NEGRO WOMAN. (1939) Acana wood, 11⅛" (28.3 cm) high. Inter-American Fund. 776.42. Repr. *Latin-Amer. Coll.*, p. 50.

RATTNER, Abraham. American, born 1893.

241 MOTHER AND CHILD. (1938) Oil on canvas, 28¾ x 39⅜" (73 x 100 cm). Given anonymously. 19.40.

RAUSCHENBERG, Robert. American, born 1925.

383 FIRST LANDING JUMP. 1961. "Combine-painting": tire, khaki shirt, license plate, leather straps, mirror, iron street light reflector, live blue light bulb, electric cable, steel spring, tin cans, various pieces of cloth and oil paint on composition board, 7'5⅛" x 6' 8⅞" (226.3 x 182.8 x 22.5 cm). Promised gift and extended loan from Philip Johnson. E.L.63.1697.

Also, thirty-four "combine-drawings" for Dante's *Inferno*, prints; and two photographs in the Study Collection.

RAY. See MAN RAY.

REDER, Bernard. American, born Rumania. 1897–1963. Worked in Prague and Paris. To U.S.A. 1943.

255 TORSO. (1938) French limestone, 45" (114.3 cm) high, at base 23¾ x 17" (60.3 x 43.2 cm). Gift of J. van Straaten. 187.52. Repr. *Suppl. IV*, p. 36.

255 LADY WITH HOUSE OF CARDS. 1957. Cast bronze, 7'5½" (227.4 cm) high, at base 34⅜ x 35¼" (87.3 x 89.5 cm). Gift of Mr. and Mrs. Albert A. List. 783.63.

Also, prints.

REDON, Odilon. French, 1840–1916.

26 REVERIE. (c. 1900) Pastel, 21¼ x 14½" (54 x 36.8 cm). Gift of Abby Aldrich Rockefeller. 135.35. Repr. *Post-Impress.* (2nd), p. 179.

401 BUTTERFLIES. (1910) Oil on canvas, 29⅛ x 21½" (73.9 x 54.6 cm). Gift of Mrs. Werner E. Josten in memory of her husband. 454.64.

26 ROGER AND ANGELICA. (c. 1910) Pastel, 36½ x 28¾" (92.7 x 73 cm). Lillie P. Bliss Collection. 111.34. Repr. *Ptg. & Sc.*, p. 35; in color, *Redon*, p. 85.

26 SILENCE. (c. 1911) Oil on gesso on paper, 21¼ x 21½" (54 x 54.6 cm). Lillie P. Bliss Collection. 113.34. Repr. *Ptg. & Sc.*, p. 36; *Redon*, p. 93; in color, *Invitation*, p. 94.

26 YELLOW FLOWERS. (1912?) Pastel, 25½ x 19½" (64.6 x 49.4 cm). Acquired through the Mary Flexner Bequest. 19.57. Repr. *Suppl. VII*, p. 3.

26 VASE OF FLOWERS. (1914) Pastel, 28¾ x 21⅛" (73 x 53.7 cm). Gift of William S. Paley. 553.54. Repr. *Suppl. V*, p. 6.

Also, drawings and prints.

REDWOOD, Junius. American, born 1917.

287 NIGHT SCENE. (1941) Oil on cardboard, 43⅜ x 33⅜" (110.2 x 84.8 cm). Purchase. 755.43.

REFREGIER, Anton. American, born Russia 1905. To U.S.A. 1920.

ACCIDENT IN THE AIR. (1939) Oil on composition board, 19 x 23" (48.3 x 58.4 cm). Gift of the New York World's Fair, 1939. 641.39.

REIMANN, William. American, born 1935.

371 ICON. (1957) Opaque plexiglass, 34¼" (87 cm) high, base, 18" (45.5 cm) diameter. Larry Aldrich Foundation Fund. 67.61. Repr. *Suppl. XI*, p. 27.

REINHARDT, Ad. American, 1913–1967.

432 Untitled. 1938. Oil on canvas, 16 x 20" (40.6 x 50.8 cm). Gift of the artist. 451.67.

The six works following are studies for paintings for the Easel Division, Federal Art Project, W.P.A., 1938–39. Gift of the artist.

Study for a painting. 1938. Collage of pasted and painted paper, brush and ink, 3⅞ x 5" (9.8 x 12.5 cm). 453.67.

Study for a painting. 1938. Collage of pasted and painted paper, 4 x 5" (9.9 x 12.5 cm). 457.67.

432 Study for a painting. 1938. Gouache, 4 x 5" (10.1 x 12.7 cm). 455.67.

Study for a painting. 1939. Gouache, 4 x 5" (10 x 12.7 cm). 452.67.

Study for a painting. 1939. Gouache, 3⅞ x 5" (9.8 x 12.5 cm). 456.67.

432 Study for a painting. 1939. Gouache, 4 x 5" (10 x 12.5 cm). 454.67.

432 COLLAGE, 1940. 1940. Collage on cardboard, 15¾ x 13⅛" (39.8 x 33.2 cm). Gift of the artist. 458.67.

NEWSPRINT COLLAGE. Dated on work 1940 and 1943. Collage on cardboard, 16 x 20" (40.6 x 50.8 cm). Gift of the artist. 459.67.

366 ABSTRACT PAINTING. 1960–61. Oil on canvas, 60 x 60" (152.4 x 152.4 cm). Purchase (by exchange). 570.63. Repr. *Amer. 1963*, p. 81.

RENOIR, Pierre-Auguste. French, 1841–1919.

16 RECLINING NUDE. (1902) Oil on canvas, 26½ x 60⅝" (67.3 x 154 cm). Gift of Mr. and Mrs. Paul Rosenberg. 23.56. Repr. *Suppl. VI*, p. 3.

16 THE WASHERWOMAN. (1917) Bronze, 48" (121.9 cm) high, at base 21¾ x 50" (55.3 x 127 cm). A. Conger Goodyear Fund. 188.53. Repr. *Masters*, p. 41.

Also, prints.

RESNICK, Milton. American, born Ukraine 1917. To U.S.A. 1922.

334 BURNING BUSH. 1959. Oil on canvas, 63 x 48" (160 x 121.8 cm). Larry Aldrich Foundation Fund. 612.59. Repr. *Suppl. IX*, p. 26.

REUTERSWÄRD, Carl Fredrik. Swedish, born 1934.

352 BAM BAM. 1958. Enamel on paper, 24 x 17" (61 x 43 cm). Gift of Theodor Ahrenberg. 662.59. Repr. *Suppl. IX*, p. 17.

Also, a print.

REYES FERREIRA, Jesús. Mexican.

ANGEL. Tempera, 29½ x 19⅝" (74.9 x 49.9 cm). Gift of Mrs. Edgar J. Kaufmann. 607.42.

Also, a tempera in the Study Collection.

REYNAL, Jeanne. American, born 1903.

340 A GOOD CIRCULAR GOD. (1948–50) Mosaic, 37 x 24⅜" (94 x 61.9 cm). Katharine Cornell Fund. 20.51. Repr. *Suppl. III*, p. 17.

REYNOLDS, Alan. British, born 1926.

COMPOSITION JULY. 1952. Oil on composition board, 30 x 47¾" (76.2 x 121.3 cm). Purchase. 188.52.

RIBEMONT-DESSAIGNES, Georges. French, born 1884.

159 SILENCE. (c. 1915) Oil on canvas, 36¼ x 28⅞" (92.1 x 73.3 cm). Katherine S. Dreier Bequest. 189.53.

Also, drawings in the Study Collection.

RICHENBURG, Robert. American, born 1917.

UPRISING. 1959. Oil on canvas, 6'4⅛" x 56" (193.2 x 142.2 cm). Given anonymously. 722.59. Repr. *Suppl. IX*, p. 26.

RICHIER, Germaine. French, 1904–1959.

294 THE DEVIL WITH CLAWS [*Le Griffu*]. (1952) Bronze, 34½ x 37¼"

(87.5 x 94.5 cm). Wildenstein Foundation Fund. 18.57. Repr. *Suppl. VI*, p. 26.

294 SIX-HEADED HORSE. (1953?) Plaster over string and wire, 14 x 14⅞" (35.4 x 37.7 cm). Gift of Mrs. Katharine Kuh. 421.60. Repr. *Suppl. X*, p. 22.

294 SCULPTURE WITH BACKGROUND. (1955–56) Gilded bronze: figure, 8¾" (22.2 cm) high; background, 9¼ x 14¾ x 4⅝" (23.5 x 37.3 x 11.8 cm). Blanchette Rockefeller Fund. 293.56a-b. Repr. *Suppl. VI*, p. 25.

Also, a print and a poster.

RICKEY, George. American, born 1907. In Great Britain 1913–30.

493 TWO LINES—TEMPORAL I. (1964) Two stainless steel mobile blades on painted steel base, 35'2⅜" (10.73 m) high. Mrs. Simon Guggenheim Fund. 506.65a-c. Repr. *What Is Mod. Sc.*, p. 104.

RILEY, Bridget. British, born 1931.

499 CURRENT. 1964. Synthetic polymer paint on composition board, 58⅜ x 58⅞" (148.1 x 149.3 cm). Philip Johnson Fund. 576.64. Repr. *Responsive Eye*, p. 34; background of cover, detail.

RIOPELLE, Jean-Paul. Canadian, born 1923. Works in Paris.

349 FOREST BLIZZARD. 1953. Oil on composition board, 67⅛" x 8'4¼" (170.5 x 254.7 cm). Gift of Mr. and Mrs. Ralph F. Colin. 26.54. Repr. *Suppl. V*, p. 26.

RIVERA, Diego. Mexican, 1886–1957. Worked in Europe 1907–21. In U.S.A. 1930–33, 1940.

206 JACQUES LIPCHITZ (PORTRAIT OF A YOUNG MAN). 1914. Oil on canvas, 25⅝ x 21⅝" (65.1 x 54.9 cm). Gift of T. Catesby Jones. 412.41. Repr. *Latin-Amer. Coll.*, p. 57.

STILL LIFE WITH VEGETABLES. 1918. Watercolor, 12½ x 19¼" (31.7 x 48.9 cm). Given anonymously. 199.40. Repr. *Rivera*, no. 56.

206 MAY DAY, MOSCOW. 1928. Sketchbook of forty-five watercolors; thirty-three, 4 x 6¼" (10.3 x 16 cm), and twelve, 6¼ x 4" (16 x 10.3 cm). Gift of Abby Aldrich Rockefeller. 137.35.1–.45. Nos. 137.35.20 and 137.35.30 are reproduced here, and nos. 137.35.20, 137.35.24, and 137.35.30 are repr. *Ptg. & Sc.*, p. 140.

206 AGRARIAN LEADER ZAPATA. 1931. Fresco, 7'9¾" x 6'2" (238.1 x 188 cm). Abby Aldrich Rockefeller Fund. 1631.40. Repr. *Ptg. & Sc.*, p. 134; in color, *Invitation*, p. 110. *Note*: the Museum invited the artist to New York to paint seven frescoes for an exhibition in 1931, under a grant from Abby Aldrich Rockefeller. *Agrarian Leader Zapata*, the only one of the seven in the Museum Collection, is a variant of the fresco in the Palace of Cortés, Cuernavaca, 1930.

206 FLOWER FESTIVAL: FEAST OF SANTA ANITA. 1931. Encaustic on canvas, 6'6½" x 64" (199.3 x 162.5 cm). Variant of a section of the fresco in the Ministry of Education, Mexico City, 1923–27. Gift of Abby Aldrich Rockefeller. 23.36. Repr. *Rivera*, no. 47.

H.P. Twenty-four watercolor designs made in 1927 and 1931 for the ballet first produced by the Philadelphia Grand Opera Company, 1932. Seventeen designs for costumes, various sizes, 20⅝ x 28½ to 5⅜ x 3⅞" (52.4 x 72.4 to 13.6 x 9.8 cm); seven designs for scenery, 17⅞ x 11⅜ to 5⅜ x 8¼" (45.4 x 28.9 to 13.6 x 21 cm). Gift of Abby Aldrich Rockefeller. 505.41.1–.24. Theatre Arts Collection.

Also, drawings and prints; works in the Study Collection.

DE RIVERA, José. American, born 1904.

374 CONSTRUCTION 8. (1954) Stainless steel forged rod, 9⅜" (23.8

cm) high. Gift of Mrs. Heinz Schultz in memory of her husband. 24.55. Repr. *Suppl. V*, p. 38; *What Is Mod. Sc.*, p. 81.

492 STEEL CENTURY TWO (CONSTRUCTION 73). 1960–65. Stainless steel, 54¹/₈″ x 10′5³/₈″ (137.3 x 319.4 cm) on painted steel base with motor, 47″ (119.3 cm) high, 24¹/₄″ (61.6 cm) diameter. Gift of American Iron and Steel Institute. 677.65a–b. *Note*: the sculpture revolves once every 4 minutes, 45 seconds.

RIVERA, Manuel. Spanish, born 1927.

378 METAMORPHOSIS (HERALDRY). (1960) Relief of wire mesh on painted wood, 32¹/₄ x 40″ (81.8 x 101.5 cm). Gift of Mr. and Mrs. Richard Rodgers. 203.63.

RIVERS, Larry. American, born 1923.

281 WASHINGTON CROSSING THE DELAWARE. (1953) Oil on canvas, 6′11⁵/₈″ x 9′3⁵/₈″ (212.4 x 283.5 cm). Given anonymously. 25.55. Repr. *Suppl. V*, p. 24. *Notes*: damaged during fire, 1958; discolored by smoke, some charcoal drawing washed away by water, lower right-hand corner charred and partly restored. Exhibition approved by artist. The Museum owns thirteen pencil studies for this painting.

281 THE POOL. (1956) Oil, charcoal, and bronze paint on canvas, 8′7³/₈″ x 7′8⁵/₈″ (262.5 x 235.2 cm). Gift of Mr. and Mrs. Donald Weisberger. 139.58. Repr. *Suppl. VIII*, p. 12.

 HEAD. (1957) Welded steel, 18¹/₈″ (46 cm) high, at base 14¹/₄ x 8¹/₄″ (36.2 x 20.9 cm). Given anonymously. 20.59. Repr. *Recent Sc. U.S.A.*

281 THE LAST CIVIL WAR VETERAN. 1959. Oil and charcoal on canvas, 6′10¹/₂″ x 64¹/₈″ (209.6 x 162.9 cm). Blanchette Rockefeller Fund. 235.62. Repr. *Suppl. XII*, p. 15. *Note*: the subject is Walter Williams of Houston, Texas, who died December 19, 1959, shortly after this painting was finished.

 Also, drawings, prints, and a poster.

ROA, Israel. Chilean, born 1909.

 THE PAINTER'S BIRTHDAY. Oil on canvas, 27⁵/₈ x 38″ (70.2 x 96.5 cm). Inter-American Fund. 213.42. Repr. *Latin-Amer. Coll.*, p. 43.

ROBUS, Hugo. American, 1885–1964.

251 GIRL WASHING HER HAIR. (1940) After plaster of 1933. Marble, 17 x 30¹/₂″ (43.2 x 77.5 cm). Abby Aldrich Rockefeller Fund. 659.39. Repr. *Ptg. & Sc.*, p. 259.

 Also, a drawing.

RODCHENKO, Alexander. Russian, 1891–1956.

130 COMPOSITION. 1918. Gouache, 13 x 6³/₈″ (33 x 16.2 cm). Gift of the artist. 28.36. Repr. *Ptg. & Sc.*, p. 115.

130 NON-OBJECTIVE PAINTING: BLACK ON BLACK. 1918. Oil on canvas, 32¹/₄ x 31¹/₄″ (81.9 x 79.4 cm). Gift of the artist, through Jay Leyda. 114.36.

130 COMPOSITION. 1919. Gouache, 12¹/₄ x 9″ (31.1 x 22.9 cm). Gift of the artist. 29.36. Repr. *Cubism*, fig. 118.

403 COMPOSITION. 1919. Watercolor and ink, 14⁵/₈ x 11¹/₂″ (37.1 x 9.2 cm). Gift of the artist. 30.36.

130 NON-OBJECTIVE PAINTING. 1919. Oil on canvas, 33¹/₄ x 28″ (84.5 x 71.1 cm). Gift of the artist, through Jay Leyda. 113.36.

 LINE CONSTRUCTION. 1920. Colored inks, 12³/₄ x 7³/₄″ (32.4 x 19.7 cm). Given anonymously. 11.40.

 Also, drawings, posters, books, and graphics.

RODIN, Auguste. French, 1840–1917.

17 ST. JOHN THE BAPTIST PREACHING. (1878–80) Bronze, 6′6³/₄″ (200.1 cm) high, at base 37 x 22¹/₂″ (94 x 57.2 cm) (irregular). Mrs. Simon Guggenheim Fund. 27.55. Repr. *Suppl. V*, p. 7; *Rodin*, p. 29 and in color opp. p. 27.

 THE MIGHTY HAND. (1884–86) Bronze, 18³/₈ x 11⁵/₈″ (46.5 x 29.5 cm). Extended loan from Mrs. Jefferson Dickson. E.L.62.1100. Repr. *Rodin*, p. 80.

17 MONUMENT TO BALZAC. (1897–98) Bronze (cast 1954), 8′10″ (269 cm) high, at base 48¹/₄ x 41″ (122.5 x 104.2 cm). Presented in memory of Curt Valentin by his friends. 28.55. Repr. *Suppl. V*, p. 1; *Rodin*, pp. 88, 100; *Rosso*, pp. 53, 72; *What Is Mod. Sc.*, p. 35.

 Also, drawings and a print.

RODRÍGUEZ-LARRAIN, Emilio (Emilio Rodríguez-Larrain y Balta). Peruvian, born 1928. Lives in France.

467 BIRTH OF A PERSONAGE. (1965) Oil and tempera on composition board, 6′6³/₄″ x 56″ (200 x 142 cm). Given anonymously. 201.66.

RODRÍGUEZ LOZANO, Manuel. Mexican, born 1896.

211 BEYOND DESPAIR. 1940. Oil on canvas, 33¹/₈ x 27⁵/₈″ (84.2 x 70.2 cm). Inter-American Fund. 5.43. Repr. *Latin-Amer. Coll.*, p. 72.

 Also, a drawing.

ROESCH, Kurt. American, born Germany 1905. To U.S.A. 1933.

 BONES ON THE TABLE. (1939) Oil on canvas, 28¹/₄ x 35⁷/₈″ (71.8 x 91.1 cm). Gift of Mr. and Mrs. Walter Hochschild. 488.41.

 Also, a print.

VAN ROGGER, Roger. Belgian, born 1914.

 DESCENT FROM THE CROSS. 1946–48. Oil on canvas, 57¹/₈″ x 6′11″ (145.1 x 210.8 cm). Given anonymously. 78.50.

ROHLFS, Christian. German, 1849–1938.

66 MAN IN TOP HAT AND TAILS. (c. 1915–16) Gouache, watercolor, and graphite, 18¹/₈ x 12¹/₂″ (45.9 x 31.5 cm). Gift of Mr. and Mrs. Walter Bareiss. 581.56.

66 BLUE FAN DANCER. 1916. Gouache and watercolor, 19 x 13³/₄″ (48.2 x 34.9 cm). Gift of Mr. and Mrs. Eugene Victor Thaw. 582.56. Repr. *Suppl. VI*, p. 14.

 MAN IN A TOP HAT. 1935. Watercolor with crayon, 19⁷/₈ x 13″ (50.5 x 32.8 cm). John S. Newberry Collection. 611.63.

 Also, prints and a linoleum block.

RONALD, William. American, born Canada 1926. To U.S.A. 1954.

348 SAINTPAULIA. 1956. Oil on canvas, 48 x 52³/₈″ (122 x 132.9 cm). Blanchette Rockefeller Fund. 32.57. Repr. *Suppl. VII*, p. 17.

ROSE, Herman. American, born 1909.

291 TOWER AND TANK. (1947) Oil on canvas, 15 x 13″ (38.1 x 33 cm). Purchase. 12.49. Repr. *Suppl. I*, p. 25.

ROSENQUIST, James. American, born 1933.

 MARILYN MONROE, I. 1962. Oil and spray enamel on canvas, 7′9″ x 6′1¹/₄″ (236.2 x 183.3 cm). The Sidney and Harriet Janis Collection (fractional gift). 646.67. Repr. *Amer. 1963*, p. 92; in color, *Janis*, p. 155; in color, *Invitation*, p. 127.

ROSENTHAL, Bernard. American, born 1914.

 THE ARK. 1958. Welded brass, 28″ (71 cm) high, at base 7³/₄ x

10½" (19.8 x 26.8 cm). Gift of Mr. and Mrs. Victor M. Carter. 613.59. Repr. *Recent Sc. U.S.A.*

ROSSO, Medardo. Italian, 1858–1928. Lived in Paris 1889–1917.

38 THE CONCIERGE [*La Portinaia*]. (1883) Wax over plaster, 14½ x 12⅝" (36.8 x 32 cm). Mrs. Wendell T. Bush Fund. 614.59. Repr. *Suppl. IX*, p. 9; *Rosso*, p. 24. *Note*: the subject is the artist's doorkeeper, Orsola.

38 THE BOOKMAKER. (1894) Wax over plaster, 17½ x 13 x 14" (44.3 x 33 x 35.5 cm) (irregular). Acquired through the Lillie P. Bliss Bequest. 673.59. Repr. *Suppl. IX*, p. 8; *Rosso*, pp. 44, 73; *What Is Mod. Sc.*, p. 31. *Note*: the subject is Eugène Marin, the son-in-law of the collector, Henri Rouart.

38 MAN READING. (1894) Bronze (cast 1960), 10 x 11¼ x 11" (25.3 x 28.5 x 27.9 cm) (irregular). Harry J. Rudick Fund. 89.60. Repr. *Suppl. X*, p. 13; *Rosso*, pp. 45, 73.

ROSZAK, Theodore J. American, born Poland 1907. To U.S.A. 1909.

356 SPECTRE OF KITTY HAWK. (1946–47) Welded and hammered steel brazed with bronze and brass, 40¼" (102.2 cm) high, at base 18 x 15" (45.7 x 38.1 cm). Purchase. 16.50. Repr. *Suppl. II*, p. 18; *Masters*, p. 176. *Note*: the Museum owns two ink studies for this sculpture.

Also, drawings.

ROTHKO, Mark. American, born Latvia. 1903–1970. To U.S.A. 1913.

326 NUMBER 10. 1950. Oil on canvas, 7'6⅜" x 57⅛" (229.6 x 145.1 cm). Gift of Philip Johnson. 38.52. Repr. *15 Amer.*, p. 19; in color, *New Amer. Ptg.*, p. 69; *Art of the Real*, p. 14.

327 RED, BROWN, AND BLACK. 1958. Oil on canvas, 8'10⅝" x 9'9¼" (270.8 x 297.8 cm). Mrs. Simon Guggenheim Fund. 21.59. Repr. *Suppl. IX*, p. 23; *Rothko*, p. 29; in color, *Invitation*, p. 35.

326 NUMBER 19. (1958) Oil on canvas, 7'11¼" x 7'6¼" (241.9 x 229 cm). Given anonymously. 389.61. Repr. *Rothko*, p. 31; *Suppl. XII*, p. 19.

 HORIZONTALS, WHITE OVER DARKS. 1961. Oil on canvas, 56½" x 7'9⅜" (143.3 x 237 cm). The Sidney and Harriet Janis Collection (fractional gift). 647.67. Repr. in color, *Janis*, p. 129.

ROUAULT, Georges. French, 1871–1958.

46 WOMAN AT A TABLE. 1906. Watercolor and pastel, 12⅛ x 9½" (30.8 x 24.1 cm). Acquired through the Lillie P. Bliss Bequest. 503.41. Repr. *Rouault* (3rd), p. 49; *Ptg. & Sc.*, p. 46.

46 CLOWN. (c. 1907) Oil on paper, 11½ x 12⅞" (29.2 x 32.7 cm). Gift of Vladimir Horowitz. 692.49. Repr. *Suppl. II*, p. 3.

46 THE THREE JUDGES. 1913. Gouache and oil on cardboard, 29⅞ x 41⅝" (75.9 x 105.7 cm). Sam A. Lewisohn Bequest. 17.52. Repr. *Suppl. IV*, p. 5; in color, *Rouault* (3rd), p. 67; in color, *Masters*, p. 57.

 THE COOK. 1914. Gouache, 11⅞ x 7¾" (30.2 x 19.7 cm). Gift of Mrs. Sam A. Lewisohn. 57.52. Repr. *Rouault* (3rd), p. 69.

47 CIRCUS TRAINER. 1915. Gouache and crayon, 15⅝ x 10⅜" (39.7 x 26.3 cm). Gift of Mr. and Mrs. Peter A. Rübel. 616.51. Repr. *Rouault* (3rd), p. 70.

47 THE LOVELY MADAME X. 1915. Gouache and gilt paint, 12 x 7¾" (30.5 x 19.7 cm). Gift of Mrs. Sam A. Lewisohn. 56.52. Repr. *Rouault* (3rd), p. 69.

47 MAN WITH SPECTACLES. 1917. Watercolor and crayon, 11¾ x 6½" (29.8 x 16.5 cm). Gift of Abby Aldrich Rockefeller. 140.35. Repr. *Ptg. & Sc.*, p. 48; *Rouault* (3rd), p. 70.

47 CHRIST MOCKED BY SOLDIERS. (1932) Oil on canvas, 36¼ x 28½" (92.1 x 72.4 cm). Given anonymously. 414.41. Repr. *Ptg. & Sc.*, p. 49; in color, *Rouault* (3rd), p. 89; in color, *Invitation*, p. 23.

47 LANDSCAPE WITH FIGURES. (c. 1937) Oil on canvas, 21⅜ x 27½" (54.3 x 69.8 cm). Gift of Sam Salz. 427.53. Repr. *Suppl. V*, p. 9.

Also, prints, a drawing, a monotype, and illustrated books.

ROUSSEAU, Henri. French, 1844–1910.

4 THE SLEEPING GYPSY. 1897. Oil on canvas, 51" x 6'7" (129.5 x 200.7 cm). Gift of Mrs. Simon Guggenheim. 646.39. Repr. *Ptg. & Sc.*, p. 14; in color, *Masters*, p. 13; *Rousseau* (2nd), opp. p. 32; *Paintings from MoMA*, p. 9; in color, *Invitation*, p. 13.

4 VASE OF FLOWERS. Oil on canvas, 16¼ x 13" (41.3 x 33 cm). In the memory of Carol Buttenwieser Loeb. 5.56. Repr. *Suppl. VI*, p. 6.

4 JUNGLE WITH A LION. (1904–10) Oil on canvas, 15⅛ x 18¼" (38.4 x 46.3 cm). Lillie P. Bliss Collection. 118.34. Repr. *Ptg. & Sc.*, p. 15.

5 THE DREAM. 1910. Oil on canvas, 6'8½" x 9'9½" (204.5 x 298.5 cm). Gift of Nelson A. Rockefeller. 252.54. Repr. in color, *Masters*, p. 15; in color, *Invitation*, p. 80.

Also, a print.

ROY, Pierre. French, 1880–1950.

193 DANGER ON THE STAIRS [*Danger dans l'escalier*]. (1927 or 1928) Oil on canvas, 36 x 23⅝" (91.4 x 60 cm). Gift of Abby Aldrich Rockefeller. 142.35. Repr. *Ptg. & Sc.*, p. 198.

193 DAYLIGHT SAVING TIME [*L'Heure d'été*]. (1929) Oil on canvas, 21½ x 15" (54.6 x 38.1 cm). Gift of Mrs. Ray Slater Murphy. 1.31. Repr. *Ptg. & Sc.*, p. 198.

 COUNTRY FAIR [*Comice agricole*]. (c. 1930) Oil on canvas, 16⅛ x 13" (41 x 33 cm). Gift of Abby Aldrich Rockefeller. 128.40.

Also, illustrations.

RUBIN, Reuven. Israeli, born Rumania. 1893–1974. To Israel 1912.

 FLUTE PLAYER. (1938) Oil on canvas, 32 x 25⅝" (81.3 x 65.1 cm). Gift of Mrs. Felix M. Warburg. 252.40.

RUIZ, Antonio. Mexican, born 1897.

211 THE NEW RICH. 1941. Oil on canvas, 12⅝ x 16⅝" (32.1 x 42.2 cm). Inter-American Fund. 6.43. Repr. *Ptg. & Sc.*, p. 141.

RUSSELL, Morgan. American, 1886–1953.

William C. Agee has revised some dates and titles.

 THREE APPLES. (1910) Oil on cardboard, 9¾ x 12⅞" (24.6 x 32.4 cm). Given anonymously. 349.49.2.

224 CREAVIT DEUS HOMINEM (SYNCHROMY NUMBER 3: COLOR COUNTERPOINT). (1913) Oil on canvas mounted on cardboard, 11⅞ x 10¼" (30.2 x 26 cm). Given anonymously. 149.51.

 ARCHAIC COMPOSITION NUMBER 2. (1915–16) Oil on canvas, 12¾ x 9¾" (32.4 x 24.7 cm). Given anonymously. 349.49.1.

224 COLOR FORM SYNCHROMY (EIDOS). (1922–23) Oil on canvas, 14½ x 10⅝" (36.8 x 27 cm). Mrs. Wendell T. Bush Fund. 21.51. Repr. *Suppl. III*, p. 16.

Also, a drawing; an oil and transparencies in the Study Collection.

RYAN, Anne. American, 1889–1954.

COLLAGE, 269. (1949) Pasted paper and cloth, 4¹/₂ x 4″ (11.4 x 10.2 cm) (irregular). Given anonymously. 159.55.

381 NUMBER 48. (1950) Collage of pasted paper, tinfoil, and cloth on cardboard, 15³/₄ x 12¹/₂″ (40 x 31.7 cm). Katharine Cornell Fund. 22.51. Repr. *Abstract Ptg. & Sc.*, p. 115; *Assemblage*, p. 99.

COLLAGE. (c. 1952) Pasted paper and cloth, 6¹/₂ x 5″ (16.5 x 12.7 cm). Given anonymously. 157.55.

COLLAGE. (c. 1953) Pasted paper and cloth, 7 x 5″ (17.8 x 12.7 cm). Given anonymously. 158.55.

Also, prints.

SAGE, Kay. American, 1898–1963.

315 HYPHEN. 1954. Oil on canvas, 30 x 20″ (76.2 x 50.9 cm). Purchase. 343.55. Repr. *Suppl. VI*, p. 21.

462 THE GREAT IMPOSSIBLE. 1961. Watercolor, ink, and collage with convex lenses, 12⁵/₈ x 9³/₈″ (32 x 23.6 cm). Kay Sage Tanguy Bequest. 1132.64.

Also, an illustration.

SALAHI, Ibrahim. Sudanese, born 1930.

437 THE MOSQUE. (1964) Oil on canvas, 12¹/₈ x 18¹/₈″ (30.7 x 46 cm). Elizabeth Bliss Parkinson Fund. 7.65.

SALEMME, Attilio. American, 1911–1955.

THE FIRST COMMUNICATION. 1943. Oil on canvas, 13 x 19⁷/₈″ (33 x 50.5 cm). Purchase. 171.45. Repr. *Ptg. & Sc.*, p. 225.

ASTRONOMICAL EXPERIMENT. 1945. Oil on canvas, 30 x 40″ (76.2 x 101.6 cm). Gift of Mrs. John D. Rockefeller 3rd. 190.52.

ANTECHAMBER TO INNER SANCTUM. 1950. Oil on canvas, 28 x 40″ (71.1 x 101.6 cm). Gift of Mrs. Gertrud A. Mellon. 191.52. Repr. *Suppl. IV*, p. 45.

Also, drawings and a print.

SAMANT, Mohan B. Indian, born 1926. In U.S.A. 1959–64.

351 GREEN SQUARE. (1963) Synthetic polymer paint, sand, and oil on canvas, 69¹/₈ x 52″ (175.4 x 132.1 cm). Gift of George M. Jaffin. 334.63.

SAMARAS, Lucas. American, born Greece 1936. To U.S.A. 1948.

387 Untitled. (1960–61) Assemblage: wood panel with plaster-covered feathers, nails, screws, nuts, pins, razor blades, flash-light bulbs, buttons, bullets, aluminum foil, 23 x 19 x 4″ (59 x 48.2 x 10.2 cm). Larry Aldrich Foundation Fund. 301.61. Repr. *Suppl. XI*, p. 40.

Also, a poster.

SANI, Alberto. Italian, born c. 1900.

10 SLAUGHTERING SWINE. (c. 1950) Gray marble relief, 11³/₄ x 12¹/₄ x 4³/₄″ (29.8 x 31.1 x 12 cm). Purchase. 26.53. Repr. *Suppl. IV*, p. 47.

SANTO, Pasquale (Patsy). American, born Italy 1893. To U.S.A. 1913.

SPRING. 1940. Oil on canvas, 24¹/₈ x 18¹/₈″ (61.3 x 46 cm). Abby Aldrich Rockefeller Fund. 1653.40. Repr. *Amer. Realists*, p. 51.

SCARAVAGLIONE, Concetta. American, 1900–1975.

VINCENT CANADÉ. (1927?) Bronze, 11″ (27.9 cm) high. Given anonymously (by exchange). 18.43. Repr. *20th-C. Portraits*, p. 76.

SCARPITTA, Salvatore. American, born 1919.

363 COMPOSITION, I. (1959) Oil and casein on canvas strips stretched over armature, 45³/₄ x 35¹/₈″ (116.2 x 89.1 cm). Gift of William S. Rubin. 615.59. Repr. *Suppl. IX*, p. 32.

SCHIELE, Egon. Austrian, 1890–1918.

75 GIRL PUTTING ON SHOE. 1910. Watercolor and charcoal, 14¹/₂ x 12¹/₂″ (36.7 x 31.6 cm). Mr. and Mrs. Donald B. Straus Fund. 23.57. Repr. *Suppl. VII*, p. 4.

75 NUDE WITH VIOLET STOCKINGS. 1912. Watercolor, pencil, brush and ink, 12⁵/₈ x 18⁵/₈″ (32 x 47.3 cm). Mr. and Mrs. Donald B. Straus Fund. 22.57. Repr. *Suppl. VII*, p. 4.

75 PROSTITUTE. 1912. Watercolor and pencil, 19 x 12³/₈″ (48.1 x 31.3 cm). Mr. and Mrs. Donald B. Straus Fund. 21.57. Repr. *Suppl. VII*, p. 4.

Also, a drawing and a poster.

SCHLEMMER, Oskar. German, 1888–1943.

STUDY FOR THE "TRIADIC BALLET." (1922) Gouache, ink, and collage of photographs, 22⁵/₈ x 14⁵/₈″ (57.5 x 37.1 cm) (irregular). Gift of Mr. and Mrs. Douglas Auchincloss. 24.56. Repr. *Suppl. VI*, p. 16; *The Machine*, p. 135. *Note*: décor for the Third Part, with costume designs for "The Abstract/The Metaphysical," "Gold Sphere," and "Wire Costume." The ballet was first produced by Schlemmer at the Landestheater, Stuttgart, in 1922. It was subsequently produced in 1926 with music by Hindemith.

140 BAUHAUS STAIRWAY. (1932) Oil on canvas, 63⁷/₈ x 45″ (162.3 x 114.3 cm). Gift of Philip Johnson. 597.42. Repr. *Ptg. & Sc.*, p. 128; in color, *German Art of 20th C.*, p. 114; in color, *Invitation*, p. 67.

Also, prints and a poster.

SCHMID, Elsa. American, born Germany. 1897–1970.

241 FATHER D'ARCY. (1948–49) Mosaic and modeled fresco, 31¹/₄ x 17¹/₂″ (79.4 x 44.5 cm). Gift of Mrs. Charles Suydam Cutting. 79.50. Repr. *Suppl. II*, p. 28. *Note*: the subject is The Very Reverend Martin C. D'Arcy, S.J., English scholar. The Museum owns a pencil and an ink study for this mosaic.

Also, drawings.

SCHMIDT, Arnold. American, born 1930.

499 Untitled. 1965. Synthetic polymer paint on canvas, 48¹/₈″ x 8′1¹/₈″ (122.1 x 244.1 cm). Gift of Mr. and Mrs. Herbert C. Bernard. 113.66. Repr. *What Is Mod. Ptg.*, p. 45.

SCHMIDT, Julius. American, born 1923.

362 IRON SCULPTURE. (1960) Cast iron, 22¹/₂ x 38¹/₄ x 21³/₄″ (57 x 97 x 55.2 cm). Gift of Mr. and Mrs. Samuel A. Marx. 123.60. Repr. *Suppl. X*, p. 42.

Also, a drawing.

SCHMIDT-ROTTLUFF, Karl. German, 1884–1976.

70 HOUSES AT NIGHT. 1912. Oil on canvas, 37⁵/₈ x 34¹/₂″ (95.6 x 87.4 cm). Gift of Mr. and Mrs. Walter Bareiss. 156.57. Repr. *Suppl. VII*, p. 6.

70 PHARISEES. 1912. Oil on canvas, 29⁷/₈ x 40¹/₂″ (75.9 x 102.9 cm). Gertrud A. Mellon Fund. 160.55. Repr. *Suppl. V*, p. 11; in color, *German Art of 20th C.*, p. 50.

WASHERWOMEN BY THE SEA. (1921) Oil on burlap, 38⁵/₈ x 44¹/₄″ (98 x 112.4 cm). Gift of Mr. and Mrs. Richard K. Weil. 265.57. Repr. *German Art of 20th C.*, p. 51; *Suppl. VII*, p. 6.

70 LANDSCAPE WITH LIGHTHOUSE. 1922. Watercolor, 18⁷/₈ x 23⁷/₈″ (47.9 x 60.6 cm). Purchase. 17.50.

Also, prints and a poster.

SCHMITHALS, Hans. German, 1878–1964.

127 THE GLACIER. (c. 1903) Mixed mediums on paper, 45¹/₄ x 29¹/₂″ (114.8 x 74.7 cm). Matthew T. Mellon Foundation Fund. 90.60. Repr. *Suppl. X*, p. 14.

SCHNEIDER, Gérard. French, born Switzerland of French and Italian parents, 1896.

347 PAINTING 95 B. 1955. Oil on canvas, 57⁵/₈ x 45″ (146.3 x 114.2 cm). Gift of Mr. and Mrs. Harold Kaye. 197.56. Repr. *Suppl. VI*, p. 25.

Also, prints.

SCHNITZLER, Max. American, born Poland 1903.

365 NUMBER 1. (1955) Oil on canvas, 65⁷/₈ x 50″ (167.3 x 126.8 cm). Given anonymously. 9.61. Repr. *Suppl. XI*, p. 28.

SCHÖFFER, Nicolas. French, born Hungary, 1912. To Paris 1936.

515 MICROTEMPS 11. (1965) Motor-driven construction of steel, duraluminum, and plexiglass, in illuminated wood stage, 24¹/₈ x 35¹/₄ x 23³/₄″ (61.3 x 89.5 x 60.1 cm). Frank Crowninshield Fund. 108.66.

SCHOOLEY, Elmer. American, born 1916.

GERMAN LANDSCAPE. 1962. Oil on canvas, 30¹/₈ x 36¹/₄″ (76.4 x 91.8 cm). Gift of the artist through the Ford Foundation Purchase Program. 175.63.

SCHWARTZ, Manfred. American, born Poland. 1909–1970. To U.S.A. 1920.

272 THE RING. 1962. Pastel, 22 x 18¹/₄″ (55.9 x 46.2 cm). Gift of Mrs. H. Harris Jonas. 204.63.

Also, a print.

SCHWITTERS, Kurt. British subject, born Germany. 1887–1948. In England 1940–48.

161 DRAWING A 2: HANSI-SCHOKOLADE [*Zeichnung A 2: Hansi*]. 1918. Collage of colored papers and wrapper, 7¹/₈ x 5³/₄″ (18.1 x 14.6 cm) (sight). Purchase. 96.36. Repr. *German Art of 20th C.*, p. 93.

160 PICTURE WITH LIGHT CENTER [*Bild mit Heller Mitte*]. 1919. Collage of paper with oil on cardboard, 33¹/₄ x 25⁷/₈″ (84.5 x 65.7 cm). Purchase. 18.50. Repr. *Suppl. II*, p. 12; in color, *German Art of 20th C.*, p. 95; in color, *Invitation*, p. 58.

161 MERZ 22. 1920. Collage of railroad and bus tickets, wallpaper, ration stamps, 6⁵/₈ x 5³/₈″ (16.8 x 13.6 cm) (sight). Katherine S. Dreier Bequest. 190.53.

161 MERZ 39: RUSSIAN PICTURE [*Russisches Bild*]. 1920. Collage of colored papers, tickets, wrappers, 7³/₈ x 5⁵/₈″ (18.7 x 14.3 cm) (sight). Katherine S. Dreier Bequest. 191.53.

MERZ 83: DRAWING F [*Zeichnung F*]. 1920. Collage of cut paper wrappers, announcements, tickets, 5³/₄ x 4¹/₂″ (14.6 x 11.4 cm) (sight). Katherine S. Dreier Bequest. 192.53. Repr. *Masters*, p. 139.

MERZ 88: RED STROKE [*Rotstrich*]. 1920. Collage of colored papers, tickets, labels, stamps, 5¹/₄ x 4¹/₈″ (13.2 x 10.3 cm). The Sidney and Harriet Janis Collection (fractional gift). 648.67. Repr. *Janis*, p. 65.

MERZ 458. (c. 1920–22) Collage of streetcar tickets, wrappers, ration stamps, colored paper, etc., 7 x 5⁵/₈″ (17.8 x 14.3 cm) (sight). Katherine S. Dreier Bequest. 193.53.

160 CHERRY PICTURE [*Das Kirschbild*]. 1921. Collage of colored papers, fabrics, printed labels and pictures, pieces of wood, etc., and gouache on cardboard background, 36¹/₈ x 27³/₄″ (91.8 x 70.5 cm). Mr. and Mrs. A. Atwater Kent, Jr. Fund. 27.54. Repr. *Suppl. V*, p. 18.

MERZ 252: COLORED SQUARES [*Farbige Quadrate*]. 1921. Collage of colored papers, 7¹/₈ x 5³/₄″ (18 x 14.4 cm). The Sidney and Harriet Janis Collection (fractional gift). 649.67. Repr. *Janis*, p. 66.

MERZ 460: TWO UNDERDRAWERS [*Twee Onderbroeken*]. 1921. Collage of colored cut papers, ribbon, printed cotton, candy wrapper, 8 x 6³/₄″ (20.3 x 17.1 cm). Katherine S. Dreier Bequest. 194.53.

FAMIGLIA. 1922. Collage of colored and printed papers, 5³/₄ x 4¹/₄″ (14.3 x 10.8 cm). The Sidney and Harriet Janis Collection (fractional gift). 650.67. Repr. *Janis*, p. 66.

160 MERZ (WITH EMERKA WRAPPER). (1922?) Collage of cut paper, carbon paper, mattress ticking, 13³/₄ x 10³/₈″ (35 x 26.3 cm) (sight). Katherine S. Dreier Bequest. 197.53.

161 MERZ: SANTA CLAUS [*Der Weihnachtsmann*]. 1922. Collage of papers and cloth, 11¹/₄ x 8¹/₄″ (28.4 x 20.8 cm). Purchase. 258.35. Repr. *Ptg. & Sc.*, p. 212.

MERZ 370: BLUE SPARK [*Blauer Funken*]. 1922. Collage of cut colored paper, 8¹/₈ x 6³/₄″ (20.6 x 17.1 cm). Katherine S. Dreier Bequest. 195.53.

MERZ 379: POTSDAMER. 1922. Collage of papers and cloth, 7¹/₈ x 5³/₄″ (18.1 x 14.6 cm). Purchase. 97.36.

161 MERZ 448: MOSCOW [*Moskau*]. 1922. Collage of cardboard and wood, 6 x 6¹/₄″ (15.2 x 15.9 cm). Katherine S. Dreier Bequest. 196.53. Repr. *Suppl. IV*, p. 13.

MERZ 704: BÜHLAU. 1923. Collage of cut papers, wrappers, tram ticket, linen, 5¹/₄ x 3⁵/₈″ (13.3 x 9.2 cm). Katherine S. Dreier Bequest. 198.53.

MERZ 8. 1924. Collage of cut papers, 5¹/₂ x 4″ (14 x 10.2 cm). Katherine S. Dreier Bequest. 200.53.

161 MERZ 32. 1924. Collage of photographic paper, 5 x 3³/₄″ (12.7 x 9.5 cm). Katherine S. Dreier Bequest. 201.53.

MERZ 2005: CONSTANTINOPLE [*Konstantinopel*]. 1924. Collage of cut paper, cardboard, tram tickets, pellet of wood, 5¹/₈ x 4¹/₈″ (13 x 10.5 cm). Katherine S. Dreier Bequest. 199.53. Repr. *German Art of 20th C.*, p. 94.

MERZ DRAWING [*Merzzeichnung*]. 1924. Collage of cut colored papers and a button, 7³/₄ x 6¹/₈″ (19.7 x 15.6 cm). Katherine S. Dreier Bequest. 202.53. Repr. *Assemblage*, p. 52.

MERZ (WITH BLACK RECTANGLE). 1925. Collage of colored papers, 5⁵/₈ x 4¹/₂″ (14.3 x 11.4 cm). Katherine S. Dreier Bequest. 204.53.

160 MERZ (WITH LETTERS "ELIKAN" REPEATED). (1925?) Collage of cut paper, candy wrappers, advertisement, 17¹/₈ x 14¹/₄″ (43.5 x 36.2 cm). Katherine S. Dreier Bequest. 208.53.

161 MERZ (WITH PAPER LACE). 1925. Collage of colored paper, paper lace, paper top of cigarette box, 4³/₈ x 3³/₈″ (11.1 x 8.6 cm). Katherine S. Dreier Bequest. 203.53. Repr. *Suppl. IV*, p. 13.

161 MERZ 17: LISSITZKY. 1926. Collage of colored papers, 5¹/₄ x 4¹/₈″ (13.3 x 10.5 cm). Katherine S. Dreier Bequest. 205.53.

MERZ 48: BERLIN. 1926. Collage of tickets, colored and painted

papers, $4^3/4$ x $3^1/2''$ (11.8 x 8.7 cm). The Sidney and Harriet Janis Collection (fractional gift). 651.67. Repr. *Janis*, p. 67.

MERZ DRAWING E [*Merzzeichnung E*]. 1928. Collage of cut paper, $5^3/4$ x $4^1/8''$ (14.6 x 10.5 cm). Katherine S. Dreier Bequest. 206.53.

V-2. 1928. Collage of colored and printed papers with pen and ink and crayon, $5^1/8$ x $3^1/2''$ (12.8 x 8.9 cm) (irregular). The Sidney and Harriet Janis Collection (fractional gift). 652.67. Repr. *Janis*, p. 67.

161 MERZ (WITH BRITISH CENSOR'S SEAL). (1940–45) Collage of cut papers, envelopes, censorship forms, $7^3/8$ x $6^1/8''$ (18.7 x 15.6 cm). Katherine S. Dreier Bequest. 207.53.

Also, prints, prints with collage, and an illustrated book.

SCLIAR, Carlos. Brazilian, born 1920.

462 PEAR AND CHERRY. 1965. Synthetic polymer paint and collage on paper over composition board, 11 x 7" (27.7 x 17.8 cm). Gift of Mr. and Mrs. David Rockefeller. 631.65.

SCOTT, Patrick. Irish, born 1921.

286 WOMAN CARRYING GRASSES. (1958) Oil on canvas, 20 x 15" (50.8 x 38.1 cm). Elizabeth Bliss Parkinson Fund. 140.58. Repr. *Suppl. VIII*, p. 17.

SEAWRIGHT, James L. American, born 1936.

512 EIGHT. (1966) Construction with sound: seven compartments containing an octagonal black-metal construction, silvered plastic spheres, a metal plate with translucent plastic panel, an oil on canvas, an oscilloscope tube, a cathode-ray tube, and a miniature speaker which repeats the word "eight" at 15-second intervals, in composition board box, $6^3/8$ x 44 x 6" (16.2 x 111.7 x 15.2 cm). Adriane Reggie Fund. 596.66.

SEGAL, George. American, born 1924.

394 THE BUS DRIVER. (1962) Figure of plaster over cheesecloth; bus parts including coin box, steering wheel, driver's seat, railing, dashboard, etc. Figure, $53^1/2$ x $26^7/8$ x 45" (136 x 68.2 x 114 cm); wood platform, $5^1/8''$ x $51^5/8''$ x $6'3^5/8''$ (13 x 131 x 191.9 cm); overall height, 6'3" (192 cm). Philip Johnson Fund. 337.63a–k. *Note*: the artist's brother-in-law, David Kutliroff, was the model.

PORTRAIT OF SIDNEY JANIS WITH MONDRIAN PAINTING. (1967) Plaster figure with Mondrian's *Composition*, 1933, on an easel; figure, 66" (167.6 cm) high; easel, 67" (170 cm) high. The Sidney and Harriet Janis Collection (fractional gift). 653.67. Repr. *Janis*, p. 167.

SEGONZAC, André Dunoyer de. French, 1884–1974.

65 LANDSCAPE. (c. 1928) Watercolor, $18^7/8$ x $24^3/4''$ (47.9 x 62.9 cm). Lillie P. Bliss Collection. 119.34. Repr. *Bliss, 1934*, no. 55.

ROAD AND CRANE. Watercolor, $24^7/8$ x $18^7/8''$ (63.2 x 47.9 cm). Gift of Frank Crowninshield. 625.43.

Also, drawings and prints.

SEGUÍ, Antonio. Argentine, born 1934. Lives in Paris.

445 BOX OF GENTLEMEN. 1964. Oil on canvas, $6'4^7/8''$ x $51^3/8''$ (195 x 130.3 cm). Inter-American Fund. 293.65.

SELEY, Jason. American, born 1919.

388 MASCULINE PRESENCE. (1961) Assemblage: welded chromium-plated steel automobile bumpers and grill, $7'2^7/8''$ x 48" (220.6 x 121.9 cm). Gift of Dr. and Mrs. Leonard Kornblee. 302.61. Repr. *Assemblage*, p. 147.

SELIGER, Charles. American, born 1926.

NATURAL HISTORY: FORM WITHIN ROCK. 1946. Oil on canvas, 25 x 30" (63.5 x 76.2 cm). Gift of August Hanniball, Jr. 139.47.

SELIGMANN, Kurt. American, born Switzerland. 1900–1962. Worked in Paris. To U.S.A. 1939.

182 THE KING. 1960. Oil on canvas, $24^1/4$ x 20" (61.4 x 50.7 cm). Gift of Stamo Papadaki (by exchange). 91.60. Repr. *Suppl. X*, p. 22.

Also, prints and an illustrated book.

SEQUEIRA. See MORALES SEQUEIRA.

SERPAN, Iaroslav. French, born Czechoslovakia 1922.

354 MURTSPHDE, 570. (1957) Oil on canvas, $57^1/2$ x $44^7/8''$ (146 x 113.7 cm). Gift of G. David Thompson. 22.59. Repr. *Suppl. IX*, p. 24.

SERRANO, Pablo (Pablo Serrano Aguilar). Spanish, born 1910.

414 HEAD OF ANTONIO MACHADO. 1965. Bronze, 26 x $20^7/8$ x $24^5/8''$ (65.8 x 53 x 62.5 cm), iron base $3/8$ x $23^3/4$ x $23^3/4''$ (.7 x 60.2 x 60.2 cm). Gift of the Organizing Committee of Homage, "Walk with Antonio Machado." 97.67. *Note*: the Spanish poet Antonio Machado died in exile in 1939. This portrait (of which the Museum's cast is the second) was commissioned as part of a larger monument to the poet in Baeza, the Andalusian city where he taught for many years. Dedication of the monument, planned for February 20, 1966, was prohibited by the Spanish government authorities.

SEURAT, Georges-Pierre. French, 1859–1891.

22 EVENING, HONFLEUR. (1886) Oil on canvas, $25^3/4$ x 32" (65.4 x 81.1 cm). Gift of Mrs. David M. Levy. 266.57. Repr. *Bulletin*, Fall 1958, p. 46; *Levy Collection*, p. 23. *Note*: original title was *L'Embouchure de la Seine, un soir, Honfleur*. The flat frame, $2^3/4''$ (7 cm) wide, was painted by the artist.

22 PORT-EN-BESSIN, ENTRANCE TO THE HARBOR. (1888) Oil on canvas, $21^5/8$ x $25^5/8''$ (54.9 x 65.1 cm). Lillie P. Bliss Collection. 126.34. Repr. *Ptg. & Sc.*, p. 31; *Seurat*, p. 89; in color, *Masters*, p. 25; *Impress.* (4th), p. 511; *Post-Impress.* (2nd), p. 115; *Paintings from MoMA*, p. 19; in color, *Invitation*, p. 17. *Note*: formerly listed by the Museum as *Fishing Fleet at Port-en-Bessin*. Seurat's second and final title, 1890, was *Port-en-Bessin, entrée de l'avant-port*. Border of canvas was painted by the artist.

Also, five drawings.

SEVERINI, Gino. Italian, 1883–1966. Active chiefly in Paris.

117 DYNAMIC HIEROGLYPHIC OF THE BAL TABARIN. (1912) Oil on canvas, with sequins, $63^5/8$ x $61^1/2''$ (161.6 x 156.2 cm). Acquired through the Lillie P. Bliss Bequest. 288.49. Repr. in color, *Masters*, p. 102; *Futurism*, p. 68; in color, *Invitation*, p. 43.

Also, drawings.

SHAHN, Ben. American, born Lithuania. 1898–1969. To U.S.A. 1906.

246 BARTOLOMEO VANZETTI AND NICOLA SACCO. From the Sacco-Vanzetti series of twenty-three paintings. (1931–32) Tempera on paper over composition board, $10^1/2$ x $14^1/2''$ (26.7 x 36.8 cm). Gift of Abby Aldrich Rockefeller. 144.35. Repr. *Ptg. & Sc.*, p. 148; in color, *Shahn*, pl. 3.

246 TWO WITNESSES, MELLIE EDEAU AND SADIE EDEAU. From the Tom Mooney series of fifteen paintings. (1932) Tempera on paper over composition board, 12 x 16" (30.5 x 40.7 cm). Purchase. 128.46. Repr. in color, *Shahn*, pl. 5.

246 HANDBALL. (1939) Tempera on paper over composition board, 22³/₄ x 31¹/₄″ (57.8 x 79.4 cm). Abby Aldrich Rockefeller Fund. 28.40. Repr. *Ptg. & Sc.*, p. 148; in color, *Masters*, p. 162.

246 WILLIS AVENUE BRIDGE. (1940) Tempera on paper over composition board, 23 x 31³/₈″ (58.4 x 79.7 cm). Gift of Lincoln Kirstein. 227.47. Repr. in color, *Shahn*, pl. 11; in color, *Invitation*, p. 112.

FRENCH WORKERS. (1942–43) Gouache on cardboard, 14³/₄ x 20⁵/₈″ (37.6 x 52.5 cm). Gift of Francis E. Brennan. 390.61. Repr. *Suppl. XI*, p. 20.

246 PORTRAIT OF MYSELF WHEN YOUNG. (1943) Tempera on cardboard, 20 x 27⁷/₈″ (50.8 x 70.8 cm). Purchase. 273.48. Repr. in color, *Shahn*, pl. 21.

247 WELDERS. (1943) Tempera on cardboard mounted on composition board, 22 x 39³/₄″ (55.9 x 100.9 cm). Purchase. 264.44. Repr. *Ptg. & Sc.*, p. 149; in color, *Shahn*, pl. 25.

247 PACIFIC LANDSCAPE. (1945) Tempera on paper over composition board, 25¹/₄ x 39″ (64.1 x 99.1 cm). Gift of Philip L. Goodwin. 1.50. Repr. *Shahn*, pl. 30; *Suppl. II*, p. 27.

247 FATHER AND CHILD. (1946) Tempera on cardboard, 40 x 30″ (101.5 x 76.1 cm). Gift of James Thrall Soby. 157.57. Repr. *Suppl. VII*, p. 13; *Soby Collection*, p. 64. *Note*: the Museum owns six charcoal studies for this painting.

246 MAN. (1946) Tempera on composition board, 22⁷/₈ x 16³/₈″ (57.9 x 41.5 cm). Gift of Mr. and Mrs. E. Powis Jones. 141.58. Repr. *Suppl. VIII*, p. 14.

247 THE VIOLIN PLAYER. (1947) Tempera on plywood, 40 x 26″ (101.6 x 66 cm). Sam A. Lewisohn Bequest. 18.52. Repr. *Suppl. IV*, p. 7.

"A GOOD MAN IS HARD TO FIND." (1948) Gouache, 8′ x 62″ (243.9 x 157.5 cm). Gift of the artist. 23.51. Repr. *Suppl. III*, p. 22. *Note*: seated at the piano, Harry S. Truman, and above him, at right, Thomas E. Dewey, presidential candidates in 1948. Subsequently posters were made of this painting.

Design for a poster. (1955) Gouache and watercolor, 38⁷/₈ x 25¹/₂″ (98.7 x 64.8 cm). Gift of Henry H. Ploch. 376.65. *Note*: designed on the occasion of the 25th anniversary of the artist's association with the Downtown Gallery.

Cartoon for mosaic mural for William E. Grady Vocational High School, Brooklyn, New York. (1956) Tempera, 7′8¹/₈″ x 49′2¹/₄″ (2.34 x 15 m). Gift of the artist. 674.59.

ARRANGEMENT OF LETTERS. (1963) Cast silver with gold wash, 3¹/₄ x 2″ (8.1 x 5 cm). Given anonymously. 403.63. Repr. *Lettering*, p. 34.

LETTERS IN A CUBE. (1963) Cast silver with gold wash, 2¹/₈ x 1⁷/₈″ (5.2 x 4.8 cm). Given anonymously. 402.63. Repr. *Lettering*, p. 34.

Also, drawings, prints, photographs, an illustrated book, posters, and graphic works; watercolors in the Study Collection.

SHALOM OF SAFED (Shalom Moskowitz). Israeli, born c. 1880.

437 NOAH'S ARK. (1965) Synthetic polymer paint on paper, 26¹/₂ x 18⁷/₈″ (67.3 x 47.8 cm). Gift of the Jerome L. and Jane Stern Foundation. 202.66. *Note*: Hebrew inscription, lower edge: "Shalom Moskowitz the Galilean/and here is the ark on the seventh month on the seventeenth day of the month on the mountains (sic) of Ararat."

SHARRER, Honoré. American, born 1920.

277 WORKERS AND PAINTINGS. 1943. Oil on composition board, 11⁵/₈ x 37″ (29.5 x 94 cm). Gift of Lincoln Kirstein. 17.44. Repr. *Ptg. & Sc.*, p. 153. *Note*: the Museum owns ten pencil and ink studies for this painting.

Also, drawings in the Study Collection.

SHASHURIN, Dimitri M. Russian, born 1919.

352 ELEMENTS OF LIFE. 1962. Oil on cardboard, 13⁷/₈ x 19⁵/₈″ (35 x 49.7 cm). Gift of Yevgeny Yevtushenko. 17.63.

SHAW, Charles. American, 1892–1974.

365 EDGE OF DUSK. 1956. Oil on canvas, 36¹/₄ x 48¹/₄″ (92.1 x 122.4 cm). Given in memory of W.D.S.B. by his wife. 25.56. Repr. *Suppl. VI*, p. 22.

SHEELER, Charles. American, 1883–1965.

228 AMERICAN LANDSCAPE. 1930. Oil on canvas, 24 x 31″ (61 x 78.8 cm). Gift of Abby Aldrich Rockefeller. 166.34. Repr. *Ptg. & Sc.*, p. 132; in color, *Invitation*, p. 119.

BUCKS COUNTY BARN. 1932. Oil on gesso on composition board, 23⁷/₈ x 29⁷/₈″ (60.6 x 75.9 cm). Gift of Abby Aldrich Rockefeller. 145.35.

Also, drawings, prints, photographs, and a film.

SHEMI, Yehiel. Israeli, born 1922.

305 BIRD. (1955) Welded iron, 22¹/₂″ (57.1 cm) high, at base 11¹/₂ x 7¹/₈″ (29.2 x 18.1 cm). Blanchette Rockefeller Fund. 142.58. Repr. *Suppl. VIII*, p. 16.

SHERMAN, Sarai. American, born 1922.

262 BEAR CAT. (1959) Casein and oil on canvas, 39¹/₂ x 27¹/₂″ (100.3 x 69.8 cm). Gift of Joseph H. Hirshhorn. 35.60. Repr. *Suppl. X*, p. 25.

SICKERT, Walter Richard. British, 1860–1942.

34 LA GAIETÉ MONTPARNASSE. (c. 1905) Oil on canvas, 24¹/₈ x 20″ (61.2 x 50.8 cm). Mr. and Mrs. Allan D. Emil Fund. 422.60. Repr. *Suppl. X*, p. 13. *Note*: the head in the bowler hat at lower center is said to be a self-portrait.

34 SIR THOMAS BEECHAM CONDUCTING. (c. 1935) Oil on burlap, 38³/₄ x 41¹/₈″ (98.5 x 104.5 cm). Bertram F. and Susie Brummer Foundation Fund. 344.55. Repr. *Masters Brit. Ptg.*, p. 99.

Also, prints.

SIEVAN, Maurice. American, born Ukraine 1898. To U.S.A. 1907.

272 OOMPALIK. 1962. Oil on canvas, 69¹/₈ x 59¹/₄″ (175.4 x 150.4 cm). Larry Aldrich Foundation Fund. 77.63.

SIGNAC, Paul. French, 1863–1935.

23 ALBENGA. (c. 1896) Watercolor, 4³/₈ x 7¹/₂″ (11.1 x 19 cm). Acquired through the Lillie P. Bliss Bequest. 25.51.

23 LIGHTHOUSE. (c. 1896) Watercolor and charcoal, 5³/₈ x 6¹/₂″ (13.6 x 16.5 cm). Acquired through the Lillie P. Bliss Bequest. 26.51. Repr. *Suppl. III*, p. 10.

23 LES ALYSCAMPS, ARLES. (1904) Watercolor and charcoal, 16 x 10¹/₂″ (40.7 x 26.7 cm). Acquired through the Lillie P. Bliss Bequest. 24.51. Repr. *Suppl. III*, p. 10.

23 HARBOR OF LA ROCHELLE. 1922. Watercolor, 11 x 17⁵/₈″ (27.9 x 44.8 cm). Lillie P. Bliss Collection. 130.34. Repr. *Bliss, 1934*, no. 65.

Also, prints and a music sheet.

SIHVONEN, Oli. American, born 1921.

505 DUPLEX. (1963) Oil on canvas, 56¹/₈ x 52″ (142.4 x 132 cm). Larry Aldrich Foundation Fund. 113.65.

SILLS, Thomas. American, born 1914.

448 LANDLOCKED. (1960) Oil on canvas, 51³/₄ x 68¹/₄″ (131.3 x 173.3 cm). Gift of Mrs. Annie McMurray. 263.64.

SIMPSON, David. American, born 1928.

RED, BLUE, PURPLE CIRCLE. (1962) Oil on canvas, 48¹/₈″ (122.2 cm) diameter. Larry Aldrich Foundation Fund. 78.63. Repr. *Amer. 1963*, p. 103.

SINTENIS, Renée. German, 1888–1965.

202 DAPHNE. (1930) Bronze, 56¹/₂″ (143.5 cm) high. Abby Aldrich Rockefeller Fund. 337.39. Repr. *Ptg. & Sc.*, p. 248.

Also, prints.

SIPORIN, Mitchell. American, 1910–1976.

THE REFUGEES. 1939. Oil on composition board, 30 x 36″ (76.2 x 91.4 cm). Purchase. 573.39. Repr. *Amer. 1942*, p. 114.

Also, a drawing and a print; and works on extended loan.

SIQUEIROS, David Alfaro. Mexican, 1896–1974.

208 PROLETARIAN VICTIM. 1933. Duco on burlap, 6′9″ x 47¹/₂″ (205.8 x 120.6 cm). Gift of the Estate of George Gershwin. 4.38. Repr. *Latin-Amer. Coll.*, p. 64.

209 COLLECTIVE SUICIDE. 1936. Duco on wood with applied sections, 49″ x 6′ (124.5 x 182.9 cm). Gift of Dr. Gregory Zilboorg. 208.37. Repr. *Fantastic Art* (3rd), p. 220.

208 ECHO OF A SCREAM. 1937. Duco on wood, 48 x 36″ (121.9 x 91.4 cm). Gift of Edward M. M. Warburg. 633.39. Repr. *Ptg. & Sc.*, p. 138; in color, *Invitation*, p. 108.

209 ETHNOGRAPHY. (1939) Duco on composition board, 48¹/₈ x 32³/₈″ (122.2 x 82.2 cm). Abby Aldrich Rockefeller Fund. 1657.40. Repr. *Ptg. & Sc.*, p. 139.

208 THE SOB. 1939. Duco on composition board, 48¹/₂ x 24³/₄″ (123.2 x 62.9 cm). Given anonymously. 490.41. Repr. *Latin-Amer. Coll.*, p. 66.

209 HANDS. 1949. Duco on composition board, 48¹/₈ x 39³/₈″ (122.2 x 100 cm). Gift of Henry R. Luce. 101.50.

Also, prints.

SIRONI, Mario. Italian, 1885–1961.

198 MULTIPLICATION. Oil on canvas, 22¹/₈ x 31¹/₂″ (56.2 x 80 cm). Gift of Eric Estorick. 480.53. Repr. *Suppl. V*, p. 19.

Also, drawings and a collage in the Study Collection.

SITNIKOV, Vasily Yakovlevich. Russian, born 1915.

SONG OF THE LARK. 1960. Oil and colored crayons on paper, 23⁵/₈ x 33″ (59.8 x 83.7 cm). Gift of Jimmy Ernst. 120.62.

THE STEPPE. 1960. Oil and crayon on paper, 23¹/₂ x 32⁷/₈″ (59.5 x 83.4 cm). Gift of Jimmy Ernst. 119.62. Repr. *Suppl. XII*, p. 27.

SUNSET. (1961) Colored crayons, 17 x 23¹/₂″ (43 x 59.6 cm). Gift of Jimmy Ernst. 176.63.

291 HILLOCK. 1962. Oil and colored crayons, 23⁵/₈ x 32³/₄″ (59.8 x 83.2 cm). Given anonymously. 404.63.

SKUNDER (Skunder Boghossian). Ethiopian, born 1937.

434 JU-JU'S WEDDING. 1964. Tempera and metallic paint on cut and torn cardboard, 21¹/₈ x 20″ (53.6 x 50.7 cm). Blanchette Rockefeller Fund. 109.66.

SMITH, David. American, 1906–1965.

HEAD. 1938. Cast iron and steel, 19³/₄ x 9⁵/₈″ (50.2 x 24.5 cm). Gift of Charles E. Merrill. 110.43. Repr. *Ptg. & Sc.*, p. 288.

301 DEATH BY GAS (from the Medals for Dishonor series). 1939–40. Bronze medallion, 11³/₈″ (28.9 cm) diameter (irregular). Given anonymously. 267.57. Repr. *Suppl. VII*, p. 14.

301 TWENTY-FOUR GREEK Ys. 1950. Forged steel, painted, 42³/₄ x 29¹/₈″ (108.6 x 73.9 cm). Blanchette Rockefeller Fund. 294.56. Repr. *Suppl. VII*, p. 14; *Lettering*, p. 28.

301 CHICAGO CIRCLE. 1955–56. Bronze medallion, 11″ (27.9 cm) diameter. Given anonymously. 268.57. Repr. *Suppl. VII*, p. 14.

301 HISTORY OF LEROY BORTON. 1956. Steel, 7′4¹/₄″ x 26³/₄″ x 24¹/₂″ (224.1 x 67.9 x 62.2 cm). Mrs. Simon Guggenheim Fund. 159.57. Repr. *Smith*, p. 30; *Suppl. VII*, p. 24. *Note*: dedicated by the artist in homage and friendship to the blacksmith and craftsman who assisted him with the power-forging of the series *Forgings 1955*.

495 ZIG, III. 1961. Painted steel, 7′8³/₄″ (225.4 cm) high, including base 4″ x 8′2¹/₄″ x 18¹/₈″ (10.1 x 249.5 x 45.9 cm). Mrs. Simon Guggenheim Fund. 387.66.

Also, posters, andirons, poker, and tongs; a drawing and a poster in the Study Collection.

SOFU. See TAKESHI.

SOMAINI, Francesco. Italian, born 1926.

WOUNDED, II. (1960) Cast iron, partly painted, with painted iron base, 17¹/₂ x 18¹/₄″ (44.5 x 46.3 cm). Blanchette Rockefeller Fund. 366.60a–b. Repr. *Suppl. X*, p. 32.

360 SANGUINARY MARTYRDOM [*Grande martirio sanguinante*, (1960) Cast iron, 52¹/₈ x 26¹/₈″ (132.3 x 66.4 cm). Promised gift and extended loan from Philip Johnson. E.L.67.740.

SØRENSEN, Jørgen Haugen. Danish, born 1934. Lives in France.

379 WOMAN. 1960. Stoneware, 43⁵/₈ x 36³/₈″ (110.8 x 92.3 cm). Purchase. 81.62. Repr. *Suppl. XII*, p. 25.

SORIANO, Juan. Mexican, born 1920.

CHILD WITH BIRD. 1941. Gouache, 25¹/₂ x 19⁵/₈″ (64.8 x 49.9 cm). Inter-American Fund. 792.42. Repr. *Latin-Amer. Coll.*, p. 72.

SOTO, Jesús Rafael. Venezuelan, born 1923. To Paris 1950.

509 OLIVE AND BLACK. 1966. Horizontal, mobile, flexible metal strips suspended in front of two plywood panels painted with synthetic polymer paint and mounted on composition board, 61¹/₂ x 42¹/₄ x 12¹/₂″ (156.1 x 107.1 x 31.7 cm). Inter-American Fund. 547.67.

SOULAGES, Pierre. French, born 1919.

346 JANUARY 10, 1951. 1951. Oil on burlap, 57¹/₂ x 38¹/₄″ (146 x 97.2 cm). Acquired through the Lillie P. Bliss Bequest. 209.53. Repr. *Suppl. IV*, p. 34.

346 PAINTING. 1956. Oil on canvas, 59¹/₄″ x 6′4³/₄″ (150.5 x 195 cm). Gift of Mr. and Mrs. Samuel M. Kootz. 23.59.

Also, prints.

SOUTINE, Chaim. French, born Lithuania. 1893–1943. To France 1913.

190 THE OLD MILL. (c. 1922–23) Oil on canvas, 26¹/₈ x 32³/₈″ (66.4 x 82.2 cm). Vladimir Horowitz and Bernard Davis Funds. 557.54. Repr. *Suppl. V*, p. 9; in color, *Invitation*, p. 122.

190 DEAD FOWL. (c. 1924) Oil on canvas, 43½ x 32″ (110.4 x 81.1 cm). Gift of Mr. and Mrs. Justin K. Thannhauser. 93.58. Repr. *Suppl. VI*, p. 10.

190 PORTRAIT OF MARIA LANI. (1929) Oil on canvas, 28⅞ x 23½″ (73.3 x 59.7 cm). Mrs. Sam A. Lewisohn Bequest. 275.54. Repr. *Suppl. V*, p. 5.

SOYER, Moses. American, born Russia. 1899–1974. To U.S.A. 1912.

237 ARTIST AND MODEL. (1962) Oil on canvas, 16⅛ x 20⅛″ (41 x 51.2 cm). Gift of Mr. and Mrs. Herbert A. Goldstone. 315.62. Repr. *Suppl. XII*, p. 13.

 Also, a drawing.

SOYER, Raphael. American, born Russia 1899. To U.S.A. 1912.

237 SEAMSTRESS. (1956–60) Oil on canvas, 30 x 24⅛″ (76.2 x 61.2 cm). Gift of Mr. and Mrs. Sidney Elliott Cohn. 10.61. Repr. *Suppl. XI*, p. 20.

 Also, prints.

SPARHAWK-JONES, Elizabeth. American, born 1885.

427 STARTLED WOMAN. (c. 1956?) Oil on canvas, 19 x 26⅛″ (48.2 x 66.2 cm). Larry Aldrich Foundation Fund. 455.64.

SPENCER, Niles. American, 1893–1952.

231 CITY WALLS. 1921. Oil on canvas, 39⅜ x 28¾″ (100 x 73 cm). Given anonymously (by exchange). 25.36. Repr. *Ptg. & Sc.*, p. 112. *Note*: the Museum owns a pencil study for this painting.

231 ORDNANCE ISLAND, BERMUDA. (1928) Oil on canvas, 24 x 36″ (61 x 91.4 cm). Gift of Sam A. Lewisohn. 302.38. Repr. *Amer. Ptg. & Sc.*, no. 99.

231 NEAR AVENUE A. 1933. Oil on canvas, 30¼ x 40¼″ (76.8 x 102.2 cm). Gift of Nelson A. Rockefeller. 3.38. Repr. *Art in Our Time*, no. 120.

231 IN FAIRMONT. 1951. Oil on canvas, 65½ x 41½″ (166.3 x 105.4 cm). Edward Joseph Gallagher 3rd Memorial Collection. 6.56. Repr. *Suppl. V*, p. 17.

 Also, prints; a drawing in the Study Collection.

SPENCER, Stanley. British, 1891–1959.

199 THE NURSERY. 1936. Oil on canvas, 30⅛ x 36⅛″ (76.5 x 91.8 cm). Gift of the Contemporary Art Society, London. 22.40. Repr. *Ptg. & Sc.*, p. 183.

 Also, a drawing.

SPOERRI, Daniel. Swiss, born Rumania 1930.

380 KICHKA'S BREAKFAST, I. 1960. Assemblage: wood chair hung on wall with board across seat, coffee pot, tumbler, china, egg cups, eggshells, cigarette butts, spoons, tin cans, etc., 14⅜ x 27⅜ x 25¾″ (36.6 x 69.5 x 65.4 cm). Philip Johnson Fund. 391.61. Repr. *Assemblage*, p. 132.

SPRUCE, Everett. American, born 1908.

 THE HAWK. 1939. Oil on composition board, 19⅜ x 23½″ (49.2 x 59.7 cm). Purchase. 574.39. Repr. *Ptg. & Sc.*, p. 174.

SQUIRRU, Carlos Maria Miguel. Argentine, born 1934.

 CANCER. 1957. Tempera, 23⅞ x 18″ (60.7 x 45.6 cm). Inter-American Fund. 269.57. Repr. *Suppl. VII*, p. 22.

STAËL, Nicolas de. French, born Russia. 1914–1955.

345 PAINTING. 1947. Oil on canvas, 6′5″ x 38⅜″ (195.6 x 97.5 cm). Gift of Mr. and Mrs. Lee A. Ault. 28.51. Repr. *Suppl. III*, p. 18.

344 PAINTING [*Bouteilles*]. (1952) Oil on canvas, 25¾ x 31¾″ (65.4 x 80.7 cm). Gift of Mr. and Mrs. Norbert Schimmel. 508.53.

 Also, prints and an illustrated book.

STAMOS, Theodoros. American, born 1922.

332 SOUNDS IN THE ROCK. 1946. Oil on composition board, 48⅛ x 28⅜″ (122.2 x 72.1 cm). Gift of Edward W. Root. 27.47. Repr. *Ptg. & Sc.*, p. 227.

 THE FALLEN FIG. (1949) Oil on composition board, 48 x 25⅞″ (121.9 x 65.7 cm). Given anonymously. 34.55.

 TAYGETOS. (1958) Oil on canvas, 60″ x 6′ (152.3 x 182.8 cm). Purchase. 24.59.

 Also, a poster design in the Study Collection.

STANKIEWICZ, Richard. American, born 1922.

386 INSTRUCTION. (1957) Welded scrap iron and steel, 12½ x 13¼ x 8⅝″ (31.7 x 33.6 x 21.8 cm). Philip Johnson Fund. 17.58. Repr. *Suppl. VIII*, p. 16; *16 Amer.*, p. 73; *What Is Mod Sc.*, p. 97.

386 NATURAL HISTORY. (1959) Welded iron pipes and boiler within wire mesh, 14¾ x 34¼ x 19¼″ (37.3 x 87 x 48.8 cm). Elizabeth Bliss Parkinson Fund. 11.61. Repr. *Suppl. XI*, p. 41.

STAZEWSKI, Henryk. Polish, born 1894.

486 COLORED RELIEF. 1963. Oil on relief construction of composition board and wood strips, 19¾ x 32¾ x 2⅞″ (50 x 83.1 x 7.3 cm). Gift of Mr. and Mrs. Maurice A. Lipschultz. 114.65.

STELLA, Frank. American, born 1936.

366 THE MARRIAGE OF REASON AND SQUALOR. 1959. Oil on canvas, 7′6¾″ x 11′3¾″ (230.5 x 337.2 cm). Larry Aldrich Foundation Fund. 725.59. Repr. *16 Amer.*, p. 78; *Stella*, p. 27.

STELLA, Joseph. American, born Italy. 1877–1946. To U.S.A. 1896.

224 BATTLE OF LIGHTS. (1913–14? Dated on painting 1914 and 1915). Oil on canvas mounted on cardboard, 20¼″ (51.4 cm) diameter (irregular). Elizabeth Bliss Parkinson Fund. 143.58. Repr. *Suppl. VIII*, p. 7. *Note*: said to be a study for the large *Battle of Lights, Coney Island*, 1913, now in the Yale University Art Gallery, Société Anonyme Collection.

224 FACTORIES. (1918) Oil on burlap, 56 x 46″ (142.2 x 116.8 cm). Acquired through the Lillie P. Bliss Bequest. 756.43. Repr. *Ptg. & Sc.*, p. 111.

224 SONG OF THE NIGHTINGALE. 1918. Pastel, 18 x 23⅛″ (45.8 x 58.6 cm). Bertram F. and Susie Brummer Foundation Fund. 121.62. Repr. *Suppl. XII*, p. 10.

427 FIRST LIGHT [*Crépuscule premier*]. (c. 1928) Oil on canvas, 16¼ x 16¼″ (41.3 x 41.3 cm). Elizabeth Bliss Parkinson Fund. 203.66. *Note*: also called *Twilight*.

 Also, a drawing.

STERN, Marina. American, born Italy 1928. To U.S.A. 1941.

464 SEVEN MINUS TWENTY-ONE EQUALS SEVEN. 1966. Oil on canvas, 50¼ x 50⅛″ (127.5 x 127.3 cm). Gift of Alfred Schwabacher. 256.66.

STERNE, Hedda. American, born Rumania 1916. To U.S.A. 1941.

339 NEW YORK, VIII. (1954) Synthetic polymer paint on canvas,

6'1/8" x 42" (183.2 x 106.7 cm). Mr. and Mrs. Roy R. Neuberger Fund. 558.54. Repr. *Suppl. V*, p. 25.

STERNE, Maurice. American, born Latvia. 1877–1957. To U.S.A. 1889.

219 RESTING AT THE BAZAAR. (1912) Oil on canvas, 26³/4 x 31¹/2" (68 x 80 cm). Abby Aldrich Rockefeller Fund. 301.38. Repr. *Ptg. & Sc.*, p. 68.

 GIRL IN BLUE CHAIR. 1928. Oil on canvas, 34¹/2 x 24¹/2" (87.6 x 62.2 cm). Gift of Sam A. Lewisohn. 298.38. Repr. *Modern Works*, no. 147.

219 AFTER THE RAIN. 1948. Oil on canvas, 26¹/2 x 34" (67.3 x 86.4 cm). Mrs. Sam A. Lewisohn Bequest. 276.54. Repr. *Suppl. V*, p. 5.

 Also, drawings.

STETTHEIMER, Florine. American, 1871–1944.

237 FAMILY PORTRAIT, II. 1933. Oil on canvas, 46¹/4 x 64⁵/8" (117.4 x 164 cm). Gift of Miss Ettie Stettheimer. 8.56. Repr. in color, *Stettheimer*, p. 35. *Note*: represented, from left to right, the artist, her sister Ettie, her mother, and her sister Carrie.

STILL, Clyfford. American, born 1904.

325 PAINTING. 1951. Oil on canvas, 7'10" x 6'10" (238.8 x 208.3 cm). Blanchette Rockefeller Fund. 277.54. Repr. *Suppl. V*, p. 20; *New Amer. Ptg.*, p. 78; *Art of the Real*, p. 16; in color, *Invitation*, p. 134.

 PAINTING. Oil on canvas, 8'8¹/4" x 7'3¹/4" (264.5 x 221.4 cm). Inscribed on reverse: *1944-N*. The Sidney and Harriet Janis Collection (fractional gift). 655.67. Repr. *Janis*, p. 127. *Note*: also called *Red Flash on Black Field*.

STOUT, Myron. American, born 1908.

369 NUMBER 3. 1954. (1954) Oil on canvas, 20¹/8 x 16" (50.9 x 40.6 cm). Philip Johnson Fund. 25.59. Repr. *Suppl. IX*, p. 39.

STREAT, Thelma Johnson. American, born 1912.

 RABBIT MAN. 1941. Gouache, 6⁵/8 x 4⁷/8" (16.8 x 12.4 cm). Purchase. 216.42.

STUART, Ian. Irish, born 1926.

379 MAYO. (1960) Assemblage: two sheep jawbones and parts of cast-iron stove, 22" (55.8 cm) high, at base 8⁷/8 x 6¹/2" (23 x 16.5 cm). Gertrud A. Mellon Fund. 303.61. Repr. *Suppl. XI*, p. 39.

STUEMPFIG, Walter. American, 1914–1970.

 CAPE MAY. (1943) Oil on canvas, 28 x 35" (71.1 x 88.9 cm). Acquired through the Lillie P. Bliss Bequest. 757.43. Repr. *Ptg. & Sc.*, p. 168.

SUGAÏ, Kumi. Japanese, born 1919. Lives in Paris.

354 KABUKI. 1958. Oil and gilt paint on canvas, 57¹/2 x 44⁵/8" (145.8 x 113.3 cm). Purchase. 26.59. Repr. *Suppl. IX*, p. 24.

 Also, a print.

SUICHIKU. See ABE.

SUIJŌ. See IKEDA.

SULLIVAN, Patrick J. American, 1894–1967.

 THE FOURTH DIMENSION. (1938) Oil on canvas, 24¹/4 x 30¹/4" (61.5 x 76.6 cm). The Sidney and Harriet Janis Collection (fractional gift). 656.67. Repr. *Janis*, p. 85.

A-HUNTING HE WOULD GO. (1940) Oil on canvas, 26¹/4 x 36¹/8" (66.7 x 91.8 cm). Purchase. 370.41. Repr. *Bulletin*, vol. 9, no. 2, 1941, p. 9.

SURVAGE, Léopold. Russian, 1879–1968. To Paris 1908.

127 COLORED RHYTHM. Fifty-nine studies for the film. (1913) Watercolor, brush and ink, 14¹/8 x 10³/8" and 13 x 12¹/4" (35.9 x 26.3 and 33 x 31.1 cm). Purchase. 661.39.1–.59. Six studies repr. *Art in Our Time*, p. 367; 661.39.58 repr. *Masters*, p. 213.

 Also, a print and an illustration.

ŠUTEJ, Miroslav. Yugoslavian, born 1936.

501 BOMBARDMENT OF THE OPTIC NERVE, II. 1963. Tempera and pencil on circular canvas, 6'7" (200.5 cm) diameter. Larry Aldrich Foundation Fund. 373.65.

SUTHERLAND, Graham. British, born 1903.

270 HORNED FORMS. 1944. Oil on composition board, 39¹/4 x 31⁷/8" (99.7 x 80.9 cm). Acquired through the Lillie P. Bliss Bequest. 129.46. Repr. *Ptg. & Sc.*, p. 232.

270 THORN HEADS. 1946. Oil on canvas, 48 x 36" (122 x 91.5 cm). Acquired through the Lillie P. Bliss Bequest. 345.55. Repr. *Masters of Brit. Ptg.*, p. 140.

 Also, prints and posters.

SVAVAR GUDNASON. Icelandic, born 1909.

 DEAD BIRD. 1934. Watercolor, 8¹/2 x 11¹/8" (21.7 x 28.2 cm). Purchase. 292.61. Repr. *Suppl. XI*, p. 21.

TADASKY (Tadasuke Kuwayama). Japanese, born 1935. To U.S.A. 1961.

500 A-101. 1964. Synthetic polymer paint on canvas, 52 x 52" (132.1 x 132.1 cm). Larry Aldrich Foundation Fund. 579.64. Repr. in color, *Responsive Eye*, p. 32.

471 B-171. 1964. Synthetic polymer paint on canvas, 15¹/8 x 15¹/8" (38.4 x 38.4 cm). Given anonymously. 8.65. *Note*: study for a larger painting, *B-199*, 6 x 6'.

TAJIRI, Shinkichi G. American, born 1923. Lives in the Netherlands.

359 MUTATION. (1959–60) Brazed and welded bronze, 8'4³/4" (255.9 cm) high, at base 8³/4 x 8³/4" (22.2 x 22.2 cm). Gift of G. David Thompson. 12.61. Repr. *Suppl. XI*, p. 34.

TAKESHI, Imaji (pen name: Sofu). Japanese, born 1913.

317 THE SUN. (c. 1953) Two-panel screen, brush and ink, each sheet 55 x 27¹/2" (139.7 x 69.8 cm). Japanese House Fund. 280.54. Repr. *Suppl. V*, p. 29.

TAKIS (Takis Vassilakis). French, born Greece 1925.

375 SIGNAL ROCKET. (1955) Painted steel and iron, 48" (121.9 cm) high, at base 5¹/4 x 5" (13.2 x 12.5 cm). Mrs. Charles V. Hickox Fund. 675.59. Repr. *Suppl. IX*, p. 34.

 HEAD IN SPACE. (1956) Bronze, 9" (22.9 cm) high. Gift of D. and J. de Menil. 368.60. Repr. *Suppl. X*, p. 59.

375 TELE-SCULPTURE. (1960–62) Three-part construction: a) an electromagnet, 10⁵/8" (26.8 cm) high x 12⁵/8" (31.9 cm) diameter; b) a top-shaped black-painted cork, 4" (10.1 cm) high x 1³/4" (4.3 cm) diameter; and c) a white-painted wood sphere, 4" (10.1 cm) diameter; both cork and sphere contain magnets. Kept in motion by gravity and by positive and negative magnetic forces, the

hanging cork and sphere swing and occasionally collide. Gift of D. and J. de Menil. 252.62a–c. Repr. *Suppl. XII*, p. 34.

Also, drawings and a print.

TAL COAT, René Pierre. French, born 1905.

LA MARSEILLAISE. (1944) Oil on canvas, 16¹⁄₈ x 12⁷⁄₈″ (41 x 32.7 cm). Mrs. Cornelius J. Sullivan Fund. 274.48.

Also, a print.

TAM, Reuben. American, born Hawaii 1916.

MOON AND SHOALS. 1949. Oil on canvas, 30 x 34⁷⁄₈″ (76.2 x 88.6 cm). Gift of Sam A. Lewisohn. 289.49. Repr. *Suppl. I*, p. 22.

Also, a print.

TAMAYO, Rufino. Mexican, born 1899. Worked in New York 1935–48; in Paris 1949–54.

WAITING WOMAN. 1936. Watercolor, 15 x 20³⁄₄″ (38.1 x 52.7 cm). Extended loan from the United States WPA Art Program. E.L.39.1829.

207 ANIMALS. 1941. Oil on canvas, 30¹⁄₈ x 40″ (76.5 x 101.6 cm). Inter-American Fund. 165.42. Repr. *Ptg. & Sc.*, p. 233; in color, *Masters*, p. 168; in color, *Invitation*, p. 82.

207 WOMAN WITH PINEAPPLE. 1941. Oil on canvas, 40 x 30″ (101.6 x 76.2 cm). Gift of friends of the artist. 79.43.

207 GIRL ATTACKED BY A STRANGE BIRD. 1947. Oil on canvas, 70 x 50¹⁄₈″ (177.8 x 127.3 cm). Gift of Mr. and Mrs. Charles Zadok. 200.55. Repr. *Suppl. VI*, p. 28.

207 MELON SLICES. 1950. Oil on canvas, 39³⁄₈ x 31³⁄₄″ (100 x 80.6 cm). Gift of Mrs. Sam A. Lewisohn. 27.53. Repr. *Suppl. IV*, p. 29.

Also, prints and an illustrated book.

TANAKA, Atsuko. Japanese, born 1932.

471 Untitled. (1964) Synthetic polymer paint on canvas, 10′11¹⁄₄″ x 7′4³⁄₄″ (333.4 x 225.4 cm). John G. Powers Fund. 612.65. Repr. in color, *New Jap. Ptg. & Sc.*, p. 17.

TANCREDI. Italian, 1927–1964.

SPRINGTIME. 1952. Gouache and pastel, 27¹⁄₂ x 39³⁄₈″ (69.8 x 100 cm). Gift of Peggy Guggenheim. 192.52.

Also, a print.

TANGUY, Yves. American, born France. 1900–1955. To U.S.A. 1939.

178 RUE DE LA SANTÉ. 1925. Oil on canvas, 19³⁄₄ x 24¹⁄₈″ (50.2 x 61.1 cm). Kay Sage Tanguy Bequest. 338.63. Repr. *Tanguy*, p. 12.

178 MAMA, PAPA IS WOUNDED! [*Maman, papa est blessé!*]. 1927. Oil on canvas, 36¹⁄₄ x 28³⁄₄″ (92.1 x 73 cm). Purchase. 78.36. Repr. *Ptg. & Sc.*, p. 196; in color, *Masters*, p. 144; *Tanguy*, p. 27.

178 EXTINCTION OF USELESS LIGHTS [*Extinction des lumières inutiles*]. 1927. Oil on canvas, 36¹⁄₄ x 25³⁄₄″ (92.1 x 65.4 cm). Purchase. 220.36. Repr. *Tanguy*, p. 26.

178 Untitled. 1931. Gouache, 4¹⁄₂ x 11¹⁄₂″ (11.4 x 29.2 cm). Purchase. 261.35. Repr. *Tanguy*, p. 35.

179 LA GRANDE MUE. (1942) Gouache and pasted paper, 11¹⁄₂ x 8³⁄₄″ (29.2 x 22 cm). Kay Sage Tanguy Bequest. 272.63.

178 SLOWLY TOWARD THE NORTH [*Vers le nord lentement*]. 1942. Oil on canvas, 42 x 36″ (106.7 x 91.4 cm). Gift of Philip Johnson. 627.43. Repr. *Ptg. & Sc.*, p. 197; in color, *Tanguy*, p. 44.

Untitled. (1945) Gouache, 17¹⁄₂ x 11⁷⁄₈″ (44.3 x 29.9 cm). Kay Sage Tanguy Bequest. 273.63.

179 THE HUNTED SKY [*Le Ciel traqué*]. 1951. Oil on canvas, 39¹⁄₈ x 32³⁄₈″ (99.3 x 82.3 cm). Kay Sage Tanguy Bequest. 339.63. Repr. *Tanguy*, p. 60.

179 MULTIPLICATION OF THE ARCS. 1954. Oil on canvas, 40 x 60″ (101.6 x 152.4 cm). Mrs. Simon Guggenheim Fund. 559.54. Repr. in color, *Tanguy*, p. 67; in color, *Invitation*, p. 92.

Also, drawings, part of a *cadavre exquis*, illustrated books, prints, and a copper plate for an etching.

TÀPIES PUIG, Antoní. Spanish, born 1923.

353 SPACE. (1956) Latex paint on canvas with marble dust, 6′4⁵⁄₈″ x 67″ (194.6 x 170 cm). Gift of Mrs. Martha Jackson. 27.59. Repr. *New Spanish Ptg. & Sc.*, p. 49; *Suppl. IX*, p. 25.

353 PAINTING. 1957. Latex paint with marble dust and sand on canvas, 57³⁄₈ x 35″ (145.7 x 88.8 cm). Gift of G. David Thompson. 28.59. Repr. *New Spanish Ptg. & Sc.*, frontispiece; *Suppl. IX*, p. 25.

353 GRAY RELIEF ON BLACK. 1959. Latex paint with marble dust on canvas, 6′4⁵⁄₈″ x 67″ (194.6 x 170 cm). Gift of G. David Thompson. 13.61. Repr. *Suppl. XI*, p. 29.

Also, prints.

TAVERNARI, Vittorio. Italian, born 1919.

298 TORSO. (1961) Wood, 6′6″ x 33¹⁄₈″ (198.1 x 84.1 cm). Blanchette Rockefeller Fund. 82.62. Repr. *Suppl. XII*, p. 24.

TCHELITCHEW, Pavel. American, born Russia. 1898–1957. Worked in Western Europe and England from 1921. In U.S.A. 1938–52.

196 NATALIE PALEY. 1931. Oil on canvas, 32 x 21¹⁄₄″ (81.3 x 54 cm). Acquired through the Lillie P. Bliss Bequest. 253.54. Repr. *Suppl. V*, p. 8.

196 THE MADHOUSE. 1935. Gouache, 19⁷⁄₈ x 25⁵⁄₈″ (50.3 x 65.1 cm). Purchase. 26.36. Repr. *Ptg. & Sc.*, p. 184. *Note*: study for *Phenomena*.

ORPHEUS. Twenty-nine costume designs for the opera-ballet produced by the American Ballet Company, New York, 1936. Gouache, 9⁵⁄₈ x 7³⁄₄″ to 18⁷⁄₈ x 8³⁄₄″ (24.4 x 19.7 cm to 45.4 x 22.1 cm). Gift of the artist. 513.41.1–.29. Theatre Arts Collection.

NOBILISSIMA VISIONE or ST. FRANCIS. Forty designs for the ballet produced by the Ballets Russes de Monte Carlo, London, 1938. Gouache, thirty-six designs for costumes, 20¹⁄₂ x 9³⁄₄″ (52 x 24.8 cm); four designs for scenery, 17³⁄₈ x 24⁷⁄₈″ to 20³⁄₄ x 25³⁄₄″ (44.4 x 63.2 cm to 52.7 x 65.4cm). Gift of the artist. 65.42.1–.40. Theatre Arts Collection.

The six works that follow are studies for *Hide-and-Seek*, 1940–42, in the Museum's collection.

AUTUMN LEAF. 1939. Gouache, 10¹⁄₂ x 8¹⁄₄″ (26.7 x 21 cm). Mrs. Simon Guggenheim Fund. 598.42.

THE DANDELION. 1939. Gouache and watercolor, 11 x 8¹⁄₂″ (27.9 x 21.6 cm). Mrs. Simon Guggenheim Fund. 351.42.

196 LEAF CHILDREN. 1939. Gouache, 25¹⁄₄ x 19³⁄₄″ (64.1 x 50.2 cm). Mrs. Simon Guggenheim Fund. 219.42. Repr. *Tchelitchew*, pl. 55.

TREE INTO HAND AND FOOT. 1939. Watercolor and ink, 14 x 9³⁄₄″ (35.6 x 24.8 cm). Mrs. Simon Guggenheim Fund. 348.42. Repr. *Masters*, p. 165.

TREE INTO HAND AND FOOT WITH CHILDREN. 1940. Watercolor and ink, 13⁷⁄₈ x 16³⁄₄″ (35.3 x 42.5 cm). Mrs. Simon Guggenheim Fund. 599.42. Repr. *Tchelitchew*, p. 86.

HEAD OF AUTUMN. 1941. Watercolor and gouache, 13 x 14⁷⁄₈″ (33

x 37.8 cm). Gift of Lincoln Kirstein. 28.47. Repr. *Tchelitchew*, p. 82.

197 HIDE-AND-SEEK [*Cache-cache*]. 1940–42. Oil on canvas, 6'6½" × 7'¾" (199.3 x 215.3 cm). Mrs. Simon Guggenheim Fund. 344.42. Repr. *Ptg. & Sc.*, p. 236. Details: *Tchelitchew*, pp. 83–85; in color, *Masters*, p. 165; *Tchelitchew*, frontispiece. In color, *Invitation*, p. 103. *Note*: the Museum also owns five ink studies for this painting.

BALUSTRADE. Design for costume for the ballet produced by W. de Basil's Original Ballet Russe, New York, 1941. Gouache, 16 x 8⅝" (40.7 x 21.9 cm) (sight). Gift of the artist. 137.44. Theatre Arts Collection.

THE CAVE OF SLEEP. Seventeen designs for the ballet, 1941, not produced. Gouache, sixteen designs for costumes: one, 11 x 14"; seven, 11¼ x 7¼"; seven, 14 x 11"; one, 14⅝ x 11" (27.9 x 35.6; 28.6 x 18.4; 35.6 x 27.9; 37.2 x 27.9 cm); one design for scenery, 19⅜ x 32⅞" (49.2 x 83.5 cm). Gift of the artist. 64.42.1–.17. Theatre Arts Collection.

PAS DE DEUX. Design for costume. 1942. Gouache, 14⅜ x 11⅜" (36.7 x 28.9 cm). Gift of Lincoln Kirstein. 25.43. Theatre Arts Collection.

APOLLON MUSAGÈTE. Two designs for scenery for the ballet, produced by the American Ballet Company, Buenos Aires, 1942. Gouache, 18⅛ x 28½; 20 x 28½" (46 x 72.3 cm; 50.7 x 72.3 cm). Gift of Lincoln Kirstein. 24.43.1–.2. Theatre Arts Collection.

Also, drawings and theatre designs.

TEBO (Angel Torres Jaramillo). Mexican, born 1916.

210 PORTRAIT OF MY MOTHER. 1937. Oil on cardboard, 9⅛ x 6⅛" (23.2 x 15.6 cm). Gift of Sam A. Lewisohn (by exchange). 796.42. Repr. *Latin-Amer. Coll.*, p. 72.

THARRATS, Joan Josep. Spanish, born 1918.

353 THAT WHICH WILL BE [*Lo que será*]. 1961. Mixed mediums on canvas, 51¼ x 38⅛" (130 x 96.8 cm). Gift of Mr. and Mrs. Gustav P. Heller. 100.61. Repr. *Suppl. XI*, p. 30.

THIEBAUD, Wayne. American, born 1920.

392 CUT MERINGUES. 1961. Oil on canvas, 16 x 20" (40.6 x 50.6 cm). Larry Aldrich Foundation Fund. 122.62. Repr. *Suppl. XII*, p. 29.

THOMAS, Byron. American, born 1902.

PASTIME BOWLING ALLEY. 1939. Oil on canvas, 15 x 40½" (38.1 x 102.9 cm). Purchase. 575.39.

THORNTON, Leslie T. British, born 1925.

297 MEN FISHING FROM A PIER. (1955) Iron wire, 23 x 21 x 14½" (58.4 x 53.4 x 36.8 cm). Mrs. Bertram Smith Fund. 347.55. Repr. *Suppl. VI*, p. 31.

TINGUELY, Jean. Swiss, born 1925. Lives in Paris and Basel.

375 HATCHING EGG. 1958. Motor-driven relief construction of painted metal and plywood, 30½ x 32½ x 9" (77.5 x 82.4 x 22.7 cm). Gift of Erwin Burghard Steiner. 616.59. Repr. *Suppl. IX*, p. 35.

375 PUSS IN BOOTS. 1959. Motor-driven construction of painted steel and wire, 30⅛" (76.4 cm) high, at base 6⅞ x 7⅞" (17.3 x 19.9 cm). Philip Johnson Fund. 369.60. Repr. *Suppl. X*, p. 51.

476 Fragment from HOMAGE TO NEW YORK. (1960) Painted metal, 6'8¼" x 29⅝" x 7'3⅞" (203.7 x 75.1 x 223.2 cm). Gift of the artist. 227.68. Repr. *The Machine*, p. 171; entire piece repr. in *The Machine*, frontispiece, and *Dada, Surrealism*, p. 22. *Note*: *Homage to New York*, a motorized assemblage of eighty bicycle

wheels, old motors, a piano, metal drums, an addressograph machine, a child's go-cart, and an enameled bathtub, was set in motion and destroyed, except for this fragment and a few smaller fragments, on March 17, 1960, in the Sculpture Garden of The Museum of Modern Art.

Also, a drawing and a print; drawings in the Study Collection.

TIPPETT, Bruce. British, born 1933. In Rome 1962–66. To U.S.A. 1968.

490 ITEM 34, 1964, SPIRAL IV. 1964. Synthetic polymer paint on canvas, 67¾ x 67¾ x 4" (172 x 172 x 10 cm). Given anonymously. 632.65.

TOBEY, Mark. American, 1890–1976. To Basel 1960.

320 THREADING LIGHT. 1942. Tempera on cardboard, 29⅜ x 19½" (74.6 x 49.5 cm). Purchase. 86.44. Repr. *Ptg. & Sc.*, p. 228; *Tobey*, p. 55.

431 THE VOID DEVOURING THE GADGET ERA. 1942. Tempera on cardboard, 21⅞ x 30" (55.3 x 76 cm). Gift of the artist. 264.64. Repr. *The Machine*, p. 163.

FATA MORGANA. 1944. Tempera on cardboard, 14⅛ x 22¼" (35.8 x 56.4 cm). The Sidney and Harriet Janis Collection (fractional gift). 657.67. Repr. *Janis*, p. 117. *Note*: also called *White Writing*.

320 REMOTE FIELD. 1944. Tempera, pencil, and crayon on cardboard, 28⅛ x 30⅛" (71.4 x 76.5 cm). Gift of Mr. and Mrs. Jan de Graaff. 143.47. Repr. *14 Amer.*, p. 71; *Tobey*, p. 63.

320 EDGE OF AUGUST. 1953. Casein on composition board, 48 x 28" (121.9 x 71.1 cm). Purchase. 5.54. Repr. *Masters*, p. 174; in color, *Tobey*, p. 39; in color, *Invitation*, p. 136.

WILD FIELD. 1959. Tempera on cardboard. 27⅛ x 28" (68.9 x 71.1 cm). The Sidney and Harriet Janis Collection (fractional gift). 658.67. Repr. *Janis*, p. 117.

TOMLIN, Bradley Walker. American, 1899–1953.

NUMBER 3. (1948) Oil on canvas, 40 x 50⅛" (101.3 x 127.2 cm). Fractional gift of John E. Hutchins in memory of Frances E. Marder Hutchins. 423.60. Repr. *Suppl. X*, p. 36.

335 NUMBER 20. (1949) Oil on canvas, 7'2" x 6'8¼" (218.5 x 203.9 cm). Gift of Philip Johnson. 58.52. Repr. *15 Amer.*, p. 25; *New Amer. Ptg.*, p. 82; in color, *Masters*, p. 180; in color, *Invitation*, p. 137.

335 NUMBER 9: IN PRAISE OF GERTRUDE STEIN. (1950) Oil on canvas, 49" x 8'6¼" (124.5 x 259.8 cm). Gift of Mrs. John D. Rockefeller 3rd. 348.55. Repr. *Suppl. VI*, p. 40; in color, *New Amer. Ptg.*, p. 81.

335 NUMBER 3. 1953. Oil on canvas, 46 x 31" (116.6 x 78.6 cm). Gift of John E. Hutchins in memory of Frances E. Marder Hutchins. 655.59. Repr. *Suppl. IX*, p. 16.

TOOKER, George. American, born 1920.

277 SLEEPERS, II. (1959) Egg tempera on gesso panel, 16⅛ x 28" (40.8 x 71.1 cm). Larry Aldrich Foundation Fund. 370.60. Repr. *Suppl. X*, p. 24.

TORRES-GARCÍA, Joaquín. Uruguayan, 1874–1949. Worked also in Spain, U.S.A., Italy, and France.

COMPOSITION. 1931. Oil on canvas, 36⅛ x 24" (91.7 x 61 cm). Gift of Larry Aldrich. 281.56. Repr. *Suppl. VI*, p. 20.

CONSTRUCTIVE PAINTING [*Pintura constructiva*]. (c. 1931) Oil on canvas, 29⅝ x 21⅞" (75.2 x 55.4 cm). The Sidney and Harriet Janis Collection (fractional gift). 659.67. Repr. *Janis*, p. 47.

212 COMPOSITION. 1932. Oil on canvas, 28¹/₄ x 19³/₄″ (71.8 x 50.2 cm). Gift of Dr. Román Fresnedo Siri. 611.42. Repr. *Ptg. & Sc.*, p. 226.

212 PORTRAIT OF WAGNER. 1940. Oil on cardboard, 16¹/₈ x 14⁵/₈″ (40.9 x 37 cm). Gift of Mr. and Mrs. Louis J. Robbins. 127.61. Repr. *Suppl. X*, p. 15. *Note*: the German composer Richard Wagner is the subject.

212 THE PORT. 1942. Oil on cardboard, 31³/₈ x 39⁷/₈″ (79.7 x 101.3 cm). Inter-American Fund. 801.42. Repr. *Latin-Amer. Coll.*, p. 86.

Also, a print, and a film based on the artist's sketches.

TOULOUSE-LAUTREC, Henri de. French, 1864–1901.

29 LA GOULUE AT THE MOULIN ROUGE. (1891–92) Oil on cardboard, 31¹/₄ x 23¹/₄″ (79.4 x 59 cm). Gift of Mrs. David M. Levy. 161.57. Repr. *Toulouse-Lautrec*, p. 15; *Bulletin*, Fall 1958, p. 48; *Suppl. X*, p. 1; *Levy Collection*, p. 25; in color, *Invitation*, p. 18. *Note*: Louise Weber, nicknamed "La Goulue" ("The Glutton"), won fame during the 1890s as a dancer. She died a pauper in 1929.

Also, prints (including lithographs colored by hand), posters, illustrations, an album cover, and book covers.

TOWN, Harold (Harold Barling Town). Canadian, born 1924.

460 OPTICAL NUMBER 9. 1964. Oil and synthetic polymer paint on canvas, 60 x 60″ (152.5 x 152.5 cm). Gift of J. G. McClelland. 507.65.

TOYOFUKU, Tomonori. Japanese, born 1925. Lives in Milan.

297 ADRIFT, 3. 1960. Wood on iron supports; figure 6′3¹/₄″ (191.2 cm) high; boat 10′ (304.8 cm) long. Philip Johnson Fund. 14.61a–b. Repr. *Suppl. XI*, p. 47; *New Jap. Ptg. & Sc.*, p. 67.

TROVA, Ernest (Ernest Tino Trova). American, born 1927.

314 STUDY. 1960. Oil and mixed mediums on canvas, 20 x 16″ (50.8 x 40.6 cm). Gift of Mr. and Mrs. Morton D. May. 159.62. Repr. *Suppl. XII*, p. 22.

479 STUDY FROM FALLING MAN SERIES. (1964) Chromium figure, lying on miniature automobile chassis, in a plexiglass case, 6⁷/₈ x 15³/₄ x 6¹/₈″ (17.3 x 40 x 15.5 cm); figure and chassis, 3³/₈ x 14 x 5³/₈″ (8.4 x 35.4 x 13.4 cm). Larry Aldrich Foundation Fund. 10.65a–b.

479 STUDY FROM FALLING MAN SERIES. (1964) Sixteen plaster figures, two plaster molds, with plastic devices, string, cloth, compass, etc., in a compartmented wood box, 48 x 32³/₄ x 6³/₄″ (121.8 x 83.1 x 16.9 cm); each figure 12¹/₂″ (31.8 cm) high. John G. Powers Fund. 11.65.

479 STUDY FROM FALLING MAN SERIES: WALKING MAN. (1964) Chromium-plated bronze (cast 1965), 58⁵/₈ x 11³/₈ x 26¹/₂″ (148.7 x 28.7 x 67 cm), on chrome base recessed in marble base 4 to 6″ high x 20¹/₈ x 35¹/₈″ (10.1 to 15.2 x 50.9 x 89.1 cm). Gift of Miss Viki Laura List. 597.66.

TRYGGVADOTTIR, Nina. Icelandic, 1913–1968. To U.S.A. 1942.

340 PAINTING. (1960) Oil on canvasboard, 24 x 17⁷/₈″ (60.8 x 45.3 cm). Larry Aldrich Foundation Fund. 392.61. Repr. *Suppl. XI*, p. 33.

TUCKER, Albert. Australian, born 1914.

271 LUNAR LANDSCAPE. 1957. Synthetic polymer paint on composition board, 37³/₄ x 51¹/₄″ (95.6 x 130.3 cm). Purchase. 94.58. Repr. *Suppl. VIII*, p. 15.

268 EXPLORERS, BURKE AND WILLS. 1960. Oil and sand on canvas,

48¹/₈ x 61¹/₂″ (122.1 x 156.1 cm). Philip Johnson Fund. 124.60. Repr. *Suppl. X*, p. 29.

TUNNARD, John. British, born 1900.

142 FUGUE. 1938. Oil and tempera on gessoed composition board, 24 x 34¹/₈″ (61 x 86.7 cm). Acquired through the Lillie P. Bliss Bequest. 19.43. Repr. *Ptg. & Sc.*, p. 121.

TWARDOWICZ, Stanley. American, born 1917.

339 NUMBER 11. 1955. Enamel and oil on canvas, 6′ x 50″ (182.9 x 127 cm). Purchase. 244.56. Repr. *Suppl. VI*, p. 34.

Also, photographs.

TWORKOV, Jack. American, born Poland 1900. To U.S.A. 1913.

THE WHEEL. 1953. Oil on canvas, 54 x 50″ (137.2 x 127 cm). Gift of the Gramercy Park Foundation, Inc. 31.54. Repr. *Suppl. V*, p. 21.

330 WEST 23RD. 1963. Oil on canvas, 60¹/₈″ x 6′8″ (152.6 x 203.3 cm). Purchase. 274.63.

TYAPUSHKIN, Alexei Alexandrovich. Russian, born 1919.

469 EMOTIONAL SIGN. 1965. Oil and tempera mixed with sawdust on canvas, 51¹/₄ x 39⁵/₈″ (130 x 100.5 cm). Purchase. 2107.67.

UBAC, Raoul. Belgian, born 1911. To Paris 1929.

346 TWO PERSONS AT A TABLE. 1950. Oil on canvas, 51 x 28³/₄″ (129.5 x 73 cm). Purchase. 30.51. Repr. *Suppl. III*, p. 18.

Also, prints, an illustration, and a poster.

UECKER, Günther. German, born 1930.

504 WHITE FIELD. 1964. Nails projecting from canvas-covered board, painted, 34³/₈ x 34³/₈ x 2³/₄″ (87.2 x 87.2 x 6.8 cm). Matthew T. Mellon Foundation Fund. 1244.64.

UEDA, Sokyu. Japanese, born 1900.

317 NINE COVES AND THREE BENDS IN THE RIVER. (c. 1953) Brush and ink, 26¹/₂ x 50¹/₄″ (67.3 x 127.6 cm). Japanese House Fund. 281.54. Repr. *Suppl. V*, p. 28.

URBAN, Albert. American, born Germany. 1909–1959. To U.S.A. 1940.

PAINTING. (1959) Oil on canvas, 68 x 71⁷/₈″ (172.6 x 182.4 cm). Purchase. 653.59. Repr. *16 Amer.*, p. 83.

URQUHART, Tony, Canadian, born 1934.

FOREST FLOOR, II, 1961. Oil and ink on paper, 11 x 13⁷/₈″ (27.8 x 35.3 cm). Gift of Emilio del Junco. 393.61. Repr. *Suppl. XI*, p. 53.

SUMMER FORMS, I. (1961) Oil and ink on paper, 11⁷/₈ x 17³/₄″ (30 x 45 cm). Gift of Emilio del Junco. 394.61.

URTEAGA, Mario (Mario Urteaga Alvarado). Peruvian, 1875–1957.

214 BURIAL OF AN ILLUSTRIOUS MAN. 1936. Oil on canvas, 23 x 32¹/₂″ (58.4 x 82.5 cm). Inter-American Fund. 806.42. Repr. *Ptg. & Sc.*, p. 179.

UTRILLO, Maurice. French, 1883–1955.

65 THE CHURCH AT BLÉVY. (Previous title: *Provincial Church*.) Oil on canvas, 25¹/₂ x 19¹/₂″ (64.8 x 49.5 cm). Given anonymously. 455.37. Repr. *Ptg. & Sc.*, p. 54

Also, prints.

VAGIS, Polygnotos. American, born Greece. 1894–1965. To U.S.A. 1910.

418 THE SNAKE. 1942. Stone (gneiss), 18 x 27⁵/₈ x 20⁷/₈" (45.5 x 70 x 53 cm). Gift of the artist in memory of his wife, Sylvia Bender Vagis. 1245.64.

255 REVELATION. (1951) Stone (gneiss), 16¹/₈ x 18" (41 x 45.7 cm) (irregular). Gift of D. and J. de Menil. 583.56. Repr. *Suppl. VI*, p. 18.

VAIL, Laurence. American, born France. 1891–1968. Lived in France.

477 BOTTLE. (1945) Glass bottle and stopper encrusted with shells, glass, barnacles, coral, and metal, 13³/₄ x 8⁷/₈ x 5⁵/₈" (34.8 x 22.4 x 14.3 cm). Gift of Peggy Guggenheim. 51.65a–b.

VALTAT, Louis. French, 1869–1952.

THREE DOGS ON A BEACH. (c. 1898) Watercolor and ink, 9⁵/₈ x 12³/₈" (24.4 x 31.4 cm). Mrs. Cornelius J. Sullivan Fund. 28.53.

32 NUDE IN FOREST. (c. 1905) Oil on burlap, 24¹/₈ x 32³/₈" (61.3 x 82.2 cm). Gift of Mr. and Mrs. Henry F. Fischbach. 291.58. Repr. *Suppl. VIII*, p. 4.

Also, a print.

VAN GOGH. See VAN GOGH.

VANTONGERLOO, Georges. Belgian, 1886–1965. To Paris 1927.

138 CONSTRUCTION WITHIN A SPHERE. (1917) Silvered plaster, 7" (17.8 cm) high, at base 2³/₄" (7 cm) diameter. Purchase. 265.37. Repr. *Ptg. & Sc.*, p. 277; *Cubism*, p. 190.

138 CONSTRUCTION OF VOLUME RELATIONS. (1921) Mahogany, 16¹/₈" (41 cm) high, at base 4³/₄ x 4¹/₈" (12.1 x 10.3 cm). Gift of Silvia Pizitz. 509.53. Repr. *Suppl. V*, p. 16.

Also, a gouache in the Study Collection, and a print.

VARAZI, Avtandil Vasilievich. Georgian, U.S.S.R., born 1926.

469 BLEEDING BUFFALO. (1963) Cloth trousers impregnated with glue, then shaped and attached to wood boards; folds highlighted with oil paint, 25¹/₈ x 14⁷/₈ x 4³/₈" (63.8 x 37.7 x 11.2 cm). Purchase. 2108.67.

VARGAS, Raúl. Chilean, born 1908.

THE DANCER, INÉS PISARRO. 1941. Terra cotta, 11¹/₂" (29.2 cm) high. Inter-American Fund. 220.42. Repr. *Latin-Amer. Coll.*, p. 42.

VARISCO, Grazia. Italian, born 1937.

512 DYNAMIC LATTICE A. (1962) Motor-driven construction with plexiglass, cardboard lattices, and light in a wood box, 20¹/₄ x 20¹/₄ x 5⁷/₈" (51.4 x 51.4 x 14.7 cm). Gift of the Olivetti Company of Italy. 1246.64.

VASARELY, Victor. French, born Hungary 1908. To Paris 1930.

370 YLLAM. 1949–52. Oil on canvas, 51³/₈ x 38¹/₄" (130.3 x 97.2 cm). Blanchette Rockefeller Fund. 280.58. Repr. *Suppl. VIII*, p. 18.

460 YARKAND, I. 1952–53. Oil on canvas, 39¹/₂ x 28³/₄" (100.1 x 73 cm). Gift of Mr. and Mrs. Allan D. Emil. 388.66.

370 ONDHO. 1956–60. Oil on canvas, 7'2⁵/₈" x 71" (220 x 180.4 cm). Gift of G. David Thompson. 15.61. Repr. *Suppl. X*, p. 49.

CAPELLA 4 B. (1965) Tempera on composition board in two parts; overall, 50⁵/₈ x 32³/₄" (128.5 x 83.1 cm). The Sidney and

Harriet Janis Collection (fractional gift). 660.67. Repr. *Janis*, p. 143.

498 CTA-104-E. (1965) Synthetic polymer and metallic paint on cardboard, 31³/₈ x 31³/₈" (79.6 x 79.6 cm). Given in memory of G. David Thompson by his New York friends. 181.66.

VASILIEV, Yuri V. Russian, born 1925.

352 CONCERN FOR LIFE. 1962. Pastel and watercolor on cardboard, 27³/₄ x 30⁷/₈" (70.5 x 78.3 cm). Gift of Yevgeny Yevtushenko. 18.63.

VASIRI, Mohsen. Iranian, born 1924.

449 Untitled. 1962. Sand and synthetic polymer paint on canvas, 39³/₈ x 71" (99.9 x 180.1 cm). Helmuth Bartsch Fund. 52.65.

VEDOVA, Emilio. Italian, born 1919.

COSMIC VISION. (1953) Tempera on plywood, 32⁵/₈ x 21⁷/₈" (82.8 x 55.5 cm). Blanchette Rockefeller Fund. 282.56. Repr. *Suppl. VI*, p. 30.

350 UNQUIET SPACE. 1957. Tempera and sand on canvas, 53¹/₈ x 67" (134.9 x 170 cm). Gift of Mr. and Mrs. Kurt Berger. 281.58. Repr. *Suppl. VIII*, p. 10.

VIANI, Alberto. Italian, born 1906.

298 TORSO. (1945) Marble, 38 x 21" (96.5 x 53.3 cm). Purchase. 352.49. Repr. *20th-C. Italian Art*, pl. 133.

VICENTE, Esteban. American, born Spain 1906. To U.S.A. 1936.

382 BLUE, RED, BLACK, AND WHITE. 1961. Collage of painted paper on cardboard, 29⁷/₈ x 40¹/₄" (75.8 x 102 cm). Larry Aldrich Foundation Fund and anonymous gift. 265.64.

Also, a print.

VIEIRA DA SILVA, Marie Hélène. French, born Portugal, 1908. Worked in Rio de Janeiro 1940–47.

345 DANCE. 1938. Oil and wax on canvas, 19¹/₂ x 59¹/₄" (49.5 x 150.5 cm). Alfred Flechtheim Fund. 29.54. Repr. *Suppl. V*, p. 39.

436 THE CITY. (1950–51) Oil on canvas, 38³/₈ x 51" (97.3 x 129.4 cm). Gift of Mrs. Gilbert W. Chapman. 508.65. Repr. *New Decade*, p. 103.

VILLAMIZAR. See RAMÍREZ.

VILLON, Jacques. French, 1875–1963.

GIRL ON BALCONY. (c. 1900) Watercolor, 7⁷/₈ x 5¹/₈" (20 x 13 cm). Katherine S. Dreier Bequest. 211.53.

WOMAN WITH UMBRELLA. (c. 1900) Watercolor and pencil, 7⁷/₈ x 4³/₄" (20 x 12 cm). Katherine S. Dreier Bequest. 212.53.

103 COLOR PERSPECTIVE. 1922. Oil on canvas, 28³/₄ x 23⁵/₈" (73 x 60 cm). Katherine S. Dreier Bequest. 213.53. Repr. *Suppl. IV*, p. 9.

103 DANCE. 1932. Oil on canvas, 15¹/₈ x 21⁵/₈" (38.4 x 54.9 cm). Gift of Mrs. Arthur L. Strasser. 576.39.

Also, drawings, prints, illustrated books, and a poster.

VINCENT, René. Haitian, born 1911.

COCK FIGHT. 1940. Oil on canvas, 18 x 26" (45.7 x 66 cm). Inter-American Fund. 150.44.

VIVIN, Louis. French, 1861–1936.

8 THE WEDDING. (c. 1925) Oil on canvas, 18¹/₄ x 21⁵/₈" (46.3 x 54.9

cm). Gift of Mr. and Mrs. Peter A. Rübel. 512.51. Repr. *Suppl. IV*, p. 47.

THE PANTHEON. (1933) Oil on canvas, 15 x 21³/₄″ (38.1 x 55.1 cm). The Sidney and Harriet Janis Collection (fractional gift). 661.67. Repr. *Janis*, p. 95.

VLAMINCK, Maurice de. French, 1876–1958.

63 MONT VALÉRIEN. (1903) Oil on canvas, 22 x 30¹/₄″ (55.9 x 76.8 cm). Acquired through the Lillie P. Bliss Bequest. 275.48.

63 STILL LIFE. (1913–14) Watercolor and gouache, 15⁵/₈ x 18⁷/₈″ (39.7 x 47.9 cm). Gift of Justin K. Thannhauser. 693.49.

63 WINTER LANDSCAPE. (1916–17) Oil on canvas, 21¹/₄ x 25¹/₂″ (54 x 64.8 cm). Gift of Mr. and Mrs. Walter Hochschild. 324.39. Repr. *Ptg. & Sc.*, p. 56.

Also, prints and illustrated books.

VOLLMER, Ruth. American, born Germany 1903. To U.S.A. 1935.

Untitled. (1960) Bronze, 10¹/₄ x 9⁷/₈″ (25.8 x 25 cm). Gift of Mr. and Mrs. Leo Rabkin. 276.63.

VUILLARD, Édouard. French, 1868–1940.

30 FAMILY OF THE ARTIST [*L'Heure du dîner*]. (1892) Oil on canvas, 28¹/₄ x 36³/₈″ (71.8 x 92.2 cm). Gift of Mr. and Mrs. Sam Salz and an anonymous donor. 101.61. Repr. *Suppl. XI*, p. 11. *Note*: from left to right, the artist's mother, Marie Michaud Vuillard, his grandmother, his sister Marie. Peering through the door in background, the artist.

30 STILL LIFE. (1892) Oil on wood, 9³/₈ x 12⁷/₈″ (23.7 x 32.6 cm). Acquired through the Lillie P. Bliss Bequest. 283.56. Repr. *Suppl. VI*, p. 6.

30 MOTHER AND SISTER OF THE ARTIST. (c. 1893) Oil on canvas, 18¹/₄ x 22¹/₄″ (46.3 x 56.5 cm). Gift of Mrs. Saidie A. May. 141.34. Repr. *Ptg. & Sc.*, p. 37; in color, *Masters*, p. 38; *Vuillard*, p. 25; in color, *Invitation*, p. 26. *Note*: the subjects are Marie Michaud Vuillard and Marie Vuillard.

31 THE PARK. (1894) Distemper on canvas, 6′11¹/₂″ x 62³/₄″ (211.8 x 159.8 cm). Fractional gift of Mr. and Mrs. William B. Jaffe. 600.59. Repr. in color, *Vuillard*, p. 37; *Bulletin*, Fall 1958, p. 52.

Also, drawings, prints, an album cover, and a theatre program.

WAGEMAKER, Jaap. Dutch, born 1906.

380 METALLIC GREY. 1960. Assemblage: wood panel relief with aluminum egg slicer and scrap metal, painted, 24 x 19⁵/₈ x 2³/₄″ (61 x 50 x 6.9 cm). Philip Johnson Fund. 304.61. Repr. *Assemblage*, p. 122.

WALKOWITZ, Abraham. American, born Russia. 1878–1965.

222 NUDE. 1910. Watercolor, 19¹/₈ x 14″ (48.6 x 35.6 cm). Gift of the artist. 214.53.

222 HUDSON RIVER LANDSCAPE WITH FIGURES. (1912) Watercolor, 21¹/₄ x 29¹/₄″ (54 x 74.3 cm). Gift of Abby Aldrich Rockefeller. 154.35.

Also, seventy-six dance studies of Isadora Duncan in the Theatre Arts Collection, a drawing in the Study Collection, and prints.

WALLACE, John and Fred. Haida Indians, British Columbia, Canada. John Wallace was born about 1860; Fred is his son.

11 TOTEM POLE. (1939) Red cedar, polychrome, 32′ (975 cm) high. Extended loan from the Indian Arts and Crafts Board, U.S. Department of the Interior. E.L.40.5034. Repr. *Ptg. & Sc.*, p. 295; *Indian Art*, p. 176.

WALLIS, Alfred. British, 1855–1942.

10 ST. IVES HARBOR. (Previous title: *Cornish Port*.) (c. 1932–33) Oil on cardboard, 10¹/₈ x 12³/₈″ (25.7 x 31.4 cm). Gift of Ben Nicholson. 1646.40. Repr. *Ptg. & Sc.*, p. 16.

402 ROUGH SEA. Oil and pencil on paper, 8³/₈ x 11¹/₄″ (21 x 28.4 cm). Gift of Robert G. Osborne. 519.64.

WALSH, Bernard. American, born 1912.

256 MINER'S SON. (1940) Cast iron, 27¹/₂″ (69.8 cm) high, at base 6¹/₄ x 6″ (15.9 x 15.2 cm). Van Gogh Purchase Fund. 372.41. Repr. *Ptg. & Sc.*, p. 262.

WALTERS, Carl. American, 1883–1955.

254 ELLA. (1927) Ceramic sculpture, 16³/₄″ (42.5 cm) high, at base 9³/₈ x 9³/₄″ (23.8 x 24.8 cm). Purchase. 373.41. Repr. *Art in Our Time*, no. 301.

BABY HIPPO. 1936. Ceramic sculpture, 6 x 19 x 8″ (15.2 x 48.3 x 20.3 cm). Gift of Abby Aldrich Rockefeller. 1.38.

Also, a ceramic plate.

WARHOL, Andy. American, born 1930.

393 GOLD MARILYN MONROE. 1962. Synthetic polymer paint, silkscreened, and oil on canvas, 6′11¹/₄″ x 57″ (211.4 x 144.7 cm). Gift of Philip Johnson. 316.62. Repr. *Suppl. XII*, p. 28.

440 CAMPBELL'S SOUP. (1965) Oil silkscreened on canvas, 36¹/₈ x 24¹/₈″ (91.7 x 61 cm). Elizabeth Bliss Parkinson Fund. 110.66.

440 CAMPBELL'S SOUP. (1965) Oil silkscreened on canvas, 36¹/₈ x 24″ (91.7 x 60.9 cm). Philip Johnson Fund. 111.66.

SELF-PORTRAIT. 1966. Synthetic polymer paint and enamel silkscreened on six canvases, each 22⁵/₈ x 22⁵/₈″ (57.5 x 57.5 cm). The Sidney and Harriet Janis Collection (fractional gift). 662.67.1–.6. Repr. *Janis*, p. 163.

SEVEN DECADES OF JANIS. (1967) Synthetic polymer paint silkscreened on eight joined canvases, each 8¹/₈ x 8¹/₈″ (20.6 x 20.5 cm); overall, 16¹/₄ x 32³/₈″ (41.1 x 82 cm). The Sidney and Harriet Janis Collection (fractional gift). 2355.67a–h. Repr. *Janis*, p. 164.

SIDNEY JANIS. (1967) Photosensitive gelatin and tinted lacquer on silkscreen on wood frame, 7′11¹/₈″ x 6′4¹/₈″ (241.6 x 193.1 cm). The Sidney and Harriet Janis Collection (fractional gift). 2354.67. Repr. *Janis*, p. 105.

WARZECHA, Marian. Polish, born 1930.

NUMBER 50. 1960. Paper collage, 13³/₄ x 21⁵/₈″ (34.7 x 54.7 cm). Philip Johnson Fund. 274.61. Repr. *15 Polish Ptrs.*, p. 56.

WATKINS, Franklin Chenault. American, 1894–1972.

TRANSCENDENCE. Fourteen designs for the ballet produced by the American Ballet Company, Hartford, Connecticut, 1934. Watercolor, eleven designs for costumes, various sizes, 10¹/₄ x 14¹/₂″ to 20¹/₂ x 12″ (26 x 36.8 cm to 52 x 30.4 cm); three designs for scenery, 4¹/₄ x 7″; 16 x 24⁷/₈″; 12 x 18⁷/₈″ (10.8 x 17.8; 40.7 x 63.2; 30.5 x 47.9 cm). Acquired through the Lillie P. Bliss Bequest. 38.42.1–.14. Theatre Arts Collection.

BALLET SCHOOL. Four designs for scenery for a projected ballet, 1935. Watercolor, 16¹/₂ x 22³/₄″; 15¹/₄ x 22⁵/₈″; 16³/₈ x 22⁵/₈″; 10⁷/₈ x 14¹/₈″ (40.9 x 57.8 cm; 38.5 x 57.3 cm; 41.4 x 57.3 cm; 27.6 x 35.9 cm). Gift of Lincoln Kirstein. 514.41.1–.4. Theatre Arts Collection.

240 BORIS BLAI. 1938. Oil on canvas, 40 x 35″ (101.6 x 88.9 cm). Gift

of A. Conger Goodyear (by exchange). 257.39. Repr. *Ptg. & Sc.*, p. 169.

WEBER, Max. American, born Russia. 1881–1961. To U.S.A. 1891.

TWO BROODING FIGURES. 1911. Oil on cardboard, 12¹/₈ x 17¹/₈" (30.8 x 43.5 cm). Gift of Nelson A. Rockefeller. 19.52. *Note:* study for *The Geranium*, 1911.

218　THE GERANIUM. 1911. Oil on canvas, 39⁷/₈ x 32¹/₄" (101.3 x 81.9 cm). Acquired through the Lillie P. Bliss Bequest. 18.44. Repr. *Ptg. & Sc.*, p. 69; in color, *Masters*, p. 112.

218　MAINE. 1914. Pastel, 24¹/₂ x 18³/₄" (62.2 x 47.6 cm). Richard D. Brixey Bequest. 632.43. Repr. *Weber*, no. 31.

218　AIR-LIGHT-SHADOW. 1915. Polychromed plaster, 28⁷/₈ x 12¹/₄" (73.2 x 31.1 cm). Blanchette Rockefeller Fund. 654.59. Repr. *Suppl. IX*, p. 12.

218　THE TWO MUSICIANS. (1917) Oil on canvas, 40¹/₈ x 30¹/₈" (101.9 x 76.5 cm). Acquired through the Richard D. Brixey Bequest. 19.44. Repr. *Ptg. & Sc.*, p. 110.

219　INTERIOR WITH FIGURES. 1918. Gouache, 4⁷/₈ x 4¹/₂" (12.4 x 11.4 cm). Richard D. Brixey Bequest. 116.43.

218　STILL LIFE WITH CHINESE TEAPOT. (1925) Oil on canvas, 20 x 24¹/₈" (50.8 x 61.3 cm). Gift of Abby Aldrich Rockefeller. 155.35. Repr. *Ptg. & Sc. (I)*, p. 80.

THE RIVER. (1926) Oil on canvas, 25 x 31" (63.5 x 78.8 cm). Richard D. Brixey Bequest. 120.43. Repr. *Weber*, no. 83.

The following fourteen small gouaches are the gifts of Abby Aldrich Rockefeller:

STILL LIFE. (1926) Gouache, 5 x 4⁵/₈" (12.7 x 11.7 cm). 160.35.

219　HEAD. (1928) Gouache, 5 x 4⁵/₈" (12.7 x 11.7 cm). 157.35.

SEATED NUDE. (1928) Gouache, 5 x 4⁵/₈" (12.7 x 11.7 cm). 158.35.

WRESTLERS. (1928) Gouache, 5¹/₄ x 4¹/₂" (13.2 x 11.4 cm) (composition). 162.35.

THE ATHLETE. 1930. Gouache, 5¹/₂ x 4¹/₈" (14 x 10.5 cm). 220.40.

THE BLUE RIBBON. 1930. Gouache, 5¹/₈ x 3⁵/₈" (13 x 9.2 cm). 221.40.

THE CHINESE VASE. 1930. Gouache, 4¹/₄ x 5¹/₄" (10.8 x 13.3 cm). 222.40.

THE FLOWER POT. 1930. Gouache, 4¹/₄ x 6¹/₄" (10.8 x 15.9 cm). 223.40.

MORNING. 1930. Gouache, 4¹/₄ x 6" (10.8 x 15.2 cm). 224.40.

THE RABBI. 1930. Gouache, 6 x 4¹/₈" (15.2 x 10.5 cm). 225.40.

THE SISTERS. 1930. Gouache, 7 x 4¹/₄" (17.8 x 10.8 cm). 226.40.

SLEEP. 1930. Gouache, 4¹/₄ x 6¹/₂" (10.8 x 16.5 cm). 227.40.

WONDERMENT. 1930. Gouache, 7 x 4¹/₈" (17.8 x 10.5 cm). 229.40.

YOUNG WOMAN. 1930. Gouache, 5 x 4⁵/₈" (12.7 x 11.7 cm). 228.40.

Also, a drawing, prints, and illustrated books.

WEINBERG, Elbert. American, born 1928.

302　RITUAL FIGURE. (1953) Beechwood, 60¹/₄" (153 cm) high, at base 12⁷/₈ x 16⁵/₈" (32.7 x 42.2 cm). A. Conger Goodyear Fund. 35.55. Repr. *Suppl. V*, p. 30.

WELLS, Luis Alberto. Argentine, born 1939.

504　Model for detail of ceiling relief in the donor's apartment,

Buenos Aires. 1966. Enamel on paper over cardboard, 3¹/₄ x 18⁷/₈ x 19¹/₈" (8.1 x 47.9 x 48.4 cm). Gift of Jorge Romero Brest. 7.67.

WERNER, Theodor. German, born 1886.

351　VENICE. 1952. Oil and tempera on canvas, 32 x 39³/₈" (81.3 x 100 cm). Gift of Mrs. Gertrud A. Mellon. 282.54. Repr. *New Decade*, p. 50.

WESSELMANN, Tom. American, born 1931.

393　THE GREAT AMERICAN NUDE, 2. 1961. Gesso, enamel, oil, and collage on plywood, 59⁵/₈ x 47¹/₂" (151.5 x 120.5 cm). Larry Aldrich Foundation Fund. 79.63. Repr. *Suppl. XII*, p. 29.

MOUTH 7. 1966. Oil on shaped canvas, 6'8¹/₄" x 65" (206.3 x 165.1 cm). The Sidney and Harriet Janis Collection (fractional gift). 663.67. Repr. *Janis*, p. 157.

VON WIEGAND, Charmion. American, born 1899.

381　NUMBER 254–1960. 1960. Collage of paper, string, bristles, 20³/₈ x 10³/₄" (51.6 x 27.2 cm). Given anonymously in place of von Wiegand *Number 180* (585.56). 126.61. Repr. *Suppl. XI*, p. 24.

WILFRED, Thomas. American, born Denmark. 1889–1968. To U.S.A. 1916.

261　VERTICAL SEQUENCE, OP. 137. 1941. Lumia composition (projected light on translucent screen). Form cycle 7 minutes; color cycle 7 minutes 17 seconds. The two cycles coincide every 50 hours and 59 minutes. Screen, 15¹/₄ x 15³/₈" (38.7 x 39 cm). Purchase. 166.42.

261　ASPIRATION, OP. 145. 1955. Lumia composition (projected light on translucent screen). Duration of composition 42 hours, 14 minutes, 11 seconds. Screen, 19¹/₄ x 15" (48.9 x 38.1 cm). Gift of Mr. and Mrs. Julius Stulman. 133.61. Repr. *Suppl. XI*, p. 4.

514　LUMIA SUITE, OP. 158. (1963–64) Lumia composition (projected light on translucent screen). Three movements, lasting 12 minutes, repeated continuously with almost endless variations. Duration of entire composition not calculated. Screen, 6 x 8' (182.8 x 243.2 cm). Commissioned by the Museum through the Mrs. Simon Guggenheim Fund. 582.64.

Also, photographs.

WILLIAMS, Hiram D. American, born 1917.

284　CHALLENGING MAN. 1958. Oil and enamel on canvas, 8'¹/₄" x 6'¹/₈" (244.3 x 183 cm). Fund from the Sumner Foundation for the Arts. 425.60. Repr. *Suppl. X*, p. 28.

WILLIAMSON, Clara McDonald. American, born 1875.

6　THE DAY THE BOSQUE FROZE OVER. 1953. Oil on composition board, 20 x 28" (50.8 x 71.1 cm). Gift of Albert Dorne. 32.54. Repr. *Suppl. V*, p. 33.

WILSON, Jane. American, born 1924.

339　THE OPEN SCENE. 1960. Oil on canvas, 60³/₈" x 6'8" (153.3 x 203.1 cm). Given anonymously. 110.60. Repr. *Suppl. X*, p. 27.

WINTER, Fritz. German, born 1905.

351　QUIET SIGN. 1953. Oil on burlap, 45 x 57¹/₂" (114.3 x 146 cm). Gertrud A. Mellon Fund. 161.55. Repr. *New Decade*, p. 55.

Also, prints; and an oil in the Study Collection.

WOJCIECHOWSKY, Agatha. American, born Germany 1893. To U.S.A. 1923.

Untitled. 1962. Watercolor, 14³/4 x 11″ (37.3 x 27.7 cm). Larry Aldrich Foundation Fund. 406.63.

Untitled. (1962?) Watercolor, 12 x 10³/4″ (30.3 x 27.1 cm). Larry Aldrich Foundation Fund. 407.63.

Also, a drawing.

WOLS (Otto Alfred Wolfgang Schulze). German, 1913–1951. To France 1932.

344 PAINTING. (1944–45) Oil on canvas, 31⁷/8 x 32″ (81 x 81.1 cm). Gift of D. and J. de Menil. 29.56. Repr. *Suppl. VI*, p. 25.

Also, a drawing, prints, and illustrated books.

WOOD, J. Trevor. Rhodesian, born Great Britain 1930.

315 FOURTH-DIMENSIONAL PEBBLE BEACH. (1962) Oil on canvas, 36¹/4 x 44³/8″ (92 x 112.7 cm). Gift of Mr. and Mrs. Walter Hochschild. 340.63. Repr. *Suppl. XII*, p. 32.

WOTRUBA, Fritz. Austrian, born 1907.

298 HEAD. (1954–55) Bronze, 16³/4″ (42.5 cm) high. Blanchette Rockefeller Fund. 162.57. Repr. *Suppl. VII*, p. 15; *New Images*, p. 148.

WRIGHT. See MACDONALD-WRIGHT.

WYETH, Andrew. American, born 1917.

276 CHRISTINA'S WORLD. (1948) Tempera on gesso panel, 32¹/4 x 47³/4″ (81.9 x 121.3 cm). Purchase. 16.49. Repr. *Suppl. I*, p. 25; in color, *Invitation*, p. 120. *Note*: Christina Olson, a personal friend and Maine neighbor of the artist, is the subject.

WYNTER, Bryan. British, born 1915.

348 MEETING PLACE. (1957) Oil on canvas, 56 x 44″ (142.2 x 111.7 cm). G. David Thompson Fund. 617.59. Repr. *Suppl. IX*, p. 27.

YACOUBI, Ahmed (Ahmed Ben Driss El Yacoubi). Moroccan, born 1928.

450 KING SOLOMON'S RING. 1963. Oil on canvas, 28³/4 x 23¹/2″ (73 x 59.6 cm). Gift of Mrs. Raymond J. Braun and David Mann. 118.66.

YAGI, Kazuo. Japanese, born 1918.

475 A CLOUD REMEMBERED. (1962) Ceramic, 9 x 8 x 10″ (22.9 x 20.3 x 25.4 cm). John G. Powers Fund. 613.65. Repr. *New Jap. Ptg. & Sc.*, p. 45.

YAMAGUCHI, Takeo. Korean, born 1902. Lives in Tokyo.

470 TAKU. 1961. Oil on canvas over wood, 35⁷/8 x 35³/4″ (90.9 x 90.8 cm). Junior Council Fund. 614.65.

YEKTAI, Manoucher. American, born Iran 1921.

339 STILL LIFE D. 1959. Oil on canvas, 48¹/4 x 68″ (122.3 x 172.7 cm). Gift of Mr. and Mrs. Bernard J. Reis. 618.59. Repr. *Suppl. IX*, p. 28.

YOSHIMURA, Masanobu. Japanese, born 1932.

474 TWO COLUMNS. (1964) Construction of plaster on wood and composition board, recessed in wood base, one column in a plexiglass vitrine, 6'2¹/4″ x 36″ x 18″ (188.4 x 91.4 x 45.6 cm). Purchase. 615.65a–d. Repr. *New Jap. Ptg. & Sc.*, p. 85.

YOUNGERMAN, Jack. American, born 1926.

340 BIG BLACK. 1959. Oil on canvas, 7'7″ x 70¹/4″ (231.1 x 178.3 cm). Larry Aldrich Foundation Fund. 16.60. Repr. *16 Amer.*, p. 87; *Suppl. X*, p. 41.

447 BLACK, RED, AND WHITE. 1962. Oil on canvas, 6'3⁵/8″ x 6'11″ (191.9 x 210.7 cm). Larry Aldrich Foundation Fund (by exchange). 1134.64. *Note*: acquired from the artist in exchange for *Big Black*, 1959 (16.60).

YUNKERS, Adja. American, born Latvia 1900. In Sweden 1933–47. To U.S.A. 1947.

BLACK CANDLE IN A BLUE ROOM. 1939. Gouache, 18⁷/8 x 13³/8″ (47.9 x 34 cm). Purchase. 16.40.

341 HOUR OF THE DOG. 1961. Pastel and gouache, 69 x 47⁷/8″ (175.1 x 121.7 cm). Gift of the artist through the Ford Foundation Purchase Program. 102.62. Repr. *Suppl. XII*, p. 20. *Note*: the title refers to a Japanese name for a period in the evening.

Also, prints.

YVARAL (Jean Pierre Vasarely). French, born 1934.

370 ACCELERATION 19, SERIES B. (1962) Construction of plastic cord, plexiglass, and wood, 23⁷/8 x 24³/8 x 3¹/8″ (60.5 x 61.8 x 8 cm). Gift of Philip Johnson. 20.63. Repr. *Responsive Eye*, p. 40.

ZADKINE, Ossip. French, born Russia. 1890–1967. To Paris 1909. In U.S.A. 1940–45.

104 TORSO. (1928) Ebony, 36″ (91.4 cm) high. Gift of Mrs. Maurice J. Speiser in memory of her husband. 17.49. Repr. *Suppl. I*, p. 28.

Also, a print.

ZAJAC, Jack. American, born 1929.

304 EASTER GOAT. (1957) Bronze, 19¹/8 x 31³/4″ (48.5 x 80.6 cm). Udo M. Reinach Estate Fund. 29.59. Repr. *Recent Sc. U.S.A.*

Also, a drawing and a print.

ZALCE, Alfredo. Mexican, born 1908.

PIRULI. 1939. Oil on wood, 15 x 21⁷/8″ (38.1 x 55.6 cm). Inter-American Fund. 810.42. Repr. *Latin-Amer. Coll.*, p. 76.

Also, prints, posters, broadsides, an illustrated book, and a calendar sheet.

ZAMMITT, Norman. American, born Canada 1931. To U.S.A. 1944.

503 Untitled. (1966) Laminated synthetic polymer, 5³/4 x 15¹/4 x 4¹/4″ (14.6 x 38.5 x 10.6 cm). Larry Aldrich Foundation Fund. 8.67.

ZAÑARTU, Enrique. Chilean, born Paris 1921. Works in Paris.

311 PERSONAGES. 1956. Oil on canvas, 39 x 32″ (99 x 81.3 cm). Inter-American Fund. 198.56. Repr. *Suppl. VI*, p. 32.

Also, prints.

ZEHRINGER, Walter. German, born 1940.

504 NUMBER 2, 1964. 1964. Plexiglass with background of painted plastic over composition board, 31⁵/8 x 31⁵/8 x 1¹/2″ (80.1 x 80.1 x 3.9 cm). Larry Aldrich Foundation Fund. 115.65.

ZENDEROUDI, Hossein (Zendh-Roudi). Iranian, born 1937. In France since 1961.

319 K + L + 32 + H + 4. 1962. Felt pen and colored ink on paper mounted on composition board, 7'5″ x 58⁵/8″ (225.9 x 148.7 cm) (irregular). Philip Johnson Fund. 317.62. Repr. *Suppl. XII*, p. 31.

ZERBE, Karl. American, born Germany. 1903–1972. To U.S.A. 1934.

241 HARLEM. 1952. Polymer tempera on canvas over composition board, 44½ x 24″ (113 x 61 cm). Gift of Mr. and Mrs. Roy R. Neuberger. 483.53. Repr. *Suppl. V*, p. 17.

Also, a print and a poster.

ZIEGLER, Laura. American, born 1927.

MAN WITH A PICKAX. (1954) Bronze, 11¾″ (29.9 cm) high. Blanchette Rockefeller Fund. 285.56. Repr. *Suppl. VI*, p. 32.

ZOLOTOW, Harry. American, born Ukraine. 1888–1963. To U.S.A. 1906.

PAINTING. (1946) Oil on canvas, 54¼ x 40″ (137.8 x 101.6 cm). Gift of the artist. 82.47.

Also, a painting in the Study Collection.

ZORACH, William. American, born Lithuania. 1889–1966. To U.S.A. 1891.

254 CHILD WITH CAT. (1926) Tennessee marble, 18″ (45.7 cm) high, at base 6⅝ x 10″ (16.8 x 25.4 cm). Gift of Mr. and Mrs. Sam A. Lewisohn. 15.39. Repr. *Ptg. & Sc.*, p. 256. *Note*: the child is the artist's daughter, Dahlov Ipcar.

FISHERMAN. 1927. Watercolor, 14⅝ x 21¾″ (37.2 x 55.2 cm). Given anonymously. 171.35.

SPRING. 1927. Watercolor, 15⅛ x 22″ (38.4 x 55.9 cm). Given anonymously (by exchange). 173.35.

SETTING HEN. (1941) Cast stone (after original marble of 1935), 14¼″ (36.2 cm) high, at base 11¼ x 11″ (28.5 x 27.9 cm). Abby Aldrich Rockefeller Fund. 497.41.

254 HEAD OF CHRIST. (1940) Stone (peridotite), 14¾″ (37.5 cm) high. Abby Aldrich Rockefeller Fund. 188.42. Repr. *Ptg. & Sc.*, p. 257. *Note*: the artist's father, Aaron Zorach, served as a model for the head. The title was given after the sculpture was finished.

Also, drawings and a print.

ZVEREV, Anatoly Timofeevich. Russian, born 1931.

289 APPLES. (1955) Gouache, 10½ x 15¼″ (26.7 x 38.7 cm) (irregular). Alfred Flechtheim Fund. 278.56. Repr. *Suppl. VI*, p. 33.

SELF-PORTRAIT IN PLAID SHIRT. (1955) Watercolor, 13½ x 9¾″ (34.3 x 24.8 cm). Purchase. 19.58. Repr. *Suppl. XII*, p. 26.

SELF-PORTRAIT—HEAD. (1955) Watercolor, 10⅞ x 8⅞″ (27.8 x 22.5 cm). Purchase. 20.58. Repr. *Suppl. XII*, p. 26.

SELF-PORTRAIT. 1957. Watercolor, 23⅜ x 16½″ (59.4 x 41.8 cm). Purchase. 18.58. Repr. *Suppl. XII*, p. 26.

Also, a drawing.

DONORS TO
THE COLLECTION OF PAINTING AND SCULPTURE

Charles Abrams
Mr. and Mrs. A. M. Adler
Theodor Ahrenberg
Mrs. Joseph James Akston
Larry Aldrich
Mrs. Frank Altschul
Mr. and Mrs. L. M. Angeleski
Leigh Athearn
Mr. and Mrs. Douglas Auchincloss
Mr. and Mrs. Lee A. Ault
Mr. and Mrs. Leslie Ault
Dr. Frederick Baekeland
Harold W. Bangert
Mr. and Mrs. Walter Bareiss
James W. Barney
Alfred H. Barr, Jr.
Mrs. George E. Barstow
Frederic Clay Bartlett
Mr. and Mrs. Armand P. Bartos
Y. K. Bedas
Larry Bell
Albert M. Bender
W. B. Bennet
LeRay W. Berdeau
Carl Magnus Berger
Mr. and Mrs. Kurt Berger
Samuel A. Berger
Eugene Berman
Mr. and Mrs. Herbert C. Bernard
Mrs. Marya Bernard
Ernst Beyeler
Alexander M. Bing
The Honorable and Mrs. Robert Woods Bliss
Richard Blow
Mrs. Harry Lynde Bradley
Mr. and Mrs. Raymond J. Braun
Francis E. Brennan
Jorge Romero Brest
Mrs. Walter D. S. Brooks
Briggs W. Buchanan
Mr. and Mrs. Gordon Bunshaft
Mr. and Mrs. William A. M. Burden
James Lee Byars
Alexander Calder
Mr. and Mrs. Joseph Cantor
Louis Carré
Carroll Carstairs
Mr. and Mrs. Victor M. Carter
Dr. H. B. G. Casimir
Mrs. Gilbert W. Chapman
Walter P. Chrysler, Jr.
Stephen C. Clark
Mr. and Mrs. Erich Cohn
Mr. and Mrs. Sidney Elliott Cohn
Mr. and Mrs. Ralph F. Colin
Mme Sibylle Cournand
Mrs. W. Murray Crane
Frank Crowninshield
Mrs. Charles Suydam Cutting
Mme Ève Daniel
Bernard Davis
Richard Davis
Albert Dorne
Mr. and Mrs. Robert W. Dowling
Jean Dubuffet
Marcel Duchamp
Douglas M. Duncan
H. S. Ede

Arne Ekstrom
Craig Ellwood
Mr. and Mrs. Allan D. Emil
Judge and Mrs. Henry Epstein
Lady Kathleen Epstein
R. H. Donnelley Erdman
Jimmy Ernst
Max Ernst
Armand G. Erpf
Dr. Andres J. Escoruela
Eric Estorick
Mr. and Mrs. Solomon Ethe
Mrs. Marjorie Falk
Richard L. Feigen
Julia Feininger
Mrs. Marie L. Feldhaeusser
Marshall Field
Mr. and Mrs. Henry F. Fischbach
Mr. and Mrs. Herbert Fischbach
Mr. and Mrs. Sol Fishko
Myrtil Frank
Mr. and Mrs. Clarence C. Franklin
Mr. and Mrs. Arthur S. Freeman
Dr. Román Fresnedo Siri
Miss Rose Fried
Naum Gabo
Edward Joseph Gallagher 3rd Memorial Collection
A. E. Gallatin
Mr. and Mrs. Theodore S. Gary
Mr. and Mrs. Monroe Geller
Estate of George Gershwin
Mrs. Bernard F. Gimbel
Hyman N. Glickstein
Dr. Alfred Gold
Mr. and Mrs. C. Gerald Goldsmith
Mr. and Mrs. Herbert A. Goldstone
Mme Natalie Gontcharova
Philip L. Goodwin
A. Conger Goodyear
Mr. and Mrs. Jan de Graaff
Mme Katia Granoff
Dr. and Mrs. Alex J. Gray
Wilder Green
Dr. Jack M. Greenbaum
Balcomb Greene
Peggy Guggenheim
Mrs. Simon Guggenheim
Edith Gregor Halpert
August Hanniball, Jr.
Mrs. Meredith Hare
Wallace K. Harrison
Mr. and Mrs. Ira Haupt
Mr. and Mrs. Joseph H. Hazen
Mr. and Mrs. Gustav P. Heller
Mr. and Mrs. Irwin Hersey
Mr. and Mrs. Thomas B. Hess
Susan Morse Hilles
Mr. and Mrs. Alex L. Hillman
Hans Hinterreiter
Norman Hirschl
Dr. and Mrs. F. H. Hirschland
Joseph H. Hirshhorn
Mr. and Mrs. Walter Hochschild
Hans Hofmann
Vladimir Horowitz
John E. Hutchins
Alexandre Iolas
Mrs. O'Donnell Iselin

Mrs. Martha Jackson
Mr. and Mrs. William B. Jaffe
Mr. and Mrs. George M. Jaffin
Edward James
Sidney and Harriet Janis
Philip Johnson
Mrs. H. Harris Jonas
Mr. and Mrs. E. Powis Jones
T. Catesby Jones
Mr. and Mrs. Samuel Josefowitz
Mr. and Mrs. Werner E. Josten
Emilio del Junco
Mr. and Mrs. Gilbert W. Kahn
Mrs. Francis Douglas Kane
Donald H. Karshan
Mr. and Mrs. Hugo Kastor
Edgar Kaufmann, Jr.
Mrs. Edgar J. Kaufmann
Mr. and Mrs. Harold Kaye
Lincoln Kirstein
Mr. and Mrs. David Kluger
Mrs. Alfred A. Knopf
Miss Belle Kogan
Joseph H. Konigsberg
Mr. and Mrs. Edward F. Kook
Mr. and Mrs. Samuel M. Kootz
Dr. and Mrs. Leonard Kornblee
Harold Kovner
Mrs. Katharine Kuh
Dr. Kuo Yu-Shou
Mr. and Mrs. František Kupka
Michael Larionov
Mr. and Mrs. Albert D. Lasker
Lee Ung-No
Lucien Lefebvre-Foinet
Dr. and Mrs. Arthur Lejwa
Dr. Rosemary Lenel
Robert Lepper
Mr. and Mrs. Fernand Leval
Mrs. Fernand Leval and children
Mrs. David M. Levy
Mr. and Mrs. Albert Lewin
Mr. and Mrs. Sam A. Lewisohn
Colonel and Mrs. Charles A. Lindbergh
Mr. and Mrs. Leo Lionni
Jacques Lipchitz
Jean and Howard Lipman
Mr. and Mrs. Maurice A. Lipschultz
Mr. and Mrs. Albert A. List
Miss Viki Laura List
George B. Locke
Pierre M. Loeb
Henry Luce, III
Henry R. Luce
Earle Ludgin
J. G. McClelland
Thomas McCray
Archibald MacLeish
Mrs. Annie McMurray
Paul Magriel
Aristide Maillol
David Mann
Mr. and Mrs. Arnold H. Maremont
Marino Marini
Mrs. Reginald Marsh
Sra. Carlos Martins
Mr. and Mrs. Samuel A. Marx
Mr. and Mrs. Pierre Matisse

Mr. and Mrs. Morton D. May
Mrs. Saidie A. May
Dr. Abraham Melamed
Mrs. Gertrud A. Mellon
Paul Mellon
The Honorable Turgut Menemencioğlu
D. and J. de Menil
Mrs. Knud Merrild
Charles E. Merrill
André Meyer
Mr. and Mrs. Ben Mildwoff
Maximilian H. Miltzlaff
Joan Miró
Mr. and Mrs. Jan Mitchell
Mrs. Sibyl Moholy-Nagy
George L. K. Morris
Mr. and Mrs. Irving Moskovitz
Mr. and Mrs. Gerald Murphy
Mrs. Ray Slater Murphy
Mrs. Elie Nadelman
Reuben Nakian
Dr. and Mrs. Ronald Neschis
Mr. and Mrs. Roy R. Neuberger
J. B. Neumann
Louise Nevelson
Albert Newall
John S. Newberry
Ben Nicholson
Isamu Noguchi
Erik Ortvad
Robert G. Osborne
Maria del Carmen Ossaye
Mrs. Roberto Ossaye
Mr. and Mrs. F. Taylor Ostrander
William S. Paley
Stamo Papadaki
Mrs. Bliss Parkinson
Carl-Henning Pedersen
Mr. and Mrs. Donald H. Peters
Antoine Pevsner
Mr. and Mrs. Walter Nelson Pharr
Duncan Phillips
Silvia Pizitz
Henry H. Ploch
George Poindexter
Mr. and Mrs. Jack I. Poses
Mr. and Mrs. Joseph Pulitzer, Jr.
Mr. and Mrs. Leo Rabkin
Theodore R. Racoosin
Dr. C. M. Ramírez Corría
Mrs. G. P. Raymond
Udo M. Reinach Estate
Ad Reinhardt
Mr. and Mrs. Bernard J. Reis
Mr. and Mrs. Stanley Resor
Mr. and Mrs. John Rewald
Miss Jeanne Reynal
Victor S. Riesenfeld
Mr. and Mrs. Louis J. Robbins
Abby Aldrich Rockefeller
Mr. and Mrs. David Rockefeller
Mrs. John D. Rockefeller 3rd
Nelson A. Rockefeller
Alexander Rodchenko
Mr. and Mrs. Richard Rodgers
Allan Roos, M.D., and B. Mathieu Roos
Edward W. Root
Dr. and Mrs. Samuel Rosen

Mr. and Mrs. Paul Rosenberg
Herbert and Nannette Rothschild
Mr. and Mrs. Peter A. Rübel
William S. Rubin
Mme Helena Rubinstein
Anthony Russo
Mr. and Mrs. A. M. Sachs
Mr. and Mrs. Daniel Saidenberg
Mr. and Mrs. Sam Salz
Mr. and Mrs. Ansley W. Sawyer
Mr. and Mrs. Norbert Schimmel
Dr. and Mrs. Daniel E. Schneider
Miss Antoinette Schulte
Mrs. Heinz Schultz
Alfred Schwabacher
Mr. and Mrs. Wolfgang S. Schwabacher
Mr. and Mrs. Eugene M. Schwartz
Mrs. Wallace M. Scudder
Mr. and Mrs. Robert C. Scull
Nelson A. Sears
William C. Seitz
Mr. and Mrs. Georges E. Seligmann
John L. Senior, Jr.
Ben Shahn
Charles Sheeler
Mrs. Saul S. Sherman
Mr. and Mrs. Herman D. Shickman
Daphne Hellman Shih
Mario da Silva
Pat and Charles Simon
Mrs. Leo Simon
Mrs. Kenneth Simpson
Mr. and Mrs. Leif Sjöberg
Mrs. Bertram Smith
James Thrall Soby
Mr. and Mrs. David M. Solinger
Mrs. Maurice J. Speiser
Miss Darthea Speyer
Miss Renée Spodheim
Mrs. Emily Staempfli
Erwin Burghard Steiner
Miss Ettie Stettheimer
Leopold Stokowski
Allan Stone
Mrs. Maurice L. Stone
J. van Straaten
Mrs. Arthur L. Strasser
Mr. and Mrs. Julius Stulman
Kay Sage Tanguy
Pavel Tchelitchew
Mr. and Mrs. Justin K. Thannhauser
Mr. and Mrs. Eugene Victor Thaw
G. David Thompson
Mr. and Mrs. Murray Thompson
Jean Tinguely
Mark Tobey
Mr. and Mrs. William Unger
Polygnotos Vagis
Curt Valentin
Dr. W. R. Valentiner
Carl van der Voort
Fania Marinoff Van Vechten
N. E. Waldman
Abraham Walkowitz
Mr. and Mrs. Edward M. M. Warburg
Mrs. Felix M. Warburg
Edna and Keith Warner
Mr. and Mrs. Richard K. Weil

Mrs. Milton Weill
Mr. and Mrs. Harold X. Weinstein
William H. Weintraub
Mr. and Mrs. Donald Weisberger
Mr. and Mrs. Frederick R. Weisman
Monroe Wheeler
Mr. and Mrs. John Hay Whitney
Mr. and Mrs. Harry Lewis Winston
Dr. Nathaniel S. Wolff
Yevgeny Yevtushenko
Mr. and Mrs. Samuel J. Zacks
Mr. and Mrs. Charles Zadok
Dr. Gregory Zilboorg
Harry Zolotow

Anonymous gift in memory of Milton Avery
Anonymous gift in memory of Holger Cahill
Anonymous gift in memory of Robert Carson
Anonymous gift in memory of Gaston Lachaise
Anonymous gift in memory of Carol Buttenwieser Loeb
Anonymous gift in memory of Jules Pascin
Anonymous gift in memory of G. David Thompson
Anonymous gift in memory of Curt Valentin
Anonymous gift in memory of Dr. Hermann Vollmer

James S. and Marvelle W. Adams Foundation
Advisory Committee of The Museum of Modern Art
American Abstract Artists
American Academy and National Institute of Arts and Letters Fund
American Iron and Steel Institute
The American Tobacco Company, Inc.
Comisión Cubana de Cooperación Intelectual, Havana
Contemporary Art Society, London
Cordier & Ekstrom, Inc.
Ford Foundation Purchase Program
The Four Seasons
French Art Galleries, Inc.
James Graham and Sons
Gramercy Park Foundation, Inc.
Griffis Foundation
M. Knoedler & Company, Inc.
Pierre Matisse Gallery
Joseph G. Mayer Foundation Fund
New York World's Fair, 1939
Olivetti Company of Italy
Organizing Committee of Homage, "Walk with Antonio Machado"
Passedoit Gallery
Henry Pearlman Foundation
Beatrice Perry, Inc.
Galerie Denise René
Galleria Schwarz
Staempfli Gallery
Jerome L. and Jane Stern Foundation
Time Inc.
Women's Committee of the Art Gallery of Toronto

BEQUESTS

Alexander M. Bing
Lillie P. Bliss
Richard D. Brixey
Katherine S. Dreier
Mary Flexner
Rose Gershwin
Philip L. Goodwin
Loula D. Lasker
Anna Erickson Levene
Mrs. David M. Levy
Sam A. Lewisohn

Mrs. Sam A. Lewisohn
John S. Newberry
Abby Aldrich Rockefeller
Grace Rainey Rogers
Lee Simonson
Kay Sage Tanguy
Curt Valentin

PURCHASE FUNDS

Advisory Committee Fund
Larry Aldrich Foundation Fund
Mr. and Mrs. Walter Bareiss Fund
Helmuth Bartsch Fund
Funds realized through the Lillie P. Bliss Bequest
Brazil Fund
Francis E. Brennan Fund
Funds realized through the Richard D. Brixey Bequest
Bertram F. and Susie Brummer Foundation Fund
Mr. and Mrs. Gordon Bunshaft Fund
William A. M. Burden Fund
Mrs. Wendell T. Bush Fund
Katharine Cornell Fund
Frank Crowninshield Fund
Bernard Davis Fund
Katherine S. Dreier Fund
Mr. and Mrs. Allan D. Emil Fund
Alfred Flechtheim Fund
Funds realized through the Mary Flexner Bequest
Rose Gershwin Fund
van Gogh Purchase Fund
Fund given in memory of Philip L. Goodwin
A. Conger Goodyear Fund
Mrs. Simon Guggenheim Fund
Mrs. Charles V. Hickox Fund
Hillman Periodicals Fund
Vladimir Horowitz Fund
Inter-American Fund
Mr. and Mrs. William B. Jaffe Fund
Japanese House Fund
Philip Johnson Fund
W. Alton Jones Foundation Fund
Mr. and Mrs. Werner E. Josten Fund
Junior Council Fund
Edgar Kaufmann, Jr., Fund
Frances Keech Fund
Mr. and Mrs. A. Atwater Kent, Jr., Fund
Loula D. Lasker Fund
Mrs. Sam A. Lewisohn Fund
Fund given by friends of Jacques Lipchitz
Aristide Maillol Fund
Saidie A. May Fund

Grace M. Mayer Fund
Gertrud A. Mellon Fund
Matthew T. Mellon Foundation Fund
D. and J. de Menil Fund
Mr. and Mrs. Roy R. Neuberger Fund
John S. Newberry Fund
William P. Jones O'Connor Fund
Elizabeth Bliss Parkinson Fund
John G. Powers Fund
Adriane Reggie Fund
Udo M. Reinach Estate Fund
Abby Aldrich Rockefeller Fund
Blanchette Rockefeller Fund
Grace Rainey Rogers Fund
Harry J. Rudick Fund
Mrs. Charles H. Russell Fund
Sir Michael Sadler Fund
Mr. and Mrs. Sam Salz Fund
Benjamin Scharps and David Scharps Fund
Mrs. George Hamlin Shaw Fund
Daphne Hellman Shih Fund
Mrs. Bertram Smith Fund
James Thrall Soby Fund
Mr. and Mrs. David M. Solinger Fund
Dr. and Mrs. Frank Stanton Fund
Mr. and Mrs. Donald B. Straus Fund
Mrs. Cornelius J. Sullivan Fund
Sumner Foundation for the Arts
Kay Sage Tanguy Fund
G. David Thompson Fund
Wildenstein Foundation Fund
Richard S. Zeisler Fund

LENDERS OF WORKS OF ART FOR AN EXTENDED PERIOD

Mr. and Mrs. Walter Bareiss
Mr. and Mrs. William A. M. Burden
Mr. and Mrs. William N. Copley
Mrs. Jefferson Dickson
Philip Johnson
Mr. and Mrs. David Kluger
The Kulicke Family
Royal S. Marks
Mrs. John D. Rockefeller 3rd
Allan Roos, M.D., and B. Mathieu Roos
Mr. and Mrs. Burton Tremaine
Mr. and Mrs. Frank S. Wyle
United States Department of the Interior, Indian Arts and Crafts Board
United States Public Works of Art Project
United States WPA Art Program (Works Progress Administration, Federal Art Project)

GIFTS, THE DONORS RETAINING LIFE INTEREST

THE WORKS LISTED below have been given to the Museum with the proviso that the donors (or, in some cases, other individuals designated by the donors) retain possession of them during their lifetimes. All works have been assigned by deed of gift, dating from 1964 or earlier. (A significant change in the tax code occasioned a number of gifts in 1964; see page 644.) Some of these works have formally entered the Collection of Painting and Sculpture since 1967.

Biographical information is given only for artists not listed elsewhere in the Catalog. In other respects the entries conform to those in the Catalog.

ARP, Jean.
> PTOLEMY. 1953. Limestone, 42″ (106.7 cm) high, on black marble base, 35 x 12 x 12″ (88.8 x 30.5 x 30.5 cm). William A. M. Burden. 494.64.

BRANCUSI, Constantin.
> YOUNG BIRD. 1928. Bronze, 16″ (40.5 cm) high, on two-part pedestal of stone and wood (carved by the artist), overall 35³/₄″ (90.7 cm) high. William A. M. Burden. 498.64. *Geist* 172. *Note:* other titles: *L'Oiselet* and *Little Bird.*

> BIRD IN SPACE. (1941?) Bronze, 6′ (182.9 cm) high, on three-part stone pedestal, overall 59¹/₈″ (150.2 cm) high. William A. M. Burden. 497.64. *Geist* 197. *Note:* fifteenth of sixteen variations from 1923 to 1941 and depending on *Geist* 185, 1933.

BRAQUE, Georges.
> UNDER THE AWNING. 1948. Oil on canvas, 51 x 35¹/₈″ (129.6 x 89.1 cm). The Adele R. Levy Fund (Dr. David M. Levy retaining life interest). 227.62.

BUCHHOLZ, Erich.
> WITH TWO YELLOW CIRCLES [*Mit zwei gelben Kreisem*]. 1954. Plaster relief, 25¹/₂ x 18³/₄″ (64.7 x 47.7 cm). Mr. and Mrs. William Feinberg. 563.64.

BURLIUK, David. American, born Ukraine. 1882–1967.
> Untitled. 1908. Oil on burlap, 23 x 25″ (58.3 x 63.5 cm). Mr. and Mrs. William Feinberg. 564.64.

CÉZANNE, Paul.
> L'ESTAQUE. (1879–83) Oil on canvas, 31¹/₂ x 39″ (80.3 x 99.4 cm). William S. Paley. 716.59.

> BOY IN A RED WAISTCOAT. (1893–95) Oil on canvas, 32 x 25⁵/₈″ (81.2 x 65 cm). David Rockefeller. 190.55.

> MONT SAINTE-VICTOIRE. (1902–06) Watercolor, 16³/₄ x 21³/₈″ (42.5 x 54.2 cm). David Rockefeller. 114.62.

DUBUFFET, Jean.
> MARRIAGE VOWS. 1955. Oil on canvas, 39 x 32″ (100.3 x 81.1 cm). From the Monolithic Figures series. William H. Weintraub. 499.64.

> GEORGES DUBUFFET IN THE GARDEN. 1955 (dated on painting 1955 and 1956). Collage of cut-up oil paintings on canvas, 61¹/₄ x 36¹/₈″ (155.5 x 91.7 cm). From the Painting Assemblages series. William H. Weintraub. 500.64.

GAUGUIN, Paul.
> PORTRAIT OF MEYER DE HAAN. 1889. Oil on wood, 31³/₈ x 20³/₈″ (79.6 x 51.7 cm). David Rockefeller. 2.58.

GIACOMETTI, Alberto.
> LARGE HEAD [*Grande tête*]. 1960. Bronze, 38″ (96.5 cm) high. David M. Solinger. 568.64.

GOTTLIEB, Adolph.
> FLOTSAM AT NOON (IMAGINARY LANDSCAPE). 1952. Oil on canvas, 36¹/₈ x 48″ (91.7 x 121.7 cm). Samuel A. Berger. 378.61.

HARE, David.
> MAN RUNNING. 1954. Welded steel and bronze, 20 x 28″ (50.7 x 71 cm). Samuel I. Rosenman. 501.64.

KLEE, Paul.
> MAN WITH TOP HAT [*Herr mit Cylinder*]. 1925. Gouache, pen and ink on paper, 15¹/₈ x 10⁵/₈″ (38.3 x 27 cm) (composition) with ¹/₂″ (1.2 cm) border on cardboard mount painted by the artist. Anonymous, in honor of Margaret Scolari Barr. 570.64.

LÉGER, Fernand.
> STILL LIFE: COMPOSITION FOR A DINING ROOM. 1930. Oil on canvas, 47¹/₂ x 33⁵/₈″ (120.4 x 85.4 cm). Henry Ittleson, Jr. 503.64.

> STILL LIFE: COMPOSITION FOR A DINING ROOM. 1930. Oil on canvas, 47¹/₂ x 33⁵/₈″ (120.4 x 85.4 cm). Henry Ittleson, Jr. 504.64.

MATHIEU, Georges.
> NUMBER 5, 1955. 1955. Oil on canvas, 38 x 64″ (96.5 x 162.5 cm). Samuel I. Rosenman. 505.64.

MATISSE, Henri.
> WOMAN ON A HIGH STOOL. (1913–14) Oil on canvas, 57⁷/₈ x 37⁵/₈″ (147 x 95.5 cm). Mr. and Mrs. Samuel A. Marx. 506.64.

> GOLDFISH. (1915?) Oil on canvas, 57³/₄ x 44¹/₄″ (146.5 x 112.4 cm). Mr. and Mrs. Samuel A. Marx. 507.64.

> VARIATION ON A STILL LIFE BY DE HEEM. (1915, 1916, or 1917) Oil on canvas, 71¹/₄″ x 7′3″ (180.9 x 220.8 cm). Mr. and Mrs. Samuel A. Marx. 508.64.

> THE RED BLOUSE. (1923) Oil on canvas, 22 x 18³/₈″ (55.7 x 46.7 cm). Mr. and Mrs. Walter Hochschild. 781.63.

MIRÓ, Joan.
> OPERA SINGER. 1934. Pastel, 41³/₈ x 29¹/₈″ (105 x 74 cm). William H. Weintraub. 509.64.

MONDRIAN, Piet.
> TRAFALGAR SQUARE. 1939–43. Oil on canvas, 57¹/₄ x 47¹/₄″ (145.2 x 120 cm). William A. M. Burden. 510.64.

OLIVEIRA, Nathan.
> HEAD OF A MAN. 1960. Watercolor, 26 x 20″ (66 x 50.7 cm). Mrs. Samuel I. Rosenman. 511.64.

PICASSO, Pablo.
> BOY LEADING A HORSE. (1905–06) Oil on canvas, 7′2¹/₄″ x 51¹/₂″ (219.7 x 130.6 cm). William S. Paley. 575.64.

> VASE OF FLOWERS. (1907) Oil on canvas, 36¹/₄ x 28³/₄″ (92 x 73 cm). Mr. and Mrs. Ralph F. Colin (the latter retaining a life interest). 311.62.

> WOMAN AND DOG IN A GARDEN. 1961–62. Oil on canvas, 63⁷/₈ x 51¹/₈″ (162.2 x 129.8 cm). David Rockefeller. 529.64.

POLLOCK, Jackson.

Untitled. 1946. Oil on paper, 11⁵/₈ x 17³/₄″ (29.5 x 45 cm). Samuel I. Rosenman. 512.64.

REDON, Odilon.

JACOB WRESTLING WITH THE ANGEL. (c. 1905) Oil on cardboard, 18¹/₂ x 16¹/₂″ (47 x 41.8 cm). Matthew H. and Erna Futter. 784.63.

ROUAULT, Georges.

CLOWN. (1912) Oil on canvas, 35³/₈ x 26⁷/₈″ (89.8 x 68.2 cm). Nate B. and Frances Spingold. 79.58.

SCHWITTERS, Kurt.

Untitled. 1946. Collage of pasted paper on corrugated cardboard, 9³/₄ x 8³/₈″ (24.6 x 21.1 cm). Mr. and Mrs. Douglas Auchincloss. 577.64.

SERPAN, Iaroslav.

BOBDUNC. Oil on canvas, 46 x 35″ (116.6 x 88.7 cm). Samuel I. Rosenman. 513.64.

SEURAT, Georges-Pierre.

THE CHANNEL AT GRAVELINES, EVENING. (1890) Oil on canvas, 25³/₄ x 32¹/₄″ (65.4 x 81.9 cm). William A. M. Burden (the donor and his wife retaining life interests). 785.63.

SHAHN, Ben.

JANITOR. (c. 1949) Tempera on cardboard, 20³/₈ x 30³/₈″ (51.7 x 77.1 cm). Dr. Meyer A. Pearlman. 578.64.

SOUTINE, Chaim.

CHARTRES CATHEDRAL. (1933) Oil on wood, 36 x 19³/₄″ (91.4 x 50 cm). Mrs. Lloyd Bruce Wescott. 514.64.

TANGUY, Yves, and BRETON, André.

Untitled. 1941. Notebook: nineteen pages with ten ink, gouache, collage, pencil, and chalk drawings on white and colored paper by Tanguy and poems by Breton, 11¹/₈ x 8⁵/₈″ (28 x 22 cm). Mrs. Yves Tanguy (Pierre Matisse retaining a life interest). 346.55.1a–23b.

TOBEY, Mark.

MICROCOSMS OF TIME. 1961. Tempera, 19³/₈ x 25¹/₈″ (49.2 x 63.6 cm). William A. Koshland. 580.64.

UTRILLO, Maurice.

FORT IN CORSICA. 1912. Oil on canvas, 25⁵/₈ x 19¹/₂″ (65 x 49.5 cm). Matthew H. and Erna Futter. 515.64.

SACRÉ COEUR. (c. 1916) Oil on canvas, 32 x 24″ (81.3 x 61 cm). Mr. and Mrs. Walter Hochschild. 786.63.

VALADON, Suzanne. French, 1867–1938.

PORTRAIT OF MME ZAMARON. 1922. Oil on canvas, 32¹/₈ x 25⁷/₈″ (81.5 x 65.6 cm). Mr. and Mrs. Maxime L. Hermanos. 581.64.

VLAMINCK, Maurice de.

AUTUMN LANDSCAPE. (c. 1905) Oil on canvas, 18¹/₄ x 21³/₄″ (46.2 x 55.2 cm). Nate B. and Frances Spingold. 80.58.

LANDSCAPE. (c. 1920?) Oil on canvas, 28⁵/₈ x 36¹/₄″ (72.6 x 92 cm). Mr. and Mrs. Walter Hochschild. 456.64.

VUILLARD, Édouard.

THE PARK. (1894) Distemper on canvas, 6′11¹/₂″ x 62³/₄″ (211.8 x 159.8 cm). Mr. and Mrs. William B. Jaffe. 600.59.

MISIA AND THADÉE NATANSON. (c. 1897) Oil on paper mounted on canvas, 36¹/₂ x 29¹/₄″ (92.7 x 74.2 cm). Nate B. and Frances Spingold. 270.57.

DONORS

Mr. and Mrs. Douglas Auchincloss
Samuel A. Berger
William A. M. Burden
Mr. and Mrs. Ralph F. Colin
Mrs. Herbert M. Dreyfus
Mr. and Mrs. William Feinberg
Matthew H. and Erna Futter
Mr. and Mrs. Maxime L. Hermanos
Mr. and Mrs. Walter Hochschild
Henry Ittleson, Jr.
Mr. and Mrs. William B. Jaffe
William A. Koshland
Mr. and Mrs. Samuel A. Marx
William S. Paley
Dr. Meyer A. Pearlman
Mr. and Mrs. Thomas Robins, Jr.
David Rockefeller
Mr. and Mrs. Francis F. Rosenbaum
Mr. and Mrs. Samuel I. Rosenman
David M. Solinger
Nate B. and Frances Spingold
Mrs. Yves Tanguy
William H. Weintraub
Mrs. Lloyd Bruce Wescott

Anonymous, in honor of Margaret Scolari Barr
Adele R. Levy Fund

PROMISED GIFTS

THE WORKS LISTED below have been committed to the Museum as future gifts or bequests. Only works promised before the end of June 1967 are included, thus omitting those that have since been promised and including some that have since been given. The entries below conform in most respects to those in the Catalog, with the exception that no parentheses are used here to distinguish undated works from those inscribed by the artist, and measurements in centimeters are not provided. Biographical information is given only for artists not listed elsewhere in the Catalog.

ARMAN.

COLLECTION. 1964. Assemblage: split toy automobiles and matchboxes embedded in polyester in a case, 16⁷/₈ x 27³/₄ x 2⁷/₈″. Mr. and Mrs. William N. Copley.

BOOM! BOOM! 1960. Assemblage: plastic water pistols in a plexiglass case, 8¹/₄ x 23¹/₄ x 4¹/₂″. Philip Johnson.

VALETUDINARIAN. 1960. Assemblage: pill bottles in painted wood box with glass top, 16 x 23³/₄ x 3¹/₈″. Philip Johnson.

ARP, Jean.

SQUARES ARRANGED ACCORDING TO THE LAW OF CHANCE. 1917. Collage of cut-and-pasted papers, gouache, ink, and bronze paint, 13¹/₈ x 10¹/₄″. Philip Johnson.

ARTSCHWAGER, Richard. American, born 1924.

TOWER. 1964. Painted formica and wood construction, 6′6¹/₈″ x 24¹/₈″ x 39¹/₈″. Philip Johnson.

BACON, Francis.

STUDY OF A BABOON. 1953. Oil on canvas, 6′6″ x 54″. James Thrall Soby.

STUDY FOR PORTRAIT, NUMBER IV. 1956. Oil on canvas, 24¹/₄ x 20″. James Thrall Soby.

BALTHUS.

THE STREET. 1933. Oil on canvas, 6′4″ x 7′10¹/₄″. James Thrall Soby.

THE LIVING ROOM. 1942. Oil on canvas, 45 x 57¹/₂″. Mr. and Mrs. John Hay Whitney.

BART, Robert. American, born Canada 1923. To U.S.A. 1928.

Untitled. 1964. Aluminum, 66¹/₂ x 28³/₄ x 28³/₄″. Philip Johnson.

BELL, Larry.

GLASS SCULPTURE NUMBER 10. 1964. Partially silvered glass with chromium frame, 10³/₈″ cube. Mr. and Mrs. William N. Copley.

BELLOWS, George.

POLO SCENE. 1910. Oil on canvas, 43⁵/₈ x 61⁷/₈″. Mr. and Mrs. John Hay Whitney.

BERMAN, Eugene.

THE CART. 1930. Oil on composition board, 45¹/₂ x 35¹/₂″. James Thrall Soby.

MEMORY OF ISCHIA. 1931. Oil on canvas, 38³/₄ x 31¹/₄″. James Thrall Soby.

BLUME, Peter.

KEY WEST BEACH. 1940. Oil on canvas, 12 x 18″. James Thrall Soby.

BOCCIONI, Umberto.

STATES OF MIND: THE FAREWELLS [*Stati d'animo: Gli addii*]. 1911. Oil on canvas, 27³/₄ x 37⁷/₈″. Nelson A. Rockefeller.

STATES OF MIND: THOSE WHO GO [*Stati d'animo: Quelli che vanno*]. 1911. Oil on canvas, 27⁷/₈ x 37³/₄″. Nelson A. Rockefeller.

STATES OF MIND: THOSE WHO STAY [*Stati d'animo: Quelli che restano*]. 1911. Oil on canvas, 27⁷/₈ x 37³/₄″. Nelson A. Rockefeller.

BONNARD, Pierre.

GRAPES. c. 1928. Oil on canvas, 16⁵/₈ x 18¹/₄″. James Thrall Soby.

BRAQUE, Georges.

THE TABLE. 1930. Oil and sand on canvas, 57⁵/₈ x 30³/₈″. Nelson A. Rockefeller.

BURY, Pol.

ERECTILE ENTITY (RED AND WHITE). 1962. Motor-driven construction of metal wires in wood panel, painted, 36 x 35³/₄ x 13¹/₂″. Philip Johnson.

BUTLER, Reg.

FIGURE IN SPACE. 1956. Bronze, c. 19″ long. James Thrall Soby.

CALDER, Alexander.

SWIZZLE STICKS. 1936. Hanging mobile: wire, wood, and lead against a plywood panel, 48 x 33″. James Thrall Soby.

Untitled. 1941. Watercolor, 22 x 30⁵/₈″. James Thrall Soby.

CHADWICK, Lynn.

STUDY FOR THE SECOND VERSION OF "THE SEASONS." 1957. Welded iron, plaster, and cement, 27¹/₂ x 13 x 16″. James Thrall Soby.

CHAMBERLAIN, John.

TOMAHAWK NOLAN. 1965. Welded and painted automobile parts, 43³/₄ x 52¹/₈ x 36¹/₄″. Philip Johnson.

DE CHIRICO, Giorgio.

GARE MONTPARNASSE (THE MELANCHOLY OF DEPARTURE). 1914. Oil on canvas, 55¹/₈″ x 6′5/₈″. James Thrall Soby.

THE SONG OF LOVE. 1914. Oil on canvas, 28³/₄ x 23¹/₂″. Nelson A. Rockefeller.

THE ENIGMA OF A DAY. 1914. Oil on canvas, 6′3/₄″ x 55¹/₂″. James Thrall Soby.

THE DUO. 1915. Oil on canvas, 32¹/₄ x 23¹/₄″. James Thrall Soby.

THE SEER. 1915. Oil on canvas, 35¹/₄ x 27³/₈″. James Thrall Soby.

THE AMUSEMENTS OF A YOUNG GIRL. 1916? Oil on canvas, 18¹/₂ x 15³/₄″. James Thrall Soby.

THE FAITHFUL SERVITOR. 1916 or 1917. Oil on canvas, 15¹/₈ x 13⁵/₈″. James Thrall Soby.

GRAND METAPHYSICAL INTERIOR. 1917. Oil on canvas, 37³/₄ x 27³/₄″. James Thrall Soby.

CONNER, Bruce.

CHILD. 1959–60. Wax figure with nylon, cloth, metal, and twine, in a high chair, 34⅝ x 17 x 16½". Philip Johnson.

COPLEY, William N.

THE COMMON MARKET. 1961. Oil on canvas, 31⅞ x 51¼". Philip Johnson.

CROSS, Henri Edmond.

GRAPE HARVEST. 1892. Oil on canvas, 37⅜ x 55¼". Mr. and Mrs. John Hay Whitney.

DALI, Salvador.

DEBRIS OF AN AUTOMOBILE GIVING BIRTH TO A BLIND HORSE BITING A TELEPHONE. 1938. Oil on canvas, 21¼ x 25½". James Thrall Soby.

DELAUNAY, Robert.

WINDOWS [Les Fenêtres simultanées]. 1912. Oil on canvas, 51" x 6'5". Mr. and Mrs. William A. M. Burden.

DEMUTH, Charles.

FEMALE ACROBATS. 1916. Watercolor, 12½ x 7½". James Thrall Soby.

DINE, Jim.

STILL LIFE PAINTING. 1962. Oil on canvas with twelve toothbrushes in plastic cup in metal holder, 35⅞ x 24¼ x 4¼". Philip Johnson.

DI SUVERO, Mark. American, born China 1933. To U.S.A. 1941.

Untitled. 1961–62. Wood, steel, joints, and chain, 6'3¼" x 13'10½" x 14". Philip Johnson.

DOMOTO, Hisao.

SOLUTION OF CONTINUITY, 24. 1964. Oil on canvas, 63⅝ x 51⅛". Mr. and Mrs. David Kluger.

DUBUFFET, Jean.

MY CART, MY GARDEN. 1955. Oil on canvas, 35 x 45¾". From the Carts, Gardens series. James Thrall Soby.

ERNST, Max.

ALICE IN 1941. 1941. Oil on canvas, 15¾ x 12½". James Thrall Soby.

FEELEY, Paul.

ALNIAM. 1964. Synthetic polymer paint on canvas, 59⅜ x 59⅜". Philip Johnson.

FLAVIN, Dan. American, born 1933.

PINK OUT OF A CORNER—TO JASPER JOHNS. 1963. Pink fluorescent light in metal fixture, 8' x 6" x 5⅜". Philip Johnson.

FONTANA, Lucio.

SPATIAL CONCEPT: EXPECTATIONS. 1960. Slashed canvas and gauze, unpainted, 39½ x 31⅝". Philip Johnson.

GIACOMETTI, Alberto.

TALL FIGURE. 1949. Painted bronze, 65⅝" high. James Thrall Soby.

COMPOSITION WITH THREE FIGURES AND A HEAD (THE SAND). 1950. Painted bronze, 22 x 21¾ x 16". Philip Johnson.

GORKY, Arshile.

DIARY OF A SEDUCER. 1945. Oil on canvas, 50 x 62". Mr. and Mrs. William A. M. Burden.

HAINS, Raymond. French, born 1926. Lives in Italy.

SAFFA SUPER MATCH BOX. 1964. Synthetic polymer paint on plywood, 45½ x 34¼ x 3". Philip Johnson.

HARTIGAN, Grace.

INTERIOR, "THE CREEKS." 1957. Oil on canvas, 7'6½" x 8'. Philip Johnson.

HEDRICK, Wally.

SPIRIT, 3. 1958. Oil on canvas, 69¾ x 52¾". Philip Johnson.

HITCHENS, Ivon. British, born 1893.

SUMMER WATER. 1957. Oil on canvas, 20¼ x 41½". John D. Preston.

HOFMANN, Hans.

SPRING. 1940. Oil on wood panel, 11¼ x 14⅛". Mr. and Mrs. Peter A. Rübel.

JOHNS, Jasper.

FLAG. 1954. Encaustic on newsprint on canvas, 42¼ x 60½". Philip Johnson.

JUDD, Donald. American, born 1928.

Untitled. 1967. Painted galvanized iron, 15" x 6'4½" x 25½". Philip Johnson.

KAHLO, Frida.

MY GRANDPARENTS, MY PARENTS, AND I. 1936. Oil and tempera on metal panel, 16¾ x 18⅝". Allan Roos, M.D., and B. Mathieu Roos.

KLEE, Paul.

THE END OF THE LAST ACT OF A DRAMA [Schluss des letzten Aktes eines Dramas]. 1920. Watercolor on transfer drawing, 8⅛ x 11⅜". Allan Roos, M.D., and B. Mathieu Roos.

FINAL SCENE OF A TRAGICOMEDY [Schlussbild einer Tragikomödie]. 1923. Watercolor and ink, 10¼ x 13¾". Philip Johnson.

THE SACRED ISLANDS [Heilige Inseln]. 1926. Watercolor and ink, 18½ x 12⅜". Philip Johnson.

GIFTS FOR I [Gaben für I]. 1928. Tempera on gesso on canvas on wood, 15¾ x 22". James Thrall Soby.

MASK OF FEAR [Maske Furcht]. 1932. Oil on burlap, 39½ x 22½". Allan Roos, M.D., and B. Mathieu Roos.

ERRAND BOY [Ausläufer]. 1934. Watercolor, 19¼ x 12⅜". James Thrall Soby.

FEAR [Angst]. 1934. Oil on burlap, 20 x 21⅞". Nelson A. Rockefeller.

HEROIC STROKES OF THE BOW [Heroische Bogenstriche]. 1938. Tempera on paper on cloth with gesso backing, 28¾ x 20⅞". Nelson A. Rockefeller.

KLEIN, Yves.

Untitled. 1957. Sponge, painted blue, 12½″ diameter, on brass stand. Philip Johnson.

KLINE, Franz.

WHITE FORMS. 1955. Oil on canvas, 6′2³/₈″ x 50¼″. Philip Johnson.

LASSAW, Ibram.

CLOUDS OF MAGELLAN. 1953. Welded brass and steel, polychromed, 52 x 70 x 18″. Philip Johnson.

LÉGER, Fernand.

WOMAN WITH A BOOK. 1923. Oil on canvas, 45½ x 32″. Nelson A. Rockefeller.

LEHMBRUCK, Wilhelm.

WOMAN'S HEAD. c. 1910. Cast stone, 16½″ high. James Thrall Soby.

TORSO. 1913–14. Cast stone, 36½″ high. James Thrall Soby.

LEONID.

THE FISHERWOMAN. 1930. Oil on wood, 11¼ x 9¼″. James Thrall Soby.

MUSSEL GATHERERS AT HIGH TIDE. 1937. Oil on canvas, 21¼ x 32″. James Thrall Soby.

LEWITIN, Landès.

KNOCKOUT. 1955–59. Oil and ground glass on composition board, 23⁷/₈ x 17⁷/₈″. Royal S. Marks.

LICHTENSTEIN, Roy.

GIRL WITH BALL. 1961. Oil on canvas, 60½ x 36¼″. Philip Johnson.

LIPCHITZ, Jacques.

RECLINING NUDE WITH GUITAR. 1928. Black limestone, 16³/₈ x 27⁵/₈ x 13½″. Mrs. John D. Rockefeller 3rd.

LÓPEZ GARCÍA, Antonio.

LOS NOVIOS. 1964. Oil on wood relief, 32½ x 32³/₄ x 9″. Mrs. Emily A. Staempfli.

MacIVER, Loren.

TREE. 1945. Oil on canvas, 40 x 25⁷/₈″. James Thrall Soby.

SKYLIGHT. 1948. Oil on canvas, 40¼ x 48¼″. James Thrall Soby.

MAILLOL, Aristide.

WOMAN ARRANGING HER HAIR. c. 1898. Bronze, 10³/₄″ high. James Thrall Soby.

LEDA. c. 1902. Bronze, 11¼″ high. James Thrall Soby.

MARINI, Marino.

THE HORSEMAN. 1946–47. Bronze, 34½″ high. James Thrall Soby.

HORSE AND RIDER. 1947. Bronze, 64″ high, including bronze base 29 x 16³/₄ x 4″ high. Mrs. John D. Rockefeller 3rd.

DANCER. 1948. Bronze (cast 1949), 69½″ high. James Thrall Soby.

MASSON, André.

FIGURE. 1921. Oil and sand on canvas, 18 x 10½″. William S. Rubin.

MATISSE, Henri.

STUDY FOR "LUXE, CALME ET VOLUPTÉ." 1904. Oil on canvas, 15 x 21½″. Mr. and Mrs. John Hay Whitney.

STILL LIFE WITH EGGPLANTS. 1911. Oil on canvas, 45³/₄ x 35¹/₈″. Mrs. Bertram Smith.

MATTA.

THE DISASTERS OF MYSTICISM. 1942. Oil on canvas, 38¼ x 51³/₈″. James Thrall Soby.

HERE SIR FIRE, EAT! 1942. Oil on canvas, 56 x 44″. James Thrall Soby.

MESSAGIER, Jean.

JUNE CROSSING [*Traversée de juin*]. 1956. Oil on canvas, 58⁷/₈ x 6′4³/₈″. Mr. and Mrs. David Kluger.

MIRÓ, Joan.

PORTRAIT OF MISTRESS MILLS IN 1750. 1929. Oil on canvas, 45½ x 35″. James Thrall Soby.

COLLAGE. 1934. Collage on sandpaper, 14⁵/₈ x 9³/₈″. James Thrall Soby.

STILL LIFE WITH OLD SHOE. 1937. Oil on canvas, 32 x 46″. James Thrall Soby.

SELF-PORTRAIT, I. 1937–38. Pencil, crayon, and oil on canvas, 57½ x 38¼″. James Thrall Soby.

MOHOLY-NAGY, László.

EM 2 (TELEPHONE PICTURE). 1922. Porcelain enamel on steel, 18³/₄ x 11⁷/₈″. Philip Johnson.

EM 3 (TELEPHONE PICTURE). 1922. Porcelain enamel on steel, 9½ x 6″. Philip Johnson.

MONET, Claude.

CORONA (WATER LILIES). c. 1920. Oil on canvas, 71″ x 6′6³/₄″. Mr. and Mrs. William A. M. Burden.

MORANDI, Giorgio.

STILL LIFE. 1949. Oil on canvas, 13½ x 17″. James Thrall Soby.

MORRIS, Robert. American, born 1931.

DOCUMENT. 1963. Two parts: typed and notarized statement on paper, and metallic powder in synthetic polymer in imitation leather mat, 17⁵/₈ x 23³/₄″. Philip Johnson. *Note:* related to *Litanies,* below, it contains a relief of the key ring and a statement withdrawing "all esthetic quality and content" from that construction.

LITANIES. 1963. Lead on wood, steel ring with twenty-seven keys, brass lock, 12 x 7¹/₈ x 2½″. Philip Johnson.

MAGNIFIED AND REDUCED INCHES. 1963. Lead and metallic powder in synthetic polymer on wood, 4⁷/₈ x 11¼ x ⁵/₈″. Philip Johnson.

ROPE PIECE. 1964. Rope with two wood bases, painted, 18′3″ long. Philip Johnson.

NADELMAN, Elie.

TWO CIRCUS WOMEN. c. 1930. Papier mâché, 62″ high, at base 28³/₄ x 17½″. Philip Johnson.

NEVELSON, Louise.

BIG BLACK. 1964. Wood, painted black, 9'4" x 10'1" x 12". Mr. and Mrs. Albert A. List.

NEWMAN, Barnett.

THE WILD. 1950. Oil on canvas, 7'11¾" x 1⅝". The Kulicke Family.

OLDENBURG, Claes.

BANANA SPLIT. 1963. Painted plaster, glass, and metal, 10 x 8 x 7". Philip Johnson.

PICASSO, Pablo.

SELF-PORTRAIT. 1901. Oil on cardboard mounted on wood, 20¼ x 12¼". Mr. and Mrs. John Hay Whitney.

TWO ACROBATS WITH A DOG. 1905. Gouache on cardboard, 41½ x 29½". Mr. and Mrs. William A. M. Burden.

GIRL WITH A MANDOLIN (FANNY TELLIER). 1910. Oil on canvas, 39½ x 29". Nelson A. Rockefeller.

STILL LIFE: LE TORERO. 1911. Oil on canvas, 18¼ x 15⅛". Nelson A. Rockefeller.

GUITAR. 1913. Pasted papers, charcoal, crayon, and ink on blue paper, 26⅛ x 19½". Nelson A. Rockefeller.

STILL LIFE: "JOB." 1916. Oil and sand on canvas, 17 x 13¼". Nelson A. Rockefeller.

NUDE SEATED ON A ROCK. 1921. Oil on wood, 6¼ x 4⅜". James Thrall Soby.

THE SIGH. 1923. Oil and charcoal on canvas, 23¾ x 19¾". James Thrall Soby.

INTERIOR WITH A GIRL DRAWING. 1935. Oil on canvas, 51⅛" x 6'4⅝". Nelson A. Rockefeller.

STILL LIFE WITH RED BULL'S HEAD. 1938. Oil and enamel on canvas, 38⅛ x 51". Mr. and Mrs. William A. M. Burden.

WOMAN DRESSING HER HAIR. 1940. Oil on canvas, 51¼ x 38¼". Mrs. Bertram Smith.

THE STRIPED BODICE. 1943. Oil on canvas, 39⅜ x 32⅛". Nelson A. Rockefeller.

MIRROR AND CHERRIES (THE MIRROR). 1947. Oil on canvas, 24 x 19⅝". Mr. and Mrs. William A. M. Burden.

POONS, Larry.

EAST INDIA JACK. 1964. Synthetic polymer paint on canvas, 6 x 12'. Philip Johnson.

PORTER, Fairfield.

SCHWENK. 1959. Oil on canvas, 22⅝ x 31". Arthur M. Bullowa.

RAUSCHENBERG, Robert.

FIRST LANDING JUMP. 1961. "Combine-painting": tire, khaki shirt, license plate, leather straps, mirror, iron street-light reflector, live blue light bulb, electric cable, steel spring, tin cans, various pieces of cloth, and oil paint on composition board, 7'5⅛" x 6' x 8⅞". Philip Johnson.

RENOIR, Auguste.

LE MOULIN DE LA GALETTE. 1876. Oil on canvas, 31⅞ x 44⅝". Mr. and Mrs. John Hay Whitney.

RILEY, Bridget.

FISSION. 1963. Tempera on composition board, 35 x 34". Philip Johnson.

ROTHKO, Mark.

YELLOW AND GOLD. 1956. Oil on canvas, 67⅛ x 62¾". Philip Johnson.

SAGE, Kay.

WATCHING THE CLOCK. 1958. Oil on canvas, 14 x 14". James Thrall Soby.

SAMARAS, Lucas.

BOOK 4. 1962. Assemblage: partly opened book with pins, razor blade, scissors, table knife, metal foil, piece of glass, and plastic rod, 5½ x 8⅞ x 11½". Philip Johnson.

SHAHN, Ben.

LIBERATION. 1945. Tempera on composition board, 29¾ x 39¾". James Thrall Soby.

SIGNAC, Paul.

FISHING BOATS AT SUNSET. 1891. Oil on canvas, 25⅝ x 32". Mr. and Mrs. John Hay Whitney.

SMITH, David.

AUSTRALIA. 1951. Painted steel, 8'1½" x 9' x 16⅛". William S. Rubin.

SOMAINI, Francesco.

SANGUINARY MARTYRDOM [*Grande martirio sanguinante*]. 1960. Cast iron, 52⅛ x 26⅛". Philip Johnson.

STANKIEWICZ, Richard.

URCHIN IN THE GRASS. 1956. Iron and steel, 23⅝ x 16½ x 13". Philip Johnson.

STELLA, Frank.

AVERROES. 1960. Aluminum paint on canvas, 6 x 6'. Philip Johnson.

ITATA. 1964. Metallic powder in synthetic polymer emulsion on canvas, 6'4½" x 11'2". Philip Johnson.

SUTHERLAND, Graham.

THORN HEAD. 1945. Chalk, ink, and gouache, 22 x 21". James Thrall Soby.

TAEUBER-ARP, Sophie. Swiss, 1889–1943. To France 1928.

SCHEMATIC COMPOSITION. 1933. Oil and wood on composition board, 35⅜ x 49¼". Silvia Pizitz.

TANGUY, Yves.

THE MOOD OF NOW [*L'Humeur des temps*]. 1928. Oil on canvas, 39⅜ x 28⅞". James Thrall Soby.

THE FURNITURE OF TIME [*Le Temps meublé*]. 1939. Oil on canvas, 45¾ x 35". James Thrall Soby.

Untitled. 1947. Gouache, 13⅛ x 9½". James Thrall Soby.

TCHELITCHEW, Pavel.

BLUE CLOWN. 1929. Oil on canvas, 31¾ x 23⅝". James Thrall Soby.

MADAME BONJEAN. 1931. Oil on canvas, 51¼ x 38¼″. James Thrall Soby.

CABBAGE HEAD. 1939. Gouache and ink, 16⅝ x 12¾″. James Thrall Soby.

TOULOUSE-LAUTREC, Henri de.

"CHILPERIC." 1895. Oil on canvas, 59⅛ x 59⅛″. Mr. and Mrs. John Hay Whitney.

VUILLARD, Édouard.

ALFRED NATANSON AND HIS WIFE. 1900. Oil on wood, 21¼ x 26½″. Frances Spingold.

DONORS

Arthur M. Bullowa
Mr. and Mrs. William A. M. Burden
Mr. and Mrs. William N. Copley
Philip Johnson
Mr. and Mrs. David Kluger
The Kulicke Family
Mr. and Mrs. Albert A. List
Royal S. Marks
Silvia Pizitz
John D. Preston
Mrs. John D. Rockefeller 3rd
Nelson A. Rockefeller
Allan Roos, M.D., and B. Mathieu Roos
Mr. and Mrs. Peter A. Rübel
William S. Rubin
Mrs. Bertram Smith
James Thrall Soby
Frances Spingold
Mrs. Emily A. Staempfli
Mr. and Mrs. John Hay Whitney

MUSEUM PUBLICATIONS CITED IN THE CATALOG

THE CATALOG contains abbreviated references to Museum of Modern Art publications in which works are reproduced. A key to those abbreviations follows, arranged chronologically for earlier editions of *Painting and Sculpture in The Museum of Modern Art* and its supplements, and alphabetically for all other publications. Although the Catalog listing is limited to works acquired through June 1967, later publications have been cited.

Ptg. & Sc. (I) Painting and Sculpture in The Museum of Modern Art. Edited by Alfred H. Barr, Jr. 1942.

Ptg. & Sc. (I) Suppl. Painting and Sculpture in The Museum of Modern Art, Supplementary List. 1945.

Ptg. & Sc. Painting and Sculpture in The Museum of Modern Art. Edited by Alfred H. Barr, Jr. 1948.

Suppl. I The Museum of Modern Art Bulletin: vol. 17, nos. 2–3, 1950.

Suppl. II The Museum of Modern Art Bulletin: vol. 18, no. 2, Winter 1950–51.

Suppl. III The Museum of Modern Art Bulletin: vol. 19, no. 3, Spring 1952.

Suppl. IV The Museum of Modern Art Bulletin: vol. 20, nos. 3–4, Summer 1953.

Suppl. V The Museum of Modern Art Bulletin: vol. 23, no. 3, 1956.

Suppl. VI The Museum of Modern Art Bulletin: vol. 24, no. 4, 1957.

Suppl. VII The Museum of Modern Art Bulletin: vol. 25, no. 4, July 1958.

Suppl. VIII The Museum of Modern Art Bulletin: vol. 26, no. 4, July 1959.

Suppl. IX The Museum of Modern Art Bulletin: vol. 27, nos. 3–4, 1960.

Suppl. X The Museum of Modern Art Bulletin: vol. 28, nos. 2–4, 1961.

Suppl. XI The Museum of Modern Art Bulletin: vol. 29, nos. 2–3, 1962.

Suppl. XII The Museum of Modern Art Bulletin: vol. 30, nos. 2–3, 1963.

Masters Masters of Modern Art. Edited by Alfred H. Barr, Jr. 1954.

Abstract Ptg. & Sc. Abstract Painting and Sculpture in America. By Andrew Carnduff Ritchie. 1951.

Amer. 1942 Americans 1942: 18 Artists from 9 States. Edited by Dorothy C. Miller. 1942.

Amer. 1963 Americans 1963. Edited by Dorothy C. Miller. 1963.

Amer. Ptg. & Sc. American Painting and Sculpture: 1862–1932. By Holger Cahill. 1932.

Amer. Realists American Realists and Magic Realists. Edited by Dorothy C. Miller and Alfred H. Barr, Jr. 1943.

Archipenko Archipenko: The Parisian Years. By William S. Lieberman and Katharine Kuh. 1970.

Arp Arp. Edited by James Thrall Soby. 1958.

Art in Our Time Art in Our Time: An Exhibition to Celebrate the Tenth Anniversary of The Museum of Modern Art and the Opening of Its New Building. 1939.

Art in Prog. Art in Progress: A Survey Prepared for the Fifteenth Anniversary of The Museum of Modern Art. 1944.

Art Israel Art Israel: 26 Painters and Sculptors. By William C. Seitz. 1964.

Art Nouveau Art Nouveau: Art and Design at the Turn of the Century. Edited by Peter Selz and Mildred Constantine. 1959. Reissued 1975.

Art of the Real The Art of the Real: U.S.A. 1948–1968. By E. C. Goossen. 1968.

Assemblage The Art of Assemblage. By William C. Seitz. 1961.

Balthus Balthus. By James Thrall Soby. 1956.

Beckmann Max Beckmann. By Peter Selz. 1964.

Bliss, 1934 The Lillie P. Bliss Collection. 1934.

Bonnard (1948) Pierre Bonnard. By John Rewald. 1948. Published by

The Museum of Modern Art in collaboration with the Cleveland Museum of Art.

Bonnard Bonnard and His Environment. Texts by James Thrall Soby, James Elliott, and Monroe Wheeler. 1964.

Braque Georges Braque. By Henry R. Hope. 1949.

Bulletin The Bulletin of The Museum of Modern Art.

Bulletin, Fall 1958 Two Exhibitions—Works of Art: Given or Promised; The Philip L. Goodwin Collection. The Museum of Modern Art Bulletin: vol. 26, no. 1, Fall 1958.

Burchfield Charles Burchfield: Early Watercolors. 1930.

Calder (2nd) Alexander Calder. By James Johnson Sweeney. 1951. 2nd edition, revised.

Chagall Marc Chagall. By James Johnson Sweeney. 1946.

de Chirico Giorgio de Chirico. By James Thrall Soby. 1955.

Contemp. Ptrs. Contemporary Painters. By James Thrall Soby. 1948.

Cubism Cubism and Abstract Art. By Alfred H. Barr, Jr. 1936. Reissued 1974.

Dada, Surrealism Dada, Surrealism, and Their Heritage. By William S. Rubin. 1968.

Dali (2nd) Salvador Dali. By James Thrall Soby. 1946. 2nd edition, revised.

Davis Stuart Davis. By James Johnson Sweeney. 1945.

Demuth Charles Demuth. By Andrew Carnduff Ritchie. 1950.

Dubuffet The Work of Jean Dubuffet. By Peter Selz. 1962.

Ernst Max Ernst. Edited by William S. Lieberman. 1961.

Fantastic Art (3rd) Fantastic Art, Dada, Surrealism. Edited by Alfred H. Barr, Jr. 1947. 3rd edition.

Feininger-Hartley Lyonel Feininger, Marsden Hartley. 1944.

Feininger-Ruin Lyonel Feininger: The Ruin by the Sea. Introduction by Eila Kokkinen, edited by William S. Lieberman. 1968.

15 Amer. 15 Americans. Edited by Dorothy C. Miller. 1952.

15 Polish Ptrs. 15 Polish Painters. By Peter Selz. 1961.

Figure U.S.A. Recent Painting U.S.A.: The Figure. Introduction by Alfred H. Barr, Jr. 1962.

Flannagan The Sculpture of John B. Flannagan. Edited by Dorothy C. Miller. 1942.

Four Amer. in Paris Four Americans in Paris: The Collections of Gertrude Stein and Her Family. 1970.

14 Amer. Fourteen Americans. Edited by Dorothy C. Miller. 1946.

Futurism Futurism. By Joshua C. Taylor. 1961.

German Art of 20th C. German Art of the Twentieth Century. By Werner Haftmann, Alfred Hentzen, and William S. Lieberman; edited by Andrew Carnduff Ritchie. 1957.

Giacometti Alberto Giacometti. By Peter Selz. 1965.

Gonzalez Julio Gonzalez. Introduction by Andrew Carnduff Ritchie. The Museum of Modern Art Bulletin: vol. 23, nos. 1–2, 1955–56.

Gorky Arshile Gorky: Paintings, Drawings, Studies. By William C. Seitz. 1962.

Gris Juan Gris. By James Thrall Soby. 1958.

Hofmann Hans Hofmann. By William C. Seitz. 1963.

Hopper Edward Hopper. By Alfred H. Barr, Jr. 1933.

Hunt The Sculpture of Richard Hunt. By William S. Lieberman and Carolyn Lanchner. 1971.

Impress. (4th) The History of Impressionism. By John Rewald. 1973. 4th, revised edition.

Indian Art (2nd) Indian Art of the United States. By Frederic H. Douglas and René d'Harnoncourt. 1949. 2nd edition.

Invitation An Invitation to See 125 Paintings from The Museum of Modern Art. By Helen M. Franc. 1973.

Janis Three Generations of Twentieth-Century Art: The Sidney and Harriet Janis Collection of The Museum of Modern Art. 1972.

Klee, 1930 Paul Klee. By Alfred H. Barr, Jr. 1930.

Klee, 1945 Paul Klee. By Alfred H. Barr, Jr., James Johnson Sweeney, Julia and Lyonel Feininger. 1945. 2nd edition.

de Kooning Willem de Kooning. By Thomas B. Hess. 1968.

Lachaise Gaston Lachaise. By Lincoln Kirstein. 1935.

Last Wks. of Matisse The Last Works of Henri Matisse: Large Cut Gouaches. By Monroe Wheeler. 1961.

Latin-Amer. Coll. The Latin-American Collection of The Museum of Modern Art. By Lincoln Kirstein. 1943.

Léger. Léger. By Katharine Kuh. 1953. Published by the Art Institute of Chicago in collaboration with The Museum of Modern Art and the San Francisco Museum of Art.

Lehmbruck & Maillol Lehmbruck and Maillol. 1930.

Lettering Lettering by Modern Artists. By Mildred Constantine. 1964.

Levy Collection The Mrs. Adele R. Levy Collection: A Memorial Exhibition. Prefaces by Blanchette H. Rockefeller, Alfred M. Frankfurter, and Alfred H. Barr, Jr. 1961.

Lipchitz The Sculpture of Jacques Lipchitz. By Henry R. Hope. 1954.

Living Amer. Painting and Sculpture by Living Americans. Foreword by Alfred H. Barr, Jr. 1930.

The Machine The Machine as Seen at the End of the Mechanical Age. By K. G. Pontus Hultén. 1968.

Magritte René Magritte. By James Thrall Soby. 1965.

Masters Brit. Ptg. Masters of British Painting: 1800–1950. By Andrew Carnduff Ritchie. 1956.

Masters Pop. Ptg. Masters of Popular Painting: Modern Primitives of Europe and America. Text by Holger Cahill et al. 1938.

Matisse Matisse: His Art and His Public. By Alfred H. Barr, Jr. 1951. Reissued 1974.

Matta Matta. By William Rubin. The Museum of Modern Art Bulletin: vol. 25, no. 1, 1957.

Miró Joan Miró. By James Thrall Soby. 1959.

Miró (1973) Miró in the Collection of The Museum of Modern Art. By William Rubin. 1973.

Mod. Art in Your Life Modern Art in Your Life. By Robert Goldwater in collaboration with René d'Harnoncourt. 1953. 2nd edition.

Modern Drwgs. (1st) Modern Drawings. Edited by Monroe Wheeler. 1944. 1st edition.

Modern Works Modern Works of Art. By Alfred H. Barr, Jr. 1934.

Modigliani (3rd) Modigliani: Paintings, Drawings, Sculpture. By James Thrall Soby. 1963. 3rd edition, revised.

Mondrian Mondrian. By James Johnson Sweeney. 1948.

Monet Claude Monet: Seasons and Moments. By William C. Seitz. 1960.

Moore Henry Moore. By James Johnson Sweeney. 1946.

Motherwell Robert Motherwell. By Frank O'Hara. 1965.

Nadelman The Sculpture of Elie Nadelman. By Lincoln Kirstein. 1948.

Nakian Nakian. By Frank O'Hara. 1966.

New Amer. Ptg. The New American Painting: As Shown in Eight European Countries, 1958–1959. 1959.

New Decade The New Decade: 22 European Painters and Sculptors. Edited by Andrew Carnduff Ritchie. 1955.

New Horizons New Horizons in American Art. Introduction by Holger Cahill. 1936.

New Images New Images of Man. By Peter Selz. 1959.

New Jap. Ptg. & Sc. The New Japanese Painting and Sculpture. Selected by Dorothy C. Miller and William S. Lieberman. 1966.

New Spanish Ptg. & Sc. New Spanish Painting and Sculpture. By Frank O'Hara. 1960.

Newman Barnett Newman. By Thomas B. Hess. 1971.

Nolde Emil Nolde. By Peter Selz. 1963.

Object Transformed The Object Transformed. By Mildred Constantine and Arthur Drexler. 1966.

Oldenburg Claes Oldenburg. By Barbara Rose. 1970.

Paintings from MoMA Paintings from The Museum of Modern Art, New York. Edited by Alfred H. Barr, Jr. 1963.

Picasso 50 (3rd) Picasso: Fifty Years of His Art. By Alfred H. Barr, Jr. 1955. 3rd edition. Reissued 1974.

Picasso 75th Anniv. Picasso: 75th Anniversary Exhibition. Edited by Alfred H. Barr, Jr. 1957.

Picasso in MoMA Picasso in the Collection of The Museum of Modern Art. By William Rubin. 1972.

La Pintura La Pintura Contemporánea Norteamericana. 1941.

Pollock Jackson Pollock. By Sam Hunter. The Museum of Modern Art Bulletin: vol. 24, no. 2, 1956–57.

Pollock, 1967 Jackson Pollock. By Francis V. O'Connor. 1967.

Post-Impress. (2nd) Post-Impressionism: From van Gogh to Gauguin. By John Rewald. 1962. 2nd edition.

Private Colls. Paintings from Private Collections. The Museum of Modern Art Bulletin: vol. 22, no. 4, Summer 1955.

Ptg. in Paris Painting in Paris. Foreword by Alfred H. Barr, Jr. 1930.

Recent Sc. U.S.A. Recent Sculpture U.S.A. By James Thrall Soby. The Museum of Modern Art Bulletin: vol. 26, no. 3, Spring 1959.

Redon Odilon Redon, Gustave Moreau, Rodolphe Bresdin. By John Rewald, Harold Joachim, and Dore Ashton. 1961.

Responsive Eye The Responsive Eye. By William C. Seitz. 1965.

Rivera Diego Rivera. Introduction by Frances Flynn Paine, notes by Jere Abbott. 1931.

Rodin Rodin. By Albert E. Elsen. 1963.

Romantic Ptg. Romantic Painting in America. By James Thrall Soby and Dorothy C. Miller. 1943.

Rosso Medardo Rosso. By Margaret Scolari Barr. 1963.

Rothko Mark Rothko. By Peter Selz. 1961.

Rouault (3rd) Georges Rouault: Paintings and Prints. By James Thrall Soby. 1947. 3rd edition.

Rousseau (2nd) Henri Rousseau. By Daniel Catton Rich. 1946. 2nd edition.

Salute to Calder A Salute to Alexander Calder. By Bernice Rose. 1969.

School of Paris The School of Paris: Paintings from the Florene May Schoenborn and Samuel A. Marx Collection. Preface by Alfred H. Barr, Jr., introduction by James Thrall Soby, notes by Lucy R. Lippard. 1965.

Sc. of Matisse The Sculpture of Matisse. By Alicia Legg. 1972.

Sc. of Picasso The Sculpture of Picasso. By Roland Penrose. 1967.

Sc. of 20th C. Sculpture of the Twentieth Century. By Andrew Carnduff Ritchie. 1952.

Seurat Seurat Paintings and Drawings. Edited by Daniel Catton Rich. 1958. Published by the Art Institute of Chicago for an exhibition at the Art Institute and The Museum of Modern Art.

Shahn Ben Shahn. By James Thrall Soby. 1947.

16 Amer. Sixteen Americans. Edited by Dorothy C. Miller. 1959.

Smith David Smith. By Sam Hunter. The Museum of Modern Art Bulletin: vol. 25, no. 2, 1957.

Soby Collection The James Thrall Soby Collection. 1961.

Stella Frank Stella. By William S. Rubin. 1970.

Stettheimer Florine Stettheimer. By Henry McBride. 1946.

de Stijl de Stijl. By Alfred H. Barr, Jr. The Museum of Modern Art Bulletin: vol. 20, no. 2, Winter 1952–53.

Tanguy Yves Tanguy. By James Thrall Soby. 1955.

Tchelitchew Tchelitchew: Paintings and Drawings. By James Thrall Soby. 1942.

Tobey Mark Tobey. By William C. Seitz. 1962.

Toulouse-Lautrec Toulouse-Lautrec. 1956.

12 Amer. 12 Americans. Edited by Dorothy C. Miller. 1956.

20th-C. Italian Art Twentieth-Century Italian Art. By James Thrall Soby and Alfred H. Barr, Jr. 1949.

20th C. Portraits 20th Century Portraits. By Monroe Wheeler. 1942.

Vuillard Edouard Vuillard. By Andrew Carnduff Ritchie. 1954.

Weber Max Weber. 1930.

What Is Mod. Ptg. (9th) What Is Modern Painting? By Alfred H. Barr, Jr. 1966. 9th edition, revised. Reissued 1976.

What Is Mod. Sc. What Is Modern Sculpture? By Robert Goldwater. 1969.

INDEX OF ARTISTS BY NATIONALITY

In this list, the artist's name is given in roman type under the country of citizenship. If an artist was born or was active or resident for a significant period of time in another country or countries, his name is also listed under those other countries, but in italics. An asterisk preceding a name indicates that it is listed under more than one country. For example, Alexander Archipenko, an American born in the Ukraine, worked in Paris from 1908 to 1921, and came to the U.S.A. in 1923. He is listed as follows:

FRANCE AND SCHOOL OF PARIS: *Archipenko
UKRAINE: *Archipenko
U.S.A.: *Archipenko

ALGERIA: *Atlan

ARGENTINA: Badi, Basaldúa, Benedit, *Bonevardi, H. Butler, *Fernández-Muro, *Fontana, Forner, Gerstein, Guido, *Le Parc, MacEntyre, Magariños, Martínez, Ocampo, Pacenza, *Paternosto, *Pettoruti, Polesello, *Segui, Squirru, Wells

ARMENIA: *Gorky, *Hague

AUSTRALIA: Constable, French, Nagwaraba, Nolan, Purves-Smith, Tucker

AUSTRIA: *Bayer, *Durchanek, *Fischer, *Gross, *Kiesler, Klimt, *Koerner, *Kokoschka, Kubin, *Mopp, *Paalen, Schiele, Wotruba

BELGIUM: *Alechinsky, *Bury, Delvaux, Ensor, *Gentils, van Hoeydonck, Jespers, Landuyt, Magritte, Minne, van Rogger, *Ubac, *Vantongerloo

BOLIVIA: *Berdecio

BRAZIL: Burle Marx, *Cardoso Junior, Carvalho, Dos Prazeres, *Fahlström, Guignard, *Krajcberg, Magalhães, *Maria, Nicolao, Pancetti, Portinari, Scliar, *Vieira da Silva

BULGARIA: *Pascin

CANADA: *Bladen, *Borduas, *Clerk, Colville, Comtois, Coughtry, *Etrog, Kurelek, McEwen, *A. Martin, Milne, Molinari, *Murch, Nakamura, *Prendergast, *Riopelle, *Ronald, Town, Urquhart, J. & F. Wallace, *Zammitt

CHILE: *Carreño, Herrera Guevara, *Matta, Roa, Vargas, *Zañartu

CHINA: Chang Dai-Chien

COLOMBIA: Ariza, *Botero, Negret, *Obregón, Ramírez-Villamizar

CUBA: C. Bermúdez, J. Bermúdez, *Carreño, *Darié, Enríquez, *Fernández, *Lam, Mariano, Martínez Pedro, Milián, *Moreno, Orlando, *Pascin, Peláez, Ponce de León, Portocarrero, Ramos Blanco

CZECHOSLOVAKIA: *R. Bouché, *Durchanek, *Kokoschka, *Kupka, *Reder, *Serpan

DENMARK: *Hoyer, *Jensen, *Kraa, *Merrild, *Nolde, Ortvad, Pedersen, *Sørensen, *Wilfred

ECUADOR: *Egas, Guayasamin, Paredes

EGYPT: *Lewitin

EIRE: See Ireland

ESTONIA: *Harkavy

ETHIOPIA: Skunder

FRANCE AND SCHOOL OF PARIS: *Agam, *Alechinsky, *Appel, *Archipenko, *Arman, *Arp, *Atlan, Balthus, B. Baschet, F. Baschet, Bauchant, Bazaine, *Bellmer, Bérard, *Berman, Bernard, *Berrocal, Bissière, *Blatas, Bombois, Bonnard, *Borduas, *Borès, *R. Bouché, Bourdelle, *Bourgeois, *Brancusi, Braque, *Brauner, Breton, Brô, Buffet, *Bury, *Calder, *Callery, *Campigli, Carrière, César, Cézanne, *Chagall, *Charlot, *de Chirico, Cross, *Cruz-Diez, *Dali, *Damian, Degas, Delaunay, *Delaunay-Terk, Denis, Derain, Despiau, Desvallières, Dmitrienko, *Dominguez, *Domoto, *Donati, *van Dongen, *Dorcély, Dubuffet, *Duchamp, Duchamp-Villon, Dufy, *M. Ernst, Ève, *Fangor, Fautrier, *Fernández, *Francis, Friesz, *Gabo, *Gargallo, *Gaudier-Brzeska, Gauguin, *Alberto Giacometti, Gilioli, Gleizes, *van Gogh, *Gontcharova, *Gonzalez, *Gris, *Gysin, *Hajdu, *Hartung, *Hayden, *Hayter, Hélion, Herbin, *Hosiasson, Ipousteguy, Jacob, *Kalinowski, *Kandinsky, *Kemeny, Klein, *Krohg, *Kupka, *Lachaise, La Fresnaye, *Lam, *Lanskoy, Larche, *Larionov, Laurencin, Laurens, *Laurent, *Lebenstein, *Le Corbusier, Le Fauconnier, *Léger, *Leonid, *Le Parc, *Levee, *Lewitin, *Lipchitz, Lurçat, *Macdonald-Wright, Maillol, Manessier, *Manolo, *Man Ray, Marchand, *Marcoussis, *Marin, *Marisol, *Masson, Mathieu, Matisse, *Matta, Mauny, Messagier, Metzinger, *Miró, *Model, *Modigliani, *Mondrian, Monet, *R. Müller, *Nadelman, *O'Conor, *Otero, Oudot, Ozenfant, *Paalen, *Pascin, Petitjean, *Pettoruti, *Pevsner, Peyronnet, Picabia, *Picasso, Pignon, *Polak, *Poliakoff, Pompon, Prévert, *Prinner, *Reder, Redon, Renoir, Ribemont-Dessaignes, Richier, *Riopelle, Rodin, *Rodríguez-Larrain, *Rosso, Rouault, Rousseau, Roy, *Schneider, *Schöffer, Segonzac, *Segui, *Seligmann, *Serpan, Seurat, *Severini, Signac, *Sørensen, *Soto, Soulages, *Soutine, *de Staël, *Sugaï, *Survage, *Takis, Tal Coat, *Tamayo, *Tanguy, *Tchelitchew, *Tinguely, *Torres-García, Toulouse-Lautrec, *Ubac, Utrillo, *Vail, Valtat, *Vantongerloo, *Vasarely, *Vieira da Silva, Villon, Vivin, Vlaminck, Vuillard, *Wols, Yvaral, *Zadkine, *Zañartu, *Zenderoudi

GERMANY: *Adler, *Albers, *Alcopley, *Ardon, *Barker, Barlach, *Bauermeister, Baumeister, *Beckmann, *Belling, *Bellmer, *Bissier, Buchholz, *Campendonk, Corinth, Dix, Droste, Eberz, *J. Ernst, *M. Ernst, *Fangor, *L. Feininger, *T. L. Feininger, *Fiene, *Freud, *Gabo, *Gego, *Grosz, Haese, *Hartung, Heckel, Heiliger, Höch, Hofer, *Hofmann, *Isenburger, *Jawlensky, *Kahn, *Kalinowski, *Kandinsky, Kirchner, *Klee, Koenig, *Kokoschka, Kolbe, *Kraa, Kricke, Lehmbruck, Lenk, *Lindner, *Lissitzky, Mack, Macke, *Malevich, Marc, Marcks, Mataré, *Moholy-Nagy, O. Mueller, *J. Müller, *Nolde, Oelze, *Oppenheim, *Pascin, Pechstein, *Péri, Piene, Quinte, *Roesch, Rohlfs, Schlemmer, *Schmid, Schmidt-Rottluff, Schmithals, *Schwitters, Sintenis, Uecker, *Urban, *Vollmer, Werner, Winter, *Wojciechowsky, *Wols, Zehringer, *Zerbe

GREAT BRITAIN: *Adler, Adzak, *Al-Kazi, Armitage, Bacon, *Barnes, *Bianco, Blow, Bratby, Burra, R. Butler, Chadwick, B. Cohen, Colquhoun, Dalwood, Davie, Denny, *Epstein, Eurich, *Fangor, *Freud, *Gabo, *Gaudier-Brzeska, *Gentils, *Gysin, *Hanson, *Hayter, Hepworth, G. John, *Kane, *Kitaj, *Knapp, *Kokoschka, *Latham, Lench, *Lewis, Lowry, MacBryde, P. J. Martin, McWilliam, Moore, *Newall, *Nicholson, Paolozzi, Pasmore, *Péri, Piper, Reynolds, *Rickey, Riley, *Schwitters, Sickert, S. Spencer, Sutherland, Thornton, *Tippett, Tunnard, Wallis, *Wood, Wynter

GREECE: *de Chirico, *Chryssa, *Daphnis, *Samaras, *Takis, *Vagis

GUATEMALA: González Goyri, *Mérida, *Mishaan, Ossaye

HAITI: Bigaud, *Dorcély, Gourgue, Liautaud, Obin, Vincent

HUNGARY: *Hajdu, *Kemeny, *Moholy-Nagy, *Péri, *Prinner, *Schöffer, *Vasarely

ICELAND: Kjarval, Svavar Gudnason, *Tryggvadottir

INDIA: Gaitonde, Gujral, Khakhar, *Samant

IRAN: *Grigorian, Pilarame, Vasiri, *Yektai, *Zenderoudi

IRELAND: *O'Conor, Scott, Stuart

ISRAEL: *Agam, *Ardon, Castel, *Etrog, Gali, Gross, Orion, *Rubin, Shalom of Safed, Shemi

INDEX OF PORTRAITS BY SUBJECT

CHRONICLE

OF THE COLLECTION OF PAINTING AND SCULPTURE

by Alfred H. Barr, Jr.

Chronicle: A historical register or account of facts or events disposed in the order of time; a history; especially, a bare or simple chronological record of events. — Webster's New International Dictionary, Second Edition, Unabridged, 1934

CHAPTER I
1929–1934

1929

MAY: Miss Lillie P. Bliss, Mrs. John D. (Abby Aldrich) Rockefeller, Jr., and Mrs. Cornelius J. Sullivan invited A. Conger Goodyear to be chairman of a committee to organize a new museum. He accepted, and Mrs. W. Murray Crane, Frank Crowninshield, and Paul J. Sachs joined them.

SUMMER: The committee applied for a charter for the new museum, began fund-raising for two years' expenses, and appointed a director, Alfred H. Barr, Jr. Space was rented on the twelfth floor of the Heckscher Building, 730 Fifth Avenue, at Fifty-seventh Street. Plans for the first exhibition were under way.

Meanwhile, the seven founders of The Museum of Modern Art issued a brochure, *A New Art Museum,* stating:

Their immediate purpose is to hold . . . some twenty exhibitions during the next two years.

The ultimate purpose will be to acquire, from time to time, either by gift or by purchase, the best modern works of art. . . .

For the last dozen years New York's great museum—the Metropolitan—has often been criticized because it did not add the works of the leading "modernists" to its collections. Nevertheless the Metropolitan's policy . . . is reasonable. As a great museum, it may justly take the stand that it wishes to acquire only those works of art which seem certainly and permanently valuable. It can well afford to wait until the present shall become the past. . . . But the public interested in modern art does not wish to wait . . . nor can it depend upon the occasional generosity of collectors and dealers to give it more than a haphazard impression of what has developed in the last half century.

The Museum of Modern Art would in no way conflict with the Metropolitan Museum of Art, but would seek rather to establish a relationship to it like that of the Luxembourg to the Louvre. It would have many functions. First of all it would attempt to establish a very fine collection of the immediate ancestors, American and European, of the modern movement; artists whose paintings are still too controversial for universal acceptance. . . .

Other galleries of the Museum might display carefully chosen permanent collections of the most important *living* masters, especially those of France and the United States, though eventually there should be representative groups from England, Germany, Italy, Mexico and other countries. Through such collections American students and artists and the general public could gain a consistent idea of what is going on in America and the rest of the world—an important step in contemporary art education. Likewise, and this is also very important, visiting foreigners could be shown a collection which would fairly represent *our own* accomplishment in painting and sculpture. This is quite impossible at the present time.

It is not unreasonable to suppose that within ten years New York,

with its vast wealth, its already magnificent private collections and its enthusiastic but not yet organized interest in modern art, could achieve perhaps the greatest museum of modern art in the world.

In preparing a draft for the brochure, the Director proposed:

In time the Museum would probably expand beyond the narrow limits of painting and sculpture in order to include departments devoted to drawings, prints, and photography, typography, the arts of design in commerce and industry, architecture (a collection of *projets* and *maquettes*), stage designing, furniture and the decorative arts. Not the least important collection might be the *filmotek*, a library of films. . . .

The above ambitious prospectus was cautiously edited by the Trustees to read: "In time the Museum would expand . . . to include other phases of modern art."

For the time being, the "fine arts" and "the general principles of the Luxembourg and the Tate" were to be the limits. However, thanks to the flexibility and courage of the Trustees, both architecture and photography entered the Museum early in 1932, although the Department of Photography was not formally established until 1940. All the other arts listed followed during the first decade, first in exhibitions, then in departmental collections. In 1967, the departments included Painting and Sculpture, Drawings and Prints, Architecture and Design, Photography, and Film.

SEPTEMBER 19: The Board of Regents, on behalf of the State Education Department, granted a Provisional Charter to "the Museum of Modern Art . . . for the purpose of encouraging and developing the study of modern arts and the application of such arts to manufacture and practical life, and furnishing popular instruction. . . ."

OCTOBER 3: The seven founders held their first formal meeting as Trustees. Mr. Goodyear was elected President; Miss Bliss, Vice President; Mrs. Rockefeller, Treasurer; and Mr. Crowninshield, Secretary. Jere Abbott was appointed Associate Director.

OCTOBER 25: Seven more Trustees were elected, including the collectors Stephen C. Clark, Sam A. Lewisohn, and Duncan Phillips.

The Committee on Gifts and Bequests, responsible for acquisitions of works of art, was appointed; its members were President Goodyear, Chairman, Professor Sachs, and, ex officio, the Director.

OCTOBER 29: "Black Tuesday"—the day of the stock market crash, soon to be followed by the Great Depression.

NOVEMBER 8: The Museum opened to the public with its first loan exhibition, *Cézanne, Gauguin, Seurat, van Gogh,* on view through December 7. A catalog, illustrating all but six of the 101 works in the exhibition, was published on the occasion of the show.

The Trustees accepted for the Museum its first major work of art, Aristide Maillol's bronze, *Île de France,* gift of President Goodyear. (A little earlier, Professor Sachs had purchased a drawing and eight prints for the Museum, its first acquisitions.)

The exhibitions of the first season, 1929–30, were:

November 8–December 7: *Cézanne, Gauguin, Seurat, van Gogh*

December 12–January 12: *Paintings by 19 Living Americans*, including works by Burchfield, Demuth, Preston Dickinson, Lyonel Feininger, "Pop" Hart, Hopper, Karfiol, Kent, Kuhn, Kuniyoshi, Lawson, Marin, Miller, O'Keeffe, Pascin, Sloan, Speicher, Maurice Sterne, Weber

January 18–March 2: *Painting in Paris*, including works by Bonnard, Braque, Chagall, de Chirico, Delaunay, Derain, Dufresne, Dufy, Fautrier, Forain, Friesz, Gromaire, Kisling, Laurencin, Léger, Lurçat, Matisse, Miró, Picasso, Rouault, Segonzac

March 12–April 2: *Weber, Klee, Lehmbruck, Maillol*

April 11–27: *Charles Burchfield: Early Watercolors, 1916–1918* and *46 Painters and Sculptors under 35 Years of Age*

May 6–June 4: *Homer, Ryder, and Eakins*

June 15–September 28: *Summer Exhibition: Painting and Sculpture*

1930

EARLY IN THE YEAR, the Museum acquired its first painting, Edward Hopper's *House by the Railroad*, the gift of Stephen C. Clark, followed by three more American paintings given by Trustees and chosen from the exhibition *19 Living Americans*. Mrs. Saidie A. May of Baltimore gave a gouache *Head* by Picasso, the Museum's first foreign painting and the first painting given by a non-Trustee. Persuaded by President Goodyear, Maillol gave three large plasters, the first gift by a foreigner; Mr. Clark gave Lehmbruck's *Standing Woman*.

A room was proposed but not approved for the collection of five paintings and eight sculptures, the first effort to secure space for showing acquisitions.

John Hay Whitney was elected to the Board of Trustees.

APRIL: The Junior Advisory Committee, composed chiefly of young collectors, was organized. George Howe served briefly as Chairman, followed by Nelson A. Rockefeller. According to the Annual Report of 1930–31, the Executive Committee included Nelson A. Rockefeller, Chairman, Philip Johnson, Lincoln Kirstein, Mrs. Percy D. Morgan, Jr., Mrs. James B. Murphy, James Johnson Sweeney, and Edward M. M. Warburg. Among the other members were Miss Elizabeth Bliss (Mrs. Bliss Parkinson), John Nicholas Brown, Miss Ethel L. Haven, Mrs. Charles S. Payson, Mrs. Charles H. Russell, Mrs. Howard J. Sachs, and John Walker III.

1931

MARCH 12: Miss Lillie P. Bliss, Vice President and a founder, died and, with certain conditions, bequeathed to the Museum the major part of her collection. It was recognized immediately as being of the greatest importance to the Museum. In an editorial in *The Arts* (April 1931), Forbes Watson wrote: "The bequest is a nucleus round which to build; a magnet for other collections; a continuing living reply to the doubters; a passing on of the torch; a goodly heritage. It begins the transition of the Museum from a temporary place of exhibitions to a permanent place of lasting activities and of acquisitions."

Cézannes dominated the Bliss Collection; there were eleven oils—including *The Bather, Man in a Blue Cap, Oranges, Pines and Rocks,* and *Still Life with Apples*—and eleven watercolors. Other works of exceptional value to the Museum were Gauguin's *The Moon and the Earth (Hina Te Fatou),* Matisse's *Interior with a Violin Case,* Modigliani's *Anna Zborowska,* Picasso's *Green Still Life* (1914) and *Woman in White,* Redon's *Roger and Angelica* and *Silence,* and Seurat's *Port-en-Bessin, Entrance to the Harbor* and eight drawings. Other painters represented were Daumier, Davies, Degas, Derain, Kuhn, Pissarro, Renoir, Henri Rousseau, and Segonzac. (For a complete list, see pages 651 ff.)

The catalog of the memorial exhibition of the collection (May 17–October 6) stated the terms of the bequest:

By the terms of Miss Bliss' will the works of art bequeathed to the Museum of Modern Art . . . are to be delivered to the Museum within three years of Miss Bliss' death, providing the Trustees of the Estate should be satisfied that the Museum of Modern Art is sufficiently endowed and in the judgment of said Trustees on a firm financial basis and in the hands of a competent board of trustees. Upon delivery of these works of art to the Museum of Modern Art they are to become the absolute property of the Museum with the exception of three paintings—*Pines and Rocks* by Cézanne; *Still Life [with Apples]* by Cézanne; and *The Laundress* by Daumier. These three paintings are to be delivered to the Museum of Modern Art under the condition that they shall never be sold. Should the Museum of Modern Art not fulfill the conditions of the bequest these paintings shall then become the sole property of The Metropolitan Museum of Art. . . . [The legal "delivery" was not made until March 12, 1934, but meanwhile the works in the bequest were generously lent to the Museum when requested.]

MARCH 19: The Absolute Charter of the Museum was granted without change of the Provisional Charter of September 1929.

APRIL: The Museum printed an elaborate fund-raising booklet, *An Effort to Secure $3,250,000 for The Museum of Modern Art, New York City.* It stated:

[The Museum] is as yet more an exhibition gallery than a museum. . . . It is impossible to proceed with the Museum's permanent collection: First, because there is no space in which to exhibit even the present nucleus. . . . Second, because extremely important gifts which are definitely in sight cannot be accepted until a permanent institution is assured with appropriate space for their display. Third, because it is impossible to solicit gifts of works of art without the promise . . . of . . . an enduring home.

Funds were to be secured for land, building, equipment, and endowment for maintenance, but no sum was listed for purchase of works of art. However, such were the uncertainties caused by the Depression at its deepest that it was decided to postpone the "Effort."

OCTOBER: Nelson A. Rockefeller, Chairman of the Junior Advisory Committee, and his lively Executive Committee agreed that the Museum's policies should be clarified, particu-

larly the question of whether the collection should be permanent. They expressed their agreement in a letter to President A. Conger Goodyear. President Goodyear gave his opinion in an article written for *Creative Art* (December 1931):

The permanent collection will not be unchangeable. It will have somewhat the same permanence that a river has. With certain exceptions, no gift will be accepted under conditions that will not permit of its retirement by sale or otherwise as the trustees may think advisable. . . .

The Museum of Modern Art should be a feeder, primarily to the Metropolitan Museum, but also to museums generally throughout the country. There would always be retained for its own collection a reasonable representation of the great men, but where yesterday we might have wanted twenty Cézannes, tomorrow five would suffice. [The ambiguous phrase "permanent collection" was abandoned in 1941 and the term "Museum Collection" used instead.]

In November of 1930 the Trustees had begun to discuss possible relations with the Metropolitan Museum. Early in 1931 President Goodyear held informal discussions with William Sloane Coffin just before and again soon after he became President of The Metropolitan Museum of Art. Mr. Coffin suggested that the Metropolitan invite the cooperation of The Museum of Modern Art in spending the Hearn Funds, which totaled about $15,000 a year and were earmarked for the purchase of paintings by living Americans. Mr. Coffin's proposal was tentative and made without consultation with his Board of Trustees.

During 1931 the Museum acquired two paintings, both gifts.

1932

MARCH: The Museum moved from 730 Fifth Avenue to a rented house at 11 West Fifty-third Street; though the building had no public elevator, its four gallery floors were an improvement in space and prestige over the loft at 730 Fifth Avenue.

In a radio broadcast at the opening of the Museum's new quarters, President Coffin of the Metropolitan Museum remarked:

The trustees of an older institution often hesitate and are timid in giving their stamp of approval to the experiments of the present. You are handicapped by no such inhibitions. The Museum of Modern Art "Believeth all things, hopeth all things, endureth all things," and more often than not your faith will be entirely justified by the judgment of posterity. When the so-called "wild" creations of today are regarded as the conservative standards of tomorrow is it too much to hope that you will permit some of them to come to the Metropolitan Museum of Art? . . .

Several proposals for the transfer of works from The Museum of Modern Art to the Metropolitan Museum followed, but no decision had been reached when unfortunately Mr. Coffin died in December 1933.

APRIL: The question of a collection was discussed at a Trustees meeting, where "it was pointed out that the Museum has not been in existence long enough to determine upon a fixed policy in the matter of a permanent collection."

Nelson A. Rockefeller and Edward M. M. Warburg were elected to the Board.

1933

DURING THIS YEAR the Depression grew deeper. The Museum's expenses for the year ending in October were reduced to $78,000. It was decided to abandon a public drive to raise endowment funds and depend entirely on the Trustees and friends of the Museum. The Trustees of Miss Bliss's will, on their part, agreed that they would consider the Museum "sufficiently endowed" with $750,000 instead of $1,000,000, which they had earlier required.

MARCH 27: The Museum's first exhibition of its collection of painting and sculpture opened and remained on view on the third floor through April 25. The collection comprised paintings by Burchfield, Preston Dickinson, Otto Dix, Friedman, Friesz (three), Hopper, Karfiol, Miller, Picasso, and Roy and sculptures by Belling, Despiau, Epstein, Haller, Lehmbruck, Maillol (four), and Nakian—twelve paintings and ten sculptures in all. At the same time a selection of the Bliss Collection was borrowed for exhibition on the second floor.

That the Museum had received twelve gifts for its collection in 1930 had seemed a hopeful sign, but it received only nine more during the three years following. Lack of space for display of accessions, emphasis on temporary shows, and the financial condition of the country were discouraging to prospective donors.

NOVEMBER: The Director prepared for the Trustees the report excerpted below. Twenty-two pages long and containing three diagrams, it was a long-range plan for the building of a collection.

I. In 1929 . . .

" . . . New York alone, among the great capitals of the world, lacks a public gallery where the works of the founders and masters of the modern schools can today be seen. That the American metropolis has no such gallery is an extraordinary anomaly." (Quoted from *A New Art Museum,* published by the Trustees in the summer of 1929) . . .

II. The Museum Has Not Fulfilled One of Its Fundamental Purposes

Of course the first two years were considered a period of trial. During this time temporary loan exhibitions were to indicate whether there was really sufficient interest in modern art to make a permanent institution advisable. But this policy was continued with little alteration during the third and fourth years and apparently will be during the fifth.

Except during the summer months the Museum has never afforded New York a chance to see a representative collection of modern pictures. . . . In other words, the New Yorker can see a Sargent or a Meissonier all year round [at the Metropolitan Museum] but he has to wait till hot weather sets in, or go to Chicago [to the Art Institute], before he can be sure of seeing a van Gogh, or a Matisse, or a Kandinsky.

III. Theory and Contents of an Ideal Permanent Collection

The Permanent Collection may be thought of graphically as a *torpedo moving through time,* its nose the ever advancing present, its tail the ever receding past of fifty to a hundred years ago. If painting is taken as an example, the bulk of the collection, as indicated in the diagram, would be concentrated in the early years of the 20th century, tapering off into the 19th with a propeller representing "Background" collections. . . .

IV. *Practical Formation of Permanent Collection*
A. *Relation to Other Institutions* . . .
1. *The Société Anonyme, The Gallery of Living Art, and the Solomon Guggenheim Collection* . . . may be grouped together. . . . Only the Gallery of Living Art is easily accessible to the public. Nevertheless if combined these three collections would form the most complete collection of experimental or advance-guard European art in America and possibly in the world. For this reason friendly relations [with them] should be cultivated by the Trustees, Advisory Committee and Staff with a view to inducing them to give their collections to the Museum. [Most of the Société Anonyme: Museum of Modern Art collection, formed by Katherine Dreier and Marcel Duchamp, is now in the Yale University Art Gallery, that of the Gallery of Living Art, which A. E. Gallatin assembled, is in the Philadelphia Museum of Art, and the Guggenheim Collection formed the nucleus of The Solomon R. Guggenheim Museum.] . . .

2. *The Metropolitan Museum.* . . . The Metropolitan's collection stops with the Impressionist generation, that is, about fifty years ago. Fifty years ago makes a convenient date for the beginning of the bulk of our collection. . . . Cézanne might form a transition between the two. . . . Our European collection proper would then begin with Seurat, van Gogh, Gauguin, Toulouse-Lautrec, Redon, Rousseau, none of whose paintings is owned by the Metropolitan. [A van Gogh watercolor was overlooked.]

It is of great importance to come to some agreement with the Metropolitan about the dividing line of the two collections with a view to adjusting future gifts to the two institutions. If it comes to bargaining our Museum is in a strong position only if the collections of our Trustees are considered as potentially ours more than they are the Metropolitan's. . . .

3. *The Problem of Our American Collection.* . . . The picture of three New York museums [The Metropolitan Museum of Art, the Whitney Museum of American Art, and The Museum of Modern Art] competing with each other for contemporary American pictures should bring joy to painters and dealers, but it would offer little evidence of intelligent cooperation or efficient economy among the museums themselves. [The Whitney and the Metropolitan museums, the latter through its Hearn Funds, could spend a total of some $25,000 a year on the work of living American artists; The Museum of Modern Art had no purchase funds in 1933.]

Our policy toward our permanent collection of American painting and sculpture need not be crystallized immediately. Should the Hearn Fund[s] be put under our control or should the activity of the Whitney Museum be seriously curtailed, our policy would then be automatically clarified. In the meantime our work in American architecture, industrial and commercial art should be emphasized.

If, however, we continue to form an American collection our acquisition policy should be at once daring and exclusive. We have at present neither space nor money nor time to form a "representative" collection. This may be left to the other two institutions. . . .

The presence of first rate contemporary foreign pictures in the same building or even on the same wall would be an advantage as well as competition for American works; . . . more people, especially foreigners, see the English contemporary pictures in the Tate, and the German, in the Kronprinzen Palais, because of the presence in both these galleries of French pictures. . . .

B. *Acquisition of Permanent Collection*
. . . Building up a permanent collection should not be left to chance. . . . A plan of campaign, a system of strategy is necessary. This requires the full cooperation of the Trustees and Advisory Committee and much time and thought on the part of the Staff.

1. *Three Channels of Acquisition*
Purchase: Money comes from the following sources: (*a*) A steady income from a fund for purchasing (e.g., the Hearn Fund[s] at the Metropolitan). (*b*) Occasional lump sums such as Samuel Courtauld's gift to the Tate Gallery, London, of £50,000 in 1923. (*c*) Money raised for a specific purchase either from one or several donors (e.g., our vain attempt to raise money to purchase the Seurat *Parade* in 1930).
Gifts from the living: These may be the accidental result of the Museum's force of attraction (e.g., the gifts from Mrs. Saidie A. May). Usually, however, they are the result of the generosity of people already connected with the Museum. . . .
Bequests: These too may be unforeseen, but more often bequests come from Trustees, or from those whose interest in the Museum has been cultivated. Of these three channels acquisition by purchase is the most valuable . . . because the acquisition can be more controlled by the Museum.

2. *Inducing Gifts to the Permanent Collection*
. . . Gifts may be induced indirectly by emphasis upon the Permanent Collection already acquired. (*a*) The Permanent Collection should be well shown in the best galleries. The most important items should always be on view. . . . (*b*) The Permanent Collection should be catalogued. . . . (*c*) New gifts should be treated with honor and should be publicized and exhibited within a reasonable length of time. . . .

3. *Acceptance of Gifts to the Permanent Collection*
(*a*) The terms of acceptance of gifts to the Permanent Collection are made unconditional whenever possible. . . . (*b*) Policy of Acceptance: . . . The standards of the Museum's Permanent Collection can be expressed by what is exhibited rather than by what is acquired. It is better to face realistically the fact that compromise will doubtless enter into the Museum's acceptance of gifts so long as:
1. The Museum has no funds for purchase.
2. The decisions are in the hands of a committee.
3. Large gifts of works of art usually contain desirable and undesirable items.
4. There is so much difference of opinion as to the relative importance of various contemporary works of art.

On the other hand the Trustees may decide to depart from the present policy in order to maintain a rigidly high standard of acquisition. Practically this may prove a boomerang, for the more guesses one makes the more chances there are of being right ten years from now—and the mistakes of an acquisition committee will then be readily forgiven providing they are on the side of commission and not of omission. . . . Fine works not acquired are often irrevocably lost. . . .

C. *Exhibition and Preservation of Permanent Collection*
The present building is already inadequate for the exhibition and storage of both the Permanent Collection and Loan Exhibitions.

V. *The "Provisional Museum Collection"*
The Permanent Collection is faced by lack of funds, lack of space, and competition along certain lines from two or three more richly endowed institutions. The Trustees should not be discouraged by these handicaps. An excellent temporary solution of the problem is at hand providing the Museum can depend upon its friends not so much for money as for loans of works of art.

The Bliss Collection and the present Permanent Collection together already form a nucleus which if supplemented by loans from private collections would form a representative collection. . . . For at least two months during the winter as well as throughout the summer the "Provisional Museum Collection" should be expanded to fill

the whole building with a magnificent general exhibition of modern art. . . .

It is proposed to inaugurate and publicize this policy in the opening exhibition of 1934–35, the fifth anniversary of the opening of the Museum. . . . Coming on this anniversary, such an exhibition would go far to re-establish and confirm the Museum's original purpose of forming a superb Permanent Collection.

If such a policy is not inaugurated the "Museum of Modern Art" may as well change its name to "Exhibition Gallery."

1934

MARCH 12: The fifth anniversary year brought good news. Exactly three years after the death of the donor, the Lillie P. Bliss Collection was deeded to the Museum, the Trustees of Miss Bliss's will having accepted $600,000 as a minimum endowment. A catalogue raisonné, *The Lillie P. Bliss Collection, 1934*, was published shortly after.

NOVEMBER 21: *Modern Works of Art: Fifth Anniversary Exhibition* opened. It was both a Museum celebration and a suggestion of what the Museum's collection of painting and sculpture might become. The show began with great post-impressionist masterpieces lent by the Trustees (who, it was hoped, might eventually give or bequeath them to the Museum Collection) and ended with abstract and surrealist works.

The exhibition, as well as the acquisition of the Bliss Collection, brought other donations. In the show were recent gifts, including works by Brancusi, Calder, Dali, Grosz, Lachaise, Marin, and Sheeler. Among future gifts were works by de Chirico, Duchamp, Mondrian, Pevsner, and Picasso (his *Three Musicians*, which dominated the main gallery, would not be acquired until 1949).

Acquisitions 1929–1934

After five years the collection comprised twenty-four paintings and eighteen sculptures, given by eight Trustees and eight other donors, and the forty-nine paintings of the Lillie P. Bliss Bequest. The totals were ninety-one works and seventeen donors.

The collection included a good many minor works and suffered from serious imbalance. French canvases and watercolors of the late nineteenth century comprised about one-half of all the paintings and were by far the most valuable. With two exceptions, all the twentieth-century painters worked in Paris or New York, as did all but three of the sculptors.

The vanguard of forty or fifty years before was fairly well represented: a Gauguin and a Seurat, both fine paintings; eleven Cézanne oils, most of them of exceptional quality, and a dozen watercolors; minor pictures by Degas and Renoir; a small Rousseau; three excellent late works by Redon; and an early Vuillard.

Almost all the twentieth-century paintings were done after 1917 and were generally conservative: two canvases by Matisse of his Nice period, a Modigliani, three Derains, and Picasso's charming *Woman in White*, all of these from the Bliss Collection. In addition there were two small late Braques and two German pictures, a Grosz and an Otto Dix. A Marin watercolor

and good "American Scene" pictures by Hopper, Burchfield, and Sheeler were the best American paintings.

The sculptures, all twentieth century, were mostly conservative but admirable: four Maillols, a Lehmbruck, a large, ebullient torso by Lachaise, and four excellent portrait heads by various artists.

Works representing the radical innovations of the twentieth century were sparse but important: two Picasso cubist paintings, of 1909 and 1914; a Brancusi; a Calder mobile; and a famous early Dali.

The Museum of Modern Art, however, could not match the great avant-garde abstract, dada, and surrealist works assembled by Katherine S. Dreier and Marcel Duchamp for the self-styled Société Anonyme, a collection with no established gallery space. A. E. Gallatin's Gallery of Living Art, on view in the downtown library of New York University, was focused on Parisian cubist and abstract art. The Guggenheim Collection, overwhelmingly devoted to "non-objective" paintings, was not yet public; and the Whitney Museum of American Art was national in scope. Only in its collection of French post-impressionists of the late nineteenth century could The Museum of Modern Art surpass the museums and quasi-public galleries of New York—including the Metropolitan—but not the Art Institute of Chicago.

Nevertheless, despite shortcomings and handicaps, this five-year-old collection of painting and sculpture of the previous half-century was perhaps the most adequate in its field among American public museums.

Acquisitions year by year (all gifts):

1929 *One sculpture:* Maillol's *Île de France*, bronze, first acquisition of the Museum's Painting and Sculpture Collection, gift of A. Conger Goodyear.

1930 *Twelve paintings and sculptures:* Hopper's *House by the Railroad*, the first painting acquired by the Museum, gift of Stephen C. Clark. Other Trustee gifts: paintings by Burchfield, Karfiol, and Miller, chosen from the exhibition *Paintings by 19 Living Americans*. Also, Picasso's *Head*, a gouache of 1909, the first foreign painting given the Museum; Maillol's *Desire, Spring,* and *Summer,* three large plasters, gifts of the sculptor, the first foreign donor to the collection; Lehmbruck's *Standing Woman,* and other bronzes by Belling, Despiau, and Haller.

1931 *Two paintings:* by Preston Dickinson and Pierre Roy.

1932 *Four paintings:* Otto Dix's *Dr. Mayer-Hermann* and three by Friesz.

1933 *Three works:* two sculptures, Epstein's *Oriel Ross* and Nakian's *"Pop" Hart,* the first American sculpture acquired; a painting, by Friedman.

1934 *Sixty-nine paintings and sculptures:* The Lillie P. Bliss Bequest, including thirty-three oils, fourteen watercolors, two pastels (see pages 651 ff). Twenty other gifts, including two paintings by Braque (1929 and 1931), Dali's *The Persistence of Memory,* a Dufy, Grosz's *Punishment,* Marin's *Buoy, Maine,* Sheeler's *American Landscape,* and Vuillard's *Mother and Sister of the Artist;* also, eight

sculptures, including Brancusi's *Bird in Space*, Calder's *A Universe*, and Lachaise's *John Marin* and *Torso*.

CHAPTER II
1935–1939

1935

ABBY ALDRICH ROCKEFELLER, acting anonymously, gave $1,000 to the Director for purchases in Europe during the summer. An event of great importance to the collection, the gift constituted the Museum's first purchase fund. The Director bought three dada collages and an oil by Ernst, a collage by Schwitters, a large pastel by Masson, a gouache by Tanguy, and two suprematist oils by Malevich.

The Advisory Committee (with the help of Mrs. Rockefeller) also raised a purchase fund for the collection; George L. K. Morris, Chairman of the purchase-fund subcommittee, made choices in consultation with the Director, who agreed with enthusiasm. In 1935 they purchased Braque's *Oval Still Life* for $1,000. Two gifts came through the Committee, a Gris (gift of Mr. Morris) and a Léger (gift of Mr. Goodyear); a member of the Committee, Walter P. Chrysler, Jr., gave Picasso's *Studio* (1927–28), the most important twentieth-century painting acquired for the collection before 1938. (The Advisory Committee continued to provide a purchase fund through 1939, adding to the collection works by Arp, Miró, Mondrian, and others.)

As a gesture of confidence, Abby Aldrich Rockefeller gave her collection of paintings to the Museum, thirty-six oils and 105 watercolors and pastels, most by Americans and almost all by living artists. The donor stated that some of the gifts could be exchanged for other works, preferably by the same artist. Mrs. Rockefeller also bought the *Gourds* by Matisse for the Museum.

SUMMER: On exhibition were *The Museum Collection of Painting and Sculpture* and an anonymous collection (that of Sidney Janis, whose greatly expanded collection was given to the Museum in 1967).

After a year as Assistant to the Director, Dorothy C. Miller was appointed Assistant Curator of Painting and Sculpture.

1936

MAY 28: A statement headed "Policy of the Museum with Regard to the Status of the Permanent Collection" was approved by the Trustees:

The Collection of works of art owned by the Museum of Modern Art shall at all times be made up principally of works produced within the previous fifty years, with a smaller number of works of earlier periods to illustrate the sources and aid in the understanding of contemporary art.

The Collection shall be exhibited, in whole or in part, to the public in galleries designated for that purpose.

From time to time works from the Collection may be distributed to other public institutions through loan, gift, sale, or exchange, by vote of the Trustees or may be sold on their direction, providing such action is not contrary to the terms of a deed of gift or bequest transferring such works to the Museum.

On the same day, two funds were given anonymously by Abby Aldrich Rockefeller: one, $2,500, for purchase of work by American artists, and the second, $2,000, for purchases abroad.

Four masterpieces were offered for sale by European private owners in this year:

Chagall: *I and the Village* (1911). Price: $1,500. Only $1,000 could then be raised. The Museum bought the painting in 1945.

van Gogh: *The Starry Night* (1889). Price: $30,000. No funds could then be raised for its purchase, but the painting was acquired by exchange with a dealer in 1941.

La Fresnaye: *The Conquest of the Air* (1913). Price: $6,000. No funds were then available, but the painting was bought in 1947.

Picasso: *Three Musicians* (1921). After long negotiation, begun in 1935, the owner agreed on a price of $10,000, but the Museum could raise only $4,800; the painting is now in the Philadelphia Museum of Art. (The other, slightly larger *Three Musicians*, also from 1921, shown in the *Fifth Anniversary Exhibition*, could also have been bought in 1936 but at twice the price. It became available again in 1949 and was then purchased.)

1937

JUNE: The Museum moved to Rockefeller Center at 14 West Forty-ninth Street to permit the construction of a new and much larger building at 11 West Fifty-third Street (completed in 1939).

Paintings and sculptures from the Museum Collection were placed on exhibition during the summer and one month in the winter.

1938

JANUARY: Mrs. Simon Guggenheim and Abby Aldrich Rockefeller provided the collection of painting and sculpture with purchase funds that were far beyond the Museum's previous resources. (From 1935 through 1937 the funds had been limited to a total of about $8,500, plus $4,500 raised by the Advisory Committee.)

Late in 1937, Mrs. Guggenheim had without solicitation proposed buying an important painting for the Museum. The Director selected Picasso's *Girl before a Mirror*, which was bought for $10,000 early in 1938. It was the first of a series of Mrs. Guggenheim's magnificent donations (see page v).

Also in January, Mrs. Rockefeller gave a purchase fund of $20,000 to which Nelson A. Rockefeller contributed $11,500 in his mother's name; the fund was renewed in July 1939, with purchases to be divided between European and American art.

NOVEMBER 10: In connection with the acquisition of works by contemporary Americans, a Trustee committee presented a

statement of policy to the Board for its approval. It recommended that:

[. . . the Museum] take into consideration the policies of other New York museums, the national character of our Museum and the relation to our strong collection of European painting.

No dogmatic rules should be set up but when possible (1) purchases should be made from artists living outside of New York City, i.e., in other parts of the country; (2) that work which seems American be purchased rather than that which shows European influence; (3) that work of younger men be purchased rather than that of established artists.

It should be repeated that the Committee agreed on the policy in general but felt that no hard and fast rule should ever be applied in such matters.

1939

APRIL: The new Museum building at 11 West Fifty-third Street was completed. Designed by Philip L. Goodwin and Edward D. Stone, it had three times as much exhibition space as the old building, and, in addition, a sculpture garden designed by John McAndrew along the Fifty-fourth Street side.

MAY 8: For the fourth time in a decade, the Museum opened in new quarters. At the same time it celebrated its tenth anniversary with a grandly comprehensive exhibition, *Art in Our Time*. All departments were represented: Painting and Sculpture, Drawings and Prints, Architecture, Industrial Design, Posters, Film, and Photography. At the opening banquet Paul J. Sachs addressed his fellow Trustees:

It seems to me that the time has come for a wise buying policy. . . . Why not use one-half of the yearly buying fund in securing one or two works of the highest quality and then use the other half of the buying fund, in a well considered selection of contemporary work, going so far as to take chances on absolutely unknown artists. . . .

There is another and even greater danger as the Museum of Modern Art grows older: the *danger of timidity*. The Museum must continue to take risks. . . .

The Museum of Modern Art has a duty to the great public. But in serving an elite it will reach, better than in any other way, the great general public by means of work done to meet the most exacting standards of an elite.

On May 10, the evening preceding the opening of the galleries to the public, President Franklin D. Roosevelt spoke on the radio from Washington. These are his most memorable remarks:

The arts cannot thrive except where men are free to be themselves and to be in charge of the discipline of their own energies and ardors. The conditions for democracy and for art are one and the same. What we call liberty in politics results in freedom in the arts. . . .

A world turned into a stereotype, a society converted into a regiment, a life translated into a routine, make it difficult for either art or artists to survive. . . .

In encouraging the creation and enjoyment of beautiful things we are furthering democracy itself. That is why this museum is a citadel of civilization.

Two days earlier, A. Conger Goodyear, after ten years in office, had resigned as President; Stephen C. Clark was elected Chairman of the Board; Nelson A. Rockefeller, President; and John Hay Whitney, Vice President. Edward M. M. Warburg was appointed Chairman of the Acquisitions Committee.

Before the exhibition *Art in Our Time* closed in September, World War II had begun in Europe.

Acquisitions 1935–1939

In 1939 Abby Aldrich Rockefeller gave the Museum her collection of thirty-six modern sculptures, a large part of her collection of paintings having been donated in 1935.

A. Conger Goodyear, in *The Museum of Modern Art: The First Ten Years* (New York, 1943), summarized events leading to another important acquisition:

Through a somewhat complicated transaction there was added to the collection early in 1938 the very large Picasso *Les Demoiselles d'Avignon*, painted about 1907, and called by Alfred Barr "one of the few pictures in the history of modern art which can be called epoch-making." The eight feet square canvas was purchased from Jacques Seligmann & Company, two members of the firm, Germain Seligmann and César de Hauke, making substantial contributions toward its purchase price. The balance required was to be obtained from the sale of *The Race Course* by Degas, one of the pictures included in the Bliss Bequest. This was the first important sale from the permanent collection. Two years later the sale was concluded and as a consequence *Les Demoiselles* actually became the property of the Museum.

Other important purchases were Picasso's *Girl before a Mirror* and Rousseau's *Sleeping Gypsy* (gifts of Mrs. Simon Guggenheim); Lehmbruck's *Standing Youth* and *Kneeling Woman* and Giacometti's *Palace at 4 A.M.* (Abby Aldrich Rockefeller Fund); Duchamp-Villon's *Horse* and Lipchitz's *Figure* (van Gogh Purchase Fund). Important gifts were Picasso's *The Studio* (1927–28; given by Walter P. Chrysler, Jr.) and Lachaise's *Floating Figure* (given by friends of the artist).

Many works were bought from the exhibitions *Cubism and Abstract Art* (1936) and *Fantastic Art, Dada, Surrealism* (1936–37) at a cost of about $4,500. Purchases were also made from *Masters of Popular Painting: Modern Primitives of Europe and America* in 1938.

Acquisitions year by year, represented by selective lists of artists and some titles of works:

1935 *Purchases:* Braque's *Oval Still Life* (1914; acquired through the Advisory Committee Fund), four Ernsts, a Masson, a Schwitters, two Maleviches, a Tanguy.

Extended Loans: six Maleviches (including *Suprematist Composition: White on White,* not formally accessioned by the Museum until 1963).

Gifts: Abby Aldrich Rockefeller collection of thirty-six oils, including Beckmann's *Family Picture* and Blume's *Parade;* also, one each by Stuart Davis, Otto Dix, du Bois, Gris, Hartley, O'Keeffe, Orozco, Roy, Niles Spencer, and Weber. Also, 105 watercolors, gouaches, and pastels, including seven Burchfields (dating from 1916 to 1918), a Chagall, four Hoppers, a Kandinsky (1915), Klee's *Slavery* (1925), four Marins, four Pascins, six Prendergasts, a Redon, three Rouaults, Shahn's *Bartolomeo Vanzetti and Nicola Sacco,* a Walkowitz,

eight Webers, and two Zorachs. Other gifts: Matisse's *Gourds*, and gifts made through the Advisory Committee: a Gris (1913), a Léger (1920), and Picasso's *Studio* (1927–28).

1936 *Purchases:* three Arps (reliefs), de Chirico's *The Nostalgia of the Infinite* and *The Evil Genius of a King*, Giacometti's *The Palace at 4 A.M.*, Magritte's *The False Mirror*, a Marin, Matisse's *Bather*, Miró's *The Hunter*, Tanguy's *Mama, Papa Is Wounded!* Advisory Committee Fund: an Arp (relief), a Ferren, a Hélion, a large Miró (1933).

By Exchange: Niles Spencer's *City Walls*.

Gifts: Gropper's *The Senate*, a Hepworth, three Larionovs, Lehmbruck's *Standing Youth*, Rodchenko's *Non-Objective Painting: Black on Black*.

1937 *Purchases:* Duchamp-Villon's *The Horse*, four Ernsts (three oils, including *Two Children Are Threatened by a Nightingale*, and a sculpture, *Les Asperges de la lune)*, Gonzalez's *Head*, Laurens's *Head*, a Le Corbusier (1920), Lipchitz's *Figure*, Masson's *Battle of Fishes*, Miró's *Person Throwing a Stone at a Bird*, Moore's *Two Forms*. Advisory Committee Fund: Arp's *Human Concretion*, a Mondrian (1936).

Gifts: a Dali, Lachaise's *Floating Figure*, four Orozcos (including *Zapatistas*), three Picassos (including *Seated Woman*, 1926–27), Siqueiros's *Collective Suicide*.

1938 *Purchases:* Balthus's *Joan Miró and His Daughter Dolores*, Flannagan's *Triumph of the Egg*, Gabo's *Head of a Woman* (c. 1917–20), Harkavy's *American Miner's Family*, Kuniyoshi's *Self-Portrait as a Golf Player*, a Nakian, Pevsner's *Bust*, Picasso's *Girl before a Mirror*.

Gift: Pascin's *Socrates and His Disciples Mocked by Courtesans*.

1939 *Gifts:* Abby Aldrich Rockefeller collection of thirty-six modern sculptures, including six Despiaus, four Kolbes, seven Lachaises, two Lehmbrucks, four Maillols, Matisse's *La Serpentine*, Modigliani's *Head* (stone), and a Zorach. Mrs. Rockefeller also gave fifty-four works from her collection of American folk art (now in Williamsburg, Virginia, excepting Pickett's *Manchester Valley*, retained by the Museum). Other gifts: a Dove, two Klees, Siqueiros's *Echo of a Scream*.

By Exchange: Picasso's *Les Demoiselles d'Avignon*.

Purchases: a Barlach, Derain's *Window at Vers*, Despiau's *Assia*, Gris's *The Chessboard*, a Kirchner, three Klees (including *Around the Fish* and *Twittering Machine*), Kokoschka's *Hans Tietze and Erica Tietze-Conrat*, Lehmbruck's *Kneeling Woman*, Matisse's *Blue Window*, two Mirós, a Peyronnet, Portinari's *Morro*, Rousseau's *The Sleeping Gypsy*.

Commission by the Advisory Committee: Calder's *Lobster Trap and Fish Tail*, a mobile for the Museum's main stairwell.

Extended Loans: Works from the WPA Art Program, including four by Graves and Levine's *The Feast of Pure Reason*.

CHAPTER III
1940–1946

THE SEVEN YEARS from 1940 through 1946 were difficult. Although 1939 had been a grand year for the Museum, World War II had broken out before the first exhibition in the new building came to an end in September. During this "phony" war in Europe, the American "Defense Effort" got under way. Two years later Pearl Harbor changed the term to "War Effort."

In connection with World War II, the Museum executed thirty-eight contracts (valued at over $1,500,000) for various governmental agencies, including the Office of War Information, the Library of Congress, and the Office of the Coordinator of Inter-American Affairs; nineteen exhibitions were sent abroad and twenty-nine were shown in the Museum, all related to the war; in addition, the manifold Armed Services Program was carried on. A dozen members of the curatorial staff joined various services.

With its own program handicapped and diverted, the Museum faced "a challenge . . . to keep to its fundamental purpose, to maintain its standards, its integrity, its faith in the value of the arts of peace now that we too are at war" (from the Annual Report published at the end of 1941).

Many changes occurred: Nelson A. Rockefeller was called to Washington in 1940 and resigned as President early in 1941 when he became the Government's Coordinator of Inter-American Affairs; John Hay Whitney was then elected President but soon left to enter the Air Force; Stephen C. Clark, Chairman of the Board, took on the arduous obligations of President, as well.

In November 1943 Alfred H. Barr, Jr., was asked to resign as Director of the Museum and Curator of Painting and Sculpture, but he continued to install the collection under the title Director of Research. James Thrall Soby was appointed Director of the Department of Painting and Sculpture, and Dorothy C. Miller was appointed Curator.

Mr. Soby resigned as Director of Painting and Sculpture on January 1, 1945, but continued to serve on various committees and remained Director of the Museum's Armed Services Program. James Johnson Sweeney was then appointed Director of Painting and Sculpture, serving from January 1945 until autumn 1946.

Edward M. M. Warburg, Chairman of the Acquisitions Committee, was succeeded by Mr. Soby in 1941 followed by Mr. Clark in 1943.

The Acquisitions Committee was replaced in May 1944 by the Committee on the Museum Collections. Mr. Soby was Trustee Chairman and Mr. Sweeney, Vice Chairman; other members were William A. M. Burden, Mr. Clark, Mrs. Simon Guggenheim, Bartlett H. Hayes, Jr., Mrs. Sam A. Lewisohn, Miss Agnes Rindge, Mrs. George H. Warren, Jr., and Mr. Barr. From 1946 until the autumn of 1947, Mr. Clark was again Chairman.

A departmental Committee on Painting and Sculpture, in existence from May 1944 through 1946, comprised Messrs. Sweeney (Chairman 1945-46), Soby, and Barr, and, briefly, Miss Rindge.

With the two young Presidents gone, one after the other, the older Trustees, founders of the Museum, resumed responsibility. The staff was a generation younger, and so were the active members of the Advisory Committee; all were stimulated by the new building and eager to give advice.

Many of the proposals and policies effected between 1929 and 1939 were reconsidered and debated during the period from 1940 to 1946, particularly since certain intentions of the previous decade had gone unfulfilled. There were new approaches, too. Much talk and more writing resulted in a score of reports and statements, some published, some private. Three Trustees, Chairman of the Board Clark, Vice President Sam A. Lewisohn, and former President Goodyear, all great collectors, had a deep interest in the Museum and a particular concern for the Department of Painting and Sculpture, but they issued no reports. (They eventually bequeathed the best of their collections to other museums.)

Henry Allen Moe, First Vice Chairman of the Board, on the other hand, wrote a sagacious report late in 1944 as Chairman of the Committee on Policy.

The Advisory Committee produced two elaborate studies, one in 1941, under the chairmanship of William A. M. Burden, and another in 1943, under Mr. Sweeney. Messrs. Soby, Sweeney, and Barr, singly or together, wrote ten or more special reports during the 1941–46 period.

1941

MARCH 12: Alfred H. Barr, Jr., prepared a report for the Advisory Committee on the Collection of the Museum. A brief excerpt follows:

We need more works of real quality and historic importance. Probably only half our collection of oils would prove really useful for exhibition in the Museum even if there were plenty of space, and perhaps only one-eighth could be considered as worthy of an ideal collection. There are still many serious gaps to be filled. . . .

No permanent exhibition of the modern arts, such as the Museum plans, exists anywhere in the world. Other collections have finer or more numerous works of particular schools or countries but no other museum is in a position to present so comprehensive a collection in such a way that it would combine recreation, education and challenging esthetic adventure. The Museum has a unique opportunity—and responsibility.

APRIL: The comprehensive, painstaking "Advisory Committee Report on the Museum Collections" was issued by William A. M. Burden, Chairman, and his committee, Lincoln Kirstein, Mrs. Duncan H. Read, James T. Soby, and Monroe Wheeler. Begun in July 1940, the study was prepared with the assistance of Charles H. Sawyer, Winslow Ames, and Michael M. Hare. The Director worked with the Committee and was in general agreement with the report. At his suggestion, the term "Permanent Collection" was replaced by the more flexible "Museum Collection." Some of the principal recommendations in the forty-eight page report are excerpted here, but many are omitted, having been considered or confirmed in reports, publications, and resolutions referred to under the dates 1929, 1931, 1933, 1935, 1936, and 1938.

The Advisory Committee considered all departments, but gave most space to Painting and Sculpture:

The American section . . . should cover more of the country and be more representative of advanced . . . American painting and sculpture. The French section needs more major works and more works by the younger generation. The 19th century is over-represented. . . .

Gaps in the representation of certain schools of modern art should be filled. Futurism, German Expressionism, Fauvism and Analytical Cubism are the schools least adequately represented. [*Note:* Futurism, by early 1950, was represented by the best collection assembled anywhere, including Italy; the representation of German Expressionism by 1955 was outstanding but was later surpassed by German museums; Fauvism was still inadequately represented as late as 1967; and Analytical Cubism, only adequate by 1945, improved in the 1950s.]

Future development of the Collection can be financed almost entirely by sales from the existing Collection. A large proportion of the 19th century pictures, particularly the Cézannes . . . should be sold. . . .

The Collection should be properly catalogued. A detailed outline of the ideal museum collection should be made at once.

The Acquisitions Committee should represent more points of view than at present . . . and should keep in touch with the art market and the current work of artists more thoroughly. Our relations with collectors and artists should be handled with more care and tact.

The Committee concurs with the Trustees' decision to show the Collection at all times. A new building for the Collection is needed, but in the present crisis [war in Europe] it is more important to build up the Collection itself.

Some statistics listed in the Advisory Committee report:

INSURANCE VALUE OF ACQUISITIONS OF PAINTING AND SCULPTURE, 1929–1940 (condensed)

Paintings	Sculpture	Total	Gifts	Purchases
$624,610*	$83,054†	$707,664	$645,268	$62,396‡

*The Lillie P. Bliss Bequest, acquired in 1934, accounts for more than half the value of the paintings.

†The Abby Aldrich Rockefeller Collection, given in 1939, accounts for about a third of the value of the sculpture.

‡There were no purchase funds until 1935. The insurance value of 1939 purchases was greater than the total of the purchases of all the previous years, thanks largely to Mrs. Simon Guggenheim's gifts.

DATES BY DECADE OF 713 OBJECTS, INCLUDING OIL PAINTINGS, WATERCOLORS, PASTELS, COLLAGES, DRAWINGS, SCULPTURE, CONSTRUCTIONS, ETC.

Date produced	Number	Percentage
Unknown (Folk Art)	24	3.4
Before 1900	48*	6.7
1900–10	27	3.8
1910–20	118	16.6
1920–30	249	34.9
1930–40	247	34.6
	713	100.0

*It is significant, however, that the forty-eight 19th-century works, valued at $319,525, account for about 45 per cent of the total value of the collection.

BREAKDOWN OF THE COLLECTION BY NATIONALITY OF ARTISTS, 1940

Nationality	Number of paintings*	Number of sculptures	Total	Insurance valuation	Percentage of total valuation
American	288 (75)	36	324	$103,476	14.7
French 19th Century	44 (19)	1	45	317,525	44.9
School of Paris	171 (81)	43	214	241,943	34.2
German	30 (9)	15	45	25,590	3.6
Russian	29 (8)	2	31	1,508	0.2
Mexican	35 (18)	0	35	15,049	2.1
English	5 (3)	5	10	1,663	0.2
Other	8 (4)	1	9	910	0.1
	610 (217)	103	713	$707,664	100.0

*Including drawings, watercolors, gouaches, collages, etc. Figures in parentheses indicate number of oil paintings.

Though the French and School of Paris works constitute the overwhelming majority of the value of the Collection, it is clear that American artists have by no means been neglected either in number of works or in total expenditures.

1942

THE FIRST GENERAL CATALOG of the collection, *Painting and Sculpture in the Museum of Modern Art*, was published. In the Foreword the President, John Hay Whitney, defended the international scope of the Museum, and in the Introduction, Alfred H. Barr, Jr., Director, wrote:

Even though the collection may seem transitory in comparison with those of other museums it takes on a certain air of permanence in relation to the Museum's kaleidoscopic program of temporary and circulating exhibitions. . . . It is one of the functions of the Museum Collection to give a core, a spine, a background for study and comparison, a sense of relative stability and continuity to an institution dedicated to the changing art of our unstable world.

1943

DECEMBER 8: The Advisory Committee received the "Report of the Subcommittee on the Museum Collection," James Johnson Sweeney, Chairman. Some excerpts follow:

It is important to define the direction of the Museum's interest in making acquisitions. Is it to acquire a collection of outstanding pieces of contemporary art—"high spots," as it were—or to acquire a well-rounded educational unit? The Committee feels that the latter should be true . . . Private collectors can be more limited and personal in their choice. A museum has its duty toward a wide public and the general education of that public.

The building up of a museum collection . . . should be given system. It should not be left to chance. Lack of system can only lead to lack of balance in the collection, such as exists today.

From reading over the previous report and studying the Collection through the published checklist, the Committee assumes that there have been five major reasons for the unbalanced, spotty condition of the Museum Collection today.

1. Lack of funds in the past;
2. The unwillingness of the Acquisitions Committee to make certain purchases because of personal dislikes for certain forms of contemporary expression, which nevertheless have a historical place;
3. The feeling that even though the gap in the Collection was serious, the works available were not good enough examples; . . .
4. The feeling that the price asked was disproportionate; . . .
5. The failure to learn that a desirable item was available . . . through the Committee members' lack of acquaintance with the market, the lack of time for such work in the case of staff members, and finally the lack of a specially deputed investigator in this field.

1944

JANUARY 15: From "The Museum Collections: A Brief Report," by Alfred H. Barr, Jr.:

1. *The Museum's Purpose: A Suggested Restatement.*

Fourteen years ago in applying for a charter . . . the Museum stated that its purpose was "to encourage and develop the study of the modern arts and the application of such arts to manufacture and practical life." In this sentence the word "study" is conspicuous. Doubtless it was used to reassure the Board of Regents as to the Museum's serious educational intentions. . . . I should like to propose a new statement based upon a deeper and more active meaning of education than is implied by the word "study." This statement would be:

The primary purpose of the Museum is to help people enjoy, understand and use the visual arts of our time.

By *enjoyment* I mean the pleasure and recreation offered by the direct experience of works of art.

By *helping to understand* I mean answering the questions raised by works of art such as: why? how? who? when? where? what for?—but not so much to add to the questioner's store of information as to increase his comprehension.

By *helping to use* I mean showing how the arts may take a more important place in everyday life, both spiritual and practical.

Obviously, these three activities—enjoying, understanding, using—should be thought of as interdependent. Each confirms, enriches and supports the others. Together they indicate the Museum's primary function, which is educational in the broadest, least academic sense.

2. *Purpose and Value of the Museum Collections.*

The value of the Museum collections can perhaps be most clearly understood if they are compared to the loan exhibitions in quality, concentration, comprehensiveness, continuity, authority, educational value and general public interest.

a. Quality: The Museum collections in so far as they are exhibited in the Museum should be superior in quality to the more hastily assembled, experimental and inclusive temporary shows.

b. Concentration: Temporary exhibitions, especially during the war years, have tended to include almost anything interesting that comes along. The Museum collections should by contrast keep strictly to the Museum's essential program of the modern visual arts. . . .

c. Comprehensiveness: Though each of its sections would have to be highly concentrated and selective, the collections as a whole would be far more comprehensive than any loan exhibition.

d. Continuity: Owned or controlled by the Museum, the Museum collections make possible exhibitions which are comparatively permanent or, to be more exact, continuous. . . .

e. Authority: The Museum collections as exhibited should be for the public the authoritative indication of what the Museum stands for in each of its departments. They should constitute a permanent visible demonstration of the Museum's essential program, its scope, its

canons of judgment, taste and value, its statements of principle, its declarations of faith. From this central base or core the temporary loan exhibitions could then set out on adventurous (and adventitious) sorties without too gravely bewildering the public.

f. Educational Value: Each of the above factors contributes obviously and specifically to the educational values of the Museum collections both for the general public and the schools and colleges. The temporary loan exhibitions, however brilliant and exciting they may be, are too transitory and often too specialized to be of consistent use to schools and colleges. The hundreds of teachers in greater New York need comparatively permanent exhibits which they can count on using in relation to their courses. . . .

g. Public Interest: Of course, semi-permanent or recurring exhibitions lack the publicity value of the big temporary shows, but if the Museum collections are fine enough in quality, interesting enough in installation and varied enough in scope, they should hold their own in the public eye. . . .

In a discussion as to whether the collection should be primarily an assemblage of fine paintings or an historical survey, there need be in my opinion no serious conflict. To acquire and exhibit works of the finest possible quality is imperative. This should be the chief objective of the Museum in this department of its collection, because the excellence of the works of art contributes not only to the public's enjoyment but also to the educational effectiveness of the Museum.

MAY 11: The Trustees of the Museum sold at auction at the Parke-Bernet Galleries, New York, "certain of its nineteenth century works of art to provide funds for the purchase of twentieth century works" (from the catalog of the sale). Further, "the proceeds . . . will be spent with the utmost care. . . . It is our intention to perpetuate the generosity of donors to the Museum Collection by making sure that their names are applied only to works comparable in importance to those originally given us."

Included were four Cézanne oils and four watercolors, two Seurat drawings, a Matisse—all from the Lillie P. Bliss Collection; in addition there were a Matisse and two large Picassos given by Stephen C. Clark. Financially the sale was not satisfactory. Furthermore, publicity surrounding a public auction created grave doubts about the Museum's acquisitions policy. (Purchases made from the sale of works in the Lillie P. Bliss Bequest are listed on pages 652–53.)

JUNE: The Museum received a letter from Sam A. Lewisohn, an older Trustee with a great collection. The Museum had not only sold some of its nineteenth-century paintings at auction the month before, it had recently purchased important paintings by Pollock, Motherwell, and Matta. Further, there had been recurrent discussions about the Museum as a center of study and education. Excerpts from the letter follow:

1. We should encourage collectors of the latter part of the 19th century, as well as of the 20th century, to bequeath [the] best examples [of their collections to the Museum]. . . .

2. It would be too bad completely to ignore all the Impressionists who might have something to say to contemporary painters; and perhaps it would revive interest in the beauty of pigment. . . .

3. After all, the Museum's purpose is not just classifying and pigeon-holing—it has a more profound educational intent. . . .

4. The Museum should not only be a classroom—it should also be a sanctuary where people can get a sort of sensual and mystical pleasure.

Art appreciation is created, it seems to me, by exposing people to the best rather than merely to examples that are useful to the intensive student.

OCTOBER: From the minutes of the Committee on the Museum Collections:

IMPORTANT EUROPEAN WORKS OF ART RECOMMENDED FOR CONSIDERATION BY THE DEPARTMENTAL COMMITTEE ON PAINTING AND SCULPTURE

Artist	Work	Owner	Insurance valuation	Price
Brancusi	*The Miracle (Seal)* (1938)	Artist	$ 6,000	$ 7,000 (1939)
Braque	*L'Homme à la guitare* (1911)	Collector	6,732	?
Chagall	*I and the Village* (1911) $1,500 (1936)	Coll.		2,500 (1939)
Duchamp	*The Large Glass* (1915–23)	Coll.	20,000	?
La Fresnaye	*The Conquest of the Air* (1913) $6,000 (1936)	Coll.		16,666 (1939)
Lipchitz	*Mother and Child* (1941) $3,600 (1941)	Artist		4,500 (1944)
Matisse	*Women at the Spring* (1917?)	Dealer		6,000 (1940)
Modigliani	*Portrait of Jean Cocteau* (1917)	Coll.	7,500	7,500
Picasso	*Woman Ironing* (1904)	Dealer	25,000	?
Picasso	*Girl with a Mandolin* (1910)	Coll.	5,000	12,000 (1940)
Picasso	*"Ma Jolie"* (1912?)	Coll.	8,976	?
Picasso	*The Race* (1922)	Artist	5,000	?
Picasso	*Three Dancers* (1925)	Artist	20,000	?
Picasso	*Guernica* and at least 20 drawings and studies (1937)	Artist	25,000	?

Here is the list of important works which we might consider for acquisition. We now have a good deal of money which is restricted to purchase of works in the "masterpiece" class. Not all the works listed belong in this class, but I think they do include a good number of the best things *now on the market*. A good many of them are works which I have had in mind for years and many of them are actually in our possession and might well have been purchased during the past few years had not the war cut us off from the owners.

Most of the prices are problematical: those given before the war started would doubtless have been raised.

Six days ago it became possible to write to Paris even though on postcards only. We could write Picasso and shortly, I suppose, Gaffé [a collector] in Brussels. . . . Already color reproductions reveal a number of works painted during the war which the Museum might soon consider. A[lfred] H. B[arr], Jr.

After some discussion Mr. Soby was authorized to send letters to the owners of the above pictures asking for an opportunity to buy without

committing the Museum to any definite purchases. . . . Mr. Clark questioned whether some of the new pictures in Europe might not be better than the ones on the list. Mr. Clark also suggested that a possible drop in prices within the next 12 months should be taken into consideration.

The Braque, Chagall, and Picasso *"Ma Jolie"* were bought in 1945; the La Fresnaye, in 1947; the Lipchitz, in 1951; the Picasso *Girl with a Mandolin* was bought by a private collector, who, in 1958, promised to give it to the Museum.

OCTOBER: The "Report of the Committee on Policy" was presented to the Board of Trustees. Henry Allen Moe, Chairman of the Committee, wrote the report; other members of the Committee were J. E. Abbott, Stephen C. Clark, Adele R. Levy, James T. Soby, James J. Sweeney, and Monroe Wheeler. Some of the statements on acquisitions were of particular significance:

In the matter of purchases, your Committee is of [the] opinion that especially in view of the Museum's limitations of exhibition space and of purchase funds, the present policy guiding purchases for the Museum's collections is much too indefinite. We think it is necessary to adopt a clearly-stated policy in reference to purchases and we recommend that the Committee on Museum Collections be directed to formulate such a statement and report it for the consideration of the Board of Trustees.

The issue to be resolved by the Trustees, as the issue developed in this Committee, is the following: If the Museum collections are limited to major works, the collections will be deficient as teaching instruments by reason of the lack of supplementary minor works. If the collections be developed with emphasis on work primarily historical in character, the collections will be deficient in major works of quality. What is the Museum's best policy in this situation?

The members of this Committee have views upon the matter but agreement has not been arrived at, and, in view of the importance of the question to the present and future of the Museum, have thought it best to put it up to the Committee on Museum Collections for an all-aspect study and report to the Board.

However, here we firmly suggest that the Museum's Permanent Collections—our acquisitions—should be shown once each year for an extended period, a showing in the nature of a report to the Trustees and to the public upon our stewardship. What the collections of the Museum contain is largely unknown, even to the Trustees, and this is an unhealthy condition in that we do not get the benefit of advice and criticism upon them; it provides fuel for charges of cultism and preciousness, and omits fulfillment of one of our primary functions.

1945

James T. Soby's resignation as Director of Painting and Sculpture became effective January 1. He was succeeded by James Johnson Sweeney. In January Mr. Soby wrote a five-page response to the Policy Committee, his document headed "Report to the Trustees in Connection with a Review of the Museum Collection" (see excerpt page 632). Mr. Barr also responded to the Policy Committee report with "Notes on Museum Collection Policy." The third member of the departmental Committee on Painting and Sculpture, Mr. Sweeney, did not write an individual response, but joined with Messrs. Soby and Barr in signing a statement of policy, dated January 25. This

statement, sent to each member of the Board of Trustees for study before the February meeting, follows:

The Chairman of the Board has asked the Committee on Painting and Sculpture to consider a problem previously discussed by the Policy Committee, and to submit their suggestions to the Trustees during the present review of the Museum's collection of painting.

"The issue to be resolved by the Trustees, as the issue developed in this Committee, is the following: If the Museum collections are limited to major works, the collections will be deficient as teaching instruments by reason of the lack of supplementary minor works. If the collections be developed with emphasis on work primarily historical in character, the collections will be deficient in major works of quality. What is the Museum's best policy in this situation? . . . From the Report of the Committee on Policy to the Board of Trustees."

Mr. Moe has described this issue accurately as it developed in the Policy Committee. Yet we feel it need not be carried to such black and white extremes. Possibly (as Mr. Lewisohn has suggested) the semantic difficulties produced a dilemma which we believe tolerant and thoughtful study would resolve.

It is generally agreed that quality is of primary importance; that quality is to be found in a great variety of works, large and small, in different media and of different, even diametrically opposed schools. Quality, for practical purposes, is a problem of finding the best of its kind. It is quality, too, that is the *primary* factor in making a work of art historically important or educationally valuable.

A reasonably balanced policy is desirable. As heretofore, the great proportion of the Museum purchase funds should be spent on works of importance; a much smaller proportion on minor works of quality by established artists, and on the exploration of new talent. — J. T. Soby, J. J. Sweeney, A. H. Barr, Jr.

JANUARY 24–30: A private exhibition of paintings from the collection of the Museum was arranged for the Trustees in explicit and firm response to the "Report of the Committee on Policy." For lack of space in the Museum, half of the 650 paintings, watercolors, pastels, color collages, and other works were on view January 24 and 25 at the Museum and the other half on January 30 at a nearby warehouse. The more valuable works were shown in the galleries on the second and third floors of the Museum and the less valuable in the warehouse, this disparity suggested by the Chairman, Mr. Clark. The division was made with some difficulty by Messrs. Soby and Barr and curator Dorothy C. Miller. Since the exhibition was arranged on short notice, many of the paintings were missing— about ninety of them on tour and thirty on loan to other museums. The sixty paintings on public view prior to the private showing were taken down and arranged against the walls with the others brought out from "study storage."

The Trustees were given a ten-page guide to the show with analysis and explanation:

What factors make a painting "valuable for exhibition in Museum Collection galleries"?

This question of course raises a general problem of Museum policy which is currently in debate. The staff, however, having to act before this debate is settled, proceeded on the principle that the Museum as in the past has broad cultural and educational responsibilities.

In the light of these responsibilities judging the value of a work of art is a complex problem.

In the minds of the staff *quality* was as always the primary factor but

the staff believes that quality *is a relative and variable criterion which differs radically in different kinds of painting. . . .*

There is . . . room for at most 90 of these paintings in the gallery space now allocated to the Museum Collection on the third floor. (The current installation, of October 1944, includes only 60.)

Of the 90 perhaps *30 or 40 might be valuable enough*—"classic" enough—to keep on view at all times leaving the balance to be changed from time to time either singly or by galleries. . . .

Section A [shown in the Museum] includes not only minor works of quality . . . but, in addition, [works of]:

a) *historical importance* such as the Burchfield (no. 70)* or the Braque (no. 703, supplement)

b) *documentary interest:* Lawrence (360)

c) *technical originality:* Dove (179), Arp (7)

d) *esthetic originality:* Ernst (195), MacIver (383)

e) *importance as the only example in the collection:* Awa Tsireh (15), Bellows (26), Duchamp (182), Dufy (185)

f) *interest as the work of exceptionally talented young Americans:* Bloom (44), Graves (256), Greene (257), Pickens (766), Pollock (767), Sharrer (775). Several of these paintings by younger Americans ought scarcely to be called minor—except in fame.

*Numbers refer to *Painting and Sculpture in the Museum of Modern Art,* 1942, and its supplement, 1945.

The Trustees were interested and their opinions interesting: many had definite feelings about certain artists and their works, but few agreed. When they did it was often for different reasons. The best-known masters were taken for granted and scarcely mentioned. Some polarity of attitudes remained but was less acute than before. The curators learned a great deal. This exchange was typical: Trustee: "Do you think that the exhibition of the Permanent Collection in its entirety will make clear the policy behind it?" Curator: "No. There will be no automatic conclusion from looking at the pictures. You must also understand why each piece was acquired."

Mr. Soby referred to the difference in approach between the private collector and the museum curator in his January "Report to the Trustees in Connection with a Review of the Museum Collection":

The Collector and Museum Acquisitions: As Professor Sachs so eloquently pointed out at the Trustees' meeting of January 11, 1945, there is a great natural difference between the collector's viewpoint on acquisitions and the museum curator's. . . .

It is not always easy to keep these problems in mind—I know that it was often difficult for me to do so, as Director of Painting and Sculpture, after fifteen years of private collecting in the Museum's own modern field. For that reason I would like to list here some of the contrasts in approach:

1. Collector: The gratification of private taste and love of the arts.
 Curator: The broad educational program of a public institution.
2. Collector: Absolute freedom of choice within financial limits.
 Curator: The necessity for covering all significant aspects of a given field.
3. Collector: Expenditure of one's own money.
 Curator: Expenditure of somebody else's money, given in faith and confidence to a public institution.
4. Collector: A free hand in changing the contents of a collection through sale, disposal or trade, following the dictates of personal taste.
 Curator: A professional responsibility in making sure that per-

sonal changes in taste do not lead to eliminations which will:

a) be hasty and perhaps a mistake

b) break the continuity of a public collection which should *illustrate* changes in taste within reasonable limits, rather than be reconstituted entirely according to these changes.

5. Collector: Freedom from public pressure and from responsibility toward living artists.
 Curator: *a)* The need to consider carefully pressure from public groups, to refute it if ill-founded, to weigh it if it appears fair.

 b) A tremendous moral responsibility toward living artists whose careers and fortunes can be drastically affected by the Museum's support or lack of it.

JUNE: The exhibition *The Museum Collection of Painting and Sculpture* opened with 355 works on the second and third floors. About one-third of the collection was on view for seven months.

The news release was headed "Museum of Modern Art Opens Large Exhibition of Its Own Painting and Sculpture." Toward the end of the release are the following remarks:

Finally, though without intending to exaggerate the sculptor's importance, two of Lehmbruck's large figures are allotted a gallery to themselves in order to give the visitor a sense of how effective sculpture can be when shown in ample, well proportioned space. . . .

A museum exhibition of this size requires more than a purely esthetic or decorative arrangement, yet categories and sequences inevitably lead to certain errors of emphasis. Only a few works of art are conveniently simple enough to fit into classifications. Many of the categories suggested by the installation are therefore tentative and inexact. Critics, scholars and the public are cordially invited to offer suggestions.

No comprehensive collection of modern art, however, can possibly assume a rigid or final character. And this was never the intention of the men and women who have given so generously of their money and faith to make the collection possible. . . . — A.H.B., Jr.

NOVEMBER 15: Stephen C. Clark, Chairman of the Board, referred to the exhibition in his address to the Sixteenth Annual Meeting of The Museum of Modern Art (his remarks were quoted in the *Museum Bulletin,* February 1946):

The principal exhibition of the year was the presentation for the first time of the Museum's Collection of Painting and Sculpture, by which the Museum's acquisition policy was strikingly vindicated. Both the general public and the critics responded to it with enthusiasm. Without much question the Museum possesses the outstanding collection of contemporary art in the world, although due to lack of space only part of it can be shown and much of it remains in storage.

American Art and Artists 1940–1946

In 1940 a number of American abstract painters picketed the Museum because they felt it paid too little attention to their work. (Later, in 1958, and again in 1960, realist painters protested.)

At that time, three other New York museums were more or less interested in twentieth-century American art: the Whitney Museum of American Art, The Metropolitan Museum of Art, and the Museum of Non-Objective Painting (renamed the Solomon R. Guggenheim Museum in 1952). The Museum of

Modern Art was involved in showing the best in contemporary art whether national or international; in addition to painting and sculpture, it was also seriously concerned with other arts, such as architecture, photography, and film. (In 1938 the Trustees had approved an informal policy on purchasing American art; see page 626. Earlier, in 1933, the same matter had been discussed in the Director's "Report on the Permanent Collection"; see page 623.)

The *Museum Bulletin* of November 1940 was devoted to "American Art and the Museum," not so much, it said, "to answer these occasional criticisms as to present to the members a report of the extent and variety of what the Museum has done in the field of American art." Most of the *Bulletin* concerns temporary exhibitions in the Museum and elsewhere, notably *Trois Siècles d'art aux États-Unis* organized by the Museum for the Musée du Jeu de Paume, Paris, in 1938, a grand effort with all departments well represented.

Twentieth-century American paintings, drawings, and sculpture in the Museum Collection were listed by comparative numbers in the same issue of the *Bulletin:*

	Paintings, etc.	Sculptures	Totals
United States	274	33	307
Latin America	38	0	38
School of Paris	181	45	226
All other countries	72	25	97

In the Museum's 1942 catalog, *Painting and Sculpture in the Museum of Modern Art,* 142 American artists were listed, by comparison with seventy-nine French and international School of Paris artists, sixteen Germans, seven Mexicans, and twelve Russians.

In the Foreword of the same 1942 catalog, John Hay Whitney, President, wrote:

There is one aspect of the Collection which seems to me to have a special meaning. . . . This is its catholicity and tolerance. It is natural and proper that American artists should be included in greater numbers than those of any other country. But it is equally important in a period when Hitler has made a lurid fetish of nationalism that no fewer than twenty-four nations other than our own should also be represented in the Museum Collection.

James T. Soby, Director of the Department of Painting and Sculpture in 1944, wrote an article for *Museum News* (June 15, 1944) entitled "Acquisitions Policy of The Museum of Modern Art," in which he forcefully defended the Museum's policy:

In recent years the Museum has sometimes been berated for not buying more painting and sculpture by American abstract and Expressionist artists. . . .

But it should be remembered that the Museum does not exist for the direct benefit and patronage of artists. . . . And viewed purely in terms of dollars and cents, the Museum has made a far more important contribution to the support of living painters and sculptors through its educational program than it could possibly have done through direct patronage. . . .

Standards of selection have been purposefully broad, and bias in favor of any one school has been avoided—always admitting that prejudice cannot be totally disabled by any force of detachment. In a word, we try to buy representative examples of work by those modern artists whom we consider to be among the best of a good kind.

We do not consider it our job to force contemporary art in one direction or another through propaganda or patronage, much as enthusiasts for a particular dogma would like to have us do so. For in the final analysis it is not our job to lead artists, but to follow them—at a close, yet respectful distance.

In the first large exhibition of the Museum's painting and sculpture collection, from June 1945 to February 1946, American works numbered 134, and foreign works, 221.

Space Problem 1940–1946

The tripled gallery space in the new building brightened hope for showing continuously some part of the Collection of Painting and Sculpture; but in the first two years after the building's opening, the collection was on view for only eighteen weeks. Four great exhibitions had occupied almost the whole Museum: *Art in Our Time* and *Picasso: Forty Years of His Art* in 1939; *Twenty Centuries of Mexican Art* in 1940; and *Indian Art of the United States* in 1941.

From the Director's March 12, 1941, report on the collection to the Advisory Committee:

The Museum . . . now has a large and valuable collection but at the present moment [with the installation throughout the Museum of *Indian Art of the United States*], . . . the casual visitor would not be aware of it. But all have agreed that the Indian exhibition should be the last huge show to occupy all three gallery floors of the Museum. After it closes, plans have been made to give over half the gallery space to curatorial departments primarily for the purpose of showing the Museum collection. . . .

To be really useful the essential part of such a collection would have to be on view at all times. Teachers, students, amateurs as well as the general public should be able to count on seeing it, the most significant works in public galleries, the less important things in easily accessible study storage rooms with trolley racks for pictures, sliding shelves for models, etc.

Even with half the Museum gallery space there are still far too few galleries to show adequately the collections of painting, sculpture and graphic arts and at the same time give a modicum of exhibition space to the departments of Photography, Architecture and Industrial Design as well as the Film Library, Education Project and Dance Archives. Nor is there any space for accessible study storage unless the very limited and crowded permanent storage is moved elsewhere. . . .

Of the 225 oil paintings . . . in the collection less than 50 could be properly hung in the space now allotted. — A.H.B., Jr.

The Museum Collection fared somewhat better in the next five years. The exhibition *Painting and Sculpture from the Museum Collection* was on view on most of one floor from May 1941 through the end of April 1944. Thereafter the 15th Anniversary Exhibition, *Art in Progress,* occupied the whole building until mid-October. After that, only fifty paintings from the collection were again shown.

From June 1945 to February 1946, however, *The Museum Collection of Painting and Sculpture* filled the entire second- and third-floor galleries with 355 works—the first comprehensive showing of the collection since 1933, when twelve paintings and ten sculptures comprised all the Museum owned.

To further dramatize the space problem, statistics were prepared in December 1946 in anticipation of a fund-raising drive the following year:

Collection	Number in Collection	Number on view
Paintings	702	105 (15%)
Sculptures	155	77 (50%)
Drawings	278	11
Prints	2,034	None
Photographs	1,933	29
Architecture	Models and enlarged photographs	None
Industrial Design	394 objects	None
Theatre and Dance	c. 300	None

The report concluded: "Lack of space has proved a more serious handicap to the Museum's collections than lack of funds."

Purchase Funds 1940–1946

By 1940–41 the ample purchase funds of the previous years were no longer available. The decline was caused partly by unforeseen maintenance expenses of the new building but also by the Defense Effort and the entry of the United States into the war late in 1941. The suggestion that five per cent of the budget be allocated for acquisitions was turned down.

At the beginning of 1942, purchase funds stood as follows:
Mrs. Simon Guggenheim Fund (restricted to major purchases), about $45,000
Inter-American Purchase Fund (restricted), about $25,000
Mrs. John D. Rockefeller, Jr., Fund (not restricted), $5,000
Anonymous Fund (not restricted), $5,000
Lillie P. Bliss Fund (residue), $680
Previously, in 1938 and 1939, Mrs. Guggenheim had given funds for specific gifts, Picasso's *Girl before a Mirror* and Rousseau's *Sleeping Gypsy*.

Subsequently other purchase funds were made available, as the lists of purchases imply. (Many acquisitions listed as gifts were actually purchases made with funds purposely solicited by the Museum or offered by a donor for the acquisition of a given work.)

The auction held on May 11, 1944, at Parke-Bernet Galleries (see page 630) provided additional funds for purchase of twentieth-century works.

Publications on the Collections 1940–1946

"Except for the Bliss catalogue, film program notes and occasional notes in the Bulletin, the collection has not received either scholarly or popular publication, a neglect at least as serious as our inability to give it adequate exhibition. It is essential that other members of the curatorial staff, in addition to the director, should have time to work upon their sections of the collection." — A. H. Barr, Jr., March 1941, Director's Report.

Between 1942 and 1945, four major publications on the painting and sculpture collection appeared:

1942 *Painting and Sculpture in the Museum of Modern Art,* Foreword by John Hay Whitney, President, edited by Alfred H. Barr, Jr.; indexes of artists by medium and nationality and by movement or school; 690 entries, 136 reproductions.

1943 *The Latin-American Collection of the Museum of Modern Art,* by Lincoln Kirstein, Foreword by Alfred H. Barr, Jr.; 267 entries, 112 reproductions; Bibliography by Bernard Karpel.

1943 *What Is Modern Painting?* by Alfred H. Barr, Jr.; 51 reproductions, 38 from the Museum Collection.

1945 *Painting and Sculpture in the Museum of Modern Art: Supplementary List, July 1942–April 1945,* edited by James J. Sweeney; 136 entries, 33 reproductions.

Acquisitions 1940–1946

Of exceptional interest were Orozco's *Dive Bomber and Tank,* a fresco in six interchangeable panels painted in the Museum in late June 1940 just after the fall of France; van Gogh's *The Starry Night,* acquired by exchanging three minor works from the Lillie P. Bliss Bequest; Beckmann's *Departure,* the first of his series of triptychs; and Mondrian's last completed work, *Broadway Boogie Woogie.*

Five extraordinary paintings were bought with the Mrs. Simon Guggenheim Fund: Léger's *Three Women,* Chagall's *I and the Village,* Matisse's *Piano Lesson,* and two elaborate allegories: Blume's *Eternal City* and Tchelitchew's *Hide-and-Seek.*

As the war came to an end several important paintings became available and were purchased: Braque's *Man with a Guitar* (1911), Picasso's *"Ma Jolie"* (1911–12) and his brilliant *Card Player* (1913–14).

The Inter-American Fund, provided by a Trustee in 1942, made possible the acquisition of fifty-eight paintings and sculptures selected in Argentina, Brazil, Chile, Colombia, Cuba, Ecuador, Mexico, Peru, and Uruguay. Lincoln Kirstein, appointed Consultant in Latin-American Art, made the purchases in South America, and Alfred H. Barr, Jr., with Edgar Kaufmann, Jr., made selections in Mexico and Cuba. To quote from the 1943 Latin-American Collection catalog cited above: "Thanks to the second World War and to certain men of good will throughout our Western Hemisphere, we are dropping those blinders in cultural understanding which have kept the eyes of all the American republics fixed on Europe with scarcely a side glance at each other during the past century and a half. In the field of art we are beginning to look each other full in the face with interest and some comprehension. . . ." — A.H.B., Jr.

With the many paintings by the Mexican masters already in the Museum, the works acquired in nine countries in 1942 made possible the "most important collection of contemporary Latin-American art in the United States, or for that matter in the world (including our sister republics to the south)."

Acquisitions year by year, represented by selective lists of artists' names and some titles of works:

1940 *Purchases:* Bérard's *Jean Cocteau,* Stuart Davis's *Summer Landscape,* Ensor's *Tribulations of St. Anthony,* Kokoschka's *Self-Portrait,* MacIver's *Hopscotch,* Rivera's *Agrarian Leader Zapata* (fresco commissioned for Museum exhibition, 1931).
 Commission: Orozco's *Dive Bomber and Tank.*

Gifts: a La Fresnaye, a Nicholson, Stanley Spencer's *The Nursery.*

1941 *By Exchange:* van Gogh's *The Starry Night.*
Purchases: Braque's *The Table* (1928), a de Chirico, a Gris (1911).
Gifts: a Barlach, Bonnard's *The Breakfast Room,* Degas's *Dancers* (c. 1899), a Gorky, Hopper's *New York Movie,* a Mondrian (1925), Noguchi's *Capital,* Rouault's *Christ Mocked by Soldiers.*

1942 *Purchases:* Blume's *The Eternal City,* Braque's *Soda* (1911), Gorky's *Garden in Sochi,* ten Graves gouaches, a Lam, a Matta, a Mérida, Orozco's *Self-Portrait,* Tamayo's *Animals,* Tchelitchew's *Hide-and-Seek.*
By Exchange: Ernst's *Napoleon in the Wilderness.*
Gifts: Beckmann's *Departure,* a Portinari (mural), Schlemmer's *Bauhaus Stairway,* a Torres-García.

1943 *Purchases:* an Archipenko, Brancusi's *The Newborn,* Calder's *The Horse,* Feininger's *The Steamer Odin, II,* Hartley's *Evening Storm,* Hopper's *Gas,* Joseph Stella's *Factories,* a Tunnard.
By Exchange: a Braque (1908).
Gifts: Chagall's *Time Is a River without Banks,* a Figari, Lipchitz's *Blossoming,* a Masson, Mondrian's *Broadway Boogie Woogie,* a David Smith (1938), a Tanguy.

1944 *Purchases:* Balthus's *André Derain,* Feininger's *Viaduct,* two Klees, a Kuniyoshi, Motherwell's *Pancho Villa, Dead and Alive,* Matta's *Le Vertige d'Éros,* Picasso's *Fruit Dish* (1909), Pollock's *The She-Wolf,* Weber's *The Geranium* and *The Two Musicians.*

1945 *Purchases:* Braque's *Man with a Guitar* (1911), Chagall's *I and the Village,* Stuart Davis's *Egg Beater,* Duchamp's *The Passage from Virgin to Bride,* Lam's *The Jungle,* Léger's *Big Julie,* Marin's *Lower Manhattan (Composing Derived from Top of Woolworth),* Miró's *Dutch Interior, I,* O'Keeffe's *Lake George Window,* Picasso's *"Ma Jolie"* (1911–12) and *Card Player* (1913–14), Prendergast's *Acadia.*

1946 *Purchases:* van Doesburg's *Rhythm of a Russian Dance,* Grosz's *Metropolis,* Matisse's *Piano Lesson,* Sutherland's *Horned Forms.*
Gifts: Gottlieb's *Voyager's Return.*

Museum exhibitions from which acquisitions were purchased or given (exhibition directors' names are in parentheses):
1942 *Americans 1942* (Dorothy C. Miller)
1943 *Alexander Calder* (James J. Sweeney)
1946 *Fourteen Americans* (Dorothy C. Miller)

CHAPTER IV
1947–1952

JOHN HAY WHITNEY, who had been elected Chairman of the Board of Trustees on June 6, 1946, was in office throughout this period, serving until December 1956; Nelson A. Rockefeller was re-elected President on June 6, 1946, and remained in that position until June 1953.

René d'Harnoncourt was appointed Director of the Museum in October 1949. During the previous five years he had been Director of the Curatorial Departments and later Chairman of the Coordinating Committee.

William A. M. Burden was appointed Chairman of the Committee on Museum Collections in 1947, serving until 1950, when James Thrall Soby succeeded him.

In February 1947, Alfred H. Barr, Jr., was appointed Director of the Museum Collections, and Dorothy C. Miller, Curator, both in special charge of painting and sculpture. Appointed Advisers to the Museum Collections were Andrew Carnduff Ritchie, Director of Painting and Sculpture, in 1948 (serving until 1957), and René d'Harnoncourt, in 1951 (serving until 1968).

1947

SEPTEMBER 15: After much discussion, an inter-museum agreement was signed by the Whitney, the Metropolitan, and the Modern museums. Under the terms of the agreement, The Museum of Modern Art agreed to "sell to the Metropolitan Museum of Art paintings and sculptures which the two museums agree have passed from the category of modern to that of 'classic.'" Twenty-six European works were sold, including Cézanne's *Man in a Blue Cap,* Maillol's *Île de France* (torso), and Picasso's *Woman in White* (for a complete list see page 654); fourteen examples of American folk art were also sold. The proceeds were used to buy contemporary works for the Museum Collection.

The Metropolitan Museum agreed that whenever a work bought from The Museum of Modern Art was exhibited, cataloged, or reproduced, appropriate reference would be made to the name of The Museum of Modern Art and the name of the original donor.

As part of the same agreement, The Museum of Modern Art received as extended loans Maillol's *Chained Action* and Picasso's *Gertrude Stein,* which the Metropolitan Museum did "not consider inappropriate for lending." (The agreement with the Metropolitan Museum was terminated in February 1953.)

1948

EARLY IN THE YEAR, some older members of the Committee on the Museum Collections, encouraged by adverse newspaper criticism, vigorously questioned the validity of certain acquisitions, including paintings called "abstract expressionist." Purchase was difficult. (Later, in 1952, a member of the Committee "reluctantly" resigned when a Rothko was acquired; another member had resigned when Giacometti's *Chariot* was purchased in 1951; it was "not a work of art," he wrote. Both men, however, remained on the Board of Trustees.)

The second edition of *Painting and Sculpture in the Museum of Modern Art* was published, the Preface by John Hay

Whitney, Chairman of the Board, and Introduction by Alfred H. Barr, Jr. Listed were 797 paintings and sculptures with 384 reproductions; 96 per cent of the works were twentieth-century; thirty-three countries and ninety-nine donors were represented.

Mr. Whitney wrote in his Preface:

The art of our fantastically various world cannot be homogeneous. Two works of art completed yesterday in one and the same city may have nothing more in common than their date and the fact that they are both painted on rectangular canvases. One may present a transforming rediscovery of ancient values too long neglected; the other may be a courageous sortie into unexplored territory. So different will the paintings be that the two artists, and their supporters, may regard each other with contempt. Yet, if the pictures seem superior in quality, both, it is to be hoped, may find their way into the Museum collection, whether they happened to be painted in an American city or somewhere on the other side of this shrinking globe.

In the course of trying to make wise, fair and discriminating choices from the vast panorama of contemporary art there will inevitably be many errors. The Trustees are fully aware of this danger. Yet they believe that it is only by taking such risks that this living, changing collection can best serve the living present and, with the helpful editing of time, the present yet to come.

The Museum's aim of making the collection accessible was explained in the Introduction:

Exhibition in the Museum galleries is, of course, the primary use made of the collection. . . . However, the collection has other uses. Much of it is currently out on loan to special exhibitions in museums throughout the country or abroad. A larger proportion is lent to the Museum's Department of Circulating Exhibitions for its touring shows. The balance is kept in accessible storerooms adjacent to the galleries. Visitors may see any works of art in the storerooms by applying to the office of the Museum Collections. Students, teachers, writers and the interested public are urged to make use of the collection. — A.H.B., Jr.

1949

NOVEMBER: Alfred H. Barr, Jr., compiled a list headed "Gaps in Collection: European Painting 1900–1920" for the Committee on the Museum Collections. (Asterisks were added in the list below to indicate acquisitions made after 1949: a single asterisk signifies a promised or remainder-interest gift, and a double asterisk, a work actually purchased or received):

France and School of Paris
Cézanne, a landscape, 1900–1906**. *Renoir*, a nude, 1915–1916. *Signac* or *Cross*, a painting, 1900–1905**. *Bonnard*, a nude; a flower piece or still life.
Matisse, a fauve painting, 1904–1907*; a still life, 1908–1910. *Rouault*, a nude, 1905–1910; a courtroom or clown picture, 1905–1920**. *Derain*, a fauve oil, 1904–1906**. *Vlaminck*, a fauve oil, 1904–1907**; a landscape, 1910–1914. *Utrillo*, a street scene, 1910–1914. *Modigliani*, a nude**.
Picasso, an early painting, blue period or before, 1900–1904; a circus period painting or pastel, 1905*; a rose period painting, 1906; an early cubist painting, 1908–1909**; a collage, 1912–1914**; an important cubist painting, 1915–1920**; a neo-classic figure, 1918–1921**. *Léger*, an early cubist painting, 1912–1915**; a "machine" painting, 1918–1920**. *Braque*, a cubist painting, 1915–1920. *Delaunay*, an early cubist painting, 1910–1912*; an orphist painting, 1912–1915**.
Outside France
Kandinsky, a painting, 1908–1910**; a painting, 1910–1916**. *Boc-*

cioni, a painting, 1910–1914**. *Carrà*, a metaphysical painting, 1916–1920. *Marc*, a painting, 1910–1914. *Nolde*, a painting, 1910–1915**. *Schmidt-Rottluff*, a painting, 1910–1920**. *Kokoschka*, a composition, 1915–1920. *Klee*, watercolors, 1912–1920**.

Acquisitions 1947–1952

"Exceptionally generous contributions by Mrs. Simon Guggenheim to her purchase fund for masterworks, and the recurring income from the sale to the Metropolitan Museum of older European works of art, particularly those from the Lillie P. Bliss Bequest, gave the Museum resources with which to seize a number of extraordinary opportunities," according to the *Museum Bulletin* (vol. 17, no. 2–3) in 1950.

Mrs. Guggenheim made possible the purchase of Matisse's *The Red Studio* and his variations in bronze of *The Back, I, III,* and *IV* (the "lost" variation *II* was to be acquired in 1956); Picasso's *Three Musicians* (long sought for the collection) and *Night Fishing at Antibes*; La Fresnaye's *The Conquest of the Air*; and Lachaise's *Standing Woman*.

Through funds from the Lillie P. Bliss Bequest, the Museum bought Chagall's *Calvary* and *Birthday*, and Brancusi's great marble *Fish*. Mr. and Mrs. Allan D. Emil gave Picasso's *Three Women at the Spring*.

Preparations for the exhibition *Twentieth Century Italian Art,* 1949, led to several purchases, notably seven Futurist works of 1910 to 1913, including four capital pieces: Boccioni's *The City Rises*, bought with the Guggenheim Fund, and the same artist's bronze striding figure, *Unique Forms of Continuity in Space*, Carrà's *Funeral of the Anarchist Galli*, and Severini's *Dynamic Hieroglyphic of the Bal Tabarin*, the last three purchased with the Bliss fund.

Twelve paintings by New York abstract expressionists were acquired between 1947 and 1952; the artists were Baziotes, Gorky, Kline, de Kooning, Motherwell, Pollock (*Number 1, 1948*, his most important work until then, was purchased in 1950 and two others in 1952), Pousette-Dart, Rothko, Stamos, and Tomlin. Earlier, between 1941 and 1946, paintings by Gorky (two), Gottlieb, Motherwell, and Pollock had been acquired.

Acquisitions year by year, represented by selective lists of artists' names and some titles of works:

1947 *Bequest:* Anna Erickson Levene in memory of her husband, Dr. Phoebus Aaron Theodor Levene: three by Gris (1912, 1913, 1913).
 Gift: Stamos's *Sounds in the Rock.*
 Purchases: Baziotes's *Dwarf*, a Gabo (1941), La Fresnaye's *The Conquest of the Air*, Moore's *The Bride.*

1948 *Bequest:* Abby Aldrich Rockefeller: van Gogh's *Hospital Corridor at Saint Rémy.*
 Gifts: Albright's *Woman*, Nadelman's *Man in the Open Air.*
 Purchases: a Bacon (1946), two Boccioni bronzes, a Braque (1937), Carrà's *Funeral of the Anarchist Galli*, van Doesburg's *Composition (The Cow)*, a Gris (1914), a de Kooning (1948), Lachaise's *Standing Woman.*

1949 *Purchases:* Balla's *Speeding Automobile* and *Swifts: Paths of Movement + Dynamic Sequences*, Brancusi's *Fish*, Chagall's *Birthday* and *Calvary*, de Chirico's *Sa-*

cred *Fish*, a Ferber, Giacometti's *Woman with Her Throat Cut*, a Guttuso, Maillol's *The River*, Matisse's *The Red Studio*, a Morandi (1916), Picasso's *Three Musicians*, Severini's *Dynamic Hieroglyphic of the Bal Tabarin*, Wyeth's *Christina's World*.

1950 *Gifts:* Calder's *Whale*, Corinth's *Self-Portrait*, Masson's *Meditation on an Oak Leaf*, Shahn's *Pacific Landscape*. *Purchases:* a de Chirico, Gorky's *Agony* (1947), Klee's *Equals Infinity*, Lippold's *Variation Number 7: Full Moon*, Modigliani's *Reclining Nude*, two Mondrians (1913–14, 1914?), Motherwell's *Western Air*, a Pevsner (1942), Picasso's *Harlequin* (1915) and *Seated Bather* (1930), Pollock's *Number 1, 1948*, Roszak's *Spectre of Kitty Hawk*, Schwitters's *Picture with Light Center* (1919).

1951 *Gifts:* Davis's *Lucky Strike*, Magritte's *Empire of Light, II*.
Purchases: Boccioni's *The City Rises*, Ensor's *Masks Confronting Death*, Giacometti's *Chariot*, Kirchner's *Street, Dresden* (1908), a Kupka (1911–12), Lipchitz's *Mother and Child, II*, Modigliani's *Caryatid* (stone), Picasso's *Still Life with Liqueur Bottle* (1909) and *Sleeping Peasants* (1919).

1952 *Bequest:* Sam A. Lewisohn: Picasso's *Pierrot* (1918), Rouault's *Three Judges* (1913), Ben Shahn's *Violin Player*.
Gifts: Derain's *London Bridge* (1906), Edwin Dickinson's *Composition with Still Life*, Dubuffet's *Work Table with Letter*, Kline's *Chief* (1950), Picasso's *Three Women at the Spring*, Pollock's *Full Fathom Five* (1947) and *Number 12* (1949), a Rothko (1950), a Tomlin (1949).
Purchases: Gauguin's *Still Life with Three Puppies*, two Légers (1919, 1925), eight Matisse bronzes (including three of *The Back* series and four of the five *Jeannette* portraits), Picasso's *Night Fishing at Antibes* (1939).

Museum exhibitions from which acquisitions were purchased or given (exhibition directors' names are in parentheses):
1947 *Ben Shahn* (James Thrall Soby)
1948 *Elie Nadelman* (Lincoln Kirstein)
1949 *Twentieth Century Italian Art* (James Thrall Soby and Alfred H. Barr, Jr.)
1950 *Chaim Soutine* (Monroe Wheeler)
1951 *Abstract Painting and Sculpture in America* (Andrew Carnduff Ritchie)
1952 *15 Americans* (Dorothy C. Miller)

CHAPTER V
1953–1958

1953

FEBRUARY 15: A radical change of policy was announced by the Board of Trustees. A permanent nucleus of "masterworks" was to be selected under the supervision of the Board. In accord-

ance with this new policy, the 1947 agreement with the Metropolitan Museum was terminated; The Museum of Modern Art would no longer sell to the other institutions its "classical" paintings in order to purchase more "modern" works. Instead it would permanently place on public view masterpieces of the modern movement beginning with the latter half of the nineteenth century.

APRIL 7: The Policy Committee for the Museum's Permanent Collection of Masterworks was appointed; it was to draw up a statement of policy for ratification by the Board. (Their resolution was not presented until three years later.)

SPRING: The Abby Aldrich Rockefeller Sculpture Garden, designed by Philip Johnson, replaced the ingenious but necessarily modest garden of 1939. The new and superb area opened with the exhibition *Sculpture of the Twentieth Century*, directed by Andrew Carnduff Ritchie. Afterwards the Museum's own collection usually occupied the Sculpture Garden.

The Katherine S. Dreier Bequest came to the Museum during this year. Miss Dreier had died on March 29, 1952, and bequeathed ninety-nine works to the Museum, among them fifty-two paintings and sculptures. They included valuable and needed works by Archipenko, Baumeister, Brancusi, Campendonk, Covert, Duchamp, Ernst, Kandinsky, Klee, Léger, Lissitzky, Marcoussis, Miró, Mondrian, Péri, Pevsner, Ribemont-Dessaignes, Schwitters, and Villon.

Miss Dreier was co-founder with Marcel Duchamp and Man Ray of the Société Anonyme: Museum of Modern Art 1920. Together they had collected avant-garde works that were expressionist, post-cubist, and dada and surrealist for the Société Anonyme as well as for Miss Dreier's personal collection. The Société Anonyme collection was presented to Yale University in 1941, at which time both she and Duchamp were appointed trustees. Works from her personal collection came to The Museum of Modern Art through the kind offices of Marcel Duchamp, her old friend and colleague.

Miss Dreier was a painter and had shown at the Armory Show in 1913, where Duchamp's *Nude Descending a Staircase* had shocked the New York art world. One of her best pictures, the *Abstract Portrait of Marcel Duchamp*, painted in 1918, was purchased for the Museum in 1959.

1954

JUNE: The Trustees of the Museum established the Patrons of the Museum Collections to honor the donors of the principal purchase funds and works of art, their names to be listed in publications about the collections and inscribed on a plaque at the entrance to the collection galleries (see list of Patrons, page vi).

OCTOBER 19: The Museum's *25th Anniversary Exhibition* opened with 495 paintings and sculptures from the Museum Collection on view on all three floors and in the new Abby Aldrich Rockefeller Sculpture Garden. Dag Hammarskjöld, Secretary-General of the United Nations, made the inaugural address, in which he said in part:

The art collected here is not modern in the sense that it has the vain ambition of expressing the latest shifting fashions of a mass civilization which long ago lost its anchorage in a firm scale of values, inspired by a generally accepted faith. Nor is it modern in the sense of the comic strips or similar attempts to use the techniques of art to cater for broad emotional needs through a cheap representation of a sentimentalized reality. It is a Museum for "modern art"—that is, for you and for me, a museum for the art which reflects the inner problems of our generation and is created in the hope of meeting some of its basic needs.

FALL: *Masters of Modern Art,* a book on the Museum Collections, was published. It comprised 240 pages and 356 reproductions, seventy-seven of them in color. Edited by Alfred H. Barr, Jr., it encompassed all the collections. A list of contents reveals its scope:

FOREWORD: The Collections of the Museum of Modern Art by John Hay Whitney, Chairman of the Board of Trustees
PREFACE by René d'Harnoncourt, Director
INTRODUCTION by A. H. Barr, Jr., Director of the Museum Collections
PAINTING, SCULPTURE, DRAWING, PRINT COLLECTIONS by A. H. Barr, Jr., and William S. Lieberman
PHOTOGRAPHY COLLECTION by Edward Steichen
THE FILM LIBRARY by Richard Griffith
ARCHITECTURE AND DESIGN COLLECTIONS by Philip C. Johnson
THE MUSEUM COLLECTIONS: COMMITTEES AND DEPARTMENTS
DONORS TO THE COLLECTIONS
BIBLIOGRAPHY AND INDEX OF ARTISTS

From the Preface:

Within the Museum's structure the collection is an intrinsic and important factor. It contributes constantly to all the Museum's varied and far-flung activities. As it grew in scope and excellence it became more and more capable of setting standards and providing a sense of continuity to the activities of the various departments of the Museum. By demonstrating the vast variety of styles and concepts so characteristic of modern art in the recent past, it makes for an open mind and helps keep the institution receptive to new trends.

On the other hand, nearly all departmental activities contributed to the development of the collection. Not only did many works of art come to the Museum's attention through these activities, but the very existence of these activities has created a non-academic climate and kept the Museum close to the realities of today's art life. — René d'Harnoncourt, Director of the Museum

From the Introduction:

The words "best" or "most characteristic" immediately raise certain fundamental questions not only about this volume but about the collection it represents and, indeed, about the Museum itself. The Museum collects works radically different in purpose, medium, school and generation. Who is to say what is really important? The public is often slow to comprehend; critics and museum people are notoriously blind.

Even the artist is no guide. Whistler's contempt for Cézanne was equalled only by Cézanne's contempt for Gauguin. Frank Lloyd Wright assails Le Corbusier. A leading authority on cubism still insists that a Mondrian is not a work of art at all; a devotee of Mondrian denounces the surrealism of Ernst and Dali as perversion of true art; a dadaist of 1920 finds the abstract expressionist of 1950 tedious; and the socialist realist cries a plague on all their bourgeois-bohemian houses.

Artists and their champions may indeed seem a squabbling banderlog of isms. But, actually, they are not; their differences are real and significant, slowly developed, passionately believed in, and expressive not simply of artistic convictions but often of deeply-felt philosophies of life.

Even granting that the Museum should collect works of many kinds, there is still the problem of choosing the best of each. Quality, of course, should be and has been the first criterion. Yet the matter is not so simple. Picasso's *Three Musicians* may be superior in quality to Picasso's *Demoiselles d'Avignon,* but the latter, with all its coarseness and experimental changes of mind may be equally important to the Museum: whatever its esthetic quality, it is a dramatic record of agonistic effort and the first detonation of a great historic movement. — Alfred H. Barr, Jr.

1955

LOANS FROM THE COLLECTION increased to a somewhat disquieting degree. During the two years from July 1, 1953, to June 30, 1955, "the Museum made no less than 783 loans of painting and sculpture to touring exhibitions, television, et cetera, and to 155 special shows in the museums of the United States, Brazil, Canada, England, France, Germany, Israel, Italy, Japan, The Netherlands, Norway, Scotland, Switzerland, and Venezuela" (*Museum Bulletin,* vol. 23, no. 3, 1956).

In addition, 130 American paintings and sculptures were included in the exhibition *50 Ans d'art aux États-Unis: Collections du Museum of Modern Art de New York,* opening in Paris in April of 1955 and later shown in Zurich, Frankfurt, Barcelona, London, The Hague, Vienna, and Belgrade. The show was important particularly because it included twenty American abstract-expressionist paintings, then little known in Europe. Aside from the risks involved in allowing so many works to travel in one group, the Museum was deprived of most of its best American paintings for eighteen months.

Loans to the United States embassies had begun informally in Oslo in 1953 and then officially in Bonn in 1960 through the Museum's International Program; loans to foreign consulates and United Nations embassies in New York had begun earlier. President Dwight D. Eisenhower borrowed a landscape by Fausett and a seascape by Sterne for the White House. Secretary-General Dag Hammarskjöld carefully chose paintings by Braque, Glarner, Gris, Kane, La Fresnaye, Léger, Picasso, and others for his office and reception rooms at the United Nations.

1956

MAY 2: The Policy Committee for the Museum's Permanent Collection of Masterworks presented a resolution to the Board of Trustees for its approval. The resolution, with part of its preamble, follows:

In its early years the Museum of Modern Art, primarily devoted to loan exhibitions, planned its Collections with the stated policy of eventually passing on the works of art to other institutions or otherwise disposing of them as they matured or no longer seemed useful.

However, the Trustees have recently determined, as a radically new departure, to establish a collection of works of art, limited in number and of the highest quality, which shall remain permanently in the Museum's possession. . . .

After discussion, it was, on motion made and seconded, unanimously resolved that:

1. The Trustees of the Museum of Modern Art herewith confirm the establishment of a Permanent Collection of Masterworks of Modern Art.
2. The Permanent Collection of Masterworks shall comprise works of art selected from the Museum's general Collection together with such additions as may be approved from time to time by the Trustees.
3. In general, the Permanent Collection of Masterworks shall not include works of art executed prior to the mid-nineteenth century.
4. The Collection of Masterworks shall have the same degree of permanence as the collections of the other great museums of this country. No work of art accepted as a gift for the Permanent Collection of Masterworks shall be eliminated from it except in accordance with the conditions, if any, originally stipulated by the donor.
5. No works of art shall be eliminated from the Permanent Collection of Masterworks, and no material change shall be made in the policies governing the Permanent Collection of Masterworks, unless approved by three quarters of the Trustees of the Museum then in office. (Quoted in *Painting and Sculpture in The Museum of Modern Art*, 3rd ed., 1958, pp. 5–6.)

DECEMBER 13: Nelson A. Rockefeller was named Chairman of the Board of Trustees, succeeding John Hay Whitney, who was appointed United States Ambassador to Great Britain.

1957

MAY 22: The *Picasso: 75th Anniversary Exhibition* opened. A birthday tribute to Picasso, organized by the Museum with the support of the Art Institute of Chicago and the Philadelphia Museum of Art, the exhibition surveyed sixty years of the artist's work. Shown were over 300 paintings, sculptures, and drawings from ninety-eight public and private collections. A catalog of the exhibition, edited by Alfred H. Barr, Jr., and the biographical record *Portrait of Picasso*, by Roland Penrose, were published in conjunction with the exhibition. Acquired from the show was the *Studio in a Painted Frame* of 1956.

1958

APRIL 15: A fire in the southwest area of the second floor during reconstruction caused total loss of a large mural painting by Monet, a smaller Monet, and a mural by Portinari; damaged but later restored were Boccioni's *The City Rises* and Rivers's *Washington Crossing the Delaware*. The restoration of *The City Rises* was a tour de force by Jean Volkmer, the Museum's conservator.

Although the fire was confined to the second floor, the entire Museum was closed, the gallery walls were dismantled, and improved fireproofing measures were begun. The ground floor was reopened on May 1 to enable visitors to see the two temporary exhibitions on view before the fire, first the *Seurat Paintings and Drawings*, which ran until May 11, and then *Juan Gris*, from May 12 until June 1. The Museum remained closed

for the rest of the summer to undertake a reconstruction program. A conservation laboratory was added and the Library was enlarged.

JUNE: The third edition of *Painting and Sculpture in the Museum of Modern Art: A Catalog* was published. The listing included 1,360 works by artists of some forty different nationalities.

OCTOBER 7: The Museum formally reopened with the exhibition *Works of Art: Given or Promised*. From the Preface to the catalog:

On this, the occasion of its reopening, the Museum of Modern Art is proud indeed to present to the public a truly extraordinary exhibition of works of art recently added to its collections or promised as future gifts. The objects from the excellent collection of the late Philip L. Goodwin; the admirable paintings given by the late Nate B. Spingold and his wife, Frances Spingold; the four superb pictures from the collection of Mrs. David M. Levy; the notable works presented by LeRay W. Berdeau, David Rockefeller and G. David Thompson; the purchases made through the generosity of Mrs. Simon Guggenheim, the great patron of the Museum Collections, and Mr. and Mrs. Peter A. Rübel; all these, taken together, form the most important treasure of new accessions since the Lillie P. Bliss Bequest was received by the Museum in 1934.

Together with the exhibition of these gifts are shown some twenty-five more works of art which occupy a status perhaps unprecedented in American museum history. Several trustees and other friends of the Museum have in the past declared their definite intention to give or bequeath to the Museum a number of the finest works in their collections. Wishing at this time in the Museum's history to make some special gesture of support, they have consulted with the Museum in selecting for the current exhibition a number of works of art, which though not yet presented to the Museum are lent with the promise that they will eventually come into its possession through gift or bequest. These patrons include Mr. and Mrs. William B. Jaffe, William S. Paley, Mrs. John D. Rockefeller, 3rd, Mr. and Mrs. Herbert M. Rothschild, Mrs. Louise R. Smith, James Thrall Soby, the Honorable and Mrs. John Hay Whitney and the two undersigned. Very likely there are others who have similar but hitherto undisclosed intentions and may indicate their willingness to join in future exhibitions of a similar character. Their participation will be very welcome. Meanwhile, the present exhibition of works of art, given or promised, attests to the devotion of the Museum's friends and their particular concern with the future of its Collections.

Nelson A. Rockefeller
Chairman of the Board

William A. M. Burden
President

From the Introduction:

The importance of these works of art to the Museum's collection is very great. Their extraordinary quality is obvious. Their enormous value makes them, practically speaking, irreplaceable. Furthermore, and to a remarkable extent, they will strengthen the collection often where it is weakest. — Alfred H. Barr, Jr.

The artists represented included Arp, Brancusi, Boccioni, Braque, Cézanne (represented by two works), de Chirico (two), Degas, Delaunay, Gauguin, Klee, Léger (two), Lipchitz, Matisse, Miró (two), Mondrian, Monet, Picasso (nine), Renoir (two), Rouault, Seurat (two), Toulouse-Lautrec (two), Vuillard

(three). (Within the next ten years, ten of the thirty-nine works were given to the Museum outright; nine were given with the donors retaining a life interest; eighteen were promised by letter.)

On the same date, October 7, the Museum opened the exhibition of works given by the late Philip L. Goodwin—a small collection but one of exceptional quality. Mr. Goodwin was the first architect of the Museum and Vice Chairman of the Board. His generosity to the architecture and design as well as to the painting and sculpture collections was indeed significant (see 1958 painting and sculpture acquisitions).

The Fall 1958 issue of the *Museum Bulletin* served as an illustrated catalog of the two exhibitions.

Acquisitions 1953–1958

Some major gifts included Rodin's *Balzac*, presented in memory of Curt Valentin by his friends; Matisse's *The Moroccans*, given by Mr. and Mrs. Samuel A. Marx; and Rousseau's *The Dream*, given by Nelson A. Rockefeller. The Katherine S. Dreier Bequest was particularly rich in works by Marcel Duchamp.

Acquisitions year by year, represented by selective lists of artists' names and some titles of works:

1953 *Bequest:* Katherine S. Dreier: Brancusi's *Magic Bird;* Duchamp's *To Be Looked At (From the Other Side of the Glass) with One Eye, Close To, for 'Almost an Hour, Fresh Widow,* and *3 Stoppages étalon;* Ernst's *Birds above the Forest;* Kandinsky's *Blue (Number 393)* and three watercolors (1913); eight Klees; Léger's *Propellers;* Lissitzky's *Proun 19D;* a Mondrian (1926); Pevsner's *Torso;* nineteen works by Schwitters.
Gifts: Stuart Davis's *Visa*, Dufy's *Sailboat at Sainte-Adresse* (1912), a Heckel (1912), Maillol's *The Mediterranean*, a Picasso, a Vantongerloo (1921).
Purchases: Bacon's *Dog*, Brancusi's *Mlle Pogany*, Butler's *The Unknown Political Prisoner* (international first-prize project for a monument), Giacometti's *Artist's Mother*, Gonzalez's *Woman Combing Her Hair*, de Kooning's *Woman, I*, Renoir's *Washerwoman* (bronze).

1954 *Bequest:* Mrs. Sam A. Lewisohn: Cézanne's *L'Estaque*, Soutine's *Maria Lani*, Maurice Sterne's *After the Rain*.
Gifts: Stuart Davis's *Salt Shaker*, Giacometti's *Man Pointing*, Man Ray's *The Rope Dancer*, Redon's *Vase of Flowers*, Rousseau's *The Dream*.
Purchases: Balla's *Street Light*, Delaunay's *Simultaneous Contrasts: Sun and Moon*, two Kandinskys (mural compositions, 1914), a Lipton, Picabia's *I See Again in Memory My Dear Udnie*, a Soutine, a Still (1951), Tanguy's *Multiplication of the Arcs*, Tobey's *Edge of August*.

1955 *Bequest:* Curt Valentin: Beckmann's *Descent from the Cross*.
Gifts: van Dongen's *Modjesko, Soprano Singer*, Ernst's *The King Playing with the Queen*, Matisse's *Goldfish and Sculpture, Jeannette, II*, and *The Moroccans*, Moth-

erwell's *The Voyage*, Nolde's *Christ among the Children*, Rivers's *Washington Crossing the Delaware*, Rodin's *Monument to Balzac*, Tamayo's *Girl Attacked by a Strange Bird*, Tomlin's *Number 9: In Praise of Gertrude Stein*.
Purchases: a Baziotes, a Sam Francis, Léger's *The Divers, II* and *Three Musicians*, Monet's *Water Lilies* (mural), a Nolan, a Picasso, Rodin's *St. John the Baptist Preaching*, a Sickert, a Sutherland.

1956 *Gifts:* a Bacon, a Baumeister, Beckmann's *Self-Portrait with a Cigarette*, Gonzalez's *Torso*, Kirchner's *Artillerymen*, Lachaise's *Knees* (marble), a Macke, Magritte's *Portrait*, a Nolde, five Picassos (including the bronzes *Glass of Absinth* and *Pregnant Woman*), a Renoir, Stettheimer's *Family Portrait, II*.
Purchases: Brancusi's *Socrates*, a Butler, Dubuffet's *The Cow with the Subtile Nose*, Kokoschka's *Tiglon* and *Port of Hamburg*, four Kupkas (including *The First Step*) a Manzù, Matisse's *The Serf, The Back, II*, and *The Rose Marble Table*, two Monets, five Picassos (including the bronzes *Baboon and Young* and *Goat Skull and Bottle*), a Wols.

1957 *Gifts:* a Bazaine, Cézanne's *Le Château Noir*, Degas's *At the Milliner's*, Kirchner's *Emmy Frisch*, Klee's *Still Life with Four Apples* (1909), two Mondrians (1913–14, 1921), a Motherwell, Picasso's *Studio in a Painted Frame* (1956), two Pollocks (1950, 1953–54), Schmidt-Rottluff's *Houses at Night*, Seurat's *Evening, Honfleur*, Shahn's *Father and Child*, Toulouse-Lautrec's *La Goulue at the Moulin Rouge*.
Purchases: Klimt's *The Park*, Picasso's *Woman by a Window*, David Smith's *History of LeRoy Borton*, a Wotruba.

1958 *Bequest:* The collection of Philip L. Goodwin, given by members of his family following the wish of the deceased: Brancusi's *Blond Negress*, de Chirico's *The Great Metaphysician*, a Demuth, a Derain (1905), Dove's *The Intellectual*, a Klee, a Léger (1913), Marin's *Lower Manhattan*, Nadelman's *Woman at the Piano*, a Noguchi, Picasso's *The Rape* (1920).
Gifts: Francis's *Big Red*, Johns's *Target with Four Faces*, Léger's *Exit the Ballets Russes*, Nevelson's *Sky Cathedral*, Rivers's *The Pool*.
Purchases: Giacometti's *Dog*, Gottlieb's *Blast, I*, Heiliger's *Ernst Reuter*, a Gwen John, Johns's *White Numbers* and *Green Target*, a Pollock (1945), a Popova, a Vasarely.

Museum exhibitions from which acquisitions were purchased or given (exhibition directors' names are in parentheses):
1955 *The New Decade* (Andrew Carnduff Ritchie)
1956 *Julio Gonzalez* (Andrew Carnduff Ritchie)
1956 *Twelve Americans* (Dorothy C. Miller)
1957 *David Smith* (Sam Hunter)
Picasso: 75th Anniversary Exhibition (Alfred H. Barr, Jr., and William S. Lieberman)

CHAPTER VI
1959–1963

1959

NOVEMBER: The Thirtieth Anniversary Drive to raise twenty-five million dollars began. A section of the Drive brochure was headed: "The Museum's Invisible Collections":

> The collections of the Museum of Modern Art are in crisis—collections which owe their existence to many hundreds of donors whose generosity has been so extraordinary that the Museum has never drawn on its endowment or its annual budget for purchase funds. Nor is it asking for such funds now, much as it needs them, because its collections face an acute predicament: *invisibility*. The collections must have space for exhibition and accessible storerooms, or the Museum will have failed to meet its obligations toward the public, the artists represented, and the donors—past, present and future—of works of art. . . .
>
> A modern museum must have storage spaces that are conveniently accessible. People with specialized interests—collectors, scholars, foreign visitors—they must be served as well as the general public.

Simultaneously, the special exhibition *Toward the "New" Museum of Modern Art* opened. To dramatize further the need for gallery space, paintings from the collection were hung two or three deep in a densely crowded installation. Some visitors sympathetically disapproved; others unexpectedly liked the rich, traditional effect of "skying."

The collector Larry Aldrich offered the Museum a fund of $10,000 a year for a five-year period to buy works by American artists not yet represented in the painting and sculpture collection. Each work was to cost no more than $1,000. At the end of the first five years, Mr. Aldrich renewed his fund for another such period. With this fund the Museum was able to acquire works by many young artists whose later achievement confirmed their early promise.

1961

FEBRUARY: An exhibition consisting of works pledged or given to the Museum by James Thrall Soby and comprising sixty-nine paintings, sculptures, and drawings was shown at the galleries of M. Knoedler and Company for the benefit of the Museum Library. Works of exceptional interest were Bacon's *Study of a Baboon;* Balthus's *The Street* (1933); eight paintings by de Chirico (1914–17), unmatched in any other collection—among them *Gare Montparnasse (The Melancholy of Departure), The Enigma of a Day, The Duo, The Seer,* and *Grand Metaphysical Interior;* three by Miró: his *Self-Portrait, Portrait of Mistress Mills in 1750,* and the unique *Still Life with Old Shoe;* Picasso's famous *Seated Woman* (1927), *The Sigh* (1923), and the grand *Nude Seated on a Rock* (1921, only 6¼ x 4⅜ inches); Dubuffet's *My Cart, My Garden;* and Shahn's *Liberation.* Also included were paintings by Berman (two), Blume, Bérard, Bonnard, Dali, Ernst, Hartigan, Johns, Klee (two), Leonid (two), MacIver (two), Matta (two), Morandi, Kay Sage, Sutherland, Tanguy (two), and Tchelitchew (three).

Sculptures included Reg Butler's *Figure in Space,* Calder's *Swizzle Sticks,* Cornell's *Taglioni's Jewel Casket,* Giacometti's *Tall Figure,* and works by Chadwick, Lehmbruck (two), Maillol (two), and Marini (two).

A fully illustrated catalog was published, with Preface by Blanchette H. Rockefeller, President of the Board of Trustees, and notes by James T. Soby and Alfred H. Barr, Jr.

1962

MAY–SEPTEMBER: *Picasso in the Museum of Modern Art: 80th Birthday Exhibition* was the most important show based on the Museum Collections during the period from 1959 to 1963. Included were seven sculptures and thirty-four paintings owned by the Museum, along with eighteen promised or fractional gifts; drawings and prints were also included. Picasso's extended loan of the *Guernica* and fifty-three of its studies enhanced the exhibition.

Other exhibitions drawn from the collection during the five-year period included *Fernand Léger* (1960–61; fifteen paintings); *America Seen: Between the Wars* (1961); *Modern Allegories* (1961–63); *André Derain in the Museum Collection* (1963; sixteen paintings).

OCTOBER 22: The Cuban crisis broke; two days later twenty-eight of the Museum's best paintings were sent to prepared vaults over a hundred miles from the city. Soon seventy-four others, almost as valuable, followed—and then still more, including drawings and prints. Other works were substituted on the gallery walls. The crisis was terrible but short.

NOVEMBER–DECEMBER: The fund-raising drive begun in 1959 came to an end, by far the largest and most successful in the Museum's history. Ground-breaking for the new building was celebrated on November 25. The building would house the East Wing Galleries (Fifty-third Street), the East Garden terrace, and beneath it, the Garden Wing (Fifty-fourth Street), with its large gallery; the West Wing would contain accessible Study Storage and the Conservation Laboratory.

1963

MRS. YVES TANGUY (Kay Sage), through the efforts of a Museum Trustee, her close friend James Thrall Soby, left the Museum $104,785.52, the largest purchase fund for painting and sculpture thus far bequeathed. In addition, her bequest included works by Breton, Calder, Delvaux, Hélion, Miró, and others, as well as a large group by her late husband, Tanguy. During her lifetime she had given the Museum a number of other works, notably Magritte's *Portrait.*

JUNE: The Museum's operating expenses for the year ending in June were $2,367,468, compared with about $78,000 in 1933. The Collection of Painting and Sculpture comprised 2,223 works in 1963; there had been nineteen works in 1933. The spaces planned for both public and study galleries were far greater than thirty years before—but they were still not great enough.

DECEMBER: At last the major part of the program of enlarging and remodeling the building could be undertaken. The Museum had to be closed for six months, and during this time none of its contents was accessible to the New York public. However, works of art from the collection were lent to leading museums in the United States and Canada.

DECEMBER 16: The National Gallery of Art in Washington, D.C., opened an exhibition of 153 paintings from the Museum Collections, carefully selected to represent the various modern movements. The choice ranged from Cézanne, van Gogh, and Prendergast to Vasarely, Jasper Johns, and Ellsworth Kelly. The exhibition was enthusiastically welcomed and was attended by 181,153 visitors in a little more than three months.

A catalog of the exhibition *Paintings from the Museum of Modern Art, New York*, was published by the National Gallery. It contained a preface by John Walker, Director of the National Gallery, a foreword by René d'Harnoncourt, and an introduction by Alfred H. Barr, Jr. One hundred pages in length, the catalog reproduced every painting, fourteen of them in color. From the Preface:

The Museum of Modern Art has played a remarkable role both in America and abroad. Opened to the public in 1929 in several rented rooms in a New York office building, it has grown until it now occupies a complex of buildings of its own. But even these quarters have proved too small. Its enlargement this year, necessitating a temporary closing, has provided an opportunity for the National Gallery of Art to show a part of what is probably the most distinguished and representative international collection of modern art to have been assembled anywhere.

The physical growth of The Museum of Modern Art is, to be sure, impressive. But far more significant is the impact it has had on a generation of taste in America. One is apt to forget that forty years ago painters of the School of Paris, artists such as Matisse, Braque and Picasso, were so controversial that for a time their work was considered too radical for many museums. . . .

John Walker, *Director*
National Gallery of Art

From the Foreword:

The Museum of Modern Art was not conceived solely as a repository for works of art; neither has it been limited to the traditional fields of painting, sculpture and the graphic arts but has included besides these architecture, design, photography and the film. Its concern has been to present the interplay among *all* the visual art forms of our time. In setting forth its future goals in its first prospectus of 1929, the Museum states: "The ultimate purpose of the Museum will be to acquire (either by gift or purchase) a collection of the best modern works of art."

René d'Harnoncourt, *Director*
The Museum of Modern Art

From the Introduction:

Art lovers are passionate—and even those who have little interest in art sometimes descend to fury in the presence of paintings they have never sought to understand, especially paintings produced by their contemporaries. Living artists create problems. Working in freedom, they can be exasperating to the individual, and even an embarrassment to the state, if we are to believe such political philosophers as Plato and Stalin. Neither truth nor poetry is often welcomed by society.

The sense of continuity, of tradition, of history is of the greatest importance in our democratic culture. This awareness of the valuable past is well served by the National Gallery collection even when visitors take it for granted. The Museum of Modern Art's period lies in the past, too, but it is a far shorter past: it begins with yesterday and looks back not a few centuries but a few decades. Yet during those few decades the art of painting appears to have widened its horizons more often and more radically than during the previous half millennium. As the expressionst Franz Marc declared, a bit defiantly, "traditions are beautiful—to create—not to follow."

Alfred H. Barr, Jr.
Director of the Museum Collections
The Museum of Modern Art

Acquisitions 1959–1963

Among major works acquired were two mural paintings by Monet from his Water Lilies series, one $19\frac{1}{2}$ feet wide, the other a triptych 42 feet wide, unmatched elsewhere except in Paris. Added to the collection in 1959, they were later installed in the new building in a gallery dedicated to the donor, Mrs. Simon Guggenheim. Thanks to her, another $19\frac{1}{2}$ foot mural, Miró's *Mural Painting*, was bought in 1963.

Also acquired in 1959 were two extraordinary works by Picasso, the bronze *She-Goat* (1950), purchased with the Mrs. Guggenheim Fund, and the *Two Nudes* (1906), the gift of G. David Thompson. In 1961, Henry Moore's *Reclining Figure, II* (1960), was also given by Mr. Thompson.

In 1963 Governor Nelson A. Rockefeller gave Matisse's *Dance* (*first version*, 1909), a mural about the same size as the second version (1910), now in Leningrad. Cézanne's *Le Château Noir*, Degas's *At the Milliner's*, Seurat's *Evening, Honfleur*, and Toulouse-Lautrec's *La Goulue at the Moulin Rouge* had been given in 1957 by Mrs. David M. Levy, the donor retaining a life interest. Upon her death in 1960, these invaluable works came to the Museum. In addition, she bequeathed Picasso's *Violin and Grapes*, reserving for her husband a life interest, which Dr. Levy most generously relinquished so that the painting might immediately join the four nineteenth-century pictures.

Analysis of the 1960 acquisitions as an example of the period: The year's harvest was richer than average in late-nineteenth-century works, sparse in works from the 1940s, and abundant in those of the last few years. Included, as usual, were pastels, watercolors, color collages, assemblages, constructions, as well as painting and sculpture:

Number of acquisitions: 94 (including an extended loan).

Number of older works acquired: 27, dating from a Degas of 1882 to a Torres-García of 1940; one dating from the period 1941 to 1951.

Number of more recent works acquired: 65, dating from 1952 to 1960.

Number of gifts: 59.

Number of purchases: 34, including four dated 1892, 1904, 1905, and 1917, and 28 dating from the last four years: 1956 (2), 1957 (2), 1958 (4), 1959 (12), 1960 (8).

Number of artists: 81. Number of nations represented: 16. Australia 1, Belgium 1, Cuba 1, France 15, Germany 3, Great Britain 3, Italy 8, Japan 1, Poland 2, Spain 2, Switzerland 3, Tanzania 1, Uruguay 1, U.S.A. 37, U.S.S.R. 1, Venezuela 1.

The acquisitions for 1960 were published in the *Museum Bulletin* (vol. 28, nos. 2–4, June 30, 1961), with introduction and eighty-eight illustrations. These checklists of new acquisitions were published regularly in the *Museum Bulletin* from 1950 to 1963.

Acquisitions year by year, represented by selective lists of artists' names and some titles of works:

1959 *Gifts:* an Avery, Boccioni's *The Laugh*, a Guston, Kandinsky's *Picture with an Archer* (1909), Picasso's *Two Nudes* (1906), a Tinguely.
 Purchases: a Léger (1926), Monet's *Water Lilies* (two murals), Newman's *Abraham*, Picasso's *She-Goat*, Rosso's *The Concierge* and *The Bookmaker,* a Rothko (1958), a Frank Stella (1958).

1960 *Bequests:* Mrs. David M. Levy: Cézanne's *Le Château Noir*, Degas's *At the Milliner's*, Seurat's *Evening, Honfleur*, Toulouse-Lautrec's *La Goulue at the Moulin Rouge*, and Picasso's *Violin and Grapes* (1912). (The first four were accessioned in 1957.) Alexander M. Bing: Duchamp-Villon's *Baudelaire* (bronze), a Klee.
 Gifts: works by Balla, Bérard, Bontecou, Burchfield, Frankenthaler, Gottlieb, Hartigan, Hepworth, Jensen, Klee (two), Matisse, Metzinger, Nakian, Noguchi, Richier.
 Purchases: works by Anuszkiewicz, César, Fontana, Kelly, Nevelson (two), Ntiro, Sickert, Tinguely.

1961 *Bequest:* Loula D. Lasker: Matisse's *Lemons against a Fleur-de-lis Background* (1943).
 Gifts: Chamberlain's *Essex*, an Ernst, a Kjarval, a Klee, a Liberman, Moore's *Reclining Figure, II* (1960), Motherwell's *Elegy to the Spanish Republic, 54*, an Oldenburg, a Tajiri, a Tàpies, a Vasarely.
 Purchases: an Albers, Arp's *Floral Nude*, a Botero, Bourdelle's *Beethoven, Tragic Mask*, a Brecht, an Edwin Dickinson, Dubuffet's *Joë Bousquet in Bed* and *Beard of Uncertain Returns*, Indiana's *The American Dream*, a Landuyt, a Latham, a Samaras.

1962 *Gifts:* Lindner's *The Meeting*, Matisse's *Music* (1907), Warhol's *Gold Marilyn Monroe*.
 Purchases: a Bernard (1887), Dubuffet's *Business Prospers*, Epstein's *The Rock Drill*, Marisol's *The Family*, Oldenburg's *Two Cheeseburgers . . . ,* a Reinhardt (1960–61).

1963 *Bequest:* Mrs. Yves Tanguy (Kay Sage): works by Calder, Delvaux, Hélion, Miró, Tanguy, and others.
 Gifts: Ferber's *Homage to Piranesi, I*, Grosz's *Explosion*, Hofmann's *Memoria in Aeternum*, Matisse's *Dance (first version, 1909)*, Ortiz's *Archeological Find*.
 Purchases: a Bontecou, Calder's *Black Widow*, Ipousteguy's *David and Goliath*, two Morris Louis works, a Miró (large mural, 1951), a Poons, a Wesselmann.

Museum exhibitions from which acquisitions were purchased or given (exhibition directors' names are in parentheses):

1959 *New Images of Man* (Peter Selz)
 16 Americans (Dorothy C. Miller)

1960 *New Spanish Painting and Sculpture* (Frank O'Hara)
1961 *Mark Rothko* (Peter Selz)
 Max Ernst (William S. Lieberman)
 15 Polish Painters (Peter Selz)
 The Art of Assemblage (William C. Seitz)
1962 *Jean Dubuffet* (Peter Selz)
 Recent Painting USA: The Figure (staff committee)
 Mark Tobey (William C. Seitz)
1963 *Americans 1963* (Dorothy C. Miller)
 Hans Hofmann (William C. Seitz)

CHAPTER VII
1964–June 1967

1964

EARLY IN THE YEAR, as the expansion of the Museum building was progressing, debates began about the distribution of space in the galleries. Because of the New York World's Fair, which would open on April 22, it was at first felt that the entire second and third floors of the Museum, including the new East Wing, should be used exclusively for the painting and sculpture collection since it had the strongest popular appeal. But this arrangement would have provided no inkling of the other fields in which the Museum is active. Therefore it was decided that all the departmental collections should be given exhibition space, which they would keep until the future phase of the building program could be completed.

MAY 27: The Museum reopened its enlarged building with the space allotted as follows:

Painting and Sculpture from the Museum Collection: exhibition space in second- and third-floor galleries, 19,000 square feet, including the Mrs. Simon Guggenheim Gallery for the Monet *Water Lilies.*

The Paul J. Sachs Galleries for Drawings and Prints: first permanent exhibition space, third-floor galleries, 2,500 square feet.

The Philip L. Goodwin Galleries for Architecture and Design: first permanent exhibition space, second-floor galleries, 2,300 square feet.

The Edward Steichen Photography Center: first permanent exhibition space, third-floor galleries, 1,900 square feet.

The Abby Aldrich Rockefeller Sculpture Garden: exhibition space for sculpture from the Museum Collection, temporary exhibitions of sculpture and, occasionally, of architecture and design, 35,000 square feet.

The ground-floor galleries: exhibition space for temporary exhibitions, 11,000 square feet.

The press release issued at the reopening of the Museum compared the new exhibition space with the old, projecting as well the future needs of the Museum:

	In square feet		
	Past	May 1964	Future
Painting and Sculpture Collection	11,000	19,000	27,600
Drawings and Prints Collection	0	2,500	4,000
Architecture and Design Collection	0	2,300	5,000
Photography Collection	0	1,900	3,400
Sculpture Garden	21,350	35,000	35,000
Temporary exhibitions, ground floor	10,600	11,000	16,000

The Auditorium continued to be used for the daily showings of the Department of Film, and its adjacent gallery for the exhibition of film stills, posters, and other material from the film collection.

In May 1964 painting and sculpture storage in the Museum occupied only 3,300 square feet. In 1966, in order to make the collection more accessible when not on exhibition, a study storeroom of 7,500 square feet was planned and then occupied early in 1968.

To celebrate the Museum's reopening and to honor the New York World's Fair, the large exhibition *Art in a Changing World: 1884–1964* was opened. All five curatorial departments were represented.

For the convenience of visitors to the newly remodeled Museum, a four-page leaflet, with floor plans and a listing and description of the contents of the second and third floors, was published. It was often reprinted as changes or additions were made. (See pages 646–47.)

Some felt that the installation of paintings and sculptures was too dense, but others found that it emphasized the wide range and riches of the collection.

SPRING: Mrs. Florene May Marx (later Mrs. Wolfgang Schoenborn) presented to the Museum (while retaining life interest) three great Matisses: *Woman on a High Stool* (1913–14), *Goldfish* (1915?), and *Variation on a Still Life by de Heem* (1915, 1916, or 1917).

Mrs. Marx and her late husband, Samuel, were residents of Chicago when they began to collect in the 1930s. In 1939–40, three singular pictures formed the nucleus and established the tone of what was to become one of the most distinguished collections in America, the Matisse *Variation* (later deeded to the Museum), Braque's *Yellow Tablecloth*, and Picasso's *Woman Combing Her Hair*. By the acquisition of these three "difficult" pictures, Mr. and Mrs. Marx gave evidence of their discrimination and their disregard for the easy and obvious. As time passed, many works joined these first three, including, in 1951, a great Matisse, *The Moroccans*, which they promised to give to the Museum in five years. It came to the Museum in 1955 followed by the Gonzalez iron *Torso* in 1956.

In 1953, Mrs. Marx was elected a Trustee of The Museum of Modern Art, and James T. Soby and Alfred H. Barr, Jr., at her request, studied the Marx collection. Monroe Wheeler and William S. Lieberman also knew it well.

Early in 1963, Mr. and Mrs. Marx moved from Chicago to New York, only a year before Mr. Marx's death. Shortly thereafter, Mrs. Marx gave to the Museum the three great Matisse paintings. Later, an admirable exhibition, *The School of*

Paris: Paintings from the Florene May Schoenborn and Samuel A. Marx Collection, was held in the Museum, from November 1, 1965, to January 2, 1966.

From the Preface to the catalog:

Now for the first time the paintings, small as well as large, in the Sam and Florene Marx collection (including works given to museums) are to be shown publicly in The Museum of Modern Art and then in the Art Institute of Chicago, the City Art Museum of St. Louis [later the St. Louis Art Museum], the San Francisco Museum of Art and the Museo de Arte Moderno in Mexico City. Florene Marx, now Mrs. Wolfgang Schoenborn, with the gracious agreement of her husband, has made these exhibitions possible. Her fellow Trustees of The Museum of Modern Art wish to thank Mrs. Schoenborn for her public-spirited generosity in lending the collection to the Museum so that it may be shown not only in New York but in other museums across the continent. — A. H. Barr, Jr.

The illustrated catalog also contained an introduction by James T. Soby and notes by Lucy R. Lippard.

Among the forty-five pictures in the exhibition were superb works by Bonnard, Braque, de Chirico, Dubuffet, Dufy, Gris, La Fresnaye, Léger, Matisse, Miró, Modigliani, Picasso, Rouault, and Soutine.

JUNE 30: Some twenty gifts were received for the collection on or before this date as a result of a change in the Internal Revenue Act of 1964, which revoked, after June 30, the tax deductibility of gifts of works of art if the donor retains a life interest. Among the donors and their gifts were:

William A. M. Burden: Arp's *Ptolemy* (1953), Brancusi's *Young Bird* (1928) and *Bird in Space* (1941?), and Mondrian's *Trafalgar Square* (1939–43)

Mr. and Mrs. Ralph F. Colin: Picasso's *Vase of Flowers* (1907)

Henry Ittleson, Jr.: Léger's *Still Life: Composition for a Dining Room* (1930)

Mr. and Mrs. William B. Jaffe: Vuillard's *The Park* (1894)

Florene May and Samuel A. Marx: Matisse's *Woman on a High Stool* (1913–14), *Goldfish* (1915?), and *Variation on a Still Life by de Heem* (1915, 1916, or 1917)

William S. Paley: Picasso's *Boy Leading a Horse* (1905–06)

David Rockefeller: Picasso's *Woman and Dog in a Garden* (1961–62)

David M. Solinger: Giacometti's *Large Head* (1960)

William M. Weintraub: Dubuffet's *Georges Dubuffet in the Garden* (1955)

1965

NOVEMBER: Mrs. Bertram Smith became a Trustee of The Museum of Modern Art, having joined the Committee on the Museum Collections in 1959. Through her friendship with Mr. and Mrs. René d'Harnoncourt, Mrs. Smith had begun to take an interest in the Museum in the mid-1940s and soon started to form her highly selective collection.

In 1956, at the suggestion of Alfred H. Barr, Jr., she bought for the Museum two Picasso bronzes: *Glass of Absinth* (1914) and *Pregnant Woman* (1950). Later she made a fractional gift of her great Kandinsky *Picture with an Archer* (1909) and prom-

ised two gifts: the Matisse *Still Life with Eggplants* (1911) and the Picasso *Woman Dressing Her Hair* (1940).

Mrs. Smith's outstanding collection includes other memorable works: the Braque *Guéridon* (1921); the Giacometti *Invisible Object* (1934) and *Walking Man* (1960); and the Picasso *Meditation* (1904) and *Paloma Asleep* (1952).

OCTOBER: The Trustees reviewed the Museum's loan policy. The ever-increasing requests for the loan of major works presented serious problems. Many factors were considered. Should the Museum continue unchanged its generous policy of making its holdings available to other institutions? Should it, in the case of foreign loans, feel responsible for international good will? Should it lend more readily to institutions that could reciprocate with loans to the Museum? Or should it strive to keep its chief masterpieces always on view for the benefit of its vast New York public and the thousands of transients who count on finding the Museum's most famous works in its galleries?

It was finally decided to limit the loan of major works to exhibitions of high scholarly interest or international importance, devoted either to the work of a single great artist or to a special movement in the history of modern art. But loans to such exhibitions should not deprive the Museum of adequate coverage of the artist's work or of the movement in its own galleries.

In all cases the element of safety was deemed paramount: works in delicate condition should on no account be moved, and loans should be granted only to institutions with reliable methods of handling and adequate security.

1966

SPRING: Alexander Calder wrote a letter to Mr. Barr, as follows: "I have long felt that whatever my success has been, [it was] greatly as a result of the show I had at MOMA in 1943, and now, as I seem to have quite a number of I think important objects 'left over' I would like to make a gift of several of them to the Museum—if you would be interested."

Alexander Calder's sculpture had been shown in an exhibition during the Museum's second season, in 1930–31; in 1934 the motorized mobile, *A Universe*, had been bought for the Museum; in 1939 the *Lobster Trap and Fish Tail* had been commissioned by the Advisory Committee for the stairwell of the Museum's new building.

On September 29, 1943, the large Calder exhibition had opened at the Museum and run through January 16, 1944; it was organized by James Johnson Sweeney, who also wrote the accompanying monograph.

The wall sculpture *Constellation with Red Object* was purchased then; and in 1945, the *Man-Eater with Pennants*, a mobile 30 feet in diameter, was commissioned; the *Whale* (1937), a stabile, was given to the Museum in 1950 by the sculptor, who replaced it with a heavier version, called *Whale, II*, in 1964. The stabile *Black Widow* (1959) was bought in 1963.

The response to Calder's letter of 1966 was immediate. Mr.

Barr and Dorothy Miller went to Roxbury, Connecticut, to see Calder's two studios and the meadow full of large sculptures. Although uncertain of what Calder would concede from their list of the thirteen selections, large and small, they were told: "Oh, you can have them all."

The Committee on the Museum Collections gladly accepted Calder's generous offer, and its Chairman, James T. Soby, declared that it was the most important gift ever made to the Museum by an artist.

Thus the Museum acquired the following works: four early wire figures, including *Josephine Baker*, and two miniature models of lamps (all of the late 1920s); two wood pieces, *Shark Sucker* (1930) and *Gibraltar* (1936); three often-exhibited works, the mobile *Spider* (1939), the stabile *Morning Star* (1943), and *Snow Flurry, I* (1948), a hanging mobile of countless white disks; the model for the huge *Teodelapio* built for the Spoleto festival in 1962, and the monumental *Sandy's Butterfly* (1964), the latter about 13 feet high, with red, black, yellow, and white wings moving above the red stabile.

These thirteen pieces, along with his five gifts of jewelry and *Whale, II*, were exhibited in the Museum for seven months, beginning February 1, 1967.

1967

THE ARCHITECT PHILIP JOHNSON asked the Museum staff to choose potential gifts from his large art collection, much of it avant-garde, in his private museum in Connecticut. Almost fifty works seemed desirable to complement the Museum's Collection of Painting and Sculpture. He generously promised them as future gifts and repeatedly made them available as loans for exhibitions.

Johnson's association with the Museum began in its first year, and in 1932 he was responsible for founding the Museum's influential department of modern architecture. In that same year he bought and gave to the Museum its first major European painting, the portrait of *Dr. Mayer-Hermann* by Otto Dix, which was followed by other gifts through the years.

Much later, in 1954, he again took the Chairmanship of the Department of Architecture and Design. He joined the Board of Trustees in 1957 and became a lively and generous member of the Committee on the Museum Collections.

The 1967 gift included works by important Americans not yet represented in the collection, principally Dine, Flavin, Judd, Robert Morris, Rauschenberg, di Suvero, as well as works by others already represented in the Museum, for example, Johns, Kline, Samaras, Frank Stella, Stankiewicz, and Europeans such as Arman, Arp, Bacon, Fontana, Giacometti, Klee, Moholy-Nagy, and Bridget Riley.

JUNE 17: Formal announcement was made of Sidney Janis's gift of 103 works from his collection to the Museum. Carefully selected over the years, these works represented several generations of artists, exponents of cubism and futurism, hard-edge abstraction, dada and surrealism, abstract expressionism and

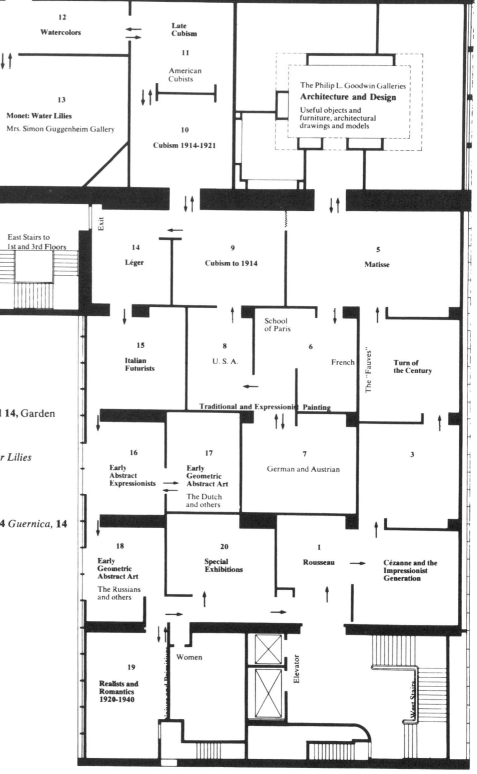

2nd Floor
Collections
Painting and Sculpture
Architecture and Design

Partial list of painters and sculptors with 2nd Floor gallery numbers and references to other floors where their works may be seen. Listing is subject to change. For lack of space not all artists can be shown at the same time. MH—Main Hall, ground floor. ES—East Stairs. WS—West Stairs. 3rd—3rd Floor.

Albers **17**
Balla **15**
Balthus **19**
Beckmann **7, 19**
Blume **19**
Boccioni **15**
Bonnard **4**
Braque **9, 10, 11**
Burchfield **12**
Cézanne **2**
Corinth **4**
Davis, S. **11**
Degas **2**
Delaunay **16**
Demuth **12**
Denis **4**
Derain **4, 6**
Dickinson, E. **8**
van Doesburg **17**
Dove **8, 3rd 3A**
Dufy **6**
Ensor **3**
Feininger **7, 8, 11**
Gabo **18**
Gauguin **3**
Graves **12**
Gris **10**
Grosz **19, 3rd 3A**
Hopper **8**
Kandinsky **16**
Kirchner **7**
Klee **12, 3rd 2**
Klimt **4**
Kokoschka **7**
Kuniyoshi **8**
Kupka **16**
La Fresnaye WS

Léger **14**
Macke **7**
Malevich **18**
Marin **12**
Matisse **4, 5, MH, 3rd 14,** Garden
Modigliani **6**
Moholy-Nagy **18**
Mondrian **17**
Monet **2, 12, 13** *Water Lilies*
Morandi **6**
Nolde **7, 12**
Orozco **19**
Pevsner **18**
Picasso **9, 10, 11, 12**
 3rd WS, 3A, 4 *Guernica,* **14**
Prendergast **4**
Redon **3**
Renoir **2,** Garden
Rickey Garden
Rouault **4, 6**
Rousseau **1**
Schlemmer WS
Seurat **3**
Severini **15**
Shahn **12, 19, 3rd 5**
Sheeler **19**
Sickert **4, 6**
Siqueiros **19**
Soutine **6**
Tchelitchew 3rd **5**
Toulouse-Lautrec **3**
van Dongen **4**
van Gogh **3**
Vlaminck **4**
Vuillard **4**
Weber **8, 11, 3rd 15**

3rd Floor
Collections
Painting and Sculpture
Drawings and Prints
Photography

Partial list of painters and sculptors with 3rd Floor gallery numbers and references to other floors where their works may be seen. Listing is subject to change. For lack of space not all artists can be shown at the same time. MH—Main Hall on the ground floor. ES—East Stairs. WS—West Stairs. 2nd—2nd Floor.

Appel **5**
Arp **3, 3A**
Bacon **5**
Barlach **13, 2nd 7**
Bourdelle **13**
Brancusi **12**
Burri **11**
Butler **16**, Garden
Calder **14, 15**, WS, Garden
Chagall **2**
de Chirico **2**
Dali **3A**
Delvaux **3A**
Dove **3A, 2nd 8**
Dubuffet **5**
Duchamp **1, 3A**
Duchamp-Villon **15**, Garden
Epstein **15**
Ernst **3, 3A**
Giacometti **3A, 14**
Gonzalez **15**
Gorky **7**
Gottlieb **7**, ES
Guston **6**
Hepworth **15**
Hofmann **7**
Ipousteguy Garden
Johns **9**
Kelly **10**
Klee **2, 2nd 12**
Kline **7**
de Kooning **5, 6**
Lachaise **14, 2nd 12**, Garden
Lehmbruck **13**, Garden
Lipchitz **15, 2nd 10**, Garden
Lippold **8**
Louis **9**, MH
Magritte **3, 3A**

Maillol **13, 14**, Garden
Manessier **6**
Marini **14**, Garden
Masson **3**
Matta **6**
Miró **3**, MH
Moore **14, 15** Garden
Motherwell **7**
Nadelman **14**, Garden
Nakian **14**
Nevelson **10**, Garden
Newman **6**
Noguchi **15**
Picabia **1**
Picasso **3A, 4, 14**, WS, **2nd**
Pollock **7**
Rauschenberg **10**
Reinhardt **9**
Richier **14**, Garden
de Rivera **11**, Garden
Rodin **13**, Garden
Rothko **6**
Schwitters **3A**
Segal **8**
Smith, D., Garden
Soulages **6**
de Staël **6**
Still **7**
Sutherland **5**
Tanguy **3A**
Tàpies WS
Tchelitchew **5**
Tobey **7**
Tomlin **7**
Vasarely **10**
Wols **6**
Wyeth **5**
Zorach **14, 2nd 8**

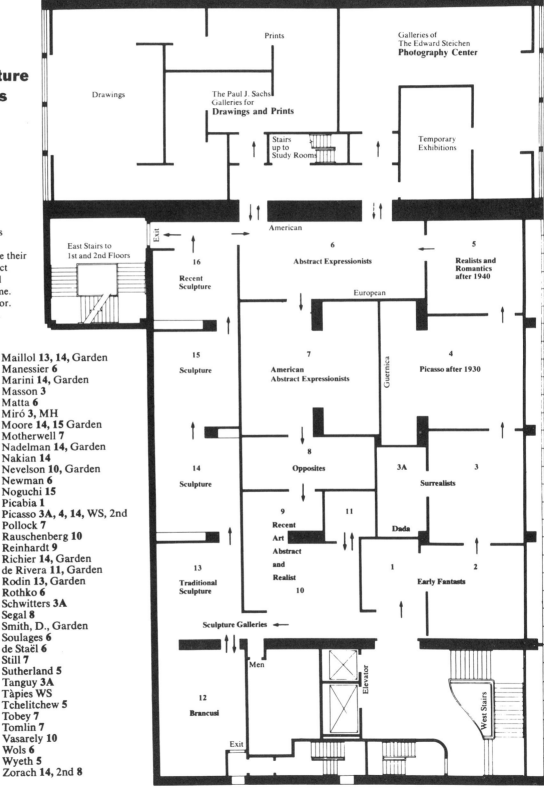

647

pop art. The acquisition enriched, complemented, and refreshed the Museum Collection.

Janis wrote of the gift: "That the Janis collection should find a home at a great museum has long been my hope, and happily the museum of my first love, The Museum of Modern Art, has graciously accepted it."

Besides two capital works, Boccioni's *Dynamism of a Soccer Player* (1913) and Picasso's *Painter and Model* (1928), there were four other Picassos, four Légers, eight Mondrians, the celebrated Klee *Actor's Mask*, as well as a wide range of excellent works by other Europeans: Delaunay (1912), Herbin, van Doesburg, de Chirico (1916), Duchamp (1913), Arp (four), Schwitters (five), Ernst, Magritte, Dali (1929), Giacometti (two), Dubuffet (six), Vasarely; three Russians, Jawlensky, Kandinsky, and Lissitzky; and three artists not previously represented in the Museum Collection, Bellmer, a German surrealist in Paris, Fahlström, a Swede, and Yves Klein, a Frenchman.

Three South Americans were represented: Torres-García, a Uruguayan, Matta, a Chilean, and Marisol, a Venezuelan.

Among the North Americans, hard-edge abstraction was represented by Albers, Macdonald-Wright, and, of a younger generation, Kelly and Anuszkiewicz; abstract expressionism by Gorky, Kline (two), de Kooning (three), Newman, Pollock (two), Rothko, Still, and Tobey; figurative or pop art by Dine, Johns, Oldenburg (two), Rosenquist, and Wesselmann, in addition to Marisol, Segal, and Warhol, who made large portraits of Sidney Janis.

In the remarkable group of "modern primitives" were Hirshfield (six), Kane, Vivin, and others.

Sidney Janis had been interested in the Museum since its opening in 1929. He was a member of its Advisory Committee from 1935 to 1942, and anonymously lent his collection for the Museum's summer show of 1935. Finally, in 1948, he opened his Fifty-seventh Street gallery, which was to become one of the most forward-looking in the city.

His collection, however, remained a thing apart; it was his private garden and naturally he was preoccupied about its final disposition. As a result of a conversation with his friend William Rubin, the newly appointed Curator of Painting and Sculpture, Sidney Janis donated it to the Museum. No less gratifying than this highly valuable gift were its generous conditions; he did not insist on having it permanently exhibited as an entity, and he authorized the Museum to dispose of any works no longer needed ten years after his death in order to provide funds for new acquisitions that would be consistent with the spirit of his collection.

(*The Sidney and Harriet Janis Collection* was exhibited in the Museum from January 17 to March 4, 1968, and was later sent on tour. The definitive, fully illustrated catalog of the collection, *Three Generations of Twentieth-Century Art: The Sidney and Harriet Janis Collection*, was published in 1972, with a foreword by A. H. Barr, Jr., and an introduction by Mr. Rubin, in addition to comments on the works by Lucy R. Lippard and others.)

JUNE 28: Opening of the exhibition *The 1960s: Painting and Sculpture from the Museum Collection*, Dorothy C. Miller, Director. From the checklist:

This exhibition of 127 works of art made in the 1960s, or shortly before, was selected from more than twice that number in the Museum Collection. . . .

The works in this show were chosen to illustrate forms of expression which have developed within the last ten years and which seem particularly characteristic of this decade. They include works influenced by dada and surrealism, assemblage, stain and color-field painting, systemic painting, hard-edge abstraction, primary sculpture, the shaped canvas, optical and kinetic art, and various forms of realism including "pop" art.

Among the works in the exhibition are 32 recent acquisitions not previously shown or announced and 16 paintings and sculptures lent by Philip Johnson, who has promised them as future gifts to the Museum. — D.C.M.

Exhibitions from the Collection 1964–1967

The diversity of the painting and sculpture collection was reflected in the scope of the special exhibitions drawn from the collection during these three years. They included:

1964 *Recent Acquisitions: South Asian Painting*
 Family Portraits
1965 *Recent Acquisitions: Assemblage*
 Around the Automobile
1966 *Recent Acquisitions: Epstein and Others*
1967 *Recent Acquisitions: Calder, 19 Gifts from the Artist*
 Latin-American Art 1931–1966
 The 1960s: Painting and Sculpture from the Museum Collection

Acquisitions 1964–1967

During this period several important funds were contributed to benefit the painting and sculpture collection:

The estate of Miss Loula D. Lasker donated $25,000 for the purchase of a painting in her name.

Mrs. George Hamlin Shaw bequeathed a nineteenth-century painting to be disposed of at the discretion of the Museum. Thanks to its sale, a fund of $20,000 was set up in her name.

Mrs. Lyonel Feininger contributed $20,000 toward the purchase of an important painting by her late husband.

Mr. Larry Aldrich, who in 1959 had set up a purchase fund, generously continued to make available $10,000 a year for the purchase of paintings and sculptures.

Mrs. Simon Guggenheim continued her generous periodic gifts, which, during this span of three-and-a-half years, amounted to $297,147 and brought her total contributions to over a million dollars.

Paintings. Of critical interest among acquisitions of European paintings of the older generation were Cézanne's *Melting Snow, Fontainebleau* (c. 1879), given by André Meyer, and Redon's remarkable *Butterflies* (1910), given by Mrs. Werner E. Josten in memory of her husband.

Among European paintings of the next generation, the Picasso *Studio with Plaster Head* (1925) was probably the most important acquisition within this period, along with his *Two Heads* (1909) and *Sylvette* (1954); also noteworthy were Léger's *Mural Painting* (1924), Derain's *Martigues* (1908–09) and *Still Life with a Blue Hat* (1912), and Carrà's *Jolts of a Cab* (1911).

The Menaced Assassin (1926) by Magritte was bought with the fund bequeathed by Kay Sage Tanguy, who had previously

given the Magritte *Portrait*, one of the Museum's surrealist gems.

From the 1966 sale of the collection of the late G. David Thompson, a Trustee, the Museum bought five exceptional paintings that reflect his discriminating taste: Dubuffet's *Wall with Inscriptions*, Appel's *Étienne-Martin*, Manessier's *For the Feast of Christ the King*, Miró's *Person, Woman, Bird, Star at Sunset*, and Klee's *Portrait of an Equilibrist*, reproduced in a simplified zinc cut by the Museum on the catalog cover of its Klee exhibition in 1930.

Americans of the older period were represented by two fine 1909 studies of a Maine mountain by Hartley, a bequest of Lee Simonson; three paintings by Eilshemius given by Fania Marinoff, widow of Carl Van Vechten; and Joseph Stella's *First Light*, Macdonald-Wright's *Embarkation*, and Tobey's *The Void Devouring the Gadget Era*.

Two paintings by Lyonel Feininger, *Uprising* (1910) and *Manhattan, I* (1940), were given by his widow, Julia Feininger; she also contributed generously, along with Mr. and Mrs. Ralph F. Colin and Mr. and Mrs. Richard K. Weil, to the purchase of Feininger's painting *Ruin by the Sea* (1930).

Accessions dating from the 1960s by an international group of artists included *The Princess*, by French, an Australian; *Skater*, by Colville, a Canadian; *The Mosque*, by Salahi, a Sudanese; *Man with Yellow Pants*, by Pistoletto, an Italian; and *Ju-Ju's Wedding* by Skunder, an Ethiopian. The Portuguese-French Vieira da Silva's *The City* was another of the international accessions, but dates from 1950–51. Among the American works added to the collection from the 1960s were Porter's *Flowers by the Sea*, Hirsch's *Daybreak*, D'Arcangelo's *Highway U.S. 1, Number 5*, Lichtenstein's *Flatten—Sand Fleas!*, Warhol's *Campbell's Soup* (two), and Copley's *Think*.

Within the field of social comment were *The Ohio Gang* by R. B. Kitaj and *Freedom Now, Number 1* by Daniel LaRue Johnson, both Americans; *Micrography* by Genovés, a Spaniard; and *Box of Gentlemen* by Seguí, an Argentine.

Among the abstract hard-edge painters represented were the Americans Gene Davis, Feitelson, Krushenick, Sills, and Youngerman; the Englishman Denny; and the Italian Dorazio.

The Wild, by Newman, *Radiance*, by Pousette-Dart, and *The Tree*, by Agnes Martin, also acquired during this period, were abstract, even transcendental.

The monumental *Double Metamorphosis, II*, by Agam, bought by Mr. and Mrs. George M. Jaffin from *The Responsive Eye* exhibition in 1965, was outstanding among accessions in the field of optical art. Others were Vasarely's *CTA-104-E*, Riley's *Current*, Town's *Optical Number 9*, Šutej's *Bombardment of the Optic Nerve, II*, Cruz-Diez's *Physichromie, 114*, Costa's *Visual Dynamics*, and works by Cunningham, Fangor, Le Parc, Mac-Entyre, Sihvonen, and Uecker.

Among the works acquired from the exhibition *The New Japanese Painting and Sculpture* in 1966 were paintings by Domoto, Inokuma, Kawashima, Tanaka, and Yamaguchi, and sculptures by Miki, Niizuma, and Yoshimura.

The 1967 exhibition *Latin-American Art 1931–1966*, drawn from the Museum Collection, included recent acquisitions by refreshingly novel artists such as Eielson, Fernández, Mishaan, Paternosto, Polesello, and Rodríguez-Larrain, their works all dating from 1964 to 1966.

Seven contemporary Russian paintings, of a kind not endorsed by the Soviet regime, were acquired in June 1967. Among these, Plavinsky's *Voices of Silence* (1962) and *Coelacanth* (1965) were of special interest.

Sculpture. A large number of American sculptures were added to the collection. Three bronzes by Lachaise, the greatest sculptor of his generation in the United States, were given: *Woman Arranging Her Hair* (1910–12), *Mountain* (1924), and *Henry McBride* (1928), a portrait of the most discerning American art critic of his time.

Five major works by Americans were acquired through the Mrs. Simon Guggenheim Fund. Three were masterly in geometrical form: the Nevelson *Atmosphere and Environment, I*, the Smith *Zig, III*, and the Rickey *Two Lines—Temporal I*. Two were abstract-expressionist in character: the Lipton *Manuscript* (1961), imposing in its quietude, and the Nakian *Hiroshima*, a vision of charred terror.

Also expressionist in style but contrasting in mood were the Kiesler *Landscape—Marriage of Heaven and Earth*, purchased with the Kay Sage Tanguy Fund, and the Noguchi *Stone of Spiritual Understanding*, a gift of the artist.

Three sculptures of the 1960s were the Bladen untitled painted-and-burnished aluminum work in three identical parts, purchased with the James Thrall Soby Fund; Liberman's burnished aluminum *Temple, I*, given in memory of Fernand Leval; and the de Rivera *Steel Century Two*, given by the American Iron and Steel Institute.

Works by sculptors of the older generation were Archipenko's *Boxing* (1914), Moore's singular *Large Torso: Arch*, and six miniature plaster figures by Giacometti, given by Mr. and Mrs. Thomas B. Hess. Works of a younger generation included Paolozzi's *Lotus*, Kalinowski's *The Gate of the Executed*, and Pomodoro's *Sphere, I*.

Besides the already mentioned *McBride* by Lachaise and the *Josephine Baker* by Calder, several portraits provided lively contrasts: Serrano's imposing bronze head of the self-exiled Spanish poet Antonio Machado relates interestingly to Gonzalez's *Head of the Montserrat, II*, for both artists were deeply involved in Spanish political issues. Lady Epstein donated six original Epstein plasters, of which three are of special interest: *Robert Flaherty, Haile Selassie*, and *Pandit Nehru*; and from Fania Marinoff came Epstein's *Paul Robeson*.

The Museum's already rich dada-surrealist collection was augmented by Mr. and Mrs. Pierre Matisse's gift of Miró's *Object*, singled out by James Thrall Soby as "one of the classic surrealist images"; by the gift of an inscribed replica of Duchamp's *Why Not Sneeze Rose Sélavy?*; and by the purchase of three works by Man Ray: *Cadeau*, a flatiron bristling with tacks; *Emak Bakia*; and *Indestructible Object*, a metronome with cutout photograph of an eye on the pendulum.

Also acquired were assemblages by younger dada-surrealists, among them Kienholz's *The Friendly Grey Computer—Star Gauge Model #54*, a motorized rocking chair; Tinguely's Fragment from *Homage to New York*, a very large and elaborate

assemblage set in motion and destroyed in the Museum Sculpture Garden in 1960; and Arman's *Collection*, an assemblage of split toy automobiles and matchboxes.

Other acquisitions from these years included three works by Trova from the Falling Man series and Gallo's *Girl in Sling Chair*, all figurative; the Baschet brothers' *Glass Trombone*, a "new musical instrument"; Bauermeister's *Progressions;* Haese's *In Tibet;* Hinman's *Poltergeist;* Kauffman's *Red-Blue;* and Baertling's *Agriaki.* Two sculptures in the field of transparency were Bell's *Shadows* and Olson's *Optochromi H 12-4.* Several examples of kinetic sculpture acquired included Soto's *Olive and Black*, depending only on air currents to be set in motion, as well as motor-driven works such as Bury's *1,914 White Points* and *31 Rods Each with a Ball*, Mack's *Silver Dynamo*, Mallory's untitled construction with mercury, and Schöffer's *Microtemps 11*, a small illuminated stage. The Chryssa *Five Variations on the Ampersand*, a neon-light construction, was acquired in 1966. Five gifts from the Olivetti Company of Italy also come under the headings of motion and light: Boriani's *Magnetic Surface*, Colombo's *Pulsating Structuralization*, Group N's *Unstable Perception*, Landi's *Geometrical Kinetic Variations,* and Varisco's *Dynamic Lattice A.*

Acquired in 1964 was Wilfred's unusual *Lumia Suite, Op. 158*, a composition in color, motion, and light, projected on a 6 x 8 foot screen, and installed in a darkened gallery near the Auditorium.

Four Japanese-paper works by the American Byars were acquired in 1965–66. Three-dimensional in form, they were designed as performance pieces.

Museum exhibitions from which acquisitions were purchased or given (exhibition directors' names are in parentheses):
1964 *Eduardo Paolozzi* (Peter Selz)
1965 *The Responsive Eye* (William C. Seitz)
 René Magritte (James Thrall Soby)
1966 *Reuben Nakian* (Frank O'Hara)
 The New Japanese Painting and Sculpture (Dorothy C. Miller and William S. Lieberman)

CODA

In the late 1960s several senior members of the staff and of the Committee on the Museum Collections retired. In 1967 this Committee was divided into separate units, one for each curatorial department, the largest and most active of which is the Committee on Painting and Sculpture.

James Thrall Soby left the Chairmanship of the Committee on the Museum Collections on June 30, 1967. He had joined the Committee in 1940 and had acted as its Chairman in 1941–42, from 1944 to 1946, and then from 1950 to 1967. He became a Trustee in 1942 when, as a staff volunteer, he directed the Museum's Armed Services Program. During 1943 he was Assistant Director of the Museum, and from late 1943 to 1945 he was Director of Painting and Sculpture. After leaving the staff he held the Chairmanship of the Department of Painting and Sculpture Exhibitions. Through the years he produced many of the Museum's important exhibitions and catalogs.

René d'Harnoncourt joined the staff in 1944 and served on its Administrative Council as Vice President in Charge of Foreign Activities. In 1946 he became director of the Museum's curatorial departments and was elected a Trustee. He became Director of the Museum in 1949, and served as Adviser to the Committee on the Museum Collections from 1951 on. He retired as Director on June 30, 1968, and died tragically on August 13 of that year.

Monroe Wheeler joined the staff as Membership Director in 1938, having served since 1936 on the Advisory Committee. In 1939 he became Director of Publications, and in 1941 Director of Exhibitions and Publications. He was elected a Trustee in 1944, and since his retirement on June 30, 1967, has been Counselor to the Trustees.

Dorothy C. Miller joined the staff in 1934. She was Assistant Curator of Painting and Sculpture from 1935 until 1943, Curator until 1947, then Curator of the Museum Collections from 1947 through 1967, with special responsibility for painting and sculpture. She retired on June 30, 1969, as Senior Curator of Painting and Sculpture.

The compiler of this chronicle, Alfred H. Barr, Jr., was Director of the Museum, as well as its Curator of Painting and Sculpture, from the Museum's founding in 1929 until late 1943. In 1940 he was elected a Trustee. He was Advisory Director from 1943 until 1947, when he became Director of the newly formed division of the Museum Collections. In this position, as Director of the Museum Collections, he had special responsibility for the Collection of Painting and Sculpture, but was also charged with overseeing the collections of the other four curatorial departments. He retired June 30, 1967, becoming a Counselor to the Trustees.

THE LILLIE P. BLISS BEQUEST

THE CORNERSTONE of the Museum Collection was the magnificent bequest of Miss Lillie P. Bliss, one of the seven founders of the Museum. At her death in 1931, many fine paintings, drawings, watercolors, and prints from her collection were promised to the Museum under the sole condition that it be sufficiently endowed to become in fact what it was in name—a museum. Within three years the Trustees had raised the required funds.

All but the fifty prints and four textiles in the Bliss Collection are listed below. Because of the generous terms of her will, the Museum has been able to sell or exchange works from the bequest to make other needed acquisitions. (A provision of her will requiring that certain works could only be released to The Metropolitan Museum of Art has been scrupulously honored.) Those works no longer in the Museum Collection are marked with an asterisk. As in the Catalog, the number preceding an entry refers to the page on which the work is illustrated, and a date appears in parentheses if it is not inscribed on the work. Biographical information is given only for artists not listed elsewhere in the Catalog. *Bliss 1934* refers to the catalog of the collection, *The Lillie P. Bliss Collection, 1934,* published at the time of accession.

The acquisitions made with the Bliss Bequest through 1967 immediately follow the listing of the collection.

CÉZANNE, Paul.

Paintings

*MAN IN A BLUE CAP (UNCLE DOMINIC). (1865–66) Oil on canvas, 32¼ x 26⅛″. *Bliss 1934,* no. 1, repr.

*THE ROAD. (c. 1875) Oil on canvas, 23½ x 28¾″. *Bliss 1934,* no. 2, repr.

*CHOCQUET IN AN ARMCHAIR. (1877) Oil on canvas, 17¾ x 14¼″. *Bliss 1934,* no. 4, repr.

*PEARS AND KNIFE. (c. 1878) Oil on canvas, 8⅛ x 12¼″. *Bliss 1934,* no. 3, repr.

*THE WATER CAN. (c. 1880–82) Oil on canvas, 10⅝ x 13¾″. *Bliss 1934,* no. 5, repr.

12 THE BATHER. (c. 1885) Oil on canvas, 50 x 38⅛″. *Bliss 1934,* no. 8, repr.

*PORTRAIT OF MME CÉZANNE. (1885–87) Oil on canvas, 18⅛ x 15⅛″. *Bliss 1934,* no. 7, repr.

*FRUIT AND WINE. (1885–88) Oil on canvas, 20⅞ x 25⅜″. *Bliss 1934,* no. 6, repr.

14 STILL LIFE WITH APPLES. (1895–98) Oil on canvas, 27 x 36½″. *Bliss 1934,* no. 9, repr.

14 PINES AND ROCKS. (c. 1900) Oil on canvas, 32 x 25¾″. *Bliss, 1934,* no. 10, repr.

15 ORANGES. (1902–06) Oil on canvas, 23⅞ x 28⅞″. *Bliss 1934,* no. 11, repr.

Watercolors and Drawings

*HOUSE AND BARRIER. (c. 1880) Watercolor, 7⅜ x 4⅝″. *Bliss 1934,* no. 14, repr.

13 THE BRIDGE AT GARDANNE. (1885–86) Watercolor, 8⅛ x 12¼″. *Bliss 1934,* no. 13a, repr. On reverse: *View of Gardanne.* Pencil. *Bliss 1934,* no. 13b, repr.

13 BATHERS. (1885–90) Watercolor and pencil, 5 x 8⅛″. *Bliss 1934,* no. 12, repr.

*PROVENÇAL HOUSE AND TREES. (c. 1890) Watercolor, 12⅝ x 19″. *Bliss 1934,* no. 15, repr.

*BATHERS UNDER A BRIDGE. (c. 1895–1900) Watercolor, 8¼ x 10¾″. *Bliss 1934,* no. 18a, repr. On reverse: Anatomical drawing (Study of Houdon's *Écorché*). Pencil, 10¾ x 8¼″. *Bliss 1934,* no. 18b, repr.

13 FOLIAGE. (1895–1900) Watercolor and pencil, 17⅝ x 22⅜″. *Bliss 1934,* no. 21a, repr. On reverse: *Study of Trees.* Watercolor. *Bliss 1934,* no. 21b

13 ROCKS AT LE CHÂTEAU NOIR. (Previous title: *Rocky Ridge.*) (1895–1900) Watercolor and pencil, 12½ x 18¾″. *Bliss 1934,* no. 20, repr.

*MONT STE.-VICTOIRE. (c. 1900) Watercolor, 11½ x 18″. *Bliss 1934,* no. 17, repr.

13 HOUSE AMONG TREES. (c. 1900) Watercolor, 11 x 17⅛″. *Bliss 1934,* no. 16, repr.

*TREES AMONG ROCKS. (c. 1900) Watercolor, 18⅛ x 11″. *Bliss 1934,* no. 19, repr.

DAUMIER, Honoré-Victorin. French, 1808–1879.

*THE LAUNDRESS. (1861) Oil on wood, 19⅝ x 13⅛″. *Bliss 1934,* no. 22, repr.

DAVIES, Arthur B.

THE WINE PRESS. (1918) Oil on canvas, 32¼ x 24¼″. *Bliss 1934,* no. 23, repr.

36 ITALIAN LANDSCAPE. (1925) Oil on canvas, 26⅛ x 40⅛″. *Bliss 1934,* no. 24, repr.

DEGAS, Hilaire-Germain-Edgar.

Paintings

*RACE HORSES. 1884. Oil on canvas, 18¼ x 21⅝″. *Bliss 1934,* no. 25, repr.

*AFTER THE BATH. 1885. Pastel, 25½ x 20″. *Bliss 1934,* no. 26, repr.

Drawings

*MADONNA AND CHILD. Study after a Milanese work of c. 1500. (Before 1860) Pencil, 13¼ x 10¼″. *Bliss 1934,* no. 27.

*HEAD OF AN OLD MAN. After a drawing attributed to Clouet. Pencil, 12 x 9¼″. *Bliss 1934,* no. 28, repr.

*HEAD OF A YOUNG MAN. Study after a 15th-century Italian portrait. Crayon, 11⅛ x 8½″. *Bliss 1934,* no. 29, repr.

*WOMAN'S HEAD. Study of the head of the Virgin in Leonardo's *Madonna of the Rocks.* Pencil, 11⅛ x 7″. *Bliss 1934,* no. 30, repr.

*PORTRAIT OF A GIRL. After a drawing attributed to Pontormo. Pencil, 14½ x 11″. *Bliss 1934,* no. 31, repr.

*BALLET DANCERS. Charcoal, 39¾ x 27½″. *Bliss 1934,* no. 32, repr.

DELACROIX, Ferdinand-Victor-Eugène. French, 1798–1863.

*Drawing of details from an altarpiece of the School of Perugino. Pencil, 6⅛ x 9″. *Bliss 1934,* no. 33, repr.

DERAIN, André.

62 MME DERAIN. (Previous title: *Head of a Woman.*) (1920) Oil on canvas, 14¾ x 9¼″. *Bliss 1934,* no. 34, repr.

*THE FARM. (1922–24) Oil on canvas, 19³/₄ x 24″. *Bliss 1934*, no. 35, repr.

62 LANDSCAPE, SOUTHERN FRANCE. (1927–28) Oil on canvas, 31¹/₂ x 38″. *Bliss 1934*, no. 36, repr.

GAUGUIN, Paul.

24 THE MOON AND THE EARTH [*Hina Te Fatou*]. 1893. Oil on burlap, 45 x 24¹/₂″. *Bliss 1934*, no. 37, repr.

*HEAD OF A TAHITIAN. Oil on canvas, 18 x 13″. *Bliss 1934*, no. 38, repr.

GUYS, Constantin. Dutch, 1805–1892.

*THE SULTAN'S COACH. Watercolor, 9 x 14″. *Bliss 1934*, no. 39, repr.

*LADY IN A PLUMED HAT. Wash, 13 x 8¹/₄″. *Bliss 1934*, no. 40, repr.

ITALIAN SCHOOL.

*CLASSICAL LANDSCAPE. (17th or 18th century) Bistre, 5¹/₈ x 7¹/₂″. *Bliss 1934*, no. 41, repr.

KUHN, Walt.

JEANNETTE. 1928. Oil on canvas, 30 x 25″. *Bliss 1934*, no. 42, repr.

LAURENCIN, Marie.

GIRL'S HEAD. (1910–20) Wash, pencil, and crayon, 6¹/₂ x 7″. *Bliss 1934*, no. 43.

MATISSE, Henri.

57 INTERIOR WITH A VIOLIN CASE. (1918–19, winter) Oil on canvas, 28³/₄ x 23⁵/₈″. *Bliss 1934*, no. 44, repr.

*GIRL IN GREEN. (c. 1921) Oil on canvas, 25¹/₂ x 21¹/₂″. *Bliss 1934*, no. 45, repr.

MODIGLIANI, Amedeo.

112 ANNA ZBOROWSKA. (1917) Oil on canvas, 51¹/₄ x 32″. *Bliss 1934*, no. 46, repr.

PICASSO, Pablo.

80 GREEN STILL LIFE. (1914) Oil on canvas, 23¹/₂ x 31¹/₄″. *Bliss 1934*, no. 47, repr.

*WOMAN IN WHITE. (1923) Oil on canvas, 39 x 31¹/₂″. *Bliss 1934*, no. 48, repr.

PISSARRO, Camille. French, 1830–1903.

*BY THE STREAM. 1894. Oil on canvas, 13 x 16″. *Bliss 1934*, no. 49, repr.

REDON, Odilon.

*ETRUSCAN VASE. Tempera, 32 x 23³/₄″. *Bliss 1934*, no. 50, repr.

26 ROGER AND ANGELICA. (c. 1910) Pastel, 36¹/₂ x 28³/₄″. *Bliss 1934*, no. 51, repr.

26 SILENCE. (c. 1911) Oil on gesso on paper, 21¹/₄ x 21¹/₂″. *Bliss 1934*, no. 52, repr.

RENOIR, Pierre-Auguste.

*FOG AT GUERNSEY. 1883. Oil on canvas, 21 x 25³/₄″. *Bliss 1934*, no. 53, repr.

ROUSSEAU, Henri.

4 JUNGLE WITH A LION. (1904–10) Oil on canvas, 15¹/₈ x 18¹/₄″. *Bliss 1934*, no. 54, repr.

SEGONZAC, André Dunoyer de.

65 LANDSCAPE. (c. 1928) Watercolor, 18⁷/₈ x 24³/₄″. *Bliss 1934*, no. 55, repr.

SEURAT, Georges-Pierre.

22 PORT-EN-BESSIN, ENTRANCE TO THE HARBOR. (1888) Oil on canvas, 21⁵/₈ x 25⁵/₈″. *Bliss 1934*, no. 56, repr.

Drawings

THE STONE BREAKERS. (c. 1881) Conté crayon, 12¹/₈ x 14³/₄″. *Bliss 1934*, no. 61, repr.

*BALLET DANCER IN A WHITE HAT. (1881–82) Crayon, 9 x 6″. *Bliss 1934*, no. 57, repr.

*REHEARSAL. (1881–82) Crayon, 8⁷/₈ x 5¹/₂″. *Bliss 1934*, no. 58, repr.

*TWO DANCERS. Crayon, 5³/₄ x 9″. *Bliss 1934*, no. 59, repr.

*THE ARTIST'S MOTHER. (c. 1883) Conté crayon, 12³/₈ x 9¹/₂″. *Bliss 1934*, no. 62, repr.

*HOUSE AT DUSK. (c. 1884) Conté crayon, 12 x 9³/₈″. *Bliss 1934*, no. 60, repr.

AT THE CONCERT EUROPÉEN. (1887–88) Conté crayon, 12¹/₄ x 9³/₈″. *Bliss 1934*, no. 63, repr.

*LADY FISHING. (c. 1885) Conté crayon, 12¹/₈ x 9³/₈″. *Bliss 1934*, no. 64, repr.

SIGNAC, Paul.

23 HARBOR OF LA ROCHELLE. 1922. Watercolor, 11 x 17⁵/₈″. *Bliss 1934*, no. 65, repr.

TOULOUSE-LAUTREC, Henri de.

*MAY BELFORT IN PINK. (1895) Oil on cardboard, 24¹/₂ x 19″. *Bliss 1934*, no. 66, repr.

ACQUIRED THROUGH THE LILLIE P. BLISS BEQUEST

1939
Picasso: *Les Demoiselles d'Avignon*, 1907

1941
Braque: *The Table*, 1928
de Chirico: *The Delights of the Poet*, 1913
van Gogh: *The Starry Night*, 1889
Gris: *Still Life*, 1911
Rouault: *Woman at a Table*, 1906

1942
Braque: *Soda*, 1911
Hélion: *Equilibrium*, 1934
Picasso: *Still Life with a Cake*, 1924
Watkins: *Transcendence* (14 costume and scenery designs for the ballet), 1934
1 drawing

1943
Archipenko: *Woman Combing Her Hair*, 1915
Barnes: *High Peak*, 1936
Bloom: *The Synagogue*, c. 1940
Brancusi: *The Newborn*, 1915
Calder: *The Horse*, 1928

Feininger: *The Steamer Odin, II*, 1927
Hartley: *Evening Storm, Schoodic, Maine*, 1942
Kandinsky: *Composition VII, Fragment I*, 1913. Sold in 1954
Stella, J.: *Factories*, 1918
Stuempfig: *Cape May*, 1943
Tunnard: *Fugue*, 1938
3 drawings

1944
Balthus: *André Derain*, 1936
Chagall: *Homage to Gogol* (design for curtain), 1917
Feininger: *Viaduct*, 1920
Klee: *Demon above the Ships*, 1916
Kuniyoshi: *Upside Down Table and Mask*, 1940
Masson: *Werewolf*, 1944
Picasso: *Fruit Dish*, 1909
Weber: *The Geranium*, 1911

1945
Braque: *Man with a Guitar*, 1911
Chagall: *Aleko* (67 scenery and costume designs for the ballet), 1942
Léger: *Big Julie*, 1945
Marin: *Lower Manhattan (Composing Derived from Top of Wool-worth)*, 1922
Miró: *The Beautiful Bird Revealing the Unknown to a Pair of Lovers*, 1941
Ozenfant: *The Vases*, 1925
Picasso: *"Ma Jolie,"* 1911–12
Picasso: *Card Player*, 1913–14
Prendergast: *The Lagoon, Venice*, 1898
1 print

1946
van Doesburg: *Rhythm of a Russian Dance*, 1918
Sutherland: *Horned Forms*, 1944
1 print

1947
Braque: *Guitar*, 1913–14
Gontcharova: *Le Coq d'Or* (design for scenery for the ballet), 1914
Moore: *The Bride*, 1939–40
Moore: *Family Group*, 1945
2 drawings and 13 prints

1948
Boccioni: *Unique Forms of Continuity in Space*, 1913
Carrà: *Funeral of the Anarchist Galli*, 1911
Gris: *Breakfast*, 1914
MacBryde: *Woman in a Red Hat*, 1947
Marini: *Horse and Rider*, 1947–48
Mondrian: *Composition C*, 1920
Vlaminck: *Mont Valérien*, 1903
2 drawings and 7 prints

1949
Brancusi: *Fish*, 1930
Chagall: *Birthday*, 1915
Chagall: *Calvary*, 1912
Chagall: *Over Vitebsk*, 1915–20
de Chirico: *The Sacred Fish*, 1919
Kandinsky: *Black Relationship*, 1924
Marini: *Lamberto Vitali*, 1945
Morandi: *Still Life*, 1916

Severini: *Dynamic Hieroglyphic of the Bal Tabarin*, 1912
1 drawing and 5 prints

1950
de Chirico: *The Anxious Journey*, 1913
Kandinsky: *Landscape with Poplars*, 1911. Sold 1955
Klee: *Equals Infinity*, 1932
Picasso: *Harlequin*, 1915
1 drawing and 1 print

1951
Derain: *L'Estaque*, 1906
Matisse: *Reclining Nude, I*, 1907
Signac: *Albenga*, c. 1896
Signac: *Lighthouse*, c. 1896
Signac: *Les Alyscamps, Arles*, 1904
1 drawing

1952
Léger: *The City* (study), 1919
Matisse: *Jeannette, I*, 1910–13
Matisse: *Jeannette, III*, 1910–13
Matisse: *Jeannette, IV*, 1910–13
Matisse: *Jeannette, V*, 1910–13
Matisse: *Interior with a Violin Case*, 1918–19
 Sold 1947. Repurchased 1952
2 drawings and 3 prints

1953
Armitage: *Family Going for a Walk*, 1951
Brancusi: *Mlle Pogany*, 1913
Butler: *Woman Standing*, 1952
Feininger: *The Disparagers*, 1911
Giacometti: *The Artist's Mother*, 1950
Jawlensky: *Head*, c. 1910?
Matisse: Maquettes for a set of red and yellow liturgical vestments, c. 1950. Gouache on paper, cut-and-pasted
Matisse: Chasuble, Stole, Maniple, Chalice Veil, Burse, c. 1950. White silk
Moore: *Mother and Child*, 1938
Pignon: *The Vintners*, 1952
Soulages: *January 10, 1951*
3 drawings

1954
Tchelitchew: *Natalie Paley*, 1931

1955
Sutherland: *Thorn Heads*, 1946

1956
O'Conor: *The Glade*, 1892
Vuillard: *Still Life*, 1892

1959
Rosso: *The Bookmaker*, 1894

1960
1 print

1962
Brô: *Spring Blossoms*, 1962

1967
3 prints

WORKS SOLD TO THE METROPOLITAN MUSEUM OF ART

LISTED BELOW are works sold by The Museum of Modern Art to the Metropolitan under the terms of an agreement dated September 15, 1947 (see page 635). The Metropolitan Museum agreed that whenever these works are exhibited, cataloged, or reproduced, the name of The Museum of Modern Art and that of the original donor to the Museum would appear. The agreement remained in effect for only a few years, terminating in February 1953.

CÉZANNE, Paul.

MAN IN A BLUE CAP (UNCLE DOMINIC). (1865–66) Oil on canvas, $32^{1/4}$ x $26^{1/8}$″. Lillie P. Bliss Collection.

BATHERS UNDER A BRIDGE. (c. 1895–1900) Watercolor, $8^{1/4}$ x $10^{3/4}$″. On reverse: Anatomical drawing (Study of Houdon's *Ecorché*). Pencil. Lillie P. Bliss Collection.

DESPIAU, Charles.

LITTLE PEASANT GIRL. (1904) Original plaster, $15^{3/4}$″ high. Gift of Abby Aldrich Rockefeller.

MME OTHON FRIESZ. (1924) Original plaster, $20^{7/8}$″ high. Gift of Abby Aldrich Rockefeller.

MARIA LANI. (1929) Bronze, 14″ high. Gift of Lillie P. Bliss.

SEATED YOUTH: MONUMENT TO EMIL MAYRISCH. (1932) Bronze, 30″ high. Gift of Abby Aldrich Rockefeller.

KOLBE, Georg.

PORTRAIT OF DR. W. R. VALENTINER. (1920) Bronze, 12″ high. Gift of Abby Aldrich Rockefeller.

SEATED FIGURE. (1926) Bronze, $11^{1/4}$″ high. Gift of Abby Aldrich Rockefeller.

CROUCHING FIGURE. (c. 1927) Terra cotta, $17^{7/8}$″ high. Given anonymously.

MAILLOL, Aristide.

STANDING WOMAN. Bronze, 25″ high. Gift of Abby Aldrich Rockefeller.

PORTRAIT OF RENOIR. (1907) Bronze, 15″ high. Gift of Mrs. Cornelius J. Sullivan, in memory of Cornelius J. Sullivan.

ÎLE DE FRANCE. (1910) Bronze (torso), 43″ high. Gift of A. Conger Goodyear.

SPRING. Plaster, 58″ high. Gift of the sculptor.

WOMAN ARRANGING HER HAIR. Bronze, $13^{5/8}$″ high. Gift of Abby Aldrich Rockefeller.

MATISSE, Henri.

BOUQUET ON A BAMBOO TABLE. (1902) Oil on canvas, $21^{1/2}$ x $18^{1/8}$″. Gift of Mrs. Wendell T. Bush.

GOURDS. 1916. Oil on canvas, $25^{5/8}$ x $31^{7/8}$″. Given anonymously. Repurchased 1952.

INTERIOR WITH A VIOLIN CASE. (1918–19) Oil on canvas, $28^{3/4}$ x $25^{5/8}$″. Lillie P. Bliss Collection. Repurchased 1952.

PICASSO, Pablo.

LA COIFFURE. (1906?) Oil on canvas, $68^{7/8}$ x $39^{1/4}$″. Given anonymously.

WOMAN IN WHITE. (1923) Oil on canvas, 39 x $31^{1/2}$″. Lillie P. Bliss Collection.

REDON, Odilon.

ETRUSCAN VASE. Tempera on canvas, 32 x $23^{1/4}$″. Lillie P. Bliss Collection.

ROUAULT, Georges.

PORTRAIT OF HENRI LEBASQUE. (1917) Oil on canvas, $36^{1/4}$ x $28^{7/8}$″. Purchase.

FUNERAL. 1930. Gouache and pastel, $11^{1/2}$ x $19^{3/4}$″. Given anonymously.

SEURAT, Georges-Pierre.

THE ARTIST'S MOTHER. (c. 1883) Conté crayon, $12^{3/8}$ x $9^{1/2}$″. Lillie P. Bliss Collection.

HOUSE AT DUSK. (c. 1884) Conté crayon, 12 x $9^{3/8}$″. Lillie P. Bliss Collection.

LADY FISHING. (c. 1885) Conté crayon, $12^{1/8}$ x $9^{3/8}$″. Lillie P. Bliss Collection.

SIGNAC, Paul.

VILLAGE FESTIVAL [*La Vogue*]. Watercolor, 6 x $11^{3/8}$″. Given anonymously.

The following works of American folk art are the gift of Abby Aldrich Rockefeller:

HICKS, Edward.

THE PEACEABLE KINGDOM. (First half of 19th century) Oil on canvas, $17^{1/2}$ x $23^{1/2}$″.

THE RESIDENCE OF DAVID TWINING IN 1787. (First half of 19th century) Oil on canvas, $27^{1/4}$ x 32″.

UNKNOWN.

BABY IN RED CHAIR. (c. 1790?) Oil on canvas, 22 x $15^{1/4}$″.

CHILD WITH DOG. (c. 1800) Oil on canvas, $24^{1/4}$ x $15^{1/4}$″.

THE QUILTING PARTY. (1850–60) Oil on wood, $19^{1/4}$ x $26^{1/4}$″.

GLASS BOWL WITH FRUIT. (Early 19th century) Watercolor and tinsel, $18^{1/8}$ x $14^{1/4}$″.

CRUCIFIXION. 1847. Pennsylvania-German quill drawing with watercolor (Fraktur), 14 x $11^{1/8}$″.

HORSE. (19th century) Pennsylvania-German quill drawing with watercolor (Fraktur), 23 x $17^{5/8}$″.

DEER. (19th century) Pennsylvania-German quill drawing, 22 x $29^{1/8}$″.

EAGLE. (19th century) Wood, 68″ high.

HENRY WARD BEECHER. (1850–60?) Wood, 21″ high.

SEATED WOMAN. (19th century) Wood, polychromed, 12″ high.

FISH WEATHERVANE. (19th century) Stamped and cutout copper, $35^{1/2}$″ long.

HORSE WEATHERVANE. (19th century) Cast iron, 21″ long.

COMMITTEES ON THE MUSEUM COLLECTIONS FROM 1929 TO 1967

COMMITTEE ON GIFTS AND BEQUESTS 1929–1933
A. Conger Goodyear, Chairman; Paul J. Sachs; ex officio: Alfred H. Barr, Jr., Director of the Museum.

ADVISORY COMMITTEE'S SUBCOMMITTEE ON THE MUSEUM COLLECTIONS 1940–1941
William A. M. Burden, Chairman; Lincoln Kirstein, Mrs. Duncan H. Read, James Thrall Soby, Monroe Wheeler.

POLICY COMMITTEE FOR THE MUSEUM'S PERMANENT COLLECTION OF MASTERWORKS 1953–1967
William A. M. Burden, Stephen C. Clark, Philip L. Goodwin, A. Conger Goodyear, Mrs. Simon Guggenheim, Mrs. David M. Levy, Henry Allen Moe, Nelson A. Rockefeller, James Thrall Soby, Edward M. M. Warburg, John Hay Whitney; ex officio: Chairman of the Board of Trustees.

ACQUISITIONS COMMITTEE 1934–1944
COMMITTEE ON THE MUSEUM COLLECTIONS 1944–1967
The Acquisitions Committee was superseded in 1944 by the Committee on the Museum Collections, which had similar but somewhat broader responsibilities:
Walter Bareiss, 1956–67
Alfred H. Barr, Jr., 1943–46; ex officio, 1934–36
Armand P. Bartos, 1963–67
William A. M. Burden, 1943–67; ex officio, 1953–59, 1961–65 (Chairman, 1947–50; Vice Chairman, 1965–67)
Stephen C. Clark, 1934, 1938–50 (Chairman, 1934, 1943–44, 1946–47)
Ralph F. Colin, 1954–67 (Vice Chairman, 1958–67)
Philip L. Goodwin, 1937–39, 1950–58 (Vice Chairman, 1950–58)
A. Conger Goodyear, 1934–44, 1947–52
Mrs. Simon Guggenheim, 1940–67
Bartlett H. Hayes, Jr., 1944–46
Mrs. Frederick W. Hilles, 1966–67
Philip Johnson, 1957–67
Sam A. Lewisohn, 1934–40, 1945–50 (Chairman, 1937–39)
Mrs. Sam A. Lewisohn, 1944–45, 1950–54
Mrs. Gertrud A. Mellon, 1953–67

Henry Allen Moe, ex officio, 1959–61
Mrs. Bliss Parkinson, 1957–67; ex officio, 1965–67
Mrs. Charles S. Payson, 1939–40
Gifford Phillips, 1966–67
Miss Agnes Rindge, 1943–46
David Rockefeller, ex officio, 1962–67
Mrs. John D. Rockefeller 3rd, 1950–59, 1962–67; ex officio, 1959–62
Nelson A. Rockefeller, ex officio, 1946–53, 1956–58
Peter A. Rübel, 1958–67
John L. Senior, Jr., 1951–57
Mrs. Bertram Smith, 1959–67
James Thrall Soby, 1940–67 (Chairman, 1944–46, 1950–67; Vice Chairman, 1946–50)
James Johnson Sweeney, 1943–46 (Vice Chairman)
G. David Thompson, 1959–65
Edward M. M. Warburg, 1934–36, 1939–42 (Chairman, 1936, 1939–41)
Mrs. George Henry Warren, Jr., 1943–47
John Hay Whitney, ex officio, 1946–56

COMMITTEE ON THE MUSEUM COLLECTIONS JUNE 1967
James Thrall Soby, Chairman; William A. M. Burden, Ralph F. Colin, Vice Chairmen; Walter Bareiss, Armand P. Bartos, Mrs. Simon Guggenheim, Mrs. Frederick W. Hilles, Philip Johnson, Mrs. Gertrud A. Mellon, Mrs. Bliss Parkinson, Gifford Phillips, Mrs. John D. Rockefeller 3rd, Peter A. Rübel, Mrs. Bertram Smith.

Ex officio: David Rockefeller, Chairman of the Board of Trustees; Adviser: René d'Harnoncourt, Director of the Museum; Junior Council Guests: Mrs. Douglas Auchincloss, T. Merrill Prentice, Jr., Mrs. Alfred R. Stern.

Staff Concerned with the Committee on Museum Collections (with special responsibility for painting and sculpture): Alfred H. Barr, Jr., Director; Dorothy C. Miller, Curator; Betsy Jones, Secretary.

Directors of the other curatorial departments: William S. Lieberman, Drawings and Prints; Arthur Drexler, Architecture and Design; John Szarkowski, Photography; Willard Van Dyke, Film.

PROCEDURE FOR MAKING GIFTS AND BEQUESTS

THE MUSEUM'S COUNSEL and the Directors of curatorial departments are glad to make themselves available for confidential consultation on gifts and bequests to the Museum Collections.

A good many collectors have disclosed privately the list of works which they intend to give or bequeath to the Museum. This is a courtesy of great value to the Museum in forming its collections. It is obviously of even greater value to the Museum if the collector is willing to confirm his intention by making a definite promise (as in the list of Gifts, The Donors Retaining Life Interest, and Promised Gifts, pages 604–10).

For those wishing to bequeath works of art to the Museum, the following form is suggested:

I give and bequeath to The Museum of Modern Art, a New York corporation, my painting (or other work of art) *by* (name of artist) *entitled* (title of work).

Gifts and bequests to The Museum of Modern Art are deductible in computing income or inheritance taxes under the laws of the United States and the State of New York to the maximum limits provided in those laws.

PHOTOGRAPH CREDITS

657

PHOTOGRAPHS of all works in The Museum of Modern Art Collection of Painting and Sculpture are on file in the Museum's Audio-Visual Archive, including those works not illustrated here. Photographs in this book were taken by:

Ansel Adams, Oliver Baker, George S. Barrows, Lee Boltin, Cosimo Boccardi, Eugene Brenwasser, Rudolph Burckhardt, Robert Cato, Geoffrey Clements, Colten Photos, Doris Coulter, George Cserna, E. J. Cyr, Frank J. Darmstaedter, Eliot Elisofon, Gerald Howson, Peter A. Juley & Son, Kate Keller, H. T. Koshiba, Nicholas Lothar, Robert Mallary, James Mathews, Herbert Matter, Robert R. McElroy, Peter Moore, O. E. Nelson, John S. Nichols, Rolf P. Petersen, Eric Pollitzer, Percy Rainford, Walter Rosenblum, Walter Russell, John D. Schiff, Robert M. Schiller, Jr., Edward Steichen, Hugh J. Stern, Adolph Studly, Soichi Sunami, Charles Uht, Malcolm Varon.